N

CARROLL

Westminster •

Susquehanna R.

Delaware R.

VA

49 51
75
65 Wilmington •

56 66

CECIL

53

72

HARFORD

73

Aberdeen •

55

CASTLE

NEW
JERSEY

50

63 58

60

54

BALTIMORE

61 70

33 Baltimore

59 44

HOWARD 67 37 Hart-Miller
Island 39

68 74
Columbia •

38

MONTGOMERY

45

ANNE
ARUNDEL

48

47 Washington,
DC

42

36 34

104 41

35

99

PRINCE
GEORGES

40

03
102

01

CHARLES

Patapsco R.

KENT

Chester R.

8

QUEEN
ANNES

11 Eastern Neck
National Wildlife Refuge

31

CAROLINE

20

TALBOT
Easton •

Poplar
Island

23

28

Patuxent R.

Choptank

6

CALVERT

43

32

Cambridge •

DORCHESTER

4
Blackwater National
Wildlife Refuge

ST. MARYS

12

14

5
Bombay Hook
National Wildlife Refuge

Dover • 16

26

KENT

10

1

24

19
Rehoboth Beach •

SUSSEX

15

29

21

Salisbury •

WICOMICO

DELAWARE
BAY

108
Cape
May

Cape Henlopen
State Park
7

Indian
River
Inlet

3

Ocean City •

17
Ocean City
Inlet

2
Assateague Island
National Seashore

WORCESTER

22

30

Rappahannock R.

Potomac River

CHESAPEAKE
BAY

9

SOMERSET

13

46

25

105

98
Chincoteague National
Wildlife Refuge

Chincoteague Bay

VA

ATLANTIC
OCEAN

D1538963

BIRDS *of* Maryland, Delaware, *and the* District of Columbia

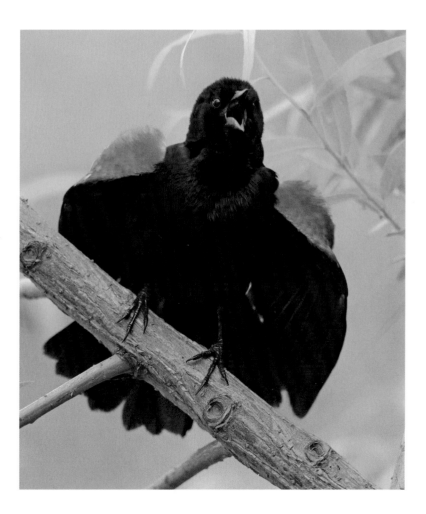

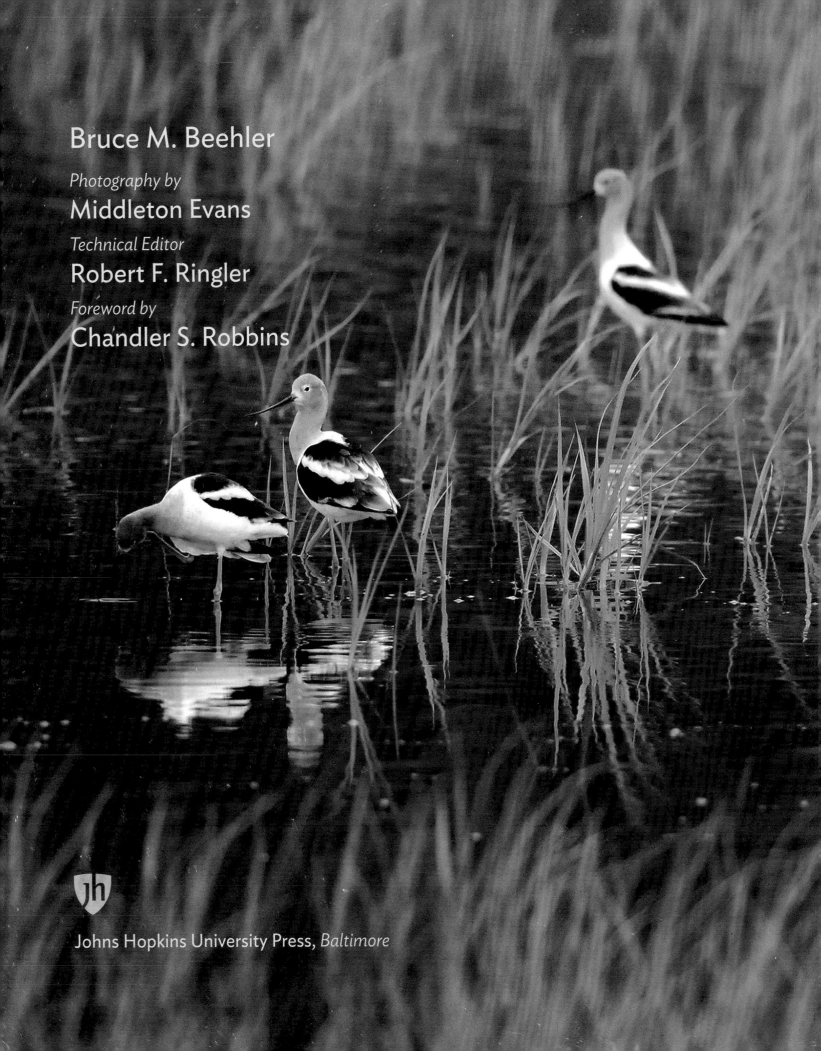

Bruce M. Beehler

Photography by
Middleton Evans

Technical Editor
Robert F. Ringler

Foreword by
Chandler S. Robbins

Johns Hopkins University Press, *Baltimore*

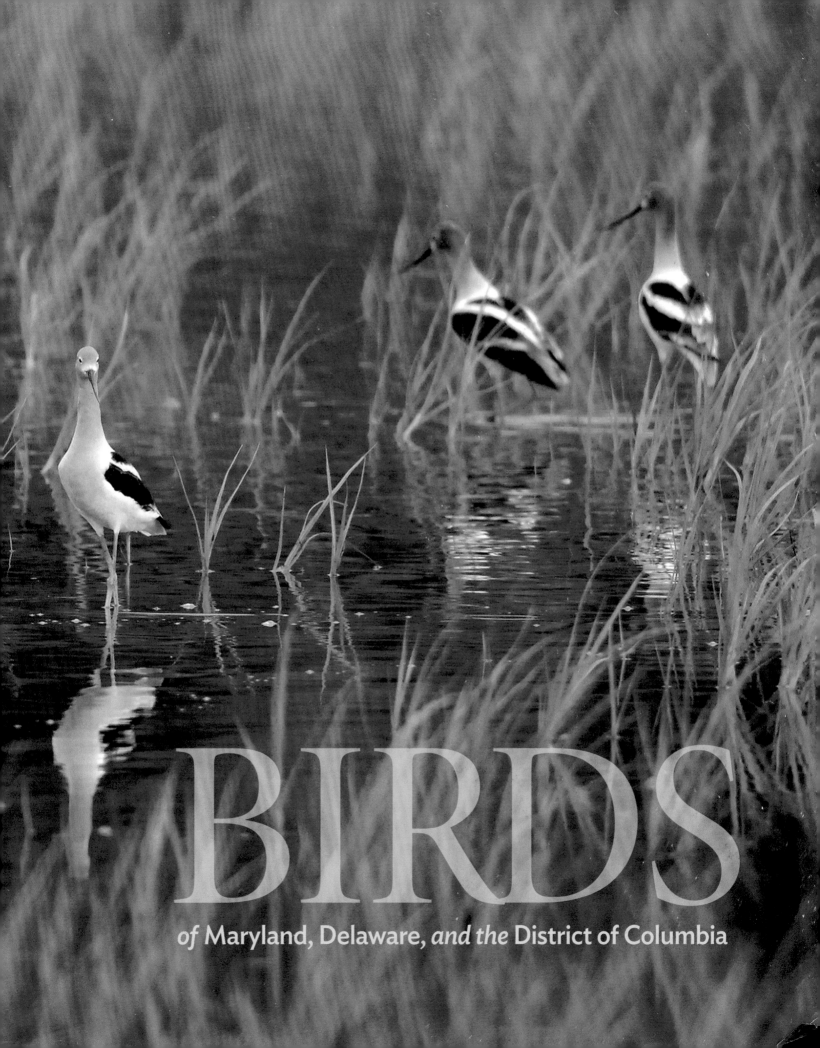

BIRDS

of Maryland, Delaware, and the District of Columbia

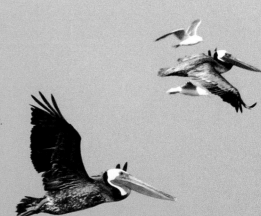
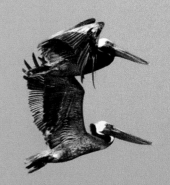

Johns Hopkins University Press
2715 North Charles Street
Baltimore, Maryland 21218-4363
www.press.jhu.edu

Library of Congress Cataloging-in-Publication Data
Names: Beehler, Bruce McP., author.
Title: Birds of Maryland, Delaware, and the District of Columbia / Bruce M. Beehler; photography by
 Middleton Evans ; technical editor Robert F. Ringler; foreword by Chandler S. Robbins.
Description: Baltimore : Johns Hopkins University Press, 2019. | Includes bibliographical references and index.
Identifiers: LCCN 2018023755 | ISBN 9781421427331 (hardcover : alk. paper) | ISBN 1421427338
 (hardcover : alk. paper) | ISBN 9781421427348 (electronic) | ISBN 1421427346 (electronic)
Subjects: LCSH: Birds—Maryland. | Birds—Delaware. | Birds—Washington (D.C.)
Classification: LCC QL684.M3 B44 2019 | DDC 598.09751—dc23
LC record available at https://lccn.loc.gov/2018023755

A catalog record for this book is available from the British Library.

Page i: A bold male Red-winged Blackbird announces his territory in the marsh. *Title-page spread:* American Avocets in breeding plumage make a spring stopover at Bombay Hook National Wildlife Refuge on the Delaware coast. *Pages iv–v:* A squadron of Brown Pelicans patrols its colony near Smith Island on the lower Chesapeake.

Maps on endpapers and on page 13 by Bill Nelson.

Special discounts are available for bulk purchases of this book. For more information, please contact Special Sales at 410-516-6936 or specialsales@press.jhu.edu.

Johns Hopkins University Press uses environmentally friendly book materials, including recycled text paper that is composed of at least 30 percent post-consumer waste, whenever possible.

Sana and Andy Brooks, who generously supported the production of this book, wish to acknowledge their mothers, Cassandra Stewart Naylor and Natalie Brooks Barringer, for showing them the wonders of the natural world, especially the joy that comes from bird-watching.

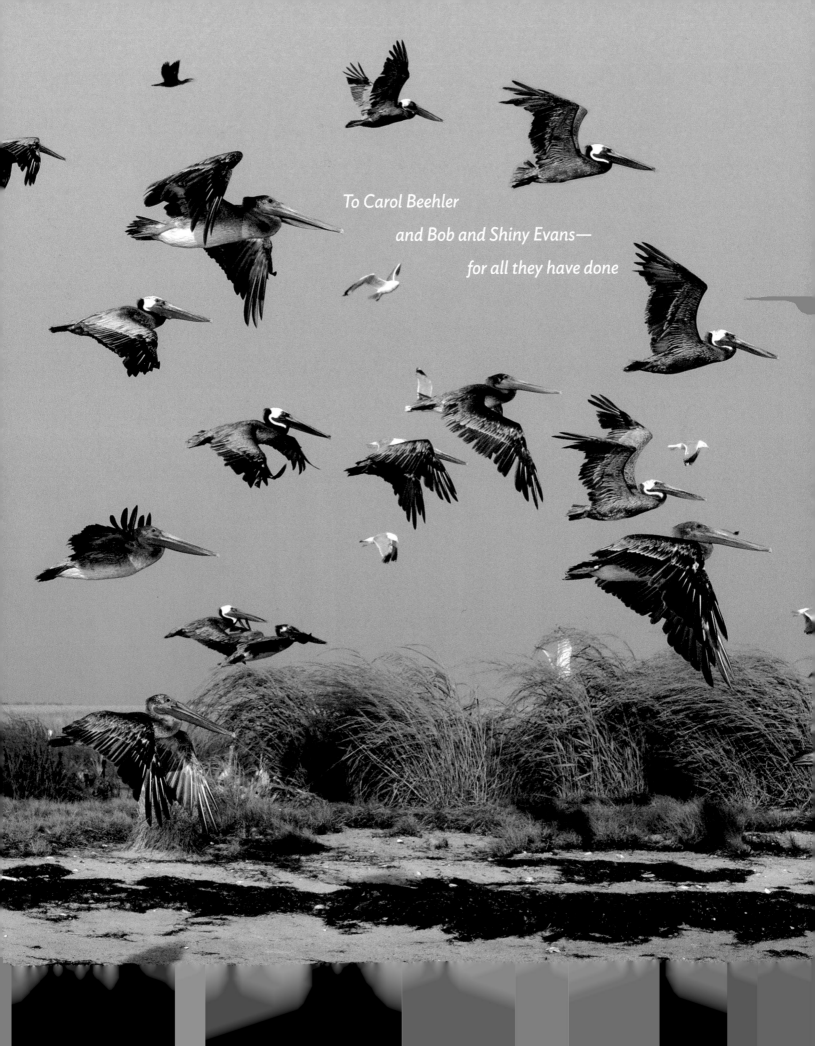

To Carol Beehler

and Bob and Shiny Evans—

for all they have done

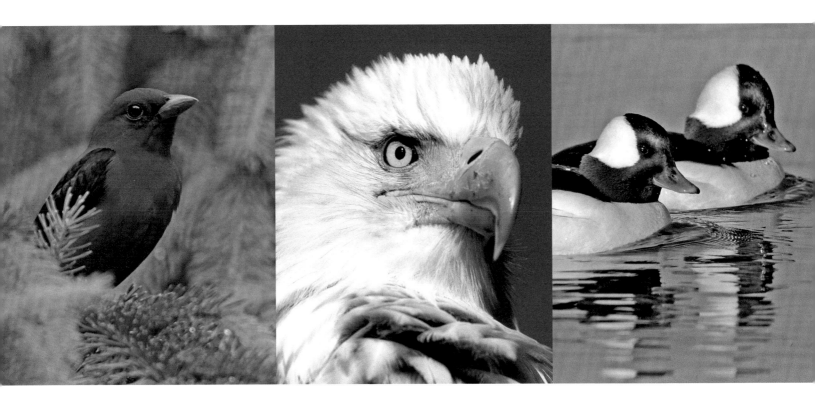

A kaleidoscopic sampler of our Region's birds; features (*left to right*) Scarlet Tanager, Bald Eagle, Bufflehead, Yellow Warbler, Short-eared Owl, and Ring-necked Pheasant.

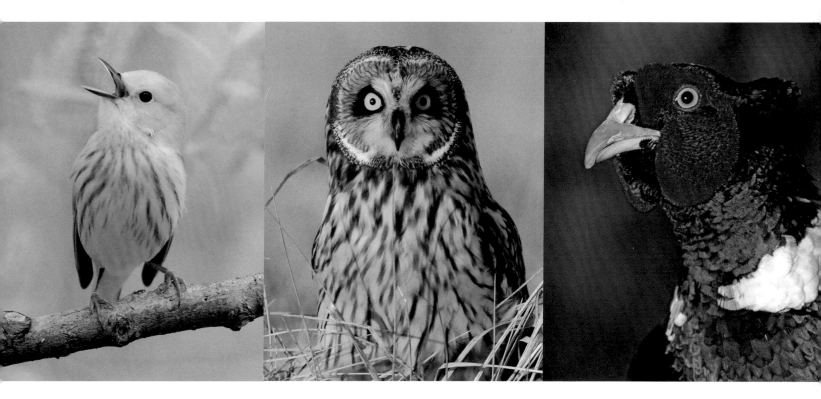

Contents

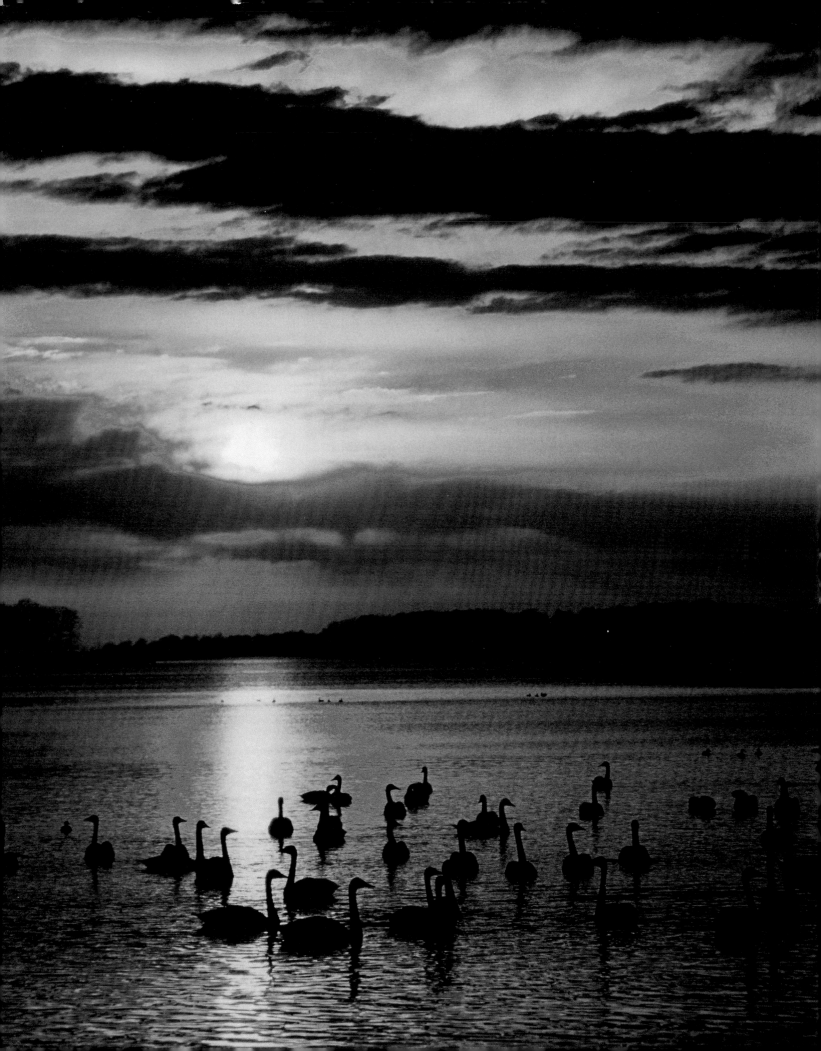

When Robert Stewart and I published our *Birds of Maryland and the District of Columbia* in 1958, the single artistic illustration in that work was a monochrome rendition of a lovely painting of two Bald Eagles hovering over a fish, painted by Louis Agassiz Fuertes. We were pleased to be able to include that wonderful painting by one of America's greatest bird illustrators. Little did we know that six decades hence, local bird books would be able to feature glorious full-color photographs of literally hundreds of our region's birds—the result of a revolution in the printing process. Of course, digital cameras have also revolutionized bird photography. Now, just about anybody can capture a stunning image of a bird just by being in the right place at the right time. In reality, the main engine of these revolutions in cameras and printing is the digital computer, which in 1958 was only an imaginative concept being put forward by several very smart engineers at Texas Instruments and Fairchild Semiconductor.

In 1966, when, with Bertel Bruun and Herbert S. Zim, I published *A Guide to Field Identification: Birds of North America*, we were happily able to feature an abundance of full-color bird illustrations produced by artist Arthur Singer. We included more than fifteen hundred distinct plumages and different poses in our book. That in itself was revolutionary for a bird book—all in a field guide that was a mere 4.5 × 7.5 inches—a book you could slip into the back pocket of your jeans while out birding. Over the decades, millions of birders of all skill levels, from students to professionals, learned from and utilized our field guide.

Wintering Tundra Swans on the Magothy River await the day's harvest.

Of course, time has marched on, and decade by decade the North American birding field guides have grown larger and more sumptuous and more profusely illustrated with ever-better paintings and range maps that capture the essence of the biodiversity of this wonderful continent. With the advances in binoculars and spotting scopes, the advent of eBird, and the arrival of smartphone birding apps, the birders in North America have it relatively easy today.

Now back to the region and this new bird book. Middleton Evans's photographs are stunning and evocative. These images are certain to draw in a whole new generation of local bird lovers—new birders, both young and old. It is never too late to pick up birding—nor too early for that matter. Every birder is also free to choose his or her level of involvement. Some will evolve into globe-trotting listers, whereas others will be happy watching the bird species that wander into their backyards. There are so many ways to be a birder these days.

One or two who read and use this new book may grow up to become professional ornithologists. The book's author, Bruce Beehler, told me that as a young boy he had a copy of my *Birds of Maryland* and that it was one of the inspirations for his career in ornithology. I don't remember it, but Bruce as a young boy joined up on bird trips in the early 1960s that I led in the winter to Cape Henlopen and in the spring to Pocomoke Swamp. In addition, he assisted me with bird-netting at the Maryland Ornithological Society's Junior Nature Camp at Camp Woodbine some five decades ago. These kinds of firsthand experiences are what spur some youngsters to devote their lives to birds and to do the hard work necessary to become a research biologist or field ornithologist. I am so pleased that some of the young people whom I have mentored grew up to carry the torch forward.

If you live in Maryland or in the District of Columbia, I encourage you to join the Maryland Ornithological Society and take advantage of all the fun and educational things that the MOS does in the region. If you live in Delaware, then consider joining the Delmarva Ornithological Society or the Delaware Valley Ornithological Club. These groups are great for the whole family.

Our work on behalf of birds, of course, is never done. Bird research will continue, generation after generation—there is so much yet to learn. Moreover, the fight to preserve all of our Region's birds and their critical natural habitats will never end. Each generation has an equal responsibility to protect those precious green spaces that are so near and dear to our hearts. If each and every one of us commits to look out for just one nearby woodland or wetland, we can ensure that these special places will be there for our grandchildren. These places

that give us the most joy are the places where our favorite birds sing, feed, roost, and nest. I am confident that this book will inspire its readers to learn to love birds and to care about the natural world around us. Knowing and caring people are what the world needs to meet the future and to ensure a better world tomorrow.

<div align="right">Chandler S. Robbins</div>

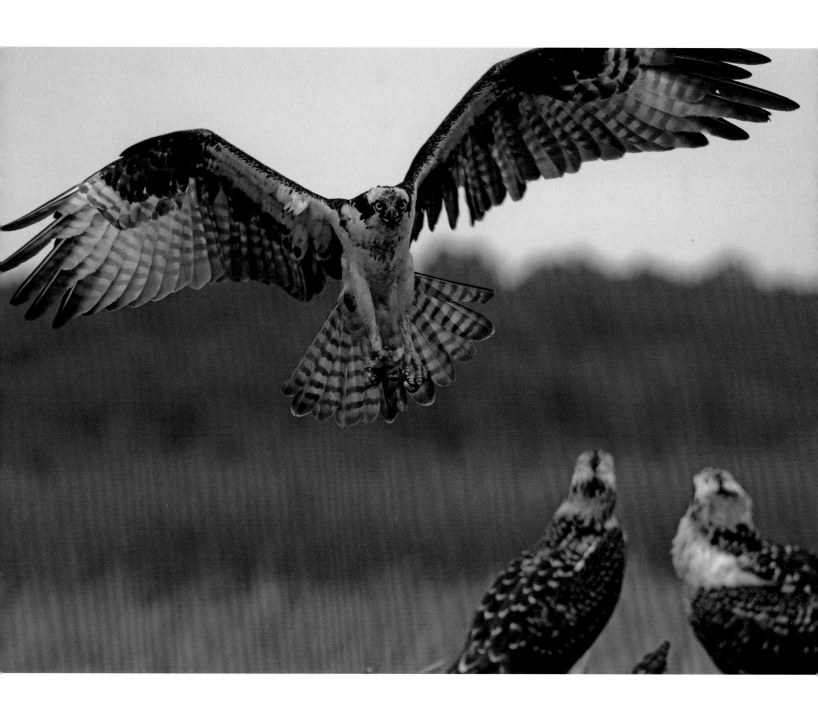

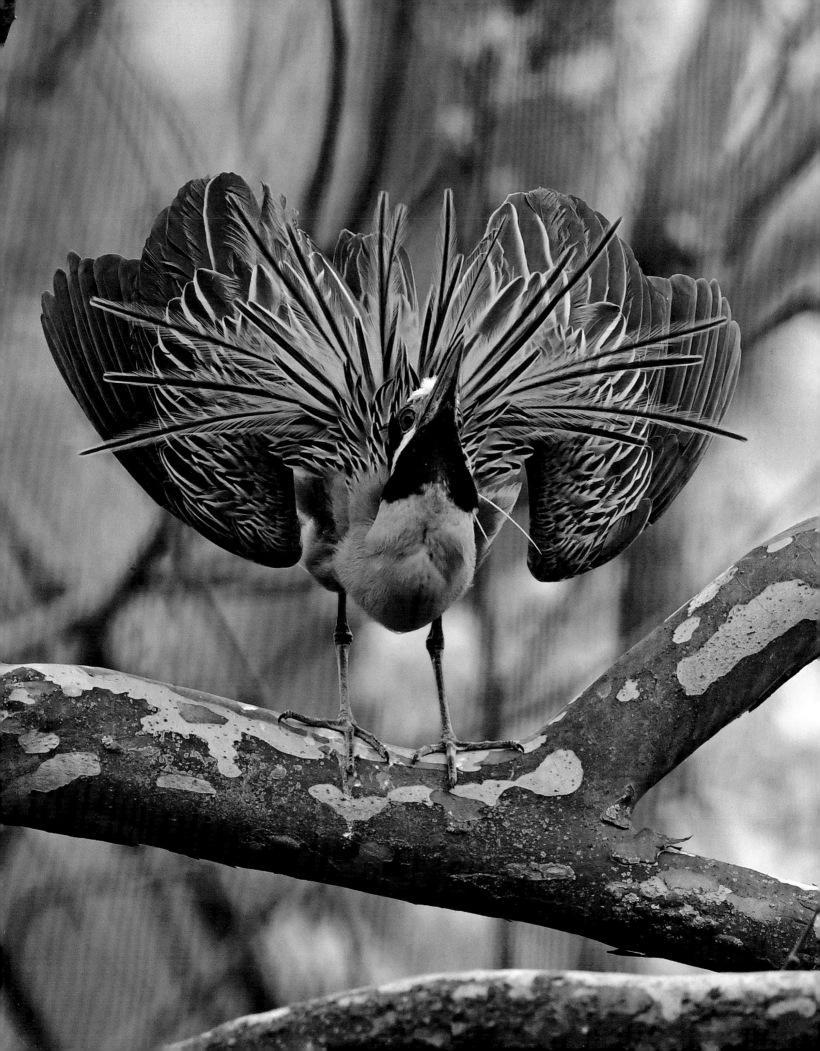

Acknowledgments

This book is the outcome of a group effort. The project was founded upon decades of bird photography carried out by Middleton Evans, focused on the Mid-Atlantic Region. It was Evans and Johns Hopkins University Press's science editor, Vincent J. Burke, who reached out to Beehler to join the project team as author. Beehler, in turn, asked his wife, Carol, to create an initial design for the book, and Bob Ringler, historian of Maryland birds, to serve as technical editor. This book is also built upon a partnership with the Maryland Ornithological Society (MOS) and its leadership, especially Barbara Johnson, Tom Strikwerda, Robin Todd, and David Webb. It has been great to have the MOS as institutional sponsor. In addition, we could not have accomplished this project without the guidance of Johns Hopkins University Press.

Putting together a book like this takes time and costs money. Both Beehler and Evans were fortunate to have the considerable time needed to bring together all its component pieces—the amazing imagery, the narrative chapters built upon scores of technical reference sources, and the personal knowledge acquired from hundreds of hours spent in the field observing and photographing birds year-round in our Region. On the financial side, the MOS was kind enough to agree to manage the funds contributed to the completion of this project over several years. We received generous donations from several sources that made the completion of this book possible. We recognize the Charles S. Bauer Foundation, the Midden-

With bows of gratitude for a willing mate, a Yellow-crowned Night-Heron struts above a promising nest site overlooking the Jones Falls in Baltimore City.

dorf Foundation, the Sana and Andy Brooks Fund, the France-Merrick Foundation, the Vane Brothers, Henry Rosenberg, and several anonymous donors for their generous contributions to the project.

The following people read sections of the book or provided critical review of tables or data: Henry T. Armistead, Margaret Barker, Jim Collatz, Phil Davis, Richard Donham, Matt Hafner, Barbara Johnson, Lucie Lehmann, Mikey Lutmerding, Bruce Peterjohn, Frank Rohrbacher, Ian Stewart, Tom Strikwerda, Sherman Suter, Robin Todd, and Sister Mary Winifred. Finally, Jane, Andrea, George, Stuart, and Nancy Robbins critically read and edited the foreword after the passing of Chan Robbins, who provided spiritual inspiration for this project.

This book depends a great deal on wonderful color images of natural environments in the Region as well as most of the Region's birds. The vast majority of these images was shot by Middleton Evans. But we also wish to acknowledge the generous contributions to this collection by the following expert nature photographers: Marie-Ann D'Aloia, Bruce Beehler, William Burt, Tim Carney, Chip Clark, J. B. Churchill, Keith Eric Costley, H. David Fleischmann, Mark L. Hoffman, Daniel Irons, Mark R. Johnson, Ryan Johnson, Josie Kalbfleisch, Emily Carter Mitchell, Frank Nicoletti, Bonnie Ott, Gene Ricks, Kurt R. Schwarz, Anthony VanSchoor, and W. Scott Young. We could not have wrapped this project up without their help. We also thank Bill Nelson, the cartographer who crafted the beautiful maps on the endpapers and in chapter 2.

We here offer thanks to our colleagues at Johns Hopkins University Press. Vincent Burke never lost faith in this project; he can be credited with making it all happen. Tiffany Gasbarrini took over from Vince and got us through the contract stage. Andre Barnett expertly copyedited the manuscript and its revision. Along the way, Lauren Straley provided all manner of assistance. Finally, Martha Sewall helpfully explained the design process, and Tracy Baldwin crafted the lovely design of the book, based on an initial concept provided by Carol Beehler.

Terms, Abbreviations, and Acronyms

Terms of Abundance and Occurrence

All refer to birding counts made in the appropriate season and habitat for the species in question:

Abundant: 20+ per day

Common: 1 to 15 per day

Uncommon: Seen as singletons or in small numbers on most but not all days

Rare: Expected to be seen once or twice a year by a good birder in the Region

Very rare: 1 to 5 records per year in the Region (from all observers combined)

Accidental: A species well outside of its geographic range with fewer than 10 records for the Region (from all observers and years combined)

Singleton: A single bird of a species, as in: "The Little Blue Heron is typically seen as a singleton."

Terms of Occurrence

Irruptive visitor: A species that visits the Region in numbers every few years but which is absent or very rare in the Region during typical years.

Passage migrant: A species found in the Region only during its passage northward in spring or southward in autumn.

Vagrant: A species that appears in the Region only when wandering out of its regular geographic range.

Visitor: A nonresident species that visits the region from time to time.

Geographic Terms

The Region: Maryland, Delaware, and the District of Columbia

The two bays: Chesapeake Bay and Delaware Bay

Atlantic bays / Atlantic estuaries: The small embayments behind the coastal Atlantic beaches and barrier islands of Delaware and Maryland (Rehoboth Bay, Indian River Bay, Little Assawoman Bay, Assawoman Bay, and Sinepuxent Bay)

The Provinces: Eastern Shore, Western Shore, Piedmont, Ridge & Valley, and Allegheny Highlands

East: The eastern United States

North: The northern United States and Canada

South: The southern United States

West: The western United States and Canada

Abbreviations

DE	Delaware
DC	District of Columbia (Washington, DC)
MD	Maryland
NA	Natural Area
NWR	National Wildlife Refuge
SP	State Park
WA	Wildlife Area
WMA	Wildlife Management Area

These Bobolinks in Garrett County use trees overlooking a lush meadow to look for danger before dropping down to their ground nest.

BIRDS *of* Maryland, Delaware, *and the* District of Columbia

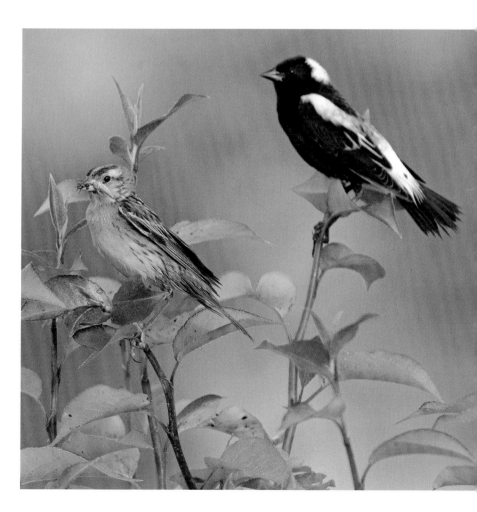

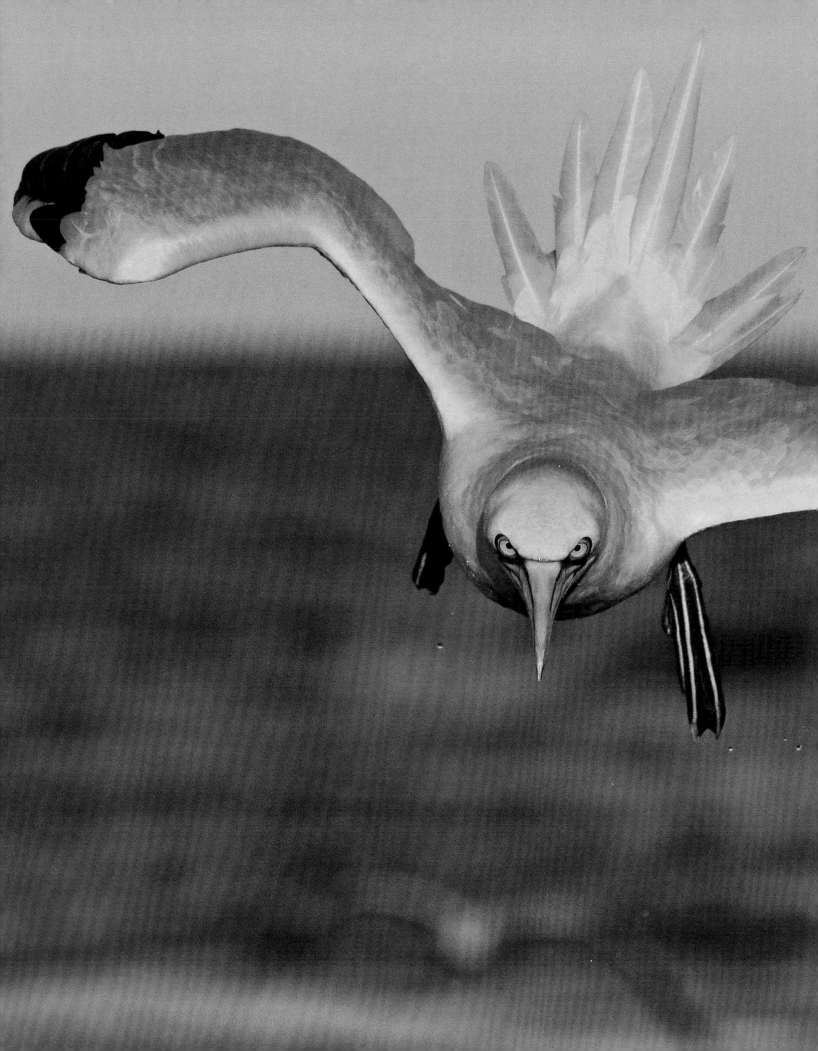

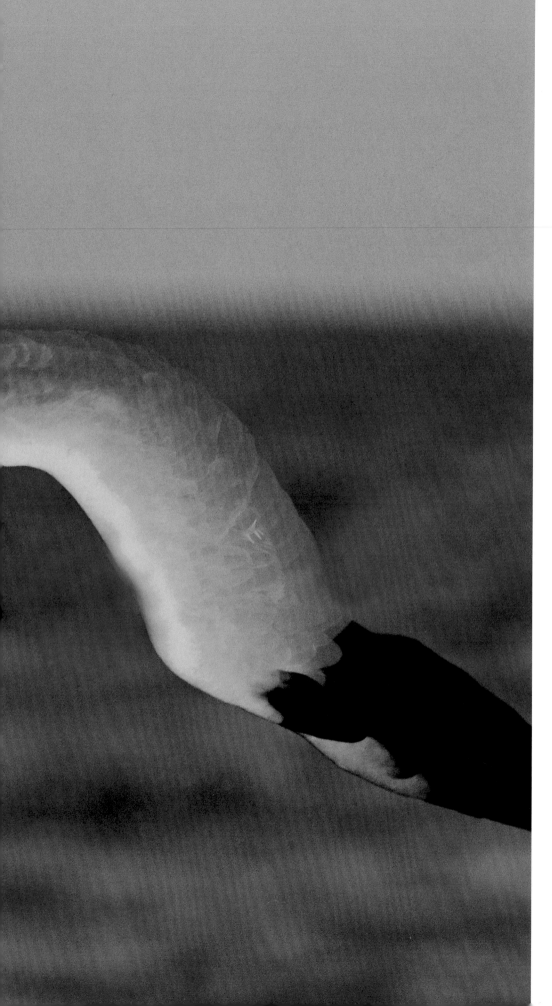

A Northern Gannet
dives with a surface
fish locked in his sights.

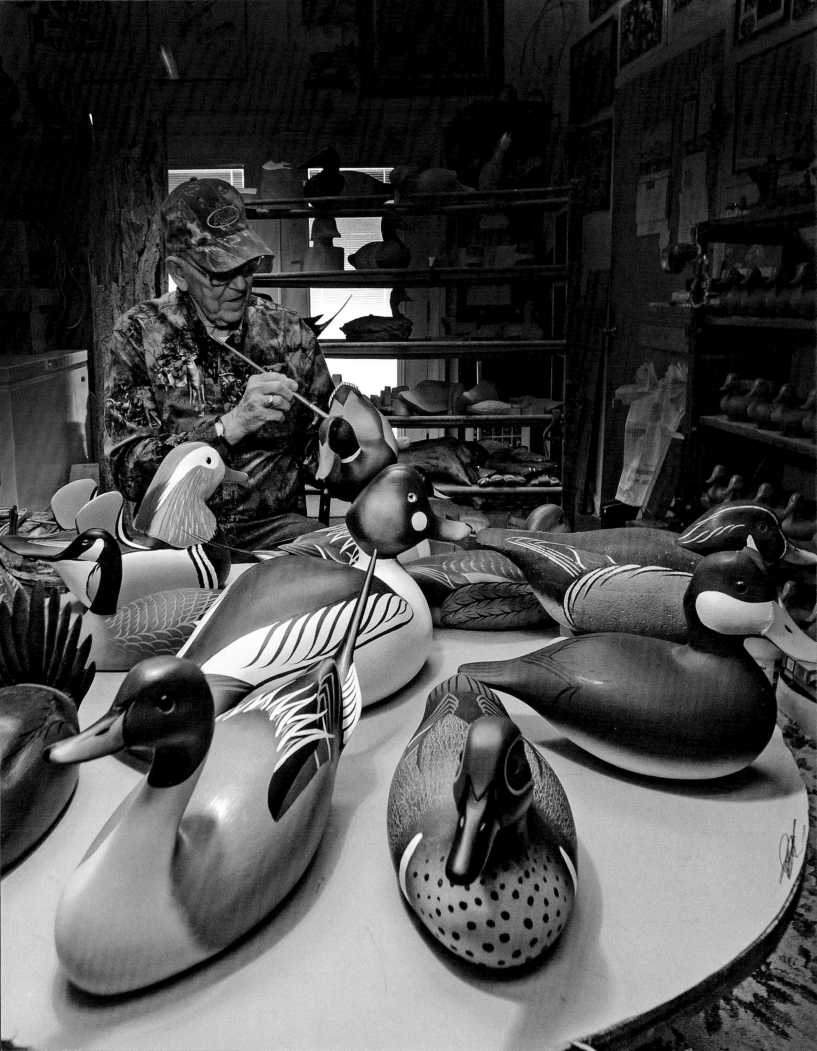

Appreciating Our Birdlife and the Gentle Art of Birding

Birds are a gift from Nature. They are all around us. Virtually all of us benefit from and enjoy the presence of birds in our world. Some of us like seeing them in our backyards. Some like photographing or drawing them. Some enjoy carving decoys or small wooden decorative birds. Some love hunting waterfowl or upland game birds. There are many ways that birds enter our lives to help us enjoy the natural world around us. They are truly ambassadors from Nature.

Every human society in history has left behind evidence that it recognized birds as important to human well-being and everyday life. Egyptian wall friezes featured geese and ducks, and ibises and falcons were the focus of painstaking mummification rituals in recognition of their deity status. Depictions of birds in Mughal art in India were so accurate that many species can still be identified, half a millennium after being painted. Even traditional rainforest-dwelling societies of New Guinea commonly use birds for totemic identification of clans, in much the same way that, today, avian imagery is artfully deployed to help us identify with local professional and college sports teams. An abundance of Raven, Oriole, Eagle, Blue Jay, and Blue Hen iconography appears on cars and flags and shirts and hats in our Region. Our curiosity about birds, our appreciation of their beauty, and our fascination with their behavior make bird-watching something that is practically hardwired in us. Who knows, maybe there is a bird-watching gene hidden in our DNA. It is no wonder that we take notice of and find pleasure in birds on a regular, even daily, basis.

Veteran decoy carver Bill Schauber, of Chestertown, MD, puts the finishing touches on a drake Mallard.

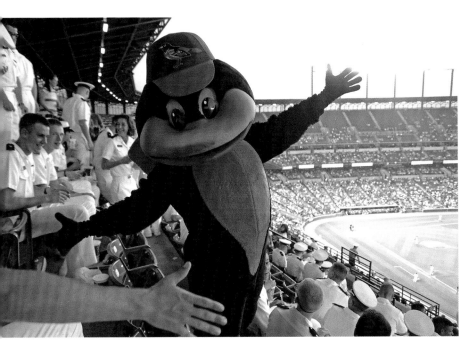

The Baltimore Orioles mascot whips up fans from the US Naval Academy at an Oriole Park night game.

Many of us took up the avocation of bird-watching at home, as children. Peering through the kitchen window, we saw, hanging on the suet feeder, a lovely feathered creature with a glossy red patch atop its head and black-and-white zebra barring on its back. We immediately wanted to know the name of that beautiful bird. For those lucky children with enlightened parents, there was a field guide by Robbins or Peterson lying near the window for this express purpose. Aha! A male Red-bellied Woodpecker.

Birders who start young are blessed with a re-current source of joy that may last all their days. These bird lovers as youths got to train their brain while it was still fresh and efficient at data storage and retrieval, making the intricacies of identifying birds by sight and sound almost second nature. Others start the hobby in college with a course in ornithology, and still others do not begin until retirement, perhaps at the urging of a neighbor, a family member, or a friend. Today, the United States has a staggering 45 million bird-watchers. Most of them simply enjoy looking at birds in their yard, but 16 million travel to go birding. These bird lovers spend some $76 billion annually on their hobby—the same amount spent each year

on fishing and hunting. Birding is big business and part of the fabric of our national recreational lifestyle.

Birds enter our lives through other avocations as well. Game hunting in our Region is a wide-spread and popular pastime. Hunters target ducks, geese, Mourning Doves, Wild Turkey, Ruffed Grouse, American Woodcock, Wilson's Snipe, and several rail species. Bird-hunting seasons come in fall and winter as well as in spring. Our two bays offer prime habitat for all sorts of waterfowl in large numbers. Hunters learn the types of game birds, not only to make sure they are meeting all regula-tions on harvest, but also because they fall in love with these beautiful birds.

Falconers practice their ancient sport in the Region, in smaller numbers. These lovers of raptors (hawks, eagles, and falcons) train their birds of prey to hunt a variety of game birds. Commonly trained species include the Red-tailed Hawk, Harris's Hawk, and Peregrine Falcon.

A less predatory means of demonstrating one's love of game birds is the art of decoy carving. Historically, decoys were crafted to deploy in a hunting area to draw in game birds or waterfowl to a position where the approaching birds could be shot from a blind. In our Region, typically, a raft of floating duck or goose decoys are set out on the water to bring the day's quarry within range. Today, most decoy carvers are hobbyists and arti-sans who produce miniature decoys for sale to col-lectors—mainly hunters and bird lovers. Annual bird-carving shows and competitions are a major tourist attraction on the Eastern Shore of Mary-land. The Ward Museum of Wildfowl Art in Salis-bury, Maryland, hosts one such competition, and an annual Waterfowl Festival is hosted in Easton, Maryland.

Aside from decoy carving, birds are also the focus of sculpture and painting by a large cadre of practitioners, delivering beautiful art objects to a discerning and knowledgeable public. Bird art has been a popular focus of collectors since

the days of John James Audubon and his double elephant folio *Birds of America.* Aficionados today assemble collections of watercolors, oil paintings, sculptures, and color photography. Bird art today is booming as more and more bird-loving people with disposable incomes are gracing their homes with craftwork featuring game birds, songbirds, and other aspects of nature. These bird lovers, whether they enjoy collecting art or simply watching birds, are a growing market for bird books, which help them identify what they see or what they have collected.

Some among us never venture beyond the occasional backyard bird experience—from time to time reminding ourselves of the name of a particular bird visiting our well-stocked feeder. For the feeder watchers, as well as those who wish to take the next step and become active birders and lovers of birdlife, we offer this book. Here we present the 469 species of birds officially recorded in Maryland, Delaware, and the District of Columbia. This number includes 199 breeding species, some regular migrants, and quite a number of occasional or irregular visitors of various sorts.

This book differs from most state or regional bird books. Today, the most common of these are the state atlases, which provide coded breeding range maps of birds based on a five-year volunteer count of nesting birds across that state, block by block. (For Maryland and Delaware atlases, each block aligns with a quadrangle of 5 × 5 kilometers, representing one-sixth of a standard 7.5 minute US Geological Survey topographic map.) Also prevalent are bird-finding guides, which list where and when to find bird species in a state or region (e.g., Claudia Wilds's 1992 volume, listed on page 284). These point to the best time and place to find a species in the Region. A third type is the state bird book. This was last published for Maryland and the District of Columbia in 1958 and for Delaware in 2000. State bird books are annotated lists of all the species recorded for the state, with information on distribution, abundance, migration, nesting, and other life history details. Finally, there are the field identification guides, which have proliferated over

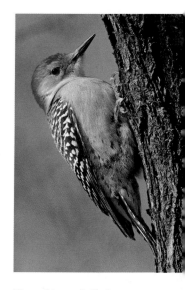

The striking male Red-bellied Woodpecker is a feeder favorite, attracted to suet cakes hanging in the backyard.

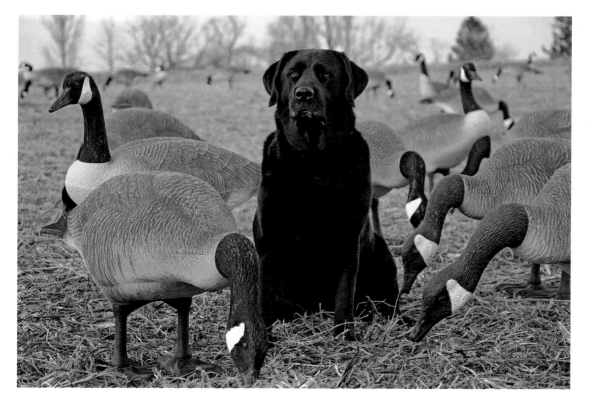

Labrador retrievers, such as Annie of Edwards Ranch, are beloved hunting dogs and family companions, quite strong enough to collect a big goose.

the years. These are profusely illustrated with photographs or paintings, together with a brief text and range map to aid the reader in identifying each species. The field guides typically cover a broad geographic area—say, eastern North America.

All of these books are useful resources for getting to know the birds in your hometown, county, or state. However, these tend to be based on a strict formula and present the birds in a formal taxonomic sequence, species account by species account. For a reader wanting to learn about the birdlife in a local context, the traditional books tend to be dominated by a long series of detailed species accounts, where one can lose the forest for the trees.

Here, we seek to break free of these traditions to help the reader appreciate the glory of birds in their natural habitats, in part by grouping birds that have similar habits and environmental needs. The book

Waterfowl Festival guests queue up in Easton, MD, every November to peruse artworks from the nation's premier wildlife artists.

also includes a set of tools for finding, identifying, and learning about the birds in the Region. And, finally, with more than 600 color images of birds and their favored habitats, we immerse the reader in the entire Regional bird fauna, highlighting the diversity of size, shape, behavior, and plumage, as well as the range of natural habitats.

This book, then, is intended to be a companion reference to the field guide, state atlas, and traditional state bird book (though it provides a mix of the useful information found in each of these companion volumes). It is not a book to be taken into the field, but one to be read and reviewed at leisure during evenings or weekends. After spending time at the shore, on the bay, or in the mountains, come back to this book and learn more about the birds that enlivened your trip. Also, we hope you use the tools in the third part of the book to plan your next field trip, perhaps one that is focused exclusively on birds.

Plan of the Book

The remaining chapters of this introduction focus on the geography, physiography (physical geography), and natural environments of the Region (we use "the Region" to refer to the entirety of Maryland, Delaware, and the District of Columbia). This first part also includes chapters on the two great estuaries in the Region (the Chesapeake and the Delaware), bird feeding, and landscaping for birds, as well as introductions to birding in urban, suburban, and rural/agricultural landscapes, bird seasonality, and conservation.

The introduction is followed by part two, a series of chapters on each of the 12 major eco-morphological groupings of birds: The Waterfowl; Marsh and Wading Birds; Coastal Waterbirds; Shorebirds; Birds of the Open Ocean; Birds of Prey; Birds of Countryside, Farm, and Field; Aerial Feeders; Neighborhood, Backyard, and Feeder Birds; Sparrows and Their Terrestrial Allies; Warblers and Look-alikes; and Orioles, Blackbirds, and Colorful

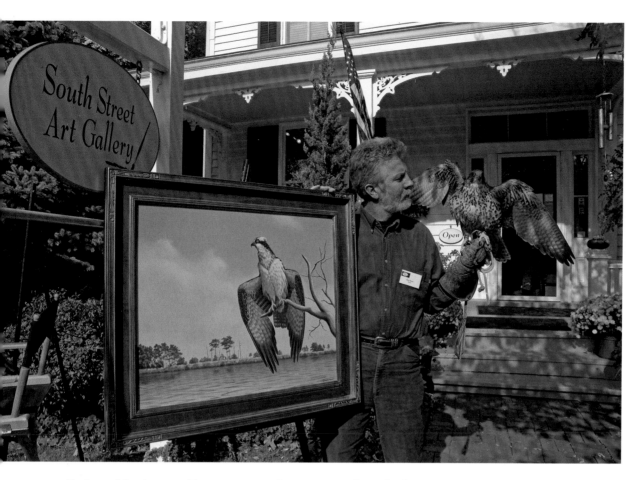

Acclaimed wildlife painter Jonathan Shaw, of Queenstown, MD, displays avian masterpieces at the South Street Art Gallery.

The ancient sport of falconry has a few devotees in our Region, including Kim Gough, with a pair of Harris's Hawks.

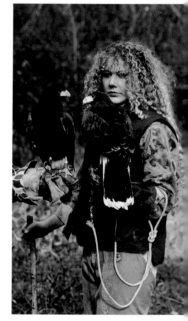

Fruit- and Seed-eaters. These summary chapters form the meat of the book, and they are illustrated with a selection of regularly occurring Regional species to give the reader a full appreciation of each group. Each text account begins with general details on the ecology, distribution, and habits of the birds within that group, and then presents a narrative for each species.

The third part of the book offers the reader a selection of birding tools. Chapter 21 discusses the best birding apps and websites. These relatively recent developments have rapidly become an essential part of the birder's arsenal, both in the field and at home. Chapter 22 focuses on birding hardware, such as binoculars, telescope, and field guides—the kind of stuff (still essential) that predates the electronic gear featured in chapter 21. Chapter 23 provides advice on planning a birding field trip, short or long. Chapter 24 lists and describes important institutions relevant to birding and ornithology, which will be essential if you intend to pursue birding as a hobby for the rest of your life. We end this third part of the book with chapter 25, an annotated list of ornitho-

logical references, providing further topical reading and study for the decades to come.

The fourth and final part serves as a bird-finding guide for the Region. Chapter 26 is a photographic atlas and finding guide. Here you will have at your fingertips thumbnail illustrations of all the regularly occurring birds in the Region, accompanied by brief texts to help you locate each species in season. Chapter 27 gives brief descriptions of the birds rarely recorded in the Region, with abbreviated texts and some illustrations of the more prominent of these species. Chapter 28 is a coded birder's checklist of all the birds recorded in the Region. This coded list boils down relevant data on each species' abundance, status, habitat preferences, seasonal occurrence, and distribution within the Region. Finally, chapter 29 provides an annotated listing of the best birding localities in and around the Region. We also include, as a bonus, a short list of nationally recognized birding sites adjacent to our Region—ones we all should visit from time to time.

Natural Geography and Local Bird Provinces

This book presents the birdlife of Maryland, Delaware, and the District of Columbia (see the map on the endpapers for geographic details). The irregular polygonal shape of the Region constitutes an east-west slice of the middle of the East Coast, from the open seas of the Atlantic Ocean westward to the Allegheny Highlands and a small sliver of the Mississippi River drainage. The Region thus includes a diversity of ecosystems and climates, despite its small size. This geographic and environmental breadth is a boon to bird-watchers eager to add to their life lists. Within a rather confined geography, the adventurous birder can visit habitats that are highly distinct, each with its own unique bird fauna. More habitats means more birds—and more fun for the birder.

Geographic and Geomorphological Overview

Our Region ranges from Gulf Stream pelagic ocean waters to the high Allegheny Plateau, which drains into the continental interior. Between these two extremes lie two of America's greatest estuaries, cutting north-south across the Region, and a series of parallel ridges of great geological antiquity, rising ever-higher as one travels westward. The high point in the Region is Backbone Mountain in westernmost Maryland, rising to 3,360 feet above sea level. This is the local high point of the Allegheny Plateau, a rocky and rugged upland surface mostly above 2,000 feet in elevation. Substantial river systems draining the uplands transect the Region,

Autumn blazes on the Appalachian Mountains, abounding with extensive upland forest habitat.

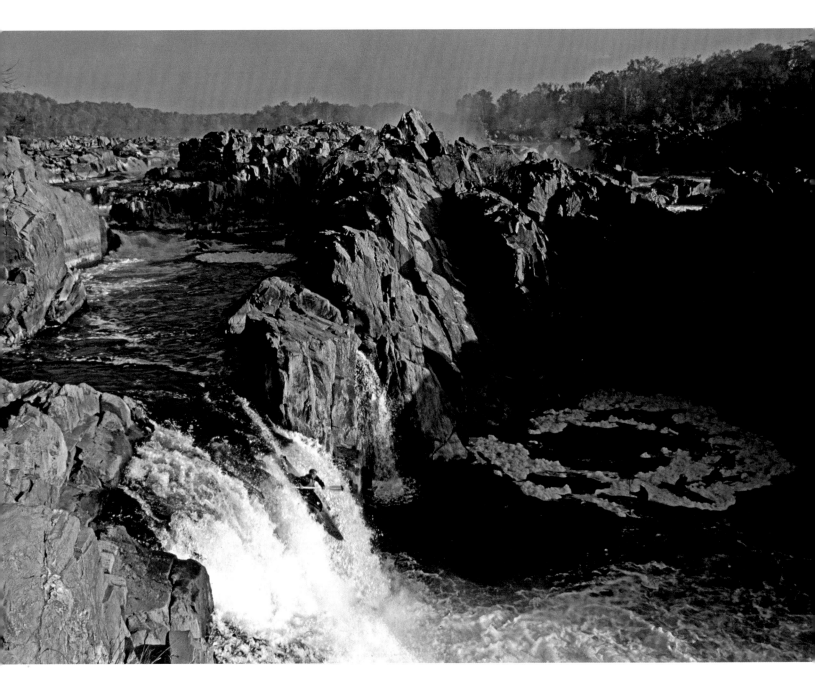

Dramatic rock formations mark the fall line at Great Falls of the Potomac, just upstream from our nation's capital.

the largest being the Potomac, which defines the Region's southwestern boundary. Other rivers include the bottom section of the Susquehanna, joined by the Elk River and Northeast River, which drain into the head of the Chesapeake, and all or virtually all of the Patuxent, Patapsco, Chester, Choptank, Nanticoke, Wicomico, and Pocomoke. The Delaware River forms much of the eastern boundary of the Region.

The fall line, the boundary between the rocky Piedmont and the coastal plain with its soft sediments, cuts the Region neatly in half, with the rocky uplands to the west of the line and the soft alluvium

of the coastal plain to the east. Because of the Region's historical importance for shipping, ports, and mills, three great cities lie on the fall line: Wilmington, Delaware; Baltimore, Maryland; and Washington, DC, lying in a straight line trending from northeast to southwest. The fall line and its rocky waterfalls and rapids in earlier days defined the limit of navigation for commercial ships carrying people and freight from the Old World, which explains why many cities established in the colonial age were placed where they were along the East Coast. During the industrial revolution, water-powered mills were situated along the fall line, because that is

where streams and rivers formed the waterfalls and rapids necessary to power the mills.

Viewed from space (or, more conveniently, on Google Maps in satellite mode), our Region's eastern verge features about 40 miles of shallow continental shelf ocean and then the Eastern Shore peninsula, which is entirely composed of former oceanic sediments. At various times in former epochs, most recently 120,000 years ago, the sea level stood more than 30 feet higher than today, inundating much of today's Eastern Shore. Much of the lower Eastern Shore is now subsiding (compacting and sinking). This subsidence, combined with the ongoing rise in sea level, explains why the marshes of the Eastern Shore are gradually disappearing under the encroaching bay waters.

Compare the coastlines of the Delaware Bay and the Chesapeake Bay. The Delaware shoreline tends to be simple and free of the complex embayments that we find in abundance in the Chesapeake because, geologically, the Chesapeake is subsiding and being drowned by postglacial rising seas. The Delaware has also grown as the sea level has risen over the past 10,000 years, but unlike the eastern coastline of the Chesapeake, the Delaware coastlines are not subsiding.

Moving westward from the Western Shore of the Chesapeake Bay, we gradually ascend in elevation until we reach the fall line, where we encounter an abrupt rise upon reaching the ancient silicate rocks that form the base of the Appalachians. We are now on the Piedmont ("foot of the mountain"

Ospreys nest-building at Terrapin Park near the Bay Bridge's eastern terminus.

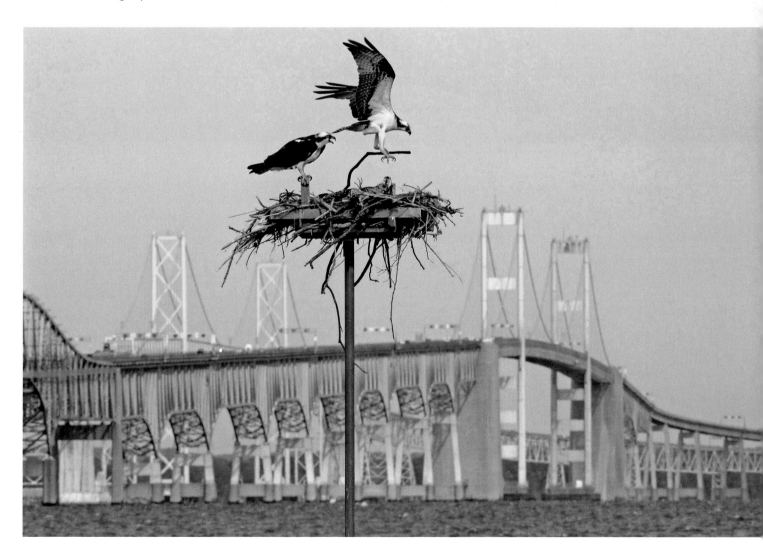

in French). The Piedmont is found just west of Wilmington, Baltimore, and Washington, DC. It is fertile farming land, much now converted to suburban housing for the cities. The Piedmont gradually rises westward until it meets the first abrupt ridges of the Appalachians—the first of these ridges is Sugarloaf, about 15 miles northwest of Rockville, Maryland. Next comes Catoctin Mountain, then South Mountain, and then more ridges as we travel westward through ever-narrowing Maryland. There are some 16 ridges of the Appalachians, separated by cleared valleys that today are largely in agriculture. The last

ridge is the Allegheny Front, which carries the traveler up onto the Allegheny Plateau. Because of its continental climate, high elevations, and northern forests, this is the Region's analog to interior New England.

Regional Bird Provinces

Adapting the treatment of Stewart and Robbins (see page 284 in chapter 25), we have modified and simplified and reduced the number of provinces from six to five (we eliminated the Upper Chesapeake

A bird's-eye view reveals the bold geometry of salt marshes in Dorchester County, MD.

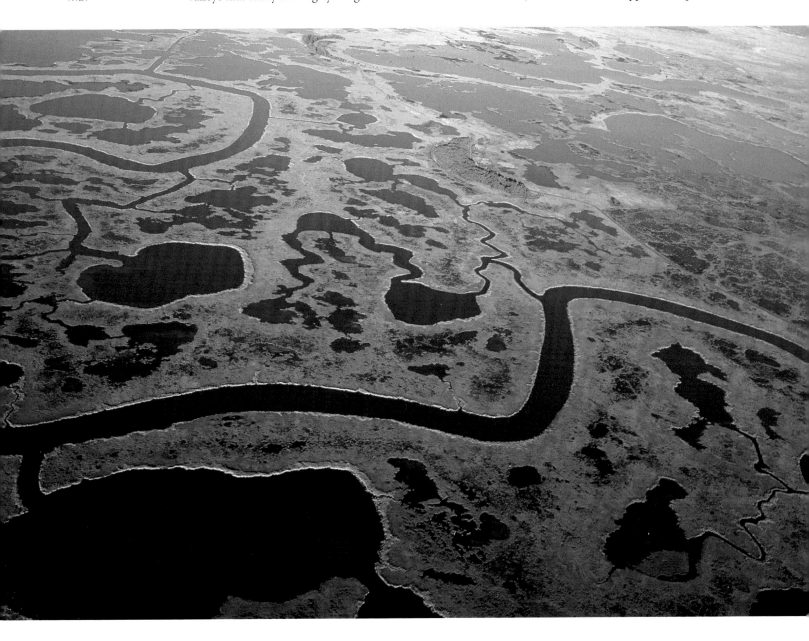

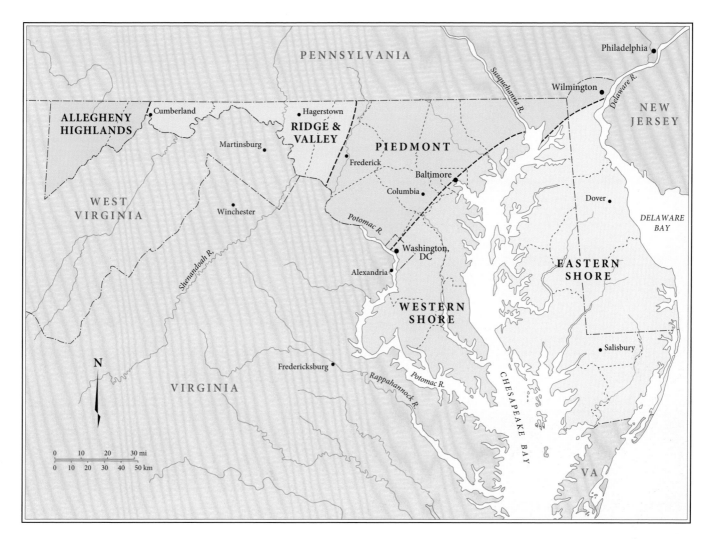

Map delineating the Region's bird provinces and major geographic features.

province because it is only thinly distinct from the Eastern Shore as defined by bird distributions). We rely on the names of these five provinces for our shorthand descriptions of bird distributions in this book. It is good to learn these for later use.

Eastern Shore

The Eastern Shore province is well defined because it is sandwiched between the Chesapeake Bay to the west, the Delaware Bay to the east, the Atlantic shore to the southeast, and the Delmarva of Virginia to the south. Our use of the term "Eastern Shore" is thus distinct from Stewart and Robbins's original use: our term also includes much of Delaware. This province is wholly coastal plain, with minimal topography. Its western boundary includes hundreds of miles of much-branching estuarine Chesapeake

shoreline, providing abundant marsh habitat for birds. Its eastern shoreline, facing Delaware Bay, is much less complex but includes important marshlands extending southward to Cape Henlopen. The southern remainder of the Eastern Shore province combines broad barrier island coastal beaches backed by enclosed interior estuaries, with extensive marshlands facing onto a series of embayments: Rehoboth Bay, Indian River Bay, Little Assawoman Bay, Assawoman Bay, Sinepuxent Bay, Newport Bay, and Chincoteague Bay (in this book called the "Atlantic bays" or "Atlantic estuaries" because they face the Atlantic Ocean and are distinct from the Chesapeake and the Delaware Bays). The interior of the Eastern Shore is today dominated by row-crop agriculture. Secondarily, there are extensive tracts of Loblolly Pine in the southern half of the

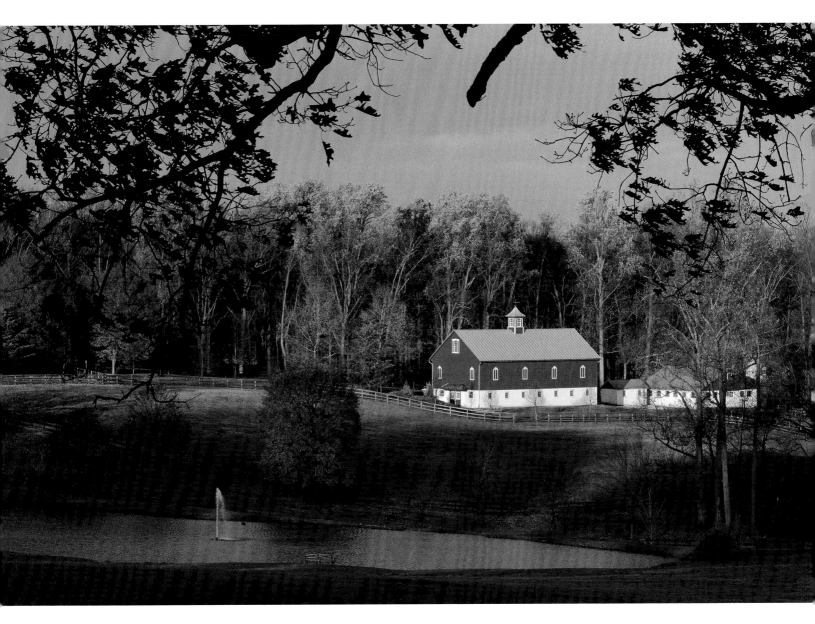

The rolling hills of the Piedmont host many beautiful farms that offer great bird habitat.

province. Before colonial settlement, much of the Eastern Shore was wetlands and wooded swamp, but centuries of ditching and draining have altered this, all to the benefit of commercial agriculture. Since the opening of the William Preston Lane Jr. Memorial Bridge spanning the Chesapeake in 1952 and the Chesapeake Bay Bridge-Tunnel in 1964, the Eastern Shore's human residential (and summer holiday) population has grown exponentially, and much of its natural lands have been developed for housing, especially areas with views of the water. Luckily, in strategic places, state and federal authorities have set aside land that otherwise would have been wholly developed, such as Assateague Island.

Distinctive permanent resident birds of the Eastern Shore include the Brown-headed Nuthatch (a piney woods specialist) and the Seaside Sparrow and Boat-tailed Grackle (both specialists of salt-marsh). Birders from west of the Chesapeake most frequently make their way to the Eastern Shore to visit Blackwater National Wildlife Refuge (mainly in fall or winter) or Bombay Hook National Wildlife Refuge (mainly from late summer to winter), although the area has dozens of other equally birdy destinations. The Eastern Shore is famous among hunters and birders for its huge flocks of wintering waterfowl, at both of the wildlife refuges. The Atlantic beaches and associated estuaries provide great spring and fall birding for waterbirds of many types. Finally, the pelagic Atlantic offers the adventurous birder an array of rarely seen seabirds, made accessible by seasonal boat trips organized by sea-

bird specialists. The small islands associated with estuaries serve as colonial breeding sites for herons, pelicans, cormorants, terns, and gulls (Pea Patch Island in the Delaware River and Skimmer Island behind Ocean City are perhaps the most famous). Falcons migrate along the coast in autumn, passing through this province in large numbers.

Western Shore

The Western Shore encompasses mainly the expanse of low coastal plain that lies west of the Chesapeake. It extends from St. Mary's County, Maryland, in a curving arc northward and eastward to the head of the Chesapeake Bay at the mouth of the Susquehanna River. Its western boundary follows the Maryland shore of the Potomac River in the south and then the fall line from Washington, DC, to Baltimore and Aberdeen, Maryland. The uplands of the Piedmont cut off the northern terminus of the Western Shore at the Susquehanna and extend into northern Delaware. The southern portion of the Western Shore is rural but rapidly urbanizing with commuters who work in Washington, DC. This lower area has two major river systems, the Potomac and the Patuxent, and the wetlands associated with these riverways. There are also extensive forests in this deep southern sector of the Western Shore, especially where Charles County faces the Potomac River. The northern portion of the Western Shore includes a number of short riverways that flow into the Chesapeake. This northern area is more urbanized than the south.

Except for the urban and suburban sections, the Western Shore is low-lying and largely forested today, and it supports some southern breeding birds such as the Blue Grosbeak and Summer Tanager. The Hooded Warbler is especially common in the middle part of this province, in Calvert County. Species more common on the Eastern Shore can be found in the southernmost quadrant of the Western Shore: Chuck-will's-widow, Brown-headed Nuthatch, and Boat-tailed Grackle. This southern area is the most promising for birders searching

for woodland and wetland birds. Both Charles and St. Mary's counties are underappreciated birding areas that merit additional serious attention.

Piedmont

The Piedmont comprises a wedge of rolling but low-relief uplands extending from Wilmington, Delaware, in the northeast to Montgomery County, Maryland, in the southwest. It marks the end of the coastal plain and lies west of the fall line, where crystalline bedrock lies near the surface. Today, it combines rural agricultural zones and developed suburban areas associated with the urban centers of Wilmington, Baltimore, and Washington, DC. The Piedmont is transected by several rivers: from north to south, Winters Run, the Big Gunpowder, the Patapsco, and the Patuxent. The middle reaches of these rivers have been dammed to form reservoirs: Winters Run: Atkisson Reservoir; Big Gunpowder: Loch Raven and Prettyboy Reservoirs; the Patapsco: Liberty Reservoir; and the Patuxent: Triadelphia and Rocky Gorge Reservoirs. These waterways tend

The beautiful and nomadic Dickcissel is a sparse breeder across the Region's agricultural landscape. Photo: Bruce Beehler

to be encompassed by forested catchments and are good for birding.

The northern sector of the Piedmont supports several northerly breeding species, including the Veery, Blue-winged Warbler, Cerulean Warbler, and Dickcissel. Since this sector is landlocked, its bird fauna is somewhat poor in species—though the reservoirs offer access to many waterbirds during spring and fall migrations, as does the Piedmont's stretch of the Potomac River, northwest of Washington, DC. The Chesapeake and Ohio Canal area offers excellent birding in Montgomery and Frederick counties.

Ridge & Valley

Just west of Frederick, Maryland, the first major ridge of the Appalachians crosses the state from north-northeast to south-southwest. This is the Catoctin Ridge, which is narrow in the south near the Potomac but quite broad and complex in the north near the Pennsylvania line. As its name suggests, this province includes a series of ridges separated by open valleys extending westward to the Allegheny Front, just west of Cumberland. In our Region, the Ridge & Valley includes, from east to west, Catoctin Ridge, Middletown Valley, South Mountain, Hagerstown Valley, Fairview Mountain, Blairs Valley, Bear Pond Mountain, Licking Creek Valley, Orchard Ridge, Ditch Run Valley, Tollgate Ridge, Sideling Hill, Green Ridge, and a jumble of uplands and valleys that take us all the way to Cumberland Valley and the North Fork of the Potomac. West of this is Dan's Mountain and the Allegheny Front.

The Ridge & Valley province encompasses the main Appalachians and is home to considerable expanses of upland forest and agricultural valleys. The Appalachian Trail follows South Mountain from the Pennsylvania line southward through Maryland, crossing the Potomac to Harper's Ferry, West Virginia. The Ridge & Valley province thus includes many forested parks and offers abundant opportunity for outdoor recreation just a short drive from the cities to the east. The birding is good, with a northerly character because of the province's elevation and mountain aspect. Featured species include the Ruffed Grouse, Broad-winged Hawk, Common Raven, Black-capped Chickadee, and Cerulean Warbler.

Allegheny Highlands

West of the Allegheny Front at Dan's Mountain lies the rugged high plateau of the Allegheny Highlands. This is a triangular province lying west of the North Fork of the Potomac River and the Cumberland Valley. Much of the province is mountainous upland, with elevations between 2,000 and 3,000 feet above sea level. The western verge of this province lies in the Mississippi drainage basin. The whole province is colder and snowier than any other part of our Region. Because of its elevation and its continental aspect, the Allegheny Highlands supports a flora and fauna typical of western New England. This is certainly the most distinct of our provinces, with a long list of birds that, in our Region, breed only here: Northern Goshawk (rare), Long-eared Owl (rare), Northern Saw-whet Owl (uncommon), Yellow-bellied Sapsucker, Alder Flycatcher, Least Flycatcher, Winter Wren, Hermit Thrush, Nashville

(Opposite) Hiking trails at Swallow Falls State Park traverse an old growth forest in Garrett County, MD.

The sublime male Blackburnian Warbler nests only in our Region's highest elevations on the Allegheny Plateau.

Spikes of Wild Rice
line the banks of Jug
Bay on the Patux-
ent River in Prince
George's County, MD.

Warbler, Magnolia Warbler, Black-throated Blue Warbler, Yellow-rumped Warbler, Northern Waterthrush, Canada Warbler, Mourning Warbler, Dark-eyed Junco, and Purple Finch.

The Chesapeake Bay and the Delaware Bay are the two most important ecological and geographic features of our Region. They create hundreds of miles of shoreline and estuary and serve as major shipping lanes to important East Coast ports. Both bays support important commercial and sport fisheries. And both, of course, are important to the Region's birdlife. In the remainder of the chapter, we discuss their physiography, ecology, and bird distributions.

The Chesapeake Bay Estuary

Encompassing 4,479 square miles of water and a catchment area of 64,299 square miles, the Chesapeake Bay is the largest estuary in the United States. The northern two-thirds of the bay lie within our Region, the remainder lies in the state of Virginia, to the south. The Chesapeake drains more than a dozen rivers, the most prominent being the Susquehanna, Potomac, Rappahannock, James, York, Patuxent, Choptank, Nanticoke, and Wicomico. The Chesapeake's catchment area extends northward into central New York State. The Chesapeake is a drowned valley of the Susquehanna, created when the global sea level was considerably lower than it is today. The Susquehanna flowed south through this area in an ancient depression created by the impact of a bolide/meteorite during the Eocene era, some 35 million years ago.

We all know the Chesapeake Bay as an important source of shellfish and various commercial fin fish, as well as a destination for water-based recreation ("the Land of Pleasant Living"). It is, of course, an area rich in birds, mainly because of its many tributaries and embayments and associated marshlands. The bay is a particularly important wintering area for ducks, geese, and swans. Duck and goose

hunting remain very popular late autumn pastimes, especially on the Eastern Shore. The presence of the vast Chesapeake estuary is one of the main reasons the Region is so rich in birds. More than any other single feature, the bay defines our Region and makes it such an interesting place to live.

The most famous animals to inhabit the Chesapeake Bay are the oysters, Blue Crabs, Bluefish, and Striped Bass ("Rockfish"). These are all popular eating and are harvested and fished both commercially and recreationally. But this is just the tip of the iceberg. More than 300 species of fishes inhabit or visit the bay annually in their migrations. Many use the Chesapeake as a critical spawning place, so the bay's health is important to the well-being of all of these species. Many of us do not realize just how big the bay is and that it is a seasonal home to sea turtles (especially Loggerheads), Ocean Sunfish, whales, various sharks, and even a few wandering West Indian Manatees.

Perhaps the Chesapeake at this moment is most infamous for its environmental deterioration. Its

A Horseshoe Crab retreats back into the Delaware Bay after laying hundreds of tiny eggs in the sand at Port Mahon, DE.

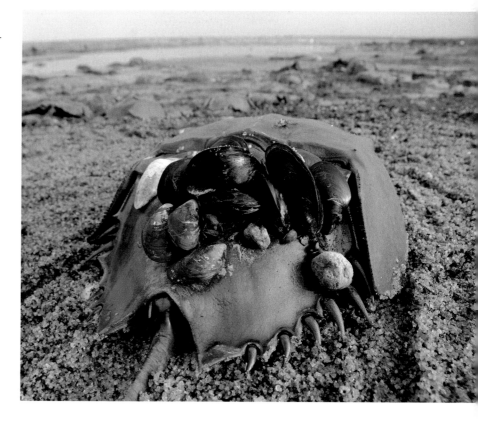

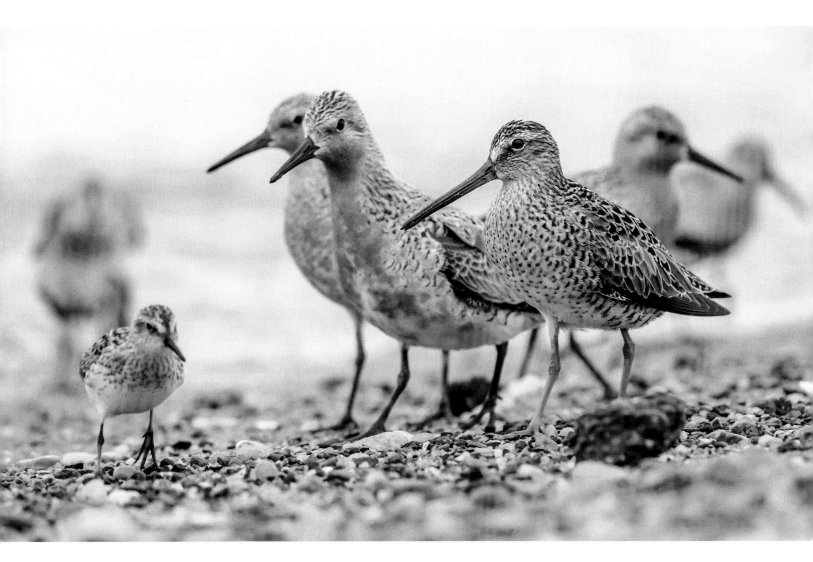

Four species of shorebirds crowd Delaware's Pickering Beach in search of Horseshoe Crab eggs. Photo: Emily Carter Mitchell

waters are polluted and its seagrass beds and major fisheries are in decline. In early 2017, the Chesapeake Bay Foundation gave the bay a rating of 34 out of 100—a C− grade. Why is the bay so sickly? There are multiple reasons. The first is the runoff of fertilizer and livestock manure from the vast Susquehanna and Potomac watersheds that support mainly farmland. The second is the vast amount of agricultural soil washing into the bay because of poor stewardship of upstream agricultural lands. Thus the bay suffers from too much phosphorus and nitrogen and over-sedimentation. Add to this the industrial, urban, and suburban runoff from the mega-corridor linking Washington, DC, Baltimore, and Wilmington. Some 10 million households and untold businesses and factories cast pollutants of

various kinds into the bay. The Chesapeake is also a major shipping channel, with container and tanker ships mainly headed to the Port of Baltimore. This is yet another source of pollution.

In terms of its water quality, its submerged aquatic vegetation, and its populations of native vertebrates and invertebrates, the Chesapeake is a mere shadow of what it was when Captain John Smith first sailed into this great Atlantic estuary. In the 1600s, the Chesapeake teemed with huge schools of fish, flocks of waterfowl, reefs of oysters, and vast populations of migrating Blue Crabs. At that time, the human population was very small, and the bay's bounty was immense. Now, it is the reverse.

Many institutions, including the Maryland League of Conservation Voters, the Maryland De-

partment of Environment, the District of Columbia Department of Environment, the Chesapeake Bay Foundation, and local river keepers, are working to reduce pollution of the bay. This is all about creating effective legislation and implementing policies that change resource management practices across the entire watershed. The behavior of tens of thousands of actors needs to be changed—that of farmers, suburban homeowners, large-scale chicken and pig production facilities, polluting industries, and many others. No single piece of legislation can correct this. It requires action by the many. Every decade, it seems, we see the launching of a grand new collaborative plan to "clean up the bay," but entrenched economic interests fight against this patently benign objective because of the supposed economic cost. In reality, the economic cost of a polluted and degraded Chesapeake Bay is huge. Sadly, short-term profit is trumping long-term benefit.

It is remarkable that the Chesapeake is as healthy as it is—a testament to the resilience of Nature, plus the hard work of many local volunteers and activists. This is not the time to give up hope. The bay is our greatest natural resource and merits our dedication. Every voter needs to demand a clean and healthy bay, and every resident needs to do the right thing in monitoring the home use of water, protecting stream sides, and recycling.

The Delaware Estuary

The Delaware Bay lies in the shadow cast by the more famous Chesapeake. In fact, the Delaware Bay drains substantial portions of the states of Delaware, New Jersey, Pennsylvania, and New York: 14,119 square miles of catchment. In that sense, it is the important geographic junior sister to the Chesapeake. It is a major shipping route, delivering all sorts of cargo to the industrial cities of Camden, New Jersey; Trenton, New Jersey; and Philadelphia, Pennsylvania. As an inland shipping route, it is second in importance only to the Mississippi. A quick look at the map of the two bays makes clear how the

Delaware Bay is distinct from the Chesapeake, lacking the abundant embayments and tributaries and reticulate coastline of the larger bay. The two have clearly been forged by different geological histories. The flow of the Delaware River is about a third of that of the Susquehanna, yet the Chesapeake (the bottom of the Susquehanna) exhibits a drowned landscape while the Delaware Bay does not. The mouths of both bays do have similar peninsulas, long and fingerlike on the east side and hook-shaped on the west side. These were obviously created by the impacts of the same Atlantic coastal currents.

The world's largest population of Horseshoe Crabs spawns in the Delaware Bay. For that reason alone, the bay is one of the four most important shorebird migration sites in the world, and it boasts the second-highest concentration of migrant shorebirds in North America. In spring, these shorebirds preferentially feed on the eggs of the Horseshoe Crab. But the spring migration is topped by the late summer and autumn passage of shorebirds of many kinds along the western shore of the Delaware Bay. The bay also provides wintering and migratory habitat to many species of songbirds, waterfowl, and raptors. In May 1992, the Delaware Bay estuary was designated a "wetland of international significance" by the Ramsar international treaty on conservation and sustainable use of wetlands, owing to the critical seasonal resting and feeding area the bay provides for migratory shorebirds and wading birds. Because of its marshlands, beaches, and prey base, the Delaware Bay is home to some wonderful birding localities: Bombay Hook National Wildlife Refuge, Prime Hook National Wildlife Refuge, Cape Henlopen State Park, and several equally attractive sites on the eastern (New Jersey) shore of the bay, including Reed's Beach and Cape May Point. Up in the northern section of the bay, near Delaware City, Pea Patch Island houses the largest breeding colony of herons and egrets on the East Coast north of Florida. Any birder who wants to see all the birding meccas of our Region will need to spend considerable time on the shores of the Delaware Bay.

Pink and white Marsh Hibiscus bloom profusely across our Region's freshwater marshes.

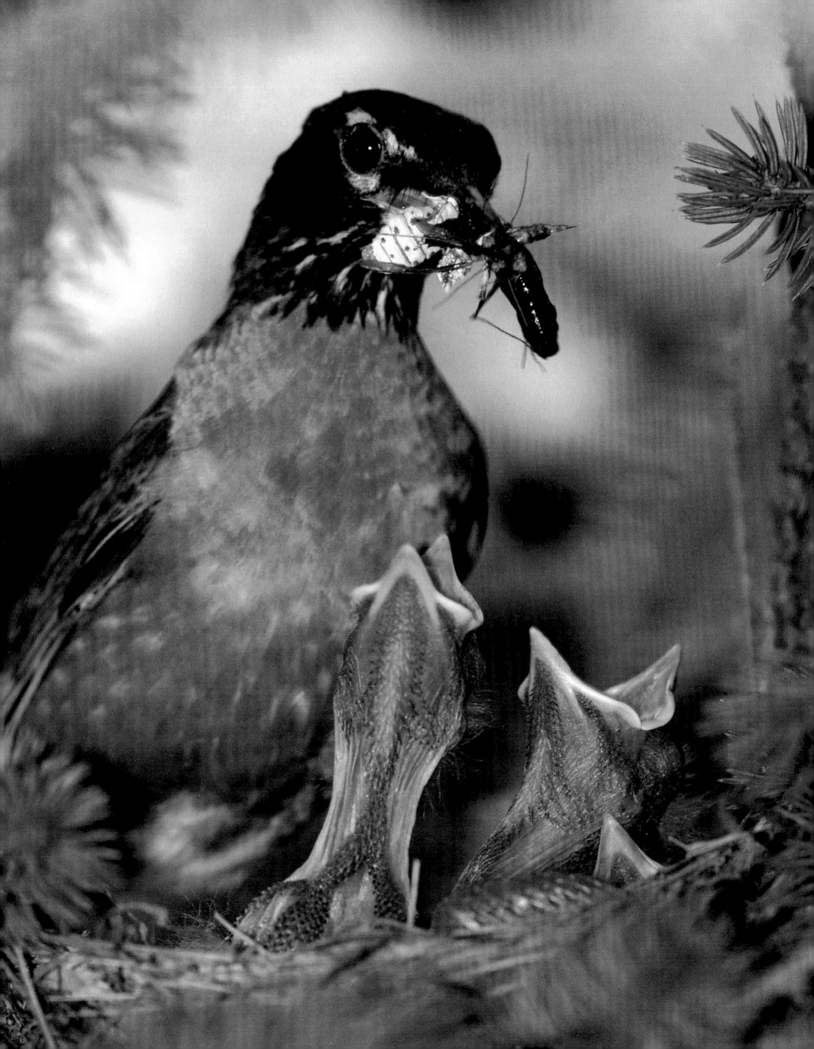

The Birding Seasons

One of the wonderful things about taking notice of the birds in our home environment is that they provide entertainment all year long. From the permanent residents with their unique seasonal behaviors, to the regularly occurring migrants that grace the area only briefly in spring and fall, and the northern species that spend the winter in our more equable climate, there are birds to be seen by the observant naturalist any season of the year. The more time spent afield, the more likely you are to come across species rare to the area. As experience increases, so does the awareness of seasonally rare occurrences. It is just a matter of taking the time to get outside and look for birds.

We have divided the Regional year into 11 seasons, as defined by avian activity. Note that these "seasons" are notional and focus on particular groups of birds, and they may overlap with one another because seasons of activity are not mutually exclusive between species—and some seasons come only once every few years. Also, due to annual climatological variation, El Niño cycles, and the impact of global climate change, the timing of these seasons will vary from year to year.

Early Spring: January to February

Believe it or not, for our birds, spring begins in the latter half of January into February. This is when forsythia begins to bloom, daffodils peek above the ground, and our backyard songbirds, such as the Tufted Titmouse and House Finch,

American Robin parents can barely keep up with their nestlings' demand for fresh invertebrate prey.

begin their spring songs. It is also when the first small groups of Red-winged Blackbirds and Common Grackles arrive at feeders and roaming flocks of American Robins flood into yards. Bald Eagles and Great Horned Owls begin nesting in February in our Region. Waterfowl and gulls are beginning to move about, and Common Mergansers start to become more visible on the major rivers.

Resident Breeding Season: March to April

A young male Summer Tanager enjoys a mulberry during his long migration north. Photo: Bruce Beehler

Local permanent resident species, such as chickadees, nuthatches, and woodpeckers, start nesting in March and April. The American Crow initiates breeding in early March. The Carolina Chickadee starts nesting in mid-March. The White-breasted

Nuthatch and American Robin start in late March. The Hairy Woodpecker and Northern Cardinal begin nesting in early April. The Downy Woodpecker starts in late April. And, with the advent of climate change, nesting dates have been inching earlier in our Region, as spring weather arrives earlier. The take-home point is that local resident birds can get started much earlier than most of the migrant species coming from the tropics. That makes sense, of course. The residents tend to do their nesting and feeding of young before their neighborhood becomes clogged with migrants that might compete for food and nesting resources. That said, the local residents may nest more than once in a single breeding season and may successfully raise two or even three broods. Thus early-nesting species may have a breeding season that starts in March and ends in July or even August.

Songbird Spring Passage Migration: Early April to Late May

For many local birders, the most exciting time of the year is the passage of songbirds during spring migration. It is in this two-month period that the wood warblers, vireos, flycatchers, thrushes, grosbeaks, orioles, swallows, and others flood through the Region from their southern wintering sites, en route to their northern breeding grounds. Some of these birds spend their winter in the southern tier of US states, while others winter as far south as the Amazon basin. Bobolinks winter mainly in the pampas of Argentina, passing north through our Region in May. Adding to the excitement of spring migration is that the male songbirds are in their colorful breeding plumages and many are in full song as they reach our latitude. The combination of the diversity of song and color in local woodlands during the spring passage migration is a marvel that few birders ever tire of experiencing.

The staged passage is exemplified by the arrivals of the various wood warblers. First, Palm Warblers, with their wagging tails, pass through in small

numbers starting in early April, followed by Louisiana Waterthrushes. Yellow-rumped and Black-and-white Warblers show up in early to mid-April, followed by Common Yellowthroats and Northern Parulas in mid- to late April. Black-throated Green Warblers start to sing, heralding the first arrival of the main flood of wood warblers—dozens of species. The timing of the highest density of warbler species seems to align with the peak of abundance of the Yellow-rumped Warbler. You will often have to search through the omnipresent Yellow-rumps to pick out the less common and more desirable (to birders) species, such as Bay-breasted or Cape May Warblers. A few days later, the peak of the Blackpoll Warbler movement indicates the beginning of the end. After the peak, a few latecomers show up—Wilson's, Canada, and Mourning Warblers, in particular. Across most of the Region, the period between 5 May and 15 May is the height of the songbird migration and is a time when all birders worth their salt will be out in their neighborhood woods in search of singing warblers. Quite a few of these migrant wood warbler species stay to breed in the Region (see next section). But most of our spring warblers are pass-through visitors (Blackpoll, Bay-breasted, and Cape May, among others), staying only briefly on their way to New England and Canada to breed.

Of course, wood warblers are just one of the migrant groups to expect. Thrushes scuffle in the forest understory. Vireos move slowly and sing in the forest canopy. Flycatchers appear in a variety of habitats, from canopy to wetland shrubbery. Colorful tanagers and grosbeaks sometimes show up at feeders, when not in the canopy of forest tracts. There is a lot to see and record.

Migrant Songbird Breeding Season: Early May to Early July

Many migrant songbirds come north to nest and produce their offspring in our Region. This is their productive time of year. Immediately upon arrival,

A male Hooded Warbler makes a welcome pit stop at Baltimore's Patterson Park, a stellar migrant trap.

males stake out territories and start singing their advertisement songs and doing battle with other males of their species. The bulk of females typically arrive later, after the males have done much of their territorial sorting-out. Each female chooses a mate, and nest building begins. The early phase of the nesting season is a great time to be out birding in the lush and forested areas of the Region. These forests are where many of the most beautiful songbirds set up their breeding territories. Smart birders head to the biggest tracts of forest, such as the bottomland forests of the Pocomoke Swamp in the southern sector of the Eastern Shore, Green Ridge State Forest in the western Ridge & Valley province, or New Germany State Park in the Allegheny Highlands. In the Pocomoke, birders will find Prothonotary, Worm-eating, and Yellow-throated Warblers in song, as well as Acadian Flycatchers and Summer Tanagers. In Green Ridge State Forest, the birder finds the Cerulean Warbler, Kentucky Warbler, Scarlet Tanager, and Great-crested Flycatcher. In New Germany State Park, Blackburnian, Magnolia, and Black-throated Green Warblers, Least Flycatch-

ers, and Winter Wrens are in song. Being in these verdant woodlands at the height of the breeding season is a glorious time for birders willing to head out on the road.

Late Spring Shorebird Season: Early May to Early June

One of the favorite seasonal birding events is the spring shorebird arrival, timed to spawning of the Horseshoe Crab along the shores of the Delaware Bay. The crabs come to the beach to spawn at high tide, so it is important to time a beach visit to the tides. For the Arctic-bound migrants, the season stretches from early May to early June, but the peak for the birds is during the latter half of May. The extreme tides associated with the full and new moons in late May typically provide the most spectacular confluence of Horseshoe Crabs and shorebirds, which swarm the beaches to feast on the crabs' eggs. The featured birds are Red Knot, Semipalmated Sandpiper, Ruddy Turnstone, Laughing

Gull, and various other small species of sandpipers (called peeps). The best beaches to see this remarkable phenomenon in our Region are Pickering Beach, Kitt's Hummock, and Slaughter Beach (all in coastal Delaware). Walk quietly so you do not disturb the birds that are feeding on the beach, and keep dogs leashed at all times.

Summer Shorebird Migration: Mid-July to Mid-September

The shorebirds—sandpipers, curlews, godwits, and the like—start their movements southward as early as the last days of June (including yearling and those unlucky individuals that did not successfully breed up north) and pick up steam from there, with a peak from mid-July to early September. This is the time to head to the shorebird hotspots on the shores of the Delaware Bay and the Atlantic shore of Maryland and eastern Virginia, places such as Bombay Hook, Prime Hook, and Chincoteague National Wildlife Refuges, or essentially any sandbar

A southbound August flock of Lesser Yellowlegs relishes shallow ponds for convenient feeding.

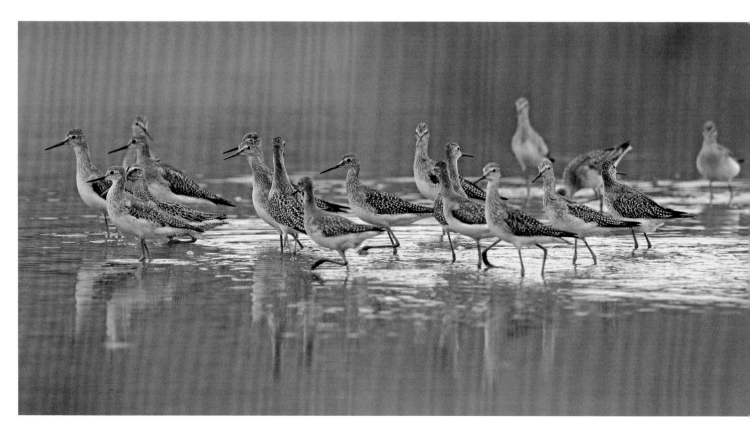

or mudflat along the coast. This is also the time to visit Chesapeake sites such as Hart-Miller Island and Poplar Island. Even interior sites that host mudflats, extensive patches of tended shortgrass (turf farms), or water treatment plants can attract shorebirds on the move south. These are exciting times because, with these globe-trotting birds, you never know what rarity might turn up in a flock of peeps or a group of yellowlegs. Get out there with your scope!

Autumn Songbird Migration: Early August to late October

The autumn migration is noteworthy for at least two reasons: the large number of birds heading south (because it includes the returning adults plus their offspring of the year) and the passage lasting much longer than spring migration (because the birds are not in such a hurry to get to their winter quarters)—more weekends for birding. Places like Assateague Island, Turkey Point, Point Lookout, and certain ridgetops can have more birds than on the best spring days in Rock Creek Park. In late August, cold fronts with northwest winds bring nice waves of warblers.

The songbird migration in autumn is very different from that in the spring. In the fall, the birds' bright colors are often gone, and the plumages of many species are cryptic and confusing. Think of the wonderful male breeding plumage of the Bay-breasted and Blackpoll Warblers. In autumn, the colors of these two favorite migrants degrade to unrecognizably drab versions of their stunning, crisp spring plumages. And the only sounds emanating from these birds in autumn are flight chip notes and alarm calls. What happened to those glorious spring songs?

Still, it is definitely worth getting out and challenging yourself with the autumn plumages, cryptic as they are. For many fall songbirds, a juvenile plumage is added to the mix, making the experience that much more interesting and puzzling. But

be sure to drink something caffeinated before taking on this challenge. You need to be alert to sort all these birds out. On a good day with a major flight, the numbers can be astounding. And being out in nature on a bracing autumn day when both the songbirds and the leaves are blowing in the northwest wind can be a splendid experience. Late in the season, look for White-crowned Sparrows in the hedgerows of farm fields, along with the ground-loving Palm Warblers. Look for clots of Yellow-rumped Warblers in thickets and bare branches, and listen for their incessant *tchepp* notes, a distinctive sound of autumn along the scrub of the Atlantic Coast. Search for Lincoln's Sparrows in the brush piles. Rarities never seen in spring also begin

It is hard work finding treasures like this migrant Lincoln's Sparrow in an autumn thicket. Photo: Bonnie Ott

(*Following pages*) Fledgling Brown Pelicans prepare for flight training on their remote nesting island on the lower Chesapeake Bay.

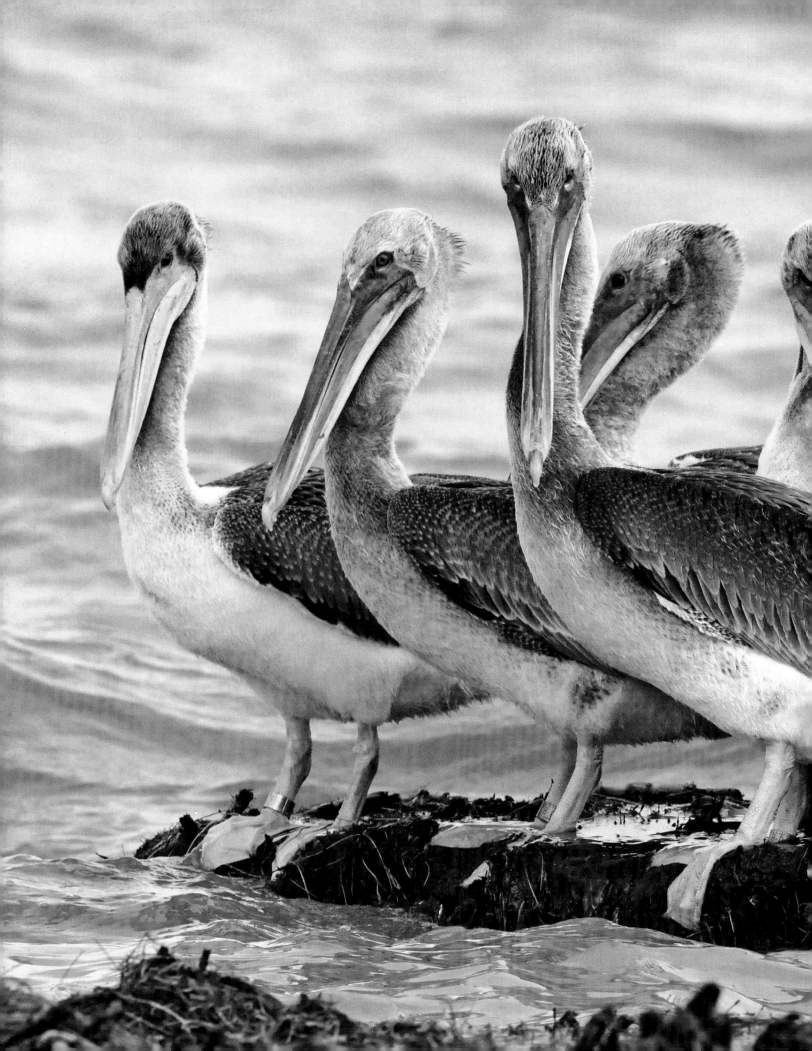

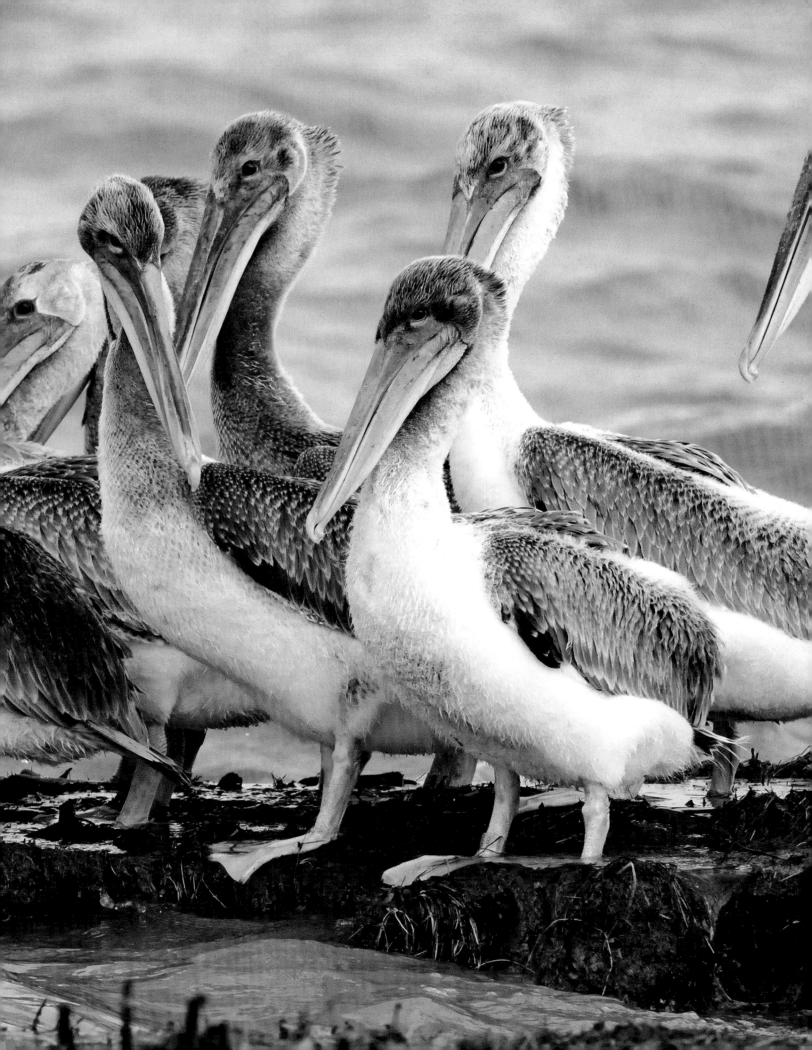

to show up, such as the Western Kingbird, Ash-throated Flycatcher, and Cave Swallow. The combination of invigorating weather, colorful leaves, confusing plumages, and large numbers makes for a great birding season.

Autumn Raptor Migration: Mid-September to Mid-November

The autumn raptor migration—of hawks, eagles, harriers, falcons, and vultures—can be spectacular and should be experienced by every birder. With the raptors, the spring migration pales in comparison with that of the fall. Autumn hawk migration takes place throughout our Region, and migrating raptors can be observed from your backyard. That said, it pays to visit a raptor watch site to really get a good sense of the phenomenon. The numbers can be mind-blowing. For instance, on 18 September 1998, *19,004* Broad-winged Hawks passed Snicker's Gap in the Blue Ridge of northern Virginia, about an hour's drive from Washington, DC. The Allegheny Front hawk watch, a couple of hours' drive from Baltimore, in central Pennsylvania, counted 74 Golden Eagles on 24 October 2015. Hawk Moun-

Late fall brings huge numbers of wintering waterfowl such as these frisky Northern Pintails.

tain, about three hours' drive from Wilmington, recorded 2,475 Sharp-shinned Hawks on 8 October 1975. So far, we have mentioned only hawk watch sites outside our Region. But Maryland hosts nine active sites, and Delaware two sites, so there are places close at hand to visit and watch. To find out the details, visit the North American Hawk Count web page, which is bursting with data and directions (http://hawkcount.org/).

Anyone can visit or participate at one of these hawk watch sites, mainly operated by citizen-scientist volunteers. The site staff will welcome you and help you get the hang of hawk watching, which can take some adjustment. The raptors commonly pass by either at high elevation or at a great distance and thus are seen as distant specks on the horizon. On other days, they barrel right overhead. Either way, it is a great outdoor experience, and we discuss this at greater length in our birding site guide later in the book (see chapter 29).

Wintering Landbirds: October to January

Large numbers of songbirds that breed in the Great North Woods spend the winter in our Region. Species such as the Yellow-bellied Sapsucker, Hermit Thrush, Golden- and Ruby-crowned Kinglets, White-throated Sparrow, Dark-eyed Junco, and Purple Finch, among many others, arrive at the end of the calendar year and remain in the area until early spring, when they head back north again. These wintering landbirds also include a large number of rarer species that birders love to look for: American Tree Sparrow, White-crowned Sparrow, Fox Sparrow, Orange-crowned Warbler, and others. It can be fun to head out into the old fields and woodland edges in search of winter arrivals—a good alternative to being a couch potato and watching yet another college football game. Late November and early December are also the best time of year to hope for western rarities, especially hummingbirds, flycatchers, and warblers.

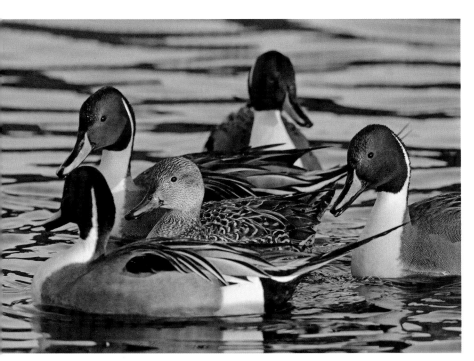

Wintering Waterbird Flocks: November to January

When it gets cold and things start to ice up, it is time to head to the Eastern Shore to visit one of the marshy wildlife sanctuaries and experience the giant flocks of wintering Snow Geese, Canada Geese, Tundra Swans, and other waterfowl. A weekend day trip to Blackwater or Bombay Hook National Wildlife Refuges can be very productive. Aside from the featured waterfowl, which may be present in vast numbers, there will be perhaps 50 or more other species, a mix of herons, other waterbirds, upland game birds, raptors, and songbirds. Combined with a visit to one of the local seafood restaurants, this can make for a festive day, most of it spent out of doors. The big flocks of waterfowl are generally present from November through early March, and then the birds head back north and northwest toward their breeding grounds. For watching waterfowl at close range, consider visiting Oakley Street in downtown Cambridge, Maryland, where various duck species can be seen on the Choptank in midwinter (so long as it is not iced over).

Irruptions of Winter Songbirds, Owls, and Other Cold-Season Specialties: December to February

Finally, there are the special winters, occurring once every few years, when several irruptive species suddenly appear in our Region. These irruptions occur because of some food-related or environmental phenomenon in the far north. Every few years we see the arrival of the hard-to-resist Snowy Owls. This species tends to hang out at airports or in a marshland but can show up just about anywhere (even in downtown Washington, DC). More irregular is the arrival of the winter finches. The irruptive species that arrive unpredictably include (from most to least common): Purple Finch, Pine Siskin, Red Crossbill, White-winged Crossbill, Common Redpoll, Evening Grosbeak, and Pine Grosbeak.

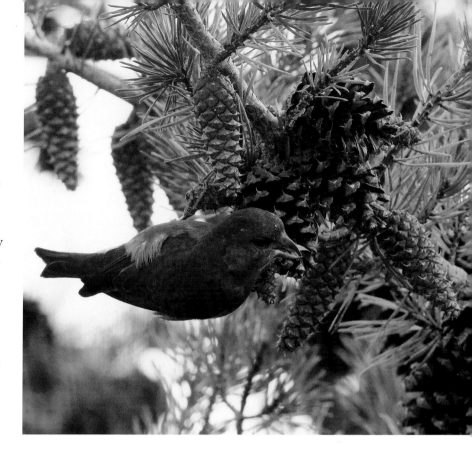

A male Red Crossbill makes easy work of pine cones at Henlopen State Park during an irruption year in our Region. Photo: Bruce Beehler

We also have a fairly regular late autumn irruption of Red-breasted Nuthatches, which pour down the coast in large numbers and appear in backyards and piney woodlots throughout the Region. Two raptors appear in numbers from time to time: Northern Goshawk and Rough-legged Hawk. Finally, the Northern Shrike will wander down into our Region every few years.

The take-home point of this chapter is that in any month of the year, there is a birding trip worth making. Check out chapter 21 for the apps that let you know what birds are around and where.

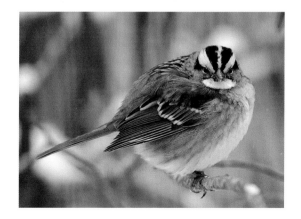

The handsomely patterned adult White-throated Sparrow is a frequent backyard visitor to winter feeders.

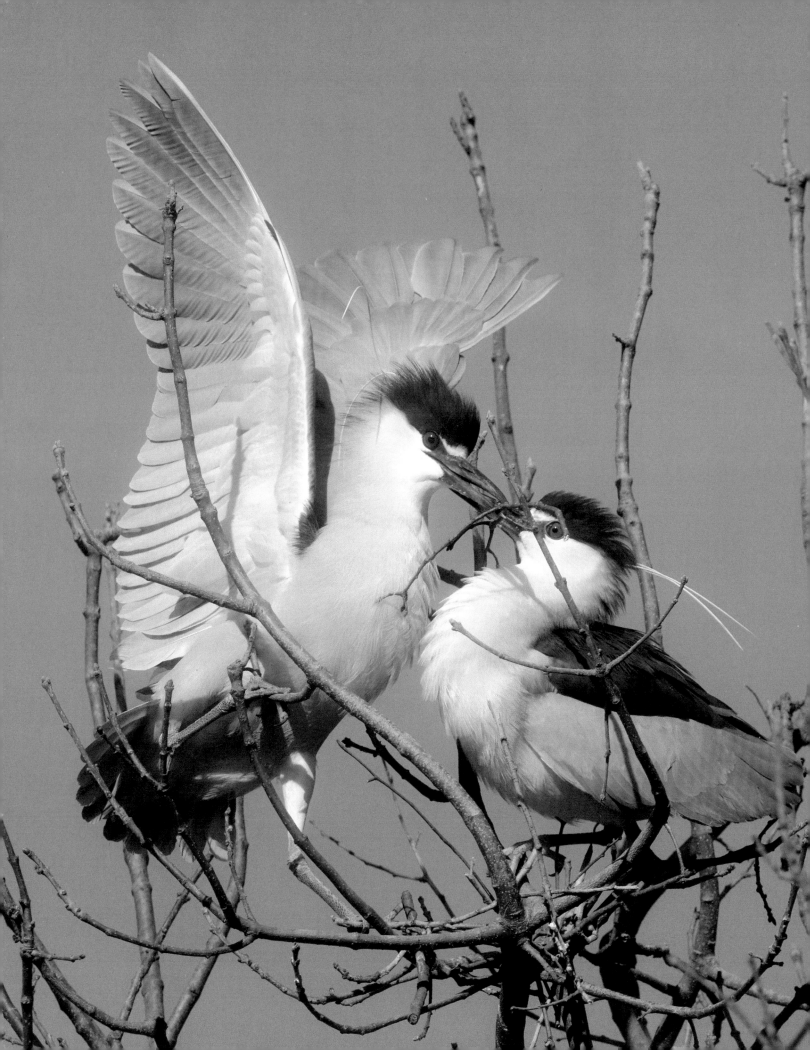

Birding in Urban, Suburban, and Agricultural Landscapes

The great thing about birds is that they are everywhere, in every habitat, all over the face of the Earth—even over our oceans, far from sight of land. So to interact with birdlife, we only need to look up from our newspaper or mobile device, turn away from the TV, and head out into the backyard or beyond. Some birders live downtown, some live in suburbia, and others live in rural farmland. In this chapter we discuss the birdlife in these three major human habitats.

The Urban Landscape

In the United States, 81% of our population now lives in cities. This percentage may be even higher in our Region, which is home to three large urban centers—Washington, DC, Baltimore, and Wilmington—as well as lesser centers such as Annapolis, Frederick, Hagerstown, Salisbury, Newark, and Dover. Thus, most of the Region's birders can be expected to live in urban environments. How can urban dwellers take best advantage of their location in their search for birds?

First, start at home. That is where most free time is spent, so that offers the biggest opportunity. No matter where you live, you can feed the birds. Even apartment dwellers can situate one or more feeders just outside a window, though it might take some clever carpentry. Putting out seed and suet will attract a wide array of urban birds, especially if the feeders are not too far from a city park or

A large colony of nesting Black-crowned Night-Herons delights visitors to the National Zoo, in Washington, DC.

woodlot. It is surprising how many species travel about in search of new sources of food. Thus, a first take-home point is that the bird-loving urban dweller should think about birding opportunities when picking a place to live in the city. Picking an apartment or house with a view facing a park will make a big difference in the number and quality of birds you can see from the window or attract to a feeder. This decision can materially improve your quality of life. How pleasant it is to have your morning coffee while looking at woodpeckers in the tree outside your window, as opposed to seeing your neighbor's brick wall.

The Boat Lake in Baltimore's Patterson Park is a magnet for friendly birds, easy to view at close range.

Birds that regularly come to urban feeders include the Mourning Dove, Downy Woodpecker, Blue Jay, Carolina Chickadee, Tufted Titmouse, European Starling, House Sparrow, and Northern Cardinal. Many others might be irregular visitors: Yellow-bellied Sapsucker, Northern Mockingbird, White-breasted Nuthatch, House Finch, American Goldfinch, to name a few. So, feeding the birds is a start. But there are some caveats. You will want to feed the birds without encouraging urban-dwelling rats. City squirrels can be an issue, too, and need to be accounted for, even though you may find their antics charming and their arboreal acrobatics amazing. Also, in an apartment, there may be rules that forbid the placement of feeders, so check beforehand to avoid trouble with the landlord. Despite these concerns, home feeding of the birds is a place to start for a birder newly arrived in the city.

Next, join the city's bird club and attend monthly meetings, and join up on weekend bird walks. This is the quickest way to learn the ins and outs of the city's geography and to find safe and desirable places for a downtown bird walk. In Baltimore, for instance, you can join the Baltimore Bird Club and attend its meetings at Cylburn Arboretum. Cylburn also happens to have a large tract of oak woods, formal gardens, and edge habitats that offer good birding. Every city has parks or wooded cemeteries. Zoos also are good places for birding because they usually include some woodland and other green space. Birding solo in certain urban locations may not be a good idea, especially if you are carrying expensive-looking binoculars and a camera. Make friends at the local bird club and go birding in pairs or groups for safety and fun. You can generally see more when birding with a friend—more eyes to see things. And it is nice to have company and perhaps end your trip at a local coffee shop.

Local knowledge of birds is hard to beat, and people who have been birding in the city for years may tell you of their favorite birding spots that are little known and little managed yet still attract great birds. Water treatment plants attract gulls. Urban

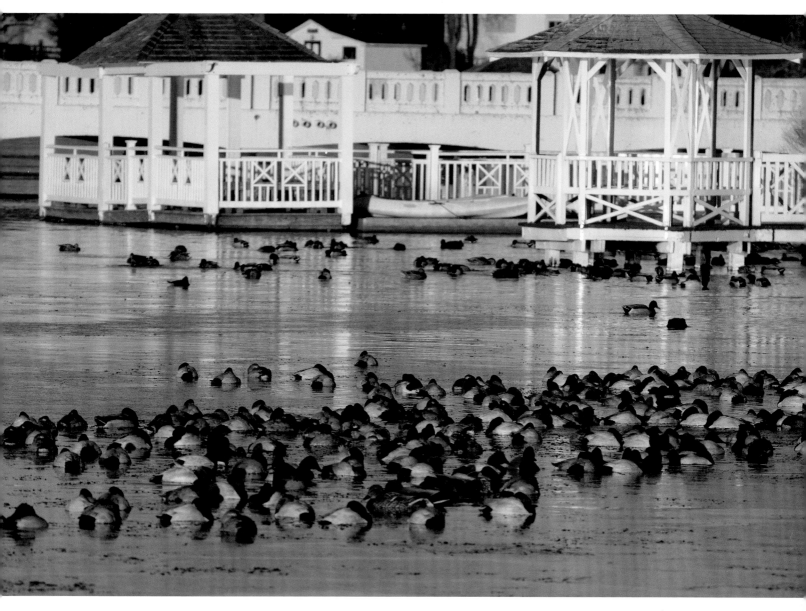

reservoirs bring in ducks. Another quick way to locate important urban birding hotspots is to use eBird's "Explore Hotspots" tool to find the most productive birding localities in and around the city (see details in chapter 21).

Wooded city parks, islands of green in a vast expanse of gray concrete, act as bird magnets during spring and fall migrations. Any songbird tired from a night of migration will see even the smallest tree-lined park as an oasis. If a good volume of migration passed overhead the previous night, a city park can be bursting with colorful migrants first thing in the morning—something we call a "fall-out." The birds literally drop out of the sky into the trees and bushes, much to the pleasure of the savvy birder who takes a chance on that park the next morning.

So, yes, in early May, city parks can produce bird bonanzas—or just as easily be not so birdy. That uncertainty produces the excitement of birding in city parks in spring. A birder might record 50 species in a couple of hours or only 15 species, depending on the volume of migration over the city.

Predicting a fall-out is next to impossible, but there are some ways to narrow the odds. First, the calendar. Spring and fall are both excellent. In our Region, the greatest volume of nocturnal songbird migration takes place between late April and mid-May and between late August and early October. Just about any day during these periods will produce an urban park list with interesting migrants: ducks, raptors, orioles, tanagers, warblers, vireos, sparrows. But the really memorable mornings de-

Silver Lake in Rehoboth, DE, attracts a variety of diving ducks in the winter, including scores of Canvasbacks.

(Following pages) Ring-billed Gulls are accustomed to handouts at the Reflecting Pool flanking the iconic Capitol in Washington, DC.

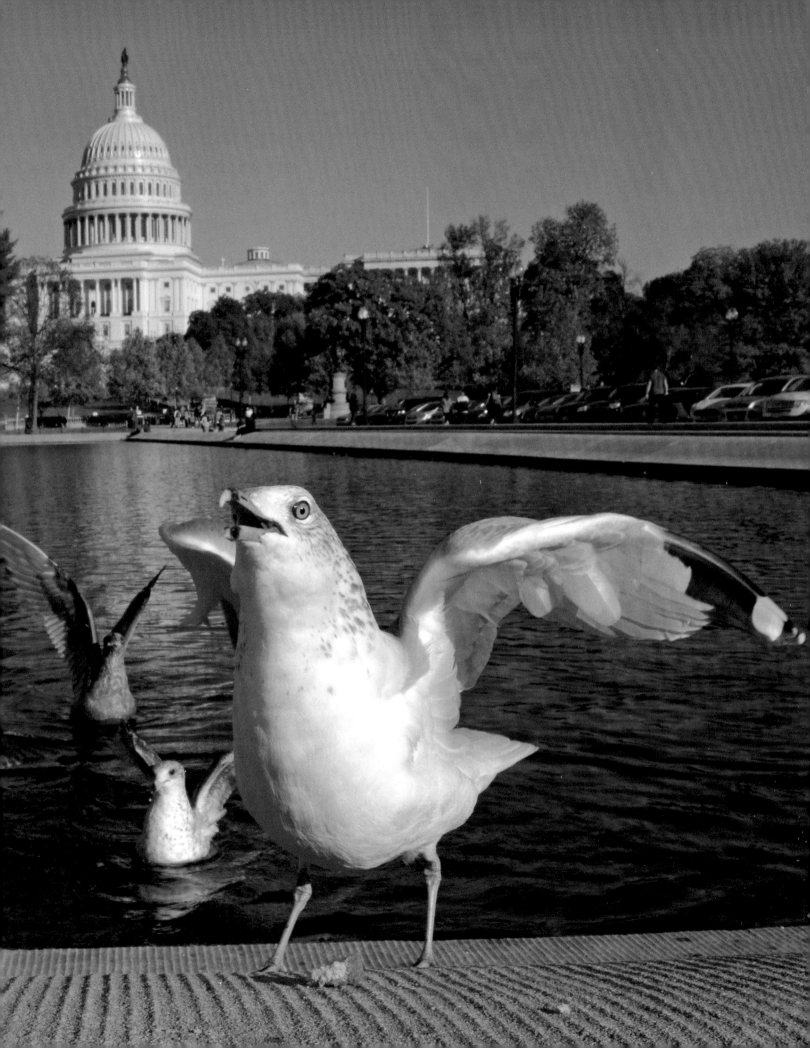

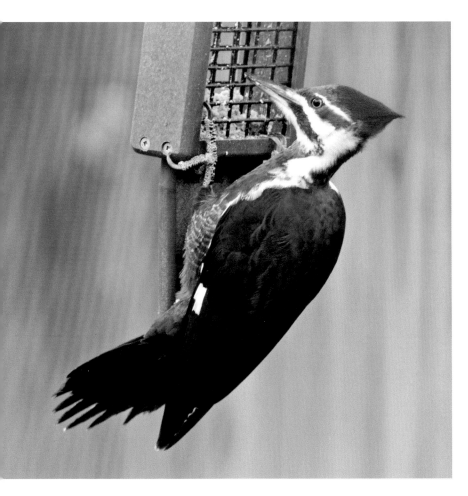

Birders young and old marvel at the sight of a Pileated Woodpecker hanging on a suet feeder. Photo: Bruce Beehler

A steady source of fresh water will draw in the birds. This bathing beauty is a female Yellow Warbler.

Winter in the city tends to be quiet, but a highlight of the season is the local Christmas Bird Count, which is always worth joining. It is fun and festive and might even produce some unexpected birds. This is a good excuse to get outside for a long day of birding in the cold, and the evening tally-up supper after the count is a great mix of food, fun, and camaraderie (see details in chapter 24). Every Christmas Bird Count produces a few surprises, including unexpected lingering migrants or even rarities. Note that these counts include feeder watches by those not ready to brave the cold. These also can produce interesting birds.

For the competitive urban birder, it is all about the window list. A window list is a cumulative list of all the birds that have been seen (or heard) from that dwelling window. One might think this would bottom out at just a handful of species, but it is surprising how many can be accumulated by the observant urban birder. The challenge makes it fun. It is great to have bragging rights based on some fantastic observation (such as hearing the croak of a Common Raven as it passed overhead when the window happened to be open on a spring morning).

pend on large-scale weather conditions. A daily check of the migration conditions on Cornell's BirdCast app (http://birdcast.info/forecasts/) may help predict a good morning. In spring, warm southwest winds out of the Gulf of Mexico bring the birds. Several days of these benign southwest winds produce numbers of migrants. That may be enough to produce some great birding in your urban park. In fall, a passing cold front with some northwest winds will generate a lot of migrants. Local conditions may raise the stakes even more. Fog, mist, and patchy rain over the city in the predawn hours can produce a fall-out, as migrating birds are knocked out of the sky by these local impediments to navigation and travel. Autumn flights can produce greater volume than those in spring, although some of the birds will be in their dull fall colors and probably will not be singing. Even so, it is still worth getting out to see what has shown up.

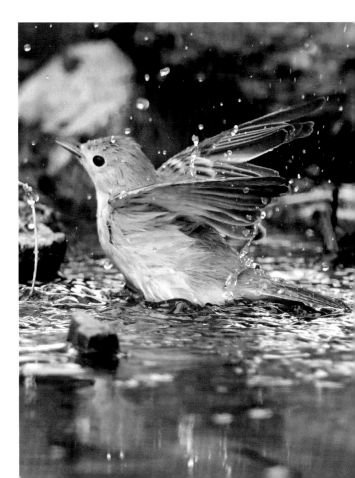

The Suburban Landscape

Many of us live in the suburbs. Much of our Region, especially in the Western Shore and Piedmont provinces, is mainly suburban today—associated with the string of great eastern cities from Washington, DC, north to New York City. For birders, the nice thing about suburbs is that they are very green, bracketed as they are by networks of green spaces composed of stream watersheds, parks, and golf courses. Most suburban communities have ready access to woodlands and stream bottoms, which are typically very birdy places.

Lots of families in the suburbs feed the birds. It is a great way to learn about the local birdlife. And many of the suggestions provided in the preceding section apply to suburbia, too. Join the local bird club. That is always a good first step. Study the bird club's literature and website, and go out on some of its bird walks. Get to know friendly local birders who might allow you to tag along when they go birding in the neighborhood or in the nearest park. You will find some magical birding spots tucked away in unexpected locations. Checking Facebook pages and signing up with local online groups are a great way to find out about these.

Living in suburbia frees you from many of the urban constraints on bird feeding. It is possible to fill a backyard with a diversity of feeders, suet cages, and water sources. You can create a whole bird-friendly environment by combining the hardware with specific plantings (see chapters 6 and 7). Go wild if you like, but there are some issues to consider. The squirrel population in suburbia may be considerable, and even a single squirrel can drain unprotected feeders in minutes. If you do not want to be feeding the squirrels, then you will have to invest in baffles and other squirrel repellent devices (e.g., the "Squirrel-Buster" feeder) to keep them from taking over. There is a lot of advice on this issue available online.

In suburbia, suet is perhaps one of the best ways to bring birds into your yard in winter. It attracts

A visiting Carolina Chickadee brings cheer to any backyard.

mainly woodpeckers, nuthatches, wrens, and chickadees—a good assortment of backyard birds. In the Region's suburbs, a well-situated backyard suet cage can attract six species of woodpeckers: Northern Flicker, Yellow-bellied Sapsucker, and Pileated, Downy, Hairy, and Red-bellied Woodpeckers. Seeing a big male Pileated Woodpecker hanging on the suet cage is worth the price of it all.

It is nice to deploy a birdbath (or other water source) in the backyard year-round. This will bring in birds that do not visit the feeder, so can increase the diversity of your backyard avifauna. And yes, again, it is all about bragging rights. How many birds have you recorded in your backyard? What is the upper limit of possibilities? There are birders in our Region with yard lists in excess of 200 species. In suburbia there is much more scope for building a good yard list, partly because of the much

greater field of view or range of hearing (without urban noise pollution). On gorgeous spring days in early or mid-May, the savvy homeowner can spend a few hours in a reclining lawn chair with binoculars at the ready and ears alert to spot that Bald Eagle soaring high overhead or hear that Hooded Warbler singing down in the hollow. Every birder worth his or her salt should keep a yard list. The nice thing about your yard list is that it never gets smaller; it just grows and grows as your expertise and knowledge grow and as the birds continue to pass through, year after year. Finally, homeowners should minimize or dispense with the application of fertilizers, herbicides, and pesticides. Many of these compounds can be dangerous to birds and native insects (be sure to avoid application of neonicotinoid pesticides, which are highly toxic to birds).

The Rural Agricultural Landscape

Our Region continues to support a substantial amount of rural agricultural land, especially in the western Piedmont, Ridge & Valley, and Eastern Shore provinces. These landscapes feature cultivated or fallow farm fields, shrubby edge, woodlot, hedgerows, and forest. Such a combination is great

Harvested grain fields in the countryside attract interesting field birds such as the Horned Lark.

for birds, and people living in the agricultural countryside have ample opportunities for productive birding and bird appreciation. The farm ecosystem is itself attractive to birds because of the opportunity to harvest adventitiously dropped seeds, grains, and other edible by-products of the farming process. Thus rural farms are birdy places even without the farm family making an effort to attract the birds.

That said, it is still worth putting out seed feeders and suet cages in the yard. The number of species coming in to these will probably exceed that found in suburbia, just because more species are moving through the rural landscape.

For those in a deep rural setting, there may not be much opportunity to actively participate in a bird club. But state or county membership is still a useful option because this gives access to a website, local bird lists, and literature. For those who live far from indoor meeting venues, one option is to plan a field trip to attend the annual state or county birding festival (usually in spring or fall).

For those living on a rural farm, it is worth considering creating a farm-wide plan for the birdlife. This would be a long-term project, carried out over years not months, with the objective of creating habitat for one or more targeted declining species living in the area. In our Region, creating habitat friendly for the drastically declining Northern Bobwhite is a high priority. In this instance, a farmer can obtain a contract from the Natural Resources Conservation Service (NRCS) of the Department of Agriculture that compensates the farmer for taking steps to create new wildlife habitat. In this manner, the farmer can work with the federal government through the NRCS's Conservation Stewardship Program to take concrete action on behalf of birds and other wildlife—a step above and beyond feeding the birds. Visit the NRCS's website to find out more about these partnership programs https://www.nrcs.usda.gov/wps/portal/nrcs/main /national/programs/financial/csp/. Because farm properties tend to be much larger than suburban

or urban properties, their owners can have a much bigger impact on the land and on bird conservation than the rest of us. It is just a matter of learning what birds are present around the farm and researching what actions can directly or indirectly benefit them. In this case, taking up the hobby of birding can lead families to do major good for the long-term health of birds in the Region. Owners of large rural properties can establish conservation easements that both provide tax benefits and help birds and the rural environment. In addition, oper-

ators of large farms should try to minimize runoff from their property into streams that drain into the Chesapeake or Delaware Bays. Greening stream ways and preventing domestic livestock or fertilizer from chronically degrading a streambed are good for everybody, including the birds. And consider putting a Purple Martin nesting box atop a tall pole in an opening near the house. There is nothing quite like a swarm of chattering martins around the home to cheer up the day and reduce the cloud of flying insects around the barn.

Pastures with livestock such as these Assateague ponies attract Cattle Egrets to the insect feast.

The Gift of Wild Places

We have spoken of urban birding, window lists, and birdbaths. You can certainly love birds and interact with them without leaving home. But one of the joyous opportunities that bird-watching can offer is travel and geographic discovery—especially of wild places near and far. Birders who start the hobby in their backyard in Delaware can find their hobby eventually taking them to Arizona, Alaska, Costa Rica, South India, or Botswana. As with most hobbies, there is much room for growth. Here we confine our discussion to the wild places within our Region, along the crowded East Coast.

Of course, "wild" can mean different things to different people. Here we define as wild those environments that retain many of their original natural characteristics. Using that definition, there are quite a few wild nooks and crannies in the Region, and we encourage you to consider visiting them for bird-watching experiences made more memorable by the beautiful natural environment in which you are seeing the birds. It is one thing to glimpse a Northern Goshawk passing overhead from a street corner in downtown Baltimore (yes, it could happen). It is an entirely different thing to find a Northern Goshawk at its nest in a gnarly mixed upland forest in the Allegheny Highlands of westernmost Maryland. Place is important to all our most memorable experiences, and the wild places in our Region can help us form indelible memories.

Tumbling mountain creeks in the Catoctin Mountains are just over an hour's drive from Baltimore and Washington, DC.

Most of the Region's wilder places take some effort to get to—a drive plus a hike or a paddle or a boat ride. We discuss here five examples to give you a sense of the opportunities. Additional wild places are noted in our birding hotspots list in chapter 29.

The Open Ocean

The wildest place in the Region is 40 miles east of the Atlantic Shore of Delaware and Maryland. The pelagic (e.g., "deep sea") zone of the Atlantic Ocean is mainly visited by commercial fishing boats, adventurous sport fishermen, and advanced birders who sign up for an offshore birding field trip (a "pelagic") with a local bird tour leader on a charter boat. In most seasons, this is not for the faint of heart. De-pending on the winds and currents, these boat trips can be rough, and usually, some percentage of the passengers suffer seasickness. But for those who take the chance (and have a dose of the sea sick medi-cine), the experience can be remarkable.

A long day at sea in search of pelagic seabirds can reveal an ocean wilderness. The boat passenger encounters the sea in its many moods and colors. You have not truly experienced the deep sea until getting at least a few dozen miles offshore, well out of sight of land. Then the world changes, and the vast scale of the ocean wilderness becomes appar-ent. Strange birds, mammals, sea turtles, and fishes appear unexpectedly: among the birds, Northern Fulmars, Dovekies, Black-legged Kittiwakes, Manx Shearwaters, and Pomarine Jaegers; among other

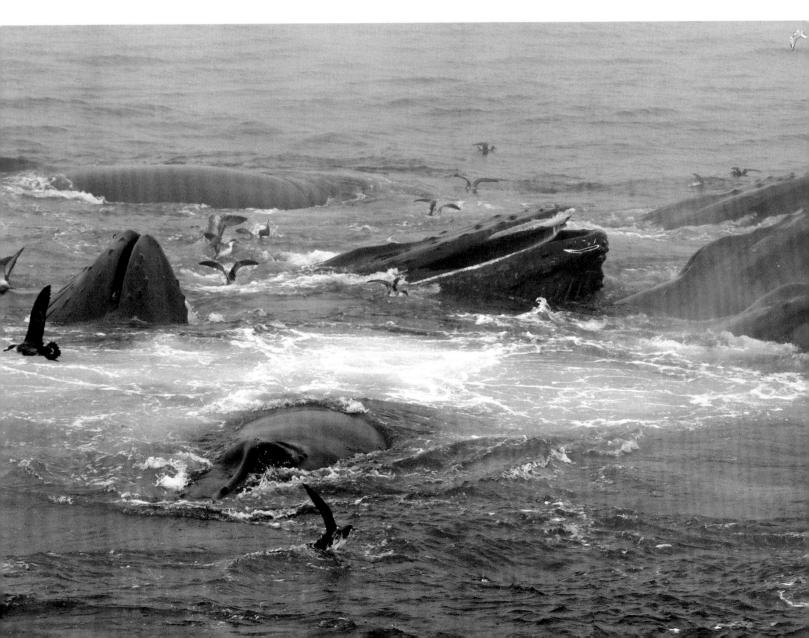

animals, Ocean Sunfish, Scalloped Hammerheads, Blue Sharks, Fin Whales, Humpback Whales, Minke Whales, and Loggerhead Sea Turtles.

The lonely ocean can come to life when these life forms converge to feed on schools of bait fish. Groups of Humpback Whales start bubble-net feeding, the seabirds join in the frenzy of consumption, and sharks and other sea life circle about. The mix of whales, sharks, gannets, shearwaters, gulls, and storm-petrels can be fantastic. The ocean comes vigorously to life in a way you have never experienced. And then the event passes, and for the next hour you see nothing but the movement of waves and the occasional pelagic gull. Most of the ocean wilderness is empty most of the time. Most of the life remains hidden below the surface. And it is

difficult to guess the feeding patterns of the pelagic seabirds. So every trip out into the deep is different and unpredictable. The two things on the open ocean that remain the same are the hint of menace and the sense of vast, open space.

Boat trips typically are scheduled in January and February, May and June, August, and October and November. The cold-weather trips can be brutal—rough and cold and windy. The summer trips can be balmy and pleasant. But be prepared, and expect the unexpected. Take note: when standing on the wet deck of a rocking boat, it can be very difficult to focus your binoculars on a distant moving seabird that is dodging behind every other wave. Pelagic birding is the most challenging birding in our Region.

Feeding humpback whales attract an assortment of opportunistic shearwater and gull species in the ocean's pelagic zone.
Photo: Bruce Beehler

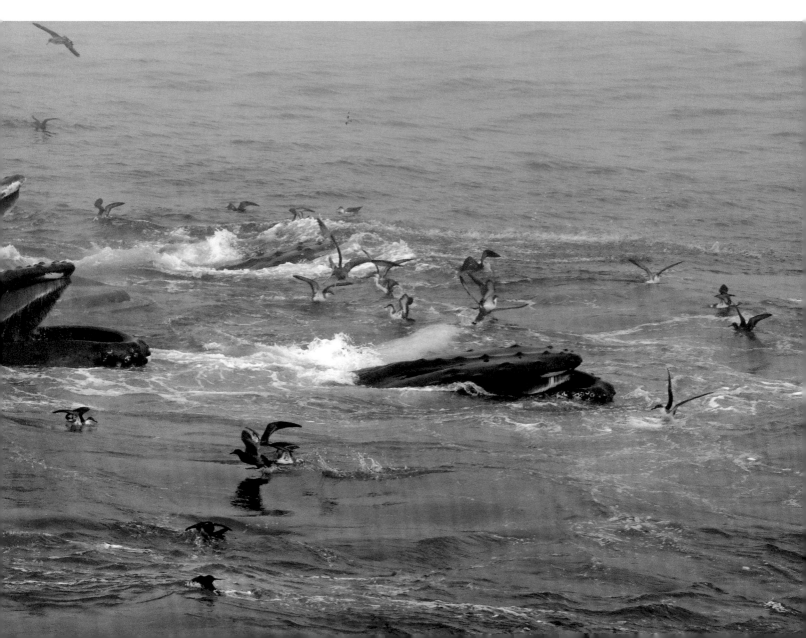

The Pocomoke

Ancient Bald Cypress trees line the banks of the Pocomoke River and its feeder streams in southern Delaware and adjacent Maryland.

Back on terra firma, the wild places in the Region are not quite as sinister or vast, but they, too, have their special qualities. In the southern reaches of the Eastern Shore is the Pocomoke Swamp, the bottomland of the Pocomoke River, flowing from the Great Cypress Swamp in southern Delaware southward to its mouth, where the Virginia-Maryland line meets the Chesapeake Bay. This southern swampland is not very extensive except in Delaware, but canoeing the Pocomoke River gives paddlers a feeling of wilderness even though they are only a dozen or so miles as the crow flies from the noise and bustle of

downtown Ocean City, Maryland. The Bald Cypress trees that cluster in parts of the Pocomoke give this swamp forest a Deep South look. You can explore the largest patch of swamp on foot, from the dirt backroads between Gumboro and Selbyville in Delaware. This is the largest tract of forest in Delaware. For birders, it is famous as the occasional breeding

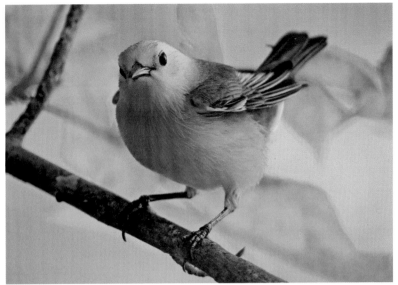

home of that elusive and highly sought-after southern swamp dweller—Swainson's Warbler. And when Prothonotary Warblers and Northern Parulas are in full song in May and June, this could be a swamp in the low country of Louisiana.

The colorful and vocal male Prothonotary Warbler favors the Pocomoke and other wooded wetlands along the coastal plain.

Catoctin Uplands

One of the largest contiguous tracts of forest in the Region sits atop the broad Catoctin Mountain, just west of Frederick, Maryland. Drive to the top of this big flat ridge and you are suddenly in a wilderness of oak forest that extends from Frederick northward across the Pennsylvania line to the 85,000 acre Michaux State Forest. In its northern reaches, this tract extends westward to the extensive forests of South Mountain. Virtually all of this mountainous upland green space is encompassed by protected areas: Gambrill State Park, City of Frederick Municipal Forest, Cunningham Falls State Park, Catoctin Mountain Park, and South Mountain State Park. This is an area where you could get lost for a while, even in a car. The Catoctin Trail transects this upland forest from south to north. Perhaps the best hiking network is in the north, at Catoctin Mountain Park, which is also home to the presidential retreat of Camp David (behind a tall fence in the forest). This woodland comes alive in late spring,

when the songbirds are moving through. It is also home to breeding populations of some uncommon songbirds, including Cerulean, Black-and-white, Worm-eating, Kentucky, and Hooded Warblers.

Green Ridge State Forest

Wild rhododendron festoons stream banks along many Allegheny Highlands preserves, including Savage River State Forest.

Heading westward to the western reaches of the Ridge & Valley province, another major green space is Green Ridge State Forest, 48,000 acres of upland forest on the bends of the upper Potomac. The contiguous forest block that encompasses

Green Ridge State Forest extends south into West Virginia and north into Pennsylvania, and certainly tops 100,000 acres of mature upland forest—the largest single contiguous block of forest centered in the Region. There are 50 miles of hiking trails in Green Ridge. The area is best visited in late spring or autumn for the songbird migration and in early summer for the beginning of the breeding season. The high and forested oak ridges are another good location for the elusive Cerulean Warbler.

The Allegheny Uplands

Our last highlighted wild space is found west of the Allegheny Front, west of Frostburg, Maryland. This series of upland forest blocks, totaling more than 50,000 acres, includes Savage River State Forest, Savage River Reservoir, Potomac State Forest, Garrett State Forest, New Germany State Park, and Big Run State Park. These forests lie about 1,000 feet higher than Green Ridge State Forest, thus having the more northerly aspect that is associated with the Allegheny Plateau. Wandering through these mountain forests is akin to a hike in western New England, with breeding species such as the Golden-crowned Kinglet, Winter Wren, Hermit Thrush, Yellow-rumped, Black-throated Green, and Black-burnian Warblers, and Dark-eyed Junco. Also look for the Long-tailed Weasel, Black Bear, Bobcat, and other wildlife infrequently encountered back east. For those who want to stay in the Region and yet get away from it all, this is a worthy destination. The area has more than 75 miles of backcountry hiking trails as well as various primitive camping opportunities.

Other Wild Places

There are scores of green spaces with wild characteristics scattered about our Region. It is just a matter of doing some research and exploring and discovering these scenic wonders. Get off the beaten track, wander down the less-used secondary and

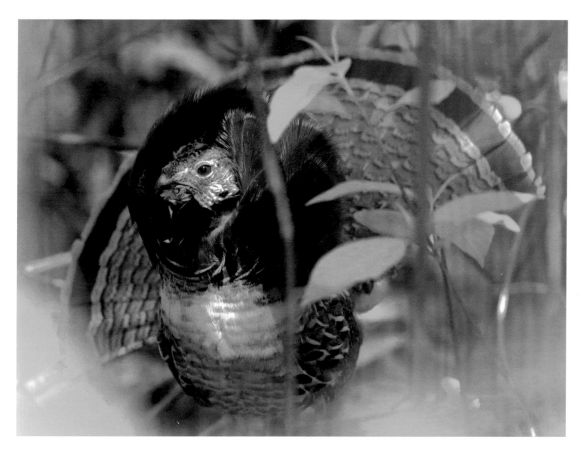

The amorous drumming of male Ruffed Grouse echoes through the springtime forests of the Allegheny Highlands. Photo: Bruce Beehler

tertiary roads, and check out places that show up as green spaces on Google Maps (toggle back and forth from map to satellite mode). Google Maps can help a great deal in this effort, especially when there are high-resolution satellite data for the area of interest. Here are a few of our favorite second-tier wild spots.

In spring, we love to visit the Patuxent bottoms where Hipsley Mill Road crosses the river. The fisherman's trails give access to verdant forest that regularly hosts breeding Kentucky Warblers, with Worm-eating Warblers on the adjacent hill slopes. The whole area enclosed by Hipsley Mill and Annapolis Rock Roads should be explored in early to late May. This area is a few miles southeast of Damascus, Maryland.

The northern sector of Sugarloaf Mountain (the Stronghold reserve) offers several lovely upland forest walks with rocky overlooks. This is worth visiting in the spring and autumn. Sugarloaf is a place where you can go off-trail and wander the forest without getting terribly lost. That said, birders could

happily lose themselves in these deep woods. Here you will hear the songs of breeding forest songbirds such as the Ovenbird, Louisiana Waterthrush, Black-and-white Warbler, Worm-eating Warbler, and Scarlet Tanager. Sugarloaf is a couple of miles due west of Hyattstown, Maryland.

The forest surrounding Blairs Valley, about 20 minutes west of Hagerstown, Maryland, is gorgeous and very birdy. It is like the land that time forgot. Best visited between early May and mid-June, this area and the mountainous lands to the west, all encompassed by Indian Springs Wildlife Management Area, are wonderful wild lands for exploration. Blairs Valley is a couple of miles due north of Clear Spring, Maryland.

There are hidden wild places in every corner of our Region, perhaps with the exception of the highly urban areas. We encourage you to find your own special places. Before wandering too far from the beaten track, however, study chapter 23 on preparing for a field trip.

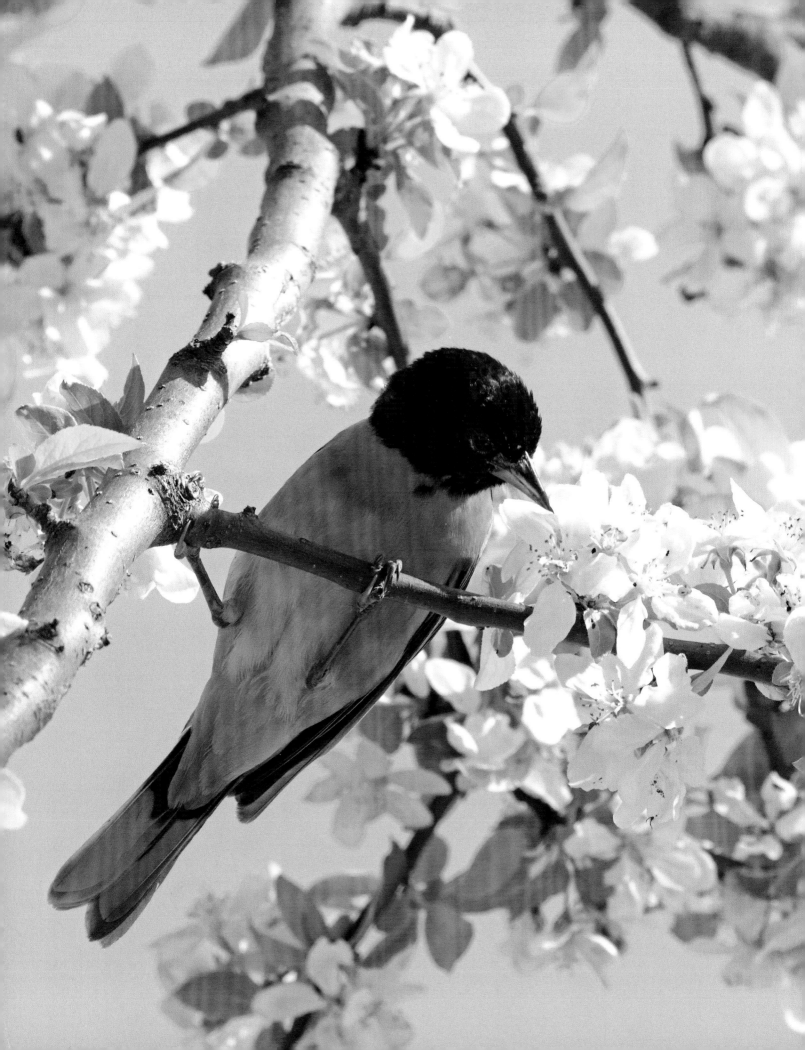

Landscaping for Birds and the Environment

As we have said, a favorite place to watch birds is the backyard. We all can take steps to attract more birds to our home territory. By factoring birds and their year-round needs into a home landscaping plan, we can improve our property's value while making it more beautiful, green, and bird-friendly. And by making it better for birds, we make it more pleasant for our families. It is just a matter of thinking about what birds need and keeping birds in mind when drafting an improvement plan, which is probably worth doing every few years. How nice it would be, on an early evening in May, to be able to point out to guests a male Rose-breasted Grosbeak with his hot-red chest patch—just one of the many golden moments that landscaping for the birds could provide.

Yard beautification is no small task, but it pays considerable benefits. There are many ways in which we can beautify the yard. Just as we plant certain flowers to bring color, beauty, and diversity, we can actively attract colorful and desirable birds to add color, song, and an opportunity to witness their fascinating behaviors. Although the flowering plants or their seeds have to be bought at the store, the birds are supplied free by Nature, requiring just a few thoughtful tweaks to our backyard environment to bring them our way. By providing food, water, safe shelter, and nesting sites, we can do a lot to bring birdlife into our yards.

The fragrant crab-apple blossoms and attending insects are inviting to a host of spring migrants such as this dapper male Baltimore Oriole. Photo: Bruce Beehler

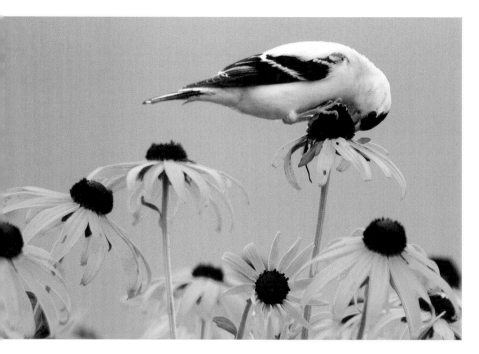

Before we get into the details, we should consider the big picture. We are not suggesting that homeowners radically alter their yard improvement plans because of the birds. We are suggesting, instead, that standard yard improvement plans should be informed by adaptations to make more space for the birds. The overall objective remains the same: to make your home and yard a beautiful and pleasing place to spend time. Bringing in the birds can make it more pleasant. We do suggest that a toxin-free and environmentally green living space is a worthy objective and is consonant with making your yard bird-friendly. But the idea is to focus on making the yard as comfortable and family-friendly as suits your needs and, while doing so, to consider birds' needs along the way.

Black-eyed Susans are not just pleasing to the eye but food for birds such as the American Goldfinch. Photo: W. Scott Young

This carefully planned backyard is a wildlife oasis through the seasons. Photo: H. David Fleischmann

The Planned Environment

First, we need to admit a few things. The home environment is a human environment, a manufactured environment, and is not wild Nature. The homeowner should manage the home environment, including the yard, to ensure the safety, health, pleasure, and satisfaction of the homeowner, the family, and their pets. Birds are added to the mix to bring extra pleasure. For most homeowners, the objective is not to create a wildlife sanctuary but to attract birds so the family can enjoy their presence. That said, most of us want to help protect populations of our favorite birds, and this planning can help.

Just about any improvement to green and beautify the yard will attract birds. The smart way forward is to create a plan, usually by mapping the yard and the proposed improvements on a piece of paper. Having a long-term vision is a useful way to ensure your reworked yard will be a success. It pays to think from big to small in terms of additions. First, map out the pathways, play areas, ponds, patios, and outdoor furniture placement. Next, think about the placement of canopy trees, understory trees, and shrubs. And then consider herbs and annuals. Focus on the larger additions and then gradually add the smaller and smaller components. This can be done over several years, taking care to plant items in the season that gives them the best chance of rapid acclimation to the new environment.

A few mature canopy trees can offer the most substantial improvements to a yard. A big White Oak or Black Gum can cast wonderful shade and give the yard a pleasingly rural aspect. Because trees take decades to mature, and because they affect sightlines and shade, selecting and situating these canopy trees is a major decision not to be taken lightly. Work with a landscaper or county arborist to achieve the proper tree planting scheme. With regard to canopy trees, fewer is usually better. The initial temptation is to plant lots of saplings because they are small. This can provide some fast satisfac-

tion, but as tree canopies spread, they require more and more space. You do not want to create a jungle. Better to think in the long term and allow space for trees to grow, to seek the sun and spread their branches. Visit the website of the Arbor Day Foundation (https://www.arborday.org/) to find out the requirements of mature canopy trees.

It is also good to keep the seasons in mind when deciding what to plant. What will the selection of plantings look like in spring, summer, fall, and winter? Include a diversity of plantings that can provide color or fruit or green leafy growth in each season. Think about colors and what will best

Rhododendron provides thick cover for birds throughout the year. Here, a Louisiana Waterthrush has a mouth full of insects.

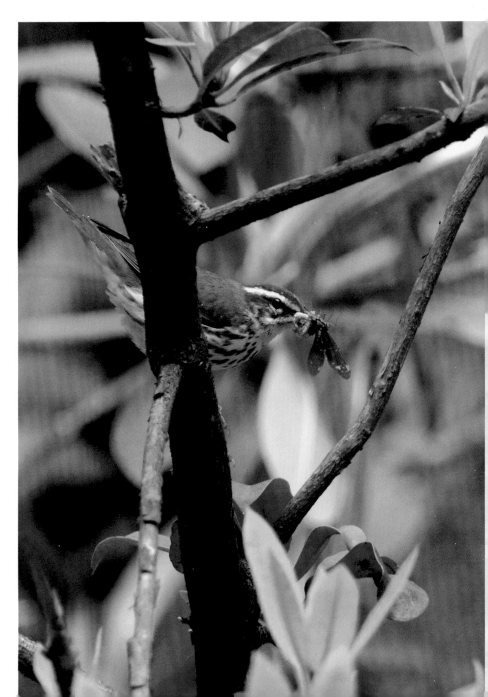

accent the yard. What autumn colors are produced by a shrub or tree, and are they right for your yard? Planting certain tree saplings can have lots of potential pitfalls that do not arise until several years later when the trees mature. For instance, a female Ginkgo may have nice yellow leaves in autumn, but it will also produce stinky, messy fruits that the homeowner will have to deal with. Sweet Gum is a wonderful canopy tree and produces many fruits with seeds that are popular with small seed-eating birds, but the spiky pods that litter the ground are a big nuisance to homeowners. American Ash produces tens of thousands of wind-borne seeds that lodge in gutters and in all manner of nooks and crannies—for instance, filling the small, narrow wells that hold the windshield wipers of cars. And this ash could fall prey to the Emerald Ash Borer beetle. Be smart and do a lot of research about the canopy trees you choose to plant—you (and perhaps your children) will have to live with them for a long time.

In general, for landscape plantings, it is better to plant native species, especially for trees and shrubs. There are plenty of bird-friendly native species that can beautify the yard and are likely to host more native insects than the exotic species. Hundreds of exotic invasive plant species are already lurking in the Maryland and Delaware countryside. As a society, we will be spending billions of dollars over the decades to come to remove these exotics from the local flora. Better not to risk adding to this expensive environmental problem.

Careful inspection of Spicebush shrubs in summer might reveal the rather comical Spicebush Swallowtail caterpillar.

Try to plant a suite of species that will provide seasonal foods for the birds year-round. This will ensure some nutrition for the birds in every month and will provide added pleasure for the homeowner, as birds visit during more months of the year. American Holly produces red fruits that add color in winter and also provide food for Pileated Woodpeckers, American Robins, and Northern Mockingbirds.

Be careful with pesticides and herbicides. For instance, the use of neonicotinoid insecticides can be devastating to birdlife. Better to avoid standard store-bought toxins altogether. Also, ensure that anyone you hire to carry out yard work uses only bird-friendly fertilizers, insecticides, and herbicides.

There is a difference between "green" and "overgrown." Keep the yard well planted but also well tended. An overgrown yard will make you unpopular with your neighbors and is not necessarily a net positive for the birds. Overgrown yards attract fewer species of birds than well-tended and well-planned yards. As with most things, the best results come from a more substantial investment of time and resources—and thoughtful planning.

Best Canopy Trees for Birds

Not everyone has space to plant new canopy trees, but if you do, you need to think ahead if you plan to make such a major environmental commitment. The best trees for the birds are those that grow well in your yard, look good, and also provide something for the birds: a place to forage, a place to roost, or a place to nest. Native trees are preferred, mainly because they serve as favored habitat for all sorts of wild creatures, big and small, some of which serve as important prey for a variety of woodland birds. For instance, the White Oak, the Maryland state tree, is very popular with migrant wood warblers in spring because its young leaves attract tiny caterpillars of native moths. The caterpillars convert the leaf material to fat and protein, ideal for hungry migrant birds that need to keep

feeding to have the energy for their flight north. Having a mature White Oak at the edge of the yard can almost guarantee visits by a whole suite of beautiful migrant warblers as well as other attractive species such as the Rose-breasted Grosbeak and Scarlet Tanager.

Trees that grow to canopy height are usually purchased when small (6 to 7 feet tall), with a root ball the size of a large pumpkin. Do not be fooled by the small size. The tree will grow to become a major part of your yard environment, so caution is in order. Most large trees are best planted far from the house, in the corner of the property. This allows for the considerable space this tree will require once mature. For example, that 6 foot spruce at the garden center looks like an adorable little Christmas tree. The temptation is to treat it like a Christmas tree and plant it by the front door or in the entrance to your driveway. Do not do so. In four decades this tree will be 70 feet tall with branches that reach out 15 feet on each side of the trunk—30 feet from side to side. If you simply must have a conifer, plant it as far from the house as possible, in the woodsiest corner of the yard, and select a native species. Another concern is root invasion. Big trees send out powerful roots in all directions, and these can push up sidewalks and patios, rupture water pipes, and penetrate basements. Some trees are more invasive than others. Do your research. Once you have made a decision on a species, buy a well-formed specimen, and one as large as you can afford, as larger saplings have a greater probability of surviving to maturity. The tree will be in place for a century or more. It is worth an investment in the best quality. Here are a few nice native trees worth considering:

Black Gum. Beautiful deep-red leaves in autumn. Small fruit popular with songbirds. Grows to be a very beautiful yard tree.

Tulip Poplar. Fast growing. Very tall. Pretty yellow-and-orange "tulip" flowers in spring. Seeds taken in winter by the Purple Finch and Northern Cardinal. Popular with the Tiger Swallowtail butterfly.

White Oak / Swamp White Oak. Very popular with songbird migrants in spring. Both form magnificent trees at maturity, but are slow growing.

American Elm. A beautiful shade tree. Popular with American Goldfinches in spring. Make sure to purchase a disease-resistant cultivar.

Northern Hackberry. An elm relative, fast growing and excellent as a screen or hedge. Seeds consumed by juncos, chickadees, and siskins in late fall and winter. Good nesting habitat for several bird species. Popular with the Hackberry Emperor butterfly.

Black Cherry. Medium-sized tree. Fruit very popular with birds. Produces lovely spring flowers.

Balsam Fir / Fraser Fir. Two very similar fast-growing conifers with a handsome pyramidal shape. Provide excellent nesting cover for various bird species and cone seeds for winter finches. They do not produce shade. Needles produce the lovely scent reminiscent of Christmas.

Eastern Hemlock. Another handsome conifer that can be planted as a screen. Popular with nesting birds and certain migrant warblers. Cones produce seed for birds. Grows large. If possible, purchase a cultivar resistant to the insect pest known as the Hemlock Woolly Adelgid.

Eastern Redcedar. A hardy native conifer that can grow anywhere. Its berrylike cones eaten in winter by birds and small mammals.

Before making a purchase, spend time studying websites that offer guidance on tree planting. Also visit a local arboretum to look over mature specimens of the trees that you intend to plant, to ensure they fit your need.

Best Understory Trees for Birds

Most yards can handle a few additional understory trees. That said, these trees can also grow large and spread, and the homeowner must plan carefully to allow space for growth. Consider planting the back

boundary of your yard with several of these small trees to form a hedgerow, interspersed with attractive shrubs. Birds will love this sort of refuge. Some small trees to consider:

American Holly. Pretty when carrying the red fruit popular with birds in fall and winter. Given its thick green foliage year-round, valuable for creating privacy.

Crabapple. Lovely pink or white flowers in spring. Stays small. Easy to manage. Fruit popular with birds in late winter as an emergency crop.

Black/River/Paper Birch. Three species of small to medium trees. Handsome in yard. Popular with foraging warblers in spring. Seeds consumed by birds in late summer and fall.

Choke Cherry. Small tree / large shrub. Can form thickets. Popular with butterflies and songbirds. Fruit available in fall and early winter.

Hawthorn. Small shrubby tree. Thorny. Good nesting tree. Fruit popular with songbirds, autumn into spring.

American Mountain-Ash. Small tree. Leaves turn yellow then red in autumn. Small red bunched fruits very popular with songbirds in late summer and autumn.

Serviceberry. Large shrub / small graceful tree. Small leaves and pretty white flowers in spring. Fruit popular with songbirds and mammals.

Persimmon. Small to medium tree. Fruit in late fall and winter, popular with birds and small mammals. Leaves turn orange in autumn. A dioecious species (separate male and female plants), so you will need plants of both sexes to get fruits.

Flowering Dogwood. Very small understory tree. Lovely white or pink flowers in spring. Red fruit popular with songbirds in autumn. Be sure to purchase a cultivar with resistance to Dogwood Anthracnose.

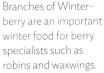

Branches of Winterberry are an important winter food for berry specialists such as robins and waxwings.

Red Osier Dogwood. Small understory tree that produces berries popular with songbirds. Crimson stems providing a beautiful flash of color in the dull days of winter.

Best Shrubs for Birds

Edging your yard with rows of low shrubs that are somewhat open underneath provides an ideal refuge for sparrows and other ground birds that tend to be wary of avian predators such as Cooper's Hawks. Place feeders close to these protective shrubs so birds have a safe place to escape to when a predator swoops in. Some useful shrubs:

Great Rhododendron. A native of the Appalachian uplands that keeps its large green leaves year-round, providing excellent cover for roosting birds. Produces beautiful flowers in spring.

Spicebush. A versatile understory shrub that produces fruit favored by songbirds in late summer.

American Elderberry. Provides good cover and nest sites in summer, as well as fruit for songbirds in late summer and fall. Be warned: spreads rapidly to form a thicket and can dominate the yard, as can rhododendrons.

Coralberry/Winterberry. Nectar attractive to hummingbirds. Late fall and winter fruits appreciated by other birds. Provide good cover and nesting sites.

Viburnum. Many varieties providing attractive landscaping and useful to birds. Fruit consumed by songbirds in autumn and winter. Good nesting habitat for several birds because of its density.

Steer clear of the large and tall broadleaf evergreen shrubs with a thick shell of leaves. Most of these are exotic, such as English Laurel and various commercial hollies, and tend to attract winter roosts of House Sparrows and spring nest sites for Common Grackles, both of which can detract from a pleasing landscape.

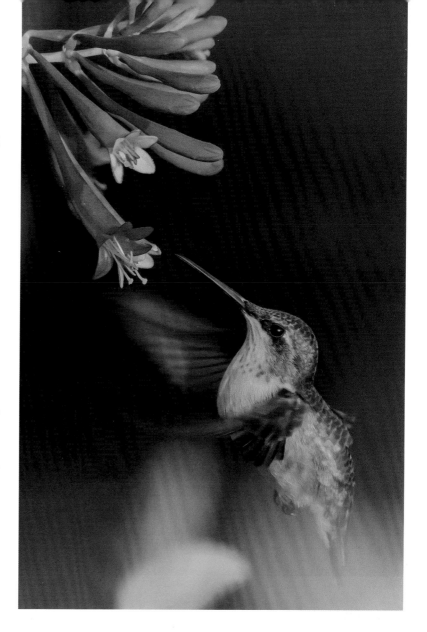

Best Vines

There are places in the landscape where a vine is an ideal solution. Vines can be pruned back as necessary from time to time. Avoid English Ivy, which is aggressively invasive. Some suitable vines:

American Bittersweet. A native vine that provides fruit, cover, and nesting locations. Fruit an important winter food source for songbirds.

Clematis. White spring flowers providing nectar for local hummingbirds and native arthropods.

Trumpet Honeysuckle. Provides nectar for hummingbirds and cover and fruit for other birds in late summer and autumn.

Ruby-throated Hummingbirds cannot resist the nectar-rich blossoms of Trumpet Honeysuckle. Photo: Bonnie Ott

provide fruit that birds love. If you have the room, evergreen conifers can provide seeds in cones. Crabapple trees can provide both fruit and seeds.

Best Annuals and Perennials for Birds and Butterflies

The best annual and perennial plantings include the Columbine (spring), Coneflower (summer), Joe-Pye Weed (late summer), Sunflower (summer), various Milkweeds (including Butterfly Weed in late summer), Cardinal Flower (late summer), Bee Balm (late summer), and Blazing Star (summer). Several websites give more detailed advice on flowers for birds and butterflies (http://www.humming birdsociety.org/hummingbird-flowers; http://www .audubon.org/news/10-plants-bird-friendly-yard; http://monarchbutterflygarden.net/butterfly -plants).

A late summer bloomer, Joe-Pye Weed is an insect magnet, especially for Common Buckeye butterflies.

Trumpetvine. A climber providing summer nectar for hummingbirds. Be warned: a very aggressive vine. If planted close to your house, will climb walls and damage the mortar.

Crossvine. Provides early spring nectar for arriving and passage migrant hummingbirds.

Virginia Creeper. A climber that provides cover for roosting birds. Fruit lasts through the winter and eaten by songbirds.

Wild Grape. A high climber that provides cover, nest sites, and fruit for birds.

Planting for Winter

Ground-feeding birds such as the Hermit Thrush will settle in when the yard has carefully tended woodland features.

Many winter plants can provide food for birds that consume seeds and fruits. Plants such as the Staghorn Sumac, viburnums, Virginia Creeper, Serviceberry, Winterberry, American Holly, and Bayberry

Reduce the Expanse of Sterile Lawn

Mowed lawns are fun as play spaces for children, but they do not do much for birds. Yes, we see American Robins searching for earthworms on the lawn, and we see European Starling flocks out on the lawn in search of insect larvae. But most homes could do with less mowed lawn and more permanent vegetation that requires minimal annual work. Think about reducing the lawn space to the center of the yard and building buffers of taller vegetation around the perimeter. This reduces the weekly chore of mowing and offers a more complex environment for the eye and for the birds.

Food, Water, Shelter, and Nesting Sites

The next chapter focuses specifically on bird feeding. Here we discuss general issues related to what birds require to benefit from the yard environment: food, water, shelter, and nesting sites. Providing nutrition for birds usually is a combination of smart plantings and direct feeding. Provide a reliable year-round water source. Also situate and prune plantings so they offer safe shelter for roosting birds or those escaping predators. Many birds (e.g., Gray Catbirds and American Robins) construct cup nests in protected shrubbery. Others, such as House Wrens, generally require a nest box of the correct dimensions with a suitably small entrance hole. Placement of a water source, food sources, shelter sites, and nest boxes should be planned, along with the landscaping, to achieve the best effect and greatest beauty.

Flowing Water All Year for Bathing and Drinking

Year-round, the Region's birds require access to fresh water for drinking and bathing. A heater, bubbler, or other device will prevent ice from forming in the birdbath in winter. You can leave this bath up all year and use the heater when needed. It is important to change the water frequently to avoid the build-up of algae and disease organisms from bird droppings. The water source should be placed close to shrubbery and other vegetation so the birds do not have to put themselves at risk when using it. It is safer and more likely to be used by birds if raised off the ground. The bath should have depths ranging from a half-inch to three inches deep. The surface of the basin should be rough to allow good footing in the water. Finally, it is not a bad idea to put a few stones in the middle so birds can stand on them to drink.

Waders such as the Green Heron have a knack for finding water gardens stocked with fish.

Shelter

Shrubs and trees that maintain their leaves during the winter can provide birds with cover from the wind, rain, and snow, and there are other ways you can offer shelter. When choosing plants, consider different canopy levels for diverse shelter needs. Brush piles can also provide a safe place for birds to hide or roost overnight; try making your own from discarded branches and leaf clippings in a hidden, undisturbed corner. Consider offering a roost box for your backyard birds, similar to the one found at the website All About Birds (https://www.allaboutbirds.org/). You can also modify a nest box (see below) to make it a temporary roost box. What about

birds that do not use cavities? They will seek shelter in an evergreen tree, often huddling together on severe nights. If possible, cluster a few evergreens in a corner of your property.

Nest Boxes

It pays to think through the nest box plan. Many nest boxes sold in stores are not properly constructed or sized to attract the desired target species. Perhaps the two most desirable species that use a nest box in our Region are the House Wren and Carolina Wren. Both are wonderful songsters and are adorable to watch as they look for food and take it back to their young. In addition, Carolina Wrens are remarkably curious and tame and become household friends year-round. They may even use the nest box as a winter roost if the box is suitably constructed and placed.

There is nothing more frustrating than setting up a nest box in the yard and seeing it sit empty through the summer. To avoid this, first determine what target species are in the immediate vicinity.

Bluebird nest boxes placed in proper countryside habitat are a sure bet for attracting nesting pairs.

Do not put a nest box out for an Eastern Bluebird and expect one to use it if you have never seen the species in your neighborhood. Bluebirds generally require lots of open space and old fields, neither of which is usually found in suburbia. Do not set up an elaborate Purple Martin house unless you are pretty sure your yard is martin-friendly; again, martins generally do not inhabit suburban neighborhoods. There are websites that can assist with carrying out due diligence on all of this (e.g., http://sialis.org/).

First, determine what favored bird species inhabit your yard and come to your feeder. Read up on the nesting habits of these selected species at Cornell's All About Birds website (https://www.allaboutbirds.org/). Then carefully buy or make nest boxes for these particular species. The most important aspects of the construction include the size of the nest hole and the overall size of the interior of the box. Use untreated and unpainted wood. The best woods are cedar, cypress, and pine. Use galvanized screws, which do not rust. A sloped roof keeps the interior dry. Recess the floor up from the bottom of the box to keep the bottom dry. Drill five-eighth inch ventilation holes on the side walls and maybe a few in the bottom for drainage in case water gets in. Do *not* put a perch under the entrance hole (it aids predators). To keep out European Starlings, keep the entrance hole smaller than one and a half inches in diameter. Add a metal facing or extra wooden layer over the main opening to keep predators from enlarging the aperture. The interior and exterior walls of the house are best left rough so the birds can grip them more easily, especially the nestlings as they attempt to leave the box to fledge.

Placement is everything. Height, location, the direction the entrance faces, the mounting pole, and other factors are critical to creating a nesting environment where a pair of birds can successfully raise and fledge offspring. It is usually best not to hang the box from a tree, as predators will gain easy access. Pole mounting is best; fence mounting is second best.

Roost Boxes

Some birds do not mind using last spring's nesting box as this winter's roost box to keep warm during windy, cold nights. Roost boxes and birdhouses both provide shelter for birds, but roost boxes are not intended for building nests or raising young. They are meant to give cavity-dwelling birds protection from cold temperatures, precipitation, and predators. Birds that nest in cavities, such as Eastern Bluebirds, may crowd together inside a nest box or a natural cavity when temperatures are harsh and food is scarce.

You can repurpose your spring birdhouses by turning them into winter shelters for your backyard birds. First, clean the birdhouse and repair it as necessary. Winter-proof it by sealing the ventilation and drainage holes to keep warm air trapped inside. Some birdhouses are designed with a movable front panel with an entrance hole at the top. If possible, flip this front panel upside down so that the entrance is on the bottom to reduce heat loss (since hot air rises). Remember: any type of shelter, no matter how imperfect, is helpful on a freezing cold night. Place the shelter in a warm and safe location. Choose a spot that has long light exposure; the more sunlight the box sees in the afternoon, the longer it will stay warm in the evening. Position the house so that the entrance is facing away from prevailing winds, to prevent gusts from blowing into the shelter. Also, be sure the box is safe from predators by placing it high off the ground or on a baffled pole.

Remember the Butterflies and Bats

When you draft your plan for making your yard into a place for birds, consider providing for all four "B's": birds, butterflies, bees, and bats. The butterflies and bees will do pollination work in and around your yard. They also add biodiversity as well as color and causes for curiosity (just what butterfly is that on the aster?). Just a few strategic plantings of milkweeds, columbines, coneflowers, asters, and goldenrods can make a big difference. Be aware that species of butterfly bush are invasive and nonnative and probably should be avoided. It is best to plant native species for several reasons, but a leading one is that most caterpillars of our favorite butterflies require native plants.

Bats frighten most people. And some people worry that bats carry disease. Bats get a bad rap. This is undeserved: bats are our friends, ridding our yards of thousands of annoying, whining, and biting insects in the evening. Because of a disease called white nose syndrome, many of our most familiar bats are in serious decline. They need help. Put up one or more bat boxes as part of your landscaping plan. Get details at the Bat Conservation International website (http://www.batcon.org/resources/getting-involved/bat-houses).

Orange Milkweed is very popular with Monarchs as a host plant for the butterfly's very distinctive striped caterpillars.

Cardinal Flower is attractive to hummingbirds and butterflies such as the splendid Pipevine Swallowtail.

YARD LIST
12-24-17

1. American Goldfinch - 37
2. Dark-Eyed Junco - 43
3. Blue Jay - 18
4. Northern Cardinal - 7
5. Tufted Titmouse - 3
6. Fox Sparrow - 1
7. White-throated Sparrow - 12
8. Mourning Dove - 5
9. Downey Woodpecker - 4
10. Hairy Woodpecker - 2
11. Northern Flicker - 1
12. Red-bellied Woodpecker - 2
13. Carolina Wren - 3
14. American Robin - 1
15. Pine Siskin - 2
16. Cooper's Hawk ☹ - 1

Feeding the Birds

Many of us like to feed the birds. There is something very satisfying in attracting beautiful birds into our backyards. A male Northern Cardinal, even though a common and year-round resident, is a lovely addition to anyone's yardscape. Chickadees offer an irresistible bit of personality and fun. And then there are the surprises that appear without warning at the backyard feeder: a glowing male Baltimore Oriole on a snowy December morning, or a sprite-like Calliope Hummingbird on a blustery November afternoon, or a Dickcissel taking seed on the ground below the feeder on a frigid January midday. These are just a few of the bonus species that can be attracted when feeding the birds.

A 2016 national survey by the US Fish and Wildlife Service reported that 37 million people in the United States feed the birds, spending $4 billion per annum on more than a million tons of birdseed, and an additional $900 million on feeders, birdbaths, birdhouses, and other accessories related to backyard birds. For many families, the main connection with birds is through backyard feeding. Having our winter yardscape brightened by the red splash of a Northern Cardinal is one of those local pleasures few of us can resist. Even hard-hearted professional ornithologists find themselves trudging out into the snow to refill a feeder with sunflower seeds. Feeding the birds is evidently a pastime that, year after year, provides some deep satisfaction to all of us, bonding us with our wild, feathered neighbors in ways we do not fully understand. As with our human friends,

Well-stocked feeders have produced a good yard list for this Baltimore County home sanctuary.

Bully of the backyard, the Blue Jay does not wait for his turn at the feeding table.

(*Opposite*) A winter storm has elicited a feeding frenzy among these American Goldfinches, drab in their winter plumage.

birds entertain us with their personalities: the sprightly White-breasted Nuthatches, the stolid and pedestrian Mourning Doves, the Blue Jays with their flashes of color and bright call notes, and the Pileated Woodpecker with its swooping flight into the suet feeder, showing its great swathes of black and white, topped with red. How empty our backyards seem when no birds are there.

Bird feeding, no doubt, arose as a winter activity. Winter is the lean time for birds that do not migrate to the southern United States or the tropics. Permanent resident species that subsist largely on insects and other invertebrates during the summer tend to shift to foods that remain available during the cold months: fruit, seeds, hibernating insect larvae, and the like. This shift opens the door to backyard bird feeding. In winter, birds tend to move about more in search of food, and territorial borders break down, so feeding can attract substantial numbers of species and individuals of each species. It is not uncommon to see four or five male Northern Cardinals arrayed in a bush, waiting to collect sunflower seeds at a feeder. These birds are looking for high-energy staples that can keep them warm

through the long, cold winter nights. Sunflower seeds and suet provide this energy in quantity and can become a reliable resource, day after day.

Remembering Why We Feed the Birds

We feed birds because it brings us pleasure and allows us to spend time with a bit of wild Nature just outside our window. Feeding the birds is more about us than about the birds. Of course, we want to think that our bird feeding is a way of reaching out to our avian neighbors—a way of doing something for innocent Nature. It may or may not be that, but it is definitely a source of satisfaction for millions of us, and people will be feeding the birds for the foreseeable future. We like to think of bird feeding as participating in "saving" the birds, but, as we discuss later in this chapter, it is not entirely clear what long-term benefit birds derive from backyard feeding. Best to stick with what we can see and know: having birds in the yard makes *us* happy.

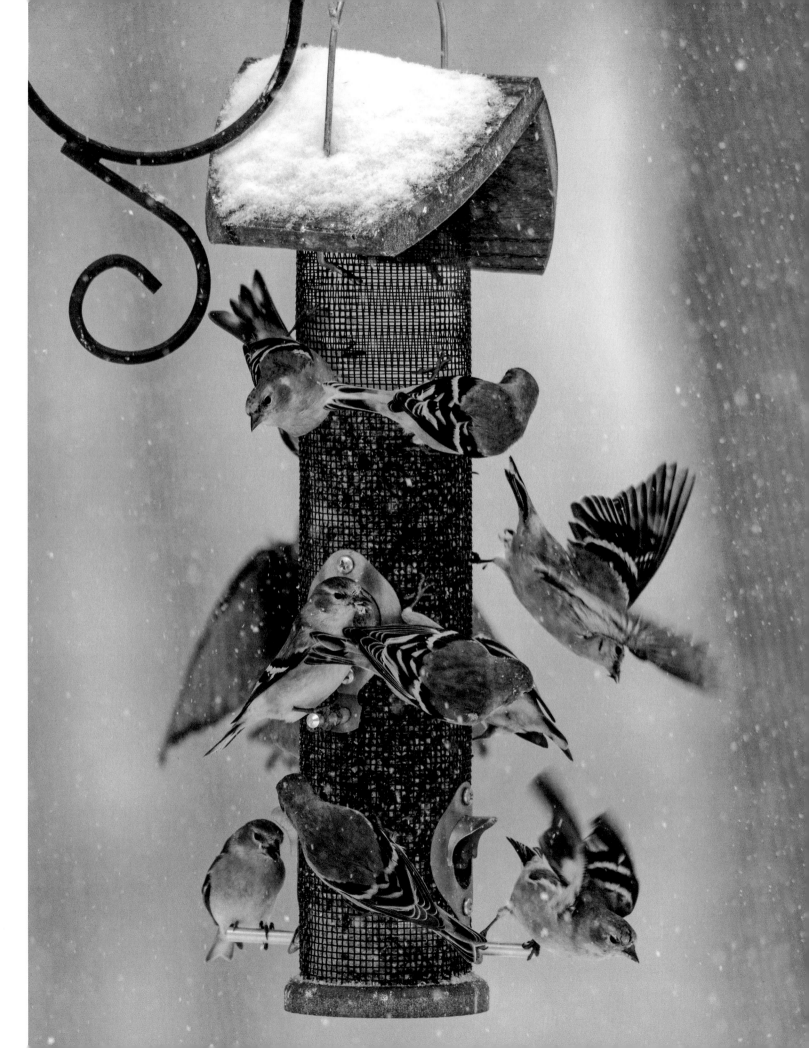

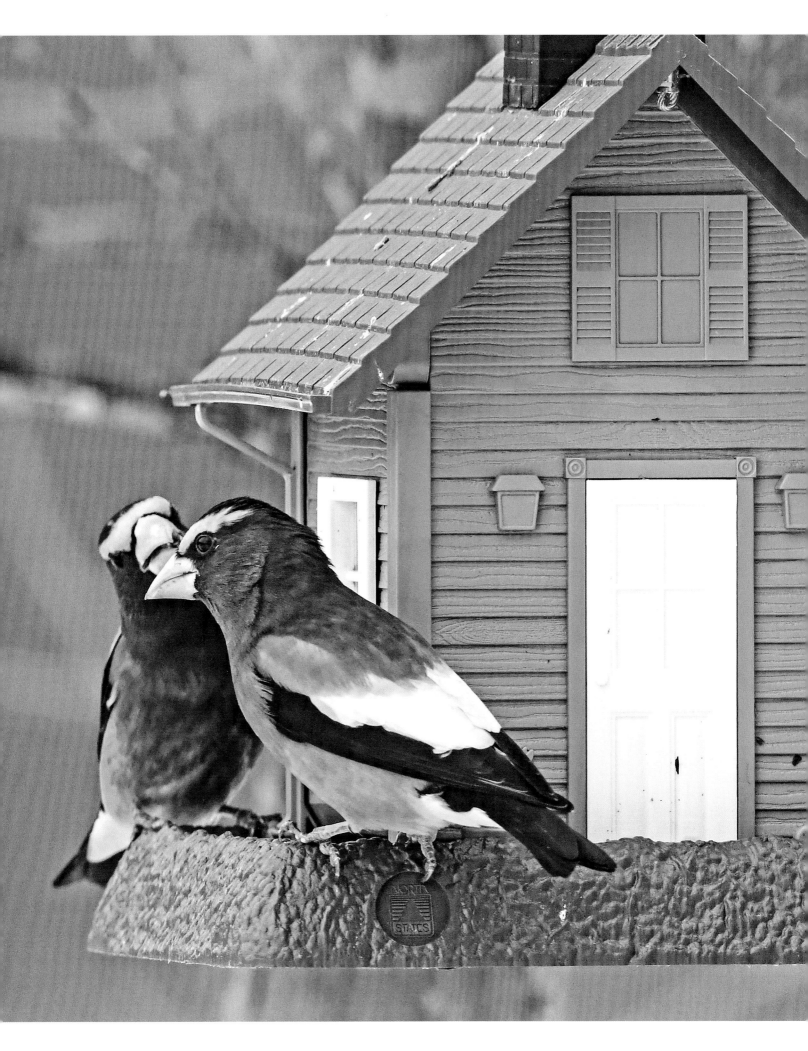

Situating Feeders

We should place feeders in a location where we can easily see and appreciate the birds that come to forage. That said, there are several caveats. The feeder should be situated away from large windows to avoid bird collisions with the glass. We may have to protect feeders from marauding squirrels—a difficult prospect. In addition, we need to acknowledge that bird-hunting hawks inhabit our neighborhoods and it is sometimes best not to encourage the smaller birds to put themselves at risk out in the open to obtain proffered seed. The compromise is to situate the feeder in clear view but not too far from protective vegetation.

Choosing the Best Feeders

The best feeders are those that dispense the seed to the intended target species (small birds, large birds) without a lot of spillage, while requiring the target species to carefully extract the seed at a limited rate, to avoid gluttony. Many households set out several different feeders that attract different birds: a big feeder with sunflower seed for Northern Cardinals and winter finches, a Nyjer feeder for American Goldfinches and Pine Siskins, and a suet cage for woodpeckers, nuthatches, chickadees, and titmice. (Nyjer, informally called "thistle," is a tiny, slim black seed favored by many finches for its high oil content.) It is also worth putting out a table feeder to serve Blue Jays, Dark-eyed Juncos, and White-throated Sparrows, which cannot take seed from the standard enclosed feeders used today.

Seasons for Feeding

Most of us feed the birds in the cold of winter. This is clearly the time when local birds are most in need of energy to combat hypothermia or even starvation. Feeding in other seasons is not as necessary, mainly because food sources are available in the local environment and birds are less energetically

One of the more desirable winter finches, Evening Grosbeaks generate much excitement among birders in the Region.

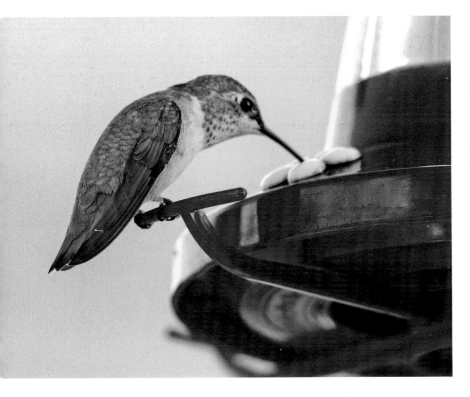

Hummingbird feeders in fall might draw in a Rufous Hummingbird, an unusual migrant from the West.

Peanut butter intended for chickadees has lured in a Red Squirrel, an animal of Appalachian evergreen forests.

Suet Cakes

Almost every type of bird seems to like high-fat suet in winter, but especially the woodpeckers, nuthatches, chickadees, titmice, and Carolina Wrens. Hang suet in a place inaccessible to squirrels. In our Region, the best suet feeders can bring in all the different woodpeckers—an achievement no other feeder can accomplish. Easy-to-use plastic-wrapped suet cakes are widely available, even in the pet sections of most supermarkets. Suet cakes can be messy to insert into cages; this can be alleviated by storing them in a cold place so that they do not go soft.

Feeding Hummingbirds

We all love hummingbirds and especially like seeing them at flowers in the backyard. Aside from smart landscaping discussed in chapter 6, you can put out a hummingbird feeder that provides sugar water to these busy little birds. Feeding hummingbirds is most productive in late summer (August and September) during the post-breeding dispersal period, and secondarily during the breeding season, from late May to early July. Things to remember are that the feeder needs to be cleaned regularly and the sugar-water nectar must be replaced before it ferments or goes cloudy from algae. Twice a week is a good standard. Main nuisances are foraging ants and leaky feeders. The best feeders provide nectar ports above the level of the sugar water, not below. An easy nectar recipe: into 4 parts of hot water mix 1 part of white cane sugar (beet sugar is acceptable

stressed. Times of severe drought are an exception, especially for hummingbirds and insect-eaters. Replenishing hummingbird feeders often and offering mealworms to other kinds of birds can be helpful in extremely dry conditions. Some people feed birds year-round.

Choosing Birdseed

The experts say the three preferred commercially available seeds to offer birds are Black Oil Sunflower seed, Safflower seed, and the tiny black Nyjer seed. The less expensive bird feed mixes, which include an array of small seeds such as millet, oats, wheat, flax, buckwheat, and red milo, are popular with Mourning Doves and also with blackbirds and European Starlings, which some households find less desirable. In particular, the aggressiveness of grackles and starlings makes for an unpleasant feeder assemblage. The golden rule of buying bird seed is to buy it only if you can see what is inside the bag. Many supermarkets and discount stores sell opaque bags of a "wild bird mix" that tends to be filled with red milo, not favored by the most desirable bird species.

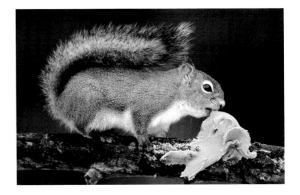

as well); stir until dissolved and then cool. For example, use half a cup of sugar and 2 cups of water. For details, visit the website of the Hummingbird Society (http://www.hummingbirdsociety.org/feeding-hummingbirds/).

Most experts do not recommend adding red dye to the sugar water, as the chemicals may be harmful to the birds. The red-and-yellow coloration of most feeders should provide enough color to attract hummingbirds. It may be worth leaving your feeders out into late fall (even until Thanksgiving in our area), as that is when several rare western hummingbirds have shown up in the Region, presumably displaced by strong westerly winds during their southbound migration.

Preventing Problems at the Feeder

Disease and Mold

Untended feeders can lead to disease outbreaks (especially among House Finches, a common visitor) and thus need to be emptied and cleaned regularly. Wash with hot water and a mild bleach solution if possible (1 part bleach to 9 parts water). Also, seed that is exposed to hot, damp weather can develop mold, which is bad for birds. Hummingbird feeders, too, can develop mold if nectar is not refreshed regularly.

Collisions between Birds and Windows

Probably everyone who has fed birds can recall hearing the jarring sound of a bird hitting a yard-facing window. Mortality and injury of feeder birds that strike windows is substantial. Glass can reflect the landscape and, to birds, looks like a pass-through. Some good remedies include placing feeders at a distance from windows and glass doors, closing any curtains or shades, covering the glass with film, pasting decals (not just one), and using screens or bird-strike tape on the closest bare glass. Find out more at the American Bird Conservancy's Bird Tape web page (http://www.collidescape.org

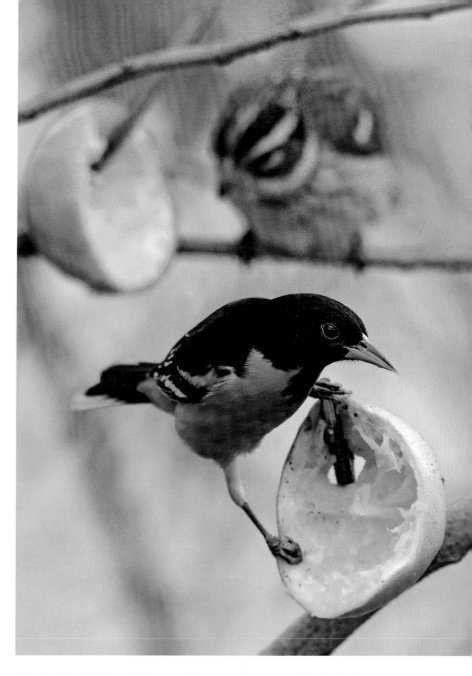

Freshly sliced oranges placed out during migration yielded a male Baltimore Oriole and a female Rose-breasted Grosbeak.

/abc-birdtape). New window and door glass has been developed that looks like a barrier to birds but is see-through to us.

Bird Hawks

By feeding the birds, the homeowner creates an artificial aggregation of small birds that assembles daily throughout the feeding season. Such a predictable aggregation is irresistible to bird-eating raptors. In our Region, the main raptor species that take birds from feeder areas are Sharp-shinned and Cooper's Hawks. The predation of feeder birds is a natural part of the living landscape, but many homeowners find this phenomenon distasteful. The easiest

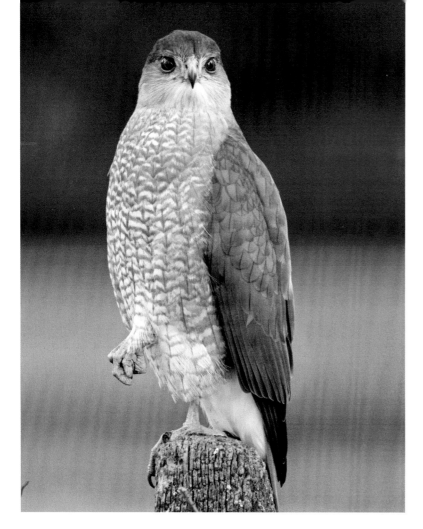

There is nothing more menacing to feeder birds than an attendant accipiter (a bird-hunting raptor that hunts in the woodland canopy), here a Cooper's Hawk. Photo: W. Scott Young

solution is to shut down the feeders for a week to encourage the overattentive raptor to move on.

Problem Species

Most households report the Eastern Gray Squirrel to be the most annoying disruptor of the backyard bird-feeding ecosystem. The squirrels are crafty and persistent, yet some homeowners find them cute and charming. Beauty is in the eye of the beholder. We have a neighbor who daily puts out mixed seed on the back driveway just to feed the squirrels, starlings, and crows. That is not most people's idea of a good practice. For most of us, the battle to keep squirrels from feeders will be nothing more than a holding action. For those determined to win this fight, we suggest spending several evenings online researching squirrel prevention. There are many tools and suggestions, but be prepared for disappointment. It seems squirrels are one of the prices we pay for the joy of feeding the birds. One hint: squirrels do not seem to like Safflower seed, a favor-

ite of cardinals. It might be worthwhile to invest in squirrel-proof feeders, which have an outer sleeve that slides over the food apertures when a squirrel tries to feed but not when a bird feeds, because of its much smaller weight. These are expensive, but they do work.

Some homeowners find Raccoons to be a problem, as Raccoons are just as intelligent and persistent as squirrels and will come back to your yard night after night once they realize food is available. If your suet cage has disappeared during the night, it is probably because a Raccoon pulled it down and dragged it off into the bushes to open. A persistent Raccoon can be trapped and released elsewhere, but it might be easier to move your feeders to a place Raccoons cannot climb up to.

Pet cats and feral cats, of course, kill birds, chipmunks, voles, shrews, and other small mammals and reptiles. Some estimates are that cats kill more than a billion birds per annum in North America (see details at the American Bird conservancy website: https://abcbirds.org/program/cats-indoors/cats-and-birds/). Deterring cats from lurking near feeders is difficult because they will hide in the same bushes you intended as shelter for the birds. Having the household's dog patrol the yard might reduce the prevalence of both cats and squirrels.

Under some situations, rats are attracted to the seed that drops from bird feeders. Rats are most prevalent in urban settings. The best way to keep rats from the yard is to prevent them from denning underground in likely places. Rats may also be deterred by scattering crushed red pepper (from the spice aisle of the supermarket) on the ground below the feeder. This may also discourage foraging squirrels and Raccoons. Mammals find the red pepper unpleasant, whereas birds do not. Replenish the red pepper after a big rain.

In rural areas of the Ridge & Valley province and Allegheny Highlands, wandering Black Bears may raid backyard feeders seasonally. The only solution to nuisance bears is bringing the feeders in nightly (though some bears make their raids in

the daytime). If feeders are constantly attacked by bears, or by Raccoons, you will need to remove them for at least a week or two while the animals find food elsewhere, or you might have to close feeders down permanently. If you have the yard space, you can hang feeders from wires strung between two trees, too far up and isolated for nuisance animals to reach.

Long-Term Effects of Bird Feeding

Bird feeding has been a massive uncontrolled experiment in supplemental provisioning of urban and suburban wild bird populations. Because it is uncontrolled, it is difficult to divine just what the effects have been on the birds. We provide a couple of examples of possible unintended consequences of bird feeding.

A study in Illinois demonstrated that the presence of a feeder led to improved feather quality, increased immune function, reduced stress, and improved antioxidant capacity in the birds that used the feeder. But there was also an increased incidence of disease in birds that used feeders compared with those that did not. In addition, the presence of a feeder led to an increased incidence of the brood-parasitic Brown-headed Cowbird. But, in general, the cowbird is a common and widespread species often found at feeders, so those of us who feed the birds perhaps should not be overly concerned. Recent scientific research on the Great Tit in England and the Netherlands has provided evidence that broad-scale feeding produces rapid evolutionary effects in birds. British tits are now longer-billed than Dutch tits, and this is correlated with more prevalent feeding in England. The longer-billed birds exhibit measurable changes in genes related to bill development. Those with longer bills, in addition, spend more time at feeders and successfully raise more offspring. So it is now evident that our feeding can cause long-term evolutionary changes. More research is needed to better measure the extent of these effects.

Most of us have favorite birds. No homeowner is displeased when a Yellow-bellied Sapsucker comes to the suet cage to feed. But most of us also have less-favored birds, such as the European Starling, House Sparrow, Common Grackle, Brown-headed Cowbird, and the like. In most cases, it is difficult to attract the favored species without also bringing in at least some of the less favored ones. By sticking with suet, Nyjer, Safflower, and sunflower seeds, this problem tends to be no more than moderate.

Keeping a Yard List

We strongly recommend starting a yard list of birds that visit your feeders. This can take your bird-feeding experience to the next level of appreciation. For beginners, start with a lined pad and a field guide on a convenient table near a window looking out on the feeder, or use a bird identification app, such as Merlin from the Cornell Lab of Ornithology (http://merlin.allaboutbirds.org). Spend time identifying the species of every bird that comes to the feeder. Over a year's time in this Region, we might expect as many as 15 to 25 feeder species, which offers a nice start to a yard list. The next step is best taken in early to late May, when migration and birdsong are in full swing. Try identifying other species of birds coming into the yard or singing close by. Track these down and identify them. Generally, yard listers agree that it is fair to count any species that can be seen or heard while standing in the yard. Thus, an adult Bald Eagle soaring high overhead on the way to the reservoir can be counted. Best to start small: work to get 50 species on the list, then go for 100. That might take several years, depending on the location of your yard. Nice yard lists, including special yard birds, provide fun bragging privileges. Keeping a yard list is also a great way to become a full-fledged birder.

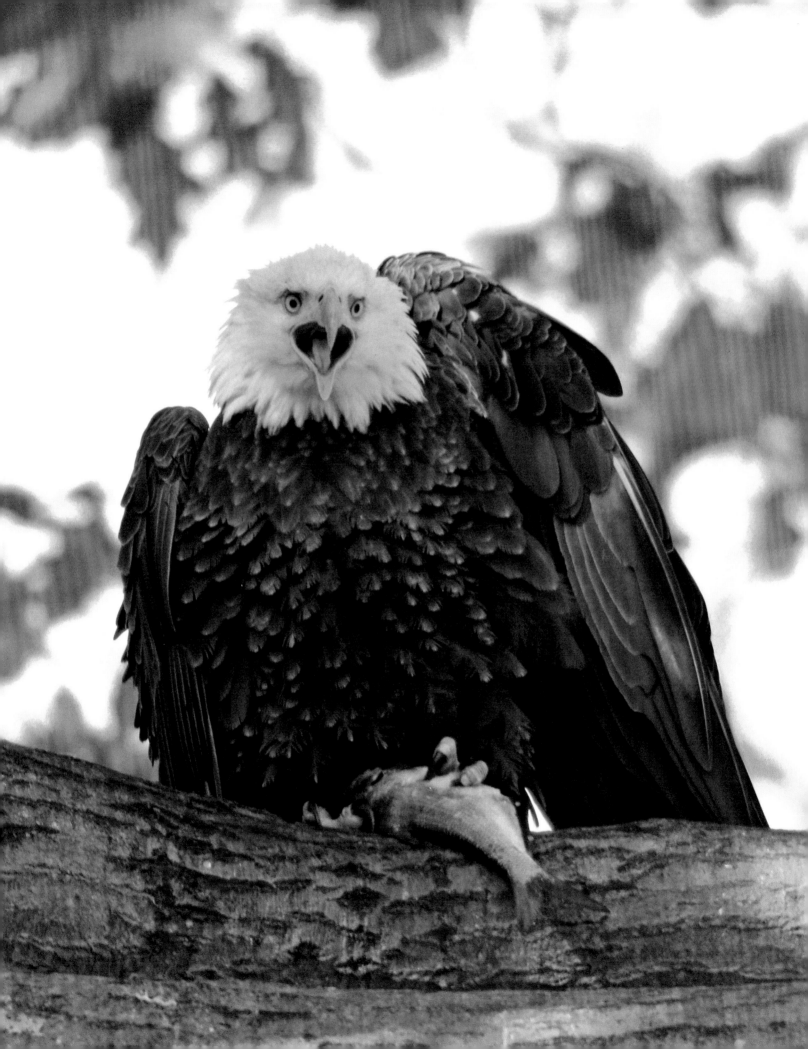

Conserving Birds and Their Habitats

The 2016 edition of the North American Bird Conservation Initiative's *The State of North America's Birds* noted that more than one-third of North American birds are in need of conservation action. The list includes birds of oceans, coastlines, grasslands, wetlands, and temperate forests. Fully 432 species—including our Region's Black-billed Cuckoo, Red-headed Woodpecker, Long-eared Owl, and Bobolink, among others—are listed on the report's Watch List, owing to troubling signs such as population loss, range reduction, and threats to habitat. For details, visit the Watch List website (http://www.stateofthebirds.org /2016/resources/species-assessments/).

We summarize here the main points of *The State of North America's Birds*, along with issues raised in the American Bird Conservancy's *Guide to Bird Conservation*. These two publications highlight a range of continental, national, and local threats that are affecting our birdlife. First, we discuss the threats. Then, lest we think all is lost, we detail various conservation successes of the past half century. There is plenty of good news to temper at least some of the bad news on bird conservation. We end the chapter with some actions needed for the future. We need to keep up the effort for birds, building on our successes, but taking seriously the remaining threats.

Bald Eagles are now a common sight in the Region, thanks to legislation banning harmful pesticides and fostering conservation action on behalf of this American icon.

Threats

Large-scale threats to birds continue to grow. These include deforestation of tropical forests (needed by many of our migrants that winter in the Caribbean and in Central and South America), clear-felling of boreal (northern conifer) forests (needed by breeding wood warblers), agricultural conversion of bird-rich wetland and grassland habitats, various effects from urbanization, and the growing influence of a changing climate.

More than 350 American bird species travel to and from Canada, Mexico and southward over the course of the year. This group of international travelers includes some of our very favorite birds: orioles, warblers, flycatchers, cuckoos, hummingbirds, and many others. Conservationists have learned that to protect these seasonally mobile birds, we

Grassland specialists such as the Bobolink face a host of threats in our Region.

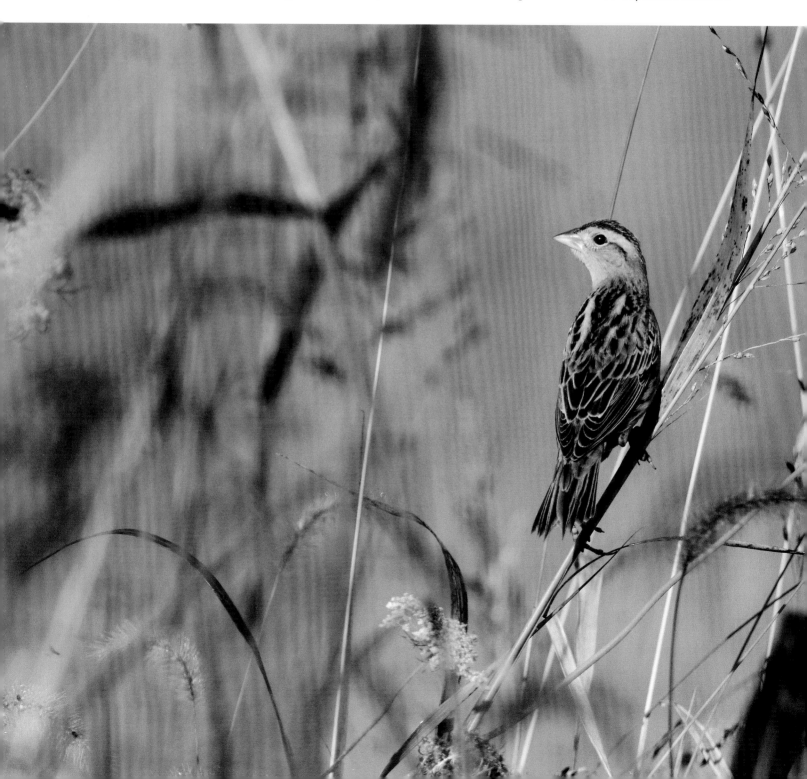

must conserve their habitat in all the places they use over the year: tropical wintering forests, mid-country stopover sites, and northern breeding habitats. These important birds need to be protected throughout their entire life cycle.

Forests in the eastern and central United States have largely recovered in the 150 years since their decimation during and after the Civil War. That said, the forests of Central America and north-

Bird banding is critical to monitoring population trends. Here, Barbara Ross displays a Golden-crowned Kinglet netted at Irvine Nature Center, in Baltimore County, MD.

ern South America are today being cleared and degraded by encroachment of the growing local populations and expanding commercial and subsistence agriculture. Many countries have established conservation areas and parks, but in many instances, these have suffered illegal logging and deforestation. And what of the northern forests where many birds nest? Large tracts of boreal forest in New England and Canada have been clear-felled for pulp. These losses harm populations of many of our popular migrant songbirds that breed in the northern United States and Canada each summer.

Grassland habitats have suffered across the continent, and grassland birds have declined as a result. Many native grasslands have been converted to commercial agriculture, and the use of pesticides and herbicides and the widespread introduction of nonnative grasses have also had detrimental effects. The Northern Bobwhite, a favorite game bird in our Region, has undergone shocking declines in the eastern United States.

Nearly 20% of wetland birds are on the Watch List. Wetland loss has accelerated by 140% since 2004, according to the latest available trend data from the US Fish and Wildlife Service. This may be the result of declining support for wetlands conservation over the past decade combined with the growing impact of climate change, especially the rising sea level in the Chesapeake Bay area. Wetland birds such as the Black Rail have essentially disappeared from our Region.

The Chesapeake Bay is perhaps the most threatened natural feature of the Region. The Delaware Bay and the Potomac watersheds are a close second and third, respectively. These vast catchment areas have been affected by forest loss, climate change, increasing development, and pollution from urban and agricultural runoff. We need to press the appropriate government agencies—federal, state, and county—to do what is necessary to conserve and restore these nationally important resources.

Migratory birds face all sorts of threats as they move north and south between their breeding and wintering habitats. Lighted buildings at night attract and disorient nocturnal migrants. Hundreds of thousands of migrating birds strike buildings and perish each year. Various kinds of transmission towers, depending on their lighting, have a similar mortal effect on migrating birds, especially on foggy and rainy nights. Wind energy projects are often situated atop prominent ridges to catch the wind. These sites are passageways for migratory birds and bats, which can be killed by the moving blades and by the severe turbulence caused by the rapid rotation. Golden Eagles, migrating down the Allegheny Front, face this threat each autumn.

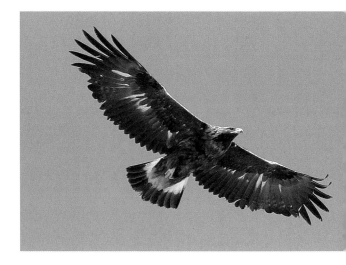

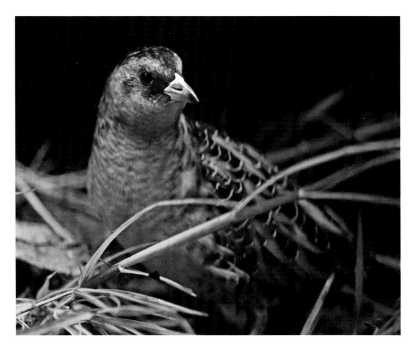

As mentioned in chapter 7, outdoor-ranging and feral cats kill many millions of birds a year in North America. Overabundant native predators such as Raccoons, Coyotes, Virginia Opossums, and Striped Skunks wreak havoc on ground-nesting birds. The affected woodland species include the Wood Thrush and several other songbirds. Grassland species include the Bobolink and Eastern Meadowlark, both in decline. Beach-nesting birds include various tern species, American Oystercatchers, Black Skimmers, and Piping Plovers.

Coastal and oceanic fisheries have both direct and indirect damaging effects on seabirds. Direct effects include bycatch in long-line fisheries, in which a single line may have as many as 120,000 hooks. Many foraging seabirds are caught on baited hooks and drowned every year. Indirectly, the local overharvest of Horseshoe Crabs (for bait and for biomedical research) has harmed Red Knots in our Region. The knots depend on the eggs of these crabs during their spring stopovers in and around the Delaware Bay. Red Knots that cannot find adequate food when they stop over in spring have reduced breeding success in their far northern nesting grounds.

Climate change produces all sorts of effects on the local and hemispheric environment that can harm birds. These include the temporal mismatching of the availability of insect prey with the passage of migrant birds in spring, because of the advancing

season when trees leaf out in our Region. Migrant songbirds from the tropics now arrive in the Region too late to encounter the peak of local productivity of caterpillar prey. Without this food resource, the birds will be underweight when they arrive on their breeding grounds in Canada. Climate-driven rises in sea level are seriously affecting marshlands of the Eastern Shore. Blackwater National Wildlife Refuge, famous for its productive marshes, has lost thousands of marshland acres over the past several decades.

The invention and aggressive marketing of new generations of pesticides highly toxic to birds is a continuing threat. The widespread use of neonicotinoid pesticides has been shown to harm our birdlife.

Mining and mountaintop removal in the Appalachians remain a problem. Ridgetop forests favored by breeding Cerulean Warblers are destroyed, and mountain stream valleys are filled with the mountaintop overburden.

Clearly, bird conservationists have their hands full addressing the various threats that face our birdlife, both locally and across the hemisphere. As we prepare for future conservation battles, we can take hope from past successes in bird conservation.

Conservation Successes

The story of the recovery of the Peregrine Falcon in the East demonstrates the remarkable ingenuity and decades-long effort of the Peregrine Fund and its many partners, both private and governmental. Once extirpated from the eastern United States by DDT pollution in the 1960s, the Peregrine is now a common migrant through the East, with small breeding populations in most of the East Coast states. The DDT threat is gone, and the captive breeding and targeted release of birds by the Peregrine Fund restored the Peregrine to many places where it formerly bred.

The Bald Eagle is another poster child for successful conservation. Just a few short decades ago, seeing a wild eagle in our Region was a reason for celebration, with only a few pairs nesting along

(*Following pages*) Sea level rise threatens tidal marshlands such as those at DuPont Environmental Education Center in Wilmington, DE.

Beach nesting birds such as the Black Skimmer are threatened due to habitat loss and human incursion.

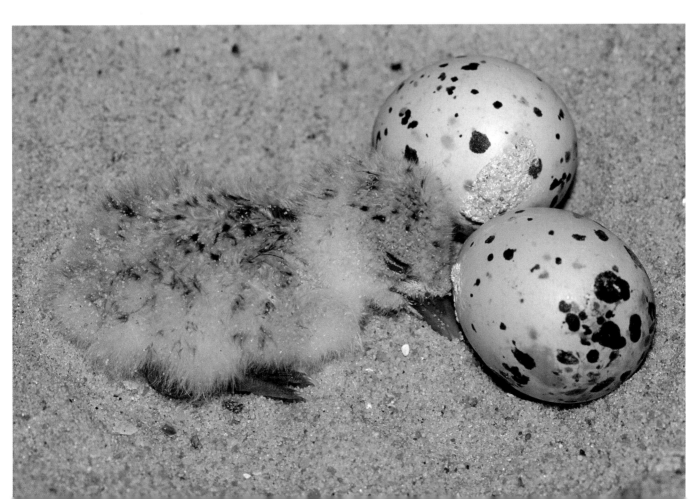

the remotest parts of the Chesapeake Bay. Today, the sight of soaring eagles is all but guaranteed at classic hotspots like Bombay Hook and Blackwater National Wildlife Refuges. The spectacle of scores of eagles at Conowingo Dam that we can witness today was unimaginable in the 1970s, when DDT ravaged the eastern eagle populations, in part because of the bird's dependence on fish that accumulated the toxic by-products of the DDT. The eagle and the fish-dependent Osprey were afflicted with eggshell thinning and infertility, mortally threatening populations of both species. Today, the Bald Eagle and Osprey are prospering in our Region and throughout the East, thanks to various conservation interventions, not least being the cessation of application of DDT across the landscape.

Like the two raptors, the Brown Pelican, because of its fish-eating habit, also suffered population collapse. Today, Brown Pelicans are off the Endangered Species List, are expanding their range up the East Coast, and are now a regular breeder in our Region.

In spite of the local issues facing wetlands and marshlands, at a national level waterfowl are among the groups of birds faring relatively well. This is thanks in large part to the targeted conservation actions supported by the $4 billion generated by the North American Wetlands Conservation Act (NAWCA) over the past two decades. The act has funded conservation projects on 30 million acres of wetlands habitat in Canada, the United States, and Mexico. North America's waterfowl populations are holding steady as a result.

Thanks to a successful reintroduction program, many Peregrine Falcon chicks have fledged from this Baltimore office building nest.

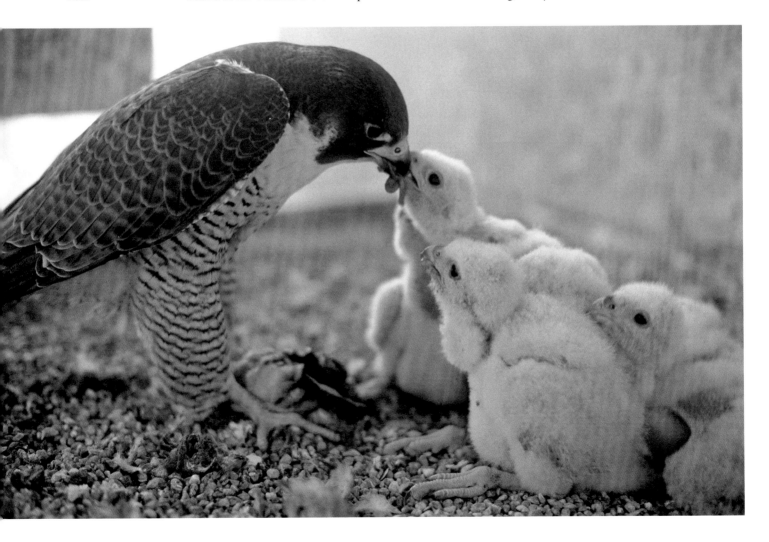

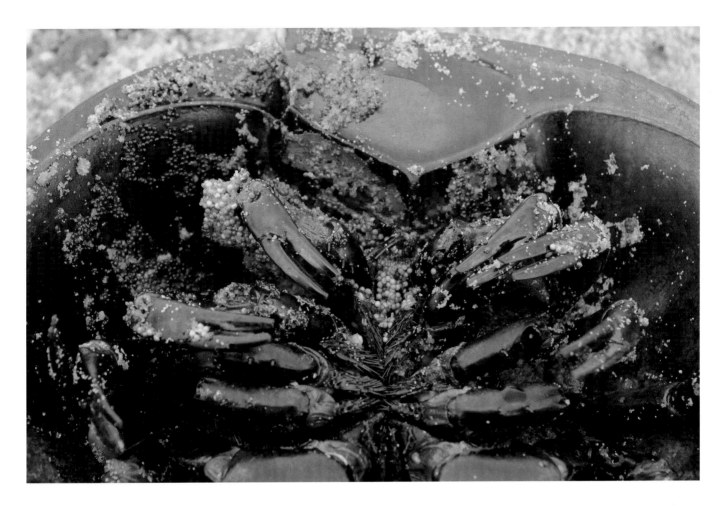

Our region is home to a world-class wildlife spectacle when, each spring, more than a million shorebirds visit beaches along the Delaware Bay, some having flown thousands of miles from their wintering grounds in South America. These birds are famished upon arrival, but their timing is excellent, as Horseshoe Crabs by the millions are visiting the same sandy beaches. The crabs come ashore on high tide, especially at night, to deposit and fertilize eggs by the billions. When this ecosystem is thriving, the beaches are carpeted with eggs, with densities reaching 100,000 eggs per square yard. For various shorebirds, including the Red Knot, Sanderling, Dunlin, and Semipalmated Sandpiper, this feast of protein-rich eggs allows them to replenish lost body weight sufficiently for the next leg of their migration to their tundra breeding grounds and for the rigors of reproduction on the arctic tundra.

In the 1990s, overharvesting of Horseshoe Crabs took off as watermen turned to whelk fishing because of a strong overseas demand, harvesting the crabs to serve as bait in whelk pots. This caused a substantial decline in productivity of the crabs on the shores of the Delaware Bay, which meant many fewer Horseshoe Crab eggs on the stopover beaches. Red Knot populations declined by half, and Semipalmated Sandpipers fared even worse.

Both Delaware and New Jersey took bold action, imposing a moratorium on Horseshoe Crab harvests in 2006. The shorebird and crab populations are now slowly recovering. Researchers from several institutions continue to closely monitor populations, but now there is hope for the shorebirds. With all of today's grim environmental news, it is easy to forget that some very important battles to conserve threatened birds have already been won.

An overturned Horseshoe Crab reveals the Delaware Bay's treasure: tiny nutritious eggs that will fuel a million shorebirds on their journey to Arctic breeding grounds.

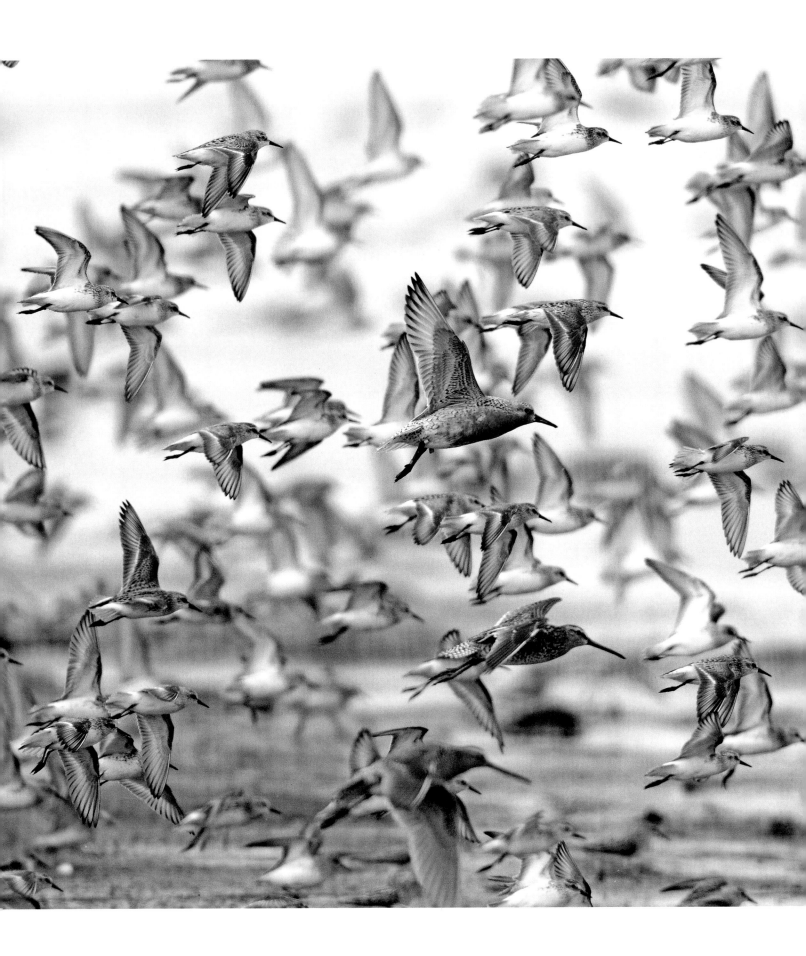

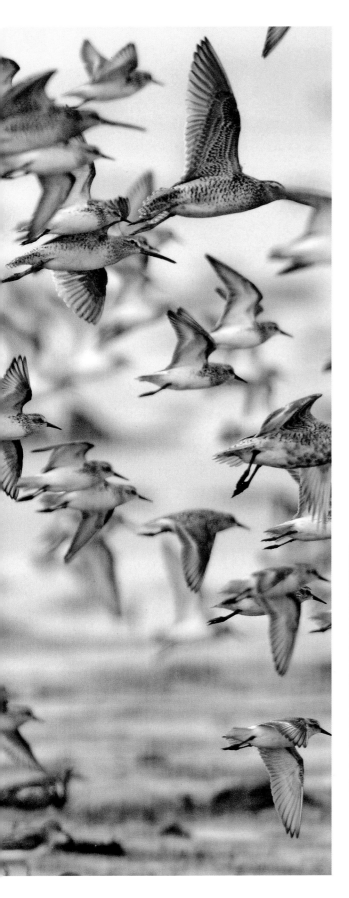

Future Solutions

For every problem there is a solution, as shown by the examples of successful conservation cited above. Here we talk a bit about how to address the pressing conservation threats that still threaten our birdlife.

The three North American treaty nations need to expand their collaboration on behalf of bird conservation. In 2015, Canadian Prime Minister Justin Trudeau and US President Barack Obama discussed such collaboration at a meeting in Washington, DC. It is essential that the governments and conservation groups of Canada, the United States, and Mexico expand the conservation model that has already produced solid results—the NAWCA model. The North American Wetlands Conservation Act has been a boon to waterfowl conservation in North America. We need to create similar well-funded continent-wide programs for nongame landbirds, seabirds, and shorebirds. One possible new funding source for the conservation of nongame birds comes from a recent proposal to dedicate $1.3 billion of federal energy and minerals development revenue to the Wildlife Conservation Restoration Program. This could be productively matched by

Steep declines in the number of Red Knots and Semipalmated Sandpipers visiting the Delaware Bay in recent years have spawned major conservation initiatives.

With a face that only a mother could love, baby Brown Pelicans are a welcome newcomer to our Region's breeding avifauna.

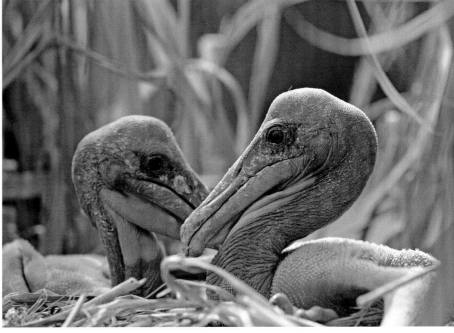

Dr. David Curson (*left*), of Audubon Maryland-DC, surveys a stretch of Blackwater NWR salt marsh, home to an important marsh restoration project.

corporations and philanthropic citizens, providing resources to mitigate deforestation, development, pollution, and climate change on behalf of the threatened bird groups.

A consortium of local and national institutions is working to address wetlands loss in the Chesapeake Bay through an array of innovative field actions, focusing initial efforts on the greater Blackwater ecosystem in southern Dorchester County, Maryland. Such pilot initiatives need to be strongly supported and, once the interventions are shown to work, expanded to the entire Chesapeake estuary.

Programs of the American Bird Conservancy and National Audubon Society seek to create safe spaces for beach-nesting birds during the breeding season. These actions include fencing on mainland beaches, educational programs during periods of high beach use in the spring and summer, active patrolling by volunteers, and creation of dredge-spoil islands as new predator-free, productive breeding habitat in the bay areas behind the barrier beaches and in the Chesapeake.

The recently created Maryland Bird Conservation Partnership is bringing together a wide array of players to study and conserve bird populations and their critical habitats. The threats are real and substantial, but researchers and conservation practitioners are working to preserve our birdlife and the best of the Region's natural environments. We all should welcome these efforts but also redouble our commitment to a green future for Maryland, Delaware, and the District of Columbia.

What needs to be done at the local level, and what can we do as concerned citizens? Many of the problems that beset our birdlife are on the national, continental, or hemispheric scale. We can best support action to address these large-scale threats by being active and generous members of an array of environmental groups: at the national level, the American Bird Conservancy, National Audubon Society, Nature Conservancy, and National Wildlife Federation; at the local level, the Maryland Ornithological Society, Delaware Nature Society, Delmarva Ornithological Society, Chesapeake Bay Founda-

tion, and local chapters of the Audubon Society and Nature Conservancy, to name just a few. You can also participate in our democracy by writing about issues of concern to your representatives in the US Congress and to state delegates. Our governments are there to work on nature conservation as well as economic development. In fact, successful implementation of nature conservation typically leads to improved economies and more jobs.

Within the Region, we can support actions that protect critical breeding and wintering habitat and stopover and staging sites for migrants. These are already identified as Important Bird Areas by the North American Bird Conservation Initiative (NABCI). That said, such identification does not always mean full and proper protection. The best thing that many of us can do is to be vigilant about ensuring the protection of our favorite green spaces close by. If we all protect the best of our neighborhood and local wild spots, then the entire Region will benefit, as will our birdlife. We can protect our precious birdlife if we, as a society, work locally, nationally, and globally on behalf of birds. A few dedicated people, working in concert, can make a difference.

Southern Maryland Audubon volunteers lend helping hands at a Barn Owl banding program for a compelling connection with nature.

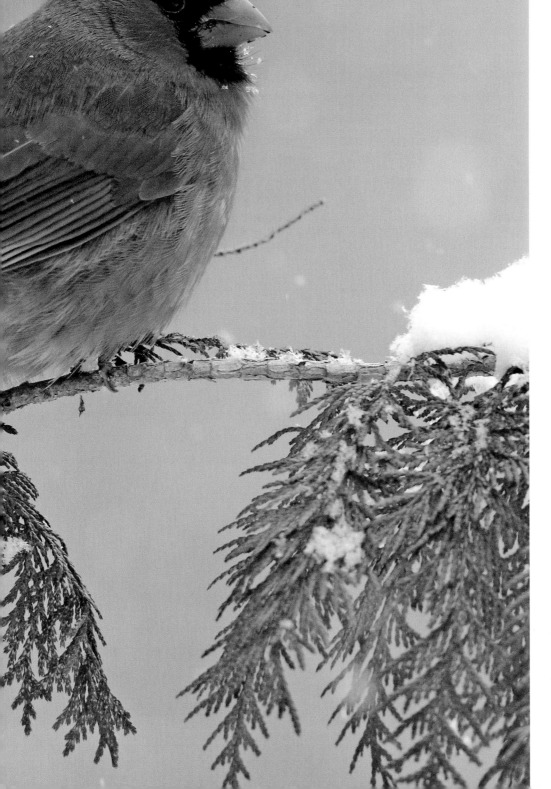

BIRD GROUP ACCOUNTS

True love birds,
Northern Cardinal
pairs stick together
throughout the year.

This book follows the English and scientific nomenclature and sequence presented in the fifty-eighth supplement of the American Ornithological Society's Check-list of North American Birds (see chapter 25). What many older birders will notice is how much the linear sequence of bird families has been rearranged in the past decade. This is the result of recent molecular systematic analyses, which have affected the placement of many families of birds. The main conundrum this "up-to-date" treatment presents to the user is that the family sequence in this book may not accord with the family sequence in your trusty field guide. This means it might be time to purchase an updated edition of that favorite guide. It will take some time to get used to the new sequence. This updated sequence will be most obvious in the treatment in part four of this book (chapters 26, 27, 28), where we present our annotated checklist of the birds. For instance, the field guide from 2000 starts with the loons, grebes, shearwaters, cormorants, and herons. The revised sequence starts with the ducks, quail, grebes, pigeons, and cuckoos. The falcons used to be placed near the hawks at the front of the guide, but they now follow the woodpeckers in the middle of the book, not far from the flycatchers.

In this section, we have taken the liberty of presenting the Region's avifauna as a series of 12 ecological/behavioral assemblages of birds, for ease of learning the birdlife in the species' preferred habitats. We have deployed a nonsystematic set of groupings, based on habit, ecology, and similarity. We think it is the best arrangement for this kind of popular book to introduce the Region's birdlife to a wide range of users, from beginners to experts.

Our Twelve General Bird Groupings

Our 12 groups are split into 5 groups of waterbirds and 7 groups of landbirds. The waterbirds include the Waterfowl; Marsh and Wading Birds; Coastal Waterbirds; Shorebirds; and Birds of the Open Ocean. The landbirds include the Birds of Prey; Birds of Countryside, Farm, and Field; Aerial Feeders; Neighborhood and Backyard Feeder Birds; Sparrows and Their Terrestrial Allies; Warblers and Look-Alikes; and Orioles, Blackbirds, and Colorful Fruit- and Seed-eaters.

Each of the 12 chapters that follow presents a summary of the habits and notable characteristics of the grouping, a succinct account of each of the regularly occurring species (named in bold) included in that grouping, and a section listing the very rare or accidental species. In many instances, the main grouping is divided into convenient subgroups (thus the Waterfowl include "Dabbling Ducks," "Diving Ducks," "Mergansers," etc.). Each chapter is accompanied by photographs of typical members of each group, often illustrating particular habits or favored habitats of the species.

Each species account focuses on the physical characteristics of the species, its breeding distribution, its winter distribution, and interesting aspects of its life history, including high counts within our Region when available (with highest counts listed first). Details of each species relevant to its seasonality, status, and occurrence in our Region are presented in three chapters in part four of the book, accompanied by thumbnail illustrations of each (chapters 26, 27, 28). This "back" part of the book is where the "bird-finding" information is gathered: chapter 26: Photographic Atlas and Finding Guide; chapter 27: Birds Rarely Recorded in the Region; and chapter 28: Coded Regional Checklist and Seasonal Occurrence Chart. And, as a bonus, we include a fourth chapter—chapter 29: Best Birding Localities—which gives directions to the best places to see birds in season.

Thus the "front" accounts in part two are quite generic and introductory, and the "back" accounts in part four are crafted to aid the birder in better understanding the species' seasonal presence in the Region and to help in locating the species on birding trips. For each bird species, the two accounts—front and back—cover complementary topics to avoid redundancy.

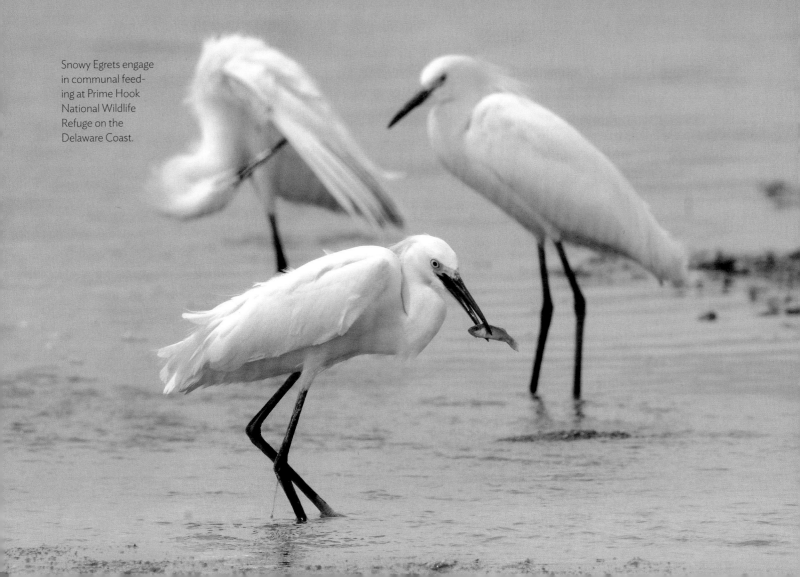

The following five chapters introduce the reader to the variety of waterbirds inhabiting and visiting our Region. More codified information on all of these birds is presented in part four.

THE WATERBIRDS

Snowy Egrets engage in communal feeding at Prime Hook National Wildlife Refuge on the Delaware Coast.

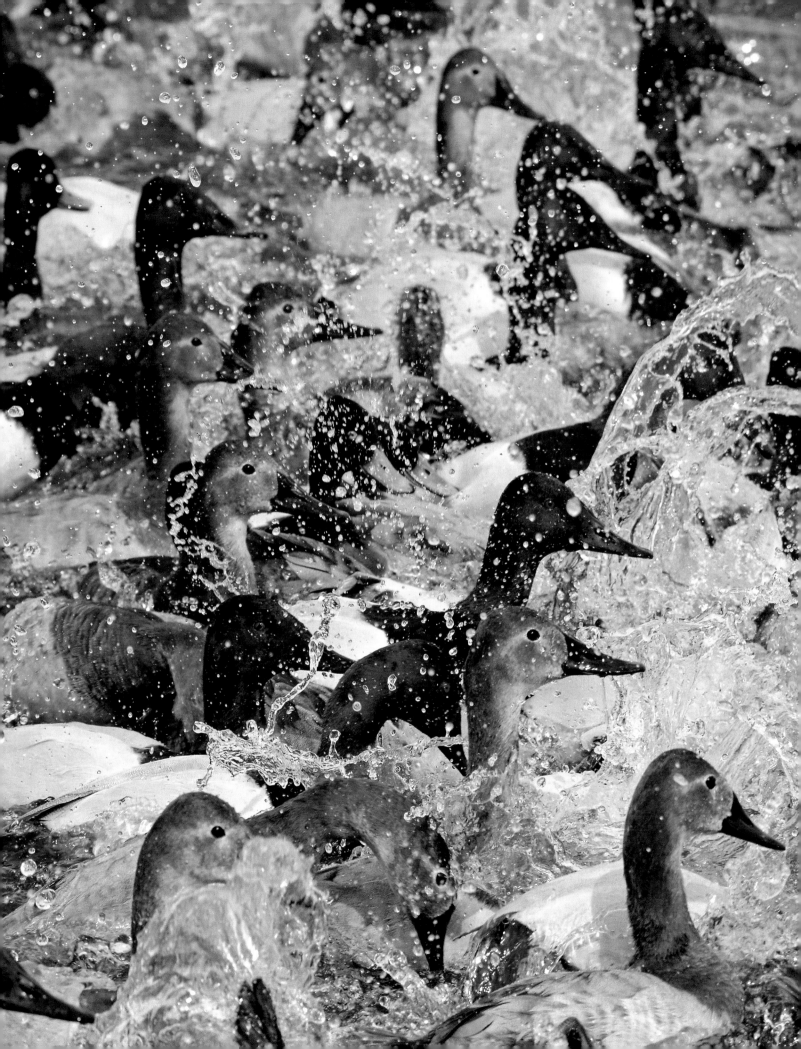

The Waterfowl

The drake Wood Duck, with its high and curving iridescent crest and its painterly combination of colors and patterns, practically defies description. The majestic Tundra Swan, with its long neck erect and straight and its snowy plumage, is one of the largest birds in the Region. The drake Common Merganser, with its patterning of white, oily green, and black, is striking afloat or in flight. These are representatives of the waterfowl, the most cohesive and identifiable avian grouping in our Region.

Our waterfowl grouping comprises 35 species of ducks, 8 geese, 3 swans, and the American Coot. Although the coot is a rail relative, we include it here because it is almost always found in association with ducks and geese and behaves like one of the waterfowl. Except for the coot, this assemblage represents a single evolutionary lineage of birds—the Anatidae—that has a worldwide distribution. The major lineage that encompasses the waterfowl is most closely related to the pheasants and quail. Members of the core waterfowl lineage are characterized by webbed feet, aquatic habit, and a broad, flattened bill. Some forage by dabbling on the surface of the water or tipping to feed just below it, whereas others feed by diving. Their diet includes aquatic vegetation, grain, fish, mollusks, and other aquatic or marine invertebrates. The flattened and elongated bodies of the waterfowl are built like a ship, for floating on the water, and this they do to perfection. Most are powerful fliers once aloft, but because of their weight, they sometimes require

A feeding frenzy of Canvasbacks churns up the Choptank River at a riverfront park in Cambridge, MD.

considerable effort to ascend out of the water. All have webbed feet, and all but the mergansers have the broad, flat, duck bill. In some species, such as the American Black Duck, the sexes are essentially alike, whereas in the majority of waterfowl, the plumage of the males is showy and the females are plain or cryptic. All of the waterfowl tend to be gregarious and are usually found in groups on open waters. These assemblages can be quite vocal when on the water, and the volume of sound they produce can swell to a cacophony when flocks are flushed into the air by a passing Bald Eagle or other raptor.

The waterfowl are mainly migratory and occur in greatest numbers in our Region in the late autumn and winter. Largest concentrations are found on the Eastern Shore. Flocks of tens of thousands of geese, thousands of ducks, and hundreds of swans can be observed in bays and marshlands of the lower Chesapeake Bay and on the Delaware Bay. Waterfowl hunting has been a popular pastime in the Region since colonial times. In the last half-century, this has created an important seasonal economy in and around prime hunting areas.

Relatively few species of waterfowl nest in the Region. Most head north or northwest to breeding grounds in the prairie potholes region of the north-central states or as far as the tundra of the Canadian and Alaskan Arctic. Those that do breed in the Region typically produce large broods of precocial young, able to move about and forage for themselves shortly after hatching. Today, it is commonplace to encounter, in suburban green spaces, groups of fuzzy golden hatchling Canada Geese attentively minded by two adults who aggressively defend their offspring from people and pets. These locally breeding Canada Geese are a relatively new phenomenon in the Region. Detractors refer to them as "golf course geese" because of their penchant for foraging (and making a mess) on golf courses. These are descendants of the Giant subspecies of the Canada Geese that were bred in captivity and released by state wildlife agencies seeking to boost goose populations to benefit hunters. With

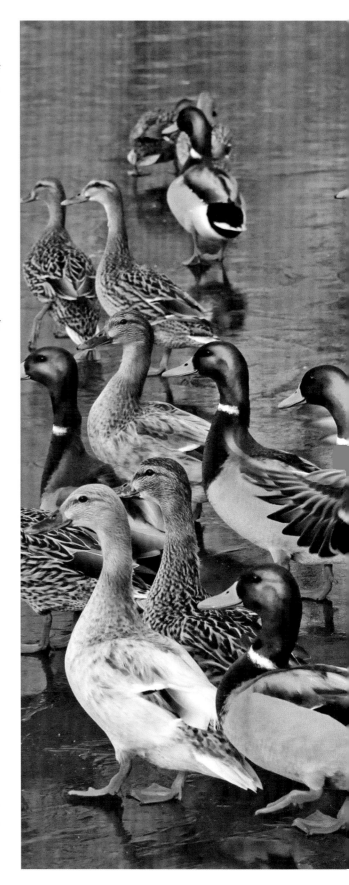

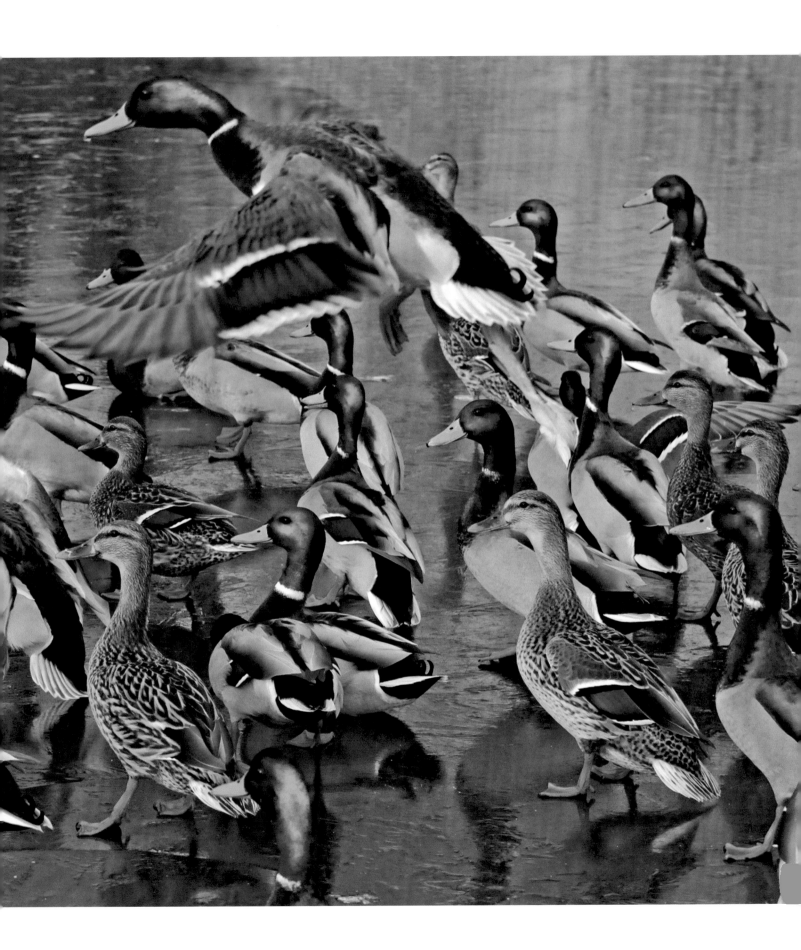

the abundance of suburban habitat, these nonmigratory local birds have proliferated, to the point that they have reached nuisance levels and are controlled in some areas. Their winter movements tend to be local because they already live at the latitude at which most Canada Geese prefer to winter.

The North American waterfowl population status report for 2016, issued by the US Fish and Wildlife Service, indicates that duck and goose populations are above the long-term average and that Tundra Swan populations are stable. Probably all of the waterfowl species that can be found in our Region have healthy populations. The many state, national, and international interventions made on behalf of North America's waterfowl have led to this happy state of affairs. Hunters and birders should be grateful to the many institutions working tirelessly on behalf of this popular bird group.

The drake Wood Duck shimmers with spectacular colors when seen on a sunny day.

The Dabbling Ducks

The Dabbling Ducks include ten regularly occurring species. These are the typical ducks, which tip head first and tail up when foraging. They are sometimes known as puddle ducks because they prefer shallow water. Males and females, excepting the American Black Duck, are strongly sexually dichromatic (distinguished by coloration). The **Mallard** is the most common of these, its populations boosted by state-sponsored breed-and-release programs. Most breeding populations here in the Region are descendants of birds produced in captivity by state agencies to provide annual game for duck hunters. The male Mallard has a shiny green head and neck, a bright yellow bill, and a brown breast. The female is mottled dull brown with a dark eye stripe and an orange-and-black bill. This is the species that is commonplace in urban ponds and parks. It is a popular game bird as well. The species breeds across North America and winters southward to the Gulf Coast and into Mexico. 15,000 were counted at Bombay Hook NWR, DE, on 10 February 1972. The Mallard's eastern sister species is the **American Black Duck**,

with the male and female resembling a very dark version of the hen Mallard but lacking white edges on the iridescent blue speculum of the inner wing. This marshland species of the East mainly breeds north of our Region and winters southward to northern Florida. Formerly, the Mallard was mainly a species of the West. Mallard populations continue expanding and occur throughout North America, whereas the American Black Duck is in decline, perhaps because of swamping of the habitat with Mallards. The two species hybridize on occasion. 70,000 American Black Ducks were reported in the Delaware River off Fort Mott, NJ, on 1 December 1935. 23,000 were counted in the Potomac in Prince Georges and Charles Counties, MD, on 10 November 1928.

The rather shy **Wood Duck** is perhaps our favorite duck—the male with his famous harlequin pattern and large, drooping, green head crest, the female cryptically plumaged with a teardrop-shaped white eye patch. This compact duck inhabits wooded ponds and marshes, especially in areas away from human activity. It nests near rivers and ponds in overhanging tree hollows, from which the emerging young throw themselves down into the water below, using their tiny, undeveloped wings

to slow their descent. Game managers put out nest boxes to attract the species and bolster breeding success of this popular game species. The species breeds west to California, and the northern populations migrate southward in autumn. Southern populations are mostly nonmigratory. Wood Duck populations appear stable and healthy at this time. 1,100 were recorded in Worcester County, MD, on 3 November 2011. The Wood Duck's closest relative, the Mandarin Duck, lives in eastern Asia and is equally beautiful. Mandarin Ducks that have escaped from local waterfowl collections are occasionally found in the Region.

The **Gadwall** is large and plain. The male is gray and buff with a black rump and a distinctive white triangle on the flank. The female is one of the plainest of ducks and resembles the female Mallard, but lacks the dark eye line and small blue-and-white wing patch. This species breeds in favored sites through much of the interior of North America as well as through Eurasia, with our local birds wintering along both US coasts south to the Gulf Coast and Mexico. This species has been on the increase for several decades. It is common in flocks with other duck species. 4,000 were recorded at Eastern Neck NWR,

MD, on 14 December 2015. The **American Wigeon** is one of the more common wintering ducks, often in flocks mixed with Gadwalls and teal. The male has a prominent white forehead and a green patch extending in a swoosh from eye to nape. This duck was formerly called the Baldpate because of the male's white forehead. The female is dull brown and buff, with a finely speckled, plain gray head. The species uses its short bill to pull up aquatic vegetation, though it is not uncommon to see flocks on dry land, grazing on grass. It breeds throughout Canada, Alaska, and the prairie potholes region, and winters along both coasts through the southern half of the United States and Mexico. The species is on the increase. 7,900 were recorded in the Carroll Island area, MD, on 16 March 1947. 5,000 were recorded at Deal Island WMA, MD, on 29 October 1995. The **Eurasian Wigeon** is a widespread breeder throughout Eurasia, with a few wandering birds appearing mainly on our two coasts in autumn and winter, usually within flocks of American Wigeon. The male is handsome and distinctive, with a chestnut head and pale forehead. The female is very similar to the female American Wigeon.

The **Green-winged Teal** is North America's smallest dabbler. The male is handsomely patterned with a chestnut-and-green head and gray body; the female is dark mottled brown. Both have a green wing patch, typically only visible in flight. The

Wood Ducks are common breeders across our Region, nesting in tree holes along secluded marshes and wooded ponds.

When a male Green-winged Teal flaps his wings, the iridescent green speculum matches his smart head stripe.

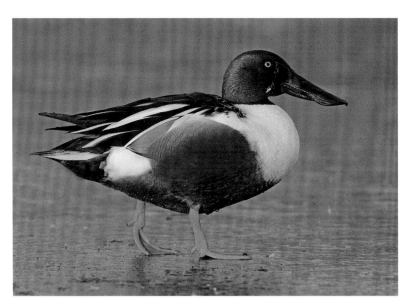

This handsome drake Northern Shoveler is making his way to open water where he can feed, sieving the surface water.

species nests mainly in Canada and the prairie potholes of the West, wintering along both US coasts through the southern United States and Mexico. 10,000 were counted at Bombay Hook NWR, DE, on 1 November 1997. A different subspecies of this teal occurs in Europe; males of this race lack the vertical white stripe on the side of the breast. This form has been seen in the Region on occasion. The **Blue-winged Teal** is another diminutive dabbler. The male is distinctive, with a blue-gray head and a large white crescent in front of the eye. In flight, the species exhibits a large pale blue patch at the front of the upper surface of the wing, near its base. The main breeding ground is in the northern United States and Canada. This duck formerly was a fairly common breeder in the lower Eastern Shore of Maryland. The winter range of the species is largely coastal, from the southern United States to South America. This is the second most abundant duck in North America, exceeded only by the Mallard. 500+ were recorded on Elliott Island, MD, on 21 September 1954. 300 were recorded at Patuxent River Park, MD, on 22 September 2007.

The **Northern Pintail** is a widespread, elegant, and well-known species popular with hunters. The handsome male is gray-bodied and brown-headed and has a diagnostic white neck stripe and long, black, pointed tail. The hen is mottled pale brown,

showing a white trailing wing stripe and plain white belly in flight. The species breeds through Canada, Alaska, and much of the western United States, wintering in the southern United States and Mexico. 15,000 were counted at Little Creek WA, DE, on 10 April 1961. The continental population of this species has been in decline. The species also breeds throughout northern Eurasia. Another striking dabbler, the **Northern Shoveler**, is so named because of its oversized bill. The male's all-green head is reminiscent of the male Mallard, but the chestnut flanks and white breast are diagnostic. The female mostly resembles a female Mallard but for the Shoveler's larger bill. The species breeds in northern and western North America and winters along both coasts, much of the southern United States, and southward to northern South America. It formerly bred in Delaware, most recently in the early 1960s. This species is increasing, and its breeding range is creeping eastward. It also breeds throughout Eurasia. 2,000 were counted at Bombay Hook NWR, DE, on 15 March 1992.

The Diving Ducks

As the name suggests, the eight species of diving ducks dive for their food instead of tipping and dabbling. These ducks tend to forage in deeper water and thus are found in bays and larger rivers and less commonly in shallows. This assemblage is most closely related to the sea ducks and the mergansers. Diving ducks tend to be more compact and less elongated, which aids their diving. This group includes our smallest duck, the Bufflehead.

The **Canvasback** is a bay duck often found in large single-species rafts in expanses of open brackish or salt water. It breeds in the prairie potholes and western Canada north to Alaska, wintering mainly on the two coasts and in the Deep South, into Mexico. The male has a rich red-brown head and a black breast, gray back, and distinctive long, sloping forehead. The female is plain and dull, with a brownish head and breast and a gray-buff body. Populations

of the species have shown substantial fluctuations, but overall numbers of this popular game bird seem to be holding stable across its broad range. That said, the huge wintering rafts of Canvasback on the Chesapeake Bay in the mid-twentieth century have substantially diminished. In the very early twentieth century, the species was quite rare on the Chesapeake, a result of early overhunting. 40,000 were recorded on the Potomac River south of Washington, DC, on 7 March 1925. 10,000 were counted at Back River, MD, on 22 January 1989. The very similar **Redhead** differs in having a shorter bluish bill and in the gray (not whitish) back and flanks of the male. The female is plain dark brown dorsally, brown-breasted, and white-bellied. The species mainly breeds in the prairie potholes northward to Alaska. It winters in large groups in southern estuaries, from coast to coast. It can be found in association with Canvasbacks and the two scaups. Redheads dive to forage for aquatic vegetation and aquatic invertebrates. 10,500 were recorded in the Carroll Island area, MD, on 16 March 1947. 10,000 were recorded in Somerset County, MD, on 30 December 1988.

The **Ring-necked Duck** is part of the scaup lineage, but unlike its sister species it prefers to winter on wooded ponds and rivers rather than out in the open water. The male sports a glossy purplish-black head, a white band near the end of the bill, and a vertical white stripe just behind its black breast. It is so named because, in the right light, an iridescent reddish "ring" can be seen at the base of the neck. The female is dull-colored, with buff flanks, a gray cheek, and slim white "spectacles." The Ring-neck breeds on lakes and wetlands of the Great North Woods and Rockies north into Alaska, wintering in the southern half of North America, as far as Central America and the Caribbean. 3,000 were counted at Cubbage Pond, DE, on 21 February 1999. This is the duck likely to be seen in urban and suburban ponds in the Region. The **Lesser Scaup** is a common bay duck typically seen in rafts on the open waters of bays and larger rivers. It breeds on ponds in Canada, Alaska, the Rockies, and the northern prairie potholes. Notable

is the simple plumage pattern of the male: mainly blackish but for the pale flanks and gray back. The female is dark brown with a white spot at the base of the bill. This is probably the most abundant diving duck in North America. 50,000 were counted at Hart-Miller Island, MD, on 24 February 1991. The **Greater Scaup**, nearly identical to the Lesser Scaup, has a greater propensity for salt water and more open bay conditions and is less common away from the coasts in winter. It breeds throughout the far north and into Eurasia. North American populations winter on the US coasts and in the lower Mississippi. 73,000 scaup (of both species) were counted on the Potomac River south of Washington, DC, on 17 March 1926. 35,000 Greater Scaup were recorded at Eastern Neck NWR, MD, on 12 December 2015. Both scaup species have declined since the 1970s.

The small, rotund, and harlequin-patterned **Bufflehead** is one of our most common and popular bay ducks. The male is strikingly patterned in black-and-white, making it easy to identify in flight or on the water. At close range and in good light, the male's head shows a beautiful green-and-purple gloss. The female is all-dark with a distinctive white oval ear patch. This species nests in tree cavities in the boreal forests of Canada, favoring old woodpecker holes. It winters throughout the United States and Mexico. An inveterate diver, it quickly disappears underwater and then suddenly reappears in a distant spot. A larger cousin of the delightful little Bufflehead is the **Common Goldeneye**, an

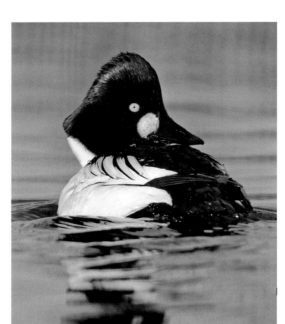

Kent Narrows in Queen Anne's County, MD, is a good place to see the Common Goldeneye up close.

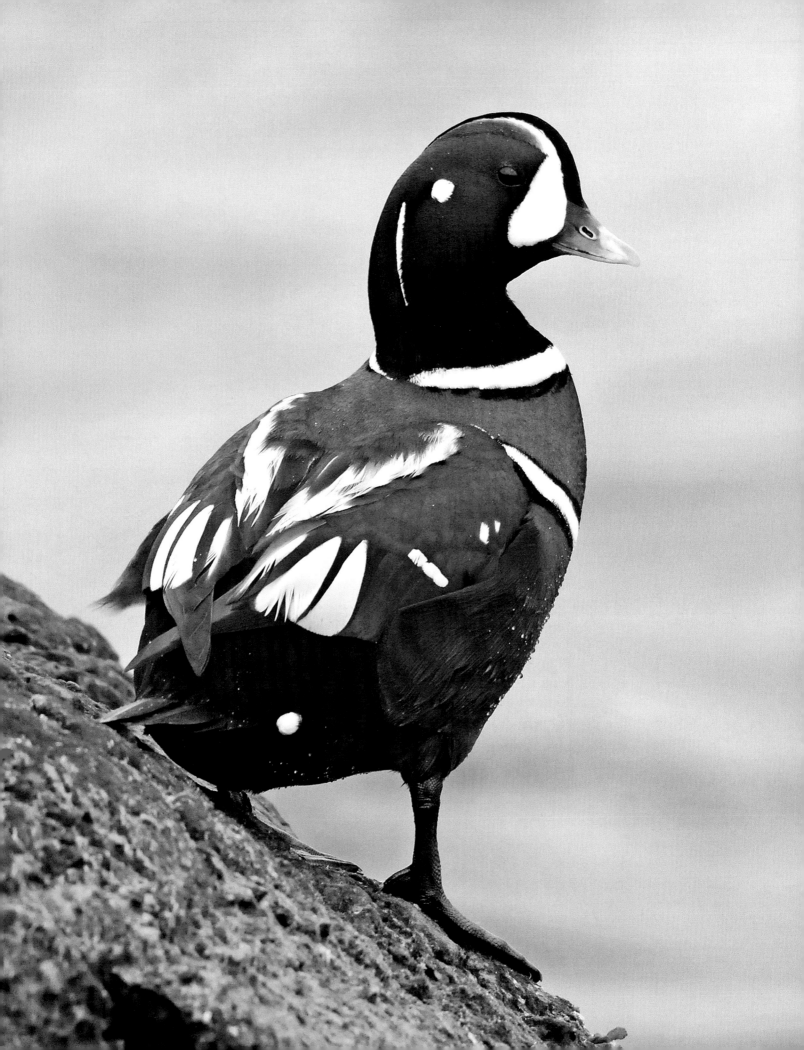

uncommon bay duck found in small numbers throughout our Region in winter. Note the male's mainly white body, green head, and diagnostic white spot between the eye and the base of the bill. The female is gray-bodied and brown-headed, with the distinctive yellow iris. The species nests in tree cavities in the boreal forests and winters across the United States. Its population is stable, in spite of its being a popular game species. 4,000 were recorded on the Chesapeake at North Beach, MD, on 11 March 1989. The diminutive **Ruddy Duck** is in a lineage that exhibits a distinctive tail of stiff feathers, often held erect. The male has a red-brown body, a black hood, and a large white cheek patch. The female is mottled gray-brown with a distinctive face that includes a dark cap, pale cheek, and a smudgy dark cheek stripe. Ruddy Ducks usually sleep on open waters during the day and feed at night. The species breeds in the prairie potholes of the United States and Canada and winters on both coasts, through the southern United States, and south to Central America. In our Region the species has declined, but it is still a popular game bird. 33,000 were recorded on the Chesapeake in central Calvert County, MD, on 1 January 2016.

The Sea Ducks

The seven species of sea ducks are robust, northern-breeding species that in our Region winter along the Atlantic Coast and in the lower Chesapeake and Delaware Bays. Sea ducks are mainly found in salt or brackish water and usually feed on mollusks and crustaceans taken from the seafloor. In migration, the species move in linear flocks offshore, low over the ocean. The group includes some of the most beautiful, unusual, and hard-to-find species of waterfowl in our Region.

The **King Eider** breeds in the high Arctic, wintering in the Aleutians and from Labrador south to the Mid-Atlantic in small numbers. The species feeds on marine invertebrates (mollusks, crustaceans) and plant matter, gathered by diving to the

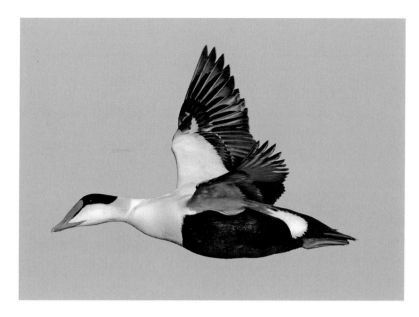

seafloor. Most King Eiders encountered in our Region are first-year birds. The immature male has a dark brown head and body, dirty-white breast, pale eye ring, and dull orange bill. The female is mottled brown with indication of a pale eye stripe. 10 were recorded at Cape Henlopen SP, DE, on 6 February 1971. The **Common Eider** breeds on northern coastlines from Massachusetts to Alaska and Eurasia, wintering in small numbers on our Region's coast, where it favors rock jetties. The very long sloping bill and forehead are distinctive. Males show a striking mix of black and white with a lime green nape, whereas the female is finely barred with brown and black. As is the case with King Eiders, most Common Eiders seen in the Region are difficult to identify because they are dull females or immature birds with patchy plumage. This species is the source of eiderdown, which is harvested from nests each summer in Iceland, Finland, and Canada. 86 were recorded at Ocean City Inlet, MD, on 23 January 2010. The **Harlequin Duck** breeds in Siberia, northeastern Canada, Alaska, and the Rockies. It winters off both coasts at the same rocky sites where eiders winter. The male is unmistakable; the female could be confused with a female scoter (though female Harlequins are typically found in association with their adult male mates). The species breeds along fast-flowing rivers of the northern

Quite common on the New England coast, Common Eiders visit our Region in small numbers.

(*Opposite*)
The stunning drake Harlequin Duck is a highly prized winter sighting, best looked for at rocky breakwaters such as those at the Ocean City Inlet.

(*Following pages*)
A raft of Surf Scoters feeds on shellfish along the jetty at Indian River Inlet just north of Bethany Beach, DE.

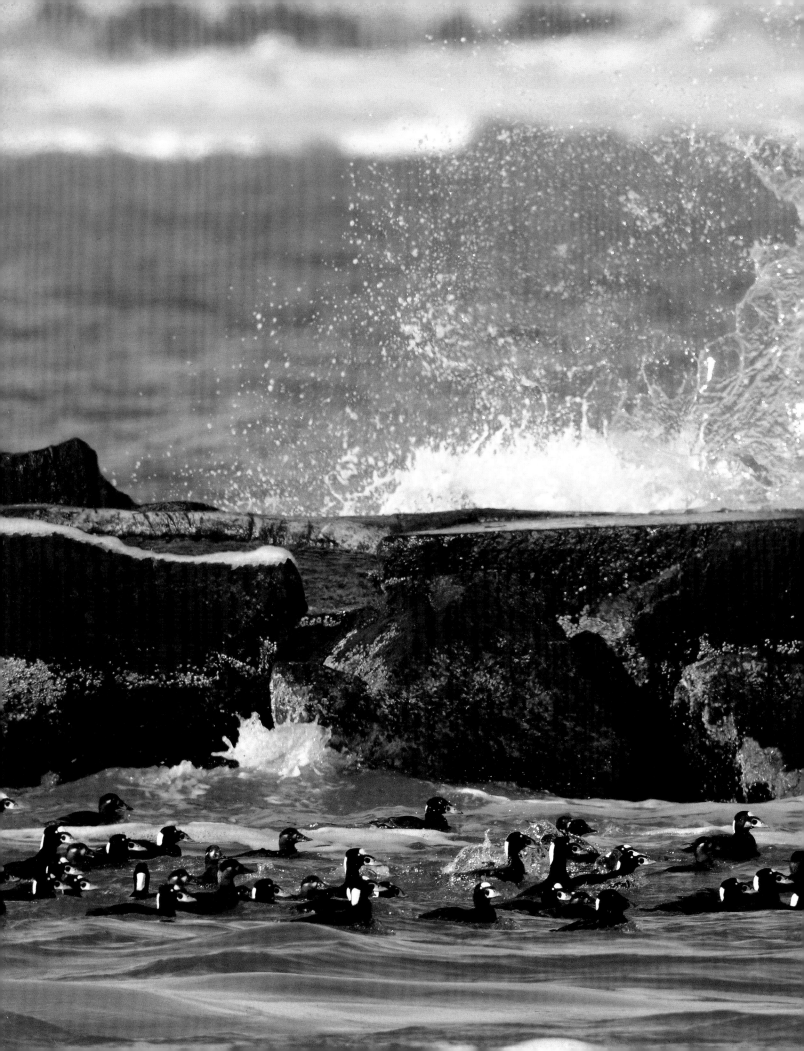

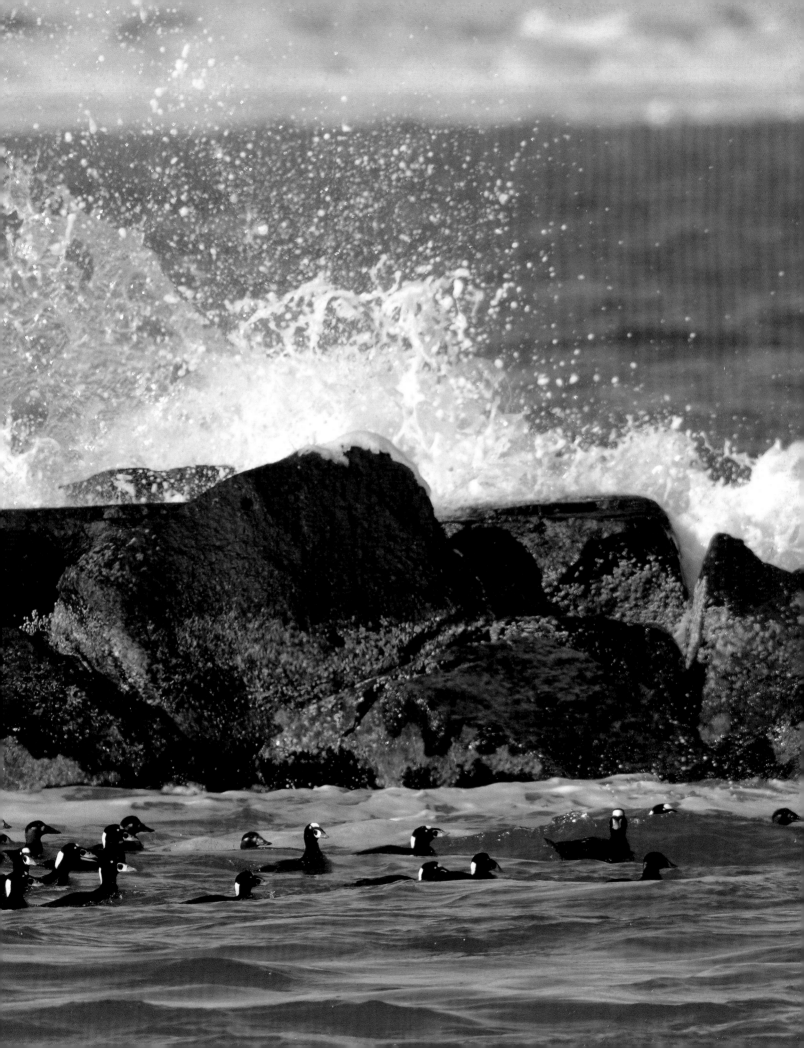

and western United States and winters in rough water off both coasts, where it dives for invertebrates and fish. 16 were counted at Ocean City Inlet, MD, on 31 January 1998.

The three types of scoter are commonly seen flying low over the ocean in long lines, one after another. In winter they feed on mollusks and other invertebrates harvested while diving. The **Surf Scoter** breeds in eastern and western Canada and Alaska and winters along both coasts. The male Surf Scoter is distinctive because of its brightly patterned and heavy bill and white patches on its forehead and nape. The female is obscurely patterned in dark brown, with a pale smudge behind the ear and a pale crescent at the base of the bill. 20,000 were recorded at Cape Henlopen SP, DE, on 18 March 2016. The **Black Scoter** is the most ocean-loving of the three and the least common in the interior. The species breeds in northeastern Canada, Alaska, and

Siberia, wintering off both coasts. The female is distinct because of the dark cap contrasting with the buff cheek and upper throat. 12,000 were recorded at Cape Henlopen SP, DE, on 18 March 2016. The **White-winged Scoter** is the least common of the three scoters in our Region. The male has a small white eye spot and a diagnostic white wing patch. The female is distinguished from the other female scoters by a circular white smudge at the base of the bill. 8,000 were counted in the ocean off the shore north of Ocean City, MD, on 6 April 1946. 650 were counted at North Beach, MD, on 16 February 2014. All three scoters can be observed from the Atlantic shore as they move in flocks along the coast in late autumn and early spring.

The highly distinctive **Long-tailed Duck** (traditionally known as the Oldsquaw) breeds in arctic Canada and Alaska and winters on both coasts. The male possesses a long pin-tail and pied plumage,

Long-tailed Ducks in winter plumage are frequently seen near coastal breakwaters such as Indian River Inlet on the Delaware Coast.

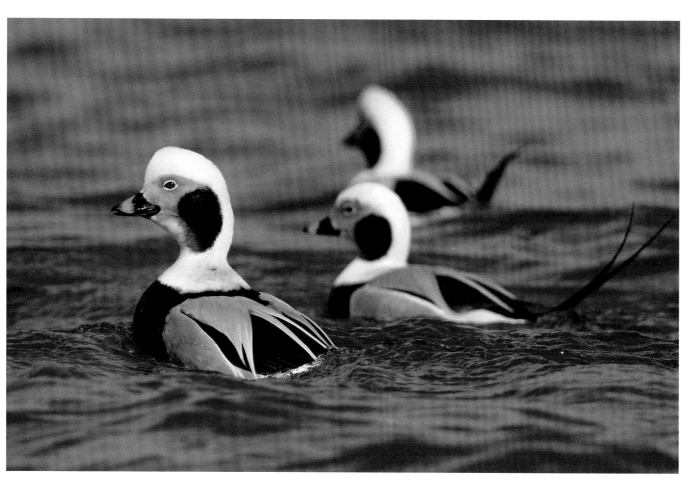

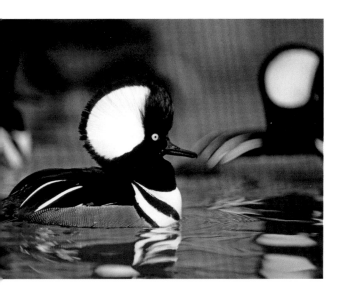

with black dominating in the summer plumage and white dominating in the winter plumage. The female is dull-colored in dark brown with a whitish face and flanks and a large black ear smudge (the female's face is mainly all-dark in the spring). It can feed in deep water, diving to 200 feet. The species feeds mainly on mollusks, crustaceans, fish, and some plant matter. This very vocal species is locally known as South, South, Southery. 7,032 were counted on a Christmas Bird Count near St. Michaels, MD, on 29 December 1953. 5,000 were recorded on the Chesapeake Bay at North Beach, MD, on 12 April 1989.

The Mergansers

The handsome crested and streamlined mergansers constitute a distinct evolutionary lineage, with species ranging from Eurasia to South America. The three species of our Region all have a narrow serrated bill—an adaptation for capturing slippery fish and crustaceans. The **Hooded Merganser** breeds occasionally in the Region near wooded ponds, placing its nest in the hollow of a tree (or a nest box), as do the Common Merganser and Wood Duck. The Hooded Merganser hatchlings flutter from the tree nest to the ground, then follow the parent to the nearest body of water. The male plumage is one of the most elegant among our waterfowl, with

the prominent erectile crest of black and white, the golden iris, and the tan, black, and white body. The female has a bright brown crest and lacks any white in her drab brown upper body. The female Hooded Merganser occasionally lays her eggs in the nest of others of the same species, a habit called brood parasitism. 100 birds were counted in the Potomac River off Mount Vernon (in MD territory) on 8 February 1920. 60 were recorded at Little Creek WA, DE, on 9 March 1963. The **Common Merganser** is the largest of our three mergansers. The drake is striking, with its red bill, dark green head, and white body with black markings. The hen has a gray body and red-brown crested head. This merganser spends more time on fresh water than the others. It breeds from Alaska southeastward to western Maryland and winters through the middle of the United States to the Mexico border. Other populations range throughout northern Eurasia. 5,000 were recorded in Cecil County, MD, on 12 January 2000. The **Red-breasted Merganser** is mainly a bay and ocean dweller in winter. The drake has a more raggedy crest and darker body than the drake Common Merganser. The female is much like the female Common Merganser but with a more distinctively pointed crest. These two species are generally not seen together in the same habitat at the same season. The Red-breasted Merganser breeds along lakes and rivers from Maine to Alaska and winters mainly along both coasts. There is strong evidence from 1986 of a breeding event at Indian River Inlet, DE. 5,000 were recorded in Sinepuxent Bay behind Assateague Island, MD, on 2–3 November 1945. 1,000 were tallied on the Chesapeake at the South River, MD, on 3 April 1976.

Coot

The **American Coot** is one of our most commonplace waterbirds. The coot can be distinguished from true waterfowl by its pointed white bill, dark red spot on the forehead, and blackish plumage. Coots also have small heads, and their toes are

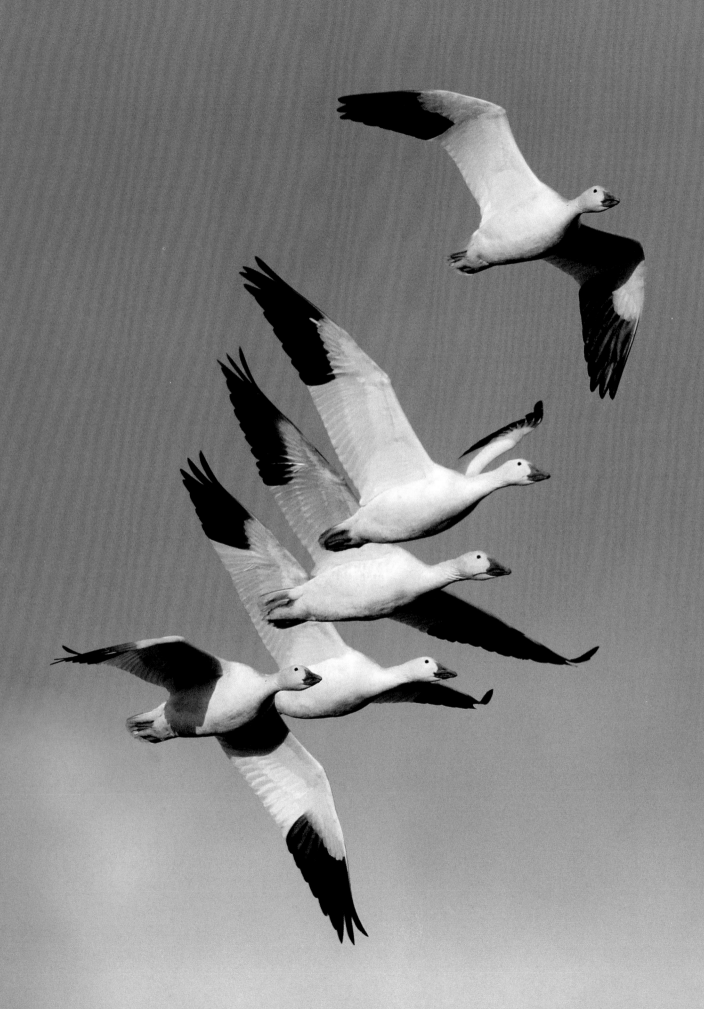

lobed rather than webbed. The American Coot breeds across northern and western North America south into Mexico and winters mainly in the southern and western United States and Mexico, south to Panama. Coots are noisy, commonly flocking in winter in bays and lakes. 4,000 were recorded at Carroll Island, Baltimore County, MD, on 19 November 1950.

The Geese

The geese constitute an evolutionary lineage of worldwide distribution, closely related to the swans. Geese are long-necked and range from small (Ross's Goose) to very large (Canada Goose). The seven species in our Region are all plant eaters, harvesting aquatic vegetation as well as leafy forage and waste grain in fields and along shorelines. Most geese are long-lived and tend to form long-lasting male-female pair bonds (unlike the ducks but like the swans). All the species are vocal, and most nest in the far north, wintering in the United States, especially along the coasts. Most are popular game birds, and areas with concentrations of wintering geese generate a substantial hunting-based economy during the season, as we see on the Eastern Shore.

The **Greater White-fronted Goose** breeds in Siberia, Alaska, arctic Canada, and Greenland, wintering mainly on the West Coast and Gulf Coast and in Mexico. The bird has a mottled brown body and neck, a belly barred with black, a large white patch under the tail, and a conspicuous white patch in front of the eye, from the base of the bill to the forehead. Note also the orange legs and feet. Males and females form a strong pair bond. This species, scarce in our Region, breeds on tundra wetlands and winters in agricultural fields and open marshlands. It is on the increase nationally. 15 were recorded at Hurlock, MD, on 30 October 2011.

The **Snow Goose** is a locally abundant wintering species, found in large, noisy flocks at various favored spots on the Eastern Shore. The dominant morph (with mainly white plumage) is common in our Region, whereas the dark morph (known as the Blue Goose, formerly thought to be a distinct species) is uncommon. The typical birds are white with black wing tips and an ochre stain on the face (from feeding). The species breeds in the Canadian Arctic and winters on the West Coast, New Mexico, the Gulf Coast, and the coast of the Mid-Atlantic Region. Our wintering birds roost in protected bays and forage during the day in agricultural fields. The morning and evening flights can be spectacular. 150,000 were recorded at Prime Hook NWR, DE, on 1 January 2017. **Ross's Goose** resembles a miniature version of the Snow Goose, but with a stubbier bill and a more rounded head. It is rare in our Region. It breeds along the shores of Hudson Bay and the high Canadian Arctic, mainly wintering in California's Central Valley, New Mexico, and the lower Mississippi to the Gulf Coast. Ross's Geese are usually located as singletons within flocks of the abundant Snow Goose. It is less than half the weight of its larger cousin, and it, too, has a dark morph, which is very rare. Overall, this diminutive species is increasing.

The **Brant** is a small, dark goose that breeds in the high Arctic and winters on the two coasts, subsisting on marine sea grasses. The adult resembles a small and very dark Canada Goose, with just a small white collar on the neck. The Brant does not usually mix with other waterfowl. The species also breeds in Siberia and winters in western Europe and coastal East Asia. 10,000 were counted off South Point, MD, on 27 December 1948. 3,000 were counted at Ocean City, MD, on 5 February 2016.

The **Canada Goose** is the most frequently encountered waterfowl species in the Region. It is our largest goose and a very popular local game species. It breeds across much of North America (to Alaska) and winters across much of the United States, from coast to coast. Male and female are alike in plumage, but the male is larger. Our Region supports a local permanent resident population and also receives large numbers of winter visitors from traditional breeding grounds in northern Canada

(*Opposite*)
Bombay Hook National Wildlife Refuge on the Delaware Bay offers great viewing of flights of Snow Geese at dawn and dusk.

(*Following pages*)
Large wintering flocks of Canada Geese take refuge on the extensive marshes of Blackwater National Wildlife Refuge in Dorchester County, MD.

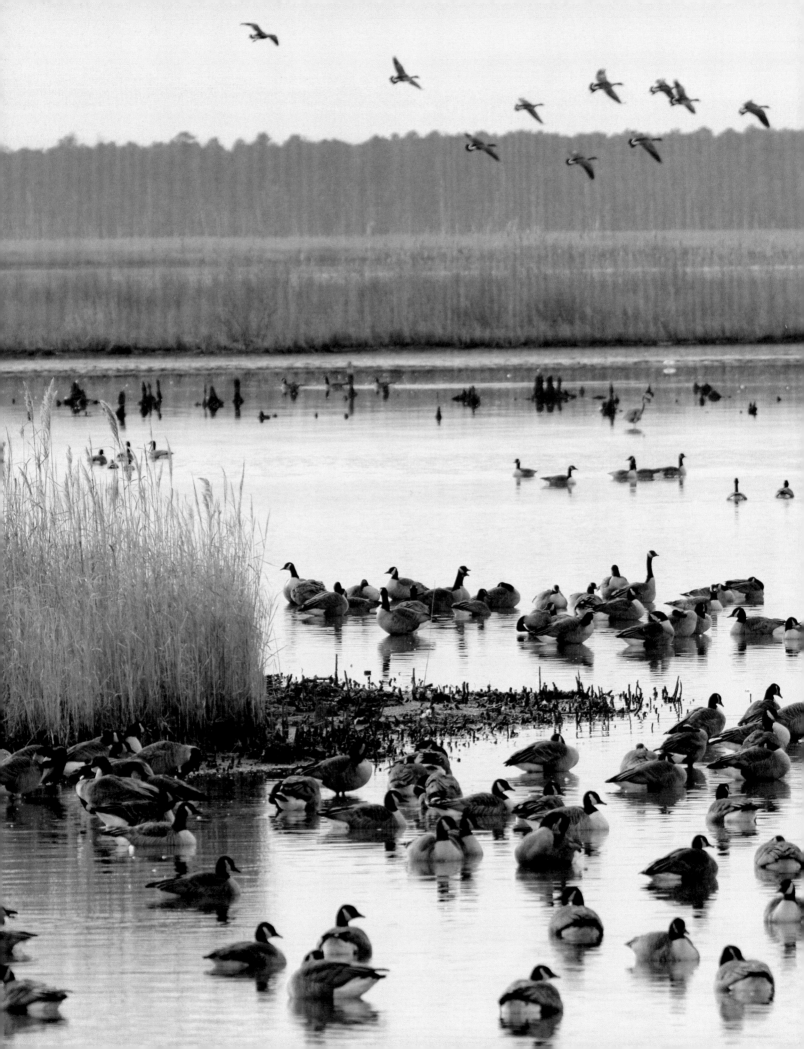

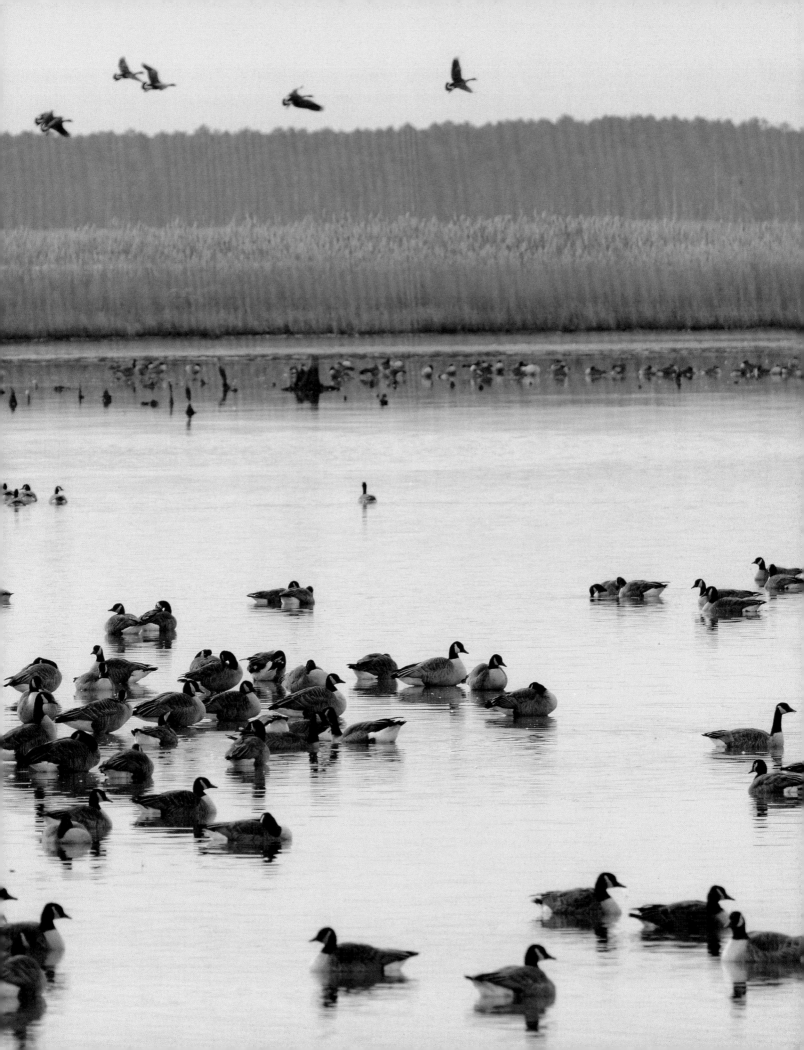

and Alaska. Wintering populations of this goose are influenced by the presence of waste grain in agricultural fields across North America. Our local geese spend much of the spring and summer foraging on mown grass fields in parks and other urban and suburban green spaces. It is not uncommon to see flocks on the National Mall in Washington, DC. 35,000 were counted in Harford County, MD, on 12 March 2014. The **Cackling Goose**, long treated as a selection of small subspecies of the Canada Goose, has now been classified as a separate species. It is distinguished from the Canada Goose by its small size, short neck, rounded head, and small bill. Because of the size variation among individuals within a Canada Goose flock, it is often difficult to identify the Cackling Goose in the flock, though it is possible to do so with careful observation and familiarity with the species' key features. The Cackling Goose breeds in the high Arctic and mainly winters in the lower Midwest. In our Region, this uncommon species is invariably found in small numbers or as singletons in association with the much more common Canada Geese. The **Barnacle Goose**, which has the look of a small, white-faced and black-breasted Canada Goose, breeds in Greenland and several arctic island regions, appearing along the East Coast in small numbers every winter.

The Swans

The swans are our Region's largest and longest-necked waterfowl and are unmistakable in the field. They use their long necks to harvest aquatic vegetation in shallow water. Our three species are all-white, with dark legs and feet. The highly migratory **Tundra Swan** breeds in northern Canada and Alaska, wintering on the West Coast and in the Mid-Atlantic region. The species has a black bill with a small yellow spot before the eye (though this can be hard to see and can be absent in some individuals). When the bird is on the water, its neck is typically held vertically. One of the pleasures of autumn migration is to hear the soft musical vocalization of a swan flock high overhead in the evening darkness. Wintering flocks of varying size can be found on bays and large estuaries. 15,000 were recorded on the Susquehanna Flats, MD, on 15 March 1931. 8,000 were counted on the water at nearby Perryville, MD, on 24 February

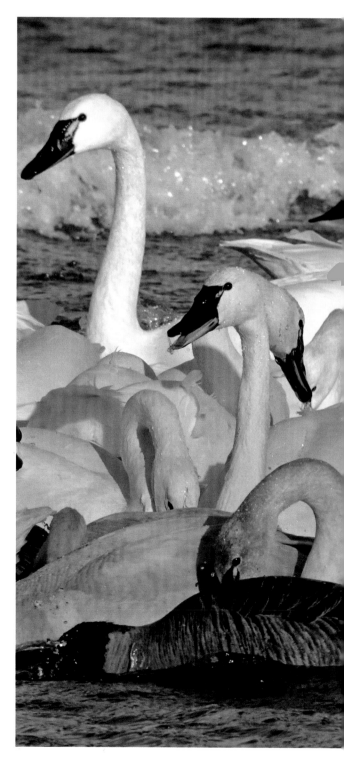

Bird Group Accounts: The Waterbirds

2017. The **Trumpeter Swan** is our largest swan and also the rarest. It is distinguishable from the Tundra Swan by the lack of the yellow eye spot (though caution is warranted since some Tundra's can also lack this), the longer neck, and the size and shape of the bill. It was a widespread breeder in the lower 48 states before being decimated by overhunting in the nineteenth century. A healthy breeding population has survived in Alaska, and there are small permanent resident populations in the Rockies. Several

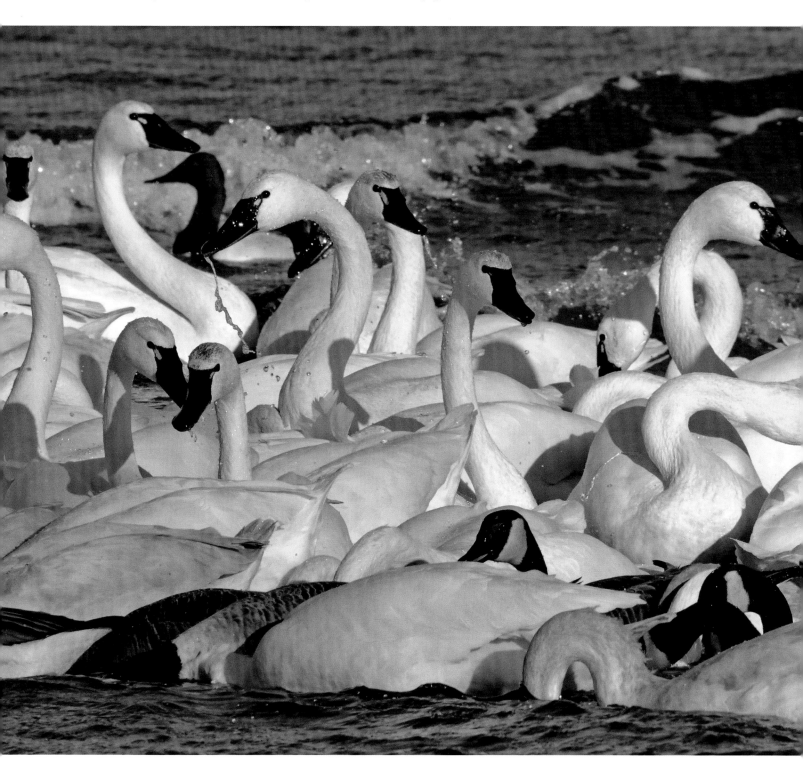

Black-bellied Whistling-Ducks at Patterson Park in Baltimore present a rare viewing opportunity for this species of the Deep South.

reintroduction efforts have brought this magnificent swan back to the Midwest, and the product of these efforts shows up in our Region just about any time of the year. 6 were recorded on the Chesapeake Bay at Edgewater, MD, on 22 February 2017. The population of this species is on the increase. The **Mute Swan** is a Eurasian species that was introduced to the eastern United States in the 1890s. It was first recorded in Maryland and Delaware in 1954. These populations started to expand greatly in the late twentieth century, until state wildlife agencies began controlling their populations (mainly by addling the eggs). The Mute Swan is identified by its orange bill with a black knob and its gracefully curved neck. It is nonmigratory. The environmental threats posed by nesting Mute Swans are twofold: the pairs are very aggressive toward other waterfowl, and the foraging birds deplete native submerged aquatic vegetation important to other waterfowl species. 900 were recorded in Dorchester County, MD, on 15 August 2011.

Rarities

A further eight species of waterfowl are known in the Region only as rarities (fewer than one record per year), and thus are not included in the main accounts. They are unlikely to be encountered on an average weekend bird walk, but are more likely to be seen as a "staked out" individual previously found by an experienced birder. The **Black-bellied Whistling-Duck** is a tropical species that breeds in the US Gulf states and rarely wanders northward to our Region. It is one of our handsomest ducks, with a deep pink bill and black-and-rufous body plumage. In flight, note the large white flash in the dark wing. It is typically seen in flocks or small groups. 8 were seen at a site in Anne Arundel County, MD, on 30 May 2016. The **Fulvous Whistling-Duck** is another Gulf Coast breeder and very rare vagrant to our Region. The Fulvous is distinguished by its dark back and bright honey-buff flanks and underparts. 35 were counted at Eastern Neck NWR, MD, on 24 November 1979. Over the past decade, records of the Fulvous Whistling-Duck in our Region have declined, whereas those for the Black-bellied have increased. The **Pink-footed Goose**, a species that breeds in Greenland and Iceland, is a vagrant to the Region. It is most similar to the Greater White-fronted Goose but has a shorter neck and lacks the white forehead and speckled belly. As the name suggests, the legs and feet are pink, which can be seen from a distance. The **Cinnamon Teal** is a western species with two records in our Region in the past decade. It usually is found in association with Blue-winged Teal. The male Cinnamon Teal is very distinctive with its deep red-brown head and flanks, whereas the female is much like the female Blue-winged Teal but for the Cinnamon's longer bill. The species breeds in the West and winters mainly in the Southwest and Mexico. Its small population is in decline. The **Garganey** is a Eurasian species that occasionally gets blown across the Atlantic while on its autumn southbound migration to its African wintering ground. The species could be overlooked

by birders in our Region because nonbreeding birds and females resemble a female Blue-winged Teal, the species with which it is most often found in North America. The **Tufted Duck** is a Eurasian species much like our Ring-necked Duck, but for the distinctive bright white sides and long head tuft (which looks like a glorified cowlick) of the adult male. The female has a small nape tuft. **Barrow's Goldeneye** is a handsome relative of our Common Goldeneye. The male is distinctive with its small white crescent before the eye and the overall darker back; in good light the head is purplish rather than greenish. The females of the two species are nearly identical. The

Barrow's Goldeneye breeds in eastern and western Canada and the Rockies and winters in New England and on the West Coast. The **Masked Duck** is a very rare vagrant from Mexico, known in our Region from a single record. It is a close relative of the Ruddy Duck. The male's all-black face and deep-chestnut breast are its most distinctive features. This species rides low in the water like the Ruddy Duck.

Farm country ponds offer sanctuary to roosting Canada Geese that feed by day in nearby agricultural fields.

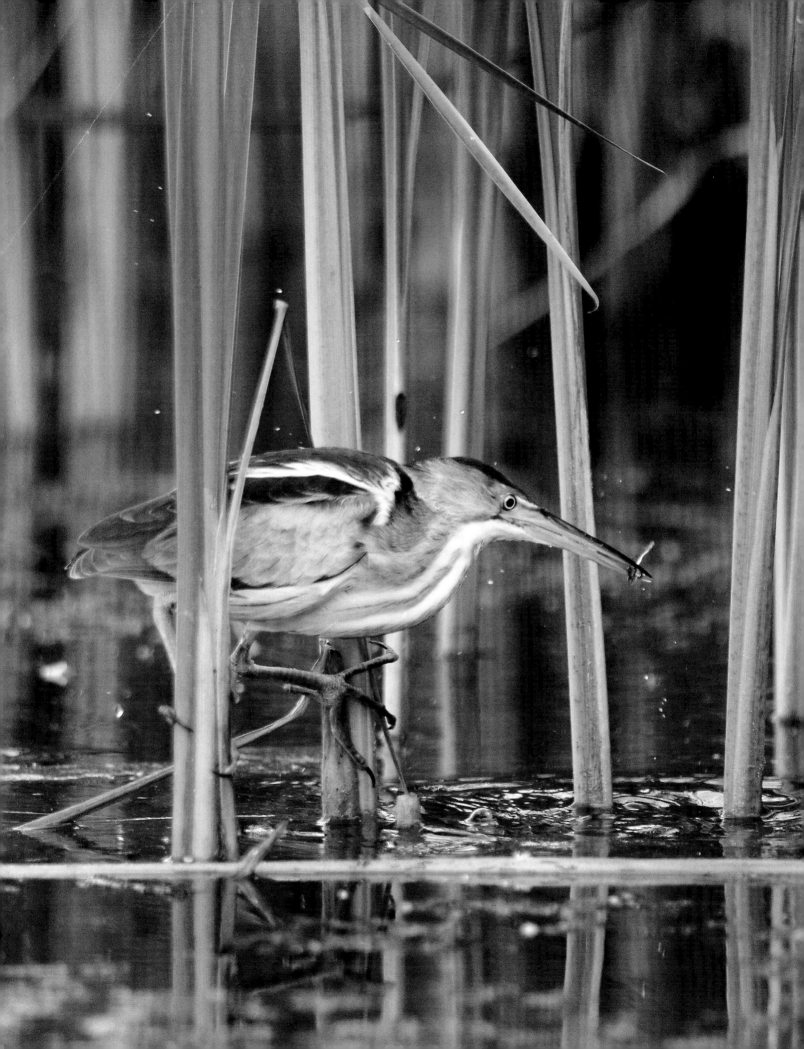

The rich marshlands of the Chesapeake, Delaware, and Atlantic bays support an assemblage of waterbirds from a variety of evolutionary lineages—herons, pelicans, cormorants, cranes, ibises, and rails. These are some of our largest and most beautiful waterbirds and are always an attraction when birding on the Eastern Shore. Many of them are long-legged waders, several are skulkers, and yet others are swimmers, spending much of their time simply floating on the water. This group includes very large and small birds, and species with a range of plumages and morphologies, all linked by the aquatic habit—birds favoring marshlands.

Herons and Allies

The herons, egrets, and bitterns are the best-known cluster within this ecological grouping and are found throughout our Region year-round. Some of the species are mainly summer residents, shifting southward during the cold months. This is a single evolutionary lineage that has a nearly worldwide distribution (but for the polar regions). All members are distinguished by a lance-like bill, a long S-shaped neck, and long legs and toes. Herons are predators, subsisting on fish and other aquatic vertebrates or invertebrates. Most are stealth hunters, standing still in shallow water, spearing fish, crayfish, or frogs with their long, sharp bills.

This shy Least Bittern has discovered that fishing is good at the edge of the marsh where the minnows run.

Birds in this group range from large and common-place (Great Blue Heron) to small and rarely seen (Least Bittern). All except for the pasture-loving Cattle Egret are closely associated with water. Many species breed colonially, in a single-species colony (Great Blue Heron) or mixed-species colony (e.g., the egrets). For birders in search of herons, the Eastern Shore is the place to go, especially the At-lantic estuaries or Pea Patch Island in the upper Delaware Bay, where a large heronry was discov-ered in 1963.

The **American Bittern** is a reclusive heron found in extensive stands of tall marsh grasses and is usually seen only fleetingly as it flies low from one hiding place to another. Unlike most herons it has a cryptic plumage, a mix of brown, buff, and white stripes that makes it difficult to see when surrounded by tall grass. The sexes are alike, as is typical of most herons. The species breeds mainly in northern North America, wintering southward to the coasts and the Deep South and into Mex-ico. Its numbers are declining in the East. 10 were counted at Deal Island WMA, MD, on 15 February 2008. The **Least Bittern**, the most rarely seen of our regularly occurring herons, is smaller than a crow and, like its larger cousin, likes to hide in the reeds. It is a migrant breeder, wintering in Mexico and the Deep South and summering in wetlands along the two coasts and the Mississippi drainage. It is more commonly heard than seen and is declining in our Region. 55 breeding pairs were censused at Little Creek WA, DE, in 1962.

The **Great Blue Heron** is our Region's best-known heron, often called a "blue crane" by non-birders. It is crane-sized but is a true heron. The adult is gray-bodied and buff-necked, with a white face and long black crest plume. The species is found wherever there is water and fish or frogs to prey upon. It breeds throughout the United States and southern Canada and winters mainly in the south-ern half of the United States and into Mexico. The Great Blue is the most commonly encountered heron in our Region, often seen flying slowly overhead

Late summer gulls and egrets swarm a coastal salt marsh on Assateague Island.

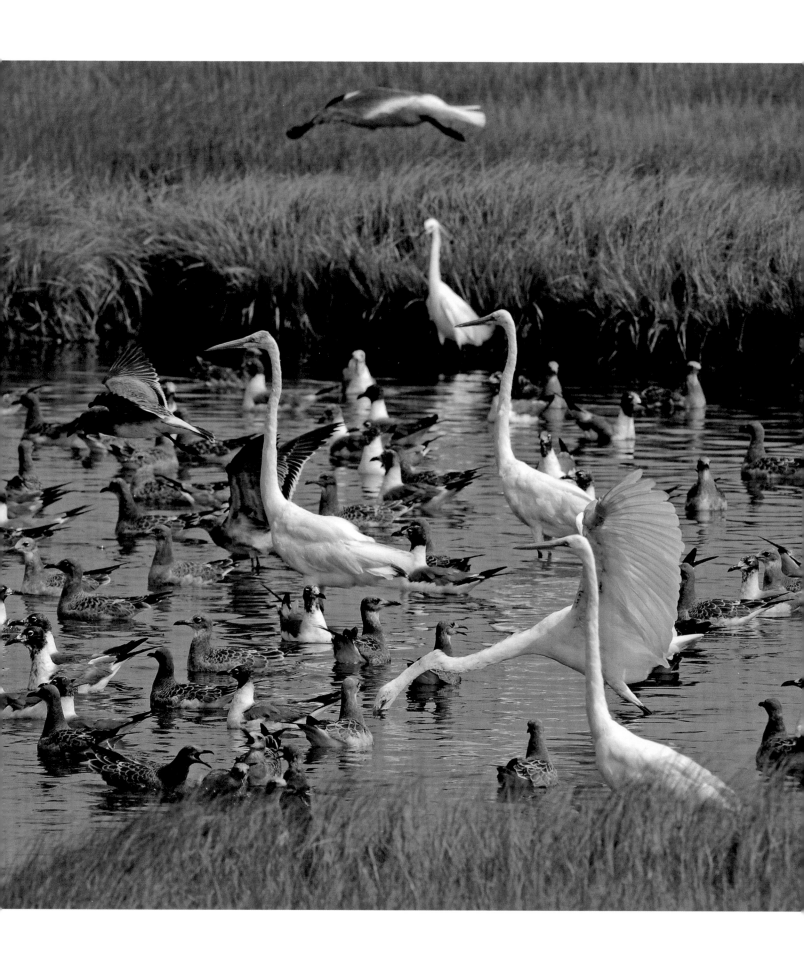

or standing motionless in some shallow waterway, hunting for small fish. 727 breeding pairs nested on Pea Patch Island, DE, in 1989. The **Great Egret**, our second best-known heron species, can be found year-round, though most commonly in the warmer months. This all-white species breeds throughout much of the United States and winters in the South and along the coasts. Note the yellow bill and black legs and feet. This species, or a very similar sister species (expert opinions differ), is found in South America, Africa, and Australasia. 639 pairs nested at Pea Patch Island, DE, in 1989.

The **Snowy Egret** is among the most beautiful of our waterbirds, especially when displaying its nuptial plumes during the breeding season. Like the Great Egret it is all-white with black legs, but it is smaller and slimmer and has conspicuous yellow feet. Because of its prominent foot color, this small egret is sometimes called Golden Slippers. The species breeds patchily through the southern United States and winters in the Deep South and along the coasts. 2,000 birds were counted at Prime Hook NWR, DE, on 9 September 2013. 1,000 pairs bred on Pea Patch Island, DE, in 1978. The **Little Blue Heron** is a small tropical heron that is a widespread breeder in South and Central America, ranging

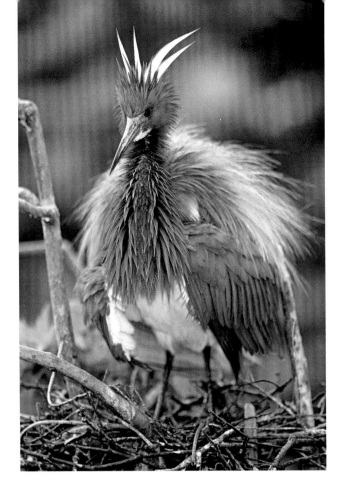

north into the lower Mississippi and Southeast (where it is most common along the Atlantic and Gulf coasts). The Little Blue winters southward to Florida and southern Central America. The adult is slate-blue with purplish tinges. The immature bird is all-white with pale greenish legs and a distinctive two-tone bill. 900 pairs nested at Pea Patch Island, DE, in 1989. This is a bird of marshland edges and estuaries, usually found as a singleton away from the breeding colony. The **Tricolored Heron** has a similar ecology to the Little Blue and nests in mixed colonies with the smaller Little Blue Heron and Snowy Egret. In the Region it is most often seen as a singleton. The adult is mainly blue-gray and white, with a prominent patterned throat stripe. The juvenile has a strong rusty wash on the neck and upper body. The diagnostic white belly of this species is prominent from a distance. Note the long neck and long narrow bill. The species' core breeding range is along the coasts of the Southeast and Gulf states, and it winters in the coastal Deep South and into Central America. It was formerly known as the Louisiana Heron.

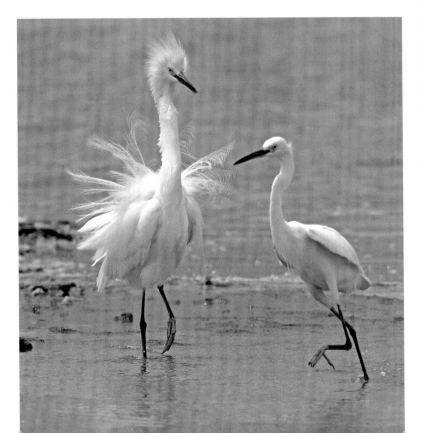

The **Cattle Egret** is an odd-ball heron ecologically, as it forages mainly in grassy fields alongside livestock, where it hunts for arthropods. It is a recent immigrant to the United States from Africa via South America. It was first recorded in our Region in 1953. This species breeds mainly in the Southeast and up the East Coast to New England, as well as patchily in the West. It winters from the Southeast and Gulf states to southern California and Mexico. The breeding adult has deep golden plumes on the crown, breast, and back. It is chunkier and shorter-necked than the other white herons. Nonbreeders have dark legs and a relatively short yellow bill. 4,500 pairs nested at Pea Patch Island, DE, in 1975. The species has declined substantially in recent decades. The **Green Heron**, a small, dark, compact heron, is the second-smallest of our herons. It is widespread but easily overlooked because of its cryptic plumage and retiring behavior, and it is perhaps most commonly seen while giving its sharp call-note in flight. The species breeds throughout the East and the Mississippi valley and patchily in the West, wintering in Central America. It hunts for small fish at the edges of streams and ponds and typically roosts in waterside thickets, out of sight. The birds are noisy when flushed. Unlike almost all the other herons of our region, the Green Heron is a solitary breeder that nests in low trees, usually near a stream or pond.

The **Black-crowned Night-Heron** is a common year-round resident, breeding in colonies, often with other herons. It is one of the more common urban-dwelling herons. Its range includes North and South America, Europe, Africa, and Asia. This large-eyed species forages at dusk and at night at the verges of streams and ponds near the cover of vegetation. The bird is white below, with gray wings and a black cap with trailing white head plumes. This species has a compact and bulky appearance in flight. It is not unusual to see small groups of these herons at dusk, winging to their evening foraging sites along the Potomac in Washington, DC. 550 pairs nested on Pea Patch Island, DE, in 1978. The **Yellow-crowned Night-Heron** is a very hand-

Nesting Yellow-crowned Night-Herons create a unique viewing opportunity along the Jones Falls Trail in Baltimore City.

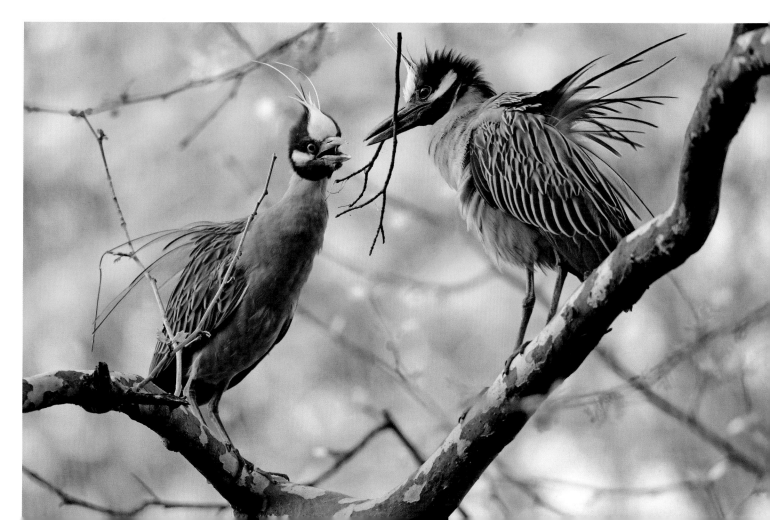

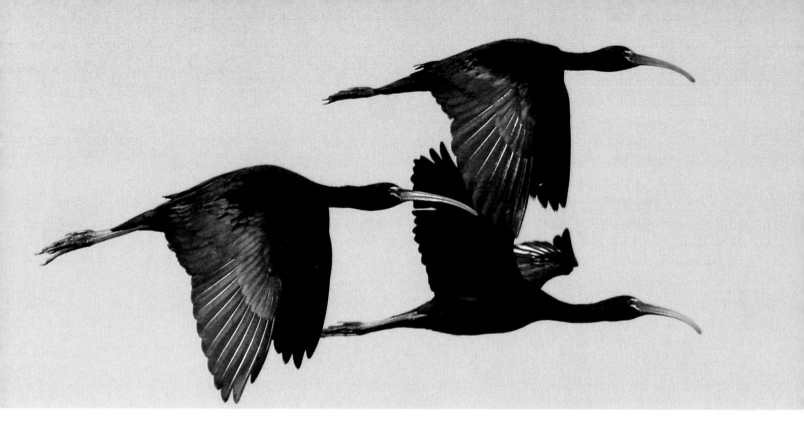

some and compact heron, nesting in small single-species colonies by woodland streams or in larger mixed-species colonies on islands. In the 1950s the species was rare and local in the Region. Now it is a regular breeder in some suburban neighborhoods in Maryland. It is perhaps one of the most exotic-looking of our local breeding birds. Note the blue-gray body and black-and-white face and stylish white head plume. The species is generally less common than the Black-crowned Night-Heron. It is a breeder in the East and South, wintering in Florida, Texas, and south of the US border. 41 pairs bred at Pea Patch Island, DE, in 1986.

Other Long-legged Waders

Several other heron-like birds have been recorded in our Region. The **White Ibis** is a bird of the Deep South and a post-breeding irruptive wanderer to our Region, and it has bred in Virginia recently. The adult is all-white except for the black wing tips and red face, bill, and legs. Young birds are mainly dull brown with a pink bill. Ibises fly with neck and legs extended and with a different wing beat than that of the herons—flapping, then sailing, with wings outstretched. The species forages in marshlands and shortgrass fields, picking up prey (especially fiddler crabs) with its curved bill. 252 birds were counted on Assateague Island, MD, on 7 October 2017. This species is expanding its range northward into our Region. The **Glossy Ibis** appears all-dark from a distance, but at close range its plumage is a mix of iridescent browns, purples, and greens. It is mainly a coastal species, with a breeding range extending from the Gulf north to New England. It wanders after the breeding season. The Glossy Ibis is usually seen in small flocks, foraging in fields and marshlands. This globally widespread species arrived in North America in the nineteenth century, presumably colonizing from West Africa via the West Indies. Note the distinctive shallow wing beats. Groups tend to fly in lines. 1,500 pairs nested at Pea Patch Island, DE, in 1975. The **White-faced Ibis** breeds in the interior West and on the Gulf Coast and is a vagrant to our Region, with increasing numbers of records, mainly between April and October. It closely resembles the Glossy Ibis and exhibits similar habits.

The **Sandhill Crane** is a very large gray waterbird with a red forehead, long legs, and a very long neck. It is typically seen foraging in agricultural fields in the nonbreeding season. Its main breeding

range extends from the Great Lakes country northwest to Alaska. There are also small disjunct breeding populations in the Deep South. The northern populations winter in the southern states and Mexico and are relatively rare along the East Coast. This crane can be distinguished from the familiar Great Blue Heron by its upright posture, the "bustle" of feathers sitting atop the rump, and its habit of flying with neck outstretched. This crane's breeding range is expanding eastward, and populations overall are on the rise. Because of its gray plumage, this very large bird is surprisingly hard to see and most often is located by its distinctive vocalization. The species is becoming more common as a visitor to our Region, and it recently bred in Maryland for the first time (in the Allegheny Highlands).

Cormorants and Pelicans

Birds of this subgroup float on the water and feed on fish. Cormorants dive from the surface, Brown Pelicans plunge from the air, and White Pelicans feed by swimming and dipping their bills. This group is most common along the Atlantic Coast and in association with large bodies of salt or brackish water. These are solidly built fish hunters—and excellent swimmers and fliers.

The **Double-crested Cormorant** is among the Region's most common waterbirds. The adult is all-black with orange facial skin and two small crests during the breeding season. The young birds have a dark brown belly and whitish breast. The species breeds mainly in northern North America and winters in the Gulf states. Over the past two decades we have seen a steady increase in the continental population of this species, so much so that there has been considerable pressure on state and federal agencies to control populations near fish farms. It returned as a breeding species in the Region in the 1970s. Breeding populations in the eastern United States were decimated in the late 1800s but have fully recovered. 20,000+ were counted at Cape Henlopen SP, DE, on 17 October 2009. The **Great Cormorant**

is a sparse winter visitor to ocean or bay jetties of the Region. Typically, single birds are found among flocks of the Double-crested Cormorant. The Great is a saltwater species wintering here from a breeding range centered in the Canadian Maritimes (and it recently bred as far south as Massachusetts). Its global range includes Europe, Asia, Africa, and Australia. It is the largest of the cormorants. The adult is all-black but for the white throat patch and oval white hip patch. Young birds are pale-bellied and dark-breasted, the reverse of the pattern in young Double-crested Cormorants. 200 were counted at Cape Henlopen SP, DE, on 15 November 2015.

Double-crested Cormorants are thriving along bays and rivers, nesting with other colonial waterbirds such as pelicans and gulls.

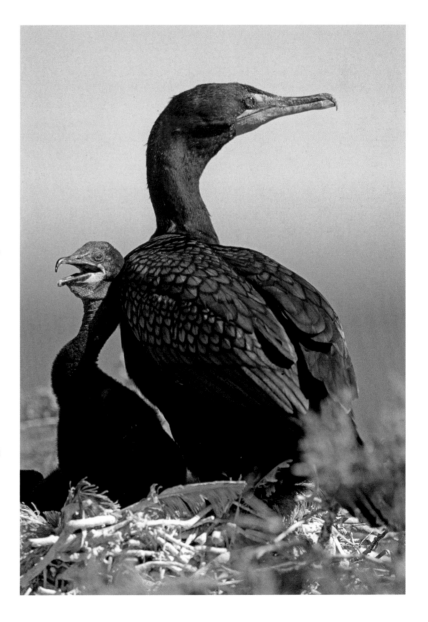

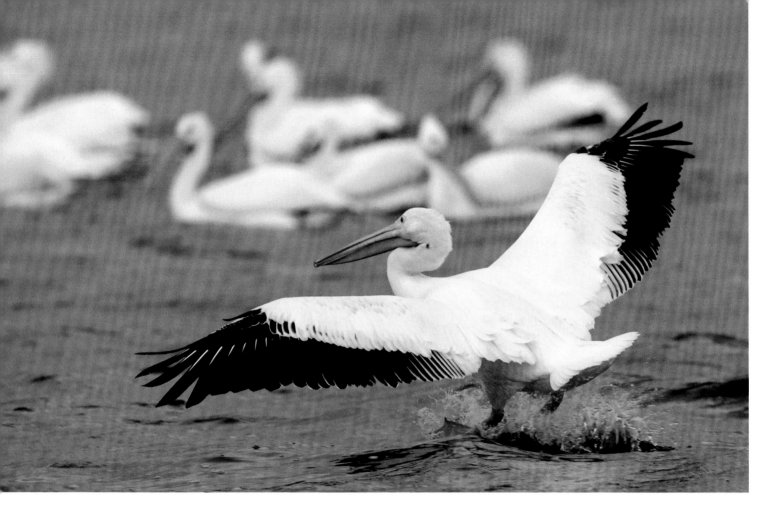

The **American White Pelican** breeds in colonies mainly in the Great Plains and Far West and wanders widely when not breeding, wintering mainly along the Gulf Coast and the southern sector of the West Coast. Small flocks show up along the East Coast at favored foraging and loafing sites in the late summer, sometimes staying into winter. This pelican is all-white with long, black, trailing-edge wing patches. Note the orange bill and feet. Weighing more than 16 pounds and with a wingspan of more than 100 inches, this is the largest bird in the Region. 163 were counted at Blackwater NWR, MD, on 6 February 2016. The **Brown Pelican**, after recovering from its population decimation by DDT poisoning in the 1960s, arrived in the Region as a breeder in Maryland in 1987, expanding its range up the Atlantic Coast from the Deep South. This strictly coastal species ranges nationally along the southern sectors of the two coasts and along the Gulf of Mexico. The young birds are dull gray, but the adult in breeding plumage has a colorful head of brown, white, and deep yellow. This bird is of-

ten seen patrolling coastal beachlines on the wing, plunge-diving expertly for fish spotted near the water's surface. 1,500 were counted at Holland Island, Dorchester County, MD, on 10 July 2016.

Rails and Allies

The rails are a family of very small to medium-large shorebird-like waterbirds most common in marshland or at the edges of ponds and waterways. The true rails tend to be quite reclusive, whereas the large and somewhat fowl-like gallinules typically frequent shallow water at the edge of marsh grasses. Most reclusive of all is the tiny **Black Rail**, a mainly crepuscular (twilight-loving) or nocturnal marsh dweller that is virtually impossible to observe in the field. Black Rails remain hidden in thick marsh tussocks and are usually detected only by their call at night. The all-black young of King or Clapper Rails, which scamper about in the open, might easily be mistaken for an adult Black Rail, but the latter can be distinguished by its dark chestnut collar and

abundant black speckling on the mantle and flanks. Its seasonal movements are not well understood, and it is in decline across its range. The Black Rail is a species of highest concern on the US Watch List. 100+ were estimated vocalizing at Elliott Island, MD, on 2 June 1954. 16 were counted along the Port Mahon Road, DE, on 1 May 1991 (whereas in 2017, only singletons were recorded here).

The **Clapper Rail** is a common and vocal inhabitant of salt marsh during the warm season, with a range from coastal New England to the Gulf Coast and the Caribbean. It has a washed-out plumage of buffs and grays with fine white flank barring. It is found only near salt water and is much more likely to be heard than seen. 62 were counted in a marsh in Somerset County, MD, on 10 May 2008.

This 1986 photo of a Black Rail tending her nest was taken when the species commonly nested in the salt marshes of Dorchester County, MD. Photo: William Burt

The very similar but much scarcer **King Rail** is more brightly colored than the Clapper and prefers fresh and brackish marshes. These two species hybridize where their populations meet. The King Rail breeds throughout the eastern United States and winters along the Gulf Coast and Florida. 23 were recorded on the Dorchester County, MD, Christmas Bird Count on 28 December 1953. The **Virginia Rail** looks like a small and richer-colored version of the King Rail and is one of our most widespread rails, found in the Region year-round. Its breeding range extends from eastern Canada to southern California. Northern populations winter in Mexico and Florida and along the Atlantic Coast of the Southeast.

The **Sora**, with its black mask and short yellow bill, breeds across northern and western North

The elusive Virginia Rail offers a fleeting, full body glimpse before disappearing into the marsh. Photo: Mark R. Johnson

The handsome Common Gallinule is typically found foraging diffidently at the watery verges of reed-beds.

America, wintering mainly in the Southeast and along the borderlands (and into Mexico). It nests in shallow wetlands with plenty of emergent vegetation. In early fall it feeds primarily on Wild Rice. This and the Virginia Rail commonly occur together. The Sora has a number of whinnying vocalizations. 55 birds were counted at Allen's Fresh, MD, on 26 September 1953. 40 were counted on the Patuxent River, MD, on 22 September 2012.

The dark-plumaged **Common Gallinule** is a medium-large, henlike waterbird usually seen swimming or wading near the edges of marsh vegetation. It has the shape and size of a slimmed-down American Coot but shows a white streak along its flanks and has a red forehead and bill with a yellow tip. The coot is much more sociable and is usually seen out in open water. 13 Common Gallinules were counted at Elliott Island, MD, on 31 August 1946.

Rarities

The iconic **American Flamingo** has been recorded once in our Region as a vagrant from the Caribbean. With its angled bill, pink plumage, and long neck and legs, it is unmistakable. The **Wood Stork** breeds in the Southeast and tropics, and single birds very occasionally wander northward to our Region in the summer season. It is typically seen soaring high in the sky—a very large bird with black-and-white wings and a dark bill and legs.

The **Neotropic Cormorant** resembles a small version of the Double-crested Cormorant. These birds breed in the Deep South, and individuals occasionally wander to our Region in the warmer months of the year. They have been seen a few times along the Potomac River northwest of Washington, DC. Most birds seen in the Region are juveniles, which can be identified by the small size, all-dark ventral plumage, and white "V" at the base of the bill. The **Anhinga** is a tropical relative of the cormorants, distinguished by its straight pointed bill, long fan-shaped tail, and soaring habit. It breeds mainly in the Deep South, southward to Argentina.

The **Little Egret** is a Eurasian vagrant, recorded several times in Delaware. It is very similar to the Snowy Egret, but with gray skin in front of the eye and two distinctive plumes trailing from the crest in breeding plumage. It breeds in the Old World, with an outlier breeding population in Barbados since 1994. The **Reddish Egret**, a well-known and charismatic species of Florida and the Gulf of Mexico, is a vagrant to the Eastern Shore. It exhibits two plumage morphs—one all-white, the other reddish-brown and slate-gray—and has a distinctive hyperactive foraging style.

The **Roseate Spoonbill** is a tropical vagrant to our Region that breeds in Florida, coastal Texas, and southward. On rare occasions it disperses northward in summer and autumn. The only other large pinkish waterbird is the much rarer flamingo.

The diminutive **Yellow Rail** is a very rare migrant, breeding in the borderlands of the north-central United States and central Canada and wintering in the Deep South, Southwest, and Mexico. This very elusive bird is probably overlooked because of its retiring habits and is usually detected only by its distinctive call, which resembles two stones being knocked together. It is a species of highest concern on the US Watch List. The **Corn Crake**, an accidental vagrant from Europe, looks a bit like an oversized Yellow Rail. The **Purple Gallinule** is a colorful tropical species, ranging north to Florida and the Gulf Coast states as a breeder and wintering south of the border. It is an irruptive post-breeding wanderer, occasionally making its way as far north as New England and eastern Canada.

Looking like an oversized and long-necked brown rail with pale streaking, the **Limpkin** is a reclusive swamp dweller, breeding in Florida and very rarely wandering northward in late spring and summer.

(Following pages) A tall American Sycamore tree along Patapsco River wetlands hosts a dozen Great Blue Heron nests full of hungry youngsters.

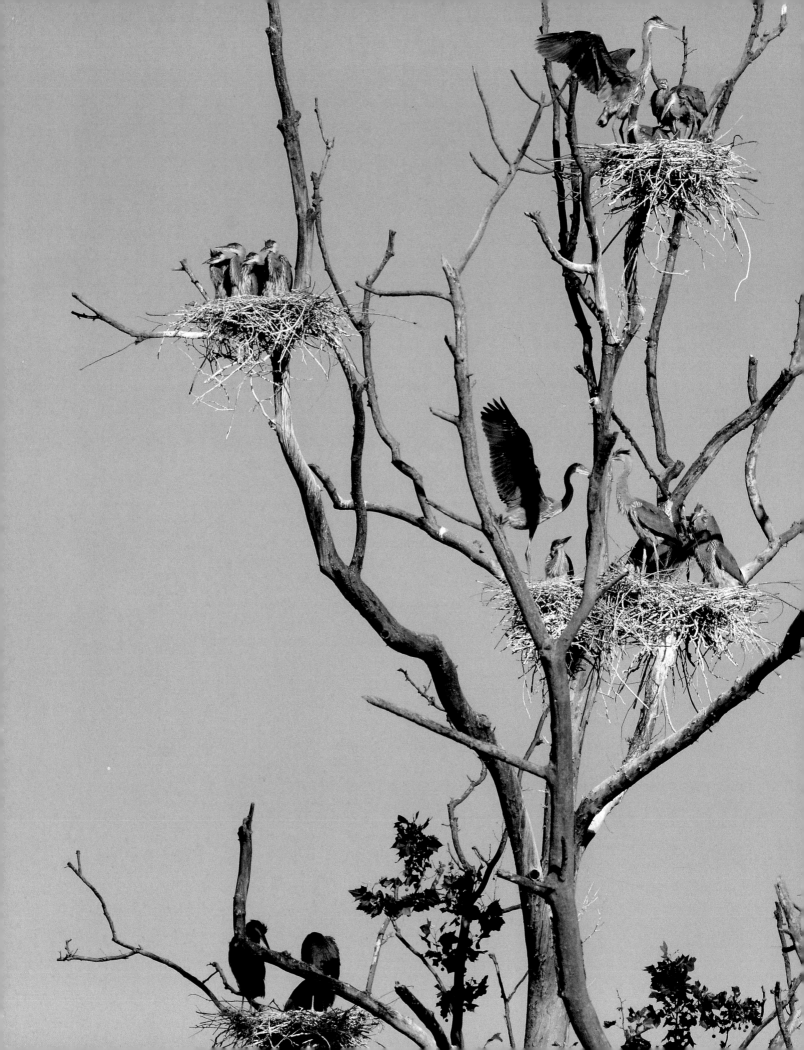

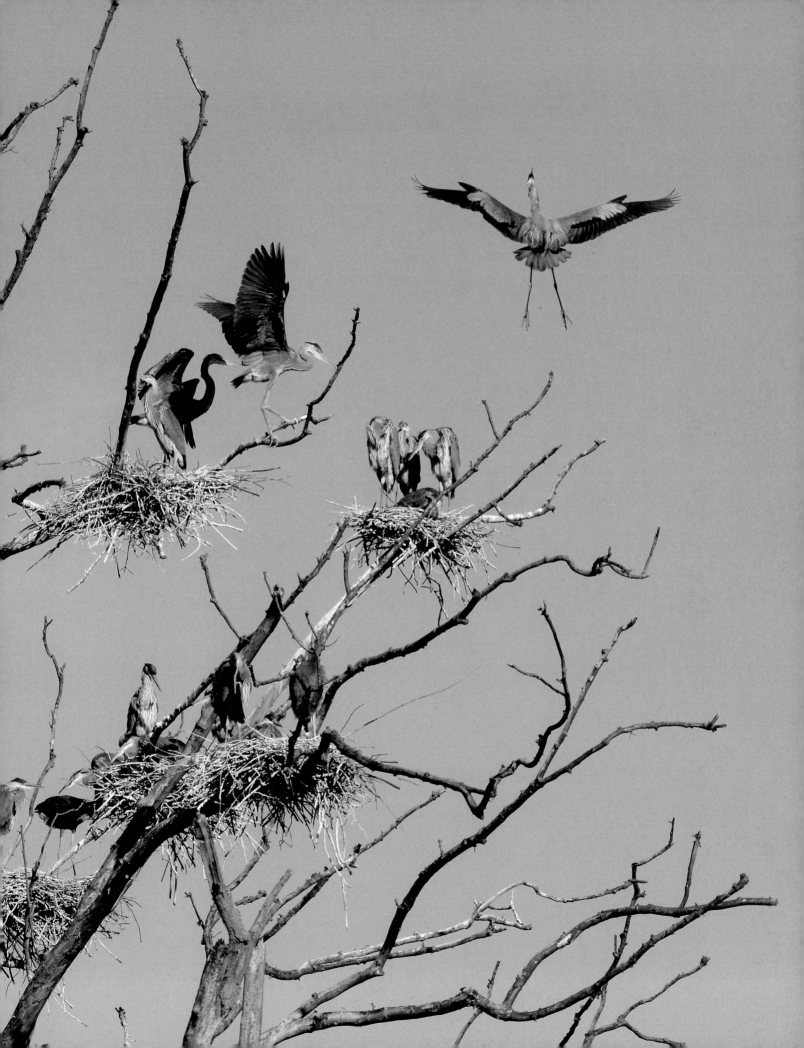

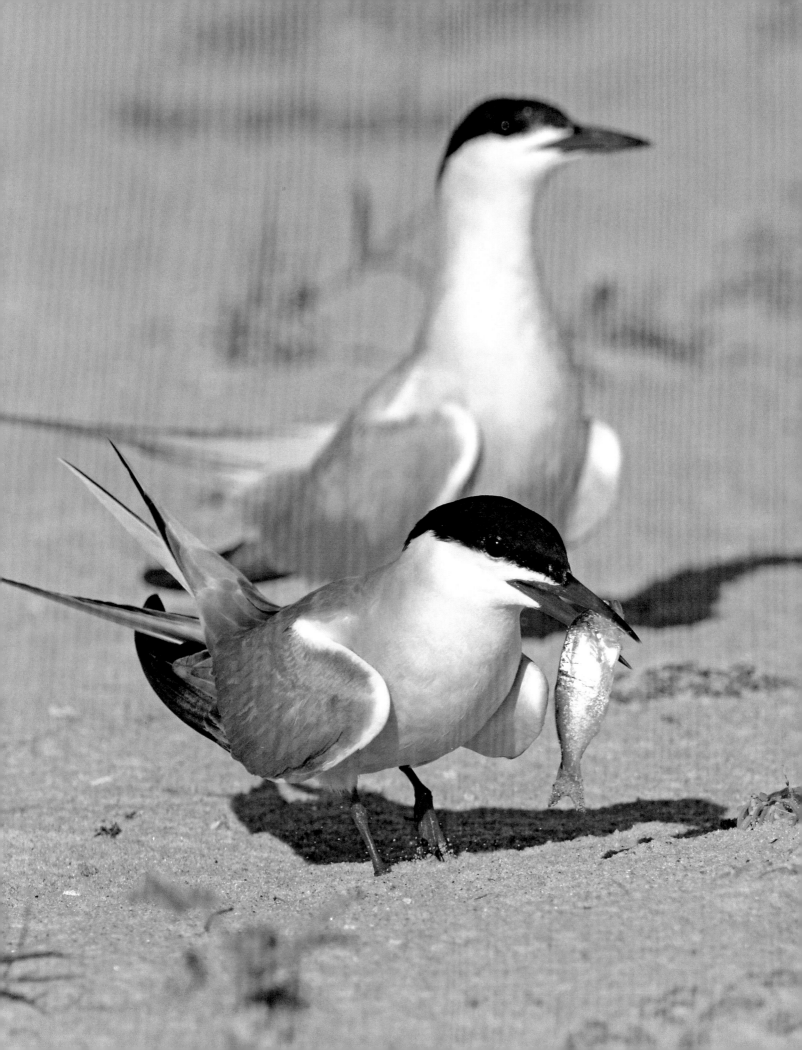

Coastal Waterbirds

Many of the coastal waterbirds are familiar to birders and other visitors to the seashore year-round, but in this grouping we also include the often-overlooked loons and grebes because of their coastal habit. The loons are specialized fish-eaters adapted to diving for elusive prey. The grebes are a morphologically similar but unrelated group of diving predators, which are generally smaller than the loons, are more sociable, and show flamboyant courtship displays. The gulls and terns are the predominant lineages in this grouping and have similar nesting and feeding habits. Most nest colonially on sandy beaches, especially on low sandy islands free of vertebrate predators. Their diet includes small fish and other prey, which, in the case of terns, are usually taken from the water surface or by diving. The Black Skimmer is an aberrant tern with a specialized elongated lower mandible used to capture fish on the water's surface. Skimmers fly low over the water with the tip of the lower mandible breaking the water's surface to contact and capture small fish. Any birding trip to the Atlantic shore or the lower Delaware Bay provides an opportunity to record a good number of species from this group.

Loons

The loons are a widespread family of five species that breed in the Arctic and boreal lakes and winter to temperate coastlines. The two species known from

Common Tern courtship includes a fish presentation ceremony to demonstrate a male's hunting skills.

our Region breed in the far north and winter southward in bays and coastal seas. The loons are isolated in their own lineage, which is allied to a large lineage that includes the shearwaters, cormorants, pelicans, storks, and herons. Loons are heavy-bodied waterbirds that ride low in the water and dive expertly for fish. They have difficulty walking on land because their feet are set so far back on their bodies. The two regularly occurring species in our Region can be found in winter along the Atlantic Coast and during migration on reservoirs and lakes in the interior. Loons are typically solitary, but small aggregations can be found on salt water in winter.

The **Common Loon** nests on boreal and tundra lakes from New England to Alaska and northern Eurasia and in North America winters along both coasts and in the Gulf of Mexico. Its unearthly summertime wails ring across isolated lakes in the Great North Woods. In our Region it is not uncommon to see the species flying high overhead in April and May as it heads to its northerly breeding lakes. In flight these birds are notably fast fliers with a very distinctive look, with narrow wings, trailing feet, and a long neck and oddly lowered head. Individuals stop over to rest and forage on interior

Common Loons linger in our Region well into spring, with full breeding plumage on display by May.

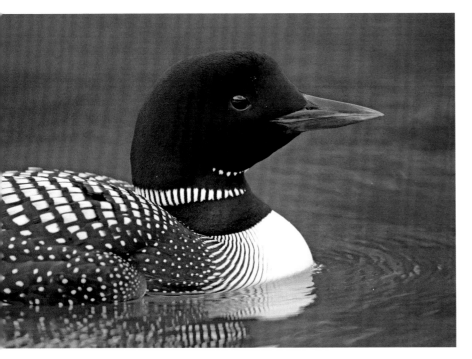

bodies of water. Groups spend the winter along the Atlantic Coast. 816 were counted in the waters off North Beach, MD, on 8 April 1989. The less familiar and declining **Red-throated Loon** breeds in the North American and Eurasian Arctic and in North America winters off both US coasts. It is smaller and slimmer-billed than the Common Loon and is less commonly seen inland. Wintering birds have a large white ear patch. 3,900 were counted at Cape Henlopen SP, DE, on 26 November 2010.

Grebes

Formerly allied with the loons, this group is now considered to have evolutionary affinities with the flamingos. Grebes are small to medium-sized waterbirds that forage by diving expertly for fish and other animal prey. Only one species (the Pied-billed Grebe) nests in our Region. The others nest in the northern or western United States and migrate or wander here. Most species have colorful breeding plumages and gray-and-white winter plumages. Pairs conduct elaborate courtship displays on the water of their breeding habitat. They build their nests on floating mats of vegetation, and the young are often seen riding on the backs of a parent. These birds are true water lovers, and certain species in Central and South America have evolved to be flightless. Grebes are known to ingest quantities of feathers, apparently to aid with the production of gut pellets of indigestible animal material that are then regurgitated.

The **Pied-billed Grebe** is the most familiar family member in our Region, present year-round and nesting locally in shallow bodies of water surrounded by emergent or floating aquatic vegetation. It is plain brown with a white rump, black chin, and bill marked with a black ring. It breeds throughout much of North America, with the northern populations wintering southward. 82 were counted near Port Tobacco, Calvert County, MD, on 7 March 1954. This grebe is in decline in our Region. The **Horned Grebe** nests in the prairie potholes north-

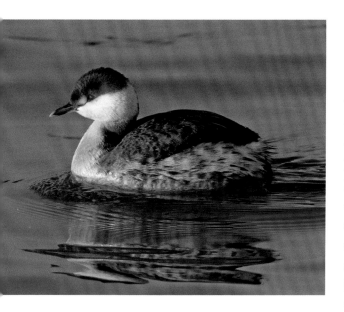

counted at Point Lookout SP, MD, on 19 April 2014. This species has been in decline since the mid-1980s. The **Red-necked Grebe** breeds from eastern Canada to Alaska and Eurasia. North American breeding populations winter in the Great Lakes and the northern sector of the two coasts. It is a rare to uncommon winter visitor to our Region, mainly to large bodies of water and along the Atlantic Coast. It usually appears here in significant numbers only during severe winters when the Great Lakes freeze over. 116 were counted on the Potomac River at Violette's Lock, MD, on 6 March 2003. This species is substantially larger than the Horned Grebe, which it superficially resembles. The **Eared Grebe** is a western species, breeding widely in the prairie potholes and inter-montane West and wintering southward in the West and the Gulf states and into Mexico. It is a rare but regular vagrant to the East Coast, mainly in spring, autumn, and winter. The breeding plumage is very dark, whereas the winter plumage is much like that of the Horned Grebe. The Eared Grebe in winter is distinguished by the mainly dark cheek and the dull white crescent behind the ear, as well as its subtle but distinctive head and bill shape.

ward to Alaska (and Eurasia), wintering in the Gulf and on both coasts. This species is a common migrant and winter resident, especially in bays and along the Atlantic shore, but also regularly appears inland on lakes and ponds. The handsome breeding plumage of the adult is unmistakable. Winter plumage includes a broad white cheek and small, pointed, pale-tipped bill. 1,000 were counted at Point Lookout, MD, on 13 April 1955. 532 were

Wintering Horned Grebes find good fishing along our Region's waterways, from the Atlantic and Chesapeake inland to lakes and rivers.

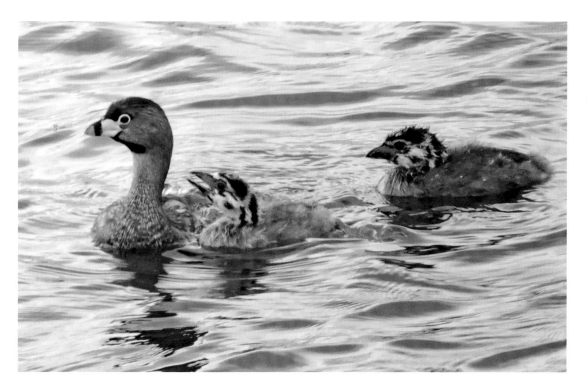

Mostly northern breeders, a few Pied-billed Grebes nest here. This family portrait was snapped at Druid Hill Park in Baltimore. Photo: Keith Eric Costley

Gulls

The gulls are a familiar lineage of waterbirds that are seasonally widespread in our Region. Thousands of Ring-billed Gulls loaf about Washington, DC, during the winter season, well away from any salt water. Several species of gulls are now common year-round in our Region because of the attraction of large landfills. Gulls can usually be distinguished from their sister group, the terns: gulls are larger, more robust, and heavier-billed. Unlike the terns, gulls have grown to be a commensal of human communities because of their strong attraction to the edible contents of landfills. Gulls have a nearly worldwide distribution but are much less common in the tropics than the terns.

Bonaparte's Gull breeds in boreal Canada and Alaska, wintering on both coasts and the Gulf. This is a small, delicate gull—smaller and thinner-billed than the abundant Ring-billed. The adult in breeding plumage has a trim black head and bright red legs and feet, making it one of the more handsome of our gulls. However, it is most commonly seen regionally in its winter plumage, distinguished by the small dark ear spot and pinkish legs. In all plumages the species has a pale wedge on the leading edge of the outer wing. 50,000 were estimated in the Ocean City, MD, area on 24 November 1991. 2,000 were reported at Cape Henlopen SP, DE, seen moving offshore, on 22 November 1964. The **Black-headed Gull** is a widespread Eurasian species that is a rare but regular vagrant to our Region. It is very similar in all plumages to Bonaparte's Gull but can be distinguished by its larger size, dark underwing, and red or orange bill. Most winter US records come from the coastal Northeast. The **Little Gull**, a diminutive version of Bonaparte's Gull, is primarily a vagrant from Europe, though a few birds breed in northern Canada. The species winters from the Great Lakes to the Atlantic Coast. The unusual all-blackish underwing and all-white upper surface of the adult wing is diagnostic. The juvenile has a black "M" pattern across the upper surface of its spread wings

and a black tip to the tail. 30 Little Gulls were reported in mid-April 1974 on the DE shore, between Little Creek WA and Indian River Inlet. For the year 2016, eBird includes four reports of six different birds in the Region, in the months of January, March, and April (three singletons, and one group of three).

The **Laughing Gull** is our summer seashore gull, abundant on the Eastern Shore and lower Chesapeake during the warmer months. It nests in large colonies scattered along the Atlantic seaboard, and winters along the Southeast coast, mainly south of our Region. The breeding adult is distinctive, with its black hood and dark red bill; the juvenile is a dull dirty-brown. Winter adults show a dark-smudged white head and mainly dark wing tips. This bird is named for its constant raucous vocalization. 20,000 were counted at Kitt's Hummock, DE, on 8 May 2008. 8,000 were recorded at Pickering Beach, DE, on 14 May 1971. **Franklin's Gull** is a rare but regular migrant to the Region. This is the Laughing Gull's smaller western counterpart, breeding in the prairie potholes of the United States and Canada and migrating to the west coast of South America for the winter season. The breeding adult can be distinguished from the Laughing Gull by the extensive white in the wing tip, the more prominent broken white eye ring, and smaller size.

The **Ring-billed Gull** is our Region's most common gull, present year-round but most prevalent in fall, spring, and especially winter. During summer most birds travel to their breeding colonies in the northern interior of North America. The species winters on both coasts and in the interior of the southern half of the United States. This is a very familiar human commensal, found in a variety of urban situations and around agricultural fields. In all plumages, look for the small size combined with the black ring on the bill. 21,750 were counted on Egypt Road, Dorchester County, MD, on 11 March 2011. 2,500 were reported south of the Chesapeake and Delaware Canal, DE, on 21 March 1986. The **Herring Gull** is the big cousin to the Ring-billed,

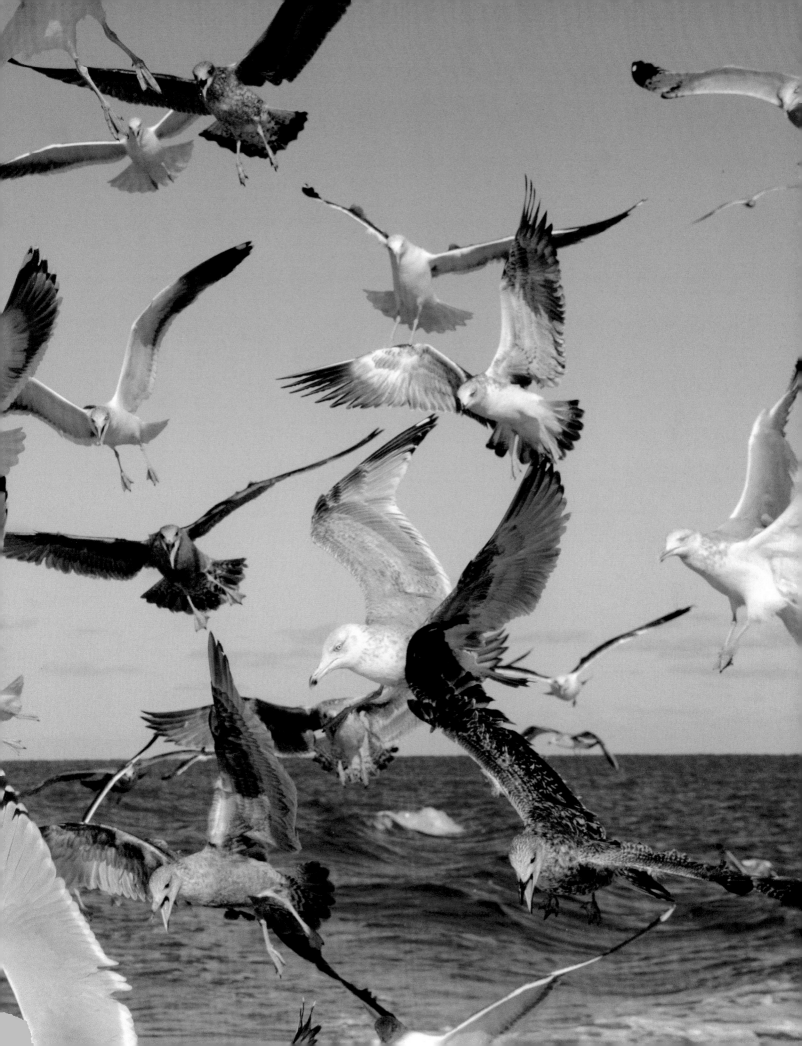

nesting along the East Coast, on the Great Lakes, throughout Canada to Alaska, and in northern Europe. The species winters widely along all coasts, northward into Labrador and coastal Alaska. This large gull is common but is less often seen in the large flocks typical for the Ring-billed, and it is more closely allied with salt water. 54,000 individuals were estimated at Fox Point SP, DE, on 7 February 2015. The **Lesser Black-backed Gull** is a relatively recent arrival in our Region (and to North America), now on the increase. It closely resembles a Herring Gull but for the noticeably darker mantle and the yellow legs of the adult. It breeds in Iceland and northern Europe, and wanderers to North America to loaf along the East Coast and coast of the Gulf of Mexico and Great Lakes. 215 were counted at Assateague Island, MD, on 13 August 2012.

The **Iceland Gull** is an Arctic-breeding species that is a rare but regular winter visitor to the Region. This is one of the "white-winged gulls" known to

appear in late winter. The species mainly winters along the North Atlantic Coast and the Great Lakes. Smaller than a Herring Gull, this species has noticeably pale wing tips, often with a pale gray pattern. Thayer's Gull is now treated as a distinct subspecies of the Iceland Gull. Thayer's Gull is darker-mantled with more black in the white tips to the primaries. The juvenile Thayer's is darker brown than the young Iceland Gull. The larger and bigger-billed **Glaucous Gull** is similar to the Iceland Gull but for its size and pale, patternless wing tips. It, too, is a rare but regular winter visitor. The species breeds in the high Arctic and winters on both coasts and on the Great Lakes. It is larger than the Herring Gull and more bulky. Most sightings in our Region are of young birds. The **Great Black-backed Gull** is a common breeder and year-round resident near salt water and the Atlantic shore. This is our largest gull and is a powerfully built, heavy-billed gull with solid black upperparts. It has been on the increase since the 1960s, benefiting

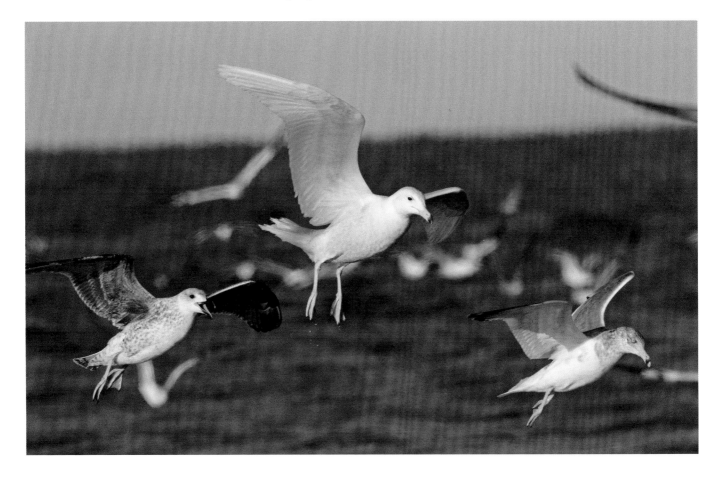

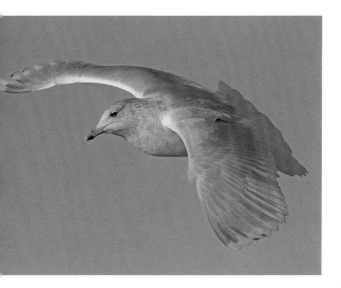

from the proliferation of solid waste landfills associated with the expanding urbanization of the Region. The species breeds in the Mid-Atlantic and Northeast, wintering along the East Coast, Great Lakes, and upper Mississippi, south to Florida. The species also is widespread in western Europe.

Terns

Terns and gulls are different ecotypes of a single evolutionary assemblage. The terns are graceful and agile waterbirds that mainly hunt small fish that they capture by diving or by picking them from the surface. Long-winged and slim-billed, terns nest on low sandy islands and are commonplace along the Atlantic shore and in open bay waters. Most are mainly white, often with a black cap. The typical tern is distinguished from the typical gull by its very short legs, narrow and sharply pointed bill, and narrow and pointed wings. Most terns are smaller than most gulls, but there are exceptions. For instance, the Caspian Tern is nearly six times heavier than the Little Gull. Terns breed in colonies on protected beaches and most successfully on islands free of mammalian predators such as foxes, skunks, and Raccoons.

The **Least Tern** is our smallest tern, breeding patchily through the United States and into Mexico. It winters in northern South America. Our East Coast populations are in decline, and their breeding colonies suffer a range of threats, including depredation by mammals and disturbance by humans

and their pets and beach-traveling vehicles. This tern has a distinctive yellow bill and legs, and the breeding adult has a diagnostic white forehead and black eye line. It occasionally nests on flat rooftops of buildings situated near productive foraging waters. 853 breeding pairs were reported nesting in Delaware in 1985. 552 were counted at Poplar Island, MD, on 9 August 2006. 285 pairs were reported in a nesting colony on the barrier beach north of Ocean City, MD, on 17 June 1948. The Least Tern is a species of highest concern on the US Watch List. The **Gull-billed Tern** has a pantropical distribution, but in the United States it is mainly found as a breeder along the Atlantic and Gulf shores. It winters in south Florida, on the Gulf Coast, and south of the US border. The species is distinguished by its short tail, very pale upperparts, and abbreviated and thick black bill. It is typically solitary and not found among the mixed-species tern flocks often seen loafing on sandbars and jetties. Instead, this species can be seen over bare agricultural fields near the coast, in search of insect prey. It is in decline in the Region and is represented by just a handful of pairs breeding in colonies of Common Terns and Black Skimmers in southernmost coastal Maryland. 33 pairs nested in Big Bay Marsh, MD, in 1986.

The **Caspian Tern**, the world's largest tern, is a common passage migrant and occasional nonbreeding summer visitor. The species breeds in colonies

Another prized white-winged winter gull is the Iceland Gull, a scarce northern visitor to the Mid-Atlantic Coast.

A Least Tern chick at a rooftop gravel nest has more than a mouthful for its meal.

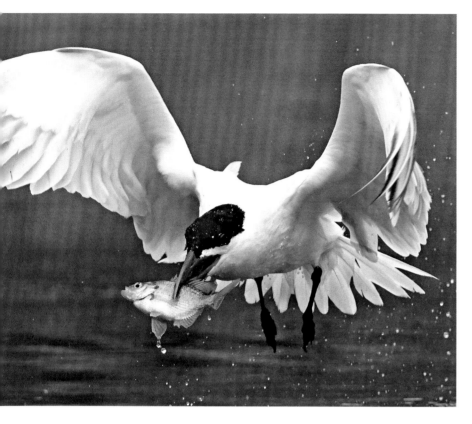

scattered across the northern United States and Canada, wintering in the Deep South and Mexico. Typically it is seen singly or in small numbers patrolling the edges of large rivers, reservoirs, and shorelines. This is a big gull-like tern with a shallow-forked tail, powerful direct flight, and bulky blood-red bill. 1,291 were counted at Hart-Miller Island, MD, on 11 August 2014. 200 were reported on a sandbar in the Delaware River opposite Delaware City, DE, on 10 September 1988. The slightly slimmer and narrower-winged **Royal Tern** breeds along the southern Atlantic and Gulf coasts, wintering in the Deep South and south of the border. This is a handsome tern of saltwater coastlines. The breeding adult has an orange or orange-red bill and an all-black cap. Nonbreeding birds show a distinctive white forehead and ragged black hind crest. Only a few breed in coastal Maryland. This powerful flyer patrols the coastlines and dives from considerable height to take small fish near the water's surface.

Late March marks the beginning of the Caspian Tern show, as these impressive dive bombers visit area lakes and rivers while on spring migration.

Nesting Royal Terns (and a lone Sandwich Tern) are struggling regionally, mainly because they require pristine undisturbed sandy beaches as nest sites.

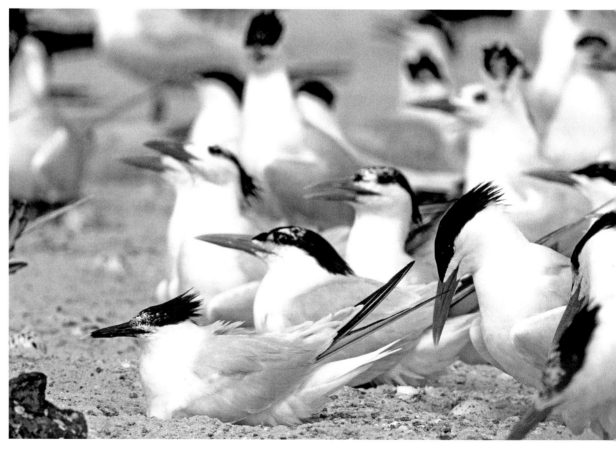

708 were counted at Ocean City, MD, on 30 July 2005. 200 were reported at Cape Henlopen SP, DE, on 19 April 1985. The **Sandwich Tern** breeds in coastal colonies from Virginia to Texas and into Mexico. The species winters in the Deep South and south of the border. There are additional populations in Europe and western Asia (considered a separate species by some authorities). This slim tern is slightly smaller than the Caspian and Royal Terns and has a distinctive long black bill with pale-yellow tip year-round. It is typically found in association with Royal Terns. 63 Sandwich Terns were counted on Assateague Island, MD, on 2 September 2000.

The **Black Tern** breeds in the northern and western United States, Canada, and Eurasia, and winters on the coasts of northern and northwestern South America (and Africa). This is a dainty and short-billed bird with wings that are dark gray above and below year-round. The breeding adult is elegantly black-bodied with contrasting gray wings and a white undertail. This bird is often seen roosting with other tern species. It mainly picks prey off the water's surface. 285 were recorded near Lapidum, Harford County, MD, on 21 August 2016.

The **Common Tern** has a nearly worldwide distribution. In North America it breeds along the Atlantic Coast, in the Great Lakes, and in Canada. It winters south to the Caribbean and northern South America. In the warmer months this species is commonplace on the two bays and along the Atlantic. It is a black-capped gray-and-white tern with a black-tipped orange-red bill. This and the Forster's Tern are the most common terns in our Region. 3,050 Common Terns were recorded in the Ocean City area on 11 May 1952. 2,500 were reported at Cape Henlopen State Park, DE, on 16 May 1971. **Forster's Tern** is like a pale version of the Common Tern, with a more deeply forked tail. Nonbreeding birds have a distinctive black eye patch. Forster's breeds patchily through coastal and interior North America, wintering to the Deep South and south of the border. 2,000 were recorded at Ocean City, MD, on 24 November 1991. The **Roseate Tern** breeds along the coast of New England and is seen as a rare passage migrant, most frequently observed offshore in early June. It formerly nested in colonies along the Maryland shore in the early 1930s. The species winters in South America. Additional populations inhabit Eurasia, Africa, and Australia. The **Arctic Tern** breeds in northern New England and northern and arctic Canada and Eurasia, our populations wintering in the far southern latitudes of South America. As a passage migrant, it is uncommon offshore and extremely rare in the interior of the Region. It is slightly smaller than the Common Tern, with a short, dark red bill lacking the black tip. Note the long forked tail in breeding plumage.

Skimmer

The **Black Skimmer** is a large, aberrant tern that is an uncommon breeder and common migrant along the Atlantic and Gulf shores from New England to Texas. Northern populations winter south to the Gulf and Florida and south of the border. The species nests in beach colonies, and in autumn it forms large post-breeding flocks on the sand before departing south to its wintering habitat. Note the very long wings with the mainly black dorsal surface, as well as the oversized red-and-black bill. This bird has a lower mandible that is larger and longer than

A freshly hatched Common Tern chick waits to greet its siblings on Skimmer Island in the bay behind Ocean City.

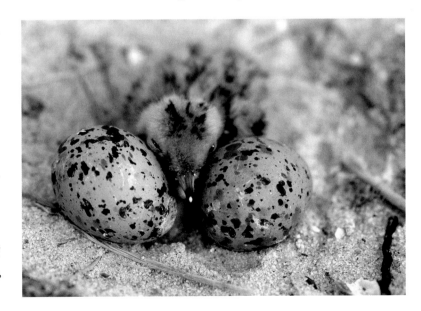

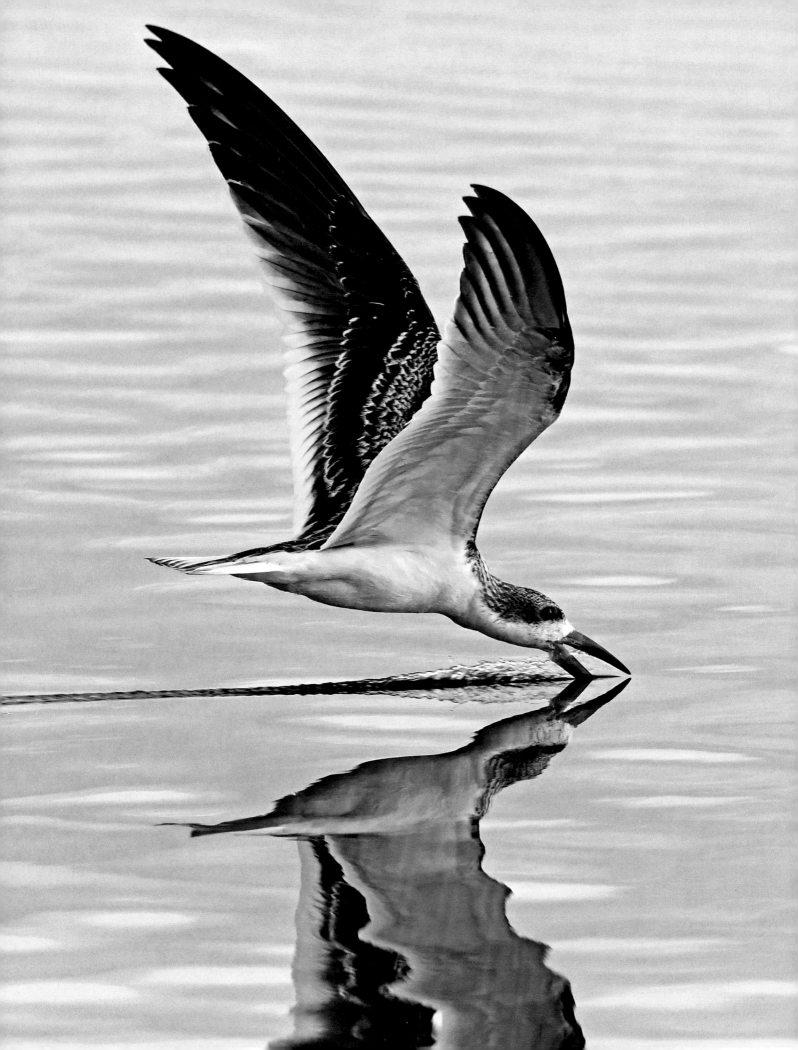

its upper mandible—a specialization for its habit of capturing prey from the surface of water by dipping the beak into the water as it skims low over the surface. 800 were reported at Cape Henlopen SP, DE, on 1 October 1983.

Rarities

The **Pacific Loon** breeds in the Canadian Arctic, Alaska, and Siberia and winters mainly along the West Coast. It is a rare but regular vagrant to the East Coast. Most records are from the winter period, but it also has been seen in spring and summer. Look for it in association with other loons. The **Western Grebe** is a large, slim-necked, black-and-white waterbird that nests in the interior West and far western United States and winters in the Southwest and Mexico. It is a rare but regular vagrant to the East Coast.

Sabine's Gull breeds in the high Arctic and migrates southward across the continent to oceanic waters, where it winters off the coast of southwestern Africa and off the western coast of tropical South America. It is an accidental in our Region, mainly seen as a pelagic migrant. The adult in breeding plumage, with its gray head and yellow-tipped dark bill, is one of the most beautiful and distinctive of our gulls. **Ross's Gull** is a rare arctic breeder that winters mainly in the Arctic. There are a handful of records for this diminutive and short-billed gull in the Lower 48. Larger than a Little Gull and the size of a Sabine's Gull, Ross's Gull is wedge-tailed, most often seen in association with Bonaparte's Gulls. The adult in breeding plumage has a rosy breast and black necklace and is a strikingly beautiful small gull.

The **Black-tailed Gull** is an East Asian species recorded in the United States about a dozen times in a wide array of localities. There are several records for our Region. The species generally resembles a Lesser Black-backed Gull but for the Black-tailed's broad, black, subterminal tail band and dark mark on the bill. The **Mew Gull** breeds in northwestern

Canada, Alaska, and northern Eurasia (where it is known as the Common Gull). The North American breeding population winters along the West Coast. This is a vagrant to our Region. It resembles a smaller version of a Ring-billed Gull. The breeding bird has an all-yellow unmarked bill. Nonbreeding birds show some dark marking on the bill.

The **California Gull** is the species that rescued Brigham Young and his Mormon flock from the scourge of "locusts" (in fact, a species of flightless katydid)—and this gull is now the Utah state bird. It breeds throughout the interior West to northern-most Alberta and winters along the West Coast. It is a fall and winter vagrant to our Region. This gull is quite like a Ring-billed Gull but larger and longer-winged. The **Yellow-legged Gull** breeds in Europe and winters in Africa and is very similar to our Herring Gull. There are winter records for our Region for a returning bird (repeatedly from 1990 to 1994), one of very few records for North America. The **Kelp Gull** is a southern hemisphere species that ranges from Argentina to South Africa and New Zealand. It is a vagrant to the Eastern United States. The adult resembles a diminutive Great Black-backed Gull, but young birds closely resemble a Lesser Black-backed Gull.

The **White-winged Tern**, a close relative of the Black Tern, breeds in Eurasia and winters in Africa and southeast Asia. In all plumages, the dorsal surface of the wing shows considerably more white than that of the Black Tern. There are about a dozen records of this vagrant in the eastern United States. The **Whiskered Tern**, another widespread Old World relative of the White-winged Tern, has been recorded only once in our Region. The Whiskered Tern is black-capped and gray-bodied, with a distinctive white cheek patch.

It will take much practice for this juvenile Black Skimmer to master the art of plucking minnows from the water's surface while on the wing.

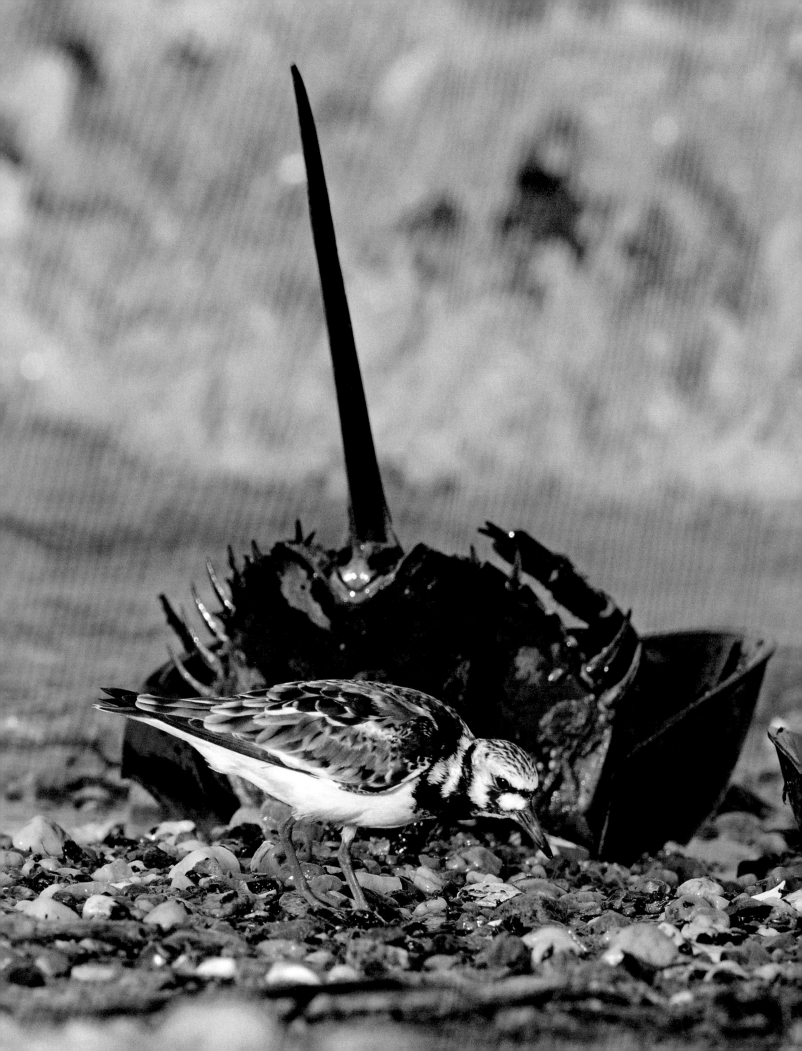

Shorebirds

The shorebirds (called "waders" in Great Britain and Europe) are familiar warm-season inhabitants of beaches, sandflats, and muddy margins of shallow wetlands. This large global assemblage of more than 200 species constitutes a single evolutionary lineage that has diversified into a number of distinct bird families. Our grouping includes the plovers, sandpipers, curlews, godwits, avocets, stilts, oystercatchers, and a single species of non-pelagic phalarope. Most of the 47 species in our Region are long-legged, long- or short-billed, fast-flying predators of shoreline invertebrates. Most shorebirds breed in the far north and migrate southward to the subtropics, tropics, or southern hemisphere. Several members of the group, such as the Red Knot and Hudsonian Godwit, are among the most accomplished long-distant migrants. Because of their diversity of form and plumage and because of their migrations, the shorebirds are among the most beloved species for advanced birders, who revel in the challenges of finding and identifying these remarkable birds, some of which are famous wanderers.

The Plovers

The plovers are a well-defined, compact lineage that ranges worldwide, and nearly all are migratory. The species seen in our Region are long-legged and fast-running, with a distinct run-and-wait thrush-like gait. Plovers are short-billed

A Ruddy Turnstone gorges on Horseshoe Crab eggs at Port Mahon, DE, in front of an overturned crab.

and pick their prey from the surface of the substrate rather than digging for it, as is common among the sandpipers. Their diet consists mainly of marine or aquatic invertebrates.

The **Black-bellied Plover** breeds in the high Arctic of North America and the Old World (where it is known as the Grey Plover). In North America it winters southward into the southern hemisphere. This species is a common passage migrant and uncommon wintering resident on beaches and mudflats of the two coasts and the Gulf. It is found singly or in small parties, often in loose association with other shorebirds. The breeding plumage is striking: black below, gray above, with a white undertail and a contrasting white edging to the black of the underparts. Winter birds lack the distinctive black underparts but show a black patch on the underwing (the axillaries or "armpit") in flight. 3,500 were reported at Prime Hook NWR, DE, on 24 May 2016. The **American Golden-Plover** breeds in arctic Canada and Alaska, wintering to southern South America. Breeding birds are much like the

The Piping Plover visits our Region in early summer to raise a family on protected Atlantic beaches.

Black-bellied but for the golden-spangled upperparts and ventral black extending to the undertail. Winter birds are spangled buffy-golden-brown with a pale belly. In flight, this bird lacks the black armpit of the Black-bellied Plover. 151 were recorded at the Kibler Road rain pools, Caroline County, MD, on 26 September 1999.

The **Killdeer** is our commonplace plover of the interior, which can be found loafing and feeding in grassy fields, open lands, and vegetation-free areas such as gravel parking lots. It breeds throughout North America and winters in the southern half of the United States and south of the border. It can be identified by its large size and twin black neck bands. It is very vocal in flight, giving the high-pitched *kill-deeah* call from which it gets its name. It lays its well-camouflaged eggs in a nest scrape on the ground in a variety of rural and urban habitats that can be surprisingly close to human habitation, such as a driveway. It is famous for the female's "broken wing" distraction display, which is intended to lead predators away from the nest. 400 were counted at Compton, St. Mary's County, MD, on 28 December 1996. The **Semipalmated Plover** breeds in the North American Arctic and winters along both coasts, on the Atlantic as far north as coastal Virginia. It frequents mudflats and beaches in small flocks, often with other waders. It is considerably smaller than the Killdeer and is darker dorsally than the Piping Plover. 5,000 were recorded at Bombay Hook NWR, DE, on 24 August 2014. 1,476 were counted at Ted Harvey CA, DE, on 15 May 1993. The **Piping Plover** breeds patchily along the East Coast and in the interior, wintering along the southeast Atlantic Coast and the Gulf Coast. It can be identified by the combination of orange legs and pale sandy mantle. Small numbers breed among the dunes at Cape Henlopen SP, DE, each year, and the state protects them by fencing off the nesting area to reduce human-based disturbance. This bird is typically solitary and rarely joins wader aggregations. It is a species of highest concern on the US Watch List.

The Sandpipers

The sandpipers are a diverse assemblage of waders with long or short legs and narrow bills that can be long or short, and straight or curved. Many breed in the Arctic and Subarctic and migrate to the tropics and even Patagonia for the winter. They are accomplished travelers and in passage often stop over at productive shoreline feeding sites in great numbers. Many of the sandpipers are in decline today, typically because of the declining productivity of their stopover areas.

The **Spotted Sandpiper** is the sandpiper birders expect to see at interior birding locations in late spring. The breeding range of the species extends from Alaska to New Mexico and Virginia. This is the most common sandpiper species of the interior, frequenting streams and the verges of ponds and wetlands rather than the coastal salt marsh haunts

of most shorebirds. It winters in southern California, Florida, Mexico, and Central and South America. Note the handsome spotting on the breast of both sexes in breeding plumage, the teetering habit, and the strange low flight on stiff wings. Wintering birds lack the distinct black spotting on the breast. The **Solitary Sandpiper** can be found in the interior and is typically seen singly or in small parties in the shallows of a pond edge. The species breeds in the boreal forests of Canada and Alaska in old songbird nests in trees, and it winters in southern Florida and Central and South America. It is most common in our Region as a spring migrant. It is taller and longer-necked than the Spotted Sandpiper. Note the pale green legs and white eye ring.

The **Greater Yellowlegs** breeds in boreal Canada and winters in the southern United States, on both coasts, and southward to South America. This and the Lesser Yellowlegs are among the most

A Semipalmated Plover in full spring color shares a shallow pond with the tiny Least Sandpiper.

common shorebirds in our Region, often found in small flocks in marshlands. It is easily identified by its strident series of call-notes: *tew tew tew.* Note in flight the white rump and finely barred white tail. The large, somewhat two-toned, and slightly upturned bill is diagnostic. 870 were counted at Little Creek WA, DE, on 24 April 1993. The **Lesser Yellowlegs** is another commonplace migrant. It breeds in the northern edge of boreal North America and winters along both coasts and the Gulf, southward to South America. Its diagnostic call is two notes, shorter and flatter than that of the Greater. It can be difficult to distinguish from the Greater Yellowlegs, but note the narrow, straight black bill. 2,915 were tallied at Hart-Miller Island, MD, on 29 July 2000. 2,000 were counted at Pickering Beach, DE, on 28 July 1998.

The **Willet** is a common and noisy breeder in our coastal environs. The species breeds along the East Coast and Gulf and in the interior West. It winters along the southern sectors of both coasts and in the Caribbean and northern South America. This large and very plain species displays striking black-and-white wing flashes when it flushes or flies. Perhaps this is the noisiest breeding shorebird—one of the sounds of the summer salt marsh. The eastern and western forms are distinct in plumage and voice and may merit splitting into two separate species. The western form (*inornata*) breeds in marshes of the prairie pothole country and winters on the coasts of the Deep South and Southeast. The eastern (nominate) population winters in the tropics. The **Upland Sandpiper** is a handsome grassland specialist of the North American interior prairies and grasslands. It breeds from Alaska to the Great Plains and patchily into New England and the Mid-Atlantic states. "Uppies" winter in southern South America. The species nests in shortgrass habitats, and during migration it stops over in patches of this uncommon habitat. Note the long yellow legs, short yellow bill, and heavily patterned upperparts and flanks. The bird is small-headed and large-eyed. The species has shown a serious decline in numbers in

A vocalizing Willet in breeding plumage towers over a Short-billed Dowitcher at Port Mahon, DE.

(*Opposite*)
Mostly a fall passage migrant through our Region, the Upland Sandpiper breeds in small numbers in the Allegheny Highlands.
Photo: Bruce Beehler

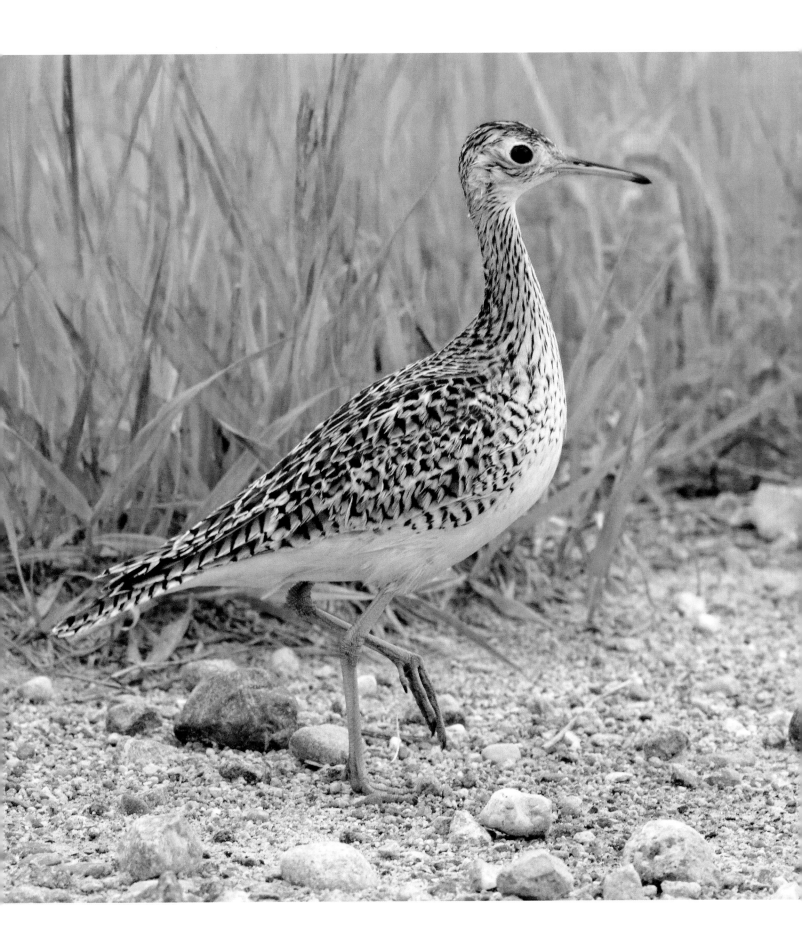

the East. 47 were counted at the Patuxent River Naval Air Station, MD, on 14 August 2004. 22 were recorded at Wilmington Airport, DE, on 26 June 1987.

The **Red Knot** is the most celebrated migratory sandpiper of our Region because of its association with the spawning of Horseshoe Crabs in the Delaware Bay in late May. It breeds in the high Arctic and our North American breeders winter from the southeastern Atlantic Coast and northern California to southern South America. The spring plumage has mottled gray upperparts and a pale salmon-tan breast, which was the reason gunners from a bygone era called the bird a "robin-snipe." A large foraging aggregation of Red Knots is one of the more memorable sights of spring in our Region, especially as this often contains breeding-plumaged individuals of other striking species such as Black-bellied Plovers, Dunlin, Ruddy Turnstones, and Laughing Gulls. Wintering knots are dull gray with

a white eyebrow or forehead. The species is in substantial decline. 16,000 were recorded at Mispillion Light, DE, on 24 May 1986. 10,000 were recorded at DuPont Nature Center, DE, on 27 May 2007. The **Ruff** is a Eurasian breeder that is a rare visitor to the East Coast. The breeding male has a flamboyant ruff of feathers around its neck, but the individuals arriving in our Region are typically in plain, non-breeding plumages and could be mistaken for a yellowlegs. 3 Ruffs were recorded at Bombay Hook NWR, DE, on 13 March 1981.

The **Stilt Sandpiper** is an uncommon migrant, most prevalent in early autumn. It breeds in the Canadian Arctic and the North Slope of Alaska and winters mainly in southern South America. The bird in breeding plumage, with its russet cheek and dark-barred underparts, is quite distinctive, but the non-breeding birds are plain, with a pale eyebrow and black, drooping bill. It is often seen wading deep into

By late summer, wetlands across the Region teem with southbound shorebirds such as this trio of Stilt Sandpipers.

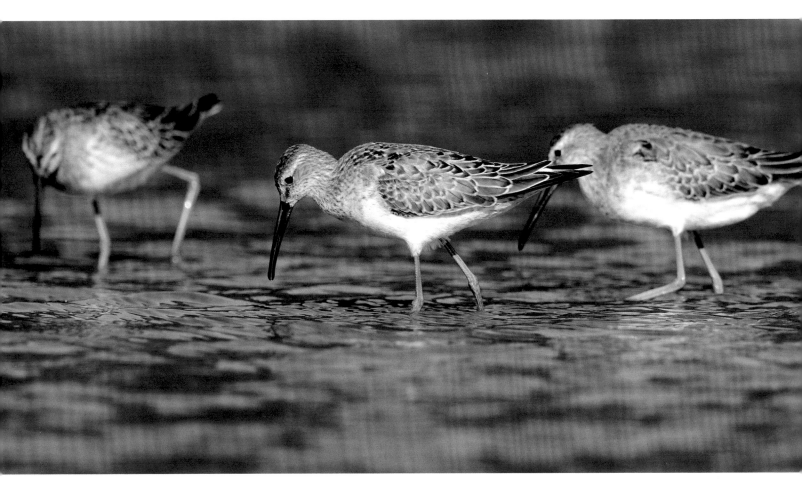

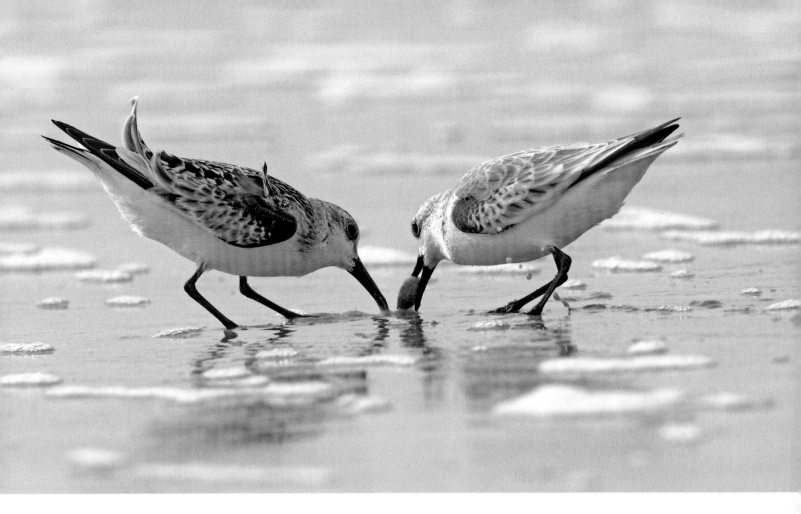

the water almost up to its belly to forage. 520 were counted along the Chesapeake and Delaware Canal on 4 August 1974. The **Sanderling** is the prototypical warm-season beach sandpiper, rapidly retreating from incoming surf on sandy beaches of the Atlantic shore and running before beach walkers like a windup toy. The species breeds in the high Arctic and winters on both coasts, south to South America. It is present on our shores year-round but most abundantly in mid-May and August through September. This is the only beach-shore specialist in our Region. It is mainly seen in its very pale winter plumage: dull gray dorsally and white below (gunners called them "whities"). 9,310 were recorded at Woodland Beach WA, DE, on 28 May 1987. The **Dunlin** is one of our most common migrant sandpipers, dominating wader aggregations in late autumn and winter. It is found in large flocks that forage in the water by mudflats. It breeds in the Canadian Arctic and Alaska and winters on both coasts, on the Gulf, and into Mexico. The breeding adult has a red-brown back and black belly patch.

The nonbreeding birds are plain gray with a pale belly. The drooping bill is diagnostic in all plumages. 20,000 were recorded at Mispillion, DE, on 24 May 2013. 12,000 were recorded at Kitts Hummock, DE, on 2 November 1983. The **Purple Sandpiper** is a rocky-shore specialist found in our Region on stone jetties from late autumn to early spring. It breeds in the high Arctic and winters along the East Coast to Georgia. In winter, look for small groups of dark, pudgy sandpipers with yellow legs on the wet, mussel-infested rocks of a saltwater jetty. 300 were recorded at Indian River Inlet, DE, on 9 March 1974.

Baird's Sandpiper is a rare migrant, difficult to identify, mainly encountered in early to mid-autumn. It breeds in the high Arctic and winters in western and southern South America. Most birds migrate through the Great Plains, a few making their way to the East Coast. This is a foraging specialist that prefers the damp verges of mudflats, away from the water and above the other foraging species; it also is found in fields of shortgrass. It is buffy-washed, pale-headed, and long-winged. 6 to 8 were

Ever-familiar Sanderlings squabble over a Mole Crab plucked from the swash zone on the beach at Assateague Island, MD.

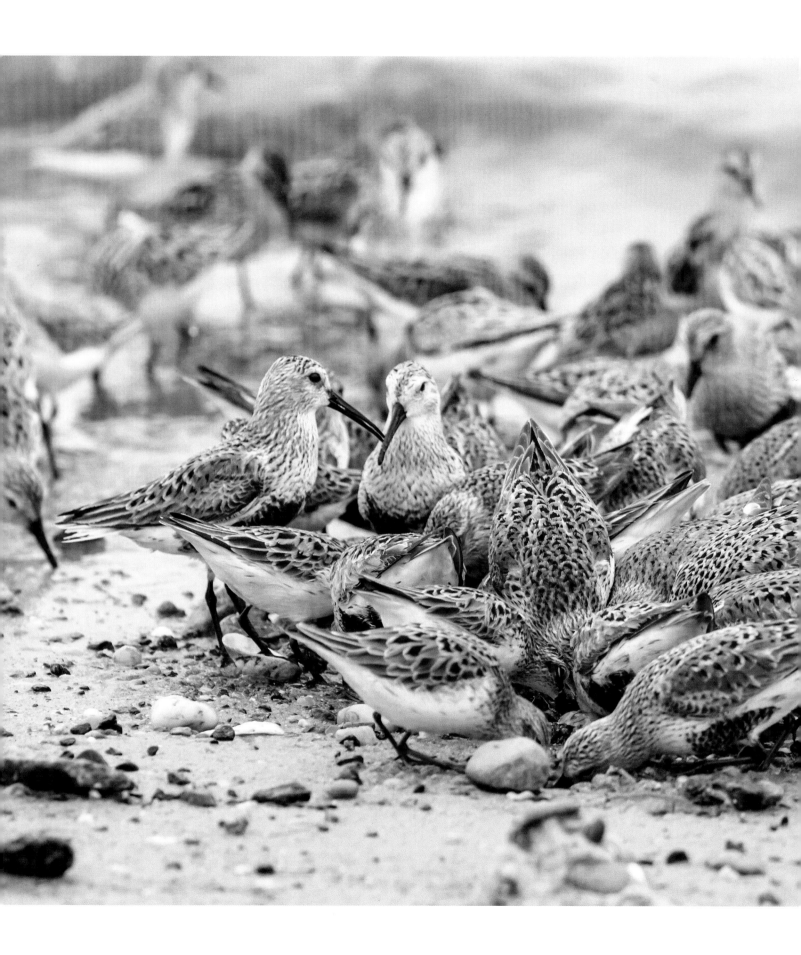

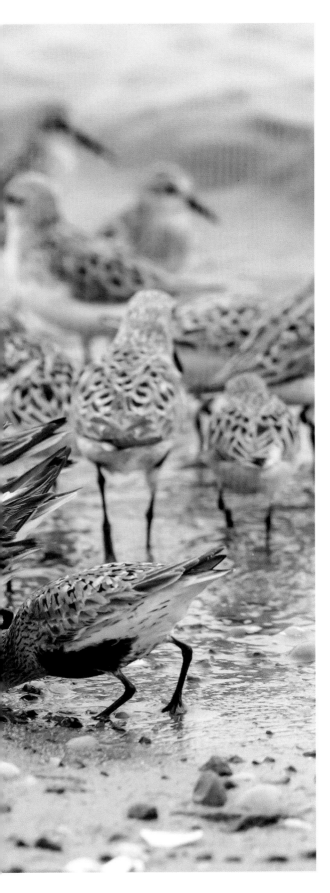

recorded at Bombay Hook NWR, DE, on 10 August 1991. 4 were recorded at Hart-Miller Island, MD, on 13 September 2003. Another grass-loving species is the **Pectoral Sandpiper**, which nests in the high Canadian Arctic and winters in South America. This is one of the largest of the "peeps," the generic term for small sandpipers. It has yellow-green legs and a brown-streaked breast that is sharply demarcated from the all-white belly. 750 were recorded at Bombay Hook NWR, DE, on 26 September 1970.

The **Least Sandpiper** is the classic peep: diminutive, compact, with greenish-yellow legs and a short, brownish-black, slightly drooping bill. The Least Sandpiper nests from Alaska to Prince Edward Island, and it winters in the southern United States and southward to northern South America. It avoids sandy beaches and prefers mudflats and their grassy verges. It is the peep most likely to be found inland at ponds, where it feeds along the edges in small flocks. 20,000 were recorded at Little Creek WA, DE, on 11 May 1963.

The **Semipalmated Sandpiper** is similar to the Least but has a straight black bill, black legs, and several subtle plumage differences. It nests in the high Arctic and winters in the Caribbean and northern South America. It is a common passage migrant to the Region, but the eastern population has declined substantially in recent decades. 75,000 were recorded at Kitts Hummock, DE, on 24 May 1964. 20,000 were counted in Sussex County, DE, on 20 May 2013. The **Western Sandpiper** is very similar to the Semipalmated but has a longer, drooping bill. The breeding bird is very handsome and one of the most distinctive peeps, marked with dorsal black spotting and reddish-brown patches on the shoulder and head. The species breeds in Alaska and winters along both coasts and the Gulf. 2,100 were recorded at Bombay Hook NWR, DE, on 8 August 1975. The **White-rumped Sandpiper** is one of the more uncommon of our peep sandpipers. The species nests in the high Arctic and winters in southern South America and is best identified by its prominent white rump, most easily seen when the bird is in flight.

Dunlins in breeding plumage forage for Horseshoe Crab eggs at Pickering Beach on the Delaware Bay. Photo: Emily Carter Mitchell

(*Following pages*) A flock of Semipalmated Sandpipers numbering in the hundreds alights on Pickering Beach, DE, during Horseshoe Crab spawning.

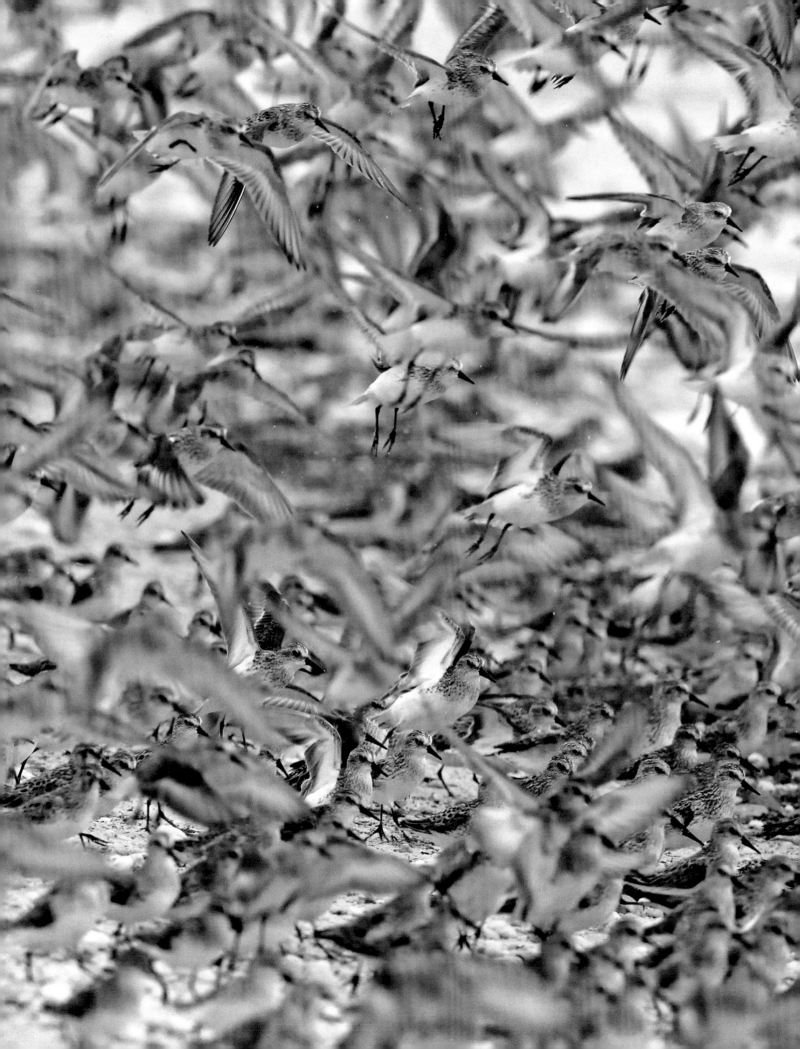

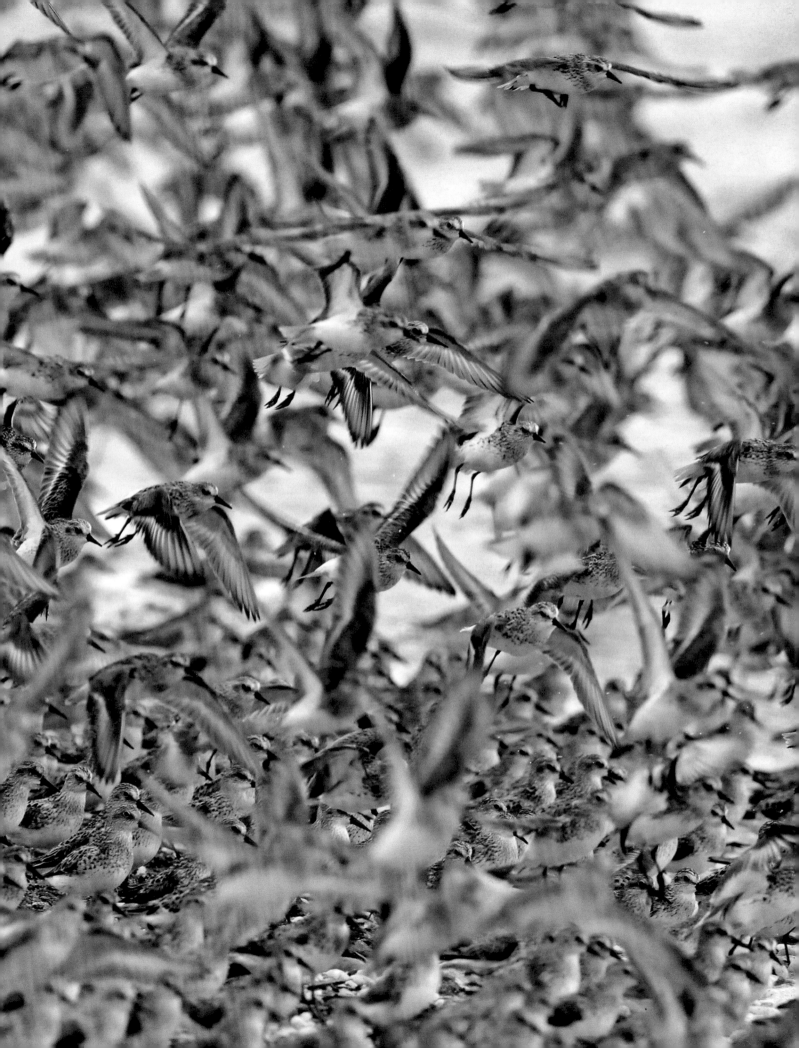

The **Buff-breasted Sandpiper** is a rare but regular autumn passage migrant. The species nests in Arctic Canada and the North Slope of Alaska and migrates mainly through the Great Plains. The species prefers shortgrass fields—the habitat favored by the American Golden Plover and Upland Sandpiper. "Buffies" winter in Patagonia, as do White-rumped, Baird's, and Pectoral Sandpipers, Red Knot, and American Golden Plover. The Buff-breasted is a species of highest concern on the US Watch List. 24 were counted at Patuxent River Naval Air Station, MD, on 15 September 2006.

Two dowitchers are migrants through the Region. These birds are long-billed and forage in water up to their belly. The **Short-billed Dowitcher** is the more common of the two. It nests in northern Canada and southern Alaska and winters along both coasts and the Gulf and southward to coastal South America. 5,500 were counted at Bombay Hook NWR, DE, on 28 July 2011. The **Long-billed Dowitcher** nests on the North Slope of Alaska and in the adjacent coastal Northwest Territories. It migrates mainly through the western half of the continent, wintering on both coasts and southward to southern Mexico. The Long-billed is more often found in freshwater wetlands, whereas the Short-billed prefers saltwater wetlands. Both rapidly move their bill up and down when probing the mud in a movement like a sewing machine. The two have very similar plumages: rusty-breasted with heavy flank markings in the spring and generally gray with a whitish belly in the autumn. Voice is the most reliable means of distinguishing the two.

The Godwits and Curlews

The godwits and curlews include the largest shorebirds, beloved by birders because of their sizable, curved bills and handsome plumages. They are all northern breeders and long-distance migrants. They are typically observed in small groups and often forage in association with an array of other shorebird species.

The **Whimbrel** is a world traveler. It nests in the far north, from Alaska eastward to Siberia. The various breeding populations winter in South America, southern Africa, southern Asia, and Australia. The North American populations winter on both coasts and southward from there. The bird is quite wary, foraging singly or in small parties in mudflats with scattered low vegetation, where it hunts fiddler crabs, in particular. This large shorebird has a long, decurved bill, a dark cap, a dark eye line, and heavily patterned buff, brown, and black plumage. The North American population is in decline. 277 were counted on Assateague Island, VA, on 22 July 1976. 200 were recorded on Fenwick Island, MD, on 27 July 1958. An individual of the distinctive white-rumped European (nominate) race was observed at Holts Landing SP, DE, on 22 December 1984.

The **Hudsonian Godwit** is a rare but regular passage migrant, with a few spring records and many more in the autumn, mainly in September. The species nests from Hudson Bay northwest to Alaska, migrating mainly through the Great Plains and through Texas south to southern South America. Some southbound birds depart New England and fly over the ocean nonstop to South America. After strong easterly winds, southbound migrants can show up anywhere with suitable open mudflats for foraging. In all plumages, note the distinctive black underwing lining and the long, upcurved bill. 40 were counted south of Little Creek WA, DE, on 11 September 2011. 32 were recorded at Bombay Hook NWR, DE, on 18 October 1964. The **Marbled Godwit** is a regular passage migrant and scarce wintering species in our Region, seen more often than the Hudsonian. This large and handsome species nests in the prairie potholes as well as on the coast of James Bay, Canada. They migrate to both coasts and the Gulf for the winter, with some traveling as far as Central America. This prairie breeder is among our most striking shorebirds and is always a treasured addition to a day list. During migration, the species forages on mudflats and sandflats, often loafing among a mix of shorebirds. The cinnamon

Fall migrant Buff-breasted Sandpipers seek out shortgrass habitat, as found on the airfields at Patuxent River Naval Air Station in St. Mary's County, MD.

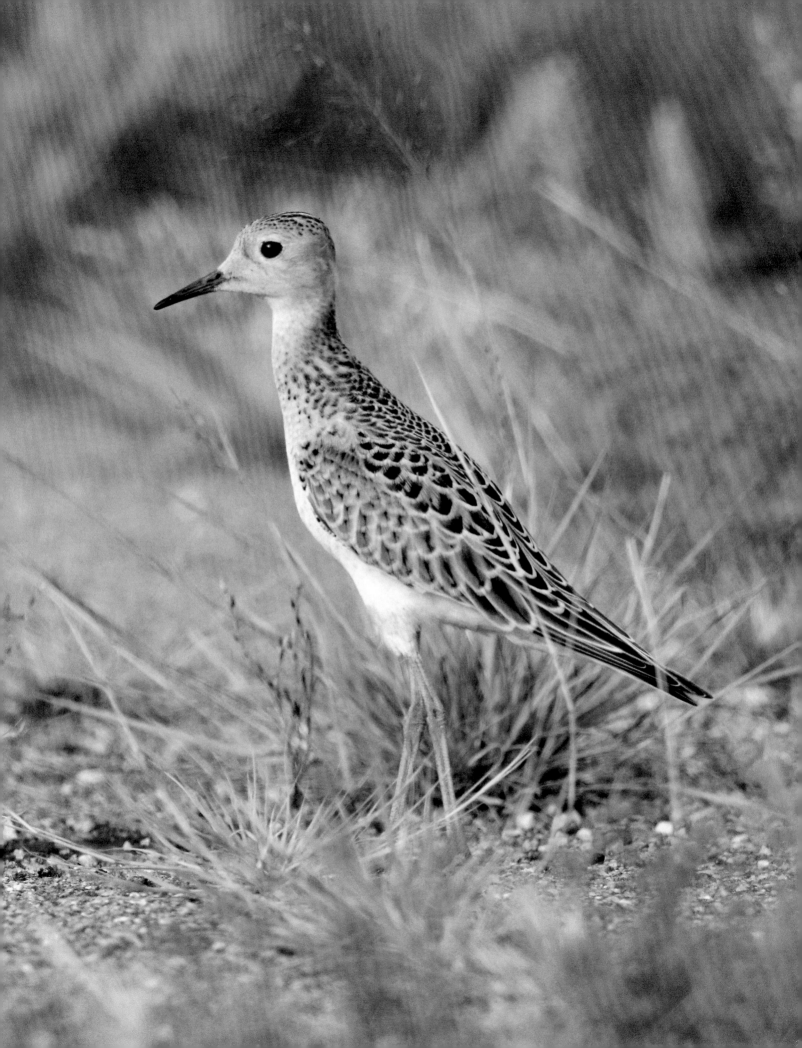

underwing in flight is reminiscent of that of the very rare Long-billed Curlew.

Odds and Ends

The **Black-necked Stilt** is a distinctive black-and-white wader with very long pinkish legs and a needle-thin, straight black bill. It has a patchy breeding distribution extending from the Mid-Atlantic westward to California and from Alberta southward to Mexico. The stilt, a summer visitor to our Region, winters in Central America and northern South America. It prefers foraging in shallow ponds and marshlands, usually in small groups or pairs. 92 birds were counted at Bombay Hook NWR, DE, on 3 May 1991. The **American Avocet**, another atypical and strikingly plumaged wader, is regularly observed in association with the Black-necked Stilt, foraging in coastal water impoundments and marshland waters. Note the upturned, extremely thin black bill. The adult summer plumage is black-and-white with a cinnamon head and neck. Winter birds lose the cinnamon wash, which is replaced by pale gray. The avocet breeds mainly in the interior West and winters along both coasts and the Gulf, as well as southward into Mexico and the Caribbean. It can be seen wintering in large feeding flocks. 441 were counted at Bombay Hook NWR, DE, on 24 September 1990. The **American Oystercatcher** is another unusual wader. Note the big red bill, black hood, white underparts, and dark brown upperparts. In flight the bird shows large white wing flashes. A specialist feeder on bivalves, especially mussels, the oystercatcher forages on sandflats and shell bars and nests on beaches above the high tide line. The species breeds along the Atlantic and Gulf shores, wintering southward. Some individuals winter in Florida and the Caribbean. This is a highly specialized coastal wader, penetrating the interior only along saltwater estuaries. It is more common as a breeder in the Region today than in the 1950s.

The **Ruddy Turnstone** is common and widespread and is present much of the year in the Region. This cosmopolitan species breeds in the Arctic and winters in the southern hemisphere, in Australia, Africa, and South America. The North American population breeds in arctic Canada and Alaska and winters along both coasts and the Gulf. Locally it is most prevalent in spring and fall, when it is found in small numbers on jetties, beaches, and flats, often mixing with other shorebird species. It uses its slightly upturned and abbreviated bill to forage for small shore-dwelling invertebrates, which it obtains after turning over seaweed, debris, and stones (hence the species' name). The breeding adult, colloquially called "Calico Back," has a har-

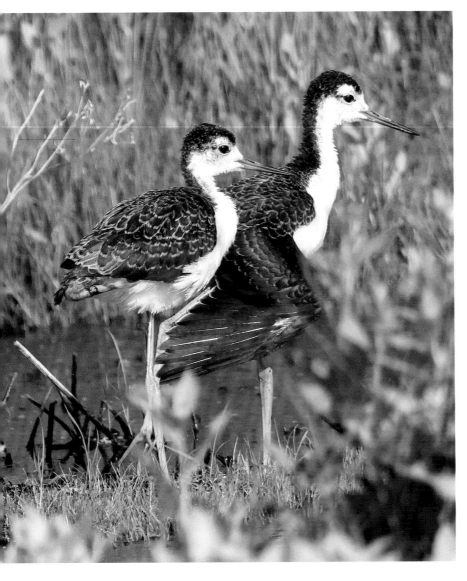

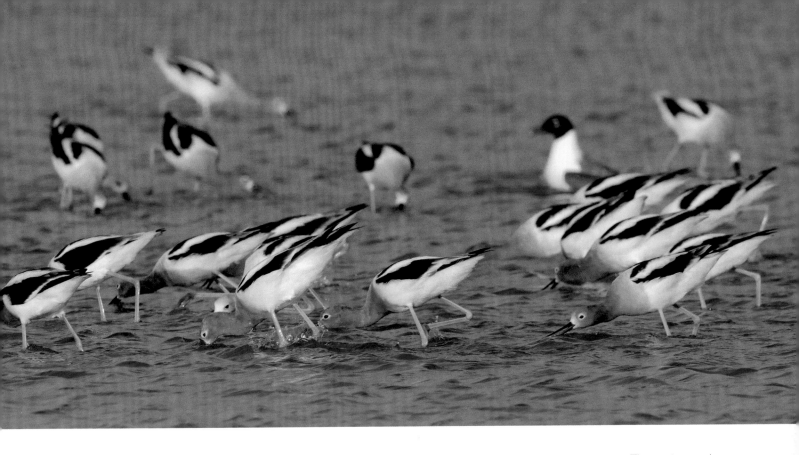

lequin pattern of black-and-white on the face and throat, chestnut wash on the back and wings, and white underparts. The winter plumage is very drab, except for the orange legs. 9,000 were recorded at Mispillion Inlet, DE, on 28 May 2017.

Wilson's Phalarope is the single landlubber of its genus (the other two phalaropes are placed with the seabirds because of their pelagic lifestyle). It nests in the Great Lakes region and in the prairie potholes of the United States and Canada, migrating to South America for the winter. This western species is a rare but regular visitor to our Region, most prevalent in autumn. It is often seen running around mudflats or bobbing and spinning in deep water to create a vortex that brings tiny invertebrates nearer to the surface for consumption. Phalaropes are a textbook example of species that display the rare phenomenon of reversed sexual dichromatism, in which the female is the brighter sex. The female Wilson's Phalarope has a large black stripe down the face and neck, rusty throat, and white cheek. Nonbreeding individuals are pale gray above and white below. Note the slim and straight black bill. 75 were recorded at Bombay Hook NWR, DE, on 8 August 1992.

Rarities

Because the shorebirds are long-distance migrants, they are prone to showing up in unlikely places, far from their normal haunts. We include 13 species of rarities here, which are mainly accidentals.

The **Northern Lapwing** is a common breeder in northern Eurasia, wintering in north Africa, south Asia, and China. It occasionally shows up on the East Coast after being storm-driven across the Atlantic. These vagrants are most likely to be found in plowed fields and pastures in winter. The species is distinguished by its unique pointed crest, dark upperparts, black throat, and white underparts. It is colloquially known as the "Peewit" in Europe because of its distinctive flight call.

The **European Golden-Plover** breeds in the Arctic of western Eurasia and winters in western Europe and north Africa. The species is accidental to the East Coast, where it can be found in the same shortgrass habitats as its American counterpart. The **Pacific Golden-Plover** nests in western Alaska and eastern arctic Asia, wintering mainly in southeast Asia and Australia. It is a rare but regular migrant to the West Coast, with only a handful of records

The vast impoundments of Bombay Hook National Wildlife Refuge, DE, attract scores of American Avocets in breeding plumage in the spring.

Winter jetties offer mussels and other edibles for American Oystercatchers and a few other hardy shorebirds species.

from the East Coast. The three golden plover species look very similar, especially in nonbreeding plumage.

Wilson's Plover is a declining beach specialist that breeds from southeastern Virginia to Texas and southward to the coasts of northern South America. It is a rare visitor to and a former breeder on the sandy beaches of our Region, with few recent records. Atlantic birds winter in the Caribbean and northern South America. It is identified by its large black bill and prominent thick neck collar. The **Snowy Plover** breeds patchily from the West Coast to Florida and in the Caribbean and South America. It is a vagrant northward up the East Coast to Nova Scotia. There is a single record from our Region in spring. Note the incomplete neck ring, gray legs, and black bill.

The **Long-billed Curlew** is recorded about once a decade in our Region (though annually in Virginia). This is perhaps our most stunning shorebird, with its large size, incredibly long, decurved bill, and handsomely patterned plumage. The species breeds through the inter-montane West, from western Canada to northern Texas, and mainly winters in Mexico and on the West Coast. The **Eskimo Curlew**, now apparently extinct, was once a passage migrant through the Region. The species bred in the Arctic, and in autumn it mainly migrated from the Canadian Maritimes southward across the Atlantic, nonstop to South America, but it was occasionally blown ashore to our Region by storms. The last record of the species was a bird collected in Barbados in September 1963, now preserved as a study skin in the Academy of Natural Sciences in Philadelphia.

The **Black-tailed Godwit** is a Eurasian breeder, wintering in Africa and Australasia. It is a very rare vagrant to the East Coast. Its nearest breeding location is Iceland.

The **Wood Sandpiper**, a Eurasian counterpart to the Solitary Sandpiper, is an accidental to our Region. It behaves much like its American counterpart, foraging solitarily in shallow grassy pools. Note the yellowish legs and strong whitish eyebrow.

The **Sharp-tailed Sandpiper** breeds in arctic Siberia and winters mainly in Australia. It is known from about a dozen records on the East Coast. It is very similar in plumage, size, and shape to the Pectoral Sandpiper, but lacks the sharp boundary between its streaked breast and white upper belly. The **Red-necked Stint** breeds in arctic Eurasia and winters in Australasia. It is known from a dozen or so records from the East Coast. In nonbreeding plumage it is much like the Semipalmated Sandpiper. The **Little Stint** breeds in arctic Eurasia and winters in Africa and south Asia. There is a scattering of records from both coasts and also the interior. This species is quite like the Red-necked Stint. Both have bright rusty breeding plumage and pale gray nonbreeding plumage. The **Curlew Sandpiper**, a bird larger than the Red-necked and Little Stints, is a vagrant from Eurasia, breeding in arctic Russia and wintering in Africa, south Asia, and Australasia. Note the evenly decurved bill and white rump patch. Spring birds have a rich red-brown breast, darker than that of a breeding Red Knot. Nonbreeding birds are pale gray with a white belly and pale eyebrow.

The rusty brick belly of the Red Knot is unmistakable on Delaware beaches in May.

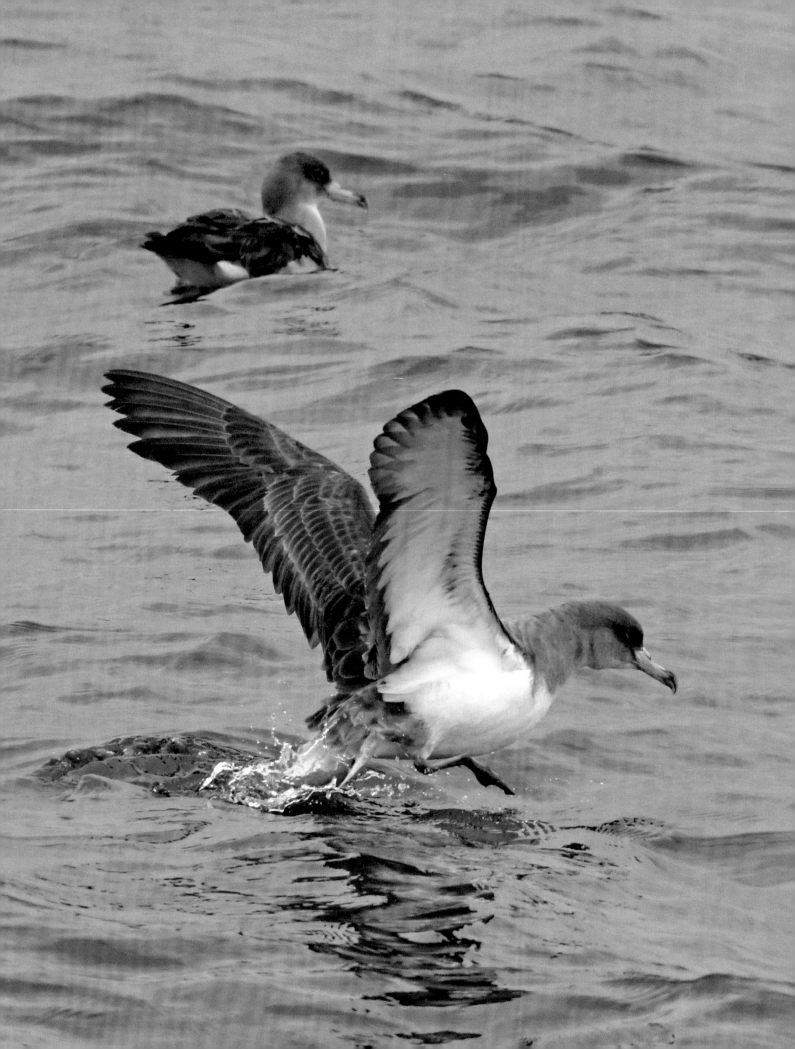

Birds of the Open Ocean

Some birds spend the bulk of their lives out on the open ocean, out of sight of the mainland coast. These birds come to land only to nest and raise their offspring, not an annual event for some of these species. These seafarers are as far from backyard birds as any on Earth, and most of us never see them, except on rare occasions, as when a single individual gets blown ashore by a hurricane that roars up the Atlantic Coast. In May and June, Wilson's Storm-Petrels and Sooty Shearwaters are sometimes seen from land along the Atlantic shore. But most of the time, bird-watchers who wish to see seabirds in numbers have to board a charter boat that heads out into the pelagic zone, the open ocean far from shore. These boat trips can be worth the effort. It is a wonderful feeling to be out in the ocean among the shearwaters, storm-petrels, auks, and jaegers. On these trips, there is also the opportunity to see a host of rare and vagrant species of seabirds, as well as Ocean Sunfish, sharks, and species of whales and dolphins.

The oceanic seabirds feed mainly on invertebrates and small vertebrates that can be taken from the surface of the ocean, although gannets and boobies will dive below the surface for fish and squid. Typically, seabirds assemble where schools of predatory fishes, such as tuna, are hunting small baitfish. These are called feeding frenzies and, at their most extreme, are memorable events that can include swarms of birds, various fishes, and even foraging cetaceans. That said, it is common to spend long periods on seabirding boats out in the pelagic zone

A pair of Cory's Shearwaters right next to the boat makes for a good summer pelagic trip.

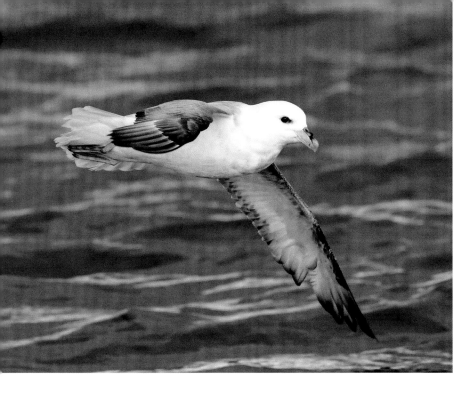

A Canadian-nesting shearwater, the Northern Fulmar demonstrates amazing acrobatic skills over the winter ocean.

(Opposite top) A summer and autumn visitor, the Great Shearwater is often found scavenging around fishing boats.

(Opposite bottom) Wilson's Storm-Petrels tippy-toe on a calm sea, looking for morsels on the surface.

with few or no birds in sight because marine life tends to clump at sites where productive upwellings of warm and cold water meet, and these can be few and far between.

Sometimes seabirds can be observed from shore. When a strong tropical storm makes landfall in our Region, it can carry large numbers of seabirds inland. Once the storm has subsided, these birds find the nearest river and follow it downstream back to the sea. Knowing birders who park themselves on a riverbank shortly after the passage of a tropical storm can be treated to a scattering of seabirds heading downriver toward the ocean. Such waifs can include Bridled and Sooty Terns, tropicbirds, jaegers, shearwaters, and storm-petrels. Favored places to observe storm-blown seabirds include Hains Point, in Washington, DC, and several piers along the upper Delaware River. However, the best location is highly dependent on the storm's track, and success varies widely between storms. Still, getting to any body of water in the storm's path once it is safe to do so is worth trying.

Tubenoses

Tubenoses constitute a lineage of pelagic seabirds that have an enlarged nostril atop their bills that is associated with an excellent sense of smell and that serves as an exit for disposal of excess salt from their diet. The group includes the fulmars, shearwaters, petrels, storm-petrels, and albatrosses. All spend most of their lives out over the sea. The **Northern Fulmar** is a regular cold-season visitor to the Region's pelagic zone, at least 10 or 20 miles offshore. A relative of the shearwaters, this compact and plain-plumaged tubenose appears in two color morphs—pale and dark. It breeds on arctic islands and winters off both coasts.

Cory's Shearwater is a summer visitor to our pelagic zone—one of the more common of our oceanic seabirds. 984 were counted in the pelagic zone off the Maryland shore on 17 August 1991. It breeds in two distinct populations—one on islands off the coast of western Europe and north Africa and the other on islands in the Mediterranean. These both disperse through the western Atlantic. This large seabird is gray-brown above and white below, with a large, dull-yellow bill. The Mediterranean form ("Scopoli's Shearwater"), which is rare in our Region, is smaller, smaller-billed, and shows more white on the underside of the primaries. The all-dark **Sooty Shearwater** breeds on islands in the far southern oceans and wanders widely. It passes through our pelagic waters mainly in summer. Note the long white patches on the underwing. 600 were counted in the pelagic zone off the Maryland coast on 18 June 1978. The **Great Shearwater** is our most common shearwater, present May through November. It nests on islands in the south Atlantic and wanders widely. It is dark-brown dorsally with a blackish cap and tail and mainly white below. 4,500 were counted in the pelagic zone off the Maryland coast on 18 June 1978. The **Manx Shearwater** is one of the small pied shearwaters, scarce but regular off the East Coast year-round, preferring cooler waters than Audubon's Shearwater. It resembles a small Great Shearwater but exhibits more extensive blackish-brown dorsally. **Audubon's Shearwater**, even smaller yet, is distinguished from the Manx Shearwater by the dark undertail and short wings and is only found as a scarce summer visitor in warm Gulf Stream wa-

ters far offshore. Audubon's breeds in the Caribbean and eastern Atlantic and winters off Europe, Africa, and the East Coast of the United States.

Wilson's Storm-Petrel is a common warm-season visitor—our most common storm-petrel. It is present in our waters mainly from May to October, wandering north from its sub-Antarctic breeding grounds. The species is dark brown, with a white rump and squared-off dark tail. 5,741 were counted in the pelagic zone off the shore of Maryland on 14 May 1983. **Leach's Storm-Petrel** is much outnumbered by the preceding species in our Region and occurs in the warm season, wandering from its breeding grounds in the northeastern Canadian Maritimes and New England. It is distinguished from the Wilson's Storm-Petrel by the longer and more deeply forked tail, which obscures the trailing legs (whereas the legs are visible in the Wilson's Storm-Petrel).

Gannet

The **Northern Gannet** is a common cold-weather visitor to our pelagic waters, also rather common in our nearshore coastal waters in season. There

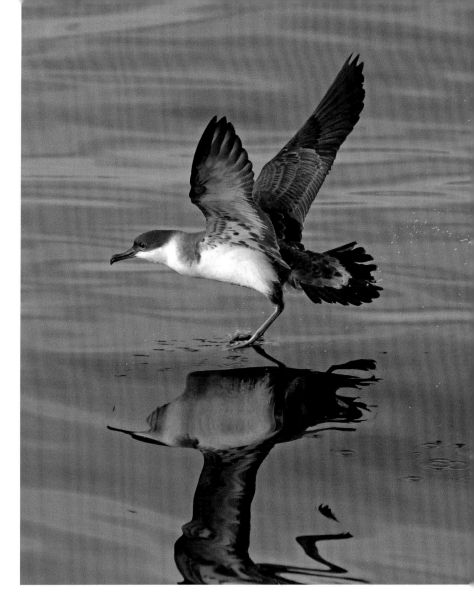

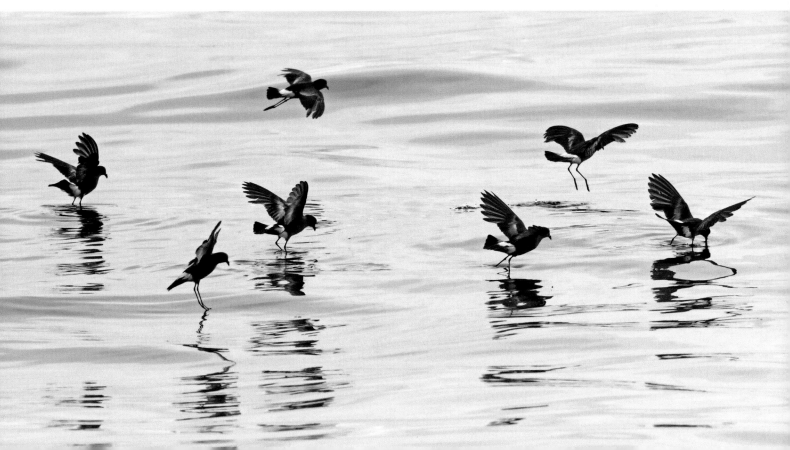

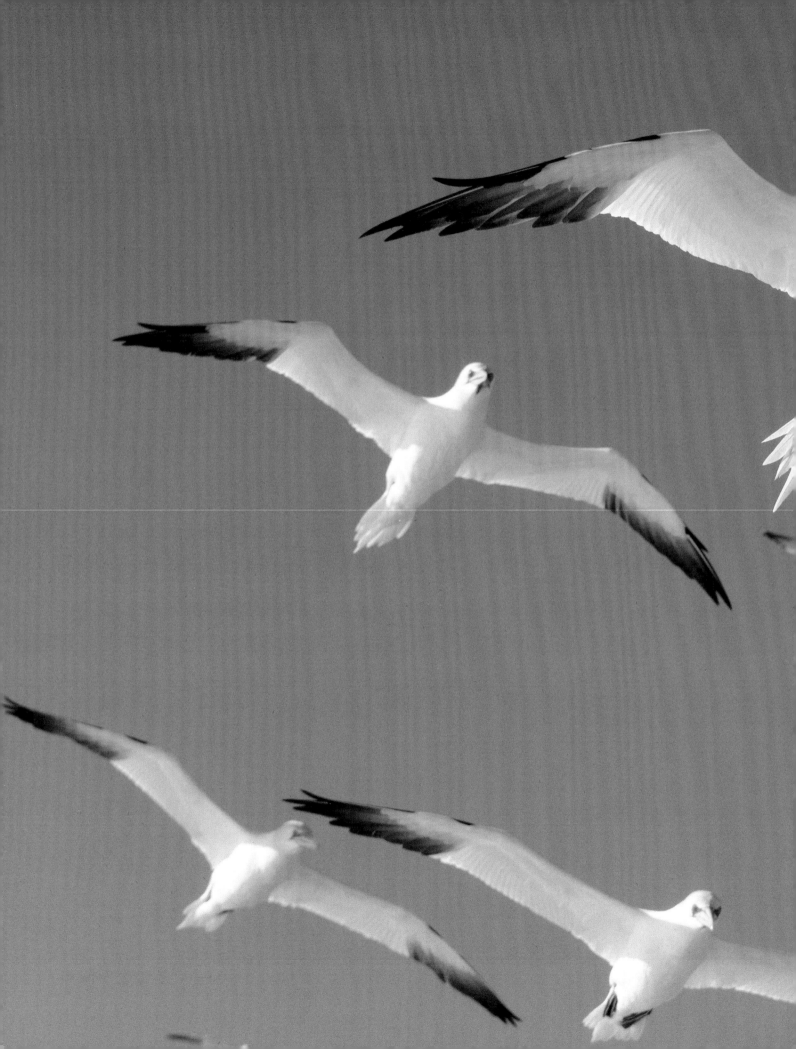

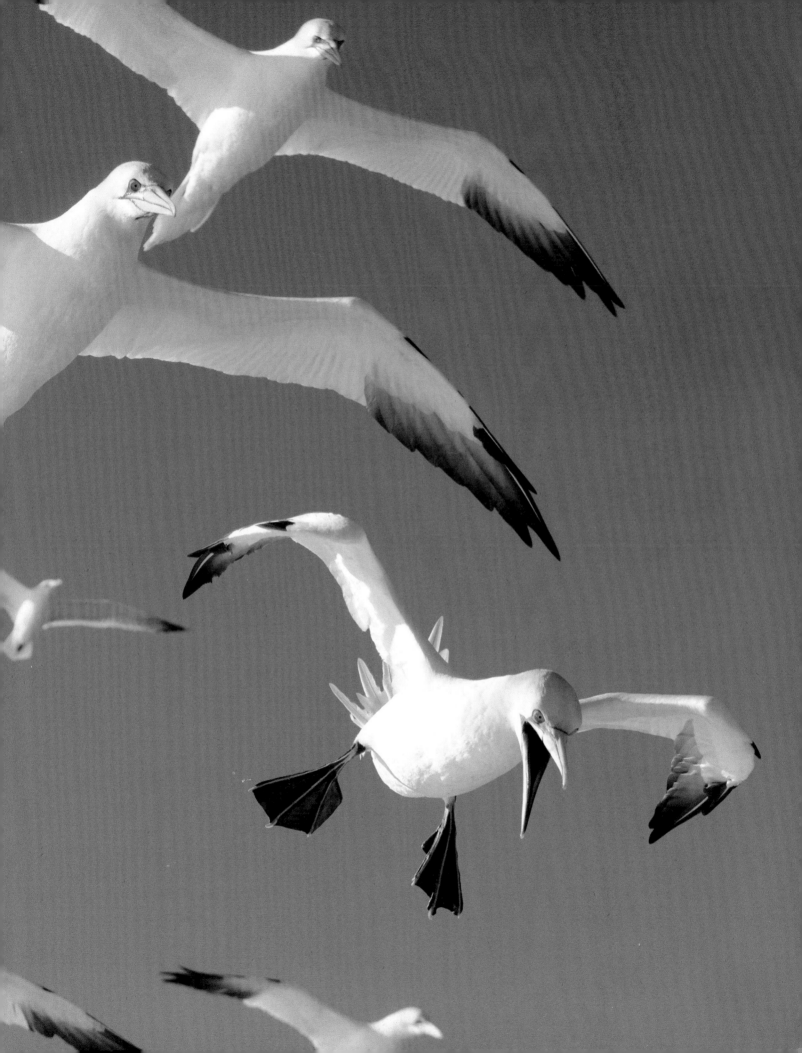

(*Preceding pages*)
Northern Gannet
flocks scour the Mid-
Atlantic Ocean for
surface fish before
plunge diving on their
targets.

are records off the coast year-round. The species sometimes forms large feeding flocks just offshore, diving for fish from impressive heights. Adults are white with black flight feathers and a yellow wash on the head. The juvenile is dark gray with profuse white spotting. On the Chesapeake, gannets occur in early spring as far north as the Bay Bridge. 6,276 were counted in the pelagic zone off the Maryland shore on 8 February 1986.

Pelagic Phalaropes

In late spring, breeding plumage Red Phalaropes head up both the Atlantic and Pacific Coasts en route to the High Arctic.

Two species of phalaropes regularly migrate through our offshore waters to and from their arctic breeding grounds. The **Red-necked Phalarope** breeds in northern Canada and Alaska and migrates through the pelagic waters off both coasts, en route to its wintering areas in the southern hemisphere. Most often seen in its dull nonbreeding plumage—streaked gray above, white below, and with a dark eye stripe and nape mark. During migration, the Red-necked Phalarope can be found in inland water impoundments, sometimes far from the coast. 939 were counted in the Maryland pelagic zone on 9 May 1976. The **Red Phalarope** breeds in the high arctic of Canada and winters off both coasts and southward. Note the plain gray back and all-white underwing. Both of the phalaropes can be seen bobbing buoyantly on the sea, in flocks far offshore. The Red is most common in April and May, though it can be found in the winter months as well. 4,665 were counted at sea in the MD pelagic zone on 29 April 1978.

Jaegers

Jaegers are predatory gull-like seabirds that mainly subsist off prey stolen from foraging terns and gulls. The word "jaeger" means hunter in German.

The jaegers are powerful and accomplished fliers, spending most of each year in the oceans' pelagic zones. They breed in the Arctic and winter mainly in the oceans of the southern hemisphere. All three jaegers occur in pale and dark morphs, and young birds are quite variable in plumage coloration. The typical pale morph plumage includes the dark cap, yellow-washed neck patch, white underparts, and dark back, wings, and tail. The pale "flash" at the base of the underside of the flight feathers is diagnostic of the group. The all-dark juvenile Laughing Gull is sometimes confused with a jaeger but lacks the pale wing patch and is not as strong a flyer. The **Pomarine Jaeger** is the largest and most robust of our three jaeger species. It breeds in the high Arctic and winters in the oceans of the tropics and southern hemisphere. Identified by size, bulk, and rounded and twisted central tail extensions. 53 were counted in the Delaware River from the Delaware City, Delaware, waterfront, on 30 October 2012, just after Hurricane Sandy. The **Parasitic Jaeger** is the species best known in our Region. It breeds in arc-

In autumn, drably attired Red-necked Phalaropes seek out clumps of *Sargassum* seaweed in the warm Gulf Stream current.

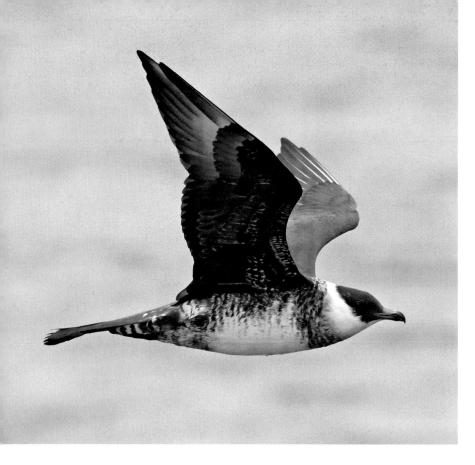

The Pomarine Jaeger is a pirate in the world of birds, intent on stealing a fish from a gull or a tern.

tic Canada and Alaska and winters in the southern hemisphere oceans. It is slimmer than the Pomarine Jaeger and has pointed central tail feathers.

Auks

The auks (or alcids—members of the family Alcidae) are a family of mostly fish-eating birds that typically nest in large colonies on northern rocky islands or cliffs and that winter well offshore. They mainly bob about the surface like a short-necked duck and forage by diving. All of our alcids breed mainly in the Canadian Maritimes and eastern Maine and winter south to our Region where they occur as singletons or in small parties. The winter plumages are essentially subdued versions of the breeding plumage and tend to be black above and white below, making it difficult to distinguish species, as they are usually seen from a distance under harsh winter viewing conditions.

The **Dovekie** is a tiny black-and-white seabird that winters in pelagic waters of our Region. Numbers vary seasonally and from year to year. This is perhaps our commonest auk. Note the rounded

head, abbreviated black bill, and white ear patch. The species breeds on islands in the far north Atlantic in Canada and Eurasia (where it is known as the Little Auk), and winters to the north Atlantic. 3,885 were tallied in the pelagic Atlantic off Maryland on 25 February 2007. The **Common Murre** is a rare but regular winter visitor to our Region, most often seen far offshore. It breeds in Alaska and the Canadian Maritimes, wintering off both coasts. It is difficult to separate in the field from the rarer Thick-billed Murre. The **Razorbill**, the other regularly wintering alcid off our shores, is found in small numbers between November and March. It is the most likely alcid to be seen from the shore. This species is larger-billed and about twice as large as the Dovekie and almost five times heavier. The Razorbill breeds on cliffs and islands in northern Europe and eastern Canada, wintering southward to adjacent seas. It feeds on small fish and marine invertebrates taken while diving. 180 Razorbills were counted in the Maryland pelagic zone on 13 January 2013. The **Atlantic Puffin** is a rather rare winter visitor, visiting the Region in small numbers annually. Puffins wintering off our shores are dark faced and without the well-known brightly colored bill possessed by the breeding birds. The species breeds widely in northern Europe and eastern Canada and winters throughout the north Atlantic. 25 were counted in Maryland pelagic waters on 25 December 2007. 17 were counted in Delaware pelagic waters on 6 February 2016.

Gulls and Terns

The **Black-legged Kittiwake** is our most pelagic gull, rarely seen in our Region from the coast but regularly seen offshore between November and March. This small yellow-billed gull breeds in the high Arctic and winters in offshore waters off both coasts. Note the distinctive all-black wingtips in all plumages. 2,278 were counted in the Maryland pelagic zone on 8 February 1986. 350 were counted 50 miles off Rehoboth Beach, DE, on 9 February 1975. The **Bridled Tern** breeds throughout the tropics and

wanders northward with the Gulf Stream toward our Region in the summer. Typically found far offshore, except when windblown by tropical storms.

The Rarities

The **Yellow-nosed Albatross** breeds on sub-Antarctic islands and wanders the seas of the southern hemisphere during the nonbreeding season. It is a vagrant to our Region. This is our largest seabird. The **Black-capped Petrel** is a rare late-summer visitor to warm Gulf Stream waters off our coast from its breeding grounds in the Caribbean. This long-winged seabird is dark gray above, black capped, and white below, with a distinctive black stripe on the underwing. It is a species of highest concern on the US Watch List.

The **Trindade Petrel** breeds off the coast of Brazil and wanders to the Mid-Atlantic region during the nonbreeding season. The **White-faced Storm-Petrel** is a rare late-summer vagrant to our waters. Its distinctive bouncing foraging movements, coupled with the extensive white underparts and patterned face, makes field identification easy. It breeds in the eastern Atlantic. The **Band-rumped Storm-Petrel** is a rare summer visitor to the warm Gulf Stream waters of our Region with records into October. It breeds in several locations in the eastern Atlantic and wanders into the western Atlantic during the nonbreeding season. It is a species of highest con-

The birding hotlines lit up in the fall of 2015 when a pair of Brown Boobies, an inhabitant of tropical seas, visited Baltimore Harbor for more than a month.

The drab winter plumage of alcids like the Common Murre is less than exciting, but it's a good bird for the checklist.

cern on the US Watch List. It looks very similar to Leach's and Wilson's Storm-Petrels.

The **Brown Booby** is a rare but increasingly detected late-summer vagrant, which wanders into our Region from the tropics. Individuals that show up on our shores tend to stay for extended periods, roosting within sight of land on pilings or jetties and making themselves obvious to birders. The adult is chocolate brown with a white belly and lower breast and a horn-colored bill. The **Masked Booby**, which breeds on islands in tropical zone oceans, is known from a single recent record in the Region. The adult resembles a small Northern Gannet but has a long black wing patch. The **Magnificent Frigatebird** is a tropical species occasionally storm-blown to the shores of our Region between spring and fall. This superb long-winged aerialist spends much of its life stealing food from other seabirds while on the wing. With a wingspan of 90 inches, this bird has angular and pointed wings and a long, narrow, forked tail. Plumages differ between adult male (all black), adult female (black with a white belly), and juvenile (white headed). The **White-tailed Tropicbird** is another

pelagic wanderer from the tropics, typically storm-blown to our Region. Mainly white with black patterning, the species resembles a large tern. Adults possess diagnostic long, white central tail streamers. Breeds on tropical and subtropical islands in the Caribbean, Atlantic, Pacific, and Indian Ocean.

The **Long-tailed Jaeger** is a very rare passage migrant throughout our Region in spring or fall and is the smallest of the jaegers. The **Great Skua** is a very rare winter visitor to the pelagic zone. This Arctic breeder looks like an oversized dark-brown gull. It breeds in Iceland and northern Europe, wintering in the Atlantic. 9 were counted in the pelagic zone off MD on 30 December 1978. The grayer-plumaged **South Polar Skua**, an Antarctic breeder, is a rare southern visitor to our pelagic zone, recorded through the warm-weather seasons. Both skuas exhibit prominent white flashes at the base of the flight feathers. The skuas, as with the jaegers, pursue other birds, robbing them of their prey.

The **Thick-billed Murre** is the rarer of the two murres. It breeds in the Canadian Maritimes, the high Arctic, and Alaska, and winters in the northern Pacific and northern Atlantic. It has been seen near the shore more frequently than the Common Murre. The **Black Guillemot** breeds on rocky coastal islands in New England, the Canadian Maritimes, and the north slope of Alaska, and winters in northern seas. There are winter records in the Atlantic south to the coast of South Carolina. Breeding plumage is black with a white wing patch. Winter plumage is white with gray-and-black upperparts, paler than the murres, which are larger and more elongated.

The **Sooty Tern** breeds on tropical islands and wanders tropical seas when not breeding. The Sooty is typically storm-blown to our Region in the late summer. Hurricanes can carry Sooty Terns far inland on occasion. 8 Sooty Terns were recorded on the Potomac River at Violette's Lock, MD, on 2 September 2006.

In the following seven chapters, we present the Region's landbirds. Our groupings are Chapter 14: Birds of Prey; Chapter 15: Birds of Countryside, Farm, and Field; Chapter 16: Aerial Feeders; Chapter 17: Neighborhood, Backyard, and Feeder Birds; Chapter 18: Sparrows and Their Terrestrial Allies; Chapter 19: Warblers and Look-alikes; and Chapter 20: Orioles, Blackbirds, and Colorful Fruit- and Seed-eaters.

The landbirds include a broad array of avian lineages, both non-passerines and passerines—raptors, upland game birds, owls, woodpeckers, hummingbirds, swifts, flycatchers, sparrows, tanagers, blackbirds, warblers, and more. This assemblage includes huge birds (Golden Eagle) and tiny birds (Golden-crowned Kinglet), diurnal birds (Downy Woodpecker) and nocturnal birds (Eastern Whip-poor-will). These are the birds we find in fields, backyards, woodlands, and mountaintops. The list includes most of the birds we see on a daily basis.

THE LANDBIRDS

A Wild Turkey hen has her choice of dancing partners in breeding season.

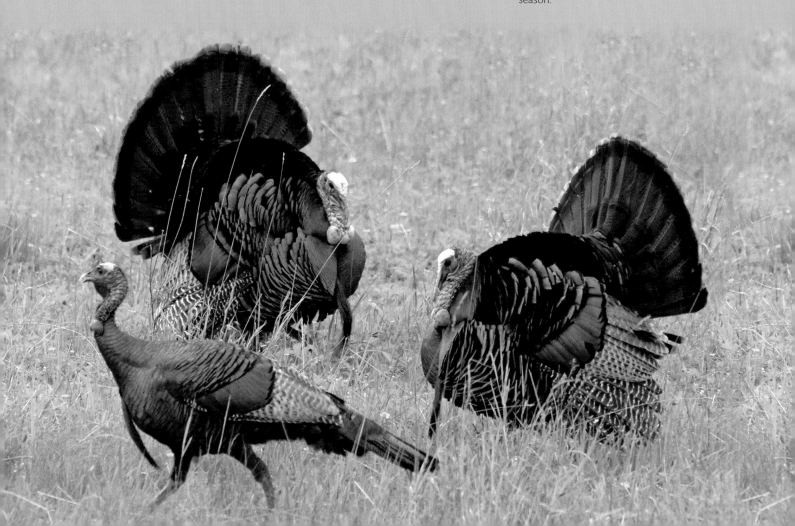

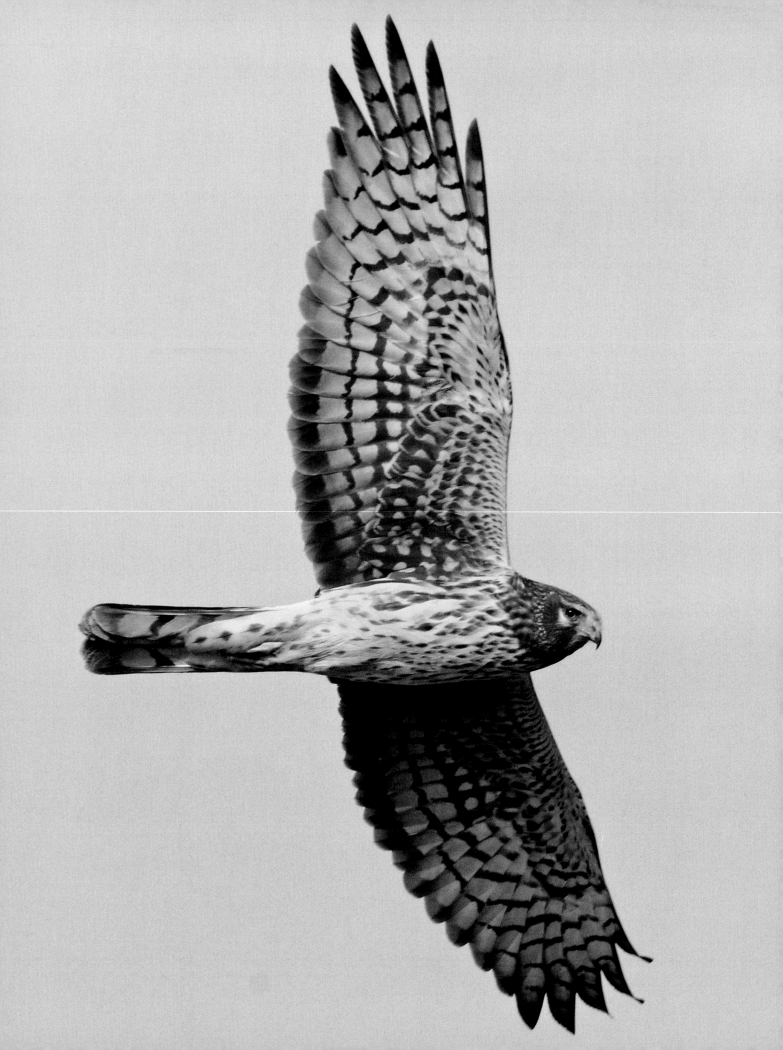

Birds of Prey

This diverse grouping of 31 species includes all the hawks and their relatives, the New World vultures, and the falcons and the owls—comprising four different evolutionary lineages. We are grouping these lineages together because they encompass all the large predatory landbirds. The falcons stand as a distant outlier group now considered a sister lineage to the passerines (the perching birds). The vultures, hawks, and owls cluster together on the evolutionary tree in the evolutionary cohort Coracornithia (which also include the hornbills, woodpeckers, and toucans). The birds of prey are primarily large predators that hunt mainly vertebrates. They are excellent fliers and possess exceptional sensory abilities for detecting prey. The group includes some of the largest flying birds on Earth—the vultures and condors.

Eagles and Ospreys

Three very large raptors are recorded from our Region annually. One, the Bald Eagle, is a year-round resident as well as a passage migrant. The Golden Eagle is a rare passage migrant. The Osprey is a summer breeding bird and passage migrant. They all three feed variously on carrion, small or medium-sized vertebrates, and fish. The species construct large nests that are often used for multiple years. In the 1950s and 1960s, populations of Osprey and Bald Eagle were decimated by the

The vast marshes of Bombay Hook National Wildlife Refuge are a favorite haunt of wintering Northern Harriers.

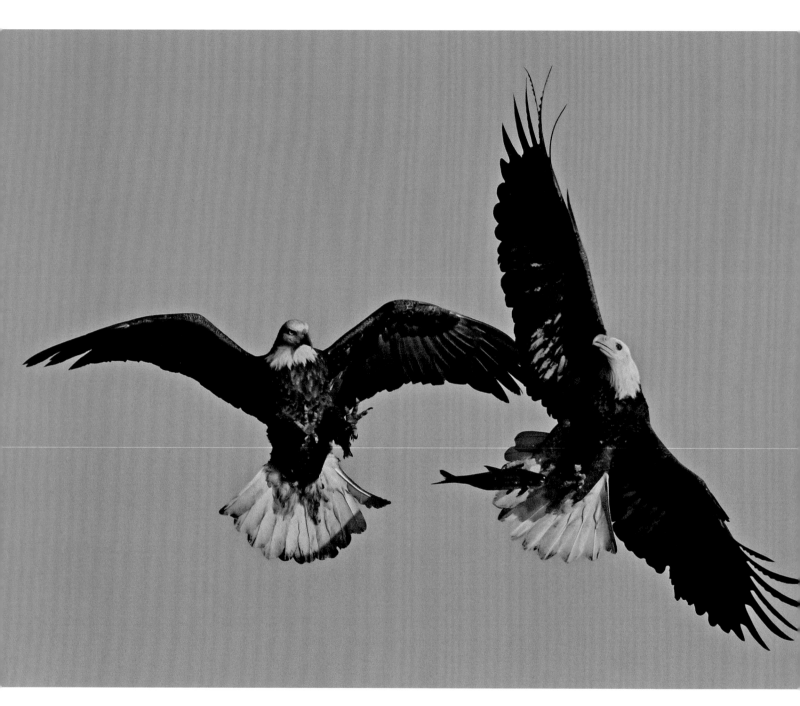

Conowingo Dam on the Susquehanna River is a great place to watch foraging Bald Eagles engage in mid-air combat.

pesticide DDT, which reduced hatching success through eggshell thinning and infertility. Happily, populations of these two are now back to pre-DDT levels, and the Bald Eagle was recently removed from the Endangered Species List.

The **Osprey** is often called "fish hawk" because it hunts fish captured by diving feet first into water. It possesses specialized barbed pads on the soles of its feet to help grip slippery fish. The Osprey

very rarely takes carrion or other small vertebrates. Ospreys breed through Canada northwestward to Alaska as well as on both coasts, south to Florida and Baja. The species winters from our Region southward into central South America. It commonly nests in our Region, mainly on rivers and estuaries of the Eastern Shore and both shores of the Chesapeake. The large stick nest is typically found in marshlands, placed in an isolated dead

tree, a navigation marker, or a wooden platform built expressly for Ospreys. It is a common seasonal migrant seen in passage in all habitats. 444 were counted at the Cape Henlopen, DE, hawk watch on 14 September 2010.

The **Bald Eagle** is our National Bird and is an all-time favorite of most birders, who never tire of observing this handsome and majestic raptor. It is a fairly common and widespread breeder in our Region, constructing its huge stick nest in an isolated tall tree, usually near a body of water. The species is most prevalent on the Eastern Shore, especially in estuaries of the Chesapeake. This eagle is primarily a fish-eater but also takes carrion as well as other smaller vertebrates such as birds or muskrats. The species breeds along the East Coast as well as through Canada to Alaska and patchily in the West. It winters mainly at sites with access to abundant fish, especially along larger rivers and other large bodies of water. In 1963, there were no more than 800 Bald Eagles in the Lower 48 States. Today that number is nearly 20,000—thanks to various governmental and nongovernmental interventions, including the DDT ban and the Endangered Species Act. 341 Bald Eagles were counted at Conowingo Dam on 17 May 2016. 65 were recorded at Bombay Hook National Wildlife Refuge, DE, on 17 May 2018. The **Golden Eagle** breeds mainly in Canada, Alaska, and the mountains and open country of the western United States (as well as Eurasia and northern Africa). It is a predator of mammals, taking hares, rabbits, ground squirrels, and marmots. The species also is known to take carrion as well as larger vertebrates such as young deer and swans. It is most regularly seen in our Region as a migrant, moving along high interior ridges in spring and fall. The adults are all dark with golden highlights on the neck and nape. Younger birds show conspicuous white at the base of the tail and at the base of the primaries. A few winter on the Eastern Shore. 27 birds were counted at the Cumberland Gap hawk watch on 7 November 2013. 8 were counted at the Cape Henlopen, DE, hawk watch on 1 November 2010.

Kites

Kites are lightly built and narrow-winged raptors most common in the South and Southwest. The **Mississippi Kite** is a rare visitor to the Region. It breeds in the Deep South and migrates to southern South America for the winter. The species' breeding range has been expanding northward over the past several decades, and numbers have been increasing along the East Coast. It is now a rare breeder in Northern Virginia, and is expected to become

By early summer, Osprey nests are bursting at the seams with fledglings exercising their long wings.

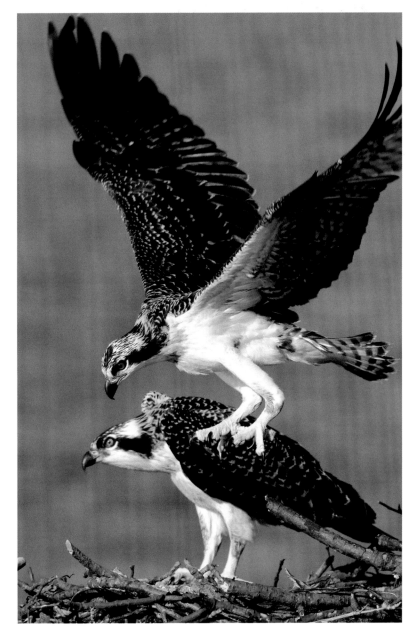

A subadult Mississippi Kite put on quite the air show, hunting a bumper crop of cicadas in a quiet neighborhood of Columbia, MD, in May 2007.

Accipiters

Accipiters, expert predators of birds, are woodland-dwelling hawks. Two species are widespread in our Region and can be difficult to tell apart. The **Sharp-shinned Hawk** is the smallest of this group and is a smaller, small-headed, and square-tailed cousin of the Cooper's Hawk. An inveterate bird-hunter, the "Sharpie" nests through Canada and mainly in mountainous regions of the United States. The species winters throughout the United States and Mexico. 1,573 were counted at the Cape Henlopen, DE, hawk watch on 8 October 2010. The larger and longer-tailed **Cooper's Hawk** is a common visitor to backyard bird feeders, where it preys on Mourning Doves and other medium-sized birds. Cooper's Hawks can be found in the Region year-round, whereas the Sharpie is mainly a migrant and wintering species here, breeding in the Allegheny Highlands. 249 Cooper's Hawks were counted at the Cape Henlopen, DE, hawk watch on 20 October 2009. The **Northern Goshawk** is a large and powerful predator that hunts larger birds and mammals, such as grouse and rabbits. It is rarely seen in our Region. This bird of the boreal forest is irruptive, with southward flights taking place every decade or so, in response to population crashes of their usual prey of Snowshoe Hares and two grouse species. Hawk Mountain Sanctuary, in Kempton, Pennsylvania, typically records about 70 migrant goshawks an autumn, though in a flight year this number is substantially higher (e.g., 347 individuals in the autumn of 1972). The adult, with its black eye stripe, white eyebrow, and pale gray breast, is unmistakable. Young birds are most similar to young Cooper's Hawks but are bulkier, larger, and more heavily patterned, with a white eyebrow. 2 goshawks were counted at the Cape Henlopen, DE, hawk watch on 5 November 2010.

established as a breeder in our Region soon. The adult is mainly various tones of plain gray; note the pointed wings and the pale patches on the upper surface of the secondary feathers seen when the bird is in flight. Four were counted at the Cape Henlopen, DE, hawk watch on 31 May 2014.

Harriers

The harriers, slim and long-tailed raptors that forage on rodents in grasslands and marshes, have a worldwide range. Northern breeders are migratory. The **Northern Harrier**, once formerly known as the Marsh Hawk, breeds across northern North America, wintering to the southern United States and Mexico. This marshland specialist hunts small grassland mammals while patrolling low across the habitat with its uptilted wings, tipping side to side in the wind. The adult male is gray above and is known as the "Gray Ghost" because of its color and silent and stealthy hunting style. The female and young birds are dark brown dorsally with a brown-barred tail and the same white rump as the male. This is a species in decline. 194 were counted at the Cape Henlopen, DE, hawk watch on 8 October 2010.

Buteos

Buteos, known as buzzards in Eurasia, include the most commonly seen species of raptors in our Region. Buteos are stocky, broad-winged, and are mainly sit-and-wait predators, which patiently station themselves on a high perch, scanning the ground for their vertebrate prey. These birds are also great soarers, searching out their prey from on high. They tend to be familiar to many birders because they perch out in the open and circle overhead for minutes at a time.

The **Red-shouldered Hawk** is a woodland raptor common in our Region year-round. It shows a fondness for bottomland woods near streams or swamps and also can be found in wooded suburban neighborhoods. It is a widespread breeder east of the Mississippi but also ranges along the West Coast. It is smaller and darker than the more familiar Red-tailed Hawk. Note the black tail with four fine white bars in the adult plumage and the pale crescents visible near the ends of the wings when the bird soars. 264 were counted at the Fort Smallwood, MD, hawk watch on 8 March 1997. The **Broad-winged Hawk** is a deep-woods breeder. Strictly forest dwelling, it is mainly seen when soaring high in the sky. The species' breeding range extends from British Columbia to Nova Scotia and thence south in the East to Louisiana and northern Florida. In autumn, it moves south en masse, often forming impressively large migratory flocks. The bulk of the population winters entirely south of the border in the Caribbean and Central and South America. It can be identified by its distinctive candle flame–shaped wings and its prominent white subterminal tail band. 8,593 were counted from the Cromwell Valley, MD, hawk watch on 17 September 2013. 7,177 birds were counted at the Ashland Nature Center, DE, hawk watch, on 15 September 2013. 3,410 hawks were tallied from the Washington Monument, MD, SP hawk watch on 19 September 2011. The **Red-tailed Hawk** is our most familiar buteo. The species is mainly an open-country species

and is commonplace across the Region year-round, with local populations swelled by migrants from the north in late autumn. Nesting range extends to Alaska and Labrador. Northern populations migrate southward in late autumn. 620 birds were counted at the Ashland Nature Center, DE, hawk watch on 4 November 2012. The **Rough-legged Hawk** is a rare migrant from the Arctic tundra of Canada and Alaska. A few wintering birds arrive in our Region at year's end and spend the winter hunting in the expansive marshlands of the Eastern Shore or in agricultural fields of the Piedmont. Six were counted on the Elliott Island Road, MD, on 5 March 1988. 3 were counted at the Cape Henlopen, DE, hawk watch on 6 November 2014.

Falcons

Falcons and hawks used to be considered evolutionary sister groups. New molecular systematics research has changed our thinking, and falcons are now placed as sister to the lineage that includes both the parrots and the passerines. Falcons are handsomely plumaged hunters adapted for speed

(Following pages) Red-shouldered Hawk nestlings are safe and secure when mom tends the nest after a big meal.

A juvenile Red-tailed Hawk scavenges on a road-killed raccoon, whose nutrients are thus cycled up through the food chain.

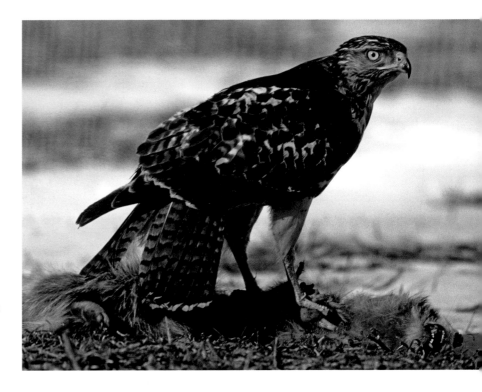

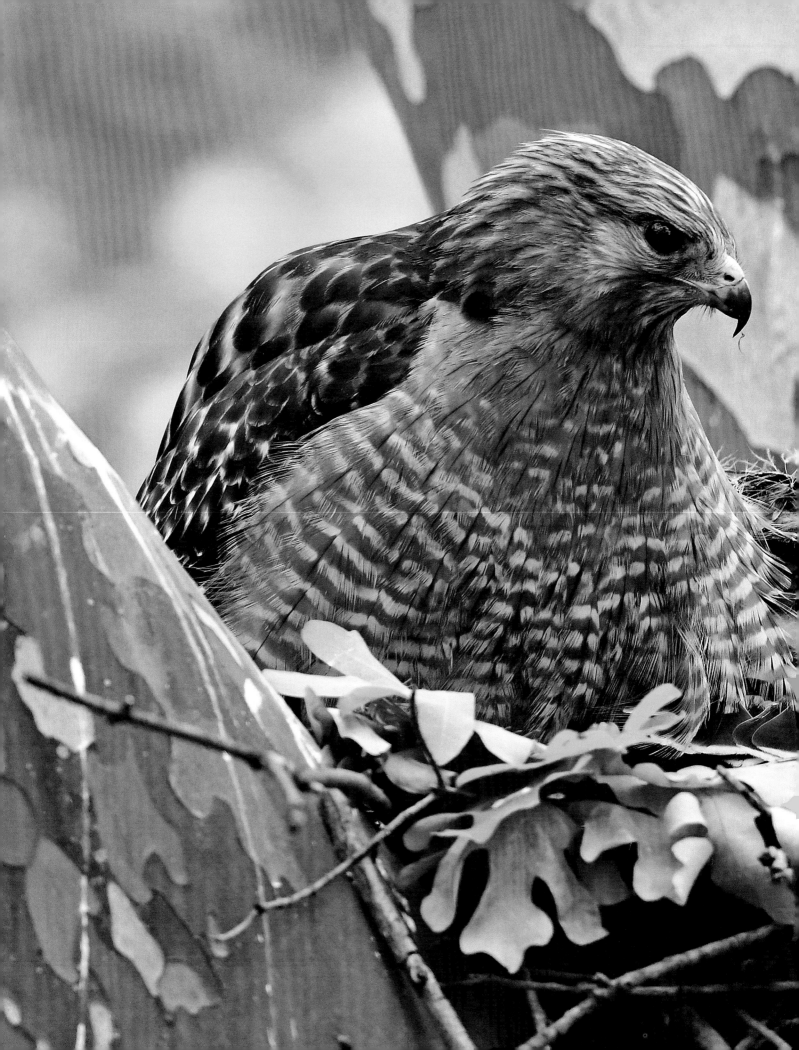

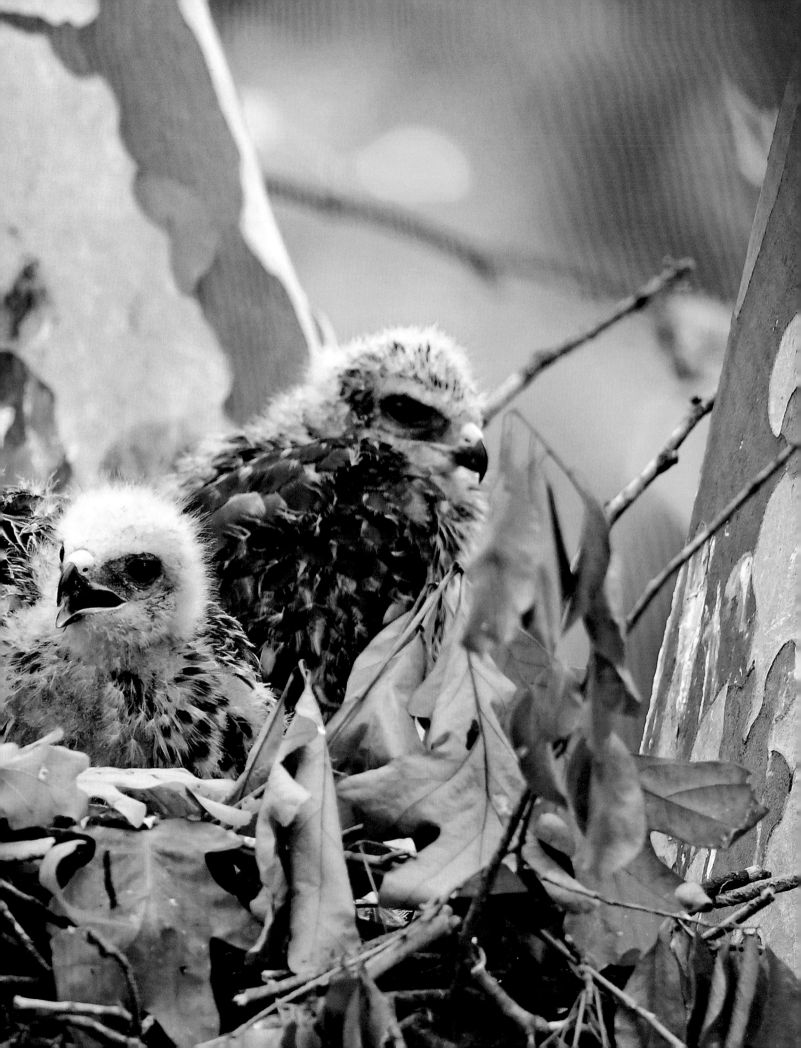

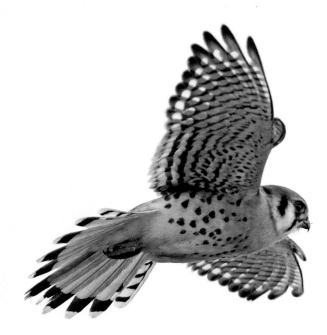

American Kestrels are most easily spotted when perched on utility lines, a good place to scan for mice and insects.

with pointed wings and a streamlined body. They feed on birds and on small mammals. Falcons are famous for their rapid dives when stooping on prey. Our Region has three familiar falcons and one rarity.

The **American Kestrel** is our most prevalent and smallest falcon. Our Region supports a local breeding population as well as passage migrants and wintering birds from farther north. This is a bird of rural agricultural fields, often seen perching on telephone lines along small country roads. The species subsists on large arthropods and small rodents, birds, and other vertebrates. The species is in decline and went from an estimated 200–500 breeding pairs in Delaware during the first breeding bird atlas (1983–1987) to currently just a handful today. The cause of the decline is unknown but may be due to changing agricultural practices, pesticides, or creeping urbanization. This handsome small raptor is the most strikingly patterned of the group, with the unique rusty back and tail. President Theodore Roosevelt reported a pair of kestrels hunting House Sparrows on the White House grounds in 1908. 692 were counted at the Cape Henlopen, DE, hawk watch on 8 October 2010. The **Merlin** is a small falcon that breeds in northern North America and winters in Florida and Mexico, with some individuals overwintering in our Region. Its breeding range has been expanding, with recent

records in West Virginia and Pennsylvania. Most birds seen here are passage migrants, mainly in autumn. The species is an accomplished hunter of small birds but also consumes dragonflies and bats. The Merlin can be distinguished from the American Kestrel in flight by the overall dark appearance and its greater bulk and more direct, faster flight. 207 were tallied at the Cape Henlopen, DE, hawk watch on 29 October 2010. The **Peregrine Falcon** is best known in our Region because of the publicity surrounding pairs that have bred on buildings in city centers, living mainly off urban-dwelling Rock Pigeons. Their home lives have been shared by thousands of intrigued city workers by web cams and newspaper reports. This magnificent falcon was essentially wiped out in the eastern United States in the 1950s and 1960s by DDT pollution but recovered following a series of reintroductions by the Peregrine Fund and their partners over several decades. The species currently breeds patchily across the United States and in arctic Canada and Alaska (and through much of the rest of the world). The northerly populations in North America migrate south to the southern United States as well as south of the border. In midautumn, these handsome hunters pass down the Atlantic Coast in numbers. The population of the species appears to be increasing in the East. 124 were tallied at the Cape Henlopen, DE, hawk watch on 27 September 2014.

Vultures

The New World Vultures are a sister group of the hawks and eagles. Our two species soar in the sky to search for roadkill or other carrion. The **Black Vulture** is a southern species that has been expanding northward over recent decades. It ranges from southern New England to South America, where it is commensal with humans and often found roosting on the ground in urban areas. It is a permanent resident here, but some birds nesting in the northern part of the species' range pass through our Region in spring and fall. More sociable and

aggressive than the Turkey Vulture, the Black Vulture locates its prey by following Turkey Vultures or by using its sharp eyesight. There have been rare instances of Black Vultures taking young stock animals as well as an array of small mammals on an opportunistic basis. 60 were counted at the Cape Henlopen, DE, hawk watch, on 23 November 2012. The **Turkey Vulture** ranges across the United States and southern Canada south to South America; northern populations migrate south, in autumn, to the southern United States and Mexico. It is a common migrant through our Region. This species is regularly seen at roadkill or soaring in the sky with tipping wings. Often seen in small parties, sometimes joined by Black Vultures. The Turkey Vulture has an exceptional sense of smell. Both vulture species are currently on the increase in the East. 1,485 were counted at the hawk watch at Fort Smallwood SP, MD, on 25 March 2017.

Owls

Owls are our nocturnal raptors, hunting at dusk or in full darkness. The owls include two family groups, the barn owls and the typical owls, both of which exhibit a worldwide distribution. They are distinctive in having large eyes situated on the front of the head, surrounded by a facial disk. Owls are famous for their otherworldly night sounds and their association both with intelligence and with ghosts. Owls are skilled hunters of mammals, birds, and even insects, using their hearing and eyesight to locate mobile prey in the dark. Today, owls tend to be much beloved by nature lovers and birders alike. Everyone appreciates hearing the various vocalizations of owls at night.

The **Barn Owl** is our only member of the family Tytonidae. Patchily distributed across the southern and central United States, west to California

On distinctive angled wings, a Turkey Vulture soars with ease, sniffing the air for traces of carrion.

The Mid-Atlantic Region has experienced several large winter flights of Snowy Owls in recent years; coastal sand dunes are prime habitat.

and Washington. Closely related species are found worldwide. This once-widespread mostly sedentary species has been on the decline in our Region for decades. It now is mainly found in marshlands of the Eastern Shore, especially along the coast of Delaware Bay. The species makes its nest in a wide range of protected sites, from old barns and offshore duck blinds to large tree holes or riverbank burrows. Nest box programs have been successful in increasing local populations. 18 were recorded at Bestpitch, Dorchester County, MD, on 14 May 1994.

The **Eastern Screech-Owl** is our Region's second-smallest owl and the most common in suburban neighborhoods and countryside. This non-

migratory species ranges from New England west to Montana and south to eastern Mexico, including all the Southeast. It comes in two color morphs—rufous and gray. The species produces a descending tremulous whinny after dark. It sometimes nests in manufactured nest boxes—those constructed for Wood Ducks in particular. Consider putting a screech owl nest box in your backyard. President Theodore Roosevelt reported this species to be a regular resident of the White House grounds in 1908. 22 were counted in Talbot County, MD, on 16 December 2012. The **Great Horned Owl** is our largest owl and is common and widespread but rarely seen. Best discovered by its distinctive

low-pitched series of four to six soft hoots. Typically roosts during the day in a thick conifer. This large predator begins nesting in late winter. A very widespread species, it prefers open countryside with patches of woods. It breeds across all of North America and south into South America. 27 were counted at the Ocean City Christmas Bird Count on 27 December 1955. The **Long-eared Owl** has the look of a smaller, slimmer Great Horned Owl. It is a widespread breeder in northern North America and in mountain regions (also through Eurasia). Northern birds winter southward to the central and southern United States. It is a very rare breeder in the Region with recent records only from the Allegheny Highlands. It is a rare wintering species, roosting singly or in small numbers in a protected thicket of conifers or other heavy vegetation where it can be difficult to locate. It is a species of concern on the US Watch List. 7 were recorded at a site in Baltimore County, MD, on 8 February 2015.

In large part because of the Harry Potter movies, the **Snowy Owl** is more popular than ever. This large, white tundra-breeder only infrequently appears in our Region, mainly during winters with irruptive flights, during which vagrant birds typically settle into open tundra-like habitat such as airports, agricultural fields, and coastal dunes. Remarkably, the wintering birds are now known to hunt for ducks at dusk out over salt water, though it is an opportunistic forager that captures a diversity of prey. Flight years appear to follow highly successful breeding seasons, the abundant offspring emigrating from the tundra in search of productive hunting territory. It is a species of concern on the US Watch List. 6 were recorded from Assateague Island, MD, on 12 February 2014. Another marsh-dweller is the crepuscular **Short-eared Owl**, known from our Region mainly as a wintering species to the vast marshlands of the Eastern Shore. The species is most often observed foraging with a moth-like flight over grasslands and marsh at dusk, suddenly plunging down to the ground to capture a vole or a mouse. Today, most breeding individuals nest in Canada

and the northwestern United States. Northern populations winter into the central and eastern United States, mainly in the Great Plains and along the East Coast (the species is also widespread through Eurasia and in South America). 15 were counted at Poplar Island, MD, on 18 February 2016.

The **Barred Owl** is one of our most familiar owls, mainly because of its eerie barking hoots that it gives at night and on cloudy days from its haunt in thick deciduous woods and bottomland forest. This permanent resident ranges throughout the East and the central United States and then through Canada to the Pacific Northwest, where it meets the range of the endangered Spotted Owl. Like several

A field full of mice will eventually attract a nomadic Short-eared Owl looking to set up a winter territory.

A recently banded
Northern Saw-whet
Owl strikes a pose
at the verge of
Assateague Island's
maritime forest.

other owls, the Barred Owl can be called in by imitating its distinct cadenced hoot. Note the dark eye and the dark-striped breast. 15 were counted on the Ocean City, MD, Christmas Bird Count on 27 December 1954. The **Northern Saw-whet Owl** is our smallest owl. It breeds throughout the boreal forest south through the mountains of the United States, including the Appalachians. It is a rare breeder in the Allegheny Highlands. It is only rarely seen, even though it migrates through the Region in large numbers, the majority passing through in November. The species winters throughout the Region in dense thickets and conifers, but finding a roosting bird is one of the most difficult tasks in birding. Most are located by audio playback, bringing the birds into mist-nets in order to band them. This has led to the happy discovery that this rarely seen species is quite common. Note the yellow eye, the large head, and

the small body. In 1908, President Theodore Roosevelt reported this species to be a winter visitor to the White House grounds. 15 were counted on Assateague Island, MD, on 8 January 2000.

Rarities

The **Swallow-tailed Kite** is a vagrant from the Deep South, mainly known from spring records, though they have been recorded from March through December. Its nearest breeding habitat is in coastal South Carolina. Perhaps the most beautiful of all raptors, it is white-bodied with black wings and back, and the black tail is long and deeply forked. In flight, it is an especially graceful bird that glides rather than flaps. The **White-tailed Kite** is an accidental visitor from the Deep South, known from a single record from Maryland.

Swainson's Hawk, a rare but regular vagrant to the East Coast, is a common western species, breeding through the Great Plains and Intermontane West, and migrating in large numbers through Texas to winter in Patagonia. The **Zone-tailed Hawk** is a rare southwestern species known in the Region from a single record in 2014. There are only a handful of records from the East Coast, which may all have been of the same wandering bird. The **Crested Caracara** inhabits central Florida, south Texas, and the Southwest but has shown up in recent years along the East Coast, where it is often seen feeding on the ground on carrion. This strange falcon-relative is long-necked and heavy-billed, and flies with a distinctive wingbeat. The **Gyrfalcon** is the largest falcon, breeding in the Arctic tundra and only very rarely wintering south to the Mid-Atlantic. Birds exhibit plumages ranging from very dark brown to mainly white. A bird of open spaces, vagrants to the Mid-Atlantic are usually located in farmland or marshy clearings. Individuals pursue ducks and other birds as prey, hunting low to the ground rather than high in the sky. The **Burrowing Owl** is a very rare vagrant from the arid West and Florida. There are East Coast records from Maine to Georgia. A very distinctive diurnal species because of its long legs and intense yellow eyes, it is usually found perched on the ground or on a fencepost in pastureland.

Late winter squatters on an empty Osprey nest, Great Horned Owls have raised a family, with chicks ready to fledge by April.

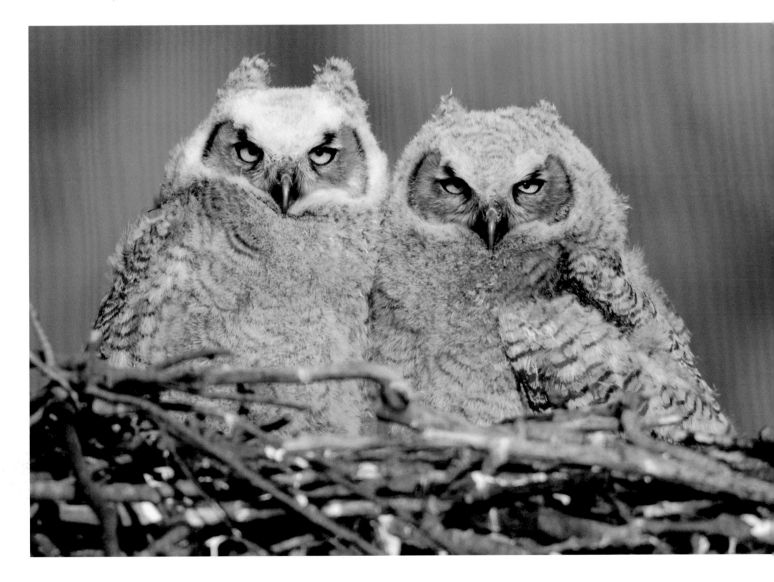

Birds of Countryside, Farm, and Field

This assemblage is a veritable grab bag of landbirds of different sizes, shapes, and lineages, all of which inhabit open country in rural areas—the birds of farm and field. We have, however, sequestered from this grouping two very distinctive subgroups, the wood warblers and the sparrows and sparrow-like birds. These latter two neatly cluster into their own cohesive groups; therefore, we have placed them into their own chapters, which follow.

This ecological grouping includes mainly singletons or small clusters of species that do not readily ally themselves with our other groupings. The ecological umbrella that includes agricultural lands, old fields, farm quarters, and open fields is an important and favored one in our Region, and many of us spend a fair amount of time birding these pleasant rural spaces. Much of the Eastern Shore and much of the Piedmont and Ridge & Valley provinces include substantial tracts of farmland and field, thus making the creation of this grouping an easy choice.

For riders, hunters, walkers, bikers, and birders, rural open countryside remains a priority habitat to visit on weekends. Something about the open and inviting nature of agricultural landscapes attracts us. It is pleasant birding habitat because of its openness and because of the tendency of many species to perch conspicuously on fence lines, on telephone wires, and atop isolated trees. In the height of spring, these are places where we can observe many birds giving their

Eastern Bluebird families make for delightful neighbors. The species is a quintessential countryside bird. Photo: Marie-Ann D'Aloia

A Northern Bobwhite quail patrols his farm pasture, whistling for his mate in the maze of buttercups.

The **Northern Bobwhite** is our local species of quail. Once a familiar and commonplace resident of our Region, it is now uncommon or absent and continues to decline. The female is distinguished by the buffy facial stripes; those of the male are bright white. This is our only native member of the New World quail family. The species is a non-migratory permanent resident of the eastern and

territorial song. In season, many hunters take to the fields in search of their quarry—doves, quail, turkeys, pheasants, snipe, and woodcock.

We offer two notes of warning with respect to birding in rural farm country. First, be sure to obtain permission to walk on any private property. This is done by simply knocking on the front door and politely asking. Second, familiarize yourself with local hunting seasons, and take care to avoid putting yourself in harm's way, especially during deer season. Most hunters favor early morning and the hours leading up to dusk, so it is best to delay birding these areas until midday during deer season.

central United States but remains most abundant in the Deep South. Its extensive range extends southward into Mexico. It favors agricultural hedgerows, brushlands, and old fields. It is small and often hunts quietly in grassy fields so that its loud and bright *ker-Kuweet* (or *Bob-white*) call is the best means of discovery. The reason for this species' decline remains somewhat mysterious but probably includes several factors, such as loss of prime habitat and loss of prey populations from overap-

plication of agricultural pesticides and herbicides. 122 were counted on the Ocean City, MD, Christmas Bird Count on 27 December 1954. Many recent records are of captive-bred individuals released or escaped from commercial game farms.

The **Ring-necked Pheasant**, a striking Old World member of the pheasant family, was introduced to the United States from Asia in the 1880s as a game bird for hunters. The species was once commonplace in rural countryside but now is de-

It's an outstanding country drive when a spectacular cock Ring-necked Pheasant struts across the road.

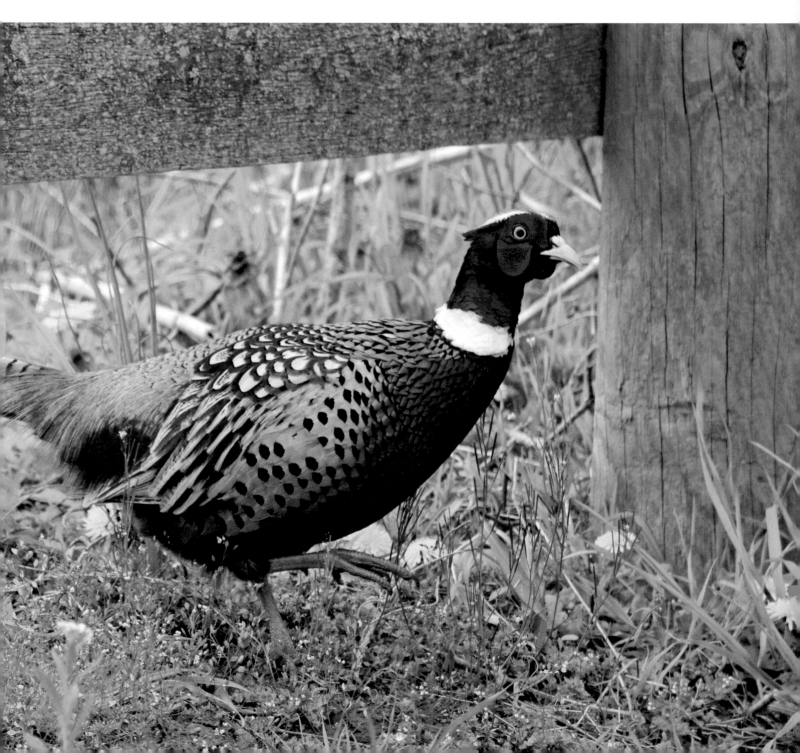

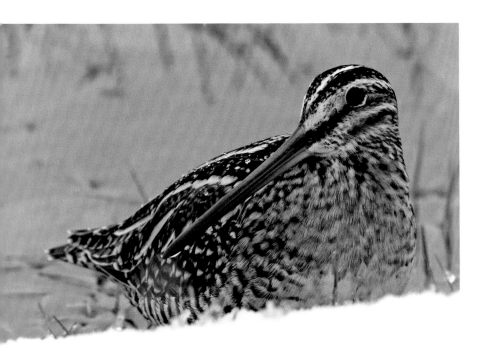

The Wilson's Snipe is a phantom of winter's wet farm fields, almost never seen until it noisily blasts into flight when spooked. Photo: Mark R. Johnson

clining and uncommon. The female is handsomely patterned in obscure browns, whereas the male is garishly plumed and multicolored. In the United States, the species ranges from coast to coast but is patchily distributed. Both this species and the Northern Bobwhite are still treated as game birds in our Region. The decline of the pheasant is probably being driven by the same causes affecting the bobwhite.

The **Ruffed Grouse** remains one of our Region's favorite game birds, inhabiting brushy mixed forest with openings. It is another member of the pheasant family. It is a nonmigratory resident, ranging from the eastern United States to the Pacific Northwest and Alaska, especially in mountainous uplands. It warily forages on the ground for buds, fruits, and the occasional insect. The male in spring carries out a display on a fallen log, drumming his wings against his flanks to make a wonderful low thrumming sound that carries considerable distance. The **Wild Turkey** was, a few decades ago, a rare species in our Region but, aided by the introduction of birds from the Midwest, is now expanding its range and rapidly increasing in abundance. This nonmigratory species is another of the pheas-

ant family, with a range that extends across the continent. Flocks assemble in fields prior to dawn. Displaying males are one of the most remarkable sights in the bird world—the large bird puffs up, lowers its wings, and fans its large tail over its back. The species subsists mainly on acorns, other nuts, fruits, buds, and the occasional animal prey item captured on the ground. The turkey is a very popular game bird, especially in the Deep South. Look for this species in early morning at the field edge of oak woods. All of the pheasants prefer to run from danger but when surprised all will fly a short distance, even the heavy turkey.

Wilson's Snipe is a small sandpiper that, believe it or not, is a hunted game bird in our Region (most people know only of "snipe hunts," which are pranks played on naive summer campers in the woods). Wilson's Snipe breeds in wooded swamps and bogs in the northern United States, the Rockies, and Canada and winters in the southern United States and southward as far as South America. This bird winters in marshes, wet ditches, and fields in open farmland. It is so well camouflaged that it is generally seen only when flushed by a walker. 185 were recorded in Anne Arundel County, MD, on 3 April 2015. 170 were reported at Dragon Run Park, DE, on 2 November 1974. The **American Woodcock** is another landlubber sandpiper that breeds throughout the eastern United States, with the northern populations migrating to the Southeast for the winter. This rarely seen game bird prefers rural habitats where there is a mix of woods, old fields, and wetlands. It is superbly camouflaged and usually only seen when flushed, although the best time to see them is in very early spring, when males carry out their display flights over wet fields. The male gives a series of *peent* calls from the ground and then flies high into the sky and circles, its wing feathers producing a distinct twittering sound. It ends its display by plummeting down to earth, during which its tail feathers produce distinctive hooting sounds. 20 were recorded at Wootons Landing, Anne Arundel County, MD, on 8 March 2009.

Pigeons and Doves

The **Rock Pigeon** is the formal name for the commonplace feral pigeon of cities, urban parks, bridge underpasses, and barnyards. These are descendants of domesticated birds brought to the United States from western Europe by fanciers, who kept the birds in "dovecotes" as a hobby. The species is quite variable here in the United States because of the interbreeding of different domesticated stocks. Today, the species is widespread across North America. The species is nonmigratory. The **Mourning Dove** is a popular native game bird in our Region. It is widespread and abundant across the United States and southern Canada, and it ranges south to Panama. It is a permanent resident in our Region and inhabits agricultural and open suburban habitats. It feeds mainly on seeds gathered on the ground and is often seen below bird feeders. Its name comes from its mournful *hoo* notes given primarily in spring. Note the dove-brown plumage, small head, and pointed tail with white bordering conspicuous in flight.

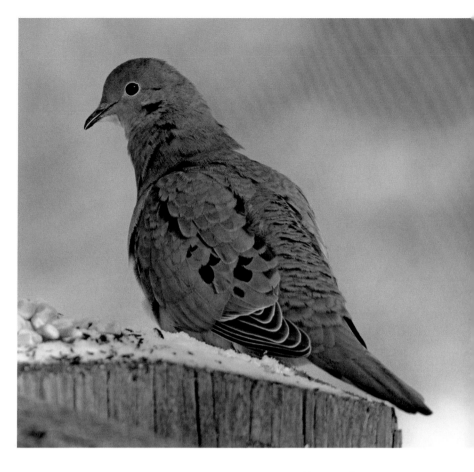

Mourning Doves are beloved members of the agricultural landscape and frequent visitors to backyard feeders.

While Rock Pigeons do not command much respect from birders, their iridescent colors are uncommonly beautiful.

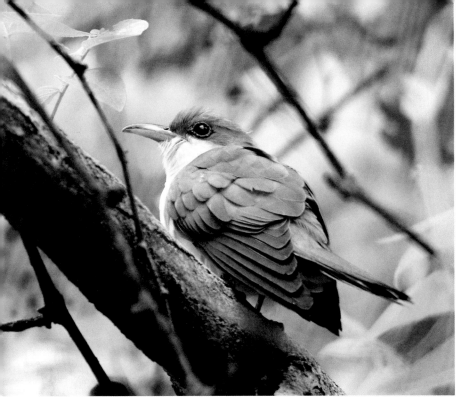

the US Watch List. 20 were recorded at Pinto Pond, Allegany County, MD, on 18 May 1996.

The **Belted Kingfisher** is widespread in North America. Its oversized bill and ragged crest give it a jaunty look. It is our Region's only kingfisher. Our kingfisher is a year-round resident, though migrant birds from New England may join our resident birds in winter if their waterways freeze. This species is unusual in that the female is more colorful than the male, having a handsome "vest" of red brown, which the male lacks. The species lives near water, foraging on small fish and other aquatic life. Kingfishers nest in earthen burrows dug into stream banks. It is one of our familiar waterside birds whose presence is often signaled by the noisy rattling call it gives in flight.

There's no point trying to find the elusive Yellow-billed Cuckoo; these secretive country birds will find you when you least expect it.

Streams and ponds stocked with minnows are irresistible to the boisterous Belted Kingfisher.

Nonpasserine Landbirds

The **Yellow-billed Cuckoo** is traditionally called the "rain crow" because of its habit of giving its distinctive cadenced, clucking call on humid summer days when rain is expected. It has all-white underparts, large white spots on the underside of the tail, and a yellow lower mandible and is a slim and graceful bird in flight. However, it is shy, easily overlooked, and heard more than seen. It is a breeder through the eastern and central United States and winters in South America. The species subsists almost exclusively on caterpillars when in our Region. Unlike many Old World cuckoos, the Western Hemisphere cuckoos do not lay their eggs in the nests of other birds (a habit called brood parasitism). 25 were censused in North Pocomoke Swamp, MD, on 24 May 1975. Its sister species, the **Black-billed Cuckoo**, is an uncommon summer visitor and passage migrant through our Region. The species nests north to southern Canada and south to the Mid-Atlantic and southern Appalachians. It winters in South America. Its habitat requirements and crypticity are similar to those of the Yellow-billed. The Black-billed can be distinguished from the very similar Yellow-billed by the small white tail spots, dark bill, and dark-red eye ring. It is a species of concern on

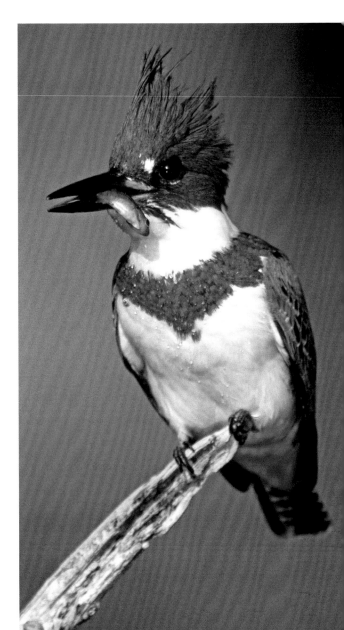

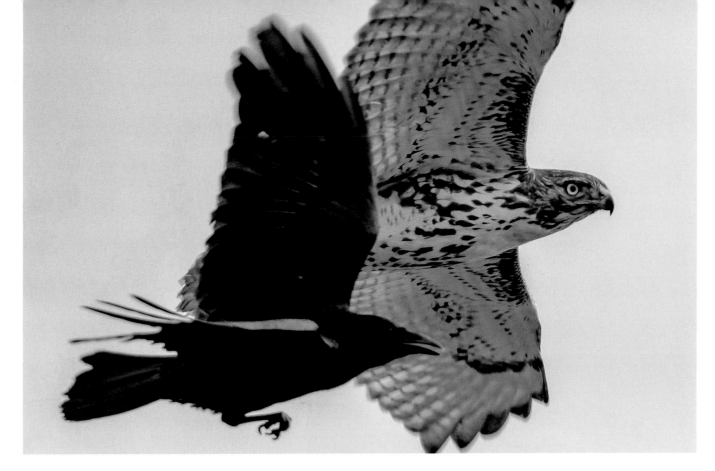

Songbirds

The **American Crow**, a permanent resident in our Region, is one of our most abundant birds, familiar to all. It ranges throughout the United States and most of the southern half of Canada. The species has a preference for open agricultural and suburban habitats and breeds throughout our Region. In winter, it forms large roosting aggregations. The species' diet is broad, including birds' eggs, baby birds, carrion, garbage, grains, fruits, and nuts. The nest is a large stick platform high in a tall tree. 200,000 were counted in a roost in the District of Columbia during the winter of 1919–1920. 70,000 were estimated in a winter roost in Hagerstown, MD, on 23 December 1989. In our Region, this species shares its habitat with the **Fish Crow**, a slightly smaller species with a softer and more nasal vocalization. It is a common bird near rivers, coasts, and low country marshland, as well as suburban and urban habitats. The two crows are difficult to separate except by their distinct vocalizations. 20,000 Fish Crows were counted at Deal Island WMA, MD, on 6 January 1992. The **Common Raven** ranges through northern and western North America, as well as northern Eurasia. In our Region it is mainly a bird of mountains and cliffs, but is on the increase on the Western Shore and Piedmont. This, our largest American songbird, is an accomplished aerial acrobat and is commonly seen along the Appalachian ridges during the autumn hawk migration. Note the large bill and wedge-shaped tail and the deep and guttural *kronk!* call. 39 were counted from High Rocks, Garrett County, MD, on 2 November 1996.

The **Sedge Wren** is a very rare summer resident and scarce passage migrant, wintering on the Eastern Shore and St. Mary's County, MD, in small numbers. This tiny sprite is difficult to observe but is a noisy songster when on territory, often vocalizing at night. The species prefers low, wet grassland. It mainly breeds in the upper Midwest into the Canadian prairie provinces, where it can be quite common in summer. Winters mainly in the Southeast. Note the small size, short bill, and short tail. 164 were counted during a Christmas Bird Count in southern Dorchester County on 23 December 1951. The **Marsh Wren** is a tall-marsh specialist, breeding across northern North America and wintering

American Crows do not take kindly to passing raptors, which are promptly escorted away. Photo: Anthony VanSchoor

A male Bobolink scouts for danger before dropping down to his ground nest in a weedy cow pasture in Garrett County.

Best views of the Eastern Meadowlark, a grassland specialist, come when the species perches on a fencepost. It typically stays hidden in the tall grass.

in the South and into Mexico. It builds distinctive ball-shaped nests in marshlands, where it is an inveterate songster on territory with a disproportionately loud song reminiscent of an electric sewing machine. Note the prominent white eyebrow and the rich chestnut unpatterned shoulder. 133 were counted at Ellis Bay WMA, MD, on 27 July 2008. Breeding populations west of the Chesapeake appear to be in decline.

The **Eastern Bluebird** is one of our Region's most beloved songbirds, mainly because it will nest in wooden nest boxes placed on fences around

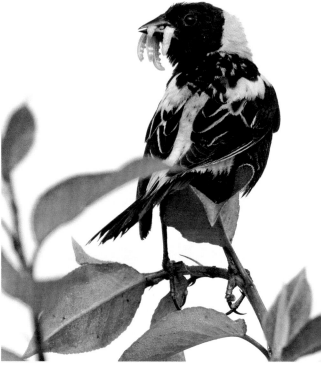

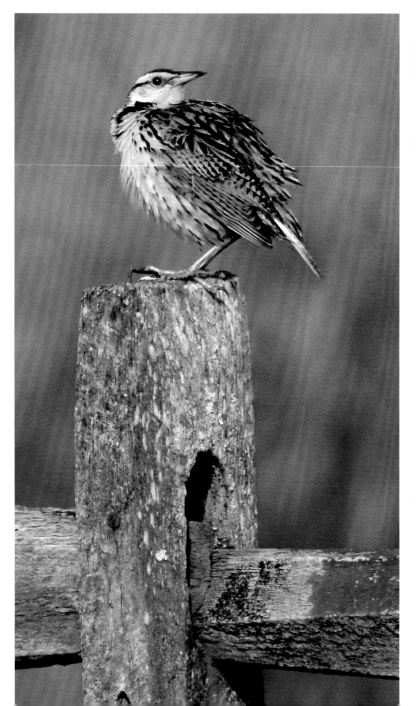

grassy pastures and rural agricultural lands. It breeds throughout the Region, with a preference for the edges of open fields and old orchards containing short grass, in which it hunts for insect prey. The adult male is cobalt blue on the head and upperparts and brick red on the throat and flanks. The female is a washed-out version of the male. The species forms small flocks in winter that wander about its preferred open habitat and consume berries as well as insects. It is easily identified when perched on a telephone line by its distinctive hunched posture. 5,000 were counted in the Gunpowder River, MD, marsh on 26 October 1903. 237 were counted at Soldier's Delight environmental area, MD, on 16 November 2003.

The **Eastern Meadowlark** is an uncommon and declining grassland resident throughout our Region. The species breeds throughout the eastern and central United States and into the Southwest and winters southward into northern South America. The northern breeders (in New England and the US Northern Tier) winter southward into the

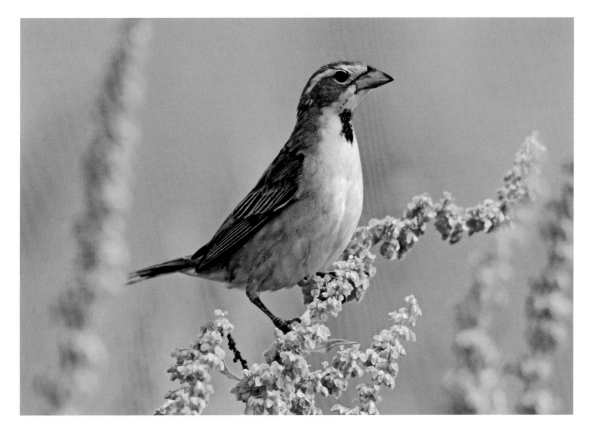

The highly nomadic and unpredictable Dickcissel seeks out overgrown pastures with just the right mix of field plants for nesting.

ranges of the permanent resident populations (in the central and southern United States). Inhabits hayfields, grasslands, meadows, and the higher parts of grassy marshlands. Gathers in flocks in stubble fields and pastures during the winter. Urbanizing areas tend to lose this species. 4,167 were censused during the Ocean City, MD, Christmas Bird Count on 27 December 1955. The **Bobolink** is a flocking passage migrant and uncommon breeder. It is a species of concern on the US Watch List. The female is sparrow-like, but the breeding-plumaged male is stunning with his black body, straw-yellow nape-patch, and white shoulder and rump. The males are especially beguiling when they do their musical and fluttering display flights over an expanse of grass-land. The species breeds in the Northeast, upper Midwest, and northern prairies into Canada. The species winters in Patagonia. Most common in our Region as a passage migrant in May and August to September. The species breeds in large untended fields. The male's song sounds a bit like R2-D2 from the Star Wars movies. 100,000 were reported at Wilmington, DE, on 2 September 1948. 20,000 were estimated at Snow's Marsh, Baltimore County, MD, on 12 September 1899. 4,200 were recorded from Bolingbroke Island, Talbot County, MD, on 2 September 2000. The **Dickcissel** is an uncommon passage migrant and rare breeder to weedy fields of the Piedmont and upper Eastern Shore. This is a species of the Great Plains, from the Canadian border south to Texas. It winters in northern South America and western Central America. It frequents weedy grass-lands, roadside hedges in agricultural landscapes, and prairie. It appears as drably plumaged singletons at feeders in winter. The plain first-winter females look much like a House Sparrow. 25 were recorded from Dickerson, MD, on 7 June 1952.

The **Yellow-breasted Chat**, long considered a large, aberrant wood warbler, has now been reclassified as the sole species in its own family, the Icterii-dae. It breeds across the United States and northern Mexico and winters in Central America. The species is a habitat specialist in our Region, found only in old overgrown fields with a mix of shrubbery and

(Following page) A rather noisy song-bird of overgrown meadows, the Yellow-breasted Chat is much more easily heard than seen.

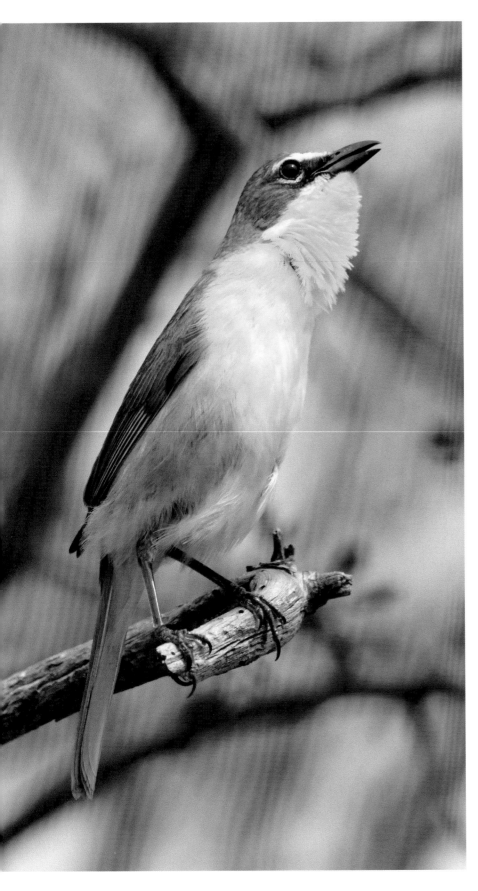

patches of open ground. Although it breeds across our Region, it is in decline as is its favored old-field habitat. The chat male carries out a flamboyant flight song when on breeding territory, singing and fluttering in midair high above the ground. A noted songster and mimic. 100+ were encountered at Port Tobacco, MD, on 11 May 1953. 16 were recorded near Delaware City, DE, on 5 June 2015.

Rarities, Extirpated Species, and Extinct Species

Two species that formerly bred in our Region are now gone. The **Greater Prairie-Chicken** formerly bred in our Region but has been extirpated. It was last reported near Washington, DC, in 1886, and hunted birds were offered for sale in a Washington, DC, market in 1893. This eastern population was known as the "Heath Hen." The species continues to breed in the tallgrass prairie of the upper Midwest. The more famous **Passenger Pigeon** once bred in the Allegheny Highlands and passed through the Region in vast numbers. It was last observed in our Region in 1903. This was perhaps the most abundant bird species in North America before its decimation. The story of its extinction is well documented and worth reading about.

The **Eurasian Collared-Dove** was introduced to the Bahamas in the 1970s and made its way to Florida in the 1980s. Well established in North Carolina and in southern Virginia, it has expanded its range through the West and South and now appears to be established in our Region, albeit weakly. The species is found in suburban and open rural settings as singletons or in small numbers, often perched on telephone lines and poles. The **White-winged Dove**, a bird of the Southwest, the Caribbean, and Mexico, now has become established in Florida. It has since expanded up the Atlantic Coast. Quite similar to the Mourning Dove but is bulkier and has white edging to its wing when perched, which becomes a large white wing bar in flight. Formerly a southern and western species, it is on the increase, with a

scattering of records in our Region from all seasons. Often heard in the background of western movies, the voice is distinctive several-note hoarse chuckle. Found mainly in suburban and other open habitats. The **Inca Dove**, a species of the Southwest and Mexico, is known from our Region from a single record. This tiny ground feeder is distinctly pale with fine dark scaling dorsally. In flight, it shows deep red-brown flight feathers and a long tail. The species is expanding its range in the South. The **Common Ground-Dove** is another well-known resident in the Deep South and into Mexico. There are a few records from our Region. In flight, this ground dweller also shows deep red-brown flight feathers though it has a very short tail and a compact overall appearance.

The **Groove-billed Ani** is a Mexican species best known from south Texas. This all-black cuckoo relative is very strange and quite unexpected from our Region, where the species is known from a single record. This species is prone to wander, with records north to Ontario, Wisconsin, and northern New Jersey. The **Carolina Parakeet** is yet another of our extinct species. Known from the Region last in 1865. This colorful parrot is not known to have bred in the Region.

The **Loggerhead Shrike** is a handsome bandit-masked songbird predator that has the distinctive habit of impaling its captured prey (a small mammal, bird, reptile, or insect) on thorns or barbed wire for storage and easy consumption, resulting in the colloquial name "butcher bird." This species of open agricultural lands has declined drastically over the past several decades and this former permanent resident is essentially gone from our Region, though vagrants do show up from time to time. It remains common in the Deep South and south Texas. 20 were counted at the Ocean City, MD, Christmas Bird Count on 27 December 1954. For the calendar year 2017, only a single individual was recorded in eBird from our Region—from a site near Hagerstown, MD, in the Ridge & Valley. The **Northern Shrike** is a winter wanderer from its

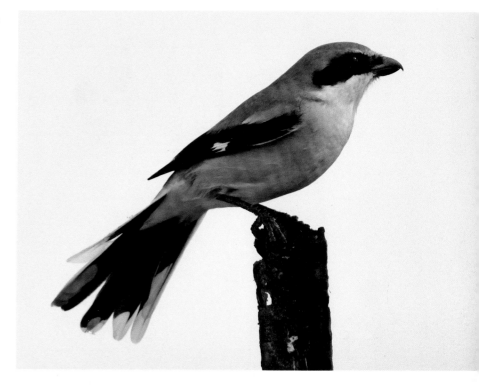

A former breeder in our Region, the Loggerhead Shrike is now a rare visitor to hedgerows in open farm country.

breeding range in sub-Arctic Canada and Alaska. It winters regularly in the northern United States but only rarely as far south as our Region. It is a large and pale version of the Loggerhead Shrike found in the same open country, perched in a shrub or on a fence pole. We typically get one to two records per winter.

Bewick's Wren formerly bred in the western uplands of our Region. The species' range has retreated westward and is no longer found here. In 2017, the nearest records were from westernmost Illinois and Missouri. The **Mountain Bluebird** breeds in the mountains of the West and northward into Alaska. It winters in Texas, the Southwest, and Mexico. This sky-blue songbird has been recorded in our Region in late fall. There are quite a few records in the Northeast, mainly during the colder months of the year.

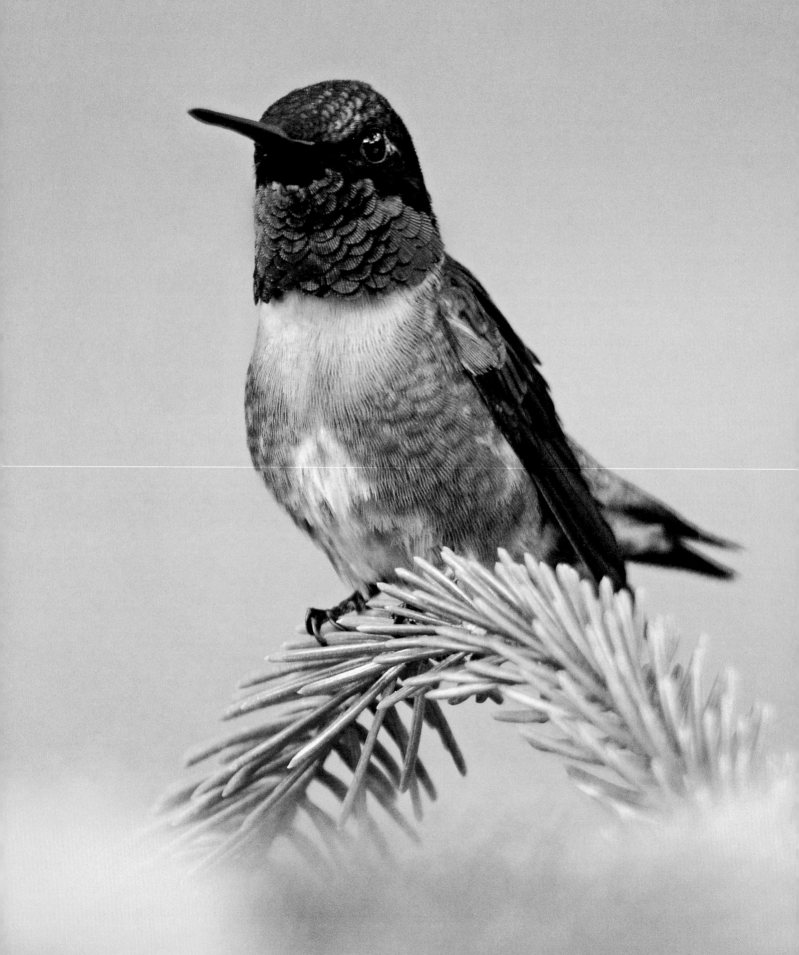

Aerial Feeders

Aerial feeders include a disparate assemblage of lineages, all linked by their habit of harvesting their food in flight. Most feed primarily on flying arthropods, but one group, the hummingbirds, feeds on nectar as well as on spiders and other tiny arthropods. All are accomplished fliers, able to agilely maneuver to capture winged prey. This grouping includes nightjars, a lineage of nocturnal feeders. Three of this group's lineages are nonpasserines, and the remaining two are passerines. In general, aerial feeders are in decline across North America probably because of a reduction in their insect prey base. Declines in the insect populations have been caused by overuse of pesticides, reduction of edge habitat, urbanization, and other less well-understood factors.

Nightjars

Nightjars are a peculiar group with an even stranger set of names. Their alternative name is "goatsucker." According to one old wives' tale, certain nightjar species suckled goats at night for sustenance. Most night birds are little known and often misunderstood. This group of three species includes a single open-country forager and two woodland dwellers that forage by sallying out from perches or flying low over the ground. All three species are vocal and are more often heard than seen, as they are well camouflaged and habitually perch along branches rather than crosswise like most birds. These birds have tiny feet, long wings, and broad mouths that they open wide to capture elusive prey.

Well-stocked nectar feeders at the Savage River Lodge ensure great views of the Ruby-throated Hummingbird, a little gem with a shimmering crimson throat.

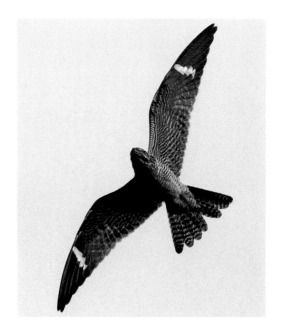

The Common Nighthawk, a regular migrant and uncommon summer breeder, swoops across the evening sky to scoop up flying insects on the wing. Photo: Mark R. Johnson

By day, the Eastern Whip-poor-will hunkers down on a comfortable limb to digest the night's catch.

The **Common Nighthawk**, traditionally called the "Bullbat," is a summer resident across the Region that has declined substantially over the last several decades. It is a widespread breeder across North America, wintering to South America. This lightweight, long-winged, insect-eater exhibits a distinctive white patch on each pointed wing. The nighthawk is a crepuscular feeder, foraging high in the sky mainly at dusk and at dawn. The species nests and roosts on bare ground and on flat gravel roofs in towns. During the breeding season, the male's display flight ends with a dive toward the ground, wings flexed to produce a whooshing sound: *Hoooov!* These days, the bird is most commonly seen in spring and fall migration, when groups are passing through the Region. 1,139 were counted over Rockville, MD, on 2 September 1998, and as many as 1,000 birds were recorded in a single flight near Newark, DE, on 18 September 1980.

The **Chuck-will's-widow** is a night bird of the South, though its population is expanding northward. It breeds through the South and Southeast and winters in Florida, the Caribbean, and Mexico. Its cryptic, leaf-like plumage makes it difficult to detect during the day as it roosts on the forest floor. At night, its presence is easy to confirm because of its loud and distinctive repeated onomatopoetic song. The Chuck forages at night low over the ground, searching for its arthropod prey. It has also been recorded preying upon small birds and bats. 32 were counted in Talbot County, MD, on 8 May 1954. The **Eastern Whip-poor-will** was once a common night bird of rural landscapes in our Region where its namesake call of *WHIP-poor-WILL!* was a sign of summer. It has much declined and now is a species of concern on the US Watch List. It breeds across the eastern United States and winters along the coast of the Southeast as well as in eastern Mexico southward into Central America. It prefers moist deciduous forest and younger and more open habitat than the Chuck-will's-widow, and it is slightly smaller than the similarly plumaged Chuck. An astounding 200 Whips were recorded in Washington County, MD, on 7 May 1949.

Hummingbirds

The **Ruby-throated Hummingbird** is this Region's only regularly occurring hummingbird. Seven other species recorded from the Region are all rarities. The Ruby-throat breeds across the eastern United States and southern Canada and winters in Florida, the Gulf Coast, and Central America. In migration,

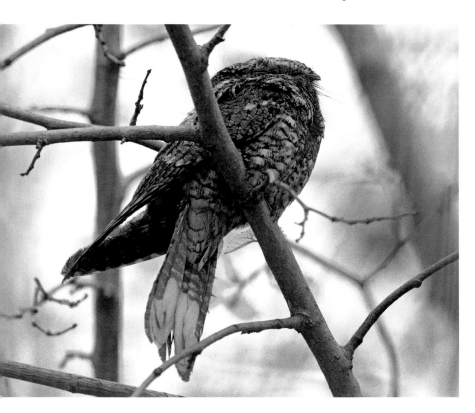

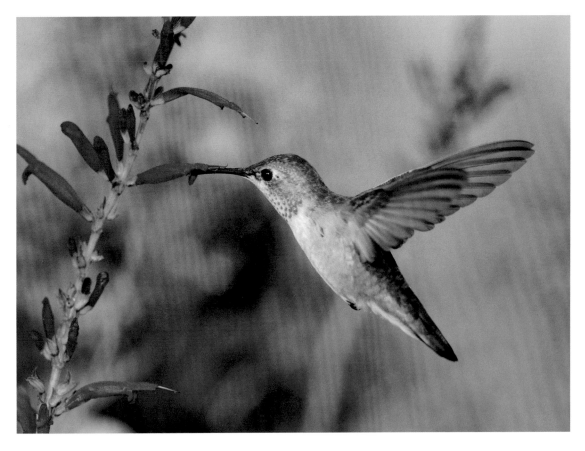

A female Rufous Hummingbird, a migrant from the far West, stakes out an autumn farm garden on the Eastern Shore.

many fly 600 miles across the Gulf of Mexico in spring and fall to and from their wintering habitat in Central America—a considerable feat for such a tiny bird. The species is a widespread breeder throughout our Region, although their small lichen-covered nests are difficult to find. This is one of our most beloved backyard birds. People put out nectar feeders to attract these lovely little birds, especially in late summer when migrants start to show up looking for nectar-producing flowers. The species can be found in open woodlands, forest-edge, and wooded suburbs and well-planted city yards. As with nightjars and swifts (which are relatives), hummingbirds have tiny feet and legs. 200 were counted in Anne Arundel County, MD, on 1 September 2016. The **Rufous Hummingbird** is a rare but regular late autumn vagrant to the East Coast. It breeds in the Pacific Northwest and winters in the Deep South and southern Mexico. This species is exceedingly similar in all plumages to Allen's Hummingbird, a much rarer vagrant from the West.

Swifts

The **Chimney Swift** is our Region's only member of the swift family and is unrelated to swallows, a family that it superficially resembles. Described by Roger Tory Peterson as "a cigar with wings," this small insectivore is one of the most specialized aerial feeders in our Region. It is a strong, agile, and speedy flier, with tiny feet and legs. The swift cannot perch on a branch or on the ground; thus, it spends most of its life either airborne or hanging from vertical surfaces (inside chimneys, hollow trees, or caves). Its four toes point forward, an adaptation to its clinging lifestyle. The small, dull-brown swift breeds in the eastern United States and winters in northern South America. Although still widespread and common, this species has been in decline. Today, it nests inside the chimneys of building and homes, using specialized glue-like saliva to secure its nest to a vertical wall. In late summer, large groups congregate in favored roosting sites

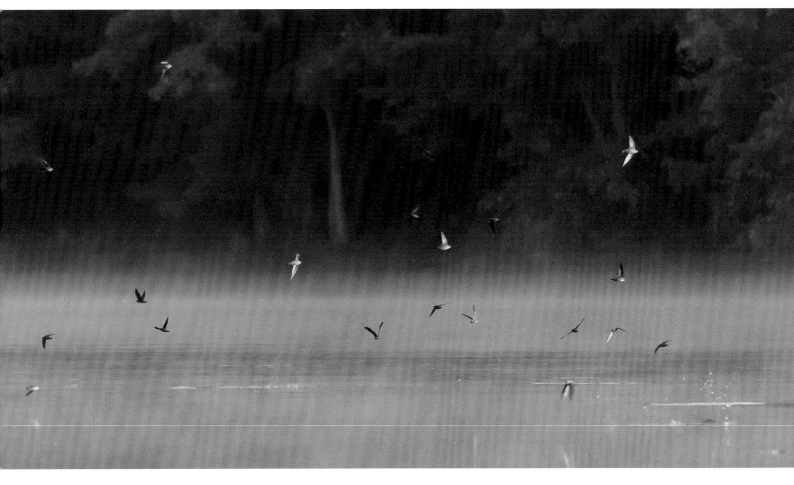

Flight school is in session for these Chimney Swifts dipping and dancing over a community pond. Photo: Bonnie Ott

(*Opposite top*) A favored rural yard bird, the Purple Martin nests in birdhouse apartment units, but it may take several years before the first tenant arrives. Photo: Emily Carter Mitchell

(*Opposite bottom*) Tree Swallows readily accept nesting boxes placed near fields where they like to forage across the open landscape.

and can be seen in the hundreds "funneling" into a chimney entrance just after sunset. 5,000 were estimated over Chevy Chase, MD, on 31 August 2012. 4,000 were funneling into a chimney in Baltimore, MD, on 10 September 2003. 1,000 birds were recorded at Lewes, DE, on 20 September 1983.

Swallows

Although swallows resemble swifts in behavior, they are not closely related. Swallows are perching birds (passerines), whereas the swifts are nonpasserines. They are grouped here because of their similar aerial foraging behavior.

The **Purple Martin** is our Region's largest swallow and probably the most popular; however, it is not terribly common, mainly because of its strict nesting requirements. Today, it only nests in martin houses placed in open fields with abundant open

air space for foraging. The adult male is entirely dark, iridescent blue, whereas the female is blue dorsally and gray ventrally, with a dark throat. The species is a pleasant vocalist and wonderful aerial forager (reducing insect pests), so rural farms often feature martin houses. Sadly, House Sparrows and European Starlings are known to outcompete martins for nesting "apartments" in martin houses. Martins form large flocks after the breeding season, especially in July, and the species is an early southbound migrant to its wintering grounds in South America. 100,000 were recorded in the District of Columbia during the third week of July 1947. 20,000 were counted at Salisbury, MD, on 15 August 1981.

The **Tree Swallow** is a common and widespread breeder in our Region and regularly winters in small numbers along the coast of our Eastern Shore. Most Tree Swallow breeders arrive in early

April from the southern United States and Mexico. The species breeds from the East Coast to Alaska but is absent as a breeder in the Deep South. It prefers open rural fields near water and nests mainly in birdhouses set out in open habitats. In autumn, huge flocks of Tree Swallows stage at sites along the East Coast. These flocks swirl about in the sky and perch on shrubbery in wetlands. Late-fall and winter birds supplement their diet by feeding on Wax Myrtle berries and bayberries; entire flocks can descend on these plants, a truly impressive sight. 50,000+ were recorded at Elliott Island, MD, on 22 October 1949. 25,000 birds were reported from Bombay Hook NWR and Little Creek WA, DE, on 8 May 1970. Like the Tree Swallow, the **Northern Rough-winged Swallow** is an early spring migrant, arriving in late March and early April from its winter quarters in Mexico and Central America. Unlike other swallows, rough-wings are not especially sociable and breed in small colonies in quarries or cliffs or more usually as single pairs in drainpipes, culverts, and small openings in man-made structures. One pair was found nesting in the mouth of a Civil War cannon. 1,000 were counted at Hurlock, MD, on 16 August 1997. 50 were reported from Dragon Run Park, DE, on 14 April 1973. The slightly smaller **Bank Swallow** is uncommon in our Region mainly because of a lack of suitable nesting sites. This sociable species nests colonially in sandy cliff banks within burrows they excavate themselves. Colonies are most prevalent along the shores of the middle Chesapeake, presumably because of the presence of soil banks cut by the many tributaries of the Bay. The species is a widespread breeder in the northern United States and Canada, migrating to South America to spend the winter. Additional populations breed across Eurasia (where it is known as the Sand Martin). The species is usually found foraging near water. 25,000 were reported at Bombay Hook NWR and Little Creek WA, DE, on 8 May 1970. 3,000 were reported at the same site on 28 August 2010. 10,000 were recorded in the Gunpowder River marsh on 15 July 1900.

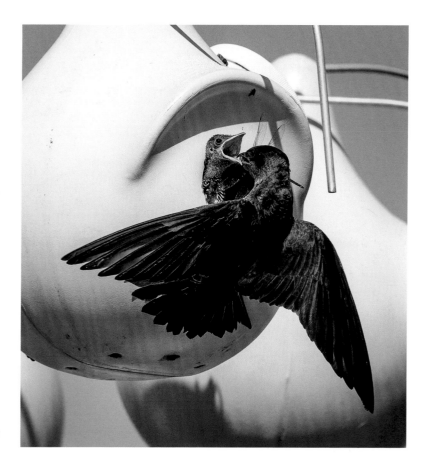

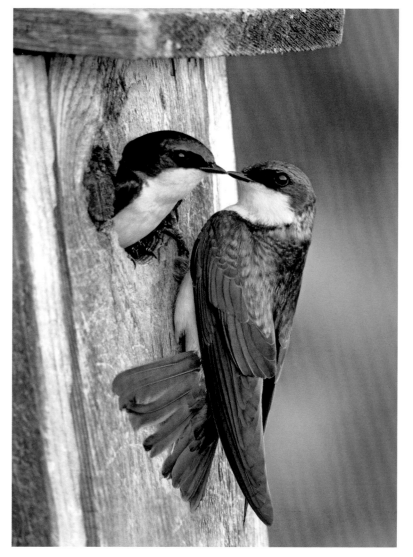

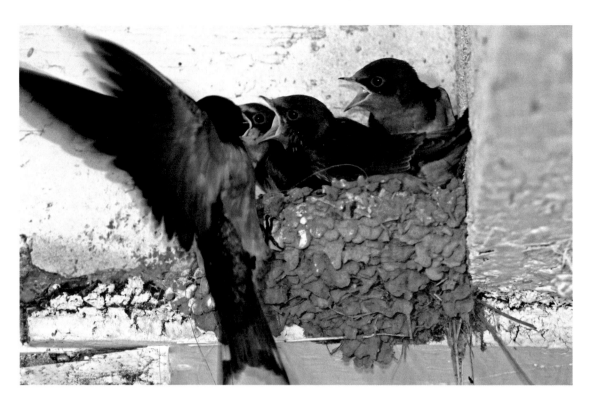

Meal delivery to this Barn Swallow nest is virtually nonstop, as the nestlings mature at warp speed.

The **Cliff Swallow** is a widespread breeder in the United States and Canada, wintering to South America. It is an uncommon breeder in our Region. The species is colonial, with groups nesting mainly under bridges and eaves, where the birds plaster their gourd-shaped mud nests with diagnostic side entrance holes. It is a handsomely patterned species that places colonies near good foraging habitat, including water and open land. The species is more common in the West and Southwest than in the East. 1,500 were recorded in the Patapsco River marsh, MD, on 15 September 1896. The **Barn Swallow** is the most familiar member of the family and nests mainly under the eaves of porches and barns in open country surrounded by ample foraging opportunities. The distinctive nest is a mud and grass half-cup plastered to a sheltered wall or beam under an eave. The species breeds throughout North America and winters in Central and South America. Other populations of this species range through Eurasia. It is a handsome and graceful flier, adorned with the long tail wires and its visual appeal combined with it being a harbinger of spring has made it one of our favorite species. 5,000 were recorded at Assateague

Island, MD, on 11 August 1994. 1,000 were reported from coastal Sussex County, DE, on 21 May 1983. The **Cave Swallow** breeds in Texas, Mexico, and the Caribbean and wanders in autumn up the East Coast as far as the Canadian Maritimes. It appears in our Region in late autumn, especially November, with a handful of records per annum. In our Region, the species may be overlooked, because of its similarity to the more common Cliff Swallow. There are a large number of autumn records from nearby Cape May, NJ. The birds seen in the Mid-Atlantic area have been assigned to the race from Texas and Mexico (the subspecies *pallida*).

Flycatchers

The tyrant flycatchers are a huge neotropical family of 449 species that mainly inhabits South and Central America. Our Region includes 11 regularly occurring species and an additional 11 rare species. Flycatchers perch upright on branches and sally out to capture flying insects. Most, but not all, are plain, colored in olive, green, or brown and have a distinctive vocalization.

The **Eastern Phoebe** is our most familiar local flycatcher, best known for its cheerful, onomato-poetic vocalizations, its characteristic constant tail-wagging, and its habit of placing its mossy nest under the eaves of porches or other covered sites associated with humans. This very plain and dark species is a partial migrant, most noticeable in spring when vocal birds are setting up territories near water. It is also a common migrant, and small numbers linger through winter. 42 were counted in Rock Creek Park, MD, on 24 September 2008. The **Eastern Wood-Pewee** is similar to the Eastern Phoebe but is slimmer, with pale wing bars, and a distinctive sweet vocalization *pee-a-wee---peee-yuu*. The pewee perches high in deciduous forest openings and is heard more often than seen. It breeds across the eastern United States and winters in northern South America. 33 were recorded at Calvert Cliffs State Park, MD, on 23 August 2011. The **Great Crested Flycatcher** is another of our common breeders, inhabiting the canopy of mature deciduous forest. It is a prominent vocalist (*wheep!*) and an active sallier for insects. It breeds across the eastern United States and southern Canada and winters in Central America. Unlike our other fly-catchers, the Great Crested breeds in cavities (and can be attracted to artificial nest boxes) where it often adds a snakeskin to its nest, for currently un-known reasons. 76 were counted at Taylor's Island, MD, on 9 May 2009. The **Ash-throated Flycatcher,** a western species, is a rare but regular late-autumn vagrant to the East Coast. It is similar but smaller and paler than the Great Crested Flycatcher. Best identified by voice and its pale throat.

The **Eastern Kingbird** is our most familiar open-country flycatcher, which hunts flying insects from a prominent open perch atop trees or on fence posts at the edge of fields or pastures. This species is pug-nacious and fearless, and will even attack predatory birds such as crows and hawks to drive them from its nesting territory, hence its name. The species breeds from Florida to Nova Scotia and west to the Rockies. It winters in South America. It breeds throughout

our Region, and although it has declined in recent decades, it still remains one of our most common and conspicuous flycatchers, partly because of its striking black and white plumage. 2,000 were re-corded in the Gunpowder River, MD, marsh on 2 September 1902. 105 were counted at Sandy Point SP, MD, on 15 August 1976. The **Western Kingbird** is a species of the Great Plains and Far West, mi-grating to Central America. Our Region sees one or two records per year, mainly in coastal sites during October or November.

The **Olive-sided Flycatcher** is a rare spring and fall passage migrant. It breeds in the boreal forests of New England, selected sites in the Appalachians, Canada, and in the Rockies south in the mountains to New Mexico; it winters in Central and South America. It sits erect on high dead snags near forest edges, sallying out long distances to capture large,

Captured in midair, this moth proves to be a challenging meal to swallow for this East-ern Wood-Pewee.

flying insects, before returning to its original perch. Best located by its loud and musical *quick-three-beers!* Its plumage is dull but it can be identified by the dark sides of the breast, which form a "waistcoat" and the white patches on each side of the rump. It is a species of concern on the US Watch List.

Empidonax Flycatchers

The Empidonax flycatchers constitute a species-rich genus of small, neotropical flycatchers with olive upperparts and two pale wing bars (with 9 species recorded from our Region). All species look quite similar and are most readily identified by their distinctive vocalizations.

The **Yellow-bellied Flycatcher** is a rare passage migrant, breeding mainly in spruce bogs in Canada and the northern United States. This small flycatcher is one of the more distinct members of the genus *Empidonax* because of its strongly yellow-washed ventral plumage. It still needs great care in field identification because other members of the genus can exhibit yellowish wash on the under-

The Willow Flycatcher is one of our five regularly occurring *Empidonax* flycatcher species. The species are notoriously difficult to identify unless in song.

parts. In migration, this species tends to hide in low brushy vegetation within woodlands, making it difficult to observe. Rare in spring and uncommon in autumn. Song is *chi-bonk!* and call is *per-wee?*

The **Acadian Flycatcher** is our most common and widespread breeding *Empidonax* flycatcher, nesting in moist deciduous forest near waterways. It breeds in the eastern United States and winters in northern South America. Difficult to observe in the canopy of forest interior, it is best located by its loud and explosive vocalization: *spit-a-KEET!* 51 were recorded along Whiton Crossing Road, Worcester County, MD, on 20 June 2014.

The **Alder Flycatcher** is a northern breeder that nests in thickets in bogs and boreal wetlands. It breeds in Canada, the northeastern United States, and the Appalachians and winters in northern South America. This habitat specialist is best searched for in alder wetlands. It can be identified by its harsh and burry *zhree-BEE-oh!* The very similar **Willow Flycatcher** nests in brushy willow thickets associated with wetlands. The species breeds through the northern United States and winters in Central and South America. Best identified by its diagnostic vocalization: *Fitz-byu!* Essentially identical in plumage to the Alder Flycatcher. Before the 1970s, the Alder and Willow Flycatchers were considered conspecific and called Traill's Flycatcher. The **Least Flycatcher** is an uncommon passage migrant through our Region. The species breeds mainly in the boreal forests of Canada and New England, wintering to Mexico and Central America. In our Region, it breeds only in mixed forests of the Allegheny Highlands. As with the other *Empidonax* species, it is best identified by its vocalization: *CHEE-bek!*

Rarities

The **Mexican Violetear**, a rare vagrant hummingbird from Mexico, has only been recorded in our Region twice. The **Black-chinned Hummingbird**, a common species of the arid West, is a late-autumn vagrant to

our Region. The **Broad-tailed Hummingbird** is another species of the arid West, known from a single Delaware record. **Anna's Hummingbird**, a West Coast species, is another late-autumn vagrant to our Region, with only a few records. **Allen's Hummingbird** is another West Coast species, with a few late-fall and winter records from our Region. The **Calliope Hummingbird**, a species of the West and Northwest, is another post-breeding vagrant to our Region.

Hammond's Flycatcher, the **Gray Flycatcher**, the **Dusky Flycatcher**, and the **Pacific Slope/Cordilleran Flycatcher** (all species of *Empidonax*) have been recorded as vagrants to the Region. Members of this cluster are all very difficult to identify because they do not vocalize outside of the breeding season. **Say's Phoebe**, a widespread species of the West, is known from a handful of records. The **Vermilion Flycatcher**, a species of Mexico and South Texas, is known from the Region from a few fall and winter records. The **Tropical Kingbird**, a mainly Mexican species, is a vagrant to the East Coast with records from our Region in late fall. **Couch's Kingbird**, which looks like a broad-billed version of the Western and Tropical Kingbirds, is a species of South Texas and eastern Mexico. It is a vagrant to the East Coast with a single record

from the Region. The **Gray Kingbird**, a neotropical species breeding from northern South America and the Caribbean to Florida, is a regular but rare vagrant to the East Coast, with a scattering of records from our Region in early summer and fall. The **Scissor-tailed Flycatcher**, a species of the southern Great Plains, winters to South America, is a regular warm-season vagrant to the Region. The **Fork-tailed Flycatcher**, which breeds in Central and South America, wanders to the East Coast with some regularity. There are a handful of records from our Region, mainly in autumn.

Flycatchers are famous long-distance vagrants. This Scissor-tailed Flycatcher made the day for several birders lucky enough to find it in the Region. Photo: Mark R. Johnson

Two Ruby-throated Hummingbird chicks disappear into a miniature teacup nest woven of spider webs and lichens.

Neighborhood, Backyard, and Feeder Birds

Our neighborhood, backyard, and feeder birds grouping includes an array of commonplace landbirds from a variety of bird families. They are all birds found near our homes and in our backyards. One of the lineages, the woodpeckers, is a nonpasserine group, whereas all the others are passerines, or perching birds. A number of perching birds are migrants that only pass through our backyards in season.

Woodpeckers

Woodpeckers are morphologically distinctive nonpasserines that stand out among the crowd of backyard birds. They perch on vertical trunks, using their specialized stiff tail feathers as a prop, and they drill into wood in search of boring insects or to construct a nest hole. Their feet are zygodactyl, meaning two toes face forward and two backward, presumably to help them cling to vertical trunks. Woodpeckers are mostly black and white and fly with a strong undulation. Most species can be attracted to the backyard with suet. Woodpeckers are famous for drumming, a territorial behavior practiced by both sexes. Individuals drum on resonant surfaces, especially dry, hollow tree trunks, to advertise their territory. Some individuals show a fondness for drumming on a gutter or piece of metal flashing on a house—a very annoying practice to homeowners.

Arguably the cutest bird to visit the backyard, the Downy Woodpecker is readily attracted to suet feeders.

Dramatic posturing during the breeding season reveals the gorgeous undertail of the Northern Flicker.

The **Red-headed Woodpecker** is our Region's least common regularly occurring woodpecker—the only Regional species with an all-red head. Its large white wing patches are particularly distinctive in flight. The Red-headed breeds in the eastern and central United States, wintering southward to the Gulf. This species has a very patchy breeding range in our Region. It is a species of concern on the US Watch List. Look for it in open oak woods and wooded swamps with lots of standing dead trees, especially the margins of Delmarva marshes, where there are thousands of trees killed by saltwater intrusion. President Theodore Roosevelt reported in 1908 that a pair nested on the White House grounds. 100 were estimated near Accokeek, MD, on 22 December 1940. 22 were counted in Calvert Cliffs SP, MD, on 21 September 2014. The **Red-bellied Woodpecker** is one of our most common species. It breeds across our Region and is a common and vocal backyard bird in the suburbs. It can be found in just about any patch of deciduous woods. It is easily distinguished from the Red-headed Woodpecker by its pale buffy throat and face, off-setting the red nape. The female exhibits a gray crown, whereas the male has a red crown. The namesake red belly is hidden on birds that creep along tree trunks and is best seen when the bird is perched at a feeder. The range of this species is confined to the eastern United States. It is a permanent resident and rarely migrates.

The **Yellow-bellied Sapsucker** is the oddball in this group. It is the group's only long-distance migrant, nesting in the Northeast and Canada and wintering to the South and in Mexico. The only breeders in our Region are to be found in the Allegheny Highlands. Most of us encounter this species as a late fall migrant and winter resident in suburban neighborhoods. These birds drill sap wells in favored trees, harvesting the sap produced and taking insects attracted to the sap. The species is also an occasional visitor to backyard suet cages and may consume some fruit in winter. 25 were counted at Elk Neck SP, MD, on 14 October 2012.

The diminutive **Downy Woodpecker** is one of our most familiar backyard birds. It is a habitual visitor to the suet feeder and joins mixed foraging flocks of small songbirds (chickadees, titmice, and nuthatches). The species is nonmigratory and has a range that extends from Florida to Alaska and Southern California. The male has a rectangular red spot on the hind crown. The species feeds mainly in small branches and twigs and nests in small holes in dead snags it excavates itself. It favors deciduous woodlands and is commonplace in suburbs. The Downy's larger cousin, the **Hairy Woodpecker**, is nearly identical in plumage but has a substantially larger bill. It is fairly common in wooded suburban neighborhoods and will come to the backyard suet feeder. It also is common in deep woods, a habitat generally shunned by the Downy. The Hairy ranges throughout North America and south into Mexico. Surprisingly, though it is the larger bird, its call is sharper and higher pitched than that of the Downy. The spring drumming patterns of the two are also distinct. The Downy's drum is a moderately rapid series of about 20 taps, softest on either end. The Hairy does about twice as many taps at double the rate of the Downy.

The **Northern Flicker** is another common partial migrant woodpecker. It is present in the Region year-round and breeds throughout, but northern migrants pass through in autumn, some of which stay for the winter. This is the only woodpecker with predominantly brown and buff plumage. It also is the only one that regularly forages on the ground (mainly for ants). The large white rump patch shown in flight is a great cue for identification. Its long call series sounds like that of the Pileated Woodpecker but is slower, more persistent, and monotone. "Nearly 1,000" were recorded on Hooper's Island, MD, on 30 September 1933. 800 were counted at Assateague Island, MD, on 5 October 2011.

The **Pileated Woodpecker** is our largest woodpecker and our only crested species. It is a forest dweller, though it does visit wooded suburbs and will come to backyard suet feeders on occasion. The sexes can be determined by head plumage. The male has a red moustache and a red forehead, whereas the female has a gray forehead and blackish moustache. The species uses its heavy chisel bill to dig into dead wood for insects, often creating distinctive large rectangular excavations in rotting tree trunks. It also will take fruit of various plants in winter. The species' range extends from Florida north to Nova Scotia and west into the northern Rockies but is absent from much of the Intermontane West. 20 were recorded in the Pocomoke Swamp, MD, on 27 December 1954.

Tiny Friends

The **Carolina Chickadee** is a popular visitor to backyard feeders. Birders and nonbirders alike appreciate the spunky behavior of this tiny peripatetic songbird. It is vocal and unwary and is a core species of most winter bird flocks that also include nuthatches, titmice, kinglets, and woodpeckers. The range of the species is restricted to the southeastern United States—from central Texas east to Florida and northeast to New Jersey. It is a permanent resident

(Following pages) Visitors to Quiet Waters Park in Annapolis got a great view of this Pileated Woodpecker nest right above a main hiking trail.

Which Chickadee is it? Discerning subtle differences between similar species is all part of the fun of birding (it's a Carolina).

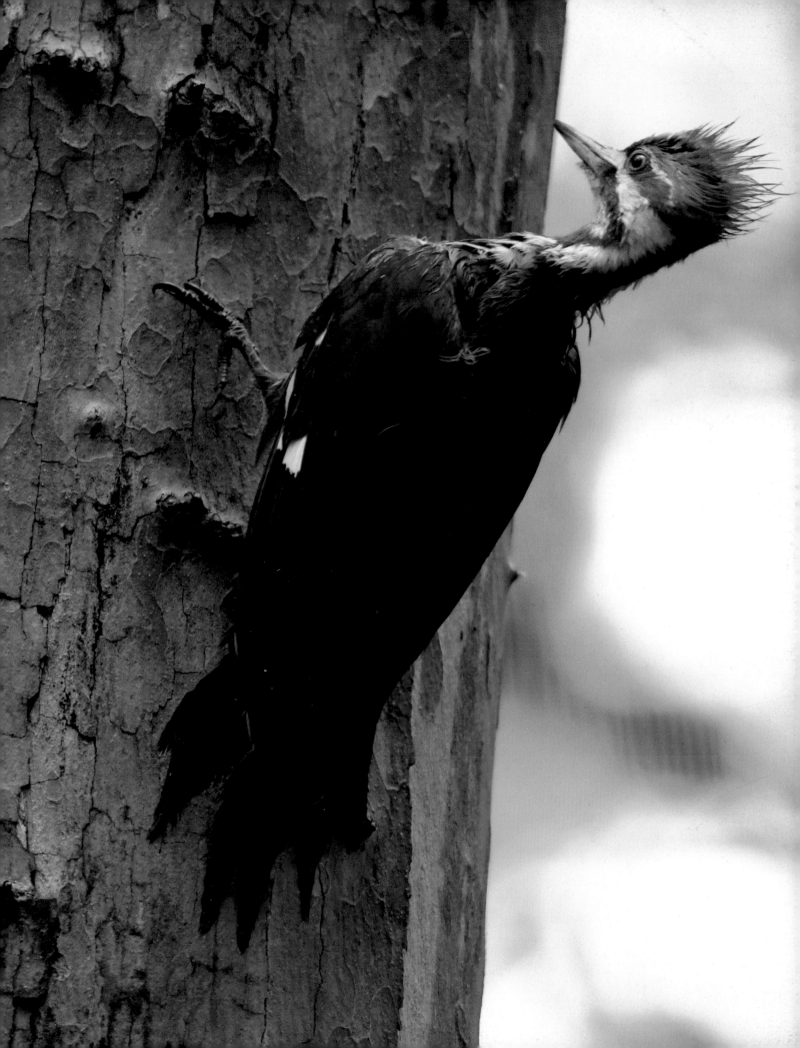

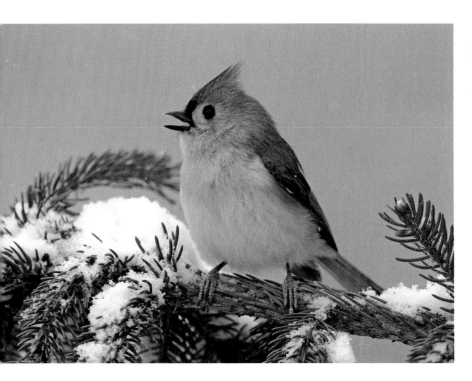

Another common feeder bird, the Tufted Titmouse, is especially fond of peanuts and comical when flying off with a huge shell in its tiny beak.

and does not migrate. This species inhabits most wooded habitats in the Southeast, making nesting cavities in dead wood. Its diet shifts from animal matter in summer to mainly plant material in winter. Surprisingly, the species has been showing a decline in recent decades. The **Black-capped Chickadee,** the northern relative of the Carolina, ranges from Western Maryland and Pennsylvania northward to Canada and Alaska. The ranges of the Black-capped and Carolina Chickadees meet but show little overlap. In these contact areas, the two species are known to hybridize. Locally, the range of the Black-cap is mainly west of the narrow neck of Maryland at Hancock. In some winters, Black-capped Chickadees irrupt south into our Region, showing up at feeders; expert birders distinguish them by voice and subtle plumage distinctions.

The **Tufted Titmouse** is a close relative of the chickadees and in winter joins them in mixed foraging flocks. This loud songster is a common backyard bird where it nests in cavities and is readily attracted to feeders. The species ranges through the eastern and central United States and is nonmigratory. Its preferred habitat includes just about any area of deciduous woods.

The **White-breasted Nuthatch** is a widespread permanent resident in our Region but rather scarce in the central and lower Eastern Shore. It is a common member of winter mixed foraging flocks. It is also a regular visitor to feeders. The species has a broad range, from New England to Georgia and from British Columbia south to California and into the mountains of Mexico. The smaller and more colorful **Red-breasted Nuthatch** is an uncommon bird of northern conifer forests that irruptively winters south into our Region, arriving in numbers every few years. The species breeds in small numbers in upland conifers in the Allegheny Highlands. It breeds throughout northern North America and southward in mountain ranges in the East and West. This little bird is bursting with personality and is a favorite of most birders. 108 were counted on Assateague Island, MD, on 5 October 2012.

The **Brown-headed Nuthatch** is a southern piney-woods specialist that travels in flocks that mainly stay in the canopy of tall Loblolly Pines. The species' range is confined to the Southeast into Florida and eastern Texas. It will join mixed flocks and visits feeders situated in the proper habitat. This small, easily overlooked bird is best located by its call, reminiscent of a child's rubber squeeze toy. 214 were counted in the Dorchester County, MD, Christmas Bird Count on 28 December 1953. 62 were counted on Taylor's Island, MD, on 29 September 2012.

The **Brown Creeper** is a small and retiring insect-eater, widespread but uncommon in our Region as a passage migrant and wintering resident. It is most common as a breeder in the Allegheny Highlands, with other scattered breeding records throughout. It is dorsally patterned in various shades of brown and easily overlooked unless the bird's high, thin *seeeee* note is recognized. This solitary, creeping bark-gleaner will join chickadee flocks in winter. It forages for arthropods while spiraling up a large tree trunk and then flying down to the base of the next tree to repeat the process. 87 were counted on the DC Christmas Bird Count

on 1 January 1955. 23 were counted in Montgomery County, MD, on 24 January 2009.

The **House Wren** is the favorite of many homeowners who manage to get this irrepressible songster to nest in their yard. The construction of wren houses has been a rite of passage for many elementary school children over the decades. This tiny bird breeds across the United States and southern Canada and winters in the Deep South and Mexico. It is a widespread breeder in our Region though less common on the Eastern Shore. A few winter in the Region each winter, mainly near the Chesapeake. In summer, the species can be found in nearly any wooded habitat with openings, shrubs, and tangles. 135 were counted at Gibson Island, MD, on 8 May 1955. 106 (25 adults, 85 nestlings) were counted at Ashland Nature Center, DE, on 10 June 2017. The

Carolina Wren is the larger counterpart to the House Wren and is a common backyard bird that will visit suet feeders in winter. This nonmigratory permanent resident ranges from southern New England to Texas and Florida. It, too, is a wonderful songster and disproportionately loud for its small size. It often nests around homes in odd spots, such as mailboxes, discarded yard supplies, or piles of old clothes left on a back porch. This species shows strong local population increases until their numbers plummet during an unusually harsh winter. 286 were recorded on the Ocean City, MD, Christmas Bird Count on 27 December 1954. The **Winter Wren,** a rarely seen little woodland sprite, winters across our Region and breeds in the Allegheny Highlands within tangles of upland mixed conifers. It breeds throughout the Appalachians and in New

The Brown-headed Nuthatch reaches its northern limit in our Region's piney woods on the coastal plain.

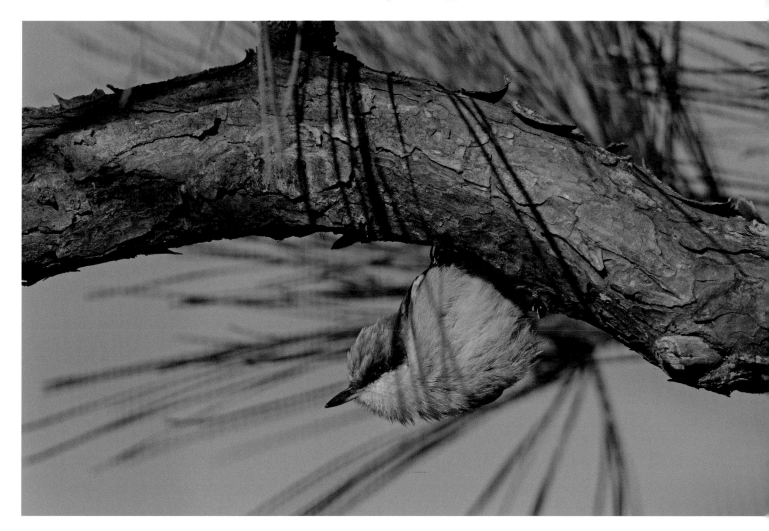

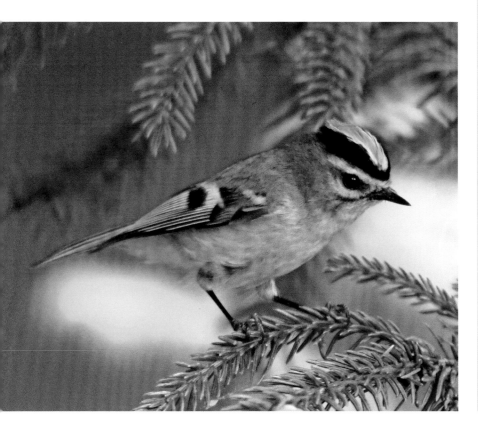

England and the northern tier into Canada. On the breeding ground, this bird sings a wonderful, rapid, and complex series of tinkling trills and warbles. It winters in low thickets near water or creek bed tangles. 47 were counted in a Christmas Bird Count in Worcester County, MD, on 23 December 1946. The populations from the West Coast have recently been separated as a distinct species, the Pacific Wren.

The **Golden-crowned Kinglet** is another tiny migrant songbird of northern conifer stands. It is an uncommon passage migrant and wintering resident in our Region. It is also a scarce breeder in the Allegheny Highlands, nesting in stands of spruce. The species breeds throughout central Canada and southward in the mountains of the West and the Appalachians. It winters across the Lower 48. This bird is sociable in winter and is often in small parties of up to a dozen hyperactive individuals. Their call is a high-pitched *see see see*. 450 were counted at Cape Henlopen SP, DE, on 18 October 2010.

The **Ruby-crowned Kinglet** is a bird of the Great North Woods, wintering south to our Region and throughout the southern United States into Mexico. This hyperactive ball of fluff forages in shrubbery, tangles, and conifers at woodland edges, joining chickadee and Yellow-rumped Warbler flocks in winter and is less sociable than the Golden-crowned Kinglet. It can be identified by the prominent pale partial eye ring. It winters across our Region in good numbers. The narrow red crest of the male is rarely exposed when feeding. 200 were counted at a site in Queen Anne's County, MD, on 30 October 2010. 40 were recorded at White Clay Creek SP, DE, on 18 April 1975.

Medium-Sized Friends

The **Blue Jay** is another of our commonplace neighborhood birds. It visits tray feeders for sunflower seeds but does not seem to be as regular a patron as other species. This species is mostly a permanent resident and ranges across the central and eastern United States and southern Canada, south

to Florida and Texas. However, large numbers migrate south in winter, especially when the mast-producing trees (e.g., oaks and beeches) on their northern breeding grounds fail. The species is a breeding resident throughout our Region and feeds mainly on insects in the summer and on seeds and acorns in the winter. It will occupy virtually any wooded habitat. 4,135 were counted flying past Fort Smallwood SP hawk watch, MD, on 28 April 2010.

Seven thrush species grace our Region every year. Our largest thrush, the **American Robin,** is of course the most familiar neighborhood bird and breeds throughout. Like the Blue Jay, it is a partial migrant, seen in large flocks in October and November, and the species is present in our Region year-round. The species is one of the most widespread of North American songbirds, ranging from Alaska and arctic Canada to Mexico and Florida. The northern birds migrate southward in the winter and mix with local resident flocks. Robins tend to disappear from backyards in winter, when birds join in flocks and head out in search of fruit and other fare. Large flocks can be found in low-country thickets near rivers. In spring, the robin is one of the neighborhood's best songsters, perching high in a branch or rooftop to deliver its repeated *cheerli-cheer-up* song. 12,200 were counted at Arbutus, MD, on 8 December 1985. 10,090 were counted passing the Cape Henlopen, DE, hawk watch on 29 October 2010.

Six forest thrushes form a group of similar-looking birds: Wood Thrush, Veery, Swainson's Thrush, Hermit Thrush, Gray-cheeked Thrush, and Bicknell's Thrush. All of these cryptically plumaged thrushes are ground-feeders, found foraging on the leafy forest floor of mature woods. Some are passage migrants but others are local breeders. All are migratory. The **Wood Thrush** is a widespread

(Left)
The electric azure hues of the Blue Jay are a welcomed splash of color on the drab winter landscape.

(Right)
Spring is in full swing when the buttercups are blooming and American Robins are hunting for worms.

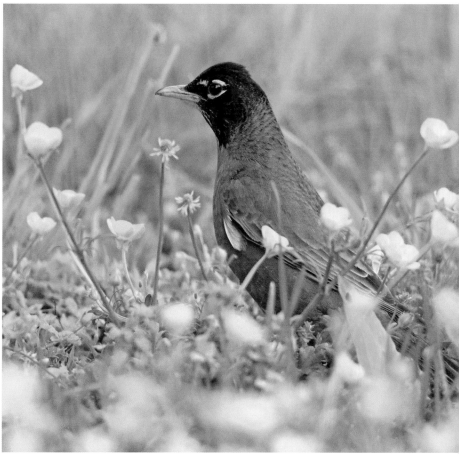

breeder throughout our Region in damp deciduous woodlands. The abundant spotting on the breast and belly and rich red-brown upperparts are diagnostic. The species breeds across the eastern and central United States and migrates in winter to Mexico and Central America. Its slow fluted *eeo-o-lay* song is one of the most distinctive and pleasing sounds of the summer woods, although now it is not heard as frequently because of substantial population declines. It is a species of concern on the US Watch List. The **Veery** is another stellar summer songster of wet deciduous woods—especially of secluded north-facing woodland slopes. To many ears, its rapid, reeling *veer-veer-veeru* song is even more beautiful than that of the Wood Thrush. President Theodore Roosevelt reported in 1908 that this species nested on the White House grounds. 150 were counted at Assateague Island, MD, on 14 September 1986. 86 were counted at Rosedale, Baltimore County, MD, on 6 May 1950.

The **Hermit Thrush** is mainly known in our Region as a regular but reclusive winter resident, hiding out in the same tangles of wooded ravines where one might find a Winter Wren. This is the only *Catharus* thrush to winter in the United States, making winter identification of this drab species straightforward; the russet rump and tail are diagnostic, and the tail is slowly dipped up and down—unique within this group. The species breeds in the Appalachians and Rockies, New England, and boreal forests north to Alaska. It winters in the southern United States and Mexico. In our Region, the species breeds in the Allegheny Highlands, especially in thickets and conifer stands. This species also possesses a high, musical, and mysterious breeding song—a song likely coming from a damp and dark glade. 156 were counted at the Cape Henlopen, DE, hawk watch on 29 October 2010.

Swainson's Thrush is our most common passage migrant thrush, found in shady places in thick vegetation during migration. It formerly bred in the Allegheny Highlands until the large stands of native conifers were felled. Today, the species breeds in boreal conifer forests from eastern Canada to Alaska, northern New England, the Appalachians south to West Virginia, and in the Rockies. It winters in the Andes of western South America. It passes through our Region in large numbers. Note the buffy eye ring and the uniform olive upperparts. 1,900 were counted at Laurel, MD, on 29 September 1950. 300 were counted at a site in Harford County, MD, on 22 May 2011. The **Gray-cheeked Thrush,** an uncommon passage migrant to our Region, breeds in the boreal forests of northern Canada and Alaska and winters in northern South America and the Caribbean. In passage, it can be found searching for invertebrates on the shaded leafy forest floor of damp woodlands. The Gray-cheeked is a dull and less common version of the Swainson's Thrush and lacks the distinctive eye ring. 1,000 were estimated at Laurel, MD, on 29 September 1950 (on the same day and at the same place as the high count of Swainson's Thrushes). 60 were counted at Sugarloaf Mountain, MD, on 29 September 2002. The nearly identical **Bicknell's Thrush** is a rare passage migrant with few records for the Region. There are few records for the Region for four reasons: (1) It was recognized as specifically distinct from the Gray-cheeked Thrush only in 1995. (2) It is rare. (3) It is difficult to distinguish from the Gray-cheeked. (4) Its diagnostic song is rarely heard in passage. It breeds atop mountains in New England, the Catskills, and the Adirondacks and winters mainly in the mountains of Hispaniola and eastern Cuba. It is a species of highest concern on the US Watch List. 9 were counted at a site in Anne Arundel County, MD, on 23 May 1999. All of the Region's woodland thrushes are vocal nocturnal migrants; by learning each species' flight call, one can record many more of these birds in a season than you would ever see.

The **Northern Mockingbird** is another well-known and beloved neighborhood bird of the suburbs. It is a common bird of the South, ranging from coastal New England to Southern California. In our Region, the species is nonmigratory. This

A little poking around the neighborhood woodlot might turn up a Hermit Thrush in fall.

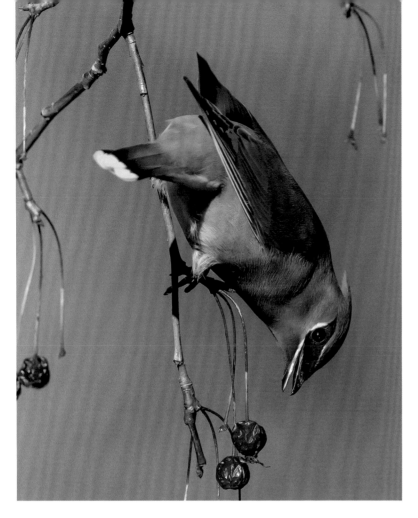

Ripe berry trees in the neighborhood are always worth a look for the dashing Cedar Waxwing. Photo: Bonnie Ott

drab bird is a wonderful songster, even singing late at night on warm summer evenings when the moon is full. It can also mimic the calls of other species. It breeds throughout our Region though it is rare in the Allegheny Highlands. The **Gray Catbird** is a relative of the mockingbird and a common backyard bird in wooded suburban neighborhoods. This species breeds across the United States to the Rockies and winters in Florida, the Caribbean, and Mexico. It breeds throughout our Region and is a sparse winter resident east of the Appalachians. This all-dark songbird is known for its friendly conversational vocalizations as well as its catlike mewing call. It nests in thickets along woodland edges and forages on the ground and in low shrubbery for invertebrates and berries. 310 were counted at Fort McHenry, MD, on 1 May 2012. The **Brown Thrasher** is our third member of the Mimidae family (the mimic thrushes) and is an uncommon but widespread breeder and sparse winter resident. This is a bird of thickets associated with old fields and clearings in agricultural and suburban lands. It mainly

forages on the ground in brush, tossing leaves in search of invertebrate prey. It breeds through the eastern and central United States and winters in the South. It is a species in decline. 100 were reported on Gibson Island, MD, on 8 May 1955.

The demurely beautiful **Cedar Waxwing** is a common though frequently overlooked mobile flocking species that ranges throughout North America and winters southward to the southern states and into Mexico and Central America. It is easily identified by its crest, black mask, and habit of switching positions while flying in flocks. It is found year-round in our Region but its highly mobile flocks, often seen in fall and winter, are always on the move in search of trees with ripe fruit. The species is most common in open habitats and clearings, especially where there are fruiting plants in abundance. 1,500 were counted at Elk Neck SP, MD, on 11 November 2014. 1,325 were counted at Patuxent, MD, on 23 February 1956.

The **European Starling** was intentionally introduced to Central Park in New York City in 1890 and 1891 and rapidly expanded its US range to include Maryland by 1902. It is now ubiquitous throughout North America. It is an abundant permanent resident in our Region and generally not a popular bird, mainly because it aggressively displaces native birds from feeders and nesting sites. Winter foraging flocks (known as murmurations) can be observed wheeling wildly in the sky when a raptor approaches. 100,000 were estimated at the Back River wastewater treatment center, in Baltimore County, MD, on 3 January 1978. The **Northern Cardinal,** one of our most familiar backyard birds, is a common visitor to feeders stocked with sunflower seeds. This permanent resident breeds throughout the eastern and central United States and into the Southwest and Mexico. The gorgeous male is beautiful year-round, but especially when seen against a background of fresh snow. In this species, both males and females sing, which is exceptional. 640 were tallied on the Annapolis, MD, Christmas Bird Count on 1 January 1956.

Rarities

The **Boreal Chickadee** is a bird of conifer forests of the Great North Woods. It is a very rare vagrant to our Region, that, unlike other chickadees, rarely visits bird feeders. The **Rock Wren** is a species of the arid West that rarely strays to the East Coast. There are a few dozen records from the East. The **Fieldfare** is a European thrush that breeds in northern Eurasia and migrates to southern Europe and North Africa for the winter. There are a dozen or more records of storm-carried vagrants to eastern North America in winter and early spring. The **Varied Thrush** is a bird of the mature conifer forests of the Pacific Northwest, breeding north into Alaska. It winters along the West Coast. It is a regular but rare winter vagrant to the East, occasionally appearing below backyard feeders. **Townsend's Solitaire** is a slim gray western thrush of the Rockies. The northern populations in Canada and Alaska winter south to the western United States and Mexico. This is a bird of montane conifer forests. There are records from the East from October to April. The **Sage Thrasher,** a bird of the interior West, breeds in the Great Basin and winters in the Southwest and Mexico. It is an accidental vagrant to the East Coast, appearing in autumn and winter. The **Bohemian Waxwing** is a larger cousin of the more familiar Cedar Waxwing. This handsome breeder of the far north of Canada, Alaska, and Eurasia winters in flocks in the northern tier of the United States, rarely irrupting farther south. Finally, the **Red-cockaded Woodpecker** was formerly a scarce breeder in the southern piney woods of our Region. It is a species of highest concern on the US Watch List.

Berry-loving species like the Gray Catbird seek out American Pokeweed, a common native herbaceous perennial.

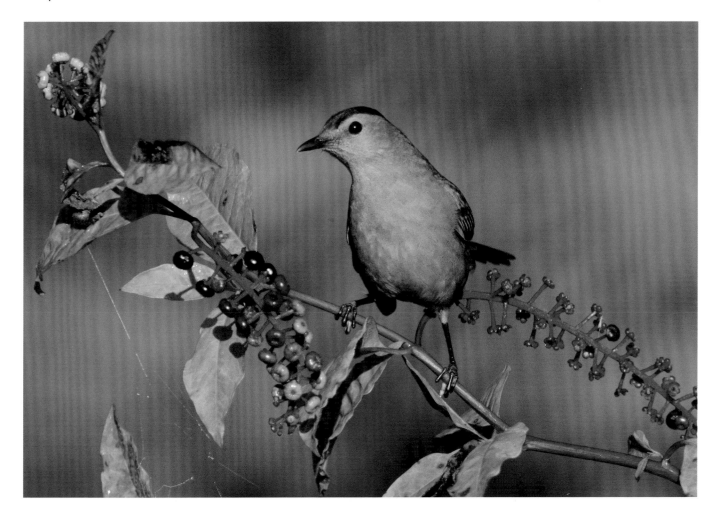

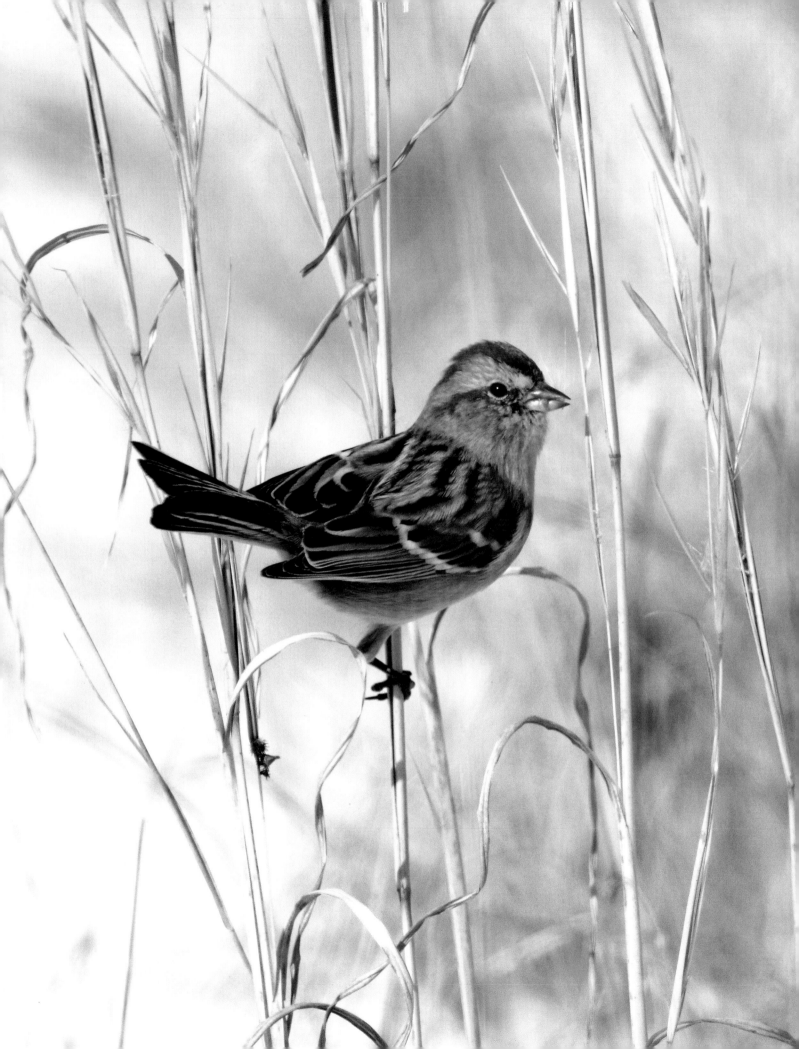

Sparrows and
Their Terrestrial Allies

The sparrows and their terrestrial allies constitute a fairly homogeneous assemblage of ground-feeding birds that are an important part of our local avifauna. These include the New World sparrows, the longspurs, and a few disparate other groups. These seed-eating birds all forage on the ground and are mostly cryptically plumaged—streaked and spotted with browns and buff; many are migratory. Although some will visit feeders, others hunt for spilled seed on the ground. Some nest in yards, whereas other species favor marshes, open fields, or agricultural lands. One species—the House Sparrow—is a common human commensal. Identifying birds from this group can often be challenging as they all look similar and lack obvious field marks, leading frustrated birders to lump them together as LBJs ("little brown jobs").

Towhees

The trimly patterned **Eastern Towhee** (formerly known as the Rufous-sided Towhee) is a common year-round resident. The handsomely patterned male and female plumages are atypical of this group. The species breeds through the eastern United States and is a partial migrant, with northern birds wintering in the Mid-Atlantic States and southward. Birds are present year-round throughout the Southeast. This is a species of thickets and clearing edges, where it forages on the

Native grasses at Irvine Nature Center, Baltimore County, MD, make for great sparrow habitat, especially for the elusive American Tree Sparrow.

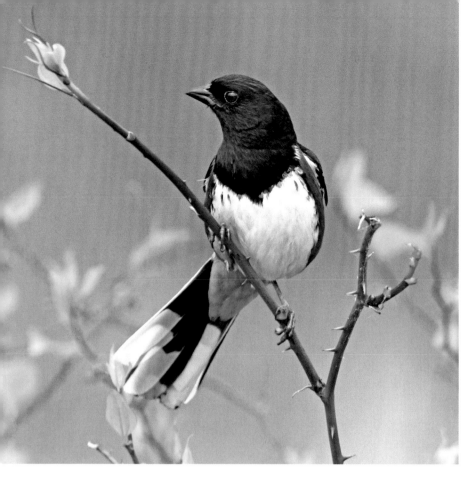

ground by scuffing up leaves in search of invertebrates and edible plant matter. The loud *drink your tea* song of the male alerts birders to the presence of this reclusive bird. Both sexes give the sharp and slurred *chew-whee?* ("towhee?") call year-round. Locally, this species has declined substantially in the last several decades. 320 were counted at Rosedale, MD, on 6 May 1950. Two additional towhee species are discussed in the rarities section.

Longspurs and Snow Bunting

The **Lapland Longspur** is an Arctic breeder that winters through much of the United States. Look for it in bare fields and other expansive open ground, often in small flocks associated with Horned Larks. Small flocks of these sparrow look-alikes tend to get lost in the furrows of fallow fields

Unusual for sparrows, the Eastern Towhee has crisp lines, high contrast, and a ruby eye.

A winter visitor from the Arctic, the Snow Bunting prefers open ground, such as bare dirt fields and sandy beaches, for feeding.

but then suddenly fly up and swirl about before settling again. 195 were reported from Clark's Lane fields, Caroline County, MD, on 16 December 1995. The **Snow Bunting** breeds in the high Arctic and winters as far south as the middle latitudes of the United States, foraging on expanses of bare open ground—including beaches, barrens, and fallow fields. It behaves much like the preceding species but is larger, whiter, and often found in larger flocks. 300 were recorded from Hart-Miller Island, MD, on 4 January 1997.

Juncos

The **Dark-eyed Junco** is a New World sparrow, but with its distinct name and look, we give it a separate account. Often informally called "snowbird," this junco is a breeder in New England, the Appalachians, Canada, Alaska, and the Rockies, wintering throughout the United States. It is a common pas-

sage migrant and winter resident, often feeding on the ground below backyard feeders. It is a regular suburban bird in our Region in winter and is easily recognized by its gray body, white belly, and white outer tail feathers, which are prominent in flight. The species nests in the Allegheny Highlands, usually in association with conifers. 2,508 were tallied on the Annapolis, MD, Christmas Bird Count on 1 January 1956. 1,100 were recorded passing the Cape Henlopen, DE, hawk watch on 29 October 2010.

Typical Sparrows

The 18 species of typical sparrows are a mix of common and rare birds, all of which forage on the ground and in grasses for seeds and roost in stands of long grass or thickets. The group is morphologically uniform and all are streaked with a variety of shades of brown, buff, black, and white. All are easily recognized as sparrows and, for identification purposes, can be divided into those with or without breast streaks. The **Song Sparrow**, a widespread and common year-round resident in our Region, is one of our most familiar neighborhood birds. It breeds across the northern half of the United States and into northern Canada and Alaska. Many of the northernmost populations migrate southward in winter, though a broad swath of birds in the middle of the country is nonmigratory. Presumably in our Region in winter, our significant numbers of migrants from the north supplement our permanent residents. The species prefers to feed and nest in thickets and shrubbery at the edges of openings and along river edges and marshes, as well as suburban neighborhoods. The species has a lovely, complex, and bright song usually delivered from a prominent perch during which its large central breast spot and profuse dark flank streaking can be seen. 1,287 were counted at the Ocean City, MD, Christmas Bird Count on 27 December 1953. 490 were recorded from a site in Talbot County, MD, on 14 October 2012. The **Swamp Sparrow** resembles a dark and washed-out Song Sparrow with a gray breast without

The Dark-eyed Junco should be familiar to anyone who has a winter feeder, as juncos love to browse the ground for fallen seeds.

any prominent streaking. This wetlands specialist breeds across the Northeast, the Northern Tier of the United States, and into western Canada, wintering to the Southeast and Mexico. It is present year-round in our Region, as a breeder, passage migrant, and over-wintering bird, although it only breeds in wetland and coastal habitats. Listen for its song in marshlands and cattails: a long series of identical musical notes: *chi-chi-chi-chi-chi-chi-chi. . . .* This is a distinctive voice of the summer marshlands. 1,271 were tallied at the Dorchester County Christmas Bird Count on 28 December 1953. **Lincoln's Sparrow** breeds in boreal spruce bogs of the North Woods and moun-tains of the West and winters in the southern United States. It is an uncommon passage migrant in our Region. The species is a shy and reclusive thicket lover, easily overlooked or mistaken for a Swamp or Song Sparrow. Usually, it is nervously moving about and flicking its wings and tail. 12 were counted at Trout Run, Garrett County, MD, on 1 October 2017. The **Fox Sparrow** is a large reddish-brown streaked sparrow that breeds in northern Canada and winters in the Southeast and the Mid-Atlantic. The species forages in leaves near brush or woodland edge and is often found in association with other sparrow species. An uncommon feeder visitor, it is in decline. 200 were counted near Unity, MD, on 14 March 1954.

The **White-throated Sparrow** is our second most familiar sparrow, arriving from its northern breeding range in late September and departing by mid-May. It is a common passage migrant and a common wintering bird, where it is found in small flocks scratching below feeders or roosting in thickets and hedgerows at the edge of woodlands. This boreal forest nester breeds in New England and across Canada and winters through the eastern and central United States south to the Gulf and west to the coast of California. Its mournful whistled song is a favorite of birders: *soh-see-suu-suu-suu-suu* ("Old Sam Peabody"). 2,765 were tallied on the St. Michaels, MD, Christmas Bird Count on 29 December 1955. 900 were recorded from the Cape Henlopen, DE, hawk watch on 29 October 2010. 297 were recorded at Dragon Run SP, DE, on 11 March 1973. The **White-crowned Sparrow** is an uncommon passage migrant and sparse winter resident in the Region. The species breeds in north-ern Canada northwestward to Alaska and south down the Rockies to California and New Mexico. This species is less associated with woodland edge and more common in roadside hedgerows in open agricultural land where small groups can be found. 85 were counted at Edgewater, MD, on 10 January 1999. 25 were counted at Brandywine Creek State Park, DE, on 20 December 2014.

The diminutive and oddly endearing **Chipping Sparrow** is a widespread and commonplace breeder, a common migrant, and a sparse wintering species through our Region. The species breeds across North America to Alaska, wintering to the southern United States and Mexico. In summer, it is most prevalent in grassy clearings of open woodlands and suburban parks that feature tall spruces and other conifers used for nesting. In winter it often associates with other sparrows where its smaller size is readily apparent. The summer song is a long trilled series of identical mechanical notes delivered rapidly and on the same pitch throughout (some-times sounding like the song of a Worm-eating Warbler). Note the bright chestnut cap and plain

The Fox Sparrow, with its lovely rusty tones and large size, is one of the easier sparrows to identify (and it does visit feeders).

gray underparts. 550 were recorded from Cape Henlopen, DE, hawk watch on 29 October 2010. The **Clay-colored Sparrow** is similar in size and plumage to the preceding species but is plainer. This midwestern species is a rare passage migrant through our Region, with a handful of records per year, mainly in October or May, but also in summer. A regular breeder in West Virginia. It nests in thick stands of small pines, such as Christmas tree farms.

The **Field Sparrow** is found mainly in weedy fields in rural settings and is prevalent year-round, though less common during the winter. The species breeds in the eastern and central United States and winters in the southern United States. The summer song is a musical and sweet series of down-slurred notes that speeds up, with the later notes shortening and compressing, often likened to a ping-pong ball being dropped on a table. 350 were recorded at Port Tobacco, MD, on 7 April 1953. 133 were recorded from a single Maryland sector of the Chincoteague Christmas Bird Count on 29 Dec 2012. 57 were recorded at Dragon Run SP, DE, on 14 April 1973. The **American Tree Sparrow**, similar in plumage to the smaller Field Sparrow but with a two-tone bill and dark breast stick pin, is an increasingly uncommon winter visitor from its northern Canadian breeding habitat. The species winters across the middle of the United States in brushy and weedy habitat with some mix of small trees. The southern extent of its wintering range is the middle of our Region. 544 were counted on the Triadelphia, MD, Christmas Bird Count on 24 December 1955. 250 were recorded from Montchanin, DE, 19 October 1931. 58 were recorded from Mount Pleasant Farm, Howard County, MD, on 3 February 2001.

The **Savannah Sparrow** superficially resembles a Song Sparrow but is smaller, shorter-tailed, has a yellow spot in front of the eye, and inhabits open grassy fields, adjacent road shoulders, and barren patches of ground. This is a species that spends most of its time on the ground or perched low in the grass. It breeds across the northern half of North America, wintering in the South. It breeds in

the northern sector of our Region, most commonly in the northern Piedmont and Allegheny Highlands. 275 were counted at a site in Howard County, MD, on 26 October 2008. 200 were estimated on the Port Mahon Road, DE, on 28 September 2003. The "Ipswich Sparrow" is a distinctive pale subspecies of the Savannah Sparrow, which nests on Sable Island east of Nova Scotia. It can be found in dune vegetation along the Atlantic shore in late fall and winter. The **Vesper Sparrow** breeds across the northern United States and into southern and western Canada. The Vesper has a distinctive white tail flash, subtle white eye ring, and small chestnut shoulder patch and, unusually for a sparrow, flies high into a tree when disturbed. "Several hundred" were reported from north Baltimore, MD, on 10 April 1897. 50 were reported from Queen Anne's County, MD, on 4 March 1893.

The **Grasshopper Sparrow**, an uncommon nester in our Region, is a small and retiring grassland specialist that breeds across much of the United States except for the arid interior West. It winters in the Deep South but is rarely seen as a migrant. It is most easily detected during the breeding season by listening for its insect-like

Fence posts in farm country are a good place to look for the Grasshopper Sparrow, otherwise invisible when tending its ground nest.

song. 126 were recorded from the Patuxent River Naval Air Station, MD, on 17 May 2005. The very similar **Henslow's Sparrow** is an old-field specialist that is rare in our Region. It mainly breeds in the upper Midwest almost entirely within the Mississippi drainage. It winters in the Deep South. Both Henslow's and Grasshopper Sparrows can be found breeding in weedy and brushy grasslands that have been restored after surface coal mining in the Allegheny Highlands. Henslow's Sparrow is a species of concern on the US Watch List. 23 were recorded in Charles and St. Mary's Counties, MD, on 9 May 1953. **Le Conte's Sparrow** breeds in wet grasslands in the north-central United States and Canada, wintering to the Deep South. It is a rare and skulking autumn migrant to the East Coast. There are a handful of records for our Region, with a few birds probably wintering annually.

Nelson's Sparrow is the northern-breeding member of the "sharp-tailed" sparrows. This species breeds in the Canadian Maritimes, north-central Canada, and the northern prairie region of the United States. It winters along the Mid-Atlantic and Gulf coasts. In our Region, it is a rare passage migrant and scarce winter resident along the coast, much rarer inland. This species is nearly identical to the closely related Saltmarsh Sparrow, and is a species of concern on the US Watch List. 24 Nelson's Sparrows were recorded from Prime Hook NWR, DE, on 3 December 2012. The **Saltmarsh Sparrow** (the other "sharp-tailed" sparrow) nests along the Atlantic Coast from New England south to North Carolina. It winters along the coastal saltmarshes of the Southeast. This is a marsh specialist, preferring shortgrass marshlands. It is in decline and is a species of highest concern on the US Watch List. 20 were recorded from a site in Worcester County, MD, on 25 June 2000. The dark-plumaged, large-headed **Seaside Sparrow** is a common coastal saltmarsh specialist, inhabiting deeper water marsh-

The sublime Henslow's Sparrow is a regional specialty, breeding at reclaimed strip mine grasslands in the Allegheny Highlands.

The Saltmarsh Sparrow is a species of concern, as the shortgrass coastal saltmarsh habitat it requires is threatened by sea-level rise.

Another saltmarsh specialist, the Seaside Sparrow is much easier to spot as it sings from elevated perches.

lands than the Saltmarsh and Nelson's Sparrows. It is partially migratory. It is a species of concern on the US Watch List. 200 were recorded at the Mispillion Wetlands, DE, on 7 May 2008.

The large and handsomely marked **Lark Sparrow** breeds through the Midwest and West, wintering to Mexico. Note the striking facial pattern and black breast spot, making it one of our most distinctive sparrows. A former breeder in the Region, it is now a rare, but regular, visitor, mostly in the fall at coastal locations. It prefers to forage on the ground in grassy verges of open agricultural land, often adjacent to hedges, into which it retreats for protection when approached. 5 were counted on the beach north of Ocean City, MD, on 4 September 1954.

Odds and Ends

These three sparrow-like species are entirely unrelated to the New World sparrows but are grouped here because they are sometimes found together with sparrows in similar habitats. The **Horned Lark** is a year-round resident and breeder in our Region, inhabiting agricultural fields and other barren openings in agricultural landscapes. The species breeds across North America and winters mainly in the United States and Mexico where it feeds on bare ground in flocks. 1,000 were counted in Clark's Lane fields of Caroline County, MD, on 16 December 1995. The **American Pipit** breeds in the Arctic, the Rockies, and atop some eastern mountain summits in New England. The species winters in the southern United States and Mexico. In our Region, this pipit is an uncommon passage migrant, especially in November, and a fairly common winter resident. Pipits forage on open ground in agricultural landscapes and coastline beaches. They are sparrow-like, but note the long legs, thin bill, rapid movement, and bobbing tail. 2,000 were reported at Seneca, MD, on 25 October 1952. 335 were reported at Prime Hook NWR, DE, on 30 December 2007.

The **House Sparrow**, along with the European Starling, is a well-known common human com-

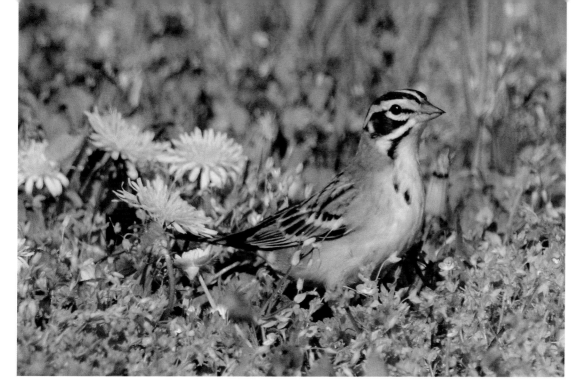

The distinctive Lark Sparrow is a prized bird, a wanderer from the nation's midsection.

mensal and introduced species in our Region but not especially popular as it outcompetes native species, such as Eastern Bluebirds, for nesting sites. It was first found in Hancock, MD, in 1865. It was introduced to the District of Columbia in 1874. It is a regular feeder visitor and congregates in barnyards and urban settings. This year-round resident breeds throughout our Region and remains common, but the species has been declining for several decades for unknown reasons. 470 were tallied in northeastern Frederick County, MD, on 15 December 2002.

Rarities

A number of rarities are recorded for this group. The **Green-tailed Towhee**, a species of the montane West that winters into Mexico, has been recorded once in Delaware and once in Maryland. The **Spotted Towhee**, the western counterpart to the Eastern Towhee, breeds widely in the West and winters in the Southwest and Mexico. It has been recorded a couple of times from our Region from May and December.

The **Northern Wheatear** breeds in Eurasia, the Canadian Arctic, and Alaska, and is a rare but regular vagrant to the eastern United States. It is known from several records in the Region.

The **Chestnut-collared Longspur**, a breeder on the northern Great Plains, winters south to Texas and the Southwest and has been recorded three times in Maryland. **Smith's Longspur**, which breeds in the Canadian Arctic and Alaska, winters south to the southern Great Plains and is known from our Region from a single record on Assateague Island, MD, in winter.

The **Lark Bunting**, which breeds widely in the western Great Plains and winters in Texas and Mexico, has been recorded from our Region a handful of times, mainly in September. **Cassin's Sparrow**, a breeder in the southern Great Plains and Southwest that winters in Mexico, has been recorded from our Region on a single occasion in September. **Bachman's Sparrow**, a nonmigratory breeder of the southern pinelands, is a former breeder in our Region last recorded in December 1957. **Baird's Sparrow**, another breeder of the northern Great Plains, winters in northern Mexico. There is a single record from Maryland.

Harris's Sparrow breeds in far northern Canada and winters south into the southern Great Plains. It is a rare late fall migrant and scarce winter visitor to our Region, with birds mainly observed at feeders. The **Golden-crowned Sparrow** breeds along the West Coast from Alaska to British Columbia, wintering down the West Coast of the United States. There is a single winter record from Maryland.

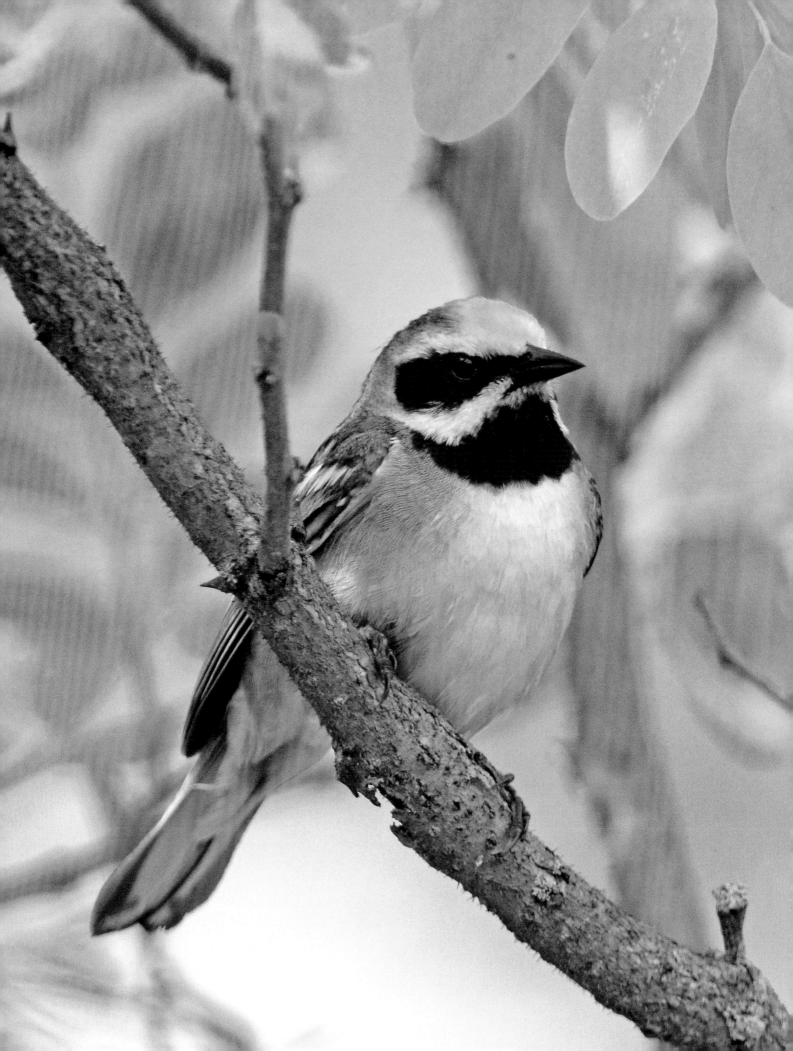

Warblers and Look-alikes

Wood warblers dominate this grouping, which also includes vireos and a gnatcatcher. The latter two groups are not uncommonly mistaken for wood warblers because of their small size, color, and similar foraging style. Nearly all of these small songbirds inhabit wooded habitats and are neotropical migrants, spending their winters mainly south of the US border. All forage for insects among leaves and twigs and are vocal on their breeding territory. The warblers are much beloved by birders: in the spring, they possess a stunning diversity of colorful male plumages, but in the fall, they often exhibit much more subdued plumage (especially juveniles), which presents serious identification challenges to the beginner. These birds can all be readily identified by their distinctive spring songs as well as by their more subtle chip notes and flight calls. Learning all of these is one of the major challenges of birding.

Gnatcatcher

The **Blue-gray Gnatcatcher** is a slim and plain-colored songbird, bluish dorsally and white ventrally, with prominent white flashes in the long tail. The species is an early-arriving breeder across the United States and winters in the Deep South and Mexico. This gnatcatcher breeds throughout our Region along the edges of woodland openings, especially in bottomlands near water. Foraging birds tend to stay rather high in the outer vegetation of trees in search of insects and become difficult to

Sightings of Golden-winged Warblers are few and far between, as it is a rare spring migrant and sparse breeder in shrublands of the Allegheny Highlands.

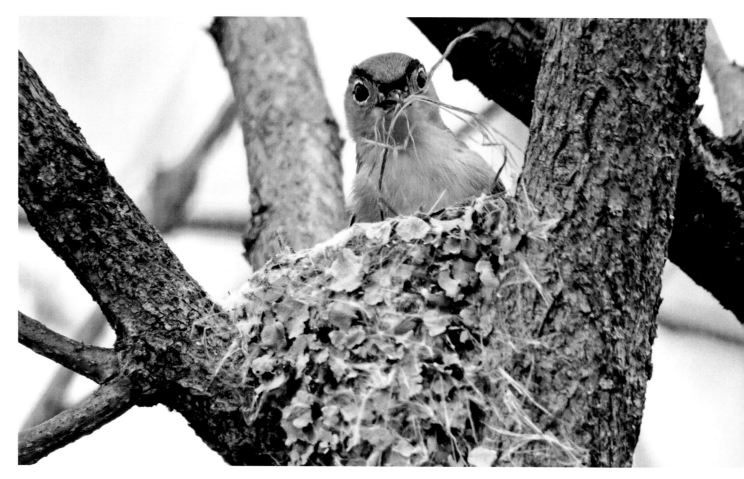

A diminutive Blue-gray Gnatcatcher finishes off its nest, which is plastered with lichens. Photo: Keith Eric Costley

When seen in proper light, the eye of the Red-eyed Vireo glows like a jewel.

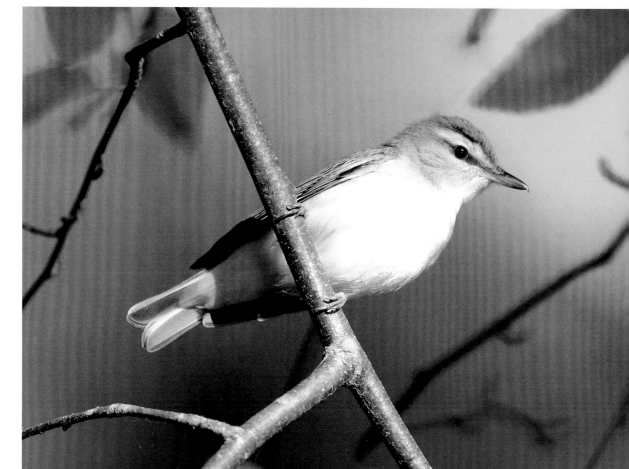

see during the breeding season. 227 were counted on 13 May 2000 in Howard County, MD.

Vireos

The vireos are stolid insect-foragers of woodlands and shade trees, noted more for their distinctive vocalizations than for their rather subdued plumages. They all are migratory and are only found in our Region as passage migrants or breeders and wintering to the south. The **White-eyed Vireo** is a common breeder, inhabiting thick vegetation in regenerating woodland and at the wooded edges of old fields, especially in damp bottoms. It breeds throughout the eastern United States and winters in the Deep South, the Caribbean, and eastern Mexico. The species tends to hide deep in vegetation but its loud and explosive song makes finding the species straightforward. 59 were counted in the Ocean City, MD, area on 5 May 1951. 18 nocturnal migrants of this species were killed when striking the Washington Monument in Washington, DC, on 12 September 1937. The **Yellow-throated Vireo** is another breeder most often found singing from high in the canopy of tall shade trees by water or other openings. The species breeds in the eastern United States and winters in Mexico and northern South America. Like the preceding species, this bird is best located by its distinctive song, a slow series of slurred and burry musical notes. 25 were counted at Wills Mountain, Allegany County, MD, on 3 September 1901. The **Blue-headed Vireo** is a bird of northern forests, breeding from New England to northwestern Canada and southward down the Appalachians. It is an uncommon early spring passage migrant through our Region and a breeder in the Allegheny Highlands. It winters in the Deep South and from eastern Mexico to Central America. 33 were counted at Carey Run Sanctuary, MD, on 5 October 2013. The **Warbling Vireo** is a common and vocal breeder in tall shade trees beside water or other open habitats. The species breeds across the United States and winters in Mexico and Central America. It is so

An uncommon passage migrant, the Philadelphia Vireo will be the highlight of a late spring bird walk. Photo: Bruce Beehler

plain that it has no distinctive field marks but for the rapid, burry warble it gives from the treetops. Note the lack of wing bars, the lack of an eye ring, and minimal markings on the face. It is scarce on most of the Eastern Shore. 75 were counted in Washington County, MD, on 7 May 1949. 37 were counted along the C&O Canal, Montgomery County, MD, on 17 May 2017. The **Philadelphia Vireo** is a passage migrant through our Region that is rare in spring and uncommon in fall. It breeds in deciduous regrowth in the North Woods and winters in Central America. Best identified by the yellow wash to the throat, lack of wing bars, and small bill. The song is much like that of the Red-eyed Vireo. The **Red-eyed Vireo** is a common and widespread breeder in deciduous forests across our Region. Its song is a commonplace early summer sound in our woodlands. The species is a sluggish insect-forager of the forest canopy. Its breeding range extends across eastern and the central United States to northwestern Canada. It winters in South America. 87 were counted at Violette's Lock, MD, on 11 May 1991.

The modestly plumaged Louisiana Waterthrush nests in crevices close to the ground along forested wetlands.

Wood Warblers

The wood warblers are our most spectacular group of songbirds. Many of the breeding males are multicolored and boldly patterned. Many species are also wonderful songsters. Most are forest breeders and all are migratory, with most wintering in the tropics. The wonderful flood of species that pass through our Region in spring draws out flocks of birders from their winter hibernation. In the first and second weeks of May, these pilgrims head to the woods in search of as many warbler species as possible. Under ideal conditions of weather and habitat, it is possible to observe 25 species in a single day with some driving and good luck, although this has become more difficult in recent decades because of the substantial declines in many of the species.

The rather plain and streak-breasted **Ovenbird** is one of our most common and widespread breeding wood warblers and can be found in mature upland deciduous forests or mixed forests. Its loud and ringing *teechur teechur teechur TEECHUR* song, usually given from a forest sapling, is a ready means of locating this rather shy ground-feeder. The species builds its distinctive domed nest on the ground throughout the eastern and central United States and Canada, and it winters to Mexico and the Caribbean. It is also a common migrant through our Region. 66 were recorded from Rosedale, Baltimore County, MD, on 6 May 1950. 30 were recorded at White Clay Creek SP, DE, on 15 May 1976. The **Louisiana Waterthrush** is another drab-plumaged warbler that forages on the ground near freshwater streams within the interior of mature deciduous forests. This and the Northern Waterthrush have the look of a miniature streak-breasted thrush. The Louisiana Waterthrush breeds in the eastern United States and winters in the Caribbean, Central America, and northern South America. The species is a widespread but patchy breeder across our Region. It has a loud ringing song that is quite like that of the much rarer Swainson's Warbler. This waterthrush constantly wags its tail as it hunts for insects along watercourses. 35 were counted along Western Branch, Prince Georges County, MD, on 19 April 1947. The nearly identical **Northern Waterthrush** is mainly a passage migrant through our Region and breeds in the Appalachians, New England, and boreal Canada. It winters in Central and northern South America and the Caribbean. This species breeds in our Allegheny Highlands, mainly in bogs. In migration, both waterthrushes are mainly found in wooded wet spots on the verges of water. 20 were recorded at Assateague Island, MD, on 30 August 1994.

The **Golden-winged Warbler**, a species in serious decline, is a rare passage migrant through our Region and also a rare breeder in the Allegheny Highlands and westernmost Ridge & Valley provinces. The species breeds on the ground under sapling-stage trees in old fields. It has a patchy

breeding range in the northern United States and the Appalachians and winters in Central and South America. It is a species of highest concern on the US Watch List. 17 were recorded at Patuxent, MD, on 8 May 1943. 8 were recorded along the C&O Canal in Western Maryland, on 7 May 1983. The **Blue-winged Warbler** is the southern and eastern counterpart of the Golden-winged, and these two species hybridize where their ranges overlap. The Blue-winged breeds in the eastern and central United States and winters in the Caribbean and Central America. In our Region, it is a patchy breeder in regenerating shrubby old fields in the Piedmont and Ridge & Valley provinces. 23 were recorded in the Pocomoke River area, MD, on 5 May 1951. 21 were recorded at White Clay Creek SP, DE, on 28 May 1977. The named hybrids produced by the crosses of these two related species are the "Brewster's Warbler" (white belly, yellow cap, yellow wing bars) and the "Lawrence's Warbler" (yellow belly, black face and throat, and white wing bars). The "Brewster's Warbler" is much more prevalent. The Blue-winged often shares its open scrubby habitat with the **Prairie Warbler,** an uncommon and patchy breeder through the Region. It is a species of concern on the US Watch List. It prefers old abandoned fields with scrubby pines and cedars. This species breeds in the eastern United States and winters in Florida and the Caribbean. It sings its distinctive and rapid insect-like rising series from small saplings in full sun and is never found in forest except during migration. 75 were counted at Port Tobacco, MD, on 11 May 1943.

The **Black-and-white Warbler** is an uncommon but widespread breeder in our deciduous and mixed forests across the Region. The species breeds throughout the eastern United States and through much of boreal Canada. It winters in the Deep South, Mexico, the Caribbean, and southward to northern South America. This species has a unique foraging style of creeping along the trunk of trees to harvest insect prey from the bark, in the manner of a nuthatch. 50 were counted at Patuxent, MD, on

28 August 1943. 42 were recorded near Dover, DE, on 3 May 2016. The **Prothonotary Warbler**—sometimes called the "Golden Swamp Warbler"—is a favorite of birders. The species is a southern breeder, extending northward in the Mississippi Valley to Wisconsin and along the East Coast to New Jersey. It winters sparingly in the Deep South as well as in Central America. It is a species of concern on the US Watch List. The species always nests in a tree

True to its name, the Prairie Warbler favors open grassy meadows with nearby shrubs and trees for sentry duty.

cavity over water and is the only eastern warbler that will use nest boxes. 138 were recorded along the Pocomoke River, MD, on 1 May 1999.

The **Worm-eating Warbler** is one of the plainest wood warblers—plain buff with a black-striped head. Its song is a rapid harsh rattling trill. It is a widespread but uncommon breeder in deciduous forests throughout the Region and is most prevalent on oak hillsides with abundant leaf litter. The species nests in the eastern United States and winters in the Caribbean and Central America. It hunts for insect prey by searching the contents of curled dead leaves. 45 were counted in the Great Cypress Swamp, DE, on 14 May 2016. The **Tennessee Warbler,** another very plain species, is an uncommon passage migrant to our Region. This wood warbler is a can-

opy dweller, and its staccato chattering song is heard much more often than the bird is seen. The species nests in the North Woods and winters in the Caribbean, Central America, and northern South America. It is sometimes confused with the much more common Red-eyed Vireo. 66 were counted at Patuxent, MD, on 14 May 1950. The **Orange-crowned Warbler** is a rare passage migrant through the Region and a rare winter resident. This very plain warbler is most common low in shrubbery at the edges of openings and could be confused with a kinglet (the latter is smaller and more compact, with a tiny beak). The Orange-crowned breeds in boreal Canada, the Rockies, and the West Coast and winters in the Deep South and Mexico. 4 were recorded at a site in Worcester County, MD, on

14 October 2017. The **Nashville Warbler** is an uncommon passage migrant and sparse breeder in the Allegheny Highlands. This tiny warbler is often confused with another, rarer species—the larger, ground-dwelling Connecticut Warbler. The Nashville is best distinguished by its all-yellow throat and small size. The species breeds in the North Woods and western mountains as well as in the Appalachians. It winters in Mexico. 20+ were recorded at Waverly, MD, on 12 May 1892.

The **Connecticut Warbler** is a rare passage migrant most often observed on the ground in thickets of goldenrod in autumn. It is very rarely seen during spring migration. The species breeds in the North Woods and winters in South America. This migrant warbler, which possesses a gray hood and a complete white eye ring, is one of the holy grails for warbler-watchers. 7 were recorded in Prince Georges County, MD, on 3 October 1947. Its more common but very similar relative is the **Mourning Warbler**, another North Woods breeder that winters in Panama and northwestern South America. This very shy species prefers to hide in raspberry thickets, giving away its location by its loud and beautiful song: *cherry cheery cheery cherrio!* It is an uncommon passage migrant through our Region, appearing very late in spring and early autumn. A few pairs breed in mountain thickets in the Allegheny Highlands. 5 were counted at Patuxent, MD, on 31 May 1943. The **Kentucky Warbler** is a widespread but declining and patchy breeder to our Region. The species breeds in the eastern and central United States and winters in the Caribbean, Central America, and northern South America. This species produces a rich rolling song reminiscent of a Carolina Wren and is much more likely to be heard than seen. 40 were recorded near Emmitsburg, MD, on 10 May 1952. 13 were recorded at White Clay Creek SP, DE, on 29 May 1976. The **Hooded Warbler** is a widespread but uncommon breeder to our Region, most prevalent in the Allegheny Highlands and lower Western Shore. It prefers the interior of deciduous forest uplands and bottomlands, sing-

ing from the mid-stages of the forest. The species breeds in the eastern and central United States and winters in the Caribbean and Central America. This species produces a loud and musical warble, ending abruptly, similar but fuller and slower than that of the Magnolia Warbler. 100 were estimated at Gibson Island, MD, on 8 May 1955.

The **Common Yellowthroat** is the most common wood warbler in our Region. It does not inhabit woods but instead is found in marshlands, old fields, and blackberry thickets. It breeds throughout North America and winters in the Deep South, Mexico, and Central America. Its *witchety witchety witchety* song is one of the most familiar sounds of the countryside in summer. 200+ were estimated at Port Tobacco, MD, on 11 May 1943. 150 were counted on Assateague Island, MD, on 14 September 1986. The **American Redstart** is another common summer bird of deciduous forests across our Region. It breeds in the eastern United States and much of Canada, wintering to southern Mexico, Central America, and northern South America. This is one of the more common passage migrants

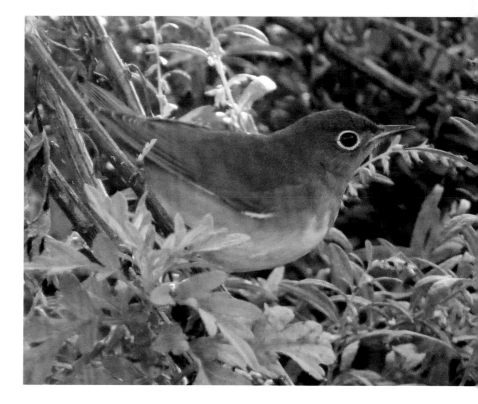

A top target for every fall birder, the drably plumaged and highly reclusive Connecticut Warbler is one of the most difficult birds to track down during the migration season. Photo: Ryan Johnson

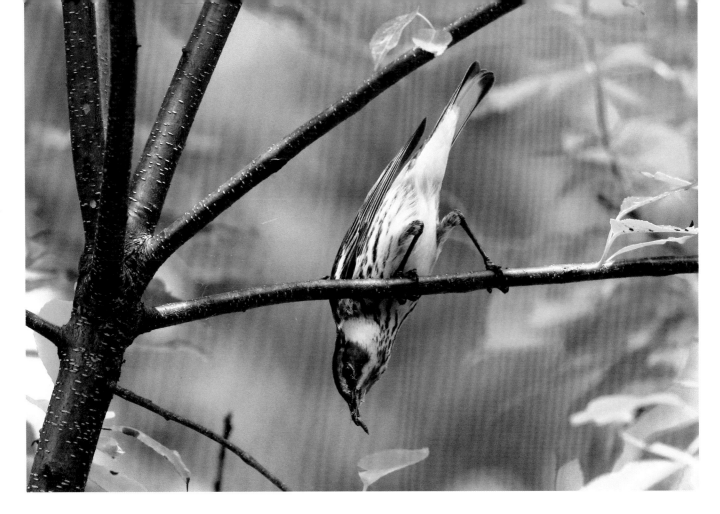

through our Region, and is one of the most familiar woodland warblers, seen foraging frenetically in the lower vegetation of open forest and edge. President Theodore Roosevelt reported that this species nested on the White House grounds (it certainly nested in nearby Rock Creek Park at the time). 200 were recorded from Assateague Island, MD, on 14 September 1996. 75 recorded from Brandywine Creek SP, DE, on 12 September 1971.

The **Cape May Warbler** is a passage migrant, rare in spring and uncommon in autumn. It breeds in the North Woods and winters in the Caribbean, Central America, and northern Venezuela. In spring, this canopy dweller is most often seen high in mature Norway Spruces. Those with good hearing will detect its high and thin *see see see see see*. This species is a spruce budworm specialist, and its population rises and falls depending on the abundance of its insect prey in its boreal conifer breeding habitat. It is often seen in Eastern Redcedars in autumn. "Thousands" were observed at Ocean City, MD, on 2 October 1949. 200 were recorded from Assateague

Island, MD, on 29 September 1994. The **Bay-breasted Warbler** is another North Woods breeder that specializes on spruce budworm. It breeds in the North Woods and winters in the Caribbean and northern South America. It is an uncommon passage migrant throughout our Region, preferring the canopy of oaks in passage. Its song is a slightly more slurred version of the preceding species—*si-syu si-syu si-syu si-syu*—and is equally high pitched and difficult to hear. 43 were recorded at Greenbelt, MD, on 12 May 1956. The sister species to the Bay-breasted is the **Blackpoll Warbler**, a familiar North Woods breeder that ranges to Alaska and winters in northern South America. It is a common passage migrant throughout our Region. It, too, has a high-pitched song at the edge of our hearing, a harsh and rapid-fire *tsi tsi tsi tsi tsi tsi tsi*. Formerly abundant in passage, this species has exhibited a substantial decline over the past several decades. 140 were counted at Patuxent, MD, on 11 October 1947. 100 were recorded from a site in Anne Arundel County, MD, on 6 October 1975.

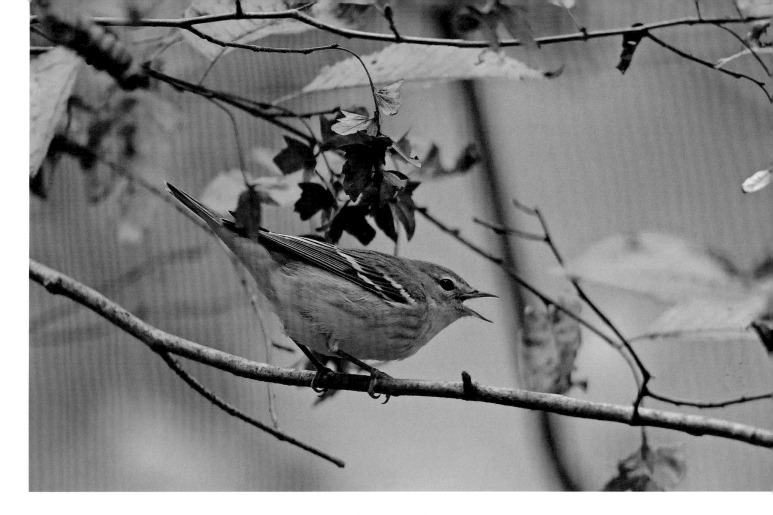

The **Northern Parula** is a widespread breeder in our Region, preferring tall sycamores in bottomlands along large rivers or openings in mature upland forest where there are suitable hanging open branches for placing its pendant nest. The species breeds in the eastern United States and southern Canada and winters in Florida, the Caribbean, and southern Mexico. It is our smallest warbler, small-billed and short-tailed. Listen for its high buzzy song with a terminal flourish, high in a riverside canopy tree. 112 were recorded at Patuxent, MD, on 6 May 1950. 22 were recorded from Brandywine Creek SP, DE, on 9 May 1970. The **Yellow-throated Warbler** is another uncommon breeder that exhibits a mainly southeastern breeding range. It winters in the Caribbean, western Mexico, and Florida. It forages high in sycamores and Loblolly Pines. This is a handsome species with a rich yellow throat, white underparts, and trimly patterned face of black and white. 30 were counted in Pocomoke SF, MD, on 18 April 1992.

Two warblers marked with blue, black, and white breed in our Region. The **Cerulean Warbler** is a rare breeder north and west of the Chesapeake, most prevalent on high oak ridges in the western Ridge & Valley province. This distinctive canopy songster has shown substantial populations declines in the past three decades. It is a species of concern on the US Watch List. It is an eastern breeder and winters in northwestern South America. It is a rare passage migrant and an early autumn migrant, best looked for in August. 16 were recorded at Susquehanna SP, MD, on 11 May 2007. The other of this pair is the **Black-throated Blue Warbler**, a widespread passage migrant and uncommon breeder in the Allegheny Highlands. This species breeds in the Northeast and winters in the Caribbean and Central America. The plumages of the male and female are so different that beginning birders mistake them for different species. The male is a striking mix of blue, black, and white while the female is plain olive-brown with a prominent small white "pocket handkerchief" mark on the folded wing. In passage, the male can be heard singing its leisurely, buzzy, rasping, and rising song from the understory

In autumn, the Black-poll Warbler is one of those "confusing fall warblers," that presents identification challenges for novice birders.

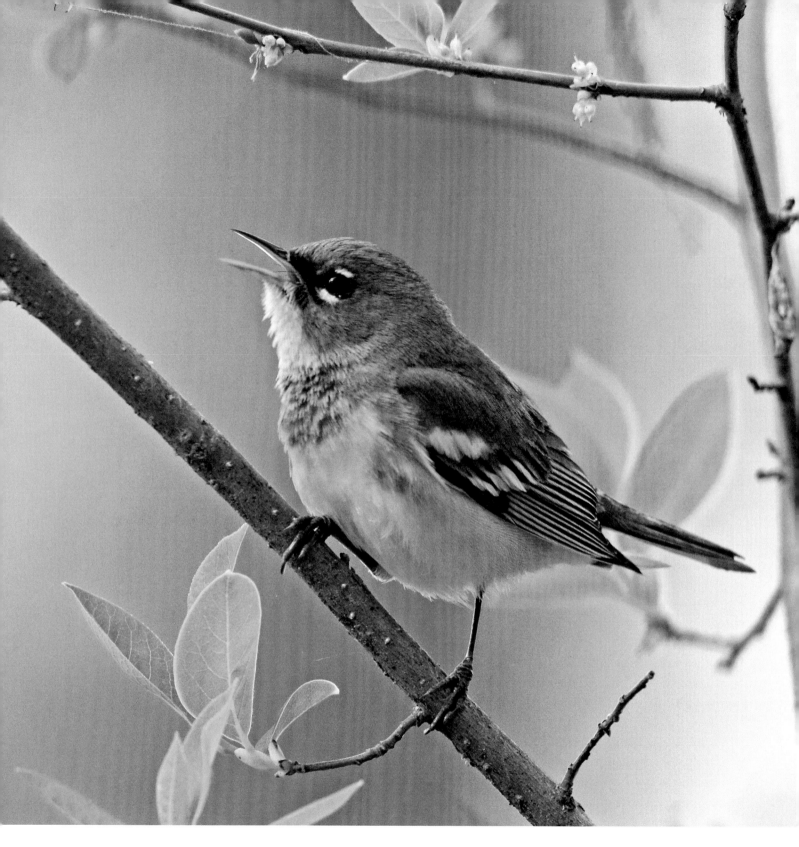

The chipper buzzing song of this Northern Parula livens up the floodplain forest at Susquehanna State Park, MD, a warbler paradise.

(*Opposite top*) It's a challenge to get a good look at the rare Cerulean Warbler, as it nests in tall trees on high ridges of the Ridge & Valley province.

(*Opposite bottom*) One of the most elusive forest breeders in the Allegheny Highlands is the black-necklaced Canada Warbler.

vegetation of deciduous forest. 119 were recorded at Patuxent, MD, on 10 May 1950.

The **Magnolia Warbler** is a common passage migrant that breeds in the North Woods and in the Appalachian uplands. It winters in southern Mexico, Central America, and the Caribbean. The breeding male is brightly patterned with gray, yellow, black, and white. It frequents the understory of forest thickets and edge, singing its musical jumble. 125 were recorded from Assateague Island, MD, on 15 May 2010. Similar in habits but less common is the **Canada Warbler.** It is an uncommon passage migrant and a breeder in the Allegheny Highlands, found in shaded undergrowth within mature deciduous forest. The species breeds in the North Woods and the Appalachians south to North Carolina. It winters in northern South America. It has suffered substantial declines in recent decades. The male gives a rapid and chattery jumble, less musical and sweet than that of the preceding species. 100+ were found along the Choptank River, MD, on 10–11 May 1952. Magnolia and Canada Warblers are often found breeding near each other. **Wilson's Warbler** is solely a passage migrant through our Region. It breeds through the North Woods to Alaska and also in the northern Rockies to California and Colorado. This small yellow bird with the tidy black crown spot is most often seen in shrubby thickets and edge habitats. Its song sometimes can be confused with songs of the Orange-crowned Warbler. 10 were counted on the C&O Canal, MD, on 12 May 1951.

Famous because of the male's brilliant orange-throat, the **Blackburnian Warbler** is a conifer specialist and an uncommon passage migrant. The species breeds in the North Woods and conifer forests of the Appalachians. Listen for its very high-pitched ascending and lisping song from the canopy of stands of hemlocks and spruces or in monoculture stands of Red Pine. 89 were counted at Patuxent, MD, on 10 May 1950. The **Black-throated Green Warbler** is similarly patterned to the preceding species but lacks the bright orange throat of the male. This species breeds through the North Woods,

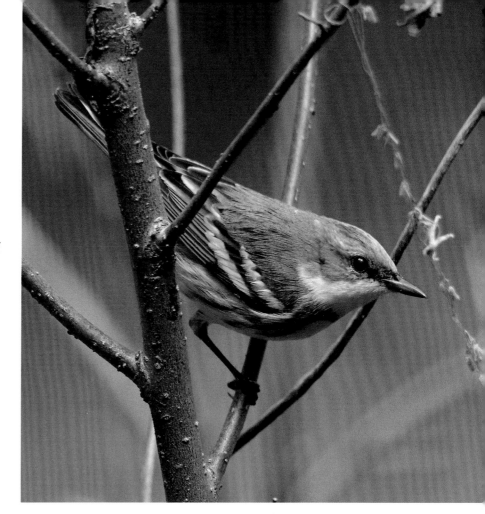

In autumn, agricultural lands host an abundance of Palm Warblers, still bright, though lacking the stylish spring plumage markings. Photo: Bonnie Ott

New England, the Appalachians, and low country of the Southeast. It winters in Mexico, the Caribbean, and northern South America. It is a common early-season spring passage migrant to mature oak woods through our Region. It nests widely in the Allegheny Highlands, preferring conifer and mixed forests, where this and the Blackburnian Warbler can be found together in some places. The Black-throated Green gives a perky and buzzy song in spring: *zee zee zee zo zeet!* or *zoo zee zoo-zoo zeet!* 37 were counted at Patuxent, MD, on 10 May 1950.

The **Yellow Warbler** is another of the nonforest breeders, preferring willow swamps and even the verges of tidal marshes. It is one of our most com-

mon breeders. It breeds throughout North America and winters in Central and South America. Olive above and yellow below with abundant orange streaking, the male sings his cheerful song from a sunny perch. 200 were recorded at Port Tobacco, MD, on 7 May 1940. 65 were recorded at Bombay Hook NWR, DE, on 20 June 1982. Another open-country species is the **Chestnut-sided Warbler**, which is prevalent in regenerating woodlands, brushy meadows, beaver swamps, and bogs. The species breeds across southern Canada, the eastern United States, and in the Appalachians south to Tennessee. The species winters in the Caribbean, Central America, and northwestern South America. Its bright song (*please, please, please to meet you!*) is reminiscent of that of the Yellow Warbler. 161 were recorded at Patuxent, MD, on 10 May 1950. 70 were counted at a site in Talbot County, MD, on 23 August 2011.

The next two warblers are distinctive as the earliest arrivals in spring and late passage migrants in autumn. The **Palm Warbler** is a dull-plumaged, tail-wagging open-country warbler. The species comes in two races—the "Yellow" form from the east and the buff-breasted "Western" form from the west. The species breeds in spruce bogs of the North Woods and winters in the Southeast, the Caribbean, and Central America. It is most common in our Region in April and October though a few individuals overwinter in coastal locations. 175 were recorded from Assateague Island, MD, on 30 September 1994. The **Yellow-rumped (Myrtle) Warbler** is North America's most common wood warbler. The species breeds throughout the North Woods and Rockies from Alaska south to the mountains of Mexico. The species winters through the South, especially along the coast, where it can subsist on wax myrtle berries at times when arthropods are scarce. 22,000 were recorded passing the Cape Henlopen, DE, hawk watch on 29 October 2010. 1,000 were recorded at Prime Hook NWR, DE, on 19 December 1982. Finally, the dull-plumaged **Pine Warbler**,

a habitat specialist, nests and winters in stands of mature pines throughout our Region. The species breeds through the eastern United States and winters in the Southeast. This dull-colored warbler has a sweet trilled song. 250 were counted at Point Lookout, MD, on 9 April 1953.

Rarities

Bell's Vireo is a rare vagrant to the East Coast from its heartland breeding range in the Mississippi watershed. **Virginia's Warbler**, with a single record from the Region, is a bird of the arid interior west, wintering to southern Mexico. There are a handful of records from the East, mainly between November and March. **Swainson's Warbler** is a bird of the southern swamp forest, wintering to the Caribbean and Central America. It has occasionally bred in

the Region. It produces one of the most distinctive, loud, and musical songs that emanate from the low-country swamp forest. The **Black-throated Gray Warbler** is another breeder from the interior West and Northwest that regularly shows up in the East in late fall and winter. There are a handful of records from our Region. **Townsend's Warbler** breeds in the Pacific Northwest and winters in the Southwest, Mexico, and Central America. It shows up on the East Coast in autumn and winter, and there are a few records from our Region.

Amazingly, thousands of warblers persist in our Region through the winter. Virtually all of these are Yellow-rumped Warblers, which subsist mainly on berries during the cold months.

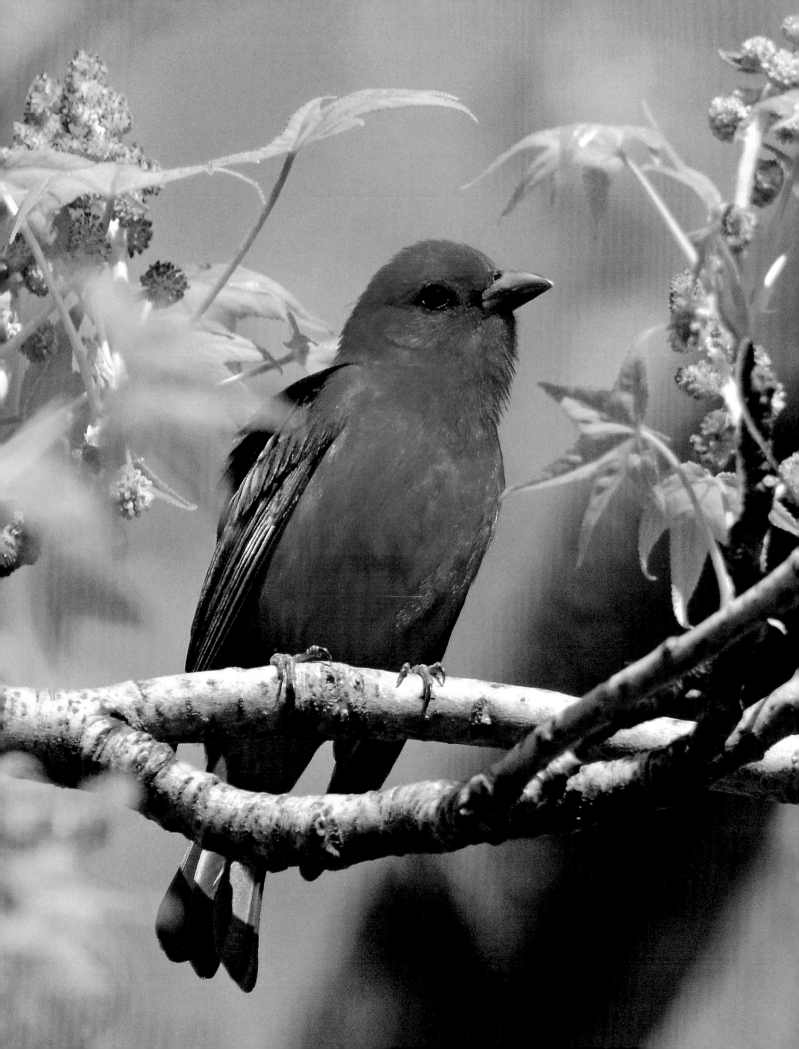

Orioles, Blackbirds, and Colorful Fruit- and Seed-eaters

The orioles and blackbirds group is another fairly heterogeneous assemblage of mainly migratory songbirds. Most consume seeds or fruit and are sociable. A selection of "winter finches" breed in the far north and irruptively appear in our Region every few winters. Many are birds of open country and grasslands, but some others are woodland nesters. The group includes some of our favorite songbirds.

Winter Finches

The winter finches breed mainly in the boreal forests of Canada and irruptively disperse south into the United States when conifer cone crops fail in the far north. Different species appear in different years. The birds wander the landscape in flocks in search of cone crops or alternate foods and regularly appear at feeders. The **Purple Finch** is perhaps the most common and least irruptive of this group, found in small numbers year after year in our Region, with numbers fluctuating with the availability of food stocks in the North. The species breeds across Canada and into New England and then down the Appalachians. This species appears at our feeders but can be confused with the much more common House Finch. The Purple Finch can be distinguished by the pointed crown and the reddish flanks and nape (dull gray brown in the House Finch). Females and immature males

When the trees leaf out in late April, look high up for Scarlet Tanagers, just arriving from their wintering grounds.

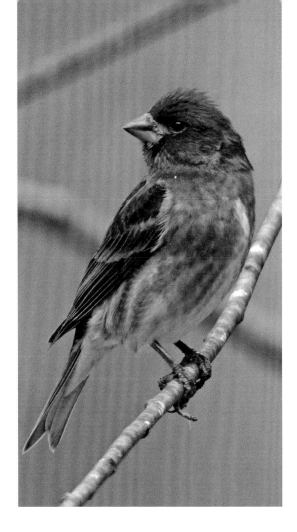

A close-up view of this backyard visitor reveals a raspberry wash over the upper-parts and flanks—the markings of a male Purple Finch.

Only when cone crops of conifers fail up north do birders in the Mid-Atlantic get to enjoy seeing irruptive White-winged Crossbill working our spruces. Photo: Mark L. Hoffman

are more easily identified as they have a distinctive streaky face pattern. 500 were estimated near Cabin John, MD, on 17 April 1949. 168 were recorded at Parkview trail, Baltimore County, MD, on 25 October 2014. 113 were recorded at White Clay Creek SP, DE, on 29 October 1977. The **Pine Siskin** is another fairly regular winter finch, which in some autumns arrives in large numbers. This species is a regular feeder bird, attracted to Nyjer seed. The species breeds in the North Woods and Rockies and winters south to the Gulf on occasion. The siskin is a buff-brown bird with dark streaking, pale wing bars, and some yellow highlighting in adult males. 400 were recorded near Emmitsburg, MD, on 18 October 1952. 250 were recorded at Town Hill, MD, hawk watch, on 1 November 2008.

The **Red Crossbill** is a rare winter visitor to our Region, appearing in roving flocks about once a decade. Most recently, we have had flights in the winters of 2008–09 and 2012–13. It favors spruce and larch. This conifer specialist breeds across the boreal

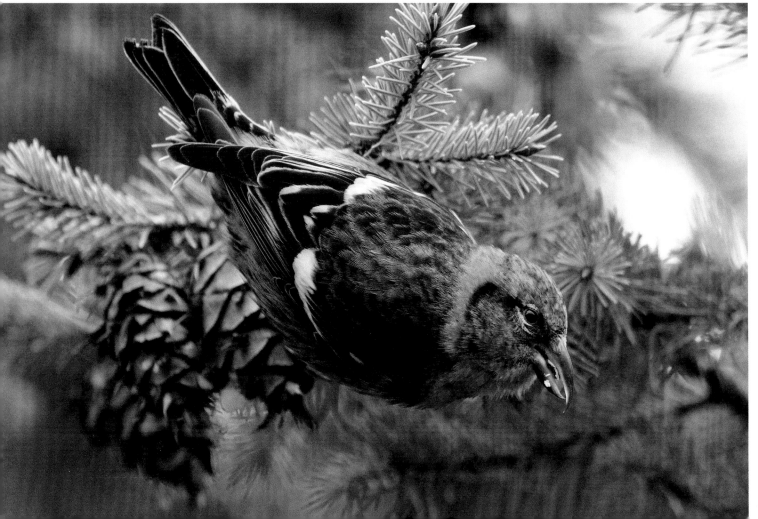

North Woods and widely in the Rockies, south into Mexico. It typically nests in the winter or very early spring when it finds a large stock of conifers with seed-bearing cones. It has apparently bred in our Region and is a sporadic breeder in West Virginia. Nonbreeding flocks are periodically encountered in the Allegheny Highlands. 233 were recorded on the Rehoboth Beach, DE, CBC, in December 1969. 113 were recorded at Cape Henlopen SP, DE, on 17 November 2012. Apparently, it was formerly more abundant as a periodic visitor to the Region. Historic flights were noted in the Piedmont in the winters of 1887–88, 1894–95, and 1916–17. The **White-winged Crossbill** is the less common (and more beautiful) cousin to the preceding species. The male is pink bodied, black winged, with white wing bars. Its breeding range is mainly Canada and Alaska. It wanders widely in some years but is always very rare in our Region. 70 were recorded at Soldier's Delight environmental area, MD, on 19 January 2013.

The **Common Redpoll** is a flocking sparrow-like species with a raspberry topknot that breeds in the high Arctic and winters southward into weedy agricultural fields and coastal dunes. It appears in our Region as a rare visitor in late winter, typically in small numbers, sometimes visiting backyard feeders. 400 were recorded at a suburban site in Montgomery County, MD, on 15 February 1994.

The **Evening Grosbeak** is a large, vocal, flocking winter finch that only rarely appears as far south as our Region. It breeds across the North Woods and in the Rockies and Pacific Northwest. It irruptively winters south toward our Region on occasion. Most years produce only a handful of records from our Region. When present, this species has a strong affinity for feeders stocked with sunflower seeds. There were major winter flights in 1951–52, 1954–55, and 1955–56. The 1951–52 flight was the largest on record. 115 birds were banded at Laurel, MD, during April and May 1952. Hundreds were seen migrating over Frederick, MD, in mid-May 1952. 80 were counted on the Garrett County, MD, Christmas Bird Count on 31 December 1954.

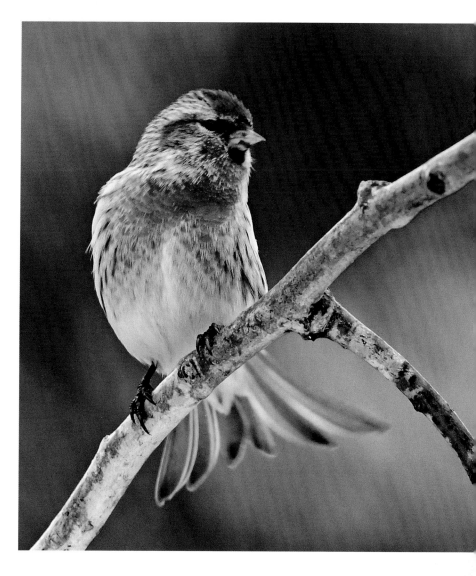

A report of a Common Redpoll, a true northern finch, will get the birders jumping into their cars to make the sighting.

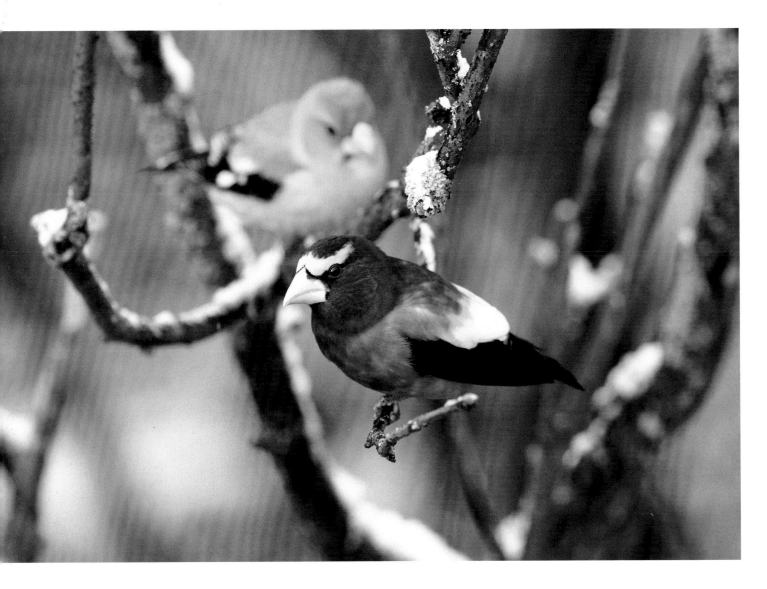

A pair of Evening Grosbeaks awaits feeder offerings on a brisk winter day, to the delight of those who realize what a treasure these winter finches are in our Region. Photo: Bruce Beehler

(Opposite)
A field of Giant Sunflowers at McKee-Beshers Wildlife Management Area attracts scores of American Goldfinches for a late summer feast.

Non-winter Finches

The **House Finch** is a western cousin to the Purple Finch. It was introduced to the East Coast from California in the 1940s to be kept as a cage bird but after a series of escapes it began breeding in the wild and gradually expanded throughout the East. It is now a common permanent resident to our Region and frequents backyard feeders. The species is most prevalent in open suburban habitats and cities, where it is fond of nesting in large ornamental conifers. It is unwary of humans and will nest under eaves of back porches and sheltered ledges on office buildings. The **American Goldfinch** is another common feeder bird in our Region, favoring the Nyjer seed. The species is quite mobile and often is found in small parties or flocks, but it remains in our Region year-round. The bright males lose their color in autumn, and both sexes appear dull greenish yellow in winter. The species is widespread across the United States, breeding coast to coast. The Canadian breeders migrate south, and some of our birds head south as far as the Gulf. The species feeds on grass seeds in weedy fields and on tree seeds. In midspring, noisy flocks of this species flood into the canopy of flowering and seeding trees (such as elms) to feed. This produces one of the distinctive sounds of spring. It breeds unusually late in the year (July to September). As its young are fed exclusively on seeds, it has to delay breeding until the seed heads of thistles ripen. 2,000 were estimated at Port Tobacco, MD, on 7 May 1940. 940 were recorded at Cape Henlopen, DE, hawk watch on 29 October 2010. 489 were counted at the Fort Smallwood Park, MD, hawk watch on 28 April 2010.

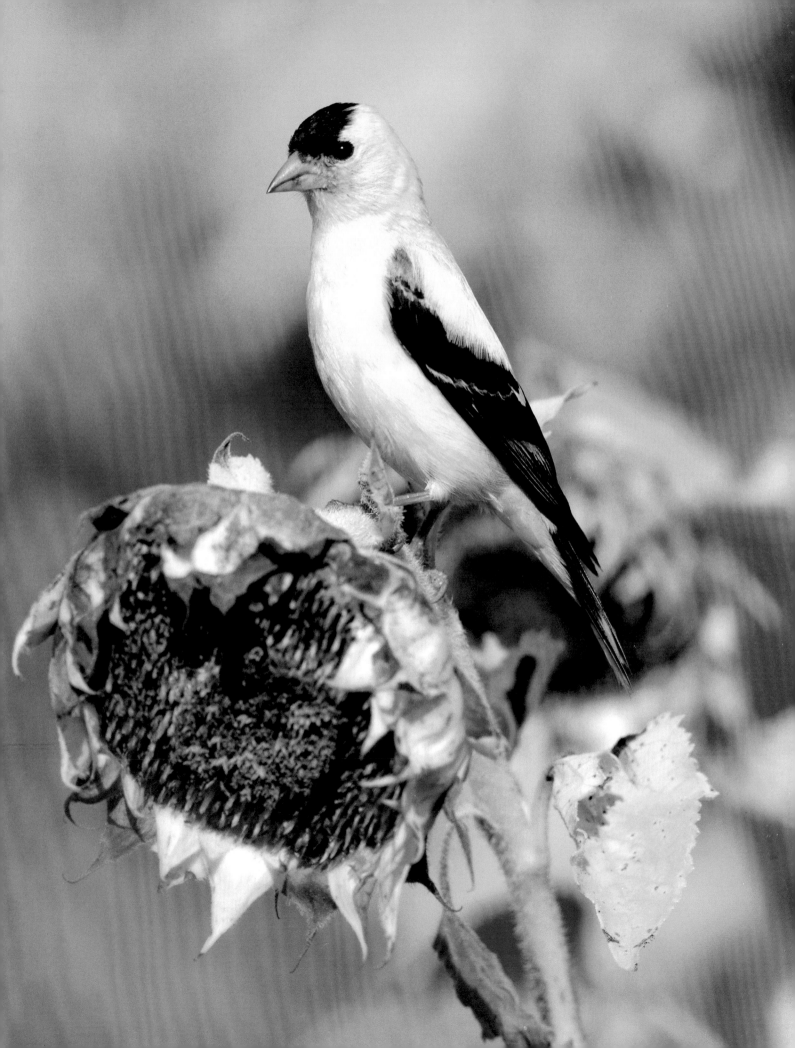

Orioles

An Orchard Oriole mother delivers insects to her nestlings, cradled by a hanging basket woven above a horse pasture.

The streamside trail at Cromwell Valley Park in Baltimore County offers some of the Region's best Baltimore Oriole viewing in late spring.

The **Baltimore Oriole** is one of our most familiar birds because it serves as mascot for Baltimore's major league baseball team. That said, most people rarely see an oriole in the wild and do not even realize it is a common nester in the northern half of our Region. It is also a common passage migrant in spring and fall. The species breeds across the United States and into central Canada and winters in Florida, Mexico, Central America, the Caribbean, and northern South America. It hangs its pendant saclike nest from the outer twigs of Amer-

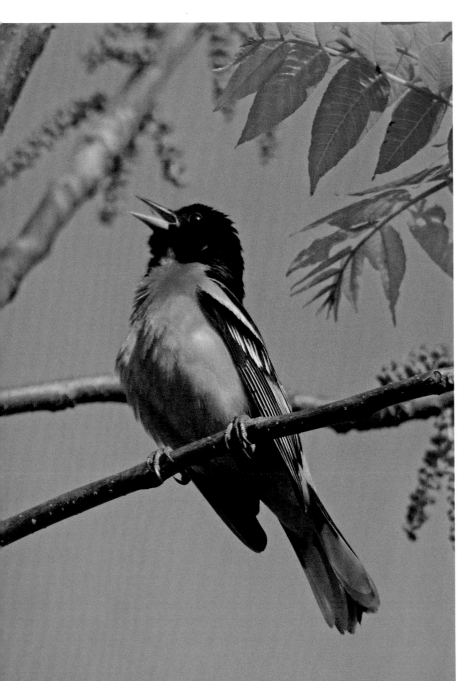

ican sycamores, elms, and other tall shade trees in woodland clearings and edges. Not uncommon in suburbia. 125 were recorded at Assateague Island, MD, on 12 September 2009. The **Orchard Oriole** is a slighter and darker cousin to the Baltimore Oriole. It nests widely through the Region and is an uncommon passage migrant. It is mainly absent from the Allegheny Highlands. It breeds in tall trees in clearings near water and in wooded edges of open agricultural landscapes. It particularly likes riverside shade trees. The species breeds across the eastern and central United States, wintering to Central America and northwestern South America. It produces a lovely and complex ringing song from high in a tree canopy. 50 were counted along the Gunpowder River, MD, on 5 May 1904.

Blackbirds

The **Red-winged Blackbird** breeds from Alaska to southern Mexico and is perhaps the most abundant bird species in North America. The species breeds throughout our Region, using just about any grassy wetland, from cattails, to roadside ditches, to the extensive marshlands of the Eastern Shore. In autumn and winter, the species forms flocks of tens of thousands of birds that wander widely in and out of our Region in search of forage (mainly waste grain and other seed). The species population has declined measurably over the past four decades, perhaps because of sustained lethal control programs implemented by the US Department of Agriculture to reduce blackbird numbers in order to protect commercial crops of sunflowers. In terms of historic high counts, 4.8 million were estimated on the Cape Henlopen CBC on 20 December 1981; "millions" were estimated at Carroll Island,

The pugnacious Red-winged Blackbird will not hesitate to confront an intruder coming into his territory.
Photo: Bonnie Ott

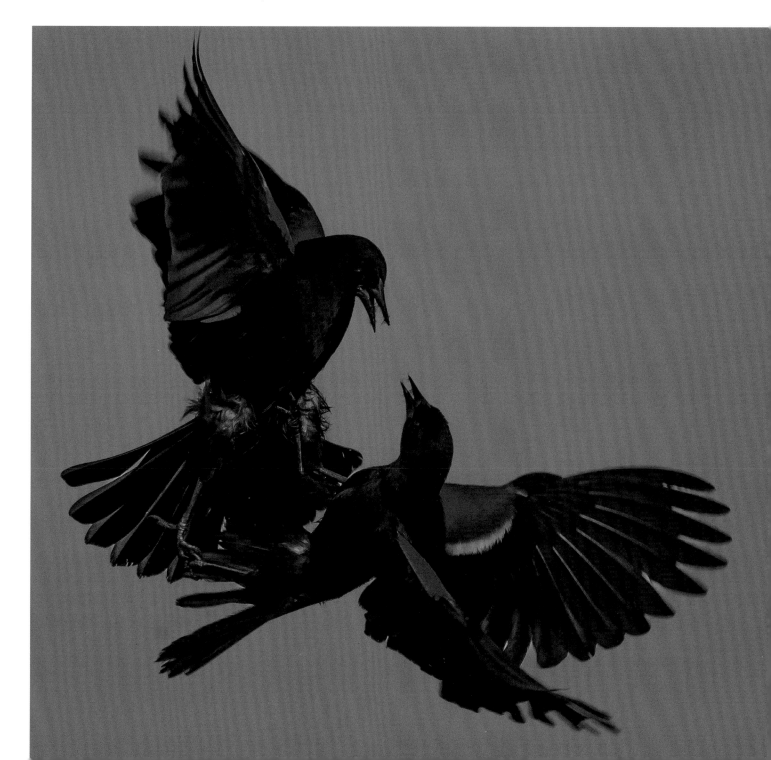

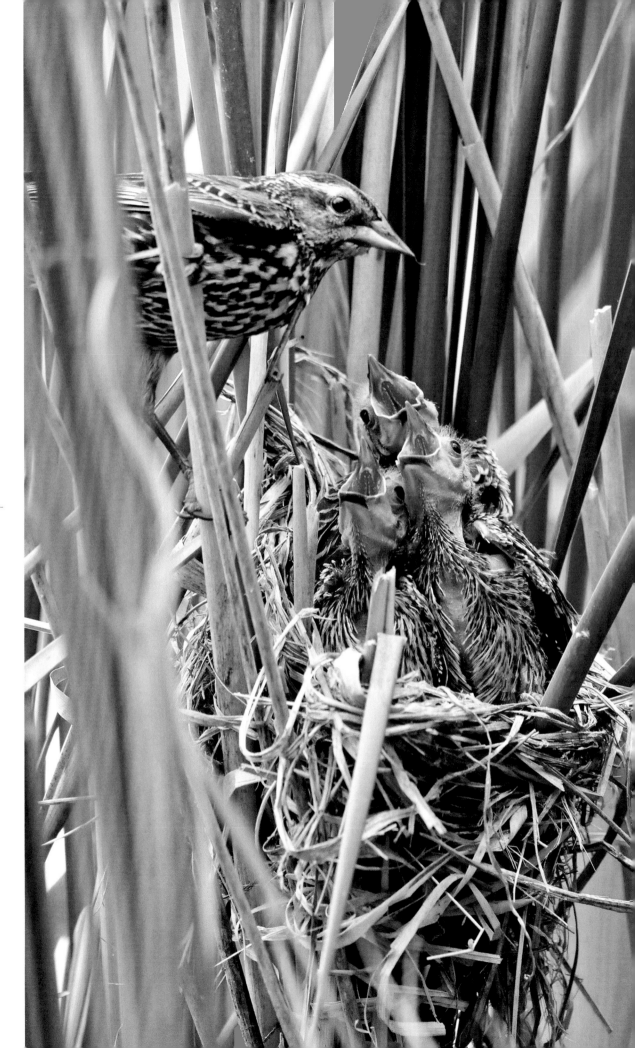

Dense Cattails make for an ideal nest site for Red-winged Blackbirds; here mom has just delivered a meal to those insatiable mouths.

252

Baltimore County, MD, on 15 March 1896; and 900,000 were estimated from a site in northern DE on 18 February 2009. The **Yellow-headed Blackbird** breeds from the upper Midwest to western Canada and south to the Southwest. It is mainly a breeder in wetlands of the arid interior. It winters in the Southwest and adjacent Mexico. The species is a rare but regular visitor to our Region, mainly during the autumn and winter months where it is almost always found in flocks of other blackbirds.

The **Rusty Blackbird** is an uncommon passage migrant and wintering wanderer in our Region. This declining species breeds in spruce bogs of Canada and Alaska and winters in much of the eastern United States south to the Gulf. Most often seen in small flocks in wooded swamps where it searches for food by flipping over leaves. Usually this species does not mix with other blackbirds, though small numbers and singletons can be found among large winter flocks of Red-winged Blackbirds. 1,200 were counted at Pocomoke City, MD, on 5 October 1995. Its western counterpart, the very similar **Brewer's Blackbird**, breeds from Michigan to British Columbia and south to New Mexico, wintering to Mexico and the Deep South. It is an increasingly rare visitor to our Region, typically between late autumn and early spring. 223 were recorded on the Bombay Hook, DE, Christmas Bird Count on 22 December 1956. 125 were reported from nearby Leipsic, DE, on 27 December 1992. The **Brown-headed Cowbird** is a commonplace flocking blackbird, found in the Region year-round in large numbers but highly mobile in the nonbreeding season. The female is an infamous brood parasite who makes no nest of her own but instead lays her eggs in the nests of other species of birds, who are then left to raise the cowbird(s) as well as their own offspring. Since the cowbird nestling is much larger than the host nestlings, these usually end up severely malnourished, often perishing in the nest or pushed out by the aggressive cowbird nestling. Individual female cowbirds tend to parasitize just a single host species (especially Indigo Bunting, Yel-low Warbler, and Song Sparrow), and yet cowbirds eggs have been found in the nests of more than 200 different host species. In earlier centuries, cowbirds inhabited the interior prairies and followed herds of American Bison, hence their colloquial name of "Buffalo Bird." The species invaded the East when the forests were cut and open land created for agriculture. Cowbirds join mixed blackbird flocks in winter. 200,000 were recorded in Cecil County, MD, on 27 December 1952. 150,000 were recorded from Wicomico County, MD, on 15 December 1995. 50,000 were recorded at Dragon Run SP, DE, on 24 November 1974.

Grackles

The **Common Grackle** is a very common year-round resident of our Region. The species arrives in rural and suburban neighborhoods in March with males displaying to females, followed by nesting. The species can be found nesting in a broad array of open wooded habitats, mainly choosing to nest in the thick cover of ornamental shrubs or conifers. After breeding, the species forms roving flocks that move about for the fall and winter, during which large assemblages move about the agricultural landscapes of the Southeast. The male, with his iridescent blue and green plumage, is quite handsome. Males have a peculiar habit of holding their wedge-shaped tail folded up in flight which presents a ready means of identification. 502,000 were recorded from McKee-Beshers WMA, MD, on 4 January 1980. 350,000 were recorded on the Sassafras River, MD, on 27 December 1952. The **Boat-tailed Grackle** is our largest blackbird. The glossy blue-black male exhibits an oversized tail. This species is a coastal marshland specialist that ranges from Long Island south to Texas. In our Region, it breeds in the Atlantic estuaries, on the coast of Delaware Bay, and in the lower Chesapeake. A few birds wander into the upper Chesapeake in spring and late summer. 3,000 were recorded at Stockton, MD, on 8 February 1992. 400 were recorded at Lewes, DE, on 23 December 1965.

Tganers

The adult male **Scarlet Tanager**, glossy red with black wings and tail, is one of our most striking songbirds. It breeds across the eastern United States and winters in western South America. It is a widespread and fairly common breeder through our Region, inhabiting the canopy of moist deciduous and mixed forest, though is less common on the lower Eastern Shore. Despite its bright colors it is more often heard than seen. Its cheerful burry song is reminiscent of an American Robin with a sore throat. 110 were counted at Patuxent, MD, on 10 May 1950. 33 were recorded at White Clay Creek SP, DE, on 20 May 1978. The less common and less well-known **Summer Tanager**, with the stunning, all-red male, breeds in the southern United States and into northern Mexico, wintering to Central and South America. In our Region, it is restricted to the southern half of the Western and Eastern Shore provinces, where it favors the canopy of dry oak-pine woodlands. This species, too, is more often heard than seen. Listen for the sweet song series

Carey Run Sanctuary, in Garrett County, MD, offers great habitat for breeding songbirds like this handsome Rose-breasted Grosbeak.

Bird nests are notoriously difficult to spot, much less get a clear picture of, like this wonderful view of an incubating Summer Tanager. Photo: Mark L. Hoffman

(not as hoarse as that of the Scarlet Tanager) or the distinctive call: *pit-tuk-t-t-tuk*. 24 were counted at the Great Cypress Swamp, DE, on 14 May 2016. Note that our "tanagers" are not true tanagers, but instead are members of a family that includes the Northern Cardinal. The true tanagers range mainly from the United States–Mexico border and Caribbean into South America and include the seed-eaters, grassquits, honeycreepers, as well as the diverse and colorful typical tanagers.

Grosbeaks

The male **Rose-breasted Grosbeak** is another songbird beauty but one seen infrequently, mainly in spring migration. The species breeds in the eastern and central United States as well as into western Canada. It winters in Central and South America and the Caribbean. In our Region, this species is mainly a passage migrant. It also breeds in the western Ridge & Valley and in the Allegheny Highlands. Breeding birds inhabit the canopy of upland deciduous forest. The male gives a beautiful musical song reminiscent of that of the American Robin, but thinner and higher pitched, sometimes described as a "Whip-poor-will in every note." The species also gives away its presence with its dis-tinct sharp foraging note *chinkk!* 33 were recorded from Elk Neck SP, MD, on 16 September 2012. The **Blue Grosbeak** is a southerner, breeding through the southern United States west to California and southward into Mexico. It winters in southern Mexico, the Caribbean, and Central America. This bird summers mainly in the southern half of our Region in open agricultural lands, singing from atop rows of trees bordering fields and roads. Its song is a rapid and rolling series sounding like a Purple Finch. It also gives an explosive *spink* note. Perched in the bright sun, the species appears black from a distance. 40 were recorded from Merkle Wildlife Sanctuary, MD, on 2 September 2012. 30 were recorded from Bombay Hook National Wildlife Refuge, DE, on 9 June 2018.

The grassy fields of Bombay Hook National Wildlife Refuge, DE, offer prime habitat for the Blue Grosbeak, a species with strong southern affinities. Photo: Emily Carter Mitchell

Overgrown country-side fields rimmed with bushes and woods offer great promise for nesting Indigo Buntings.

Buntings

The **Indigo Bunting** is our common small blue bunting of shrubby woodland clearings and old fields and agricultural hedgerows. The species breeds throughout the eastern and central United States, wintering south to Florida, Mexico, and the Caribbean. It is a common breeder throughout our Region. The song of the male in late spring is a classic sound of rural landscapes. 200+ were estimated at Port Tobacco, MD, on 14 May 1936. 141 were recorded from McKee-Beshers WMA, MD, on 19 September 2010. The **Painted Bunting**, a regular vagrant, is mainly encountered in spring and winter as singletons at backyard feeders. The male displays a gorgeous patchwork of bright colors. The species breeds in the Deep South and into northern Mexico, wintering to Mexico, Central America, and the Caribbean.

Rarities

The **Pine Grosbeak** is an irruptive winter finch, very rare Regionally. It breeds through the North Woods and in the Rockies, wintering south in some years. It rarely disperses south of New England. 12 were counted in Frederick County, MD, on 25 November 1951. The **Hoary Redpoll** breeds in the high Arctic and is a vagrant to our Region some winters. Often found with the smaller and darker Common Redpoll. The **Lesser Goldfinch**, a species of the West and Southwest, is a vagrant to our Region.

The **Bullock's Oriole** is the western counterpart of the Baltimore Oriole, breeding in the Great Plains and Mountain West. It winters in Mexico and Guatemala. The species is a rare vagrant to the East. A handful of records for our Region are from the autumn and winter. The **Western Meadowlark** is the western counterpart to our Eastern Meadowlark and best distinguished from it by its voice. It breeds through the Great Plains and the Mountain West and winters southward. The species is known from our Region from records in January and Au-

gust to September. The **Shiny Cowbird** is a bird of the Caribbean and South America that now breeds in South Florida. It is known from a single record to our Region.

The **Western Tanager** is the western counterpart to our Scarlet Tanager. The Western nests throughout the Mountain West north into the Canadian Rockies and south to the border with Mexico. It winters in Mexico and Central America. It is a very rare but increasingly regular vagrant to the East Coast, with a record from our Region usually every other year. Birds appear in spring and late fall and winter. The **Black-headed Grosbeak** breeds in the Mountain West from Canada south to Mexico. It winters in Mexico. It is a rare vagrant to our Region in late fall, winter, and spring and is most commonly recorded at backyard feeders.

The **Lazuli Bunting** is the western counterpart to our Indigo Bunting. The Lazuli breeds through the Mountain West and winters in Mexico. It is a very rare vagrant to the East Coast, with a handful of late fall and winter records to our Region.

Nearly every year a spectacular male Painted Bunting stakes out a regional feeder, and generous property owners allow birders access to the treasure. Photo: H. David Fleischmann

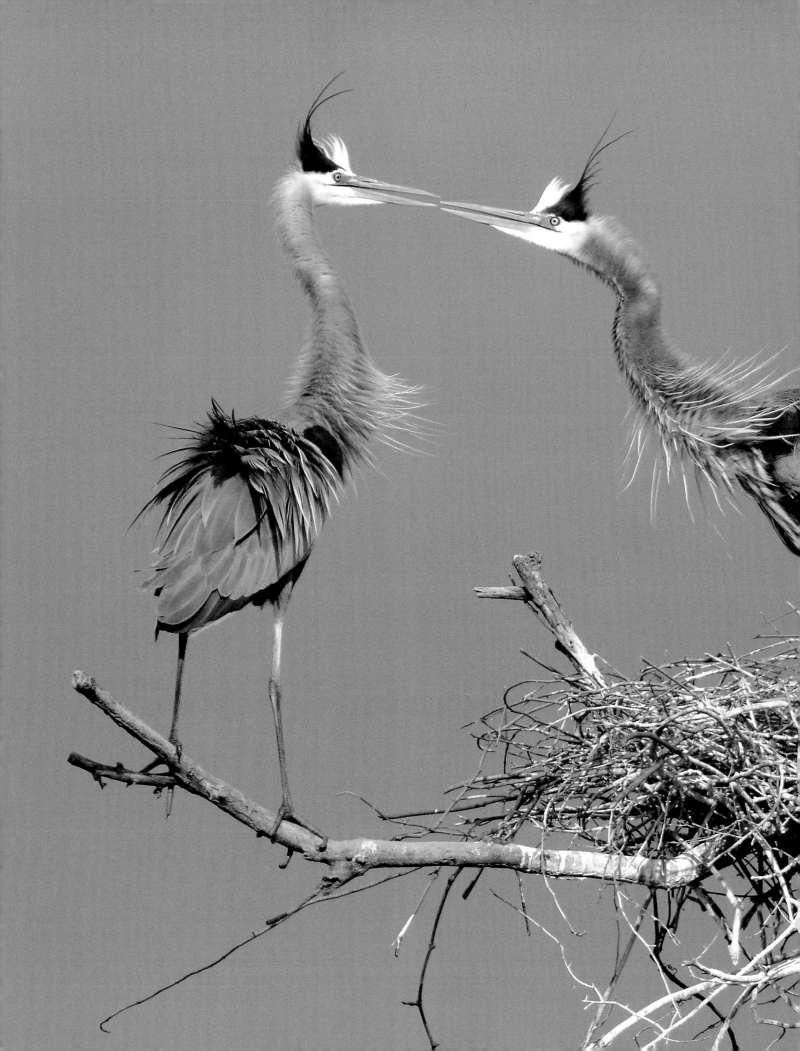

Spirits run high for these courting Great Blue Herons along the Patapsco wetlands.

Best Birding Apps and Websites

Each passing year brings new applications for smartphones and computers to assist in identifying, recording, and studying our birdlife. Given the pace of innovation, this chapter will be out-of-date by the time it is published. Well, at least we can highlight what we think are the current best of the existing apps and the savvy reader can launch ahead from these.

eBird is the superstar among ornithological apps. It is a searchable database of geo-referenced and dated bird observations from around the world, all presented on a map that one can zoom in and out of. eBird includes too many tools to mention, but here are a few simple but rewarding things a smart birder can do in eBird. You can check for the location of recent observations of a particular species in your area. You can determine the winter range of a species by filtering the data for that season. You can generate seasonal abundance charts for a favored birding hotspot. Each observation point can be clicked on in order to draw out the complete checklist of observations from that point for that particular day by a named observer that can include sound recordings and photographs. Every reader should upload all of his or her observations to eBird. This is a way of managing your own life list, while contributing to an important global database on the distribution of birds. Believe it or not, your daily observations of birds in your backyard will have scientific value for a researcher conducting ornithological studies in years to come. Do it! Become an eBirder! Website: http://ebird.org/content/ebird/

Learning about avian research like Dave Brinker's Project Owlnet is just a few keystrokes away in today's internet age.

eBird Mobile (formerly BirdLog) is a field observations upload app for smartphones. It is now possible to upload your observations on the fly as you do your birding. The leading US birders do this and perhaps so should you.

Merlin is an eBird identification tool for your smartphone. It asks the user a series of questions and references your answers to the eBird database that uses your location and observation date to help narrow down the possible identity of the bird you have seen. It is also a digital field guide that has many images and sound recordings of each species.

Birdseye is a bird-finding app. It uses the eBird data set to inform the user of either (a) what birds have been recently observed at your site or (b) where to find a particular species based on recent observations. It is very useful for planning an outing in search of particular birds.

Birdcast, a website managed by the Cornell Lab of Ornithology, provides both forecasts and recent summaries of bird migration across North America. Great for planning weekend birding trips during the fall and spring. Website: http://birdcast.info/

Tempest radar provides a nationwide real-time radar signature that shows the movement of precipitation across the United States as well as discernible signatures of avian migration when the airborne movement is sufficiently large.

The **Sibley eGuide** App is, quite simply, the Sibley Field Guide as a smartphone app. In addition to the illustrations, range map, and text, the app includes a fairly comprehensive collection of bird sounds to aid in identification. Other field guide apps for North America include the **iBird Pro Guide**, **Peterson's Birds of North America,** the **Audubon Birds App**, and **National Geographic's Birds** app. All provide an array of art, maps, sound, and text to aid bird identification.

The **Maryland Ornithological Society** website offers guidance on membership, the annual birding convention, state lists, field checklists, favorite birding locations, scholarships, MOS sanctuaries, the MD/DC Records Committee database, environmental education, and local conservation issues. Website: http://www.mdbirds.org/

The **Delmarva Ornithological Society** website provides local birders with information on DOS field trips, meetings, the youth birding club (the Dunlins), the Bird-A-Thon, citizen science, Delaware birding sites, and more. Website: https://www.dosbirds.org/

Delaware Valley Ornithological Club website provides information on the club's activities in Delaware, Pennsylvania, and New Jersey. Includes information on upcoming meetings and field trips, recent sightings, and more. Website: http://dvoc.org/

Delaware Audubon hosts the Delaware birding trail, which is an online guide to the best sites in Delaware together with clickable maps and directions. Paper foldout copies can be picked up for free at several wildlife centers and have a concise state map for easy navigation. Website: http://www.delawareaudubon.org/birding/BirdingTrail.html

Project FeederWatch. Project FeederWatch is a winter-long survey of birds that visit feeders at backyards, nature centers, community areas, and other locales in North America. Feeder watchers periodically count the birds they see at their feeders from November through early April and send their counts to Project FeederWatch at the Cornell Lab. These help scientists track broadscale movements of winter bird populations and long-term trends in bird distribution and abundance. Anyone interested in birds can participate provided they join and pay a small participation fee. FeederWatch is conducted by people of all skill levels and backgrounds, including children, families, individuals, classrooms, retired persons, youth groups, nature centers, and bird clubs. Website: feederwatch.org

Cornell Lab of Ornithology's website provides all manner of helpful information and resources for birders, including an online field guide, migration

forecasts, a huge collection of bird sounds (the Macaulay Library), active bird cams, bird conservation information, advice on bird feeding and building nest boxes, and an online store. The Lab also provides home-study courses in ornithology. Website: http://www.birds.cornell.edu/

The National Audubon Society's website includes an online field guide, feature articles on NAS's multiple ongoing conservation projects, Priority Watch-list species, great places to visit, membership opportunities with local Audubon chapters, an online store, and more. Website: http://www.audubon.org/

The American Bird Conservancy's website focuses on conservation of birds throughout the Western Hemisphere. The website includes conservation news, conservation issues, citizen involvement, and more. Website: https://abcbirds.org/

American Ornithological Society. Formerly the American Ornithologists' Union. When it recently merged with the Cooper Ornithological Society, it changed its name to herald this important partnership for bird study. The AOS is America's preeminent professional organization for ornithologists (bird scientists). The AOS website includes all sorts of regularly updated information on the science of ornithology and opportunities for those seeking this career. It, with Cornell, is also the home of the AOU/AOS Classification Committee's official list of the birds of North America, as well as the *Birds of North America* species accounts—the most authoritative and up-to-date narratives on the species of North American birds (stored online). Website: http://www.americanornithology.org/

IOC World Bird List. Frequently updated by a committee led by Frank Gill and David Donsker, this online list of birds of the world includes all the recognized species and subspecies of birds of the world. Updates follow recent cutting-edge scientific publication on bird systematics. This is the most current list of birds available, because it is updated several times each year. The whole list (in various

forms) is available for download as an Excel file. Website: http://www.worldbirdnames.org/

Cape May Bird Observatory. For those interested in regional movements of birds, it pays to read the blogs from the experts at Cape May. This provides a heads-up on what we should be looking for in our adjacent Region. Website: http://www.njaudubon .org/SectionCapeMayBirdObservatory/CMBO Home.aspx

Hawk Migration Association. This website provides all manner of information regarding the 200+ hawk watch sites in North America, including location, watch season, a written description of the site, plus all the years of data (day by day) of the hawk species and numbers observed. This is a remarkable data set that allows birders to plan hawk watch visits in an efficient and productive manner. Who would have thought that Snicker's Gap, VA, could have recorded 19,004 Broad-winged Hawks on September 18, 1998? Website: http://www.hmana.org/hawk-watch-sites

There are also various LISTSERVS and Facebook pages devoted to local birding and recent observations of rarities. These are fast-evolving and thus are not presented in detail here (because they will be superseded soon as this book is published). They can be found by perusing the organizational websites presented in this chapter and in chapter 24.

A reported Chuck-will's-widow in Patterson Park has drawn top birders to document this special southern visitor.

Necessary Birding Gear

One of the nice things about birding is that not much is required to get started, mainly a willingness to get outside and start listening and looking. That said, as with all hobbies, gear has become an essential part of the hobby, and those gear-inclined can spend a lot of time and money loading up with the latest and finest. Below we review the basics.

Binoculars. Binoculars are the single-most important tool for birding: a bad pair will leave you frustrated, but a good pair will brighten every bird you see. Today, there are scores of binocular makes and models to choose from, making this purchase a difficult choice. One can purchase perfectly workable binoculars for less than $100. Those with a taste for the very best can pay as much as $2,600. If you intend to bird for life, go for the best pair you can afford, because they will last longer and provide a better experience over the years. For the average beginning birder, select a pair featuring 7, 7.5, or 8 power, with the objective lens either 40 mm or 45 mm. These would be advertised as 7 × 40 or 7.5 × 40, or 8 × 45, and so on. The larger objective lens provides more light, and the power is, essentially, the magnification of the image. A lower magnification with a larger objective lens (such as 7 × 50) provides a lot of light and a typically wider field of view—making it easier to find the moving bird with your binoculars. That said, many advanced birders choose 10× binoculars because of the extra magnification provided, which can make the difference between identifying a distant hawk or letting it go. However, 10× binoculars are a bit more difficult to manage for beginners, because they are heavier and have a narrower field of view.

A major additional choice is binocular frame. The older-fashioned Porro-prism binocular, with the irregular shape, will be cheaper but a bit less sturdy and waterproof than

Sanderlings running across the beach at the end of the day inspired this photographer to capture the moment.

Distant birds are best identified with the long reach of a spotting scope.

the more expensive roof-prism binocular. The difference here relates less to optics than to weatherproofing and weight.

A final consideration is the eyecup and exit pupil—at the top end of the binocular—the end you put up to your eye. It is important for you to be able to see easily through the front of the binocular. This is particularly relevant to people who wear eyeglasses. If you wear glasses be sure to test the binoculars while wearing them. This is best done with the eyecups of the binocular folded down, so your eyeglasses are as close to the lens as possible. Buy a pair of binoculars that are comfortable to hold, easy to focus, and easy to look through with your glasses on. The Cornell Lab of Ornithology periodically carries out a review of the leading binoculars. Look for the latest review article on line. It is worthwhile to visit a well-stocked birding store to try out different models to see which one provides the best feel and utility.

Field Guides. As with binoculars, there is a dizzying array of field guides available. For most of us, the best bet is the *Sibley East* guide. It is compact, well illustrated, and with color range maps, and it restricts its focus to birds of the eastern and central United States. For true beginners, the *Peterson Field Guide to Eastern and Central North America* is a good match. That guide has large color range maps, which are easier to use. The high-powered birder will prefer to use the full Sibley guide or the National Geographic guide (both covering all of North America). These are very complex, include scores of vagrant species unlikely to be seen by the majority of birders, and tend to feature too many illustrations of marginally distinct subspecies or plumages. We also want to mention Claudia Wilds's *Finding Birds in the National Capital Area* as a volume for the car on field trips. As with our chapter 29, it guides the birder to the best places to find birds in Maryland, Delaware, and vicinity. It is out of print but can be found in a used bookstore or online.

Handbooks. Birders tend to have books for the field and books for home—the latter too large or too heavy to carry around in the bushes. The *Sibley Guide*, which is a bulky and heavy field guide, falls into this latter category. We tend to keep the *Sibley Guide* in the house or car, and carry the *Sibley East* into the field, when necessary. Also useful books to keep in the home library are the *Breeding Bird Atlases for Maryland and Delaware* (see details on p. 284).

Specialty Guides. As interest grows, it is nice to have access to specialty guides, especially if one becomes interested in a particular type of bird. There are multiple specialty guides for raptors, shorebirds, waterfowl, warblers, and others (see p. 286 in chapter 25).

Spotting Scope. Perhaps the third most important item to a field birder is a spotting scope. This is a telescope with a 20× or 25× objective lens (or often a 20×–60× zoom lens) that sits on a tripod and can be used for looking at birds too distant to be identified with binoculars (typically, distant ducks, gulls, shorebirds, and seabirds sitting on water or on expansive mudflats). With the need to purchase the scope, the objective lens, and the tripod, this is an expensive proposition. The more expensive scopes merit the more expensive heavy-duty tripods and so forth. We recommend researching scopes and tripods online, perhaps mainly at the Cornell Lab of Ornithology website or in back issues of *Living Bird.* Better yet, go on some bird trips and test out the scopes carried by the leaders. They can advise on details of usability. Many of the best scopes will cost in excess of $2,000 (when the eyepiece is included). A sturdy tripod with a fully pivotable head is advisable when investing in such a valuable piece of optics.

Digiscoping. Advanced birders have developed a technique of bird photography that combines a spotting scope and a digital camera (even the one on your smartphone will do). This allows ready documentation of sightings of rare species that can be shared online. Digiscoping is a less expensive option to the purchase of a digital SLR camera with a long lens. There are special adapters that link the spotting scope to the camera to allow remarkably sharp images to be captured.

Smartphone Field Guide App. There are several options for complete field guides available as smartphone apps. This precludes having to carry a paper field guide but, more importantly, provides access to all the bird vocalizations—something a paper field guide cannot do. The sound collection is certainly the most valuable thing about these apps, permitting the observer to instantly compare a sound heard in the field with a playback from the app. Please play back the recording quietly (if at all) if you know or suspect you are on the breeding grounds of a threatened bird species.

Winter sparrows are the quarry for this father and daughter team at Irvine Nature Center.

The art of bird photography has taken off with workshop leaders such as Nikhil Bahl sharing professional techniques at marquee venues across the country.

Hearing Aids. Most birders over 55 start losing their ability to hear some birdsong, especially those songs of a higher pitch. Hearing aids can aid in bringing back the ability to hear many of these lost sounds.

Digital Camera and Long Lens. Many birders today go out with both binoculars and camera, seeking to capture images of the birds they are seeing. The most affordable path to bird photography is digiscoping, but the other option is to purchase a digital SLR camera and an accompanying lens. A camera body will cost between $500 and $6,000. Professional-quality images can be made with bodies at the lower end of that range. The more expensive bodies simply have many more bells and whistles, not necessarily required for bird photography. The lens choice is between a telephoto lens (300 mm, 400 mm, 500 mm, 600 mm) or a zoom lens (say, 100–400 mm or 150–600 mm). The zoom, as its name implies, allows the user to quickly change the magnification (lower zoom for a large heron, higher zoom for a hummingbird). Zoom lenses tend to be more expensive and produce marginally less sharp images for their dollar value (because they are so much more complicated to build). Most birders who are beginning bird photography

go with a 400 mm f5.6 lens. The other option is to get a smaller telephoto lens (say, a 300 mm) and add a tele-extender on the back end that increases magnification 1.4× or 2.0×. There are many options here, and each birder needs to do a fair amount of research (especially reading user reviews) to discover the best option that combines cost and quality. A final note: the big expensive lenses are heavy and can weigh down a birder in the field. There is a world of difference between birding and bird photography.

Notebook or Digital Recorder. With the advent of eBird, everyone can contribute bird occurrence data to a global master data set used by researchers and birders around the world. Submitting your observations makes a tangible contribution to bird science. And now, images and recorded sounds can be submitted to eBird to accompany the bird lists. But for those less technically minded, one can log sightings into a field notebook or, alternatively, carry a small digital sound recorder (which is tiny and can be worn around the neck) and speak your observations into it. We use an Olympus VN-7100. The important thing is to record your sightings in some manner and then to upload them to eBird. There are several good apps available for recording and editing bird calls as MP3s (e.g., VoiceMate) and most smartphones produce usable recordings without the need for an external microphone. If a bird is calling from too far away to be recorded try imitating the call yourself into your phone. You'd be surprised how often you can later identify the song based on your impression.

Footwear. For most around-town birding, footwear is not a concern. For longer and gnarlier field travels, it pays to wear the right shoes or boots or your day may be spoiled by having to trudge around in wet, cold feet. We simply want to recommend that, for going afield, one often-overlooked but excellent option is the tall, rubber, unlined pull-on knee boot known variously as Wellingtons, Muck Boots, or gum boots. Usually shin high, they can be pur-

chased at a big-box store for about $25 and are most comfortable when worn with two layers of socks—a thin nylon liner sock and a thicker hiking sock over that. For these, it is also good to consider a foot insert to ease strain on the feet. This boot option is waterproof, provides some leg protection, and has the added benefit of repelling deer ticks, especially when the outer surface of the boot is sprayed with repellent before the beginning of a bird walk.

Outerwear. Catalog companies, such as L.L. Bean, REI, Big Pockets, Gander Mountain, and the like, sell all sorts of hunting and outdoor clothing made of new miracle fiber materials, some quite expensive. Our only suggestion is that when you head out birding it may pay to keep your outer layers to camo, olive, or gray colors. Birds are not color blind and may be alerted to your presence by bright parkas and raincoats. Hunters have it figured out. You want to blend in, not stand out. There are also big birder's vests with lots of pockets for gear and field guides.

Sunscreen and Insect Repellent. It is important to apply both sunscreen and insect repellent before heading into the woods or fields. Sunscreen should be applied to whatever skin will be exposed to the sun. Skin cancers are on the increase. It is worth considering the purchase of sun-blocking clothing for extended field use. Repellent should be liberally applied from the belt on down, especially on the footwear and socks if exposed to brush. Lyme disease is not to be trifled with.

Cooler and Thermos. Having a decent-sized cooler in the back of the car always is a good idea. Pack it with plenty of bottled water and some snacks that will reenergize sagging energy levels during breaks in the birding. For winter birding, a thermos with hot coffee or cocoa is a must.

The spectacular Bald Eagle winter feeding frenzy at Conowingo Dam draws more big lenses than the Super Bowl.

Planning Your Birding Field Trip

Going out on a birding field trip for a day or even a whole week is a purely recreational affair, and yet some advance planning can make the field trip more comfortable, more fun, and more successful, bird-wise. It is thus best to make some plans. The farther you travel and the longer the trip, the more planning needed. What follows are steps to a better field trip.

■ First, some general guidelines. The best birding field trips require adequate time. It is always preferable to allot more time to the effort. Adding together travel time to and from the destination, time for a snack or a meal, and adequate time to be out in the habitat can eat up a day. Rushing a birding field trip destroys the whole point of the trip—to have fun. Also, do not plan to attend a social event on the evening following an all-day field trip, because you probably will get home late, dirty, and tired. Always take food, water, and a field guide with you, and don't forget the binoculars. Better yet, always keep a cheap pair in the trunk just in case (you can always give them to a non-birder trip-mate—who knows, you might then turn them on to birding!)

■ In most cases, the best time for birding is at dawn or shortly thereafter. Midafternoon is typically the worst time for birding, especially in the height of summer when it's hot and uncomfortable. There are some exceptions. If you are headed out to the Eastern Shore in December in search of those big flocks of Snow Geese, they can't really hide, but be aware that such flocks depart from their aquatic roosting places early to range about in the fields in search of waste grain. Plan visits to specific birding sites that consider the position of the sun, if possible. It's no fun scanning a huge flock of shorebirds with the sun low behind the birds. It's all about being in the right place at the right time.

Appalachian ridges in the fall offer close-up views of migrating raptors.

Kayakers put in for some fall birding on the Wye River on Maryland's Eastern Shore.

■ eBird it! BirdsEye it! If you are planning a day trip to Bombay Hook National Wildlife Refuge, research online, using eBird or BirdsEye, the types of special birds you might expect to encounter the time of year in the environs you're visiting, and look for the most recent field reports from the area. There may be a Little Gull at nearby Port Mahon and a Ruff at Shearness Pool. And maybe there is a Northern Wheatear reported at a small park right along your route to Bombay Hook. If you know this in advance, you can plan your day around searching for these various rare species.

■ Check the Weather Channel! Use an online weather service to predict a day with appropriate good birding weather, and don't forget to recheck the forecast a few hours before you leave in order to dress accordingly. Take extra clothing, just in case. Weather is probably the single-most uncontrollable variable that can determine the success of a birding trip. Some overlooked weather conditions include the following: Wind can ruin a day of birding. If you are out in spring in search of singing songbirds, a strong and blustery wind will be your downfall. Wind tends to build during the day, and midafternoon can be the windiest time of all. Avoid the wind by getting out early or moving to a sheltered location, such as the bottom of a wooded valley, where the birds may also have aggregated. If your weather app predicts winds exceeding 15 miles per hour, you may wish to reschedule your birding trip to another day. Also note that open areas tend to be much windier than wooded areas.

If you are in search of ducks in winter, think about the presence or absence of ice on the waters you are visiting. Areas that ice over send their ducks elsewhere, so try to visit sites where you know the water will be flowing, such as inlets, larger rivers, sewage outlets, waterfalls, or large public parks with active fountains. This is probably where the ducks will be concentrated. Heavy fog can also make bird-watching almost impossible, although it tends to burn off as the day goes by.

After wind, rain is probably the second biggest enemy of bird-watchers. Rain fogs your binoculars and eyeglasses, it stops you using your smartphone, it makes you miserable, and it severely curtails the activity of small birds. However, there are some birds that seem blissfully unaware of all but the heaviest rain (e.g., ducks, seabirds, shorebirds), and these can still be enjoyed provided you are watching them from a sheltered location, such as below a bridge or building or inside of a car or a bird blind. Some of the larger reserves have bird blinds or similar places where you can watch birds from shelter. Check their websites before you go. Some birds seem to enjoy a shower and remain very active in light rain, especially if it is sunny and warm (e.g., wood warblers in May).

■ Know the times of sunrise and sunset. If you are planning an all-day trip, it is best to do your traveling before dawn so that you arrive at the first birding site shortly before dawn, which is the sweetest time of day and often the best for birding. That's when birds like to sing.

■ Google Maps it! Take some time the night before to familiarize yourself with your route by visiting Google Maps. Also use a GPS in the car to get you

to obscure destinations off the beaten track. However, always print a paper map or sketch the directions if you are going to an obscure place so that you have a backup if the batteries in your GPS fail.

▪ Check the occurrence chart in chapter 28. Get a sense of what desired birds are to be expected in the area you are visiting and familiarize yourself with them before you go.

▪ Listen to the voices of your target birds in advance. If you are looking to locate a Golden-winged Warbler in the fields of Old Legislative Road in the Allegheny Highlands, listen to recordings of the species from a smartphone app or online from the Cornell Lab of Ornithology's All About Birds website (https://www.allaboutbirds.org). Several good CDs are available and can be played in the car while you drive to your birding destination. This will help you pick out your warbler from among the cacophony of sound produced by other birds singing at dawn.

▪ Take extra clothing for wind, cold, and rain. From the comfort of our homes, we tend to forget how different things can be out in the field. Prepare for the unexpected by taking extra layers, a windbreaker, a raincoat, a down vest, gloves, and maybe even a spare set of dry socks. These can be kept in the car, ready for use if you find conditions are more extreme than expected.

▪ Take sunglasses, sunscreen, insect repellent, and a hat with a visor. Be aware of the threat of Lyme disease. This merits some detail. The tiny deer ticks that carry Lyme disease are present year-round, anywhere deer are abundant—which is just about any outdoor location in the Region. The best way to prevent ticks from attaching to you and transmitting the disease is to wear boots and long pants and to spray both before going into the field. Also, it is advisable to stay out of long grasses and brushy areas frequented by deer. We like to wear those tall black rubber pull-on boots that come up to the shin. These are a good tick deterrent, especially when they are sprayed with repellent. Also spray

inside and outside of the knee boots and spray pants from the top of the boots to the waist. After a day in the field it is best, after returning home, to deposit all field clothing in a hamper, take a hot shower, and do a body search for these insidious little ectoparasites. It pays to be careful. Lyme disease can cause chronic, debilitating symptoms. If you start to feel joint pain several days after possible exposure to ticks, check your body for the telltale bull's-eye rash that signifies a bite from an infected tick. Get professional medical advice right away. Fortunately, doctors in our Region are well aware of the symptoms of Lyme disease and will prescribe you a course of the appropriate antibiotic if they suspect you are infected.

▪ Take a friend or a colleague. Birding is fun alone, but it is usually more productive in the company of a fellow birder—more birds get seen or heard by a duo. It is also safer, especially if you plan to be deep in the woods or mountains. If you do go alone, let someone know of your plans, so they can follow up in an emergency or if you don't return home by a certain time. Keep your cell phone with you at all times.

▪ Stop and ask. If you get lost, stop and ask directions. If you see birders on the side of the road

The Savage River Lodge in Garrett County, MD, is a great base camp for a birding trip on the Allegheny Highlands.

using binoculars or a telescope, definitely stop and find out what they are looking at (but turn off your engine when doing so). Maybe they have a bird in the scope that is a lifer for you! Also query them about other interesting sightings of the day. Other birders are a huge aid to finding the birds you are hunting for. In most cases, they have done the work in advance. If you get out of your car to speak to them be sure to close your door carefully. If you slam it, and that rarity flies off, you'll be very unpopular.

▪ Call in advance or visit a website. If you are planning to visit a refuge that is an hour or two away, it pays to check things out before departure (perhaps the afternoon in advance). Call the refuge headquarters to inquire about road or area closures or to find out about sightings of rarities.

▪ For a weeklong birding excursion, it is worth taking some extra steps. Spend at least a full evening planning the trip. Make all of your bookings well in advance, especially if you are visiting popular birding spots during the migration high season. Lay out your gear and equipment in a place where you can review your needs.

▪ Create an itinerary of birding sites. Using eBird and websites, make a short list of the best birding localities in the region you are visiting. Make a rough plan of what sites you will visit on which mornings or afternoons and in which sequence. Remember, time is short and everything takes more time than you think. The farther you are traveling, the more days you should plan spending at your destination. Always leave some time to be extemporaneous, after all, you may get an alert of a mega-rarity in the area that forces you to change your plan.

▪ Print out maps of the parks you are visiting. Most protected areas have websites, and most of these websites offer downloadable maps of the park. Print these out in advance and stick them in your backpack or pocket. These can be valuable when you are in the field and someone you meet in the field

tells you about a rare species "up the Canyon Trail, which is just south of the River Trail and east of the Mountain Trail." Also it pays to pick up state highway maps when you cross a border into a new state. These can be obtained for free at welcome centers or ordered online for no cost. Maps are fun to study in the evening or during a meal in transit and can generate backup options when an original plan or route breaks down. The handheld GPS and iPhone are nice gizmos, but a map is a physical entity that is a nice conversation piece to spread out at your table in a restaurant and can eventually become a trip souvenir if you take time to annotate it with the locations of specific sightings of rare birds.

▪ Book a motel using Trivago or a similar hotel room–aggregating website. It pays to book your lodging well in advance. Specialty lodges in or near parks and protected areas tend to fill up quickly in the high season (there are lots of birders out there).

▪ Consider hiring a local guide. With birding, local knowledge is everything. Some species have very narrow habitat requirements and only experienced locals know their locations. Having a local guide take you out can make a huge difference in what you see. The problem is only major birding hotspots (such as Cape May, New Jersey) have year-round local guides available. One might have to track down a local expert birder through the American Birding Association. An alternative is to send out a message to the birding LISTSERV of the state you plan to visit, stating where and when you are going and what your target species are and asking for advice. Birders are generally a friendly group, and people may either recommend some sites or even better, offer to take you around (provided the species in question are not highly sensitive or threatened—people will rarely give advice on where to find owls, for example).

▪ Consider having a bicycle with you. Many birding sites cover extensive territory. These can be more easily covered if you use a bicycle. Bicycling is a great way to bird by ear, traveling until you hear

something interesting. Pack a bicycle on the car rack, and use it when needed. Another option is to do the whole birding day by bicycle. Being in a car makes it harder to hear birds and is not as friendly to the environment. Cape Henlopen SP, DE, has an excellent biking trail, for example, and bicycles can be rented from the nature center.

▪ Create an action list specifically for the trip with supplies, equipment, important phone numbers, and other reminders. Keep a clipboard in the car with lists, maps, reminders, shopping needs, and the like.

▪ Be aware of speed traps. Certain small communities on the Eastern Shore are famous for these, situated at town edges.

▪ Driving versus birding. Be wary of getting distracted by birds while driving! It's easy to look up at a hawk and not realize you are leaving your lane!

Tips for Beginning Birders

Walk slowly, quietly, and carefully through the habitat. Walking directly toward a bird will often cause it to flush. Walking at a tangent oblique to the bird will allow you to keep on looking at it but with less likelihood of flushing it. Try sketching the bird in a field notebook, noting key ID features like beak shape, wing bars, color, all of which will teach you what field marks (critical cues to identification) to look for.

Try to avoid making sudden movements. If you see a bird in a bush, it's tempting to point at it or shout it out to your colleagues or grab your binoculars or camera. Better to quietly try to give clockface directions with as reasonably precise description as possible (e.g., "Cape May Warbler at two o'clock in the top of the big sweetgum"). This is especially important if you're on a group walk.

The top birders all have the enviable ability to keep their eye on the bird while bringing their binoculars up into position. Practice this important skill. Also, if you see a bird you don't recognize resist the temptation to grab your field guide. Always get a good look at the bird and its key features before you look at your field guide. With most songbirds, the best place to start is the head. Almost all male wood warblers in spring, for example, can be identified provided you get a good look at the head. Look for anything you will remember as a field mark, including colors, patterns, bill shape, and size, whether or not it has an eye ring. Then, in the case of warblers or vireos, especially, look at the wings for the presence or absence of wing bars. For warblers, sparrows, and thrushes, look at their upper breast for the presence or extent of streaks or spots.

The strenuous Billy Goat Trail at Great Falls of the Potomac (in Montgomery County, MD) requires some advance planning to ensure a smooth hike.

Important Institutions for Birds and Birding

Here you will find an annotated listing of institutions both local and national that can help further birding, bird appreciation, and bird conservation, beginning with local societies of most relevance to our Region's birders then broadening to the national level. Quite a few of these are membership organizations, and we encourage readers to consider joining some of these. Many are volunteer run and depend on membership dues to continue their mission.

The institutional sponsor of this book, the **Maryland Ornithological Society** (MOS) is a nonprofit, statewide organization of people interested in birds and nature. It was founded in 1945 and incorporated in 1956 to promote the study and enjoyment of birds. MOS promotes knowledge about our natural resources and fosters their appreciation and conservation. The society also maintains a system of 10 bird sanctuaries to encourage the conservation of birds and bird habitat. These bird-rich local sanctuaries can be visited at no charge by MOS members. Finally, the MOS publishes *Maryland Birdlife* to document the status, abundance, and movements of birds in the state. All are encouraged to submit to this and other local journals. Most counties have a local MOS chapter that offers field trips, bird counts, and conservation projects for members and partners. Lively and informative programs complement regular meetings where members and guest speakers share their knowledge and expertise. Most local chapters have a website. Website: http://www.mdbirds.org/

Delmarva Ornithological Society. The object and purpose of the DOS is the promotion of the study of birds, the advancement and diffusion of ornithological knowledge, and the conservation of birds and their environments. The activities of the DOS are centered primarily on

The bird skin collection at the National Museum of Natural History (Smithsonian Institution) is a renowned resource for ornithologists carrying out all manner of scientific studies. The collection represents a permanent record of historical bird distributions, evidence of geographic variation, and a source of DNA for analysis. This collection contains birds collected by John James Audubon, Theodore Roosevelt, and many other illustrious naturalists. Photo: Chip Clark

The Chesapeake Bay Foundation and various institutional partners lead the way to "Save the Bay." Here a Diamondback Terrapin steals the show at Pickering Creek Audubon Center in Talbot County, MD.

Bird banders help various conservation organizations keep tabs on the health of local and migratory bird populations. This bander is looking for skull ossification as a means of determining the age of this Northern Cardinal male.

the Delaware portion of the Delmarva Peninsula. Monthly meetings are held at the Ashland Nature Center, located near Hockessin, Delaware, and members lead frequent field trips throughout the state and in nearby portions of Maryland and Pennsylvania. In recent years, DOS has become very conservation oriented and instigated the Delaware Bird-A-Thon, a friendly competitive event in which teams compete to raise funds for local conservation projects. It also co-sponsors the Ashland Hawk Watch and the Delaware Birding Trail project and operates six Christmas Bird Counts across Delaware. Explore the DOS website to learn more about the DOS and take advantage of the many resources that the DOS has gathered. DOS welcomes all to its monthly meetings or field trips. Website: https:// www.dosbirds.org/

Audubon Naturalist Society (of the Central Atlantic States), centered in the Washington, DC, area, annually offers several hundred lectures, field trips, and courses conducted by experts. Perhaps a third of these offerings are directly related to birds; others focus on plants, other animal groups, conservation methods, and geology. Over its 120 years, it has had a venerable history of education and conservation

advocacy. The *Naturalist News* keeps members apprised of these myriad activities and opportunities as well as local conservation issues. Many of these activities are free, but some, especially those offering academic credit, require a fee. It is a dynamic, multifaceted organization with several thousand members. Its "Voice of the Naturalist" is a weekly summary of bird sightings (https://anshome.org /voice-of-the-naturalist/). Website: anshome.org. Woodend Sanctuary (headquarters), 8940 Jones Mill Road, Chevy Chase, Maryland 20815. Telephone: 301-652-9188.

The Delaware Valley Ornithological Club is an organization for birders and bird enthusiasts in the Delaware Valley Region. The Delaware Valley is the region that lies on either side of the Delaware River, centered on Philadelphia. This consists of southeastern Pennsylvania, central and southern New Jersey and the state of Delaware. All who are interested in birds are invited to attend the functions

and field trips of the DVOC. Bimonthly meetings are held at the Academy of Natural Sciences in Philadelphia. Website: http://dvoc.org/

Delaware Natural History Museum, 4840 Kennett Pike (Route 52), Box 3937, Wilmington, Delaware 19807 (5 miles northwest of Wilmington). The scientific focus of this small but friendly museum includes ornithology and malacology. It has the second largest collection of bird eggs in North America, including one of the few remaining elephant bird eggs on public display. It offers many events, most of them in-house. It has dioramas, exhibits, and a research library. Researchers can apply to view the specimen collection, which is also used for instructions during occasional DOS workshops. Website: www.delmnh.org. Hours: Monday through Saturday, 9:30 a.m.–4:30 p.m.; Sunday, 12 p.m.–4:30 p.m. Telephone: 302-658-9111, email: info@delmnh.org

The American Birding Association (ABA) is a nonprofit organization that provides leadership to birders by increasing their knowledge, skills, and enjoyment of birding. ABA is the only organization in North America that specifically caters to recreational birding. As its mission, the ABA inspires all people to enjoy and protect wild birds. The ABA represents the North American birding community and supports birders through publications, conferences, workshops, tours, partnerships, and networks. The ABA's education programs promote birding skills, ornithological knowledge, and the development of a conservation ethic. The ABA encourages birders to apply their skills to help conserve birds and their habitats, and ABA represents the interests of birders in planning and legislative arenas. The ABA welcomes all birders as members. Website: www.aba.org. PO Box 744, 93 Clinton Street, Suite ABA, Delaware City, Delaware 19706. Telephone: 830-895-1144.

Christmas Bird Count. The National Audubon Society manages Christmas Bird Counts across North America. These all-volunteer winter bird surveys are carried out from mid-December to early January each year. Each count surveys birds on a single day within a fixed 15-mile-diameter circle. The 2017–2018 counts were the 118th year of this historic winter birding activity. Each year, more than 2,000

Dynamic public exhibits at the Smithsonian's National Museum of Natural History, on the Mall in Washington, DC, help to foster appreciation of the natural world. Photo: Bruce Beehler

counts are made across North America. Sign up to participate in a CBC near your home. To find out the nearest count, visit the website: http://www.audubon.org/conservation/science/christmas-bird-count

Great Backyard Bird Count. This is an annual backyard feeder count conducted over a few days in mid-February, though the term *backyard* is defined loosely. Much of these data represent citizen-science and are used for long-term analysis of winter bird numbers and distribution of populations. Hosted by the Cornell Lab of Ornithology and the National Audubon Society. Website: http://gbbc.birdcount.org/

The Association of Field Ornithologists was founded in 1922 as the New England Bird Banding Association. Today, the AFO is a society of professional and amateur ornithologists dedicated specially to bird-banding and bird population studies through trapping and banding. All bird-banders or aspiring bird-banders should be members of the AFO. The AFO is also an important source of bird-banding supplies and equipment. Website: http://www.afonet.org/

The Maryland Bird Conservation Partnership (MBCP) was launched in 2014 to build the foundation of a collaborative, sustained effort to conserve Maryland birds and their habitats. Modeled after the North American Bird Conservation Initiative, state bird conservation partnerships are coalitions of government agencies, nonprofits, and citizen stakeholders to ensure long-term health of native bird populations. To undertake this complex goal, the MBCP facilitates partnerships on land conservation, research, data gathering and collation, citizen-science monitoring, and education. Website: https://marylandbirds.org/

The Nature Conservancy (TNC) conserves the lands and waters on which all life depends. The TNC vision is a world where the diversity of life thrives and people act to conserve nature for its own sake and its ability to enrich our lives. TNC achieves this vision through the dedicated efforts of its diverse staff of more than 600 scientists, all of whom work to impact conservation in the United States and around the world. TNC deploys a non-confrontational and collaborative approach. There are also state TNC programs for Delaware and for Maryland / District of Columbia. Website: https://www.nature.org/

The Chesapeake Bay Foundation (CBF), founded in 1967, is solely dedicated to conserving the natural values of the Chesapeake Bay. Serving as a watchdog, CBF fights for effective, science-based solutions to threats to the Chesapeake Bay and its rivers and streams. CBF's motto, "Save the Bay," is a regional rallying cry for pollution reduction throughout the Chesapeake's six-state, 64,000-square-mile watershed, which is home to more than 17 million people and many thousand species of plants and animals. With offices in Maryland, Virginia, Pennsylvania, and the District of Columbia and 15 field centers. Website: http://www.cbf.org/

The National Museum of Natural History (of the Smithsonian Institution). With its several floors of wonderful natural history exhibits, the National Museum is one of the world's leaders in the study of nature. Its collections form the most comprehensive natural history collection in the world. By comparing items gathered in different eras and regions, scientists learn how our world has varied across time and space. Such collections-based research then provides the essential building blocks for answering broader questions about our world and our future. The museum's Bird Division houses a large collection of the world's birds, an expert staff, and a fine ornithological research library. Research ornithologists and groups can book a behind-the-scenes tour to the Bird Division by prior arrangement. Websites: https://naturalhistory.si.edu/ and http://vertebrates.si.edu/birds/

The Smithsonian Migratory Bird Center (SMBC) is dedicated to understanding, conserving, and cham-

pioning bird migration in the western hemisphere. Founded in 1991, SMBC is located at the Smithsonian's National Zoological Park in Washington, DC. The SMBC seeks to clarify why migratory bird populations are declining and offers effective solutions to these issues. SMBC programs help raise awareness about migratory birds and the need to protect diverse habitats across the western hemisphere. Website: https://nationalzoo.si.edu/migratory-birds

The American Bird Conservancy is the western hemisphere's bird conservation specialist—the only organization with a single and steadfast commitment to achieving conservation of birds and their habitats throughout the Americas. ABC believes that conserving birds and their habitats benefits all other species, including people. ABC's actions are founded on sound science, and ABC works in partnership to achieve four goals: (1) halt extinctions, (2) protect habitats, (3) eliminate threats, and (4) build institutional capacity for bird conservation. Website: https://abcbirds.org/

The National Audubon Society is dedicated to the conservation of birds and their habitats. Located in the United States and incorporated in 1905, Audubon is one of the oldest of such organizations in the world and uses science, education, and grassroots advocacy to advance its conservation mission. The society has nearly 500 local chapters, each of which is an independent nonprofit organization voluntarily affiliated with the National Audubon Society. The society's main offices are in New York City and Washington, DC, and it has state offices in 24 states. It also owns and operates a number of nature centers open to the public. Audubon Centers help to forge lifelong connections between people and nature, developing stewards for conservation among young and diverse communities. Website: http://www.audubon.org/

The Cornell Lab of Ornithology is a member-supported unit of Cornell University in Ithaca, New York, which studies birds and other wildlife. It is housed in the Imogene Powers Johnson Cen-

ter for Birds and Biodiversity in Sapsucker Woods Sanctuary. Approximately 250 scientists, professors, staff, and students work to achieve the lab's mission: interpreting and conserving the Earth's biological diversity through research, education, and citizen science focused on birds. The Cornell Lab issues a quarterly publication, *Living Bird* magazine, and a monthly electronic newsletter and manages the eBird online database. Website: http://www.birds.cornell.edu/

American Ornithological Society (AOS) is an ornithological organization based in the United States. Its members are primarily professional ornithologists, although membership is open to anyone with an interest in birds. The AOS is a member of the Ornithological Council and Ornithological Societies of North America. AOS publishes the scholarly journals *The Auk* and *The Condor,* as well as the AOU Classification Committee's checklist of North American Birds. Website: http://www.americanornithology.org/

Dr. David Curson, Director of Bird Conservation for Audubon Maryland-DC, leads a monthly bird walk in Baltimore's Patterson Park.

Warblers

HUMMINGBIRDS
A Life-size Guide to Every Species

STOKES FIELD GUIDE TO BIRDS EASTERN REGION

BOYLE
A Guide to Bird Finding in New Jersey

A FALCON GUIDE
Birding Texas

STOKES BIRDS OF NORTH AMERICA

BIRDS OF PREY PETE DUNNE
with KEVIN T. KARLSON

MICHAEL O'BRIEN, RICHARD CROSSLEY, AND KEVIN KARLSON
The Shorebird Guide

Armistead & Sullivan Better Birding

Stephenson and Whittle The Warbler Guide

SCOTT WEIDENSAUL Of a Feather A Brief History of American Birding

NATIONAL AUDUBON SOCIETY THE SIBLEY GUIDE TO BIRDS

Peterson Seawatching Ken Behrens &
Eastern Waterbirds in Flight Cameron Cox

Gulls of the Americas

BIRDS
OF NORTH AMERICA Editor-in-Chief
FRANÇOIS VUILLEUMIER DK

BIRDS

Key Birding and Ornithological References

Every scholarly book is built on a foundation of knowledge that includes an assortment of reference books that came before it. This book is no exception. Here we present and discuss the most important sources for this work. These merit attention, appreciation, and continued use by practitioners of all sorts. Some of these books you will want to have in your own library. The following are listed in sections, based on use and focus.

Critical References

eBird. Species Range Maps. http://ebird.org/ebird/map/.

The species mapping tool within the eBird website is perhaps the single most useful reference for the occurrence, distribution, and abundance of birds in North America, with the ability to filter the data by year, season, and geography. It will grow in importance as more current and historical records are entered into the database. All birders should consider uploading their observations to eBird. The database features tens of thousands of bird records from our Region, with new records being added every day.

Hess, Gene K., Richard L. West, Maurice V. Barnhill III, and Lorraine M. Fleming. 2000. *Birds of Delaware*. University of Pittsburgh Press, Pittsburgh, PA. 635 pages.

Combines the results of a breeding bird atlas (1983–1987) with additional historical, seasonal, habitat, and distributional data of a state bird book, providing accounts for all species ever recorded from the state of Delaware at the time of printing.

A stack of field guides illustrates that modern-day birders have amazing resources to put wind under their wings.

Volunteering at a banding site allows for close-up viewing of the fine details of tiny birds like this male Canada Warbler.

Ellison, Walter G. (Editor). 2010. *Second Atlas of Breeding Birds of Maryland and the District of Columbia.* Johns Hopkins University Press, Baltimore, MD. 494 pages.

A classic state breeding bird atlas, treating all the birds found to be breeding in the state between the years 2002 and 2006. For each of these species, it provides a map that shows where they recorded breeding during these five years, a color photograph of the species, and a narrative describing its habits, habitat choice, and current breeding status. It also includes data on change in abundance of the species since the first Maryland atlas.

Robbins, Chandler S. (Editor), and Eirik A. T. Blom (Project Coordinator). 1996. *Atlas of the Breeding Birds of Maryland and the District of Columbia.* University of Pittsburgh Press, Pittsburgh, PA. 479 pages.

This excellent atlas, conducted 1983–1987, the first for Maryland, provides extremely important baseline information lending significance to the second atlas.

Iliff, Marshall J., Robert F. Ringler, and James L. Stasz. 1996. *Field List of the Birds of Maryland.* Maryland Avifauna No. 2. Maryland Ornithological Society, Baltimore, MD. 53 pages. http://www.biodi versitylibrary.org/bibliography/119538#/summary.

An important companion to the Maryland breeding bird atlas, because it includes all species recorded from Maryland and the District of Columbia, not

just the breeding species. This is a compact coded checklist and seasonal abundance chart for the region covered, on which chapter 28 was built.

Stewart, Robert E., and Chandler S. Robbins. 1958. *Birds of Maryland and the District of Columbia.* North American Fauna 62. US Department of Interior, Washington, DC. 401 pages.

An important technical treatise on the avifauna of Maryland, with important baseline and historical data.

Sibley, David. 1997. *The Birds of Cape May.* Second edition, revised by Vince Elia and David Sibley. Cape May Bird Observatory, Cape May, NJ. 168 pages.

This compact distributional guide to the birds of Cape May, New Jersey, is relevant to bird occurrence in the less-well-known areas of eastern Delaware, just across the bay from Cape May. The thumbnail species accounts and occurrence chart provide valuable data on seasonal abundance of the birdlife.

Poole, Allan (Series Editor). *Birds of North America.* Cornell Lab of Ornithology, Ithaca, NY.

A collaboration between the Cornell Lab of Ornithology and the American Ornithological Society. Originally produced as a series of separate species accounts on the life history of all species of birds breeding in North America, it is now available online through https://birdsna.org/ as a paid subscription or through membership at the American Ornithological Society. The accounts are updated on a rotating basis and provide the most current accounts on each species of North American bird. These species accounts are comprehensive treatments for all of the birds of the continent north of Mexico.

Wilds, Claudia. 1992. *Finding Birds in the National Capital Area.* Revised edition. Smithsonian Institution Press, Washington, DC. 263 pages.

Great for learning the best birding spots in the Region. An important reference for chapter 29—Best Birding Localities.

Sibley, David Allen. 2014. *The Sibley Guide to Birds.* Second edition. Alfred A. Knopf, New York. 599 pages.

> *This is a comprehensive and authoritative field guide to the birds of North America. A valuable reference for office and car.*

Maryland Birdlife. Quarterly journal of the Maryland Ornithological Society now available online through SORA (Searchable Ornithological Research Archive), https://sora.unm.edu/node/132691.

> *Field observers publish their distributional records for Maryland in Maryland Birdlife. Important observations are still written up for publication in this journal.*

Cassinia.

> *The journal of the Delaware Valley Ornithological Club. Some recent issues are available online at http://dvoc.org/CassiniaOnLine/Cassinia71_80.htm.*

The Delmarva Ornithologist.

> *An annually published scientific journal of the Delmarva Ornithological Society. It publishes articles concerning birds in the Delmarva region, including behavior and rare bird sightings. It also publishes the results from the two fall Delaware hawk watches, the Spring Round (May bird survey), the Christmas Bird Count, the Passing Scene (rarity round up), and the report of the Delaware Bird Records Committee.*

Field Books

Sibley, David Allen. 2016. *Sibley Birds East—Field Guide to the Birds of Eastern North America.* Second edition. Alfred A. Knopf, New York. 439 pages.

> *This compact field guide to the eastern birds is, hands down, the best identification tool for intermediate or advanced birders to take into the field in our Region.*

Kaufman, Kenn. 2000. *Birds of North America.* Houghton Mifflin, Boston, MA. 383 pages.

> *For those who prefer color photos over paintings, this will be a useful field guide.*

Dunn, John L., and Jonathan Alderfer. 2017. *Field Guide to the Birds of North America.* Seventh edition. National Geographic Society, Washington, DC. 591 pages.

> *Very popular with advanced birders. The slightly larger trim size allows larger illustrations of the birds and more of the super-rare species are included.*

Peterson, Roger Tory. 2010. *Field Guide to the Birds of Eastern and Central North America.* Sixth edition. Houghton Mifflin, Boston, MA. 464 pages.

> *This is the granddaddy of field guides and is perhaps the very best for beginning birders and intermediates, especially because of the simplicity of the bird depictions and the highlighting of their key field marks. Also it has the range maps in a larger format.*

This team of birders has backup binoculars at the ready with a canine companion.

Specialized Field References

Dunn, Jon, and Kimball Garrett. 1997. *Warblers*. Peterson Field Guides. Houghton Mifflin, Boston, MA. 656 pages.

> *Combining substantial text, paintings, maps, and color photographs, this is a tour de force on the subject of North America's wood warblers.*

Stephenson, Tom, and Scott Whittle. 2013. *The Warbler Guide*. Princeton University Press, Princeton, NJ. 560 pages.

> *For identification of one of birders' favorite groups of birds. An abundance of color photographs of every species makes this a valuable reference for the identification of a very popular, much sought-after group of birds.*

Clark, William S., and Brian K. Wheeler. 2001. *A Field Guide to Hawks of North America*. Second edition. Peterson Field Guides. Houghton Mifflin Harcourt, Boston, MA. 316 pages.

> *Field identification of another important, well-watched avian group of birds, many of which occur in our Region year-round.*

O'Brien, Michael, Richard Crossley, and Kevin Karlson. 2006. *The Shorebird Guide*. Houghton Mifflin, Boston, MA. 496 pages.

> *Another specialty guide about a favorite group of birds for many birders.*

Svensson, Lars. 2009. *Princeton Field Guides: Birds of Europe*. Second edition. Princeton University Press, Princeton, NJ. 448 pages.

> *This is the best guide for the birds of Europe, which can come in handy for identifying rare vagrants that cross the Atlantic and end up on the shores of Delaware or Maryland.*

Knowing when and where to look is the biggest part of the challenge of finding birds of interest in the field.

Jonsson, Lars. 1999. *Birds of Europe*. Christopher Helm, London. 560 pages.

> *Another great guide for identification of European vagrants. The paintings in this volume are large and gorgeous. A great book for learning the birds of Europe and includes beautiful renderings of many species from our Region.*

Recommended Additional Reading about Birds, Bird Conservation, and the Regional Environment

Cronin, William B. 2005. *The Disappearing Islands of the Chesapeake*. Johns Hopkins University Press, Baltimore, MD. 182 pages.

Fleming, Lorraine M. 1978. *Delaware's Outstanding Natural Areas and Their Preservation*. Delaware Nature Education Society, Hockessin, DE. 422 pages.

Harding, John J., and Justin J. Harding. 1980. *Birding the Delaware Valley Region*. Temple University Press, Philadelphia, PA. 223 pages.

Horton, Tom. 1987. *Bay Country*. Johns Hopkins University Press, Baltimore, MD. 223 pages.

Horton, Tom. 1996. *An Island Out of Time: A Memoir of Smith Island in the Chesapeake*. W. W. Norton, New York, NY. 316 pages.

Kirschbaum, Elliot A. (Editor). 1998. *A Birder's Guide to Baltimore and Baltimore County, Maryland*. Baltimore Bird Club, Maryland Ornithological Society, Hagerstown, MD. 105 pages.

Lebbin, Daniel J., Michael J. Parr, and George H. Fenwick. 2010. *The American Bird Conservancy Guide to Bird Conservation*. University of Chicago Press, Chicago, IL.

Lippson, Alice Jane, and Robert L. Lippson. 2006. *Life in the Chesapeake Bay*. Third edition. Johns Hopkins University Press, Baltimore, MD. 324 pages.

Meanley, Brooke. 1975. *Birds and Marshes of the Chesapeake Bay Country*. Tidewater Publishers, Cambridge, MD. 157 pages.

Meanley, Brooke. 1978. *Blackwater*. Tidewater Publishers, Cambridge, MD. 148 pages.

Meanley, Brooke. 1982. *Waterfowl of the Chesapeake Bay Country*. Tidewater Publishers, Cambridge, MD. 210 pages.

Meanley, Brooke. 1996. *The Patuxent River Wild Rice Marsh*. Maryland-National Capital Park and Planning Commission, [Prince George's County, MD]. 91 pages.

Montgomery County Chapter, Maryland Ornithological Society. 2001. *A Birder's Guide to Montgomery County, Maryland*. Potomac, MD. 215 pages.

State of North America's Birds 2016. http://www .stateofthebirds.org/2016/state-of-the-birds-2016 -pdf-download/.

Tallamy, Doug. 2009. *Bringing Nature Home*: *How You Can Sustain Wildlife with Native Plants*. Timber Press, Portland, OR. 360 pages.

US Fish and Wildlife Service, National Park Service. 1980. *Assateague Island National Seashore, Maryland and Virginia*. National Park Service, Washington, DC. 175 pages.

Warner, William W. 1976. *Beautiful Swimmers: Watermen, Crabs and the Chesapeake Bay*. Little, Brown, Boston, MA. 304 pages.

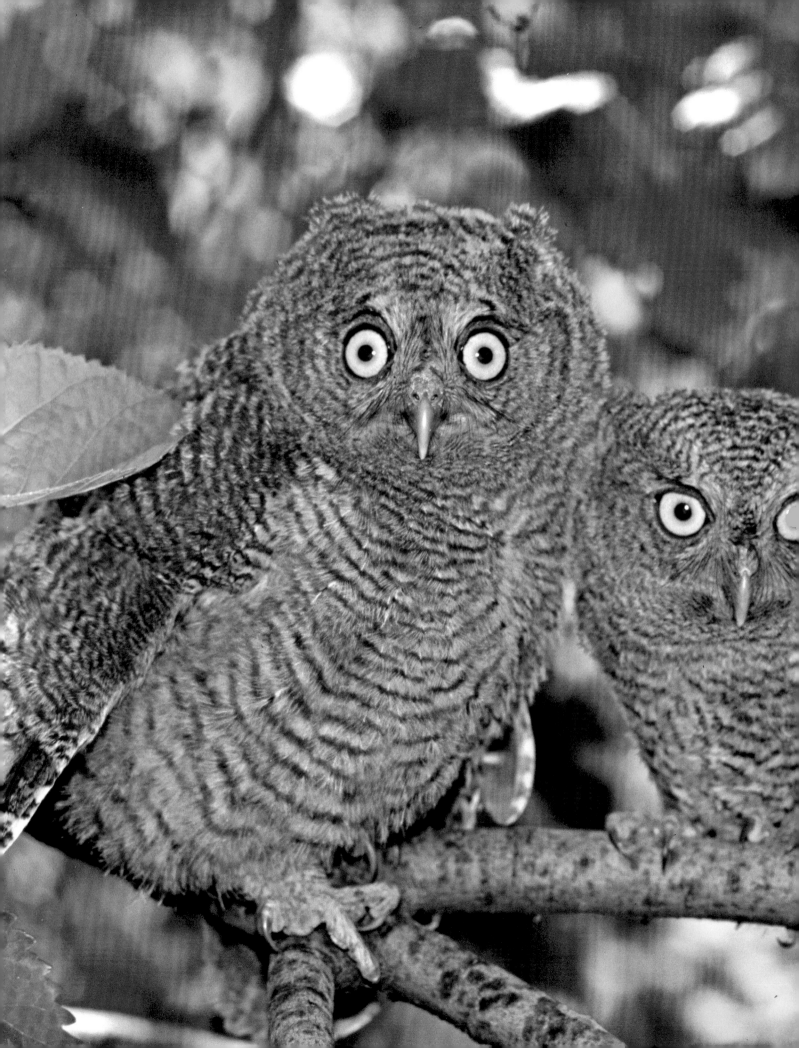

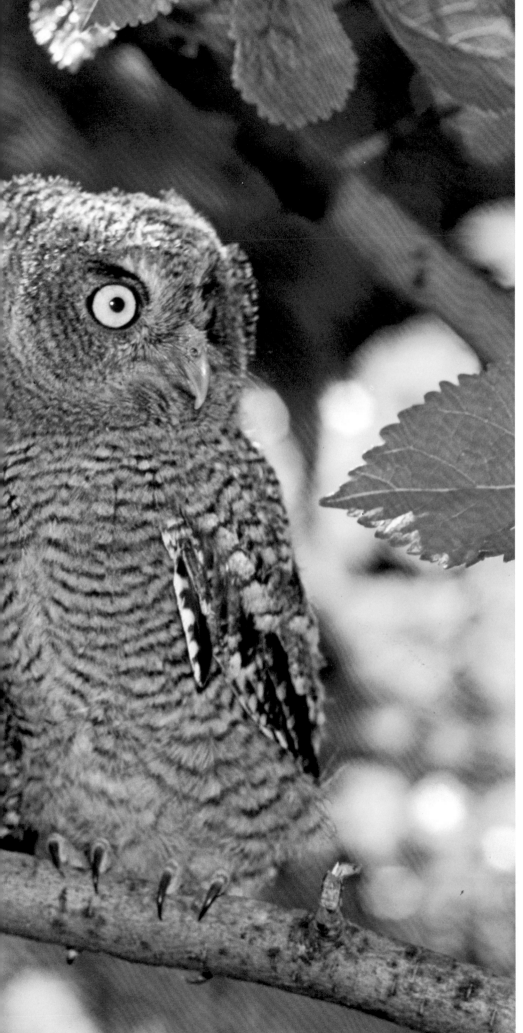

Life out of the nest
is full of surprises for
these fledgling Eastern
Screech-Owls.

Photographic Atlas and Finding Guide

We provide here a thumbnail illustration of every bird regularly found in our Region. We also offer advice on finding each one—information on when it is most prevalent in our Region, in what provinces it might best be seen, and, when appropriate, exactly where and when to go look for the bird. Many of these specific birding sites are discussed in detail in chapter 29.

We discuss all the regularly occurring species in the main list that follows. These illustrated thumbnail accounts are counterparts to the species accounts in part one, which treat the species generically with key details of their ecology or behavior. The accounts below are focused on the species in the context of finding them in our Region. Note that the rarely recorded species are sequestered in chapter 27. We keep these rare birds separate because they are found in the Region less than once a year and are best considered as a distinct bird-finding challenge for advanced birders.

A final comment: the sequence followed here is the same as that followed in the coded Regional checklist in chapter 28—both follow the linear sequence provided by the 58th Supplement of the North American Classification Committee of the American Ornithological Society. By contrast, the listings in chapters 9–20 were based on ecological and morphological groupings, not the evolutionary sequence presented here. Scientific names for all the birds are provided in the table in chapter 28. Here we provide instead the standardized four-letter alphabetical codes that serve as shorthand species names for each North American bird species. This shorthand nomenclature is handy for field notes and other bird communications, and we encourage their use.

Abbreviated terms

►	the suggested place and season to find this species
DC	Washington, DC
DE	Delaware
MD	Maryland
NA	Natural Area
NWR	National Wildlife Refuge
SP	State Park
the Region	Maryland, Delaware, and District of Columbia
the two bays	Chesapeake and Delaware Bays
WA	Wildlife Area
WMA	Wildlife Management Area

Neighborhood green spaces such as Stony Run Park in Baltimore's Roland Park can be fabulous migrant traps, as this handsome American Redstart illustrates.

Bird-finding Accounts

Snow Goose. SNGO

Adult, 11/2014 Bombay Hook NWR, Kent County, DE
Common to abundant in large flocks in late fall and winter, especially on the Eastern Shore. Most records from near the two bays and major estuaries, and while the birds are foraging in adjacent agricultural fields. ▶ Large flocks at Prime Hook, Bombay Hook, and Blackwater NWRs. Between mid-November and late February.

Ross's Goose. ROGO

Adult, 1/2016 Johns Hopkins Road, Howard County, MD
Photo: Mark R. Johnson
A rare but increasing wanderer from the West. About 20 records per year here, typically in association with flocks of Snow Geese (or with Canada Geese in the absence of Snows). ▶ Search large flocks of Snow Geese for singletons of this diminutive goose. November to March.

Greater White-fronted Goose. GWFG

Adult, 1/2015 Whittier Lake, Frederick County, MD
A rare but increasing migrant with most records coming from agricultural fields near the two bays or near major watercourses in midwinter. Usually affiliated with large flocks of either Snow or Canada Geese. ▶ Vicinity of Bombay Hook NWR, DE. October to March.

Brant. BRAN

Adult, 2/2015 Inlet, Ocean City, MD
Locally common between November and March in salt and open brackish waters of Delaware Bay and the Atlantic Ocean estuaries and shore. Also a small scattering of records annually from the Chesapeake and its major tributaries. ▶ Small flocks on the Atlantic Coast from Cape Henlopen, DE, to Assateague Island, MD. In the colder months.

Barnacle Goose. BARG

Adult captive, 5/2007 Livingston-Ripley Waterfowl Conservancy, Litchfield, CT. Photo: Bruce Beehler
A very rare winter visitor usually found with Canada Geese. Typically 1 to 2 records per year. ▶ Most records are from the Chesapeake and Delaware Bays or the Potomac River. September to January.

Cackling Goose. CACG

Adult, 2/2015 Jean S. Roberts Memorial Park, Harford County, MD. Photo: Mark R. Johnson
Difficult to distinguish from small-sized Canada Geese, this bird is usually found as a singleton or in small family groups associated with flocks of Canada Geese in winter. Records from across the Region in agricultural fields of the Eastern and Western Shores. ▶ Search for smaller, short-beaked, and short-necked singletons of this species within large flocks of Canada Geese in agricultural fields of the Eastern or Western Shores.

Canada Goose. CANG

Adults, 4/2016 Swan Harbor Farm, Harford County, MD
Common to abundant year-round. The Region supports both local breeding populations (so-called golf course geese) as well as tundra-breeding populations that winter along estuaries of the two bays, foraging for waste grain in agricultural fields. ► Any suburban park with water. Year-round.

Mute Swan. MUSW

Adult, 5/1996 Maxmore Creek, Talbot County, MD
An introduced species from Europe that first appeared in the Region in the 1950s, which is now being eliminated by targeted action by wildlife authorities. Formerly a widespread breeder near marshes, lakes, and large rivers that drain into the Chesapeake and Delaware Bays or on the bays proper. Any swan seen between April and September is most likely this species. Typically seen as pairs or family groups. ► In small numbers in Dragon Run Marsh, near Delaware City, DE.

Trumpeter Swan. TRUS

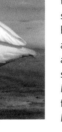

Adult, 2/2015 Black Hill Regional Park, Montgomery County, MD
Known to be a regular wintering species in the Region in the nineteenth century. A recent effort to reintroduce the species to former breeding haunts in the northern Midwest has resulted in wanderers showing up in our Region, with annual records from the Western Shore and lower Chesapeake Bay, especially during winter and spring. Swans seen on the Eastern Shore are more likely to be Tundra or Mute. Trumpeters appear to avoid the open bay waters favored by Tundra Swans. ► Black Hill Regional Park, MD. Midwinter.

Tundra Swan. TUSW

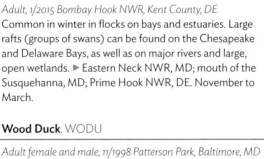

Adult, 1/2015 Bombay Hook NWR, Kent County, DE
Common in winter in flocks on bays and estuaries. Large rafts (groups of swans) can be found on the Chesapeake and Delaware Bays, as well as on major rivers and large, open wetlands. ► Eastern Neck NWR, MD; mouth of the Susquehanna, MD; Prime Hook NWR, DE. November to March.

Wood Duck. WODU

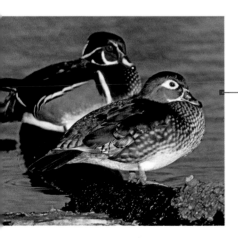

Adult female and male, 11/1998 Patterson Park, Baltimore, MD
In pairs or small groups year-round throughout the Region, with a mix of breeders and migrants seasonally. Common in the warmer months, scarce in winter. Most often found in wooded wetlands, but also occurs in freshwater marshes near woodlands. ► McKee-Beshers WMA, MD; Jug Bay Wetlands Sanctuary, MD; Prime Hook NWR, DE. Spring and early autumn.

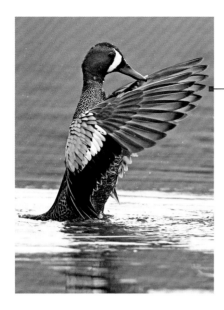

Blue-winged Teal. BWTE

Adult male, 4/2016 Patterson Park, Baltimore, MD
A common spring and fall migrant on refuge impoundments (managed bodies of water in protected areas) and in marshlands throughout, but most abundant on the Eastern Shore, where it also breeds in small, declining numbers in the tidal marshlands of the lower Chesapeake Bay. ▶ Blackwater and Bombay Hook NWRs. Late September.

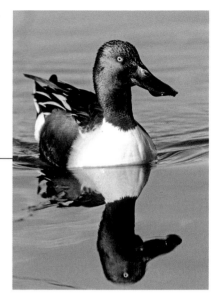

Northern Shoveler. NSHO

Adult male, 3/1997 Blackwater NWR, Dorchester County, MD
Common migrant. Winters in small numbers throughout the Region. Most common in the tidewater regions of the Eastern Shore, where there are a small scattering of breeding records. Found in freshwater marshlands, impoundments, weedy ponds, and estuaries. ▶ Blackwater and Bombay Hook NWRs. October to March.

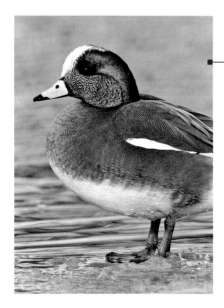

Gadwall. GADW

Adult male and female, 11/2007 community pond, Seattle, WA
Photo: Bruce Beehler
A common and widespread nonbreeding migrant to lakes, estuaries, and marshlands of the Region, with a small breeding population in the southern sector of the Eastern Shore. Small numbers throughout. ▶ Eastern Shore refuges. Late autumn and winter.

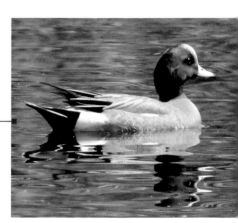

Eurasian Wigeon. EUWI

Adult male, 4/2015 Loch Raven, Baltimore County, MD
A rare but regular autumn and winter vagrant, with a handful of records each year, typically as a singleton affiliated with other dabbling ducks (usually in flocks of American Wigeons) on ponds and freshwater wetlands. ▶ Coastal refuges.

American Wigeon. AMWI

Adult male, 1/2012 Patterson Park, Baltimore, MD
Widespread in small flocks on ponds, impoundments, and wetlands from fall until spring. One of the more common cool-season dabbling ducks. There is also a scattering of records from the summer months and a breeding record from Delaware in 1962. ▶ Refuges, ponds, freshwater marshes. September to May.

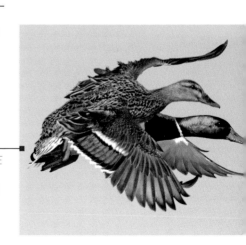

Mallard. MALL

Adult female and male, 11/2014 Silver Lake, Rehoboth Beach, DE
Widespread and abundant in pairs and small groups year-round. ▶ Lakes, freshwater marshlands, and suburban and urban parks. Especially spring and autumn.

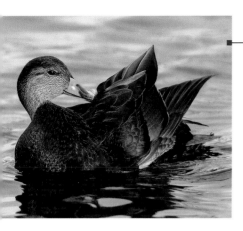

American Black Duck. ABDU

Adult male, 3/2011 Patterson Park, Baltimore, MD
Present year-round in estuaries and marshes of the Eastern Shore. West of the Bay the species is less common but present in small numbers, usually in association with Mallards. Breeds throughout, but most prevalent in large tidal marshlands of the Eastern Shore in autumn and winter. ▶ Eastern Shore refuges. Fall and winter.

Northern Pintail. NOPI

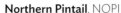

Adult male, 12/2014 Bombay Hook NWR, Kent County, DE
A common migrant throughout the Region, with smaller numbers wintering on major rivers and tidewater marshlands. Larger flocks can be found at the major wildlife refuges of the Eastern Shore in winter. A few breeding reports from the Eastern Shore. ▶ Blackwater and Bombay Hook NWRs. October to February.

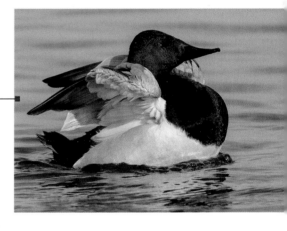

Green-winged Teal. GWTE

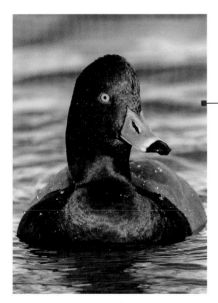

Adult male, 4/2013 Patterson Park, Baltimore, MD
A common and widespread migrant, wintering in small flocks in freshwater and brackish marshlands and shallow ponds, especially in the tidewater. A few breeding records from the Eastern Shore. Most prevalent in the colder months, east of the Ridge & Valley province. ▶ Eastern Shore refuges. Autumn.

Canvasback. CANV

Adult male, 2/2015 Oakley Street, Cambridge, MD
A widespread but uncommon migrant to open waters, found in bays, large estuarine rivers, and reservoirs. Most large wintering concentrations are found on the lower Potomac River and upper Chesapeake Bay. ▶ Silver Lake, Rehoboth Beach, DE. Winter.

Redhead. REDH

Adult male, 12/2014 Oakley Street, Cambridge, MD
A widespread but uncommon migrant and wintering species found in small numbers on open water of larger reservoirs, lakes, and the two bays, often in association with scaup. Mainly November to March. ▶ Wintering flocks in the upper Chesapeake Bay; on the Potomac River south of Washington, DC; Pocomoke Sound, MD; near Hooper's Island, MD.

Ring-necked Duck. RNDU

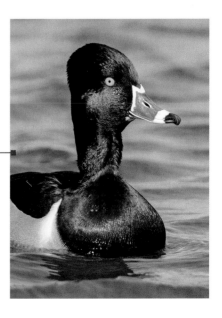

Adult male, 12/2014 Silver Lake, Rehoboth Beach, DE
A common migrant and winter resident in small flocks inhabiting sheltered inlets of rivers and on small wooded ponds. Often found in winter on ponds in urban parks. Arrives in late October and departs by early April. Prefers fresh water. The most widespread of our diving ducks in winter. ▶ Loch Raven Reservoir, MD; Potomac River above Great Falls, MD; Constitutions Gardens pond, DC. Late autumn and winter.

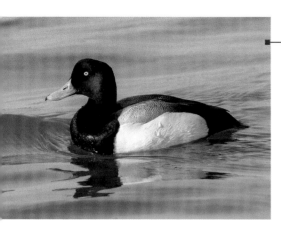

Greater Scaup. GRSC

Adult male, 2/2015 Inlet, Ocean City, MD

An uncommon migrant that winters in small numbers mainly on the open waters of the Chesapeake Bay and lower Potomac River. In most instances is outnumbered by the Lesser Scaup. Prefers bays and more open waters than the Lesser. The two are difficult to distinguish when observed from great distances, which is typical. ▶ Chesapeake Beach, MD; Hooper's Island, MD; Indian River Inlet, DE. Midwinter.

Lesser Scaup. LESC

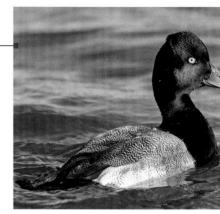

Adult male, 12/2014 Oakley Street, Cambridge, MD

A common migrant, wintering in flocks on larger rivers, estuaries, and tidewater. Much more likely to be found on inland lakes and ponds than the less common Greater Scaup, which prefers more open bay waters. ▶ Baltimore Harbor; Potomac River below Washington, DC; Veolia Water Treatment Plant, downtown Wilmington, DE. Midwinter.

King Eider. KIEI

Immature male, 7/2010 Poplar Island, Talbot County, MD
Photo: Kurt R. Schwarz

A very rare winter visitor with 1 to 2 records per year from the Region. Recorded mainly near jetties in waters of the Atlantic Ocean and the Delaware and Chesapeake Bays between November and April. Also scattered spring and summer records. Typically, birds are in subdued immature or nonbreeding plumage. ▶ Off rock jetties of Ocean City Inlet, MD, or Indian River Inlet, DE. Late winter.

Common Eider. COEI

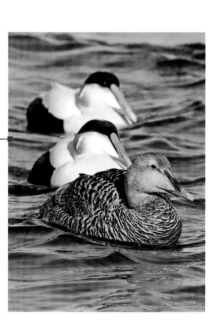

Adult female and males, 3/2009 Jetty, Barnegat Light, NJ

A rare but regular winter visitor to rocky jetties and breakwaters of inlets on the Atlantic Coast and lower Delaware Bay. Mainly young birds and birds in nonbreeding plumage. Mostly recorded between November and March. An eider in the Chesapeake Bay is more likely to be a King. ▶ Ocean City Inlet, MD; Indian River Inlet, DE.

Harlequin Duck. HADU

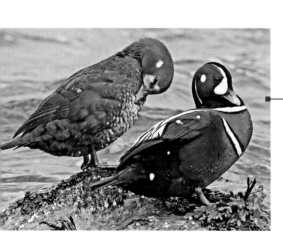

Adult female and male, 2/2015 Inlet, Ocean City, MD

A rare but regular winter visitor to rocky jetties and breakwaters of inlets on the Atlantic Coast and lower Delaware Bay between December and March. Typically observed in small parties that include adult males and females. A very few are found in the Chesapeake Bay in most winters. ▶ Ocean City Inlet, MD; Indian River Inlet, DE.

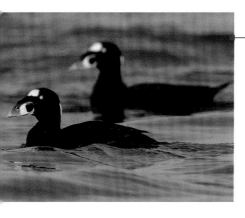

Surf Scoter. SUSC

Adult male, 2/2015 Indian River Inlet, Sussex County, DE
Common in small groups off the Atlantic Coast or in open tidal bays in spring, fall, and winter. Uncommon as a migrant on large reservoirs and large tidal rivers. Peak movements along the Atlantic shore in late March and early November. The commonest of the scoters. ▶ Assateague Island, MD; Point Lookout, MD; coastal rock jetties of Indian River Inlet, DE.

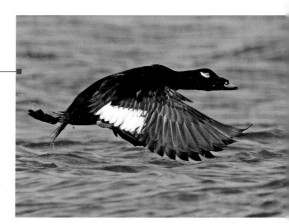

White-winged Scoter. WWSC

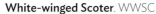

Adult male, 1/2015 Indian River Inlet, Sussex County, DE
Uncommon in flocks along the Atlantic Coast and in open tidal bays in spring, fall, and winter. Uncommon as a migrant on large reservoirs and large tidal rivers. Peaks in migration in late April and late October. The scarcest scoter, and yet, this species is the most prevalent scoter found inland during migration and winter. ▶ Assateague Island, MD; Point Lookout, MD; coastal rock jetties of Indian River Inlet, DE.

Black Scoter. BLSC

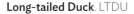

Adult male, 2/2015 Inlet, Ocean City, MD
Uncommon in flocks moving along the Atlantic shore (peaks early April and early November) and also in open tidal bays in spring, fall, and winter. Rare as a migrant on large reservoirs and large tidal rivers. The most likely scoter to linger into summer. ▶ Assateague Island, MD; Point Lookout, MD; coastal rock jetties of Indian River Inlet, DE.

Long-tailed Duck. LTDU

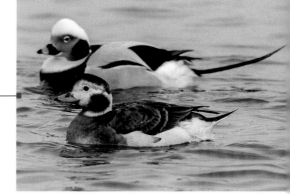

Adult winter female and male, 2/2015 Indian River Inlet, Sussex County, DE
Uncommon in small parties on open waters of the Atlantic Ocean and the Chesapeake and Delaware Bays in spring, fall, and winter. Uncommon to rare as a migrant on large reservoirs and large tidal rivers of west of the Chesapeake Bay. Peak migration late March and mid-November. ▶ Point Lookout, MD; Ocean City Inlet, MD; Indian River Inlet, DE. Winter.

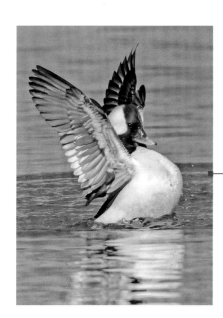

Bufflehead. BUFF

Adult male, 2/2009 Kent Narrows, Queen Anne's County, MD
Common and widespread as a spring and fall migrant and wintering bird on bays, larger river estuaries, and larger reservoirs of the Region, often in association with other diving ducks. Migration peaks early April and mid-November. Found in small- to medium-sized flocks, occasionally larger. The most common of the bay ducks. ▶ Potomac River below Washington, DC; Greenbury Point, Annapolis, MD; Chesapeake Beach, MD; Rehoboth Bay environs, DE. Midwinter.

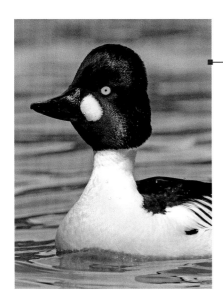

Common Goldeneye. COGO

Adult male, 2/2009 Kent Narrows, Queen Anne's County, MD
Uncommon as a spring and fall migrant and wintering on bays, larger river estuaries, and large reservoirs of the Region. Found in small groups. Often found in association with Buffleheads. Migration peaks mid-March and late November. ▶ Sandy Point SP, MD; Point Lookout SP, MD; Indian River Bay, DE. Midwinter.

Hooded Merganser. HOME

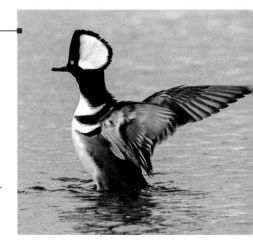

Adult male, 11/2014 Blackwater NWR, Dorchester County, MD
Primarily an uncommon migrant and wintering species, most prevalent on interior wooded ponds and streams of the Western Shore. Also a rare breeder with records both east and west of the Chesapeake Bay. Found in habitats similar to the more common Wood Duck. ▶ Violette's Lock, MD; Elliott Island, MD; Bombay Hook NWR, DE. In the cooler months.

Common Merganser. COME

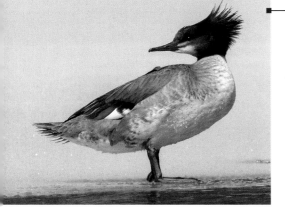

Adult female, 2/2015 Elliott's Pond, West Ocean City, MD
Common and widespread, found in small numbers along river edges and lakes. Mainly an early spring and late fall migrant (peaks late February and early December). An uncommon wintering bird, to be found mainly along streams and rivers west of the Chesapeake Bay and the Piedmont. A rare breeder along the upper Potomac River. More common on interior freshwater than the following species. Scarce on the lower Eastern Shore. ▶ Bombay Hook NWR, DE; Conowingo Dam, MD; Potomac River above Washington, DC. In the cooler months.

Red-breasted Merganser. RBME

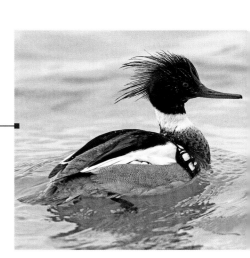

Adult male, 2/2015 Inlet, Ocean City, MD
A common migrant and uncommon wintering species, to be found mainly on saltwater bays and estuaries and less commonly on interior waters. More common in saltwater habitats than the Common Merganser. Interior records predominate along the Potomac River, other major rivers, and large reservoirs. Peak migration dates: mid-March and early November. ▶ Sinepuxent Bay, MD; Assateague State Park, MD; Cape Henlopen SP, DE. In early winter.

Ruddy Duck. RUDU

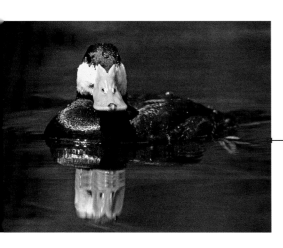

Adult male summer plumage, 5/1994 Druid Hill Park, Baltimore, MD
A widespread and common wintering species and a common migrant (peaks early April and late November), most prevalent on bays and tidewater, but also found on large reservoirs and river openings. A few recent breeding records from MD. Sometimes found in assemblages of hundreds or thousands. ▶ The Chesapeake Bay; the estuarine Potomac River; the shore of Delaware Bay and its estuaries. Midwinter.

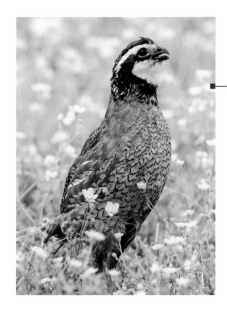

Northern Bobwhite. NOBO

Adult male, 5/2015 Wye Farm (private), Queen Anne's County, MD

An uncommon to rare permanent resident. Most common east of the Chesapeake Bay, especially along the shore of Delaware Bay. Inhabits brushy margins between woodland and abandoned fields. Very sparse west of the Chesapeake Bay. ► Bombay Hook and Blackwater NWRs; Chino Farms, MD. In early summer.

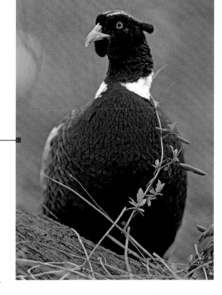

Ring-necked Pheasant. RNEP

Adult male, 5/1994 Laurel woodlands, Prince George's County, MD

Found in tiny numbers scattered through the Region. ► This nonmigratory permanent resident is best looked for on the western shore of upper Delaware Bay, especially Bombay Hook NWR, DE, and the vicinity of Delaware City, DE. In the warmer months.

Ruffed Grouse. RUGR

Adult female, 4/2013 West Shale Road, Garrett County, MD
Photo: J. B. Churchill

An uncommon permanent resident of the Allegheny Highlands, with few records east of Hancock, MD. Prefers mixed forest with shrubby clearings and regrowth. In decline. ► Brushy forest openings in mountainous woodland tracts of the westernmost sectors. April and May.

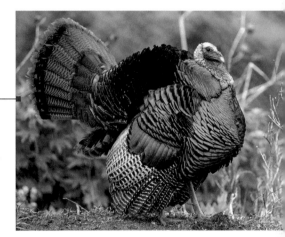

Wild Turkey. WITU

Adult male, 3/1993 Soldiers Delight NEA, Baltimore County, MD

A widespread permanent resident, inhabiting landscapes with a mix of forest, brushy edge, and agricultural openings. Adapting to suburban and urban green spaces. ► C&O Canal above Washington, DC; Prime Hook NWR, DE; western Ridge & Valley province. Mid-spring.

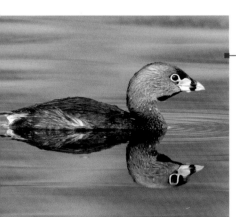

Pied-billed Grebe. PBGR

Adult summer plumage, 3/2011 Patterson Park, Baltimore, MD
An uncommon breeder but widespread and common migrant, found as singletons or in small parties on virtually any body of water (peaks late March and late October). Numbers thin out during the coldest periods of winter. The few breeders occur mainly in the Eastern and Western Shore provinces. Breeding birds prefer open waters of freshwater marshlands with abundant emergent vegetation. ► Autumn at local marsh-fringed bodies of water popular with waterfowl. Deal Island WMA, MD; Bombay Hook NWR, DE. Mid-autumn.

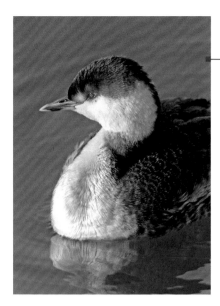

Horned Grebe. HOGR

Adult winter plumage, 1/2015 Inlet, Ocean City, MD
An uncommon migrant and winter resident of bays and large open waters, fresh, brackish, or salt, especially the two bays, the Potomac River, and the Atlantic Coast. An uncommon or rare migrant to any interior body of water in Region. ▶ Early April or late November on the middle Potomac below or above Washington, DC; Assateague Island, MD; Point Lookout, MD; Cape Henlopen SP, DE. November to March.

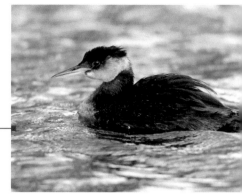

Red-necked Grebe. RNGR

Adult summer plumage, 4/2015 Piscataway Park, Prince George's County, MD
Typically a rare migrant and wintering species to open waters of the Atlantic Coast, the two bays, the lower Potomac River, and larger reservoirs. Migration peaks mid-March and mid-November. When the Great Lakes freeze over (as in early 2014), the species appears in numbers on open waters throughout the Region. ▶ Potomac River south of Wilson Bridge. March.

Eared Grebe. EAGR

Adult winter plumage, 2/2017 Black Walnut Point, Talbot County, MD. Photo: Gene Ricks
A rare visitor between August and May, with most records in the spring, and, surprisingly, in September. Might be expected on any body of water. ▶ Atlantic Coast between Cape Henlopen and Assateague Island; Chesapeake Beach, MD.

Rock Pigeon. ROPI

Adult, 1/2015 The Mall, Washington, DC
Common year-round in flocks throughout the Region.
▶ Found most reliably near farms, urban landscapes, and bridge underpasses. Year-round.

Eurasian Collared-Dove. EUCD

Adult, 11/2016 Waterfront Drive, Rockport, TX
To be looked for in suburbia, rural towns, and at backyard feeders. Only one established (but tiny) population, in Selbyville, DE. ▶ Small towns of the interior of the Eastern Shore.

White-winged Dove. WWDO

Adult, 5/2015 Slaughter Beach, Sussex Counnty, DE
Photo: Kurt R. Schwarz
A nonbreeding vagrant. ▶ Usually seen below feeders in suburban locations of the Eastern and Western Shores and Piedmont. Autumn or winter.

Mourning Dove. MODO

Adult, 5/2007 Patterson Park, Baltimore, MD
An ever-present permanent resident, but there is some seasonal movement of birds in and out of the Region. ▶ Abundant on the Western Shore and Piedmont. Common year-round.

Yellow-billed Cuckoo. YBCU

Juvenile, 9/2015 Cromwell Valley Park, Baltimore County, MD
Uncommon to common seasonal migrant and breeder, May to early October. Breeds throughout. Inhabits the edges of deciduous woodlands, preferring open agricultural landscapes with a mix of woods, old fields, and regrowth. Especially common in the presence of outbreaks of leaf-eating tent caterpillars. ▶ C&O Canal, MD. May.

Black-billed Cuckoo. BBCU

Adult, 5/2016 Audrey Carroll Audubon Sanctuary, Frederick County, MD
Uncommon to rare as a migrant and local breeder. Breeding mainly in the Ridge & Valley province and Allegheny Highlands, more sparsely elsewhere. Prefers early successional deciduous woodland and edge. Breeding associated with outbreaks of leaf-eating moths, such as tent caterpillars. ▶ Finzel Swamp, MD. Late spring and early summer.

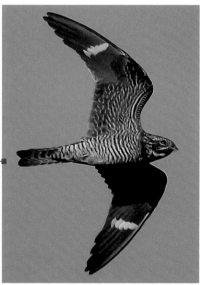

Common Nighthawk. CONI

Adult, 8/2016 Queenstown, Queen Anne's County, MD
Photo: Daniel Irons
An uncommon seasonal passage migrant and breeder, found throughout the Region. Most prevalent in autumn migratory flocks foraging above open lands in the Piedmont and upper Western Shore. ▶ Potomac River above Great Falls, MD, in mid-May; Cape Henlopen SP, DE, in August.

Chuck-will's-widow. CWWI

Adult, 5/1995 Gerda's yard, Baltimore County, MD
An uncommon night bird of the piney woods and dry oak openings between late April and August. Breeds on the lower Western Shore and lower half of the Eastern Shore, mainly south of the Bay Bridge. ▶ Assawoman WA, DE; Elliott Island Road, MD. Early June.

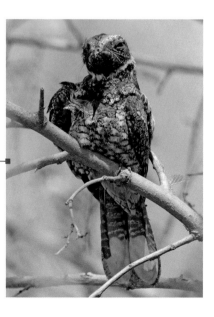

Eastern Whip-poor-will. EWPW

Adult, 5/2012 Patterson Park, Baltimore, MD
An uncommon and declining night bird of rural deciduous woodlands, including southern swamplands and mountain forest openings. Present mainly between April and September. These days the "Whip" can be heard singing in fewer places, mainly the most rural areas of the Ridge & Valley, the lower Western Shore, and the Eastern Shore Provinces. ▶ Green Ridge SF, MD; Prime Hook NWR, DE. Late spring and early summer.

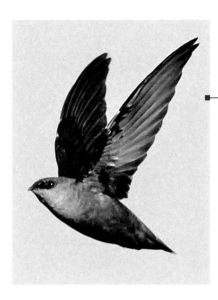

Chimney Swift. CHSW

Adult, 5/2011 Patterson Park, Baltimore, MD

A common summer resident, found throughout, between April and mid-October. Migration peaks May and September. ▶ Large flocks roost in chimneys in urban locations prior to migration in August and September. Look for evening "funneling" of the birds into their roost at dusk in late August or early September.

Ruby-throated Hummingbird. RTHU

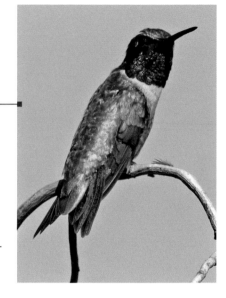

Adult male, 6/2013 Wye Farm (private) Queen Anne's County, MD

A common and widespread but often overlooked summer resident and passage migrant, found throughout, between May and late September. ▶ C&O Canal, MD; Blackwater NWR, MD; Bombay Hook NWR, DE. August and early September.

Rufous Hummingbird. RUHU

Adult female, 10/2009 Wye Farm (private), Queen Anne's County, MD

Typically found at a backyard hummingbird feeder. The Rufous and much rarer Allen's Hummingbirds are essentially indistinguishable without in-hand measurements taken after bird is captured for banding. ▶ A rare but regular vagrant, with a handful of records annually, mainly in late autumn and winter.

Black Rail. BLRA

Adult, 8/1996 Elliott Island, Dorchester County, MD
Photo: William Burt

Rare breeder in extensive tidewater marshes of the lower Eastern Shore and Delaware Bay. Rarely recorded in autumn and winter. Best located by its nocturnal vocalization in late spring (mid-April to early June). Apparently, the long-standing population in the Elliott Island marshes south of Blackwater NWR is on the brink of disappearance, a single individual being recorded in 2015. ▶ Most recently heard vocalizing in the late spring of 2017 in the coastal marshes of Delaware Bay south of Bombay Hook NWR, DE.

Clapper Rail. CLRA

Adult, 5/2015 Prime Hook NWR, Sussex County, DE
Photo: Emily Carter Mitchell

Common permanent resident of extensive salt marshes of the lower Eastern Shore—both in the Chesapeake and Atlantic estuaries. Also along the coast of Delaware Bay north to Delaware City. Some migration takes place in late April to early May and late August to early September. Present in small numbers through the winter, with birds retreating to the southern fringes of the Region during strong cold spells. ▶ Bombay Hook NWR, DE; the entrance road to Mispillion Harbor, DE. In the warmer months.

King Rail. KIRA

Adult, 5/2017 Swan Harbor Farm, Harford County, MD
Photo: Mark R. Johnson

Uncommon resident of freshwater and brackish marshlands of the Chesapeake and of the larger tidal rivers. Moves south during the coldest months and thus scarce in winter. ▶ Interior freshwater or brackish marshes on the south side of Blackwater NWR; Staves Landing Road of Appoquinimink WA, DE. Late spring.

Virginia Rail. VIRA

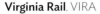

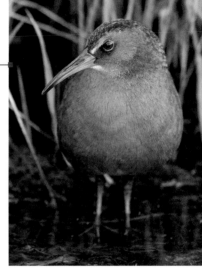

Adult, 4/2016 Finzel Swamp, Garrett County, MD
Photo: J. B. Churchill

Common but reclusive inhabitant of freshwater and brackish tidal marshes. Prefers the drier upland sectors of marshlands, especially in Needlerush. Also a widespread migrant that might show up anywhere. Nocturnal vocalizations can aid in locating the species. Shows a noticeable migratory passage from mid-April to mid-May. The most common typical rail encountered during the colder months. ▶ Jug Bay Wetlands Sanctuary, MD; Blackwater NWR, MD; Bombay Hook NWR, DE. Spring and summer.

Sora. SORA

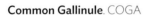

Adult, 5/2016 Patterson Park, Baltimore, MD

A widespread but scarce breeder in both freshwater and brackish marshlands. Uncommon as a migrant in spring (late April to early May) and very common in autumn. Records from all sectors. A few birds winter in the milder years. ▶ Along the Wild Rice marshes of the Patuxent River. September.

Common Gallinule. COGA

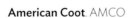

Adult, 6/2001 Patterson Park, Baltimore, MD

Uncommon breeder and seasonal migrant, most prevalent between April and September. Rare in winter. Inhabits marshy wetlands and ponds fringed with abundant marshy vegetation. Wandering birds found most often in May. ▶ McKee-Beshers WMA, MD; Deal Island WMA, MD; Augustine WMA, DE. In the warmer months.

American Coot. AMCO

Adult, 1/2009 C&D Canal, Chesapeake City, MD
Abundant migrant. Common in winter. Rare in summer. Occasional breeder. One of the most widespread and commonplace waterbirds in the Region. ▶ May be found on any open water, often in flocks. Spring and fall.

Sandhill Crane. SACR

Adult, 2/2015 Bradshaw Road, Baltimore County, MD
Rare but regular migrant and wintering species. Records (mainly October to April) scattered across the Region. Recent breeding record in Allegheny Highlands. ▶ To be looked for in extensive open agricultural fields or marshlands of the upper Delaware and along the Potomac above Great Falls. Spring and fall.

Black-necked Stilt. BNST

Adult male, 6/1995 Deal Island WMA, Somerset County, MD
Uncommon breeder, mainly found along the shore of Delaware Bay and in the lower Eastern Shore. Arrives in April and departs by early September. Most common in shallow-water impoundments. ▶ Little Creek WA, DE; Poplar Island, MD; Bombay Hook and Prime Hook NWRs, DE. Late spring.

American Avocet. AMAV

Adult summer plumage, 5/2009 Bombay Hook NWR, Kent County, DE
Uncommon spring and fall migrant. Departs mainly by November, with a few overwintering. Uncommon as a summer visitor. Not a breeder. Best looked for in large shallow-water impoundments with Black-necked Stilts and other shorebirds. ▶ Large flocks settle in autumn at Bombay Hook and Prime Hook NWRs, DE.

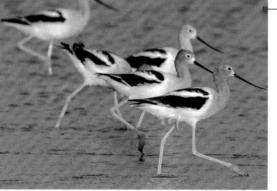

American Oystercatcher. AMOY

Adult, 6/2013 Inlet, Ocean City, MD
Most records from the lower Eastern Shore. A few persist in winter in prime habitat, especially along the coast. In small numbers on undeveloped sandy shorelines, jetties, seawalls, and barrier beaches of the Atlantic Coast, the shore of the Delaware Bay, and the lower Chesapeake Bay. A scattering of records elsewhere, in appropriate shoreline habitat. ▶ Cape Henlopen SP, DE; Indian River Inlet, DE; Sinepuxent Bay, MD. During the warmer months.

Black-bellied Plover. BBPL

Adult summer plumage, 5/2009 Slaughter Beach, Sussex County, DE
A common migrant on mudflats and sandflats along the shore of Delaware Bay, the Atlantic estuaries, and barrier islands. Uncommon along the Chesapeake Bay; rare inland. ▶ Any coastal beach or mudflat in May and September-October.

American Golden-Plover. AMGP

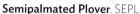

Juvenile winter plumage, 9/2012 Assateague Island, Worcester County, MD. Photo: Mark L. Hoffman

An uncommon migrant with records mainly from April and September-October. Prefers plowed fields, turf farms, short-grass pastures and not so much the mudflats favored by the preceding species. Usually singletons, but occasionally in flocks, sometimes in loose association with other plovers or shorebirds. Storms over the ocean may push larger numbers to land in the fall. ▶ Upper Delaware Bay south to Assateague Island. Early and mid-autumn.

Semipalmated Plover. SEPL

Adult summer plumage, 5/2015 Pickering Creek Audubon Center, Talbot County, MD

The second most common plover to the Killdeer. A common migrant to sandflats and mudflats. More common along the fringes of the Chesapeake Bay and less commonly in the interior. ▶ Shore of Delaware Bay south to Assateague Island. May and August.

Piping Plover. PIPL

Adult summer plumage, 6/2012 Assateague Island, Worcester County, MD

Rare seasonal migrant and breeder and very rare wintering species, restricted to sandy beaches, mainly of the Atlantic shore and secondarily the coast of lower Delaware Bay. Typically found on the upper beach, away from the surf. There are a few records in spring and fall from the Chesapeake Bay and the lower Potomac River. ▶ Search white-sand beaches of Cape Henlopen, DE, and Assateague Island, MD, between April and September, but *do not enter the roped-off breeding areas.*

Killdeer. KILL

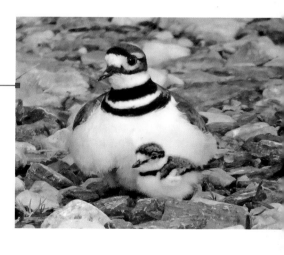

Adult and chick, 4/2016 Music Fair Marsh, Baltimore County, MD Photo: Keith Eric Costley

Our commonplace plover, found throughout on short grass or bare fields of all kinds, and often nesting on the flat roofs of large single-story buildings as well as in gravel parking lots. The species can become scarce in winter, moving about in search of productive foraging sites such as fallow fields and muddy wetlands. ▶ Bare fields with puddles in agricultural lands.

Upland Sandpiper. UPSA

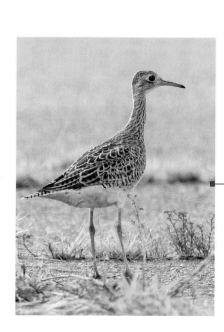

Juvenile, 9/2015 Patuxent River NAS, St. Mary's County, MD

Uncommon southbound migrant in July and August at favored sites with abundant expanses of short grass (such as airfields and turf farms). A few sporadically nest in grassy fields of the Allegheny Highlands (formerly in northern DE). ▶ Expanses of short grass in coastal DE and MD. Early April to mid-September.

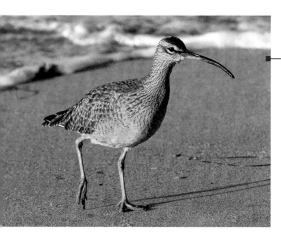

Whimbrel. WHIM

Adult, 11/2007 Pacific Palisades, Los Angeles, CA
Photo: Bruce Beehler

An uncommon migrant in May and July-August. Single-tons or small groups can be found foraging in salt marsh expanses with very short vegetation, typically back from the water's edge. A widespread but scarce migrant in late May. ▶ July and August in the salt marshes and flats of the shore of Delaware Bay south to Assateague Island.

Hudsonian Godwit. HUGO

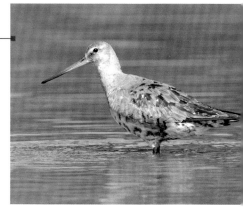

Adult transition to winter plumage, 9/2015 Pickering Creek Audubon Center, Talbot County, MD
Rare migrant found on extensive tidal mudflats with other migrant waders. Usually in small flocks or singly. Fewer records for this species than for the Marbled Godwit. Very rare in spring. Autumn records stretch from July to November. ▶ Bombay Hook NWR, DE. September.

Marbled Godwit. MAGO

Adult transition to winter plumage, 9/2016 Assateague Island, Worcester County, MD
Uncommon migrant found on extensive tidal mudflats or muddy impoundments with other migrant waders in mid-spring or early to mid-autumn. More common than the Hudsonian Godwit. Usually singly or in small flocks. ▶ Bombay Hook NWR and Little Creek WA, DE. August to October.

Ruddy Turnstone. RUTU

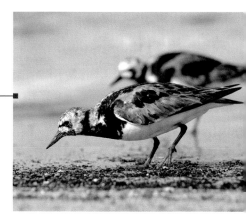

Adult summer plumage, 8/2013 Inlet, Ocean City, MD
A common seasonal migrant and loafing nonbreeder in summer and winter. Most common in late May and November. Prefers rocky breakwaters, jetties, and shorelines. ▶ Indian River Inlet, DE; Ocean City Inlet, MD.

Red Knot. REKN

Adult summer plumage, 5/2009 Slaughter Beach, Sussex County, DE
Uncommon to locally abundant passage migrant. Most records from the shore of Delaware Bay and the Atlantic estuaries in late spring. Rare in winter, as most birds move south of the Region by December. ▶ In shorebird aggregations in tidal flats of the Mispillion marshes, DE, and adjacent Slaughter Beach, DE. Late May.

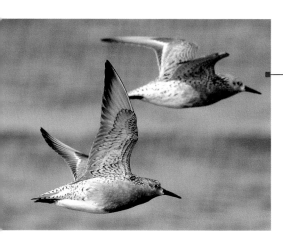

Ruff. RUFF

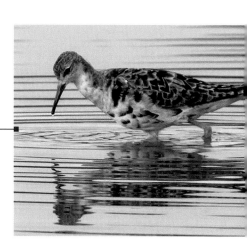

Adult male transition to winter plumage, 7/2016 Swan Harbor Farm, Harford County, MD. Photo: Mark R. Johnson
Rare visitor. Formerly, 5 to 10 were reported per year, found foraging with other shorebirds in mudflats and shallow impoundments. Fewer records since 2008. ▶ Shore of Delaware Bay; Thousand Island Marsh, DE. April–May and late June–September.

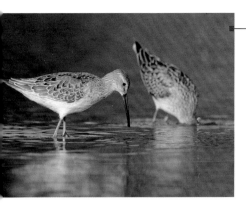

Stilt Sandpiper. STSA

Juvenile, 9/2015 Pickering Creek Audubon Center, Talbot County, MD

Uncommon spring migrant (mid-May), but more common in late July or early August. Found with shorebird flocks foraging in water adjacent to mudflats. A scattering of records throughout, but most sightings concentrated on the shore of Delaware Bay and from the middle and lower Chesapeake Bay. ▶ Bombay Hook and Prime Hook NWRs, DE. Late summer.

Sanderling. SAND

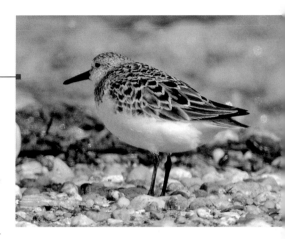

Adult summer plumage, 5/2009 Slaughter Beach, Sussex County, DE

On sandy Atlantic beaches near the surf line nearly year-round. Uncommon on sandy beaches of the Chesapeake Bay. Scattered records for similar habitats in the interior. Most prevalent in mid-spring and late summer. ▶ Cape Henlopen SP, DE; Indian River Inlet, DE; Assateague Island, MD. August and September.

Dunlin. DUNL

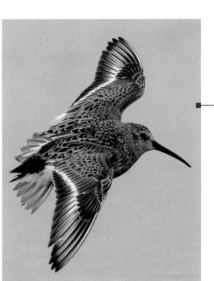

Adult summer plumage, 5/2009 Slaughter Beach, Sussex County, DE

A common to abundant seasonal migrant and wintering species to flats, shallow-water estuaries, and muddy margins of estuaries. A scattering of interior records from appropriate wetland habitats. ▶ In flocks; shore of Delaware Bay; the Atlantic estuaries; the Chesapeake shoreline. May and November.

Purple Sandpiper. PUSA

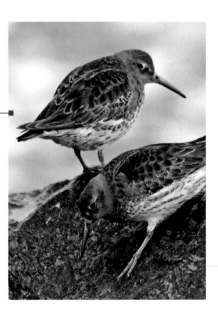

Adult winter plumage, 2/2015 Inlet, Ocean City, MD

An uncommon wintering species localized to rocky breakwaters and jetties along the Atlantic Coast and lower Delaware Bay. Also regular in the Chesapeake Bay at a few sites with appropriate rocky habitat. ▶ Indian River Inlet, DE; Ocean City Inlet, MD. November to April.

Baird's Sandpiper. BASA

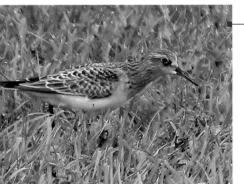

Juvenile, 8/2017 Friendly Farms Restaurant, Baltimore County, MD. Photo: Gene Ricks

A rare fall migrant, recorded from August to October. A rare spring migrant, mainly in May. Most records come from the Western Shore eastward to the Atlantic, but there are scattered records from throughout, in suitable habitat—the grassy and dry upper verges of mudflats. ▶ Eastern Shore refuges. September.

Least Sandpiper. LESA

Adult summer plumage, 5/2015 Pickering Creek Audubon Center, Talbot County, MD
Common seasonal migrant throughout the Region, with peaks in passage in late spring and late summer. Found in freshwater mudflats and grassy edges of tidal flats, but the edges of any small open inland water body should be checked. Autumn records stretch into December. Rare in winter. ▶ Eastern Shore refuges. May and August.

White-rumped Sandpiper. WRSA

Adult summer plumage, 6/2010 Crane Beach, Ipswich, MA
Uncommon seasonal migrant, with peaks of passage in late May and September. To be found with other peeps in various flats.▶ Bombay Hook NWR, DE. Early September.

Buff-breasted Sandpiper. BBSA

Juvenile, 9/2015 Patuxent River NAS, St. Mary's County, MD
Rare passage migrant, found singly or in small parties, foraging on dry land in favored sites with abundant expanses of short grass (turf farms, grassy airfields, etc.)—sites also favored by Upland Sandpipers and American Golden-Plovers. Records from both sides of the Chesapeake. Not necessarily to be expected in or near water. Very rare in spring. Scattered fall records, mainly between late summer and mid-autumn. Most easily found in appropriate habitat in the Eastern Shore region, especially turf farms and harvested fields with exposed dirt. ▶ Fields near the entrance to Bombay Hook NWR, DE. September.

Pectoral Sandpiper. PESA

Adult summer plumage worn, 9/2011 Swan Creek, Anne Arundel County, MD
Uncommon but widespread in passage, especially early autumn, but also in mid-spring. Regularly found in the interior. Forages on mudflats, especially those with some short grassy cover. ▶ Eastern Shore refuges; Lilypons, MD. September.

Semipalmated Sandpiper. SESA

Adult summer plumage, 5/2016 Swan Harbor Farm, Harford County, MD
A common passage migrant. Prefers wet mudflats. Essentially absent by November. Most prevalent east of the Chesapeake. ▶ Coastal refuges. Late May and mid-August.

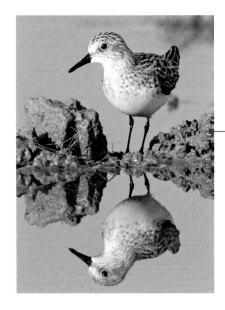

Western Sandpiper. WESA

Juvenile winter plumage, 9/1997 Hart-Miller Island, Baltimore County, MD
Uncommon spring migrant to be expected in May (if at all); common southbound migrant from mid-July to early October. Feeds on flats and forages near or in the water. Peeps observed in November or thereafter would most likely be Western or Least Sandpipers. ▶ Coastal refuges. August to September.

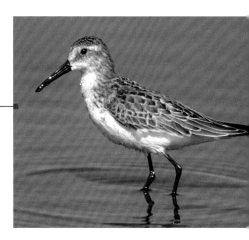

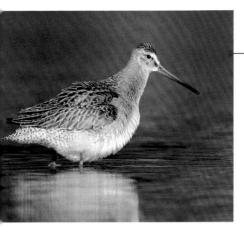

Short-billed Dowitcher. SBDO

Juvenile, 9/2015 Pickering Creek Audubon Center, Talbot County, MD

A common and widespread passage migrant, with largest numbers passing through the Eastern Shore. Absent in winter. Prefers expansive saltwater mudflats and forages in deeper water, probing with its long bill. Difficult to distinguish from the much less common Long-billed Dowitcher unless it calls. Long-billed achieves its highest density later in the autumn. ▶ Coastal refuges. Late May and early August.

Long-billed Dowitcher. LBDO

Adult winter plumage, 2/2013 Gilbert Water Ranch, Phoenix, AZ

Rare in spring and uncommon in autumn, with a peak between mid-October and late November, after the Short-bills are largely gone. Prefers foraging in grassy margins of freshwater wetlands and impounded wetlands. ▶ Bombay Hook or Prime Hook NWR, DE. November.

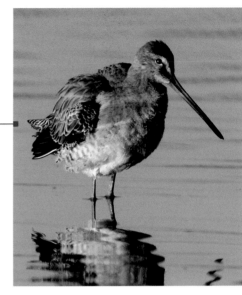

American Woodcock. AMWO

Adult, 2/2017 Patuxent River SP, Howard County, MD
Photo: Anthony VanSchoor

An uncommon breeder throughout Region and also a common spring and fall migrant, with peaks in early March and early November. In spite of the movement, birds are present year-round. Inhabits rural upland habitat with a mix of wet woods, regenerating edge, and old fields. Most easily found when males are displaying in an old field in early spring. ▶ Sycamore Landing, MD; Middle Run Valley NA, DE. Mid-March.

Wilson's Snipe. WISN

Adult, 9/2015 Patuxent River NAS, St. Mary's County, MD
Common passage migrant and uncommon winter resident. Prefers wet ditches in grassy agricultural fields as well as boggy areas in marshlands. Usually forages in hiding. Difficult to observe. Best flushed from wet grassy ditches at the edge of fields. ▶ Blackwater NWR, MD; Bombay Hook NWR, DE. Early April and late November.

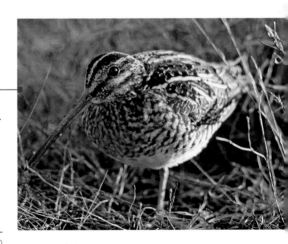

Spotted Sandpiper. SPSA

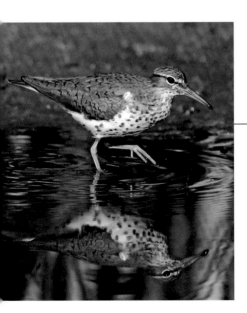

Adult, summer plumage, 5/2006 Patterson Park, Baltimore, MD
Most common as a spring and fall migrant. Also a rare breeder and rare winter resident. Our most widespread sandpiper, often seen teetering at the muddy verges of streams and ponds of the interior. ▶ C&O Canal, MD; Lilypons, MD; White Clay Creek, SP, DE. Mid-May and late July.

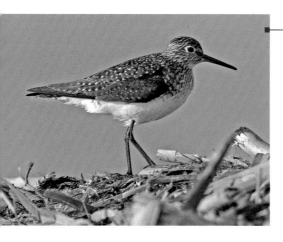

Solitary Sandpiper. SOSA

Adult summer plumage, 5/2015 Swan Harbor Farm, Harford County, MD

Our second most widespread migrant sandpiper, seen throughout Region as a migrant. Prefers muddy margins of ponds and streams. Typically seen as a singleton. ▶ C&O Canal, MD; Lilypons, MD; White Clay Creek, SP, DE. May and August.

Lesser Yellowlegs. LEYE

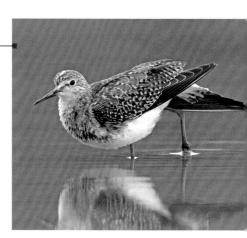

Adult winter plumage, 9/2015 Pickering Creek Audubon Center, Talbot County, MD

One of the Region's most common migratory waders, along with its larger cousin (Greater Yellowlegs). Records from the year-round, but most commonly seen in April–May and July through September. The Lesser Yellowlegs is the more common species from late July to early September. The more likely Yellowlegs seen in small ponds and flooded fields. Generally disappears from our Region by December. ▶ Eastern Shore refuges. Autumn.

Willet. WILL

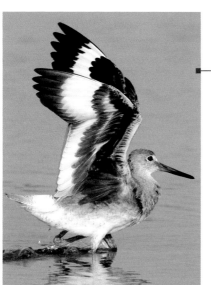

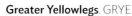

Adult winter plumage, 10/2013 Assateague Island, Worcester County, MD

A common breeder in the salt marshes of the Eastern Shore: the Atlantic Coast, Delaware Bay, and the lower Chesapeake Bay. In spring and autumn there are a few annual records of scattered vagrants from west of the Chesapeake. Most prevalent from late April to late August. Local breeders are gone by August, after which there is an influx of the quite distinct western subspecies. ▶ Back-bay salt marshes from Bombay Hook NWR, DE, south to Assateague Island, MD; also Elliott Island, MD. Late spring.

Greater Yellowlegs. GRYE

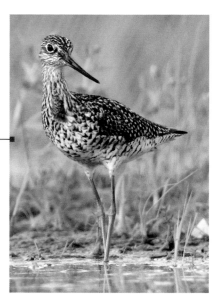

Adult summer plumage, 5/2015 Pickering Creek Audubon Center, Talbot County, MD

One of the Region's most common migratory waders, along with its smaller cousin, the Lesser Yellowlegs. Records from year-round, but most commonly seen in April–May and July–August. Of the two, the Greater Yellowlegs is slightly more common in the depths of winter. ▶ Eastern Shore refuges. Late summer and autumn.

Wilson's Phalarope. WIPH

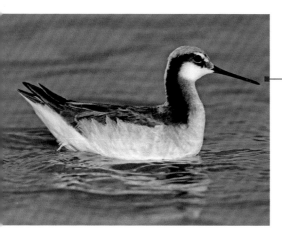

Adult female summer plumage, 4/2017 Estero Llano Grande SP, McAllen, TX

Rare to uncommon seasonal migrant from the West, with records stretching from April to December, peaking in August. An irregular vagrant to shallow freshwater ponds, water impoundments, and wetlands. Most records come from the coastal plain east of the fall line. ▶ Bombay Hook NWR, DE; Hart-Miller Island, MD. Mid-August.

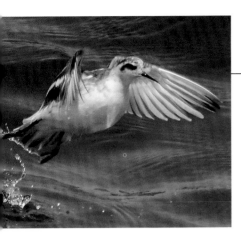

Red-necked Phalarope. RNPH

Adult winter plumage, 8/2016 New Jersey pelagic zone
Uncommon seasonal migrant in the Atlantic pelagic (offshore oceanic) zone. A rare but regular visitor onshore to the Region. ▶ Bombay Hook NWR and Little Creek WA, DE. May and September.

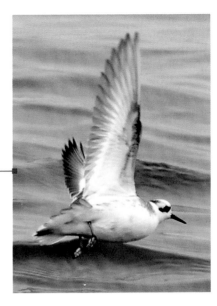

Red Phalarope. REPH

Adult winter plumage, 9/2008 California pelagic zone
Uncommon seasonal migrant in the Atlantic pelagic zone. A rare vagrant onshore. ▶ Pelagic boat trips. Early May and mid-September.

Pomarine Jaeger. POJA

Adult summer plumage, 6/2016 Delaware pelagic zone
An uncommon pelagic seasonal migrant, found in the offshore Atlantic Ocean. Less common than the Parasitic near shore but perhaps more common than Parasitic farther offshore. ▶ Pelagic boat trips. May and September through November.

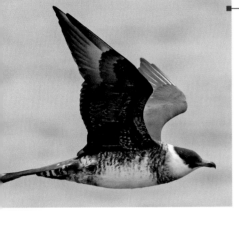

Parasitic Jaeger. PAJA

Adult summer plumage, 6/2011 Churchill, Manitoba, Canada
An uncommon pelagic migrant, found in the offshore Atlantic Ocean between late April and early June and between September and November. There are a few records of individual passage migrants on inland reservoirs and rivers, but birds are seen in the interior waters mainly following passage of a tropical storm. ▶ Cape Henlopen Point, DE, in late October to early November; during periods of strong easterly winds or seen chasing gulls and terns in large offshore foraging aggregations.

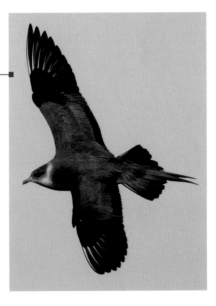

Dovekie. DOVE

Adult winter plumage, 1/2015 St. Johns, Newfoundland, Canada
An uncommon winter visitor to the Atlantic pelagic zone, mainly observed on winter boat trips 20–30 miles offshore between early December and mid-March. Only rarely seen from land, when blown onshore by strong winter storms. ▶ Pelagic boat trips.

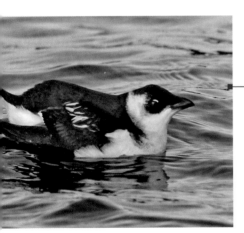

Common Murre. COMU

Adult winter plumage, 2/2015 New Jersey pelagic zone
Rare but regular winter pelagic visitor. Rarely seen from shore. Offshore this species is substantially more prevalent than the Thick-billed Murre. ▶ Pelagic boat trips.

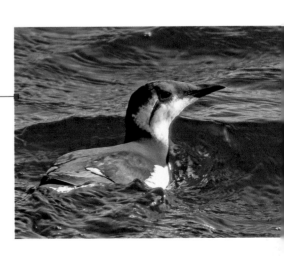

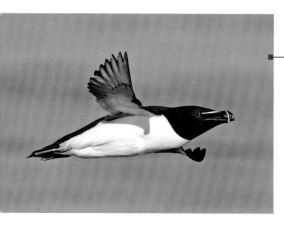

Razorbill. RAZO

Adult summer plumage, 6/2010 Bonaventure Island, Quebec, Canada

An uncommon winter pelagic, mainly observed on winter boat trips 20–30 miles off the Atlantic Coast between early December and mid-March, but also increasingly from shore. (Nearly 8,000 were seen from Nags Head, NC, on February 27, 2017.) ▶ Indian River Inlet, DE; pelagic boat trips.

Atlantic Puffin. ATPU

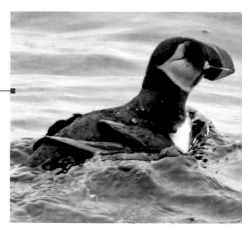

Adult winter plumage, 1/2015 Maryland pelagic zone
Rare pelagic winter visitor. In small numbers offshore. Records from December to June. ▶ Pelagic boat trips.

Black-legged Kittiwake. BLKI

Juvenile winter plumage, 1/2015 Maryland pelagic zone
Fairly common in the Atlantic pelagic zone in winter. Records as early as late August and as late as early June. Rarely seen from land. A handful of records from the Chesapeake Bay. Occasionally, a few birds are blown into the interior by strong storms. Offshore sightings in decline. ▶ Pelagic boat trips. December to February.

Bonaparte's Gull. BOGU

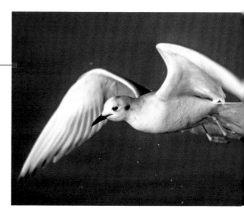

Adult winter plumage, 2/2015 Inlet, Ocean City, MD
Common spring and fall migrant and irregular winter visitor. Less common or absent in other seasons, but records from Region for every month of year and from all provinces. Prefers the Atlantic waters and the Chesapeake and Delaware Bays. ▶ Numbers appear on the Potomac, Back, and Susquehanna Rivers and other large bodies of water in the interior in March–April and November–December; also Indian River Inlet, DE, in winter.

Black-headed Gull. BHGU

Adult winter plumage, 1/2015 St. Johns, Newfoundland, Canada
Rare straggler from Europe, with records year-round, but with clusters of sightings in March–April and December–January, and lowest numbers in summer. Most records come from the coast of lower Delaware Bay, the Atlantic shore, and the western shore of the Chesapeake Bay. ▶ Search for this bird where there are large congregations of Bonaparte's Gulls.

Little Gull. LIGU

Adult winter plumage, 4/2014 Centennial Park, Howard County, MD. Photo: Bonnie Ott
A rare visitor, occurring about a dozen times a year, mainly on bodies of water where other gulls habitually congregate, especially when there are large flocks of Bonaparte's Gulls in late fall, winter, and spring. ▶ Most records come from the Chesapeake Bay, the coast of Delaware Bay, the Susquehanna River, and the Potomac River. December and April.

Laughing Gull. LAGU

Adult summer plumage, 4/2012 Bombay Hook NWR, Kent County, DE

The predominant summer gull of the lower Eastern Shore. The Region's few breeding colonies are known from the Atlantic estuaries and the lower Chesapeake Bay. Non-breeders are recorded from all the tributaries of the Chesapeake. Most abundant in April–May and August–September, and least common from late December to mid-March. ▶ Any Atlantic beach in the warmer months.

Franklin's Gull. FRGU

Juvenile, 11/2015 Inlet parking lot, Ocean City, MD
Photo: Gene Ricks

A vagrant from the West, appearing during periodic irruptive movements mainly between April and early December. A major invasion took place in November 2015. In a typical year, 2–3 records are posted for the Region. ▶ Most records come from the Western Shore province.

Ring-billed Gull. RBGU

Adult summer plumage, 4/2009 Tydings Memorial Park, Havre de Grace, Harford County, MD

The most common gull of the Region. Forages at dumps, on agricultural fields, and along shorelines. Present year-round, with a peak in abundance between September and March, but does not breed in Region. ▶ In the cooler months, flocks loiter on the National Mall in downtown Washington, DC, on lakes and rivers, and around the Chesapeake Bay.

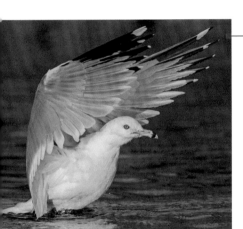
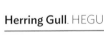

Herring Gull. HEGU

Adult winter plumage and juvenile, 2/2015 Inlet, Ocean City, MD
Another common gull, which prefers shorelines of the Atlantic Ocean, Delaware Bay, and Chesapeake Bay. Less common in the interior than the Ring-billed. Breeds in small numbers in the estuaries of the Chesapeake Bay and Atlantic Ocean. Most common in autumn, winter, and spring. Present year-round in our Region, it is least common in the summer, when birds are largely confined to their breeding colonies on salt marsh islands. First bred in the 1950s. ▶ Found in any concentration of gulls on salt or brackish water and at landfills in the cooler months.

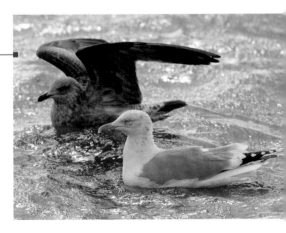

Iceland Gull. ICGU

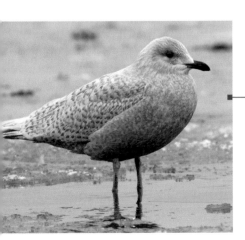

Juvenile 1st winter, 1/2017 North East Park, Cecil County, MD
Photo: Mark R. Johnson

Rare wintering gull, with 15–20 records per annum, mainly between November and March. A few inland records annually, especially at landfills. Note that Thayer's Gull is now treated as a subspecies of Iceland Gull. ▶ In winter, search large aggregations of gulls, mainly in the Atlantic estuaries and the tributaries of the Chesapeake Bay.

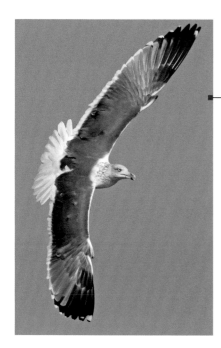

Lesser Black-backed Gull. LBBG

Adult winter plumage, 2/2009 Assateague Island, Worcester County, MD
Formerly rare and now uncommon and regular the year-round. Largest numbers are found in summer on the Atlantic shore. Most widespread through Region between October and March. ▶ Found in aggregations of large gulls near the Delaware and Chesapeake Bays or the Atlantic coast.

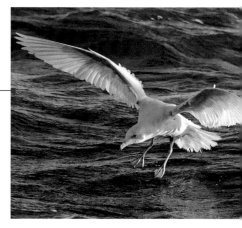

Glaucous Gull. GLGU

Juvenile 1st winter, 2/2016 North Carolina pelagic zone
A rare northern gull with about a dozen records each winter. Most records come from the coast of the Delaware or Atlantic estuaries, but some from the Chesapeake Bay and Western Shore. ▶ Search large winter gull aggregations, especially at landfills.

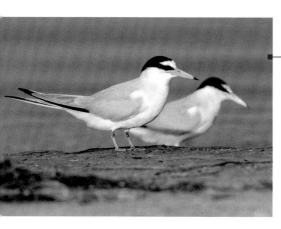

Great Black-backed Gull. GBBG

Adult winter plumage, 1/2015 Maryland pelagic zone
Common year-round east of the Appalachians. Most abundant on the Delaware Bay, the Atlantic shore, and the Chesapeake Bay and its tributaries. Breeds on the Chesapeake Bay and in the Atlantic estuaries. ▶ Perches atop large bridges and other large structures in bays and other saltwater bodies.

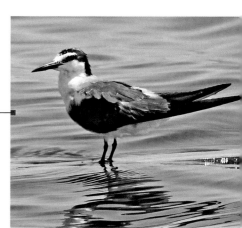

Bridled Tern. BRTE

Adult, 8/2016 North Carolina pelagic zone
Rare late summer visitor to the far offshore Gulf Stream waters of our Atlantic pelagic zone. Virtually all land-based records are of birds driven onshore by a tropical storm. ▶ Pelagic trips. Mid-August to early September.

Least Tern. LETE

Adult, 6/2010 Assateague Island, Worcester County, MD
Uncommon on salt and brackish waters mainly between May and August. Breeds in the Chesapeake and Delaware Bays and in the Atlantic estuaries. Nesting colonies are sited mainly on protected sandy beaches. ▶ Cape Henlopen SP, DE; Assateague Island, MD. Late summer.

Gull-billed Tern. GBTE

Adult, 4/2012 Aransas Bay, Rockport, TX
An uncommon migrant along the Atlantic shore and Delaware Bay and affiliated estuaries. Very rare on the Chesapeake Bay. Records between late April and early October (mainly May to August). Forages mainly over marshes and agricultural fields. A scarce breeder along the Atlantic coastal estuaries in MD. ▶ Bombay Hook NWR, DE. Summer.

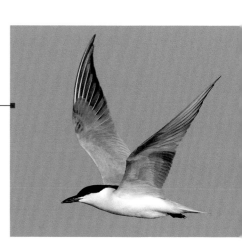

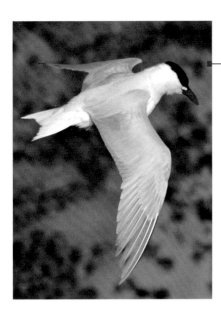

Caspian Tern. CATE

Adult, 4/2015 Patterson Park, Baltimore, MD
Common seasonal migrant (April and May, August and September); present from late March to early November. Seen foraging along tributaries of the Chesapeake Bay or over larger reservoirs in spring and fall. On migration, quite prevalent on the west side of the Chesapeake, but also along the shore in numbers. ▶ Cape Henlopen SP and Prime Hook NWR, DE. Early September.

Black Tern. BLTE

Adult summer plumage, 6/2010 Kamloops, British Columbia, Canada
An uncommon spring and fall migrant, found foraging over waters of estuaries, marshlands, reservoirs, and tributaries of the Chesapeake Bay. The species can show up on just about any body of water during migration, especially in late summer. Also often seen on pelagic trips in July and August. ▶ Bombay Hook NWR and Little Creek WA, DE. May and August–September.

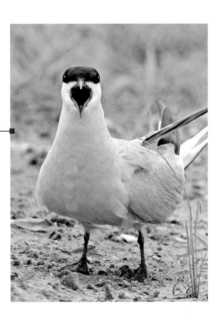

Roseate Tern. ROST

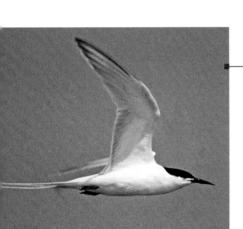

Adult summer plumage, 6/1994 Skimmer Island, Ocean City, MD. Photo: Mark L. Hoffman
Rare spring migrant recorded from the lower Delaware Bay and off the Atlantic Coast. Most pass by our Region far offshore. There is a reliable upper Chesapeake Bay record in 2006 from Hart-Miller Island. ▶ Ocean beaches and Skimmer Island, near Ocean City, MD; also pelagic boat trips. May and June.

Common Tern. COTE

Adult summer plumage, 6/2015 Poplar Island, Talbot County, MD
Common to abundant migrant and breeder. Mainly coastal. In migration (May, September), found along rivers and over reservoirs in small numbers. Nests in the Atlantic estuaries and the eastern shore of the lower Chesapeake Bay. Mainly absent from the Region from mid-November to mid-March. This species tends to clear out of the Region by early October. ▶ Delaware Bay, Atlantic estuaries, and Chesapeake Bay. May through September.

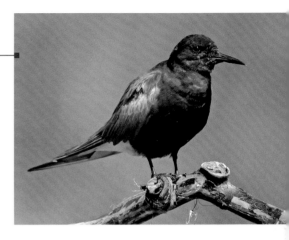

Arctic Tern. ARTE

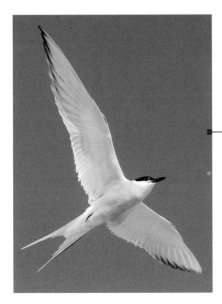

Adult summer plumage, 6/2011 Churchill, Manitoba, Canada
Presumably a regular spring and fall migrant in the Atlantic pelagic zone far offshore. Rare passage migrant on the coast and on larger rivers of the interior. Only one or two records annually for the Region, most from offshore.
▶ Pelagic boat trips. Late May, early June, and August.

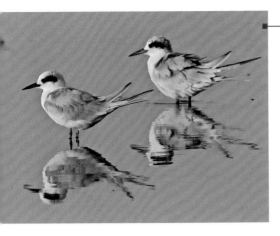

Forster's Tern. FOTE

Adult winter plumage, 9/2016 Assateague Island, Worcester County, MD

Most common in protected bays and shallow marshy estuaries. Breeds on the coast of Delaware Bay, the Atlantic estuaries, and the Eastern Shore of the lower Chesapeake Bay. Mainly absent between mid-January and mid-March. Most medium-sized white terns found in November and December are Forster's Terns. ▶ Point Lookout SP, MD; Bombay Hook NWR, DE. Between mid-April and mid-November.

Royal Tern. ROYT

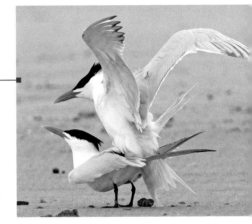

Adult summer plumage, 6/2016 Prime Hook NWR, Sussex County, DE

A common coastal tern, present between late March and November. Has been recorded as a sparse breeder in the Atlantic estuaries of MD, but most breeding takes place south of the Region. Regular in the Chesapeake Bay, lower Potomac River, and Delaware Bay. Forages over salt and brackish water, and roosts on sandy beaches. ▶ Cape Henlopen State Park, DE. May and August–September.

Sandwich Tern. SATE

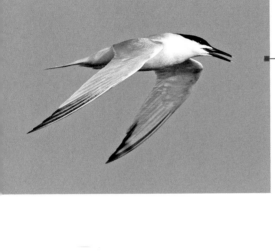

Adult summer plumage, 6/1993 Skimmer Island, Ocean City, MD
A rare but regular summer vagrant to the Region, found mainly along the Atlantic Coast and lower Delaware Bay between May and late September. Forages over salt water and roosts on sandy beaches. A few records annually from the lower Chesapeake Bay. ▶ Cape Henlopen SP, DE; Assateague Island, MD; associating with loafing Royal Terns in late summer.

Black Skimmer. BLSK

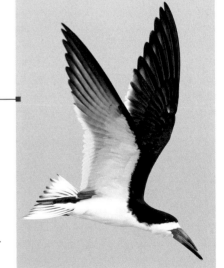

Adult summer plumage, 6/2016 Prime Hook NWR, Sussex County, DE

An uncommon migrant and breeder, expected mainly between April and October. Nests on sandy beaches of the Atlantic and its barrier islands. Departs by the end of November, returning in April. ▶ Prime Hook NWR, DE; Cape Henlopen SP, DE; Assateague Island, MD. Late summer.

Red-throated Loon. RTLO

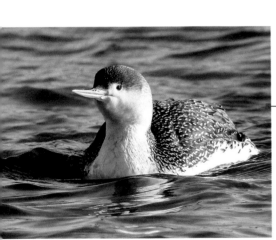

Adult winter plumage, 2/2015 Inlet, Ocean City, MD
An uncommon migrant and wintering species mainly found along the Atlantic Coast and as a migrant to the open waters of the Chesapeake and Delaware Bays. Rare as a migrant on larger reservoirs and open waters of larger rivers from the Piedmont eastward. Typically solitary or in small groups. ▶ Cape Henlopen SP, DE; Ocean City Inlet, MD; Indian River Inlet, DE. Late November or mid-March.

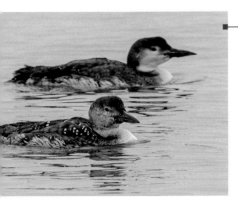

Common Loon. COLO

Adult winter plumage, 1/2015 Inlet, Ocean City, MD
Fairly common migrant to deep water reservoirs and large river embayments in small numbers throughout, especially in November and mid-March to early May. Also a winter resident on the Atlantic Coast and along the shore of Delaware Bay. In late April and early May, singletons and small groups can be seen migrating high overhead during daylight hours from virtually any place in the Region.
▶ Cape Henlopen SP, DE; Ocean City inlet, MD. November through January.

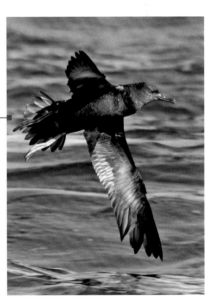

Northern Fulmar. NOFU

Adult pale morph, 2/2015 New Jersey pelagic zone
Uncommon to rare in the pelagic zone off the Atlantic Coast. ▶ Pelagic boat trips. February through May.

Cory's Shearwater. COSH

Adult, 8/2009 North Carolina pelagic zone
Uncommon in the pelagic zone off the Atlantic Coast between May and August. Records also from March, September, and October. Both described populations (Cory's and Scopoli's Shearwaters by some authorities) appear in our waters, but the nominate form (Scopoli's) is much less common. ▶ Pelagic boat trips. Late summer.

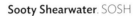

Sooty Shearwater. SOSH

Adult, 2/2009 North Carolina pelagic zone
Uncommon to fairly common in the pelagic zone off the Atlantic Coast between late March and late September. Rare or absent in other months. ▶ The shearwater most often seen from shore. Mid-June.

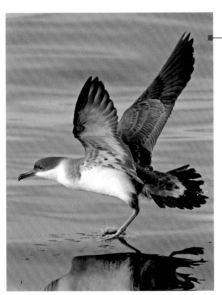

Great Shearwater. GRSH

Adult, 6/2016 Delaware pelagic zone
Common in the pelagic zone off the Atlantic Coast between May and early December. Most prevalent between May and August. ▶ Pelagic boat trips. June.

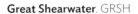

Manx Shearwater. MASH

Adult, 11/2012 Maryland pelagic zone. Photo: Bruce Beehler
Rare to uncommon in the pelagic zone off the Atlantic Coast. Records from the year-round, with most concentrated between August and December. The fourth most prevalent shearwater in our pelagic waters. Found closer to shore in the cooler waters than Audubon's Shearwater.
▶ Pelagic boat trips. May and June.

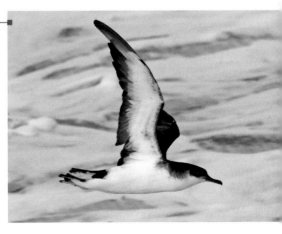

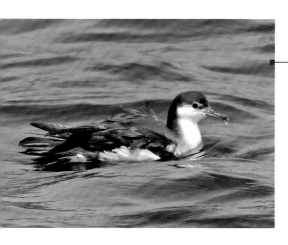

Audubon's Shearwater. AUSH

Adult, 8/2008 North Carolina Pelagic zone

Mainly rare in the pelagic zone off the Atlantic Coast between June and September. ▶ Pelagic boat trips; most prevalent far from shore out in the Gulf Stream. Late summer.

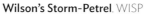

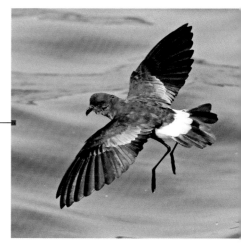

Wilson's Storm-Petrel. WISP

Adult, 8/2008 North Carolina pelagic zone

Uncommon to common in the pelagic zone off the Atlantic Coast between May and October. ▶ Occasionally seen from the Cape May–Lewes Ferry crossing. Most prevalent in summer.

Leach's Storm-Petrel. LESP

Adult, 8/2016 New Jersey pelagic zone

Rare. ▶ Seen in the pelagic zone offshore. May through October.

Northern Gannet. NOGA

Adult, 1/2016 Virginia pelagic zone

Common off the Atlantic Coast and lower and middle Delaware and Chesapeake Bays between October and April. Rare in other months. Best found when strong winds with an easterly component are blowing onshore or after the passing of an oceanic storm. Less common in the higher reaches of the two Bays. ▶ Most common in February to March and November to December from the Atlantic shore and Cape May–Lewes Ferry.

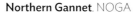

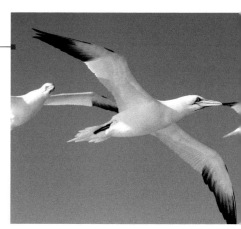

Double-crested Cormorant. DCCO

Adult female, 5/2011 Patterson Park, Baltimore, MD

Abundant and widespread and continuing to increase. Most common on larger bodies of water and the two bays, with migratory peaks in April and October. Breeds in a dozen or so colonies scattered around the eastern third of the Region. ▶ Breakwaters, jetties, and other structures in the water, including pound nets and navigational markers.

Great Cormorant. GRCO

Adult winter plumage, 2/2015 Indian River Inlet Sussex County, DE

Rare or uncommon, mainly between October and March. Typically single birds mixed in with the omnipresent Double-crested Cormorant flocks. Annually along the Chesapeake shoreline. Very few inland records. ▶ Breakwaters and rock jetties of the Atlantic Coast and lower Delaware Bay; the navigational marker at Indian River Inlet, DE. Winter.

American White Pelican. AWPE

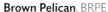

Adult winter plumage, 2/2015 Blackwater NWR, Dorchester County, MD

A rare but regular visitor, to be found loafing on mudflats on larger bodies of water, especially both bays and in the vicinity of the Atlantic Coast. There are about a dozen records per year, mainly between November and April. ▶ Blackwater, Prime Hook, and Bombay Hook NWRs. Winter.

Brown Pelican. BRPE

Adult summer plumage and juvenile, 6/1994 Sinepuxent Bay, Worcester County, MD

An uncommon though increasing summer resident and breeder, present between April and December. Always associated with salt or brackish water. Breeds in colonies on isolated islands in the lower Chesapeake and Chincoteague Bays. Post-breeding individuals disperse to the waters of the Chesapeake around the Bay Bridge and the lower Patapsco River. ▶ Atlantic Coast between Cape Henlopen and Assateague Island. Late summer and autumn.

American Bittern. AMBI

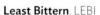

Adult, 5/1993 North Central Railroad Bike Trail, Baltimore County, MD

An uncommon spring and fall migrant. Formerly a widespread breeder, but now is scarce in summer. Rare in winter in its favored marshland haunts. ▶ Extensive marshlands of Bombay Hook NWR, DE, or Elliott Island, MD. Autumn.

Least Bittern. LEBI

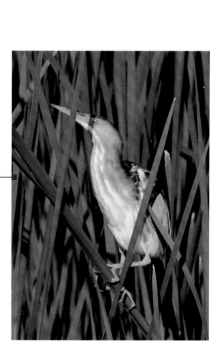

Adult female, 5/2013 Patterson Park, Baltimore, MD

An uncommon migrant and breeder, mainly found in extensive fresh or brackish marshlands of the Eastern and Western Shore sectors, with few annual records west of the Piedmont. ▶ Coastal marshlands of Delaware Bay between Delaware City and Prime Hook NWR, DE. May to September.

Great Blue Heron. GBHE

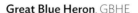

Adult, 10/2016 Trap Pond SP, Sussex County, DE

The Region's most common heron, found throughout, breeding in colonies scattered about in the Piedmont eastward. Most commonplace in the Western and Eastern Shore sectors. Present year-round, but least common during the coldest winter months, when favored shallow foraging sites freeze over. The white morph of the species, traditionally known as the Great White Heron, has been observed more than a dozen times in the Region. ▶ Any NWR, any season.

Great Egret. GREG

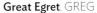

Adult breeding plumage, 5/2009 Bombay Hook NWR, Kent County, DE

The Region's most common white egret, mainly in association with large rivers and the two bays. There are fewer than twenty breeding colonies, concentrated in the lower Chesapeake Bay and Atlantic Coast. Present in very small numbers in winter, mainly in extensive marshlands.
▶ Widespread in late summer, with singletons on larger rivers and reservoirs in the interior.

Snowy Egret. SNEG

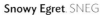

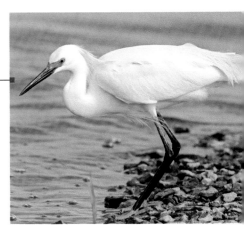

Adult high breeding plumage, 6/2016 Prime Hook NWR, Sussex County, DE

Common summer resident and seasonal migrant, with very few winter records from southern and eastern marshlands. No more than a dozen breeding colonies, confined to the estuaries of the two bays and the Atlantic barrier islands. Few records west of the Piedmont. ▶ Eastern Shore refuges. Late summer.

Little Blue Heron. LBHE

Adult high breeding plumage, 6/1994 Smith Island, Somerset County, MD

Rare breeder and uncommon seasonal migrant. The few winter records come mainly from the Delaware Bay and Atlantic Coast. The handful of breeding colonies are confined to the lower Chesapeake Bay, the Atlantic sector, and the upper Delaware Bay. ▶ The Eastern Shore refuges; also Dragon Run SP, DE. Late summer.

Tricolored Heron. TRHE

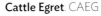

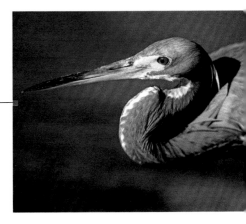

Adult, 7/1994 Smith Island, Somerset County, MD

Present in small numbers the year-round (very few in winter), but most prevalent in summer. Fewer than a handful of breeding colonies confined to the lower Chesapeake Bay, the Atlantic sector, and the upper Delaware Bay. Most records come from spring and late summer, when individuals are on the move. Essentially no records west of the Piedmont sector. ▶ Estuaries of the Atlantic shore; the shore of Delaware Bay; the lower Chesapeake. Late summer.

Cattle Egret. CAEG

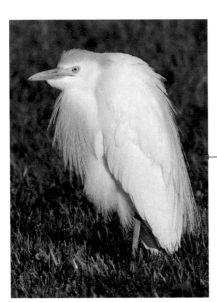

Adult breeding plumage, 6/2016 Maple Dam Road, Dorchester County, MD

Locally common from April to September, mainly in the Western and Eastern Shore sectors. Entirely absent west of the Piedmont. Breeds in colonies in the Chesapeake Bay, upper Delaware Bay, and Atlantic estuaries. The only small white heron to be found regularly foraging in agricultural fields in association with cattle. ▶ North Point State Park, MD; Assateague State Park, MD. Spring and summer.

Bird-Finding Guide

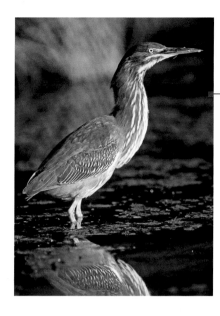

Green Heron. GRHE

Adult, 8/1995 Harford Glen, Harford County, MD
Uncommon but widespread as a migrant and breeder. Frequents wetlands, stream edges, and marshlands. Usually seen singly. Very scarce in winter. ▶ McKee-Beshers WMA, MD; White Clay Creek SP DE. Early summer.

Black-crowned Night-Heron. BCNH

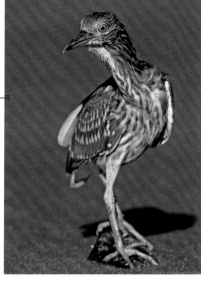

Juvenile, 9/1998 Patterson Park, Baltimore, MD
An uncommon but widespread year-round resident, most common during the spring and summer months. Breeds in colonies scattered across the eastern two-thirds of the Region, with most confined to the southern part of the Eastern Shore. Found in wetlands and stream edges. Few records west of Frederick County. Many records from the Baltimore and Washington, DC, metropolitan areas. ▶ National Zoological Park, DC; Conowingo Dam, MD. During warmer months.

Yellow-crowned Night-Heron. YCNH

Adult breeding plumage, 4/2017 Jones Falls Trail, Baltimore, MD
An uncommon summer resident. Typically nests in small woodland colonies, which can be found in the Baltimore and Washington, DC, areas, the southern Chesapeake Bay, and the northern Delaware Bay. Found in various wetland habitats east of the Appalachians, including woodland streams, ponds, and tidal marshes. In most places outnumbered by the Black-crowned Night-Heron. ▶ Lake Roland Park, MD; Jones Falls Trail, Baltimore city; Bombay Hook, NWR, DE. During warmer months.

White Ibis. WHIB

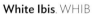

Juvenile, 8/2014 Lily Pons Water Gardens, Frederick County, MD
A rare but periodically irruptive species, with young birds arriving in numbers in certain years in late summer / early autumn. Most records come from coastal marshlands, but in irruptive years it can appear in interior areas (but mainly east of the Appalachians). ▶ Coastal marshes from Delaware City south to Assateague Island. Late summer and autumn.

Glossy Ibis. GLIB

Adult summer plumage, 6/2015 Poplar Island, Talbot County, MD
A common summer resident and seasonal migrant mainly associated with marshlands of the Chesapeake and Delaware Bays as well as the Atlantic estuaries. Forages in parties on mudflats, wet pastures, and plowed fields. In migration found scattered throughout Region east of the Appalachians. ▶ Bombay Hook and Prime Hook NWRs; near Pea Patch Island, DE. Late summer / early autumn.

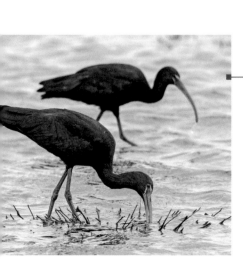

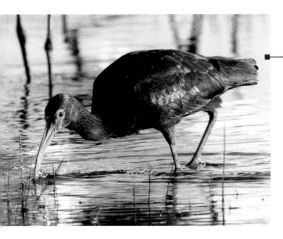

White-faced Ibis. WFIB
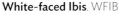

Adult summer plumage, 6/2017 Deal Island WMA, Somerset County, MD. Photo: Mark R. Johnson

Rare, with records between March and October. Most records come from the Eastern Shore—mainly the coast of Delaware Bay and the Atlantic estuaries. Increasing as a warm season vagrant in the East.

Black Vulture. BLVU
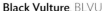

Adult, 9/2015 Abandoned farmhouse, Somerset County, MD

A common permanent resident, most prevalent in the southern and eastern sectors. Continues to be on the increase. Second most common soaring raptor. ▶ Often found soaring with Turkey Vultures.

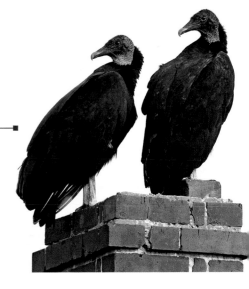

Turkey Vulture. TUVU
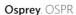

Adult, 9/2016 Middle Run Natural Area, Newark, DE

A commonplace permanent resident and seasonal migrant (peaks March and late October). Common in the west and in heavily forested country where the Black Vulture is less common. ▶ Most common soaring raptor, preferring a mix of agricultural fields and woodlots.

Osprey. OSPR

Adult female and juvenile, 5/2016 Piscataway Park, Prince George's County, MD

A common seasonal migrant and breeder, most prevalent in the estuarine waters of the Chesapeake Bay and the tidal backwaters of the Atlantic Coast. Seen throughout Region during migration (peaks early April and late September). Breeds mainly east of the Appalachians. Continues its recovery since the pesticide DDT was banned in 1972. ▶ Bays and larger waterways. During the warmer months.

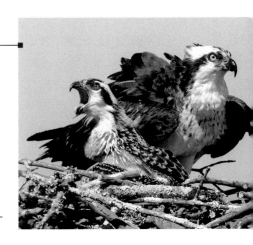

Mississippi Kite. MIKI
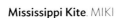

Subadult, 5/2017 Catchfly Court, Columbia, MD
Photo: Anthony VanSchoor

Rare migrant and probable very rare breeder. Found between May and October. Most records from the month of May. Prefers wooded clearings adjacent to lowland swamps and slow rivers. Most records are from the Western Shore province. ▶ Fort Smallwood hawk watch, MD. Latter half of May.

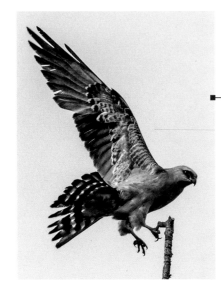

Bald Eagle. BAEA
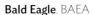

Juvenile and adult, 2/1998 Blackwater NWR, Dorchester County, MD

Uncommon but widespread throughout, mainly in vicinity of large rivers, marshlands, or reservoirs. Widespread in migration (autumn peak mid-September to mid-October). Continues its increase. ▶ Blackwater and Bombay Hook NWRs, in the winter months. Also in large numbers at the Conowingo Dam on the lower Susquehanna River in April–May and December through February.

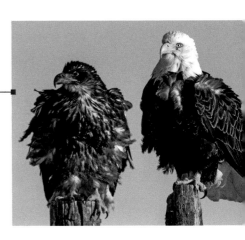

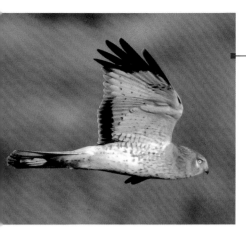

Northern Harrier. NOHA

Adult male, 12/2014 Bombay Hook NWR, Kent County, DE
Uncommon throughout Region year-round. A sparse breeder in marshlands of the lower Eastern Shore and in extensive weedy fields of the Allegheny Highlands. Most prevalent in our Region in spring and fall when local numbers are swelled by passage migrants. ▶ The extensive marshlands along Delaware Bay. Autumn and winter.

Sharp-shinned Hawk. SSHA

Juvenile, 10/1998 Point Lookout SP, St. Mary's County, MD
A common and widespread migrant in April and October. A sparse breeder, mainly from the Appalachians west to the Alleghenies, but also northern DE. Shows a greater preference for extensive forest than does the larger Cooper's Hawk. ▶ Cape Henlopen hawk watch, DE. September–October.

Cooper's Hawk. COHA

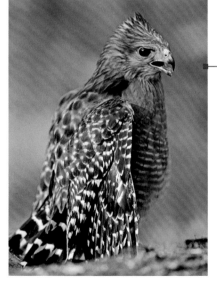

Adult, 3/2006 Patterson Park, Baltimore, MD
Common year-round, with an influx of passage migrants in late March and, especially, October. A widespread breeder throughout the Region, preferring woodlots adjacent to open habitats for hunting. Continues its increase. ▶ Cape Henlopen hawk watch, DE. October.

Northern Goshawk. NOGO

Adult, 6/2004 Savage River State Forest, Garrett County, MD
A scarce late-autumn migrant and very rare wintering species. There are a few breeding records from the Allegheny Highlands. ▶ A hawk watch along one of the high ridges of the Appalachians (e.g., Waggoner's Gap, near Carlisle, PA). Late October and early November.

Red-shouldered Hawk. RSHA

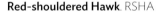

Adult, 5/1995 Gunpowder Falls SP, Baltimore County, MD
A common breeding resident of wet woodlands of the Western Shore and Piedmont; slightly less common elsewhere. Found year-round. Migration peaks in late March and from late October to early November. ▶ At edges of bottomland woods near water in low country, in spring, when vocal.

Broad-winged Hawk. BWHA

Adult, 7/2009 Dan's Rock Road, Allegany County, MD
Photo: J. B. Churchill
A common autumn migrant, with passage peaking in mid-September. Less common as a spring migrant. Nests mainly in the mountains west of the Piedmont, with only a scattering of nesting birds east of the Appalachians. ▶ In passing flocks from a hawk watch. Around the 15th of September.

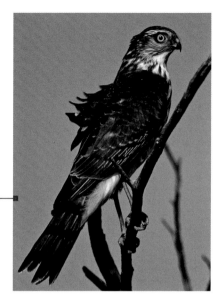

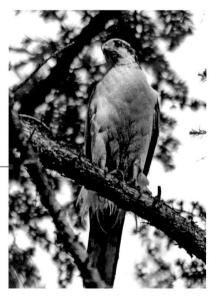

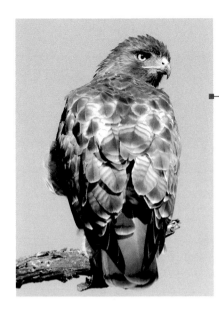

Red-tailed Hawk. RTHA

Adult, 9/2012 Patterson Park, Baltimore, MD
Our Region's most common soaring hawk. ▶ Present year-round. Populations boosted by migrants in March and early November.

Rough-legged Hawk. RLHA

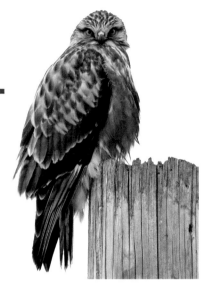

Adult, 2/2015 Stull Road, Frederick County, MD
Photo: Mark R. Johnson
An uncommon to rare irruptive wintering raptor of expansive marshlands or fields expected between November and April. Perhaps 25 records in a good year, mainly from the estuarine marshlands of the lower Eastern Shore and shore of Delaware Bay. ▶ Over the marshes of the Elliott Island Road, MD. Midwinter.

Golden Eagle. GOEA

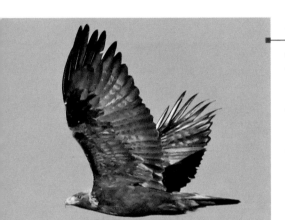

Adult, 11/2016 Allegheny Front, PA. Photo: Bruce Beehler
A rare migrant and wintering species, usually seen as a singleton. Wintering birds typically found in extensive open lands. ▶ Passes hawk watches west of the Piedmont with other migrating raptors, in late October and early November. Two most productive eastern US sites for this species are outside our Region: Allegheny Front, PA, and Waggoner's Gap, PA. Also should be looked for in winter in Eastern Shore marshlands or open country in the Allegheny Highlands.

Barn Owl. BANO

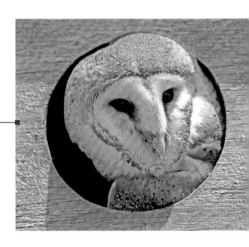

Adult, 5/1995 Blackwater NWR, Dorchester County, MD
Breeds sparsely on the lower Eastern Shore, the lower Western Shore, and the Piedmont. Prefers marshland and open agricultural habitat. There is some coastal migratory movement in autumn. ▶ Most prevalent as a permanent resident in the tidal marshlands of coastal DE.

Eastern Screech-Owl. EASO

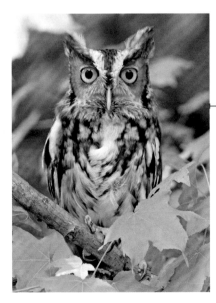

Adult captive, 5/2012 Carrie Murray Nature Center, Baltimore, MD
Common permanent resident throughout, but easily overlooked because of its nocturnal habits. Found in various woodland habitats where there are ample openings for hunting grounds—urban parks, cemeteries, woodlots, and right-of-ways. ▶ Can be called in at night from suburban woodlots by imitating the voice or playback. Roosts during winter in Wood Duck nest boxes and can often be seen looking out of them, at Bombay Hook NWR, DE.

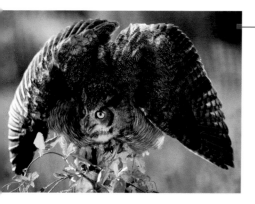

Great Horned Owl. GHOW

Adult, captive 3/1995 Gunpowder Falls State Park, Baltimore County, MD

A widespread permanent resident found in all sectors. Prefers rural landscapes with a mix of fields and woods where there is plenty of open ground for hunting. Also will nest in urban and suburban parks. ▶ The common owl of the piney woods of the Eastern Shore.

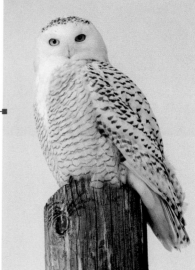

Snowy Owl. SNOW

Immature female, 2/1998 Farm country, Frederick County, MD

A rare but irruptive winter visitor that appears in periodic cycles, usually every 4–5 years. The owls arrive in late autumn and remain through the winter, taking up residence on expansive marshlands, coastal beaches and dunes, agricultural fields, and airports. Some show up in urban habitats and perch on office buildings. Records from late October to early April. ▶ Most likely along the Atlantic Coast and shore of Delaware Bay. Late autumn and winter.

Barred Owl. BADO

Adult, 1/2017 North Potomac, Montgomery County, MD
Photo: W. Scott Young

A common permanent resident throughout. Particularly common in the triangle of Piedmont between Baltimore, Washington, DC, and Harper's Ferry. Also inhabits woods in suburbia. ▶ This deep-woods owl is commonplace in swampy hardwood bottomlands along woodsy sectors of the C&O Canal; also Middle Run Valley NA, DE.

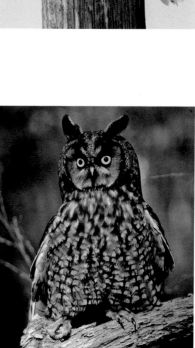

Long-eared Owl. LEOW

Adult, just banded 11/1995 Assateague Island, Worcester County, MD

A rare migrant and winter visitor. Also a rare breeder with old records from the Western Shore, Piedmont (of MD and DE), and a nesting record from the Allegheny Highlands in the year 2000. ▶ Best located at a winter roost that is used night after night, but great care should be taken to avoid disturbing these sensitive roosting birds.

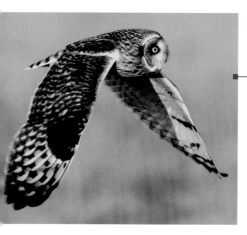

Short-eared Owl. SEOW

Adult, 12/2014 Trappe farmlands, Talbot County, MD
Uncommon winter resident and migrant. To be expected mainly between November and early March. This owl inhabits extensive grasslands and marshlands, foraging mainly in the twilight hours. Records scattered about the Region, with concentrations in the lower Chesapeake and upper Delaware Bays. Has bred in the Allegheny Highlands as recently as 2000. ▶ Best looked for in January and February at Elliott Island Road, MD; or Fowler Creek Road in Prime Hook NWR, DE. At dusk and dawn.

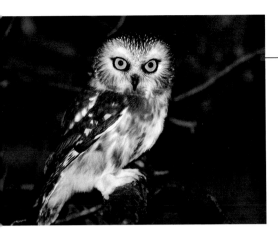

Northern Saw-whet Owl. NSWO

Adult, 11/2016 Chestertown, Kent County, MD
Photo: Daniel Irons

A common but rarely seen passage migrant in late October and early November. Also a little-noticed winter resident. There are a few breeding records from the Allegheny Highlands. Wintering birds to be searched for in thickets of holly and pine and in dense windfalls. Strictly nocturnal. ▶ Best observed at a nocturnal mist-netting operation in autumn along a wooded Appalachian ridge.

Belted Kingfisher. BEKI

Adult female, 5/1993 Cromwell Valley Park, Baltimore County, MD
A common permanent resident, occurring throughout. Invariably found in association with streams, rivers, ponds, and marshlands. Migrants pass through in March and from late August to November. Less common on the lower Eastern Shore. Becomes scarce in winter when shallow-water feeding areas freeze over. ▶ Lilypons, MD; Prime Hook NWR, DE. During all but the coldest months.

Red-headed Woodpecker. RHWO

Adult, Bumpy Oak Road, Charles County, MD
Uncommon to rare (and typically absent) from suitable open habitat across many parts of the Region. Found year-round, with individuals subject to local seasonal movements. Most prevalent north and west of Washington, DC, and Baltimore, and near to the eastern verge of the Ridge & Valley province near the Pennsylvania line. ▶ Blackwater or Prime Hook NWRs, in autumn. Breeds in small numbers in Redden State Forest, DE.

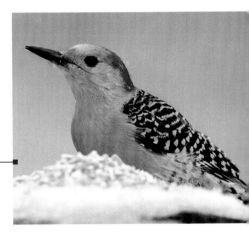

Red-bellied Woodpecker. RBWO

Adult female, 2/2015 Mariner Point Park, Harford County, MD
A commonplace permanent resident throughout, slightly less abundant on the lower Eastern Shore. Found in most habitats with trees, especially suburban woodlands. ▶ A common feeder bird, attracted by suet.

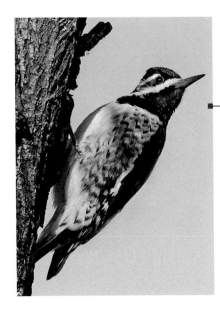

Yellow-bellied Sapsucker. YBSA

Adult male, 3/2015 Mariner Point Park, Harford County, MD
A common but often overlooked passage migrant and winter resident. Typically, singletons are found during the colder months in suburban neighborhoods and woodlots. Best located by voice. ▶ Middle Run Valley NA, DE; Rock Creek Park, DC. Mid-October.

Downy Woodpecker. DOWO

Adult male, 4/2008 Yard bird, Bethesda, MD
Photo: Bruce Beehler

A commonplace permanent resident throughout. Found in most habitats with trees, especially suburban woodlands. ▶ A common feeder bird, attracted by suet. Less abundant in large stands of closed mature forest.

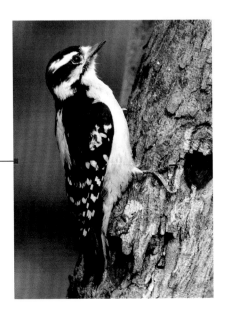

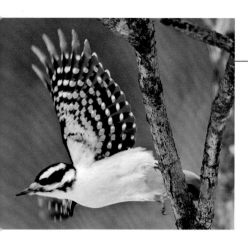

Hairy Woodpecker. HAWO

Adult female, 11/2006 Savage River Lodge, Garrett County, MD
A common permanent resident throughout. Found in most habitats with trees, especially deciduous forests, mixed forests, and suburban woodlands. A regular feeder bird, attracted by suet. Generally less common than the Downy except in large stands of closed mature forest and in the interior piney woods of the Eastern Shore. ▶ Most prevalent in woodlots of the Western Shore and Piedmont.

Northern Flicker. NOFL

Adult female, 4/2014 Rock Creek Park, Washington, DC
Common year-round, with populations boosted by an influx of migrants in March–April and September–October. Prefers edges and openings. Autumn migration (peaking in late September) is more prominent than the spring movement. ▶ Suburban parks, in grassy opening surrounded by oak woods. Early October.

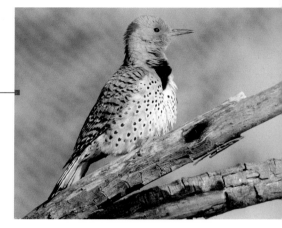

Pileated Woodpecker. PIWO

Adult male 4/2016 Yard bird, Phoenix, MD
Uncommon year-round, but present in virtually all heavily wooded habitats, even in urban parks. Most common where there are large woodlots and mature forest tracts. Absent from expanses of open agricultural lands. Apparently more common in deciduous forests and less so in the piney woods. This permanent resident breeds widely but is mainly absent from along the DE coastline. ▶ C&O Canal, MD; Middle Run Valley NA, DE. Mid-spring, when birds are vocalizing.

American Kestrel. AMKE

Adult male, 12/2015 Warren Road, Baltimore County, MD
Uncommon in open agricultural lands with available high perches. Present year-round, with numbers boosted by migrants during March–April and September–October. A species in decline as a breeding bird. ▶ On telephone lines beside tertiary roads in extensive countryside of fields and hedgerows; Bombay Hook NWR, DE.

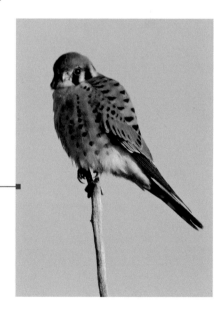

Merlin. MERL

Adult female, 2/2016 Trinity School, Ellicott City, MD
Photo: Anthony VanSchoor
Uncommon or rare except along the Atlantic Coast, where many migrants pass in mid-autumn. Also prevalent in migration along the fall line. Present mainly between September and April. ▶ Bombay Hook and Prime Hook NWRs, DE; Cape Henlopen SP, DE. During late September and early October.

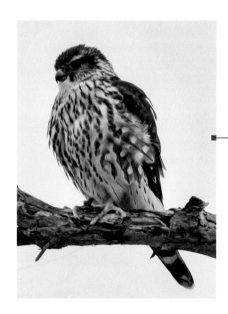

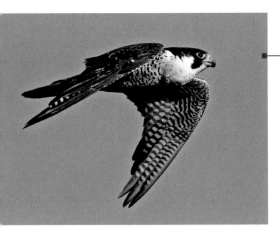

Peregrine Falcon. PEFA

Adult, 5/2006 Calvert Cliffs SP, Calvert County, MD
Rare year-round, boosted by the passage of autumn migrants along the Atlantic Coast. Migrants also pass along the shore of the Chesapeake and along the fall line. A few pairs breed, mainly in urban settings and coastal locations where suitable prey species are abundant (Rock Pigeons in the cities, waterfowl in the coastal locations). ▶ Migrates along the Atlantic shoreline at Cape Henlopen State Park, DE. Late September and early October.

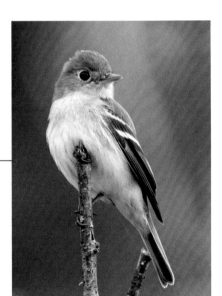

Olive-sided Flycatcher. OSFL

Adult, 5/2015 Holt Park, Baltimore County, MD
Photo: Ryan Johnson
A rare passage migrant, from mid-May to early June and from late August to early October. Fewer records from the Eastern Shore. ▶ Best looked for perched on a high dead limb at forest edge. Usually found by its distinctive vocalization.

Eastern Wood-Pewee. EAWP

Adult, 5/2015 Soldiers Delight NEA, Baltimore County, MD
A common spring and fall migrant and a widespread breeder in the interior of deciduous forest, woodlands, and suburban woodlots. Present mainly from May to September. ▶ C&O Canal, MD; White Clay Creek SP, DE. May–June.

Yellow-bellied Flycatcher. YBFL

Adult, 6/2017 Upper Connecticut Lakes, NH
Photo: Bruce Beehler
A rare spring and uncommon fall migrant, expected from May to early June and from August to early October. Probably no more than 25 records a year. ▶ Might be found in any wooded edge or woody thicket.

Acadian Flycatcher. ACFL

Adult, 4/2015 Susquehanna SP, Harford County, MD
A common and widely distributed seasonal migrant and breeder in damp interiors of mature deciduous forests throughout. Particularly attracted to wooded streams. Ranges west into the habitat of the Least Flycatcher in the Allegheny Highlands. Migration peaks mid-May and early September. ▶ C&O Canal, DC & MD; White Clay Creek SP DE. June.

Alder Flycatcher. ALFL

Adult, 6/2015 Finzel Swamp, Garrett County, MD
Uncommon migrant and rare breeder in alder swamps in the Allegheny Highlands. Found between early May and late September. ▶ Only singing or calling birds can be positively identified. In the alders of Finzel Swamp, MD. Early June.

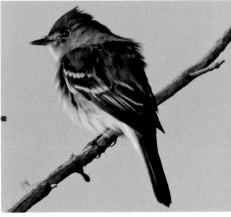

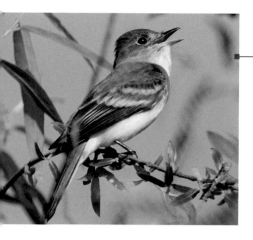

Willow Flycatcher. WIFL

Adult, 5/2016 Swan Harbor Farm, Harford County, MD
Uncommon migrant and summer resident. Present between early May and late September. Nests in willow thickets in swamps and shallow lake edges in the coastal Eastern Shore, the upper Western Shore, Piedmont, and Allegheny Highlands. Most common in the Piedmont. Some breeders settle in appropriate habitat on the coast of upper Delaware Bay and the Assateague dunes. Both Willow and Alder Flycatchers can be found on territory near each other in the Allegheny Highlands, presumably being separated by micro-habitat preferences. Both can be found in Finzel Swamp in early June. ▶ McKee-Beshers WMA, MD; Ashland Nature Center, DE. Late May.

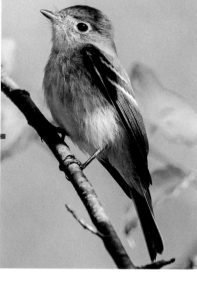

Least Flycatcher. LEFL

Adult, 9/2015 Cromwell Valley Park, Baltimore County, MD
Uncommon passage migrant, with a small breeding population in the Allegheny Highlands. Both Least and Acadian Flycatchers can be heard singing on territory in adjacent forest patches in the Allegheny Highlands. ▶ Swallow Falls State Park, in early June; or Middle Run Valley NA, DE, in September.

Eastern Phoebe. EAPH

Adult, 9/2016 Middle Run Natural Area, Newark, DE
A common and widespread breeder and an uncommon or rare wintering bird throughout; spring and fall migrants pass through as well. Most common between mid-March and early November. Least prevalent in the piney woods of the lower Eastern Shore. During the depths of winter it lingers in riverine lowlands. ▶ Near streams; nests under eaves or below small bridges. March through May.

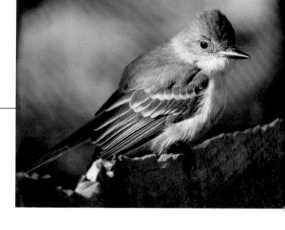

Ash-throated Flycatcher. ATFL

Adult, 1/2016 Turkey Foot Road, Montgomery County, MD
Photo: Tim Carney

A rare vagrant from the Southwest, with about 20 records, mainly between October and January. Most records from the lower Eastern Shore and Western Shore.

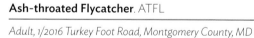

Great Crested Flycatcher. GCFL

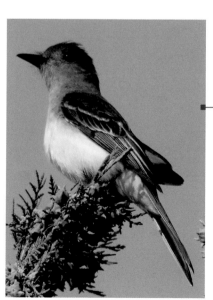

Adult, 6/2008 Wye Farm (private), Queen Anne's County, MD
A common breeder, arriving in late April and departing in early September. Widespread in deciduous and mixed woodlands and woodland edge. Because of its canopy-dwelling habits, it is more commonly heard than seen. ▶ C&O Canal, MD; White Clay Creek SP, DE. May–June.

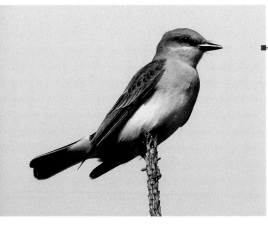

Western Kingbird. WEKI

Adult, 10/2007 Assateague Island, Worcester County, MD
Photo: Mark L. Hoffman
A rare stray from the Great Plains, most often encountered between September and December. Very few spring records. ▶ Perched on phone lines in autumn in coastal locations where migrants congregate.

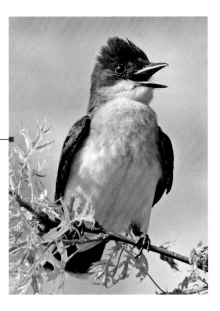

Eastern Kingbird. EAKI

Adult, 5/2015 Irvine Nature Center, Baltimore County, MD
A common and widespread breeder, arriving in late April and departing by early September. In early summer, should be looked for on exposed perches overlooking fields and large openings, including those of water features. ▶ McKee-Beshers WMA, MD. May–June.

White-eyed Vireo. WEVI

Adult, 5/2016 Audrey Carroll Audubon Sanctuary, Frederick County, MD
A common breeder present from late April to late September. Also an uncommon passage migrant in April and October. A bird of thickets and woody edge, especially near water. Most common east of the Ridge & Valley province. Best located by its loud and distinctive song. ▶ Tangles at edges of bottomland woods. McKee-Beshers WMA, MD; Middle Run Valley NA, DE. May–June.

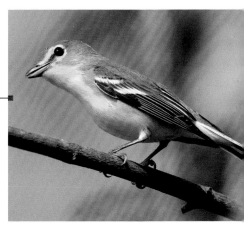

Yellow-throated Vireo. YTVI

Adult, 5/2015 Susquehanna SP, Harford County, MD
Uncommon but widespread in Region, most commonly found high in tall riverside and bottomland shade trees, especially sycamores. Less common in upland oak forest canopy. Heard often but difficult to see. ▶ Along the Susquehanna and Potomac Rivers and C&O Canal in DC and MD. May–June.

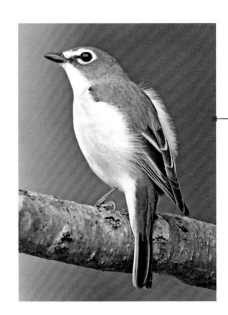

Blue-headed Vireo. BHVI

Adult, 6/2016 Savage River Lodge, Garrett County, MD
An uncommon passage migrant (early April to early May; mid-September to mid-October). Breeds in the Allegheny Highlands, with a few scattered nesting records east to the Piedmont. Found singing in mature upland deciduous and mixed forests as a spring passage migrant. This is the first vireo that appears in the woods in spring. ▶ Rock Creek Park, DC; White Clay Creek SP, DE. April–May.

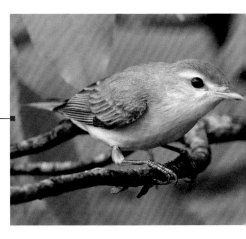

Warbling Vireo. WAVI

Adult, 5/2015 Irvine Nature Center, Baltimore County, MD
A common breeder in Ridge & Valley province, Piedmont, the upper Western Shore, and the northernmost sector of the Eastern Shore. Uncommon to rare on the lower Eastern Shore and in the Allegheny Highlands. An uncommon migrant rarely seen in passage. ▶ Riverside bottomlands, especially in tall sycamores in clearings. Mid-May to late June.

Philadelphia Vireo. PHVI

Adult, 9/2016 Queenstown, Queen Anne's County, MD
Photo: Daniel Irons
A rare passage migrant in May; slightly less rare fall migrant from late August to mid-October. Found in deciduous forest on passage. Difficult to identify and easily overlooked. ▶ Violette's Lock, MD; Middle Run Valley NA, DE. September.

Red-eyed Vireo. REVI

Adult, 9/2016 Ashland Nature Center, New Castle County, DE
A common to abundant breeder in mature deciduous forests from May to September. An inveterate songster from the forest canopy. Peak migration occurs in mid-May and mid-September. Slightly less common in the piney woods of the Eastern Shore, and most abundant in the Piedmont and the Allegheny Highlands. ▶ Virtually any large tract of deciduous forest in May–June.

Blue Jay. BLJA

Adult, 11/1995 Tom Nuttle's Yard, Baltimore County, MD
A common and widespread breeder, passage migrant, and wintering species. ▶ All sectors, in woodlands, forest edge, and suburbia. Exhibits pulses of prominent daytime migration in spring and fall, peaking in early May and early October.

American Crow. AMCR

Adult, 4/2016 National Zoo, Washington, DC
A common to abundant permanent resident throughout. Roosts in large flocks in fall and winter. Best distinguished from the slightly smaller Fish Crow by voice. ▶ One of the most familiar birds of suburbia and rural agricultural lands. Look for winter roosts.

Fish Crow. FICR

Juvenile, 8/2008 Fisherman's Wharf, Lewes, DE
A slightly smaller cousin of the American Crow, outnumbered except near rivers, bays, shores, and some suburban areas. Flocks form in spring and fall. Joins large mixed roosts in winter. The Fish Crow is widespread in the eastern two-thirds of our Region. Mainly absent from the Allegheny Highlands. This species has a strange predilection for suburban mall parking lots during the spring breeding season. ▶ Along the Potomac River; in the Washington, DC, suburbs; around Atlantic shore estuaries. Spring and early summer.

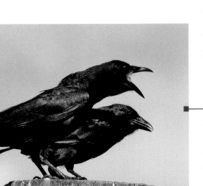

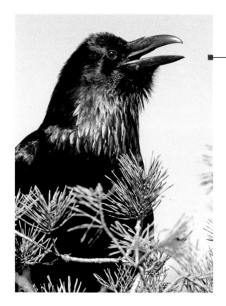

Common Raven. CORA

Adult (captive) Gunpowder Falls SP, Baltimore County, MD
An uncommon large crow-relative most often encountered in association with mountain ridges and rocky nesting sites west of the Piedmont. More recently has been found nesting on cell towers west of Baltimore and Washington, DC, and, in one instance, nesting on Chain Bridge crossing the Potomac River in Washington, DC, proper. Seen singly or in pairs, less commonly in family groups. ▶ Soars around the rocky cliffs of Sugarloaf Mountain, northwest of Washington, DC. Year-round.

Horned Lark. HOLA

Adult male, 2/2015 Trappe farmlands, Talbot County, MD
Uncommon breeder in open agricultural landscapes of the Piedmont and Eastern Shore. Also a common wintering bird in those same open habitats. Largely absent from the Western Shore and Allegheny Highlands. ▶ New Design Road, MD; Bombay Hook NWR, DE. November through February.

Purple Martin. PUMA

Adult male, 5/2015 Wye Farm (private), Queen Anne's County, MD
An uncommon colonial breeder, arriving in April and departing in August and early September. Mainly found in the vicinity of martin houses placed in large rural yards in agricultural country. Most prevalent on the Eastern Shore. ▶ Environs of Bombay Hook NWR, DE; Slaughter Beach, DE. June–July.

Tree Swallow. TRES

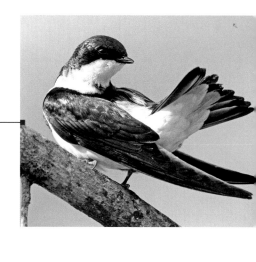

Adult, 5/2015 Lake Roland, Baltimore County, MD
A common open-country swallow, arriving to breed by mid-April and mainly departing by late October. A few overwinter along the coast. Most common near marshlands, ponds, and shores, especially where nesting boxes have been provided. Gathers in huge swirling flocks along the shores of Delaware Bay in the autumn, peaking in mid-October. Increasing. ▶ Nests at Lilypons, MD, Blairs Valley, MD, and Brandywine Creek SP, DE, in June. Huge migrant flocks gather at Lewes and Cape Henlopen, DE, in October.

Northern Rough-winged Swallow. NRWS

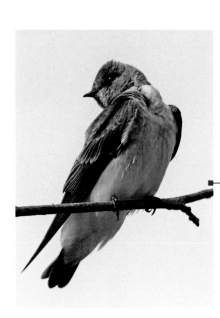

Adult, 5/2015 Lake Roland, Baltimore County, MD
This is typically the first swallow that arrives in early spring, usually by early April. It is a widespread breeder in small numbers; pairs nest in dry culverts, drain pipes in walls, and other artificial structures. Most common on the upper Western Shore and in the Piedmont, but with breeding records throughout. Sparsely distributed in the southernmost sectors of the Region. ▶ C&O Canal, DC. May.

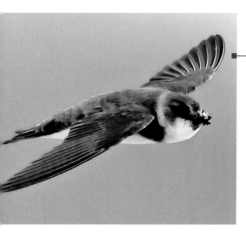

Bank Swallow. BANS

Adult, 6/2016 Poplar Island, Talbot County, MD
An uncommon colonial breeder found in early summer around sand quarries, stream banks, and dirt cliffs. Mainly found in the central Western Shore and upper Eastern Shore, depending on the availability of suitable breeding sites, which are few. Also a passage migrant in mid-May and July–August. ▶ Jug Bay Wetlands Sanctuary, MD, and Cedar Swamp Road, DE, in early summer; Bombay Hook NWR, DE, in early autumn, when various species of migrant swallows gather and roost on telephone lines near the shore.

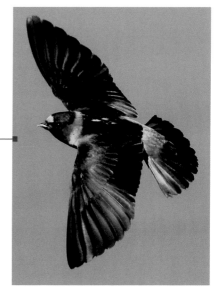

Cliff Swallow. CLSW

Adult, 5/2015 Prettyboy Dam, Baltimore County, MD
An uncommon colonial swallow that breeds in domed mud-nests constructed under bridges or the eaves of barns. It arrives in late April and departs largely by late August. As a breeder it is mostly found in the Allegheny Highlands and the Piedmont. Prefers the vicinity of water. There are a few local breeding colonies on the Eastern Shore. ▶ Under bridges at Triadelphia or Loch Raven Reservoirs, MD; Appoquinimink River Bridge on Route 9, DE. May–June.

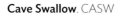

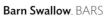

Cave Swallow. CASW

Adult, 11/2016 South Padre Island, TX
Rare autumn vagrant, with a few records annually.
▶ Augustine WMA, DE. November–December.

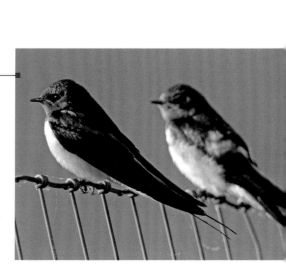

Barn Swallow. BARS

Adult males, 6/2014 Pea Ridge Road, Garrett County, MD
Widespread throughout, especially in agricultural landscapes, reservoirs, and places with access to both open foraging habitat and man-made covered nesting substrates. Arrives in April and departs mainly by early September. ▶ Cape Henlopen SP, DE; Jug Bay Wetlands Sanctuary, MD; Abbotts Mill, DE. May–June.

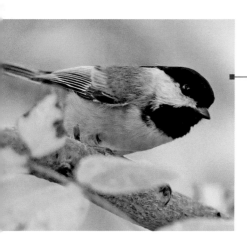

Carolina Chickadee. CACH

Adult, 9/2016 Brandywine Creek SP, New Castle County, DE
A common permanent resident east of Hancock, MD. Frequents backyard feeders and joins local mixed foraging flocks during the nonbreeding season. One of our commonplace species, occupying suburban habitats, woodlots, and deciduous forest. Difficult to distinguish from its close relative, the Black-capped Chickadee, which breeds in the Allegheny Highlands and atop the highest elevations in the western Ridge & Valley province. ▶ All wooded localities east of Hagerstown, MD.

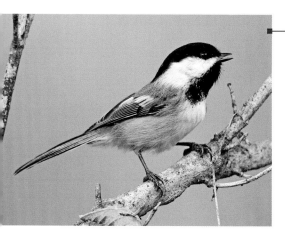

Black-capped Chickadee. BCCH

Adult, 11/2016 Brandywine Creek SP, New Castle County, DE
A common permanent resident in the wooded habitats of the Allegheny Highlands and the western portion of the Ridge & Valley province, where it meets the range of the Carolina Chickadee. The Black-capped in some winters irrupts southward and eastward into the Piedmont, upper Western Shore, and uppermost Eastern Shore, but it is very difficult to distinguish from the Carolina Chickadee, with the situation complicated by the occurrence of hybrids.
► All wooded localities west of Hancock, MD. Best identified in spring when vocal.

Tufted Titmouse. TUTI

Adult, 9/2016 Middle Run Natural Area, New Castle County, DE
A common and widespread woodland and suburban resident, present the year-round. A very common visitor to backyard feeders. ► Any deciduous woodland on the Western Shore. Best located by its whistled song.

Red-breasted Nuthatch. RBNU

Adult, 10/2016 Trap Pond SP, Sussex County, DE
A periodically irruptive autumn migrant and winter visitor, quite common in some years, especially in the autumn. Most years, the species is an uncommon cool season visitor. Also breeds in stands of conifers on the Allegheny Plateau. ► The campground conifers at Cape Henlopen SP, DE. Late autumn.

White-breasted Nuthatch. WBNU

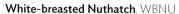

Adult, 10/2016 Ashland Nature Center, New Castle County, DE
A common woodland and suburban resident, present throughout the year-round. A regular visitor to backyard feeders. Prefers deciduous woodland. Less common in the piney woods of the lower Eastern Shore, where Brown-headed Nuthatches are found. Generally on the increase.
► Any deciduous woodland on the Western Shore or Piedmont.

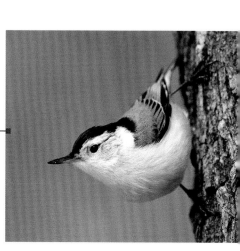

Brown-headed Nuthatch. BHNU

Adult, 12/2014 Cape Henlopen SP, Sussex County, DE
An uncommon and easily overlooked permanent resident of the piney woods of the lower Eastern Shore, ranging northward to Eastern Neck NWR, MD, and Milford Neck Wildlife Area, DE. Also occurs in St. Mary's and southernmost Calvert Counties of the lower Western Shore. Travels in squeaking flocks in open stands of Loblolly Pines in sandy bottomlands. Expanding northward and increasing in our Region. Most common in Loblolly Pines, but can be found in stands of other pine species. ► Cape Henlopen SP Nature Center feeder, DE; Assawoman WA, DE. Year-round.

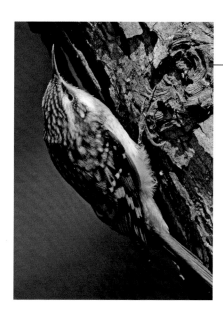

Brown Creeper. BRCR

Adult, 03/2006 Patterson Park, Baltimore, MD

Uncommon breeder in the Allegheny Highlands and a few summering or breeding birds are scattered sparsely through the Western Shore and Eastern Shore. More common as a passage migrant (especially in November) and winter visitor. Easily overlooked. Breeds in mature conifer and mixed forest and winters in all woodland types. ▶ Any deciduous bottomland woods in winter; conifer stands in the Allegheny Highlands in summer.

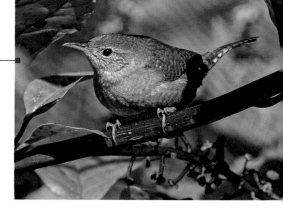

House Wren. HOWR

Adult, 9/2016 Middle Run Natural Area, New Castle County, DE

A common bird of backyards, suburbia, and hedgerows in agricultural landscapes, nesting often in nest boxes. Prevalent from early May to late September. Small numbers overwinter. On the Eastern Shore, the species is most common near water and in urban and suburban yards. ▶ In Piedmont backyards, hedgerows, and thickets. May–June.

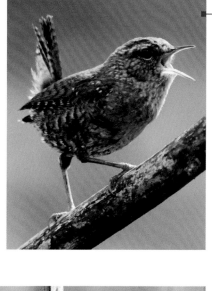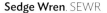

Winter Wren. WIWR

Adult, 6/2015 New Germany SP, Garrett County, MD

Mainly a visitor in the cold months, arriving in numbers in October and remaining until April. Also an uncommon breeder in the Allegheny Highlands. ▶ In winter months in tangles and thickets within bottomland woodlands on hillsides adjacent to water. Located in winter by its sputtered call-notes.

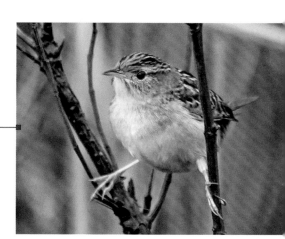

Sedge Wren. SEWR

Adult, 4/2016 Finzel Swamp, Garrett County, MD
Photo: J. B. Churchill

A very rare breeder in the Allegheny Highlands and coastal marshlands facing Delaware Bay. Also an uncommon passage migrant and wintering species, found mainly in rank grasslands and in low vegetation of the drier upper fringe of marshlands. Except when in spring song, mainly a mouselike skulker difficult to observe. ▶ Coastal marshlands of DE and MD. Winter.

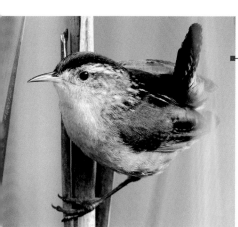

Marsh Wren. MAWR

Adult, 5/2015 Swan Harbor Farm, Harford County, MD

A common breeder in brackish and saltwater marshlands fringing the Chesapeake and Delaware Bays and other tidal environments. Arrives in late April and mostly departs by mid-September. Difficult to observe but highly vocal in season. Also an uncommon migrant to and wintering species in suitable wetland habitats. Usually in rather tall and luxuriant marsh vegetation, a habitat where the similar Sedge Wren is not found. ▶ Jug Bay Wetlands Sanctuary, MD; the Boardwalk Trail at Bombay Hook NWR, DE. May–June.

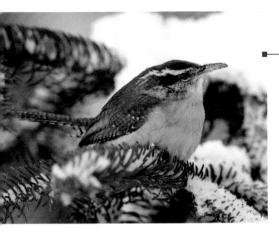

Carolina Wren. CAWR

Adult, 2/2015 National Arboretum, Washington, DC

An abundant and widespread permanent resident. This commonplace yard bird also inhabits woodland thickets and edges throughout. It is an inveterate songster heard year-round. In most localities, this is the most common of our wrens. ► C&O Canal in DC and MD. Year-round.

Blue-gray Gnatcatcher. BGGN

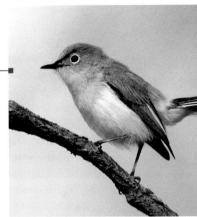

Adult, 4/2016 Rock Creek Park, Washington, DC

A common but easily overlooked breeder, arriving in early April and departing by early September. Forages and nests in canopy trees at the edges of woodlands, often in damp bottomlands and near water. Usually in pairs that give their high-pitched lisping notes. A few winter records. ► C&O Canal, DC and MD. May–June.

Golden-crowned Kinglet. GCKI

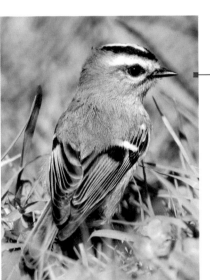

Adult female, 4/2016 Rock Creek Park, Washington, DC

Best known as a common passage migrant, as well as an uncommon wintering species throughout. Found as a breeder in the Allegheny Highlands; also should be looked for in large plantations of conifers elsewhere. Migration peaks occur in late March and late October. Fall southward passage more evident and prolonged. ► In winter, foraging in twigs in the middle and upper stages of woodland edges and in conifers.

Ruby-crowned Kinglet. RCKI

Adult, 9/2016 Middle Run Natural Area, New Castle County, DE

A common passage migrant as well as an uncommon wintering species throughout. Migration peaks occur in mid-April and late October. Fall southward passage more evident and prolonged. ► In bottomland woodland edges, foraging in twigs in the middle stages of the vegetation. Late fall and winter.

Eastern Bluebird. EABL

Adult male, 8/2015 Howard County Conservancy, Woodstock, MD

A common year-round resident, with seasonal pulses of migration especially in late October and early November, but with the species present in all months. Inhabits old fields, hedgerows, and orchards, especially where nest boxes are present. Breeds throughout. Prefers rural habitats with abundant low and mid-level perches overlooking open ground. Commonly seen perched on telephone lines along country roads. A particularly harsh winter leads to a noticeable decline the subsequent spring. ► Centennial Lake, Howard County, MD; White Clay Creek SP, DE; Bombay Hook NWR, DE. Winter.

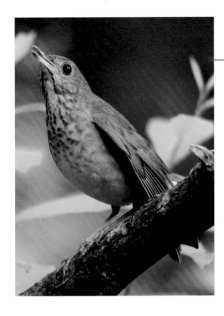

Veery. VEER

Adult, 5/2015 Milford Mill Trail Park, Baltimore County, MD
An uncommon breeder and common seasonal passage migrant, with peaks in early May and early September. Sparingly breeds in moist bottomland and upland forest of the Piedmont, the Allegheny Highlands, and to a lesser extent the eastern Ridge & Valley province. Widespread as a migrant. ▶ Mountain Laurel thickets in deciduous forest situated on a north-facing slope. Ashland Nature Center, DE; Patapsco Valley SP (Henryton), MD. May–June.

Gray-cheeked Thrush. GCTH

Adult, 5/2015 Milford Mill Trail Park, Baltimore County, MD
An uncommon spring and fairly common autumn passage migrant, with peaks in mid-May and the end of September. Forages on leafy floor of shaded mature forest interior. ▶ At favored migrant traps, such as Rock Creek Park, DC, or Susquehanna SP, MD. Late September to early October.

Bicknell's Thrush. BITH

Adult, 5/2007 Ferndale, Anne Arundel County, MD
Photo: Mark L. Hoffman
Almost impossible to distinguish this passage migrant from its very close relative, the Gray-cheeked Thrush. Passage peaks in the latter half of May and from late September to early October. Perhaps more frequently encountered in the autumn. Forages on leafy floor of shaded mature forest interior. Only a handful of records annually. ▶ At favored migrant traps, such as Rock Creek Park, DC, or Susquehanna SP, MD. Late September to early October.

Swainson's Thrush. SWTH

Adult, 5/2015 Patterson Park, Baltimore, MD
A common passage migrant in spring and fall, with peaks in mid-May and late September. Can sometimes be heard singing a quiet version of its distinctive song during spring passage. During migration, forages warily in shaded leafy forest floor of all forest types, isolated woodlots, and wooded city parks. ▶ At favored migrant traps, such as Rock Creek Park, DC, or Susquehanna SP, MD. Mid-May and late September.

Hermit Thrush. HETH

Adult, 10/2016 Brandywine Creek SP, New Castle County, DE
An uncommon breeder in the Allegheny Highlands. An uncommon passage migrant and reclusive wintering species, inhabiting the leafy forest floor of moist forest tracts, especially near water. Migrants pass through in mid-March and late September. The only *Catharus* thrush wintering in our Region. ▶ Wet bottomland deciduous woodland thickets. Late autumn and winter.

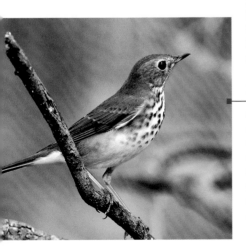

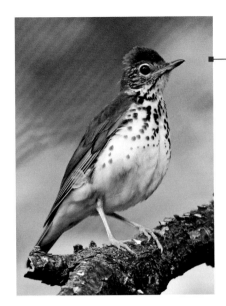

Wood Thrush. WOTH

Adult, 5/2015 Milford Mill Trail Park, Baltimore County, MD
A fairly common woodland thrush found throughout in deciduous floodplains and ravines with adequate understory vegetation. Uncommon or absent in the piney woods of the Eastern Shore. Arrives by early May and departs by mid-September. A few winter records. ▶ Damp deciduous woodland interior; Patuxent Research Refuge, MD; Sugarloaf Mountain, MD; Brandywine Creek SP, DE. May–June.

American Robin. AMRO

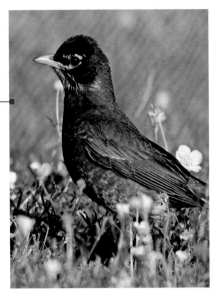

Adult male, 5/2016 Rock Creek Park, Washington, DC
One of the commonplace year-round birds. Breeders abound in urban parks and backyards, as well as all other wooded and edge habitats. Found in mobile flocks in late autumn and winter as well as early spring. These flocks search out patchy fruit resources. Least common in the height of winter, as the local fruit resources dissipate. Most abundant in November. ▶ Wooded suburbia in April–May; also large flocks gather in fruiting trees in late autumn and winter.

Gray Catbird. GRCA

Adult, 10/2016 Brandywine Creek SP, New Castle County, DE
A common and widespread breeder throughout. Inhabits forest edge, urban parks, and backyards with trees and shrubbery. An uncommon wintering bird. Migrants mainly arrive by late April and depart by early October. Less abundant in the southern and eastern sectors of the Region. ▶ C&O Canal, MD; White Clay Creek SP, DE. May through September.

Brown Thrasher. BRTH

Adult, 4/2015 North Point SP, Baltimore County, MD
An uncommon bird of thickets, shrubbery, and edge in open agricultural habitats and, occasionally, in suburban woodland openings and parks. Hedgerows of old fields are particularly popular. Uncommon to rare in winter. The species arrives by early April and departs by mid-October. Most wintering birds in our Region are found east of the Piedmont. ▶ Overgrown thickets in open agricultural lands during the warmer months.

Northern Mockingbird. NOMO

Adult, 12/2014 Sandy Point SP, Anne Arundel County, MD
A common and widespread resident in open agricultural, marshland, suburban, and urban habitats except for the Allegheny Highlands, where it is scarce. ▶ Suburban and agricultural hedgerows. Year-round.

Bird-Finding Guide

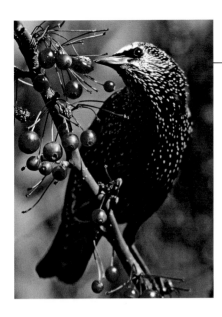

European Starling. EUST

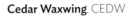

Adult winter plumage, 11/2002 Otterbein Neighborhood Park, Baltimore, MD

This common to abundant exotic invasive species favors association with humans and is found in urban, suburban, and rural agricultural lands. Flocks move considerable distances in search of winter food resources. ▶ Look for large flocks roosting in urban areas. Winter.

Cedar Waxwing. CEDW

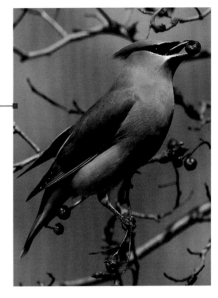

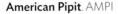

Adult, 1/2015 Centennial Park, Howard County, MD
Photo: Bonnie Ott

A common flocking wanderer that is present year-round. Most common in May and from early October to mid-December. As a breeder, the species is most common in the western and northern sectors of the Region. Flocks move far and wide in search of productive fruiting trees. Mainly found in openings and edges where fruiting resources are most abundant. ▶ Flocks found in association with ornamental trees producing ripe berries in autumn.

House Sparrow. HOSP

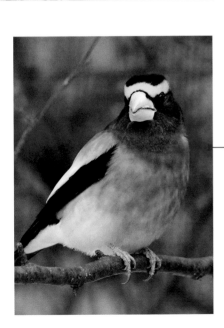

Adult male, 5/2015 Irvine Nature Center, Baltimore County, MD
A commonplace human commensal prevalent in urban, suburban, and agricultural settings. A permanent resident with no migratory tendencies. Forages on the ground in small parties searching for weed seeds. ▶ Visits backyard feeders and found in any urban area, scavenging for spilled food.

American Pipit. AMPI

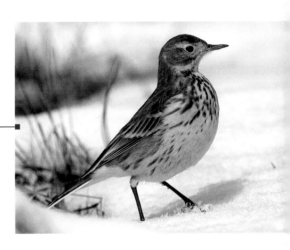

Adult, 2/2015 Herring Creek Nature Park, West Ocean City, MD
An uncommon migrant and fairly common wintering species, favoring bare ground or short-grass fields in large expanses of rural agriculture. Can appear anywhere in migration, so long as there is a patch of suitable habitat. Arrives in mid-autumn and departs by the end of April. ▶ Prime Hook NWR, DE; Blackwater NWR, MD. Midwinter.

Evening Grosbeak. EVGR

Adult male, 1/2017 Frank's yard, Duluth, MN
A rare irruptive winter finch, only appearing when the northern cone crop fails. Appears at backyard feeders in search of sunflower seeds. Travels in mobile and vocal flocks. To be looked for from late autumn to early spring, but there has not been a major irruption into our Region for many years. Typically, only a handful of records per winter. ▶ Could appear at a feeder in any sector in late winter.

House Finch. HOFI

Adult male, 4/2014 Patterson Park, Baltimore, MD
A West Coast species that arrived in our Region in 1958.
It is a common permanent resident, inhabiting suburbia,
city parks, and other similar non-forest and edge habitats.
▶ Visits backyard bird feeders. Has declined substantially
because of disease in recent years.

Purple Finch. PUFI

Adult male, 4/2002 Savage River Lodge, Garrett County, MD
Primarily an uncommon passage migrant and winter visitor.
It arrives in September and departs in April. Feeds on tree
seeds (especially Tuliptree and Sweet Gum) and visits bird
feeders on occasion to take sunflower seeds. Most com-
mon in October and November. Records in winter come
mostly from the Piedmont and Western Shore. Also breeds
in conifers in the Allegheny Highlands. ▶ Violette's Lock,
MD. October–November.

Common Redpoll. CORE

Adult male, 1/2015 Lake Elkhorn, Howard County, MD
Photo: Bonnie Ott
A rare winter visitor, expected mainly between November
and March. Appears in larger numbers every few years.
Most years see few or no records. ▶ Found mainly visiting
feeders in small flocks and weedy fields in Piedmont in late
winter.

Red Crossbill. RECR

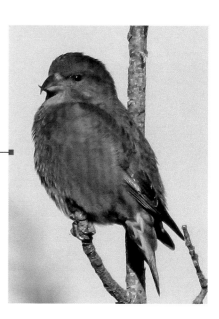

Adult male, 1/2013 Assateague Island SP, Worcester County, MD
Photo: Kurt R. Schwarz
An irruptive winter finch present in small numbers every
few years. Substantial numbers visit every decade or so,
when the cone crop fails in Canada and New England.
Found mainly in pines with mature cones, especially along
the coast. ▶ Cape Henlopen SP, DE. Autumn, during a
flight year. Various call-types are recognized.

White-winged Crossbill. WWCR

Adult female, 3/2009 Centennial Park, Howard County, MD
Photo: Mark L. Hoffman
A very rare (to rare) irruptive winter finch that in some
years arrives in small numbers between late fall and early
spring. Feeds on conifers with productive cone crops.
Much rarer than the preceding species, but often appears
in the same years that the Red Crossbill irrupts. ▶ Cape
Henlopen SP, DE. Autumn, during a flight year.

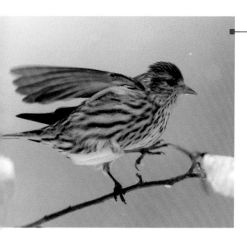

Pine Siskin. PISI

Adult, 1/2015 Black Hill Regional Park, Montgomery County, MD
An uncommon irruptive winter visitor and autumn passage migrant. Also a rare breeder in conifer stands in the Allegheny Highlands. Visits backyard feeders (especially for Nyjer seed) and also forages in various conifers. This and the Purple Finch are the most common of the irruptive winter finches (present in varying numbers most years). ▶ In irruption years, it visits feeders in small flocks in late autumn and winter.

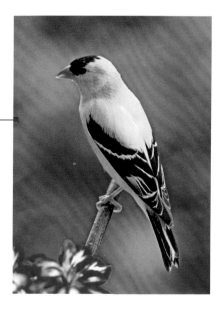

American Goldfinch. AMGO

Adult male summer plumage, 6/1990 Charlesbrook neighborhood, Baltimore County, MD
A common resident, but when not breeding it joins mobile flocks that move far and wide. The birds are on the move in April–May and October–November. Feeds on seeds in weedy fields (in fall) and also in productive canopy trees (in spring). ▶ Visits feeders in small parties in spring, fall, and winter.

Lapland Longspur. LALO

Adult winter plumage, 3/2015 Swan Harbor Farm, Harford County, MD. Photo: Mark R. Johnson
An uncommon to rare winter visitor from the far north. Arrives in small numbers from mid-October and departs by late March. Found in fields, beaches, roadsides, and other land bare of vegetation. Usually found with Horned Larks, but sometimes found in association with Snow Buntings. Most records come from open country of the Piedmont, Western Shore, and Eastern Shore, especially at roadside edges of agricultural fields. ▶ Cartanza Road, near Little Creek, DE. Winter.

Snow Bunting. SNBU

Adult winter plumage, 12/ 2014 Sandy Point SP, Anne Arundel County, MD
An uncommon to rare winter visitor wandering in flocks through open habitats: expansive agricultural fields, coastal beaches, and other wide-open spaces. ▶ Cape Henlopen SP, DE; Indian River Inlet campground DE; Assateague Island, MD. November through March.

Eastern Towhee. EATO

Adult male, 2/2015 Mariner Point Park, Harford County, MD
Widespread throughout. Typically, thinly distributed through scrubby regrowth, edge, hedgerows, and old fields, especially in agricultural habitat. Present year-round, but decreasingly common through the winter months and earliest spring. Withdraws from the mountainous west in winter. ▶ Thickets in shrublands in regional parks. April through October.

American Tree Sparrow. ATSP

Adult, 3/2015 Irvine Nature Center, Baltimore County, MD
An uncommon and declining winter visitor, arriving in November and departing in March. Winters in small flocks in old fields and edges in agricultural landscapes. Our Region constitutes the southern edge of this species' winter range. More common in the northern sectors of our Region.
► Ashland Nature Center, DE; Blue Mash Nature Trail, MD. December through February.

Chipping Sparrow. CHSP

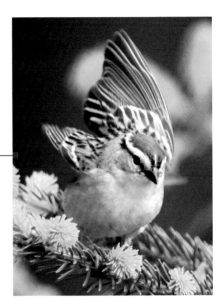

Adult, 6/2016 Savage River Lodge, Garrett County, MD
A commonplace and widespread breeder, arriving in mid-April and departing by the end of October. Diminutive and confiding, this species inhabits well-tended parklands and suburbia and is found where canopy trees (especially tall conifers) are mixed with expanses of short grass and bare ground. Winters sparingly, most commonly on the Eastern Shore. ► Grassy clearings in regional parkland. April through July.

Clay-colored Sparrow. CCSP

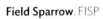

Adult, 11/2011 Assateague Island SP, Worcester County, MD
Photo: Mark L. Hoffman
A rare passage migrant. Most prevalent in the autumn, especially from mid-September to mid-October. The species has summered a handful of times, but there is no evidence of breeding. ► Prefers brushy edges and young conifer plantings adjacent to short grass, from the Piedmont east to the fall line. September–October.

Field Sparrow. FISP

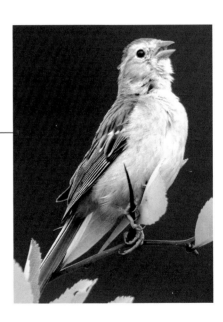

Adult, 6/2016 Old Legislative Road, Allegany County, MD
A fairly common and widespread breeder, migrant, and wintering species, with a preference for old fields with plenty of brush and a scattering of small trees. The species passes through the Region in the latter half of March and October–November. In winter, the population thins as some birds shift south of our Region. ► Brushy old fields in agricultural lands. April through September.

Vesper Sparrow. VESP

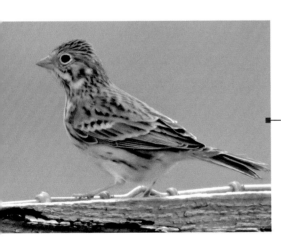

Adult, 10/2015 Maryland Agriculture & Farm Park, Baltimore County, MD. Photo: Keith Eric Costley
An uncommon passage migrant and a declining breeder in sparsely vegetated agricultural fields of the middle Eastern Shore, northern Piedmont, and Allegheny Highlands. Mainly absent in winter. Breeding population strongholds appear in the Allegheny Highlands, Ridge & Valley province, and the agricultural interior of the lower Eastern Shore. The species prefers agricultural lands with plowed fields and short-grass pastures with fence lines and some shrubbery for cover. ► In spring in the rural lands around Poolesville, MD; in autumn at Bombay Hook NWR, DE.

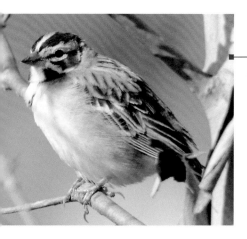

Lark Sparrow. LASP

Adult, 5/2013 Patterson Park, Baltimore, MD
A rare autumn migrant, most prevalent on the coast in August and September. Also a scattering of records from late winter to late spring. Typically fewer than a dozen records per annum. Found in hedgerows and near shrubbery in agricultural landscapes or suburbia. Also in coastal dunes and shrubby areas. Bred in the Allegheny Highlands in the early 1900s. ▶ Assateague Island, MD. September.

Savannah Sparrow. SAVS

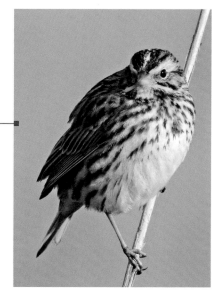

Adult, 12/2014 Little Creek Wildlife Area, Kent County, DE
A common passage migrant (peaks mid-April and mid-October) and an uncommon winter resident. Also a fairly common breeder in weedy fields of the valleys within the Piedmont, Ridge & Valley province, and Allegheny Highlands. ▶ On the Eastern Shore, common in the cooler months on grassy road shoulders, such as along diked roads in coastal marshlands.

Grasshopper Sparrow. GRSP

Adult, 9/2015 Howard County Conservancy, Woodstock, MD
An uncommon and declining breeder most prevalent in the central agricultural landscape of the Eastern Shore, southern Western Shore, western Piedmont, Ridge & Valley province, and Allegheny Highlands. Prefers overgrown pastures, hayfields, weedy fields, and grasslands restored atop former surface coal mines. Also a rare migrant and occasional winter vagrant. ▶ Bombay Hook NWR, DE; country roads south of Poolesville, MD; Chino Farms, Chestertown, MD; Fair Hill NRMA, MD. May–June.

Henslow's Sparrow. HESP

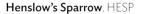

Adult, 6/2015 Old Legislative Road, Allegany County, MD
A rare passage migrant. Also a rare breeder in weedy overgrown fields and reclaimed strip-mine grasslands in the Allegheny Highlands. ▶ To be searched for in late May in the eastern sector of Garrett County where former surface coal mines have been revegetated, producing scrubby fields with scattered shrubs and rank grass. Found with Grasshopper Sparrows and Golden-winged Warblers. Now absent from its former stronghold on the lower Eastern Shore.

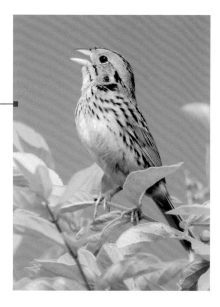

Le Conte's Sparrow. LCSP

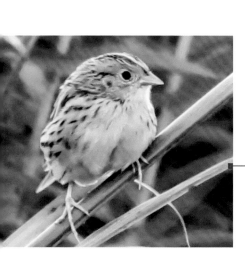

Adult, 10/2013 Hydes Road Park, Baltimore County, MD
Photo: Tim Carney (MDOT MPA/MES)
A very rare migrant, with a scattering of records from September to May. ▶ To be searched for in rank fields, low wet grasslands, or salt marsh. October–November.

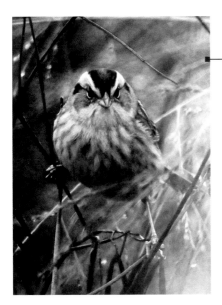

Nelson's Sparrow. NESP

Adult, 10/2012 Swan Creek Wetland, Anne Arundel County, MD
Photo: Tim Carney (MDOT MPA / MES)
A rare northern migrant with most records in May and
October. Inhabits marshlands, but can be found in interior
thickets and hedgerows in migration. ▶ A scarce wintering
resident along coastal tidal marshes. Most records come
from the two bays and the Atlantic shore in the cooler
months.

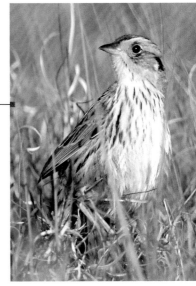

Saltmarsh Sparrow. SALS

Adult, 5/2016 Farm Creek Marsh, Dorchester County, MD
An uncommon breeder in tidal marshes of Saltmarsh
Cordgrass and Salt Hay. Breeds in the southern sector of
the Eastern Shore, both on the Chesapeake Bay and in the
Atlantic estuaries. Also a rare passage migrant to marsh-
lands of the Chesapeake and Delaware Bays. Presumed
most prevalent in passage in earliest May and latest Sep-
tember. A scarce wintering bird in the same marshlands
of the Eastern Shore. ▶ Elliott Island Road, MD; Mispillion
tidal marshes, DE. May–June.

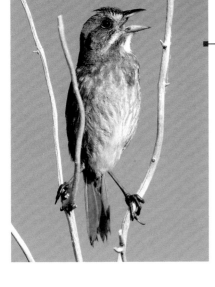

Seaside Sparrow. SESP

Adult, 5/2015 Farm Creek Marsh, Dorchester County, MD
A common partially migratory resident of tidal marshes
of the lower Eastern Shore—both the Chesapeake Bay
and Atlantic sides. Inhabits Saltmarsh Cordgrass and
Needlerush marshes. This and the Saltmarsh Sparrow can
be found in the same marshlands, but the Seaside Sparrow
inhabits the marsh closer to the tideline. During the cold-
est periods of winter, most birds apparently shift to areas
south of the Region. The three saltmarsh sparrows can
sometimes be found together in the cooler months along
the Atlantic and Delaware Bay estuaries. ▶ Elliott Island
Road, MD; Mispillion tidal marshes, DE. May–June.

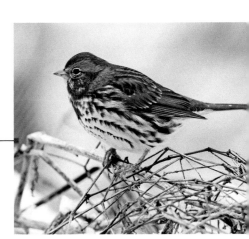

Fox Sparrow. FOSP

Adult, 2/2015 Mariner Point Park, Harford County, MD
An uncommon passage migrant (peaks early March and
mid-November) and an uncommon wintering resident.
Prefers leafy ground in brushy areas under mature oak
woodland and edge. ▶ In winter at Bombay Hook NWR,
DE, or the Poolesville, MD, environs.

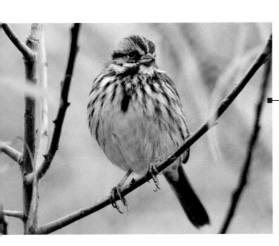

Song Sparrow. SOSP

Adult, 10/2013 Patterson Park, Baltimore, MD
A commonplace and widespread permanent resident of
suburbia, agricultural hedgerows, and marshlands. Also an
occasional backyard feeder bird. Begins singing in March.
Scarce breeder on the lower Eastern Shore. Evidence from
Cape May, NJ, indicates there is a substantial migration of
this species through the Mid-Atlantic that is most evident
in the autumn. ▶ Hedges and thickets in residential areas
and old fields. Most vocal in April–May.

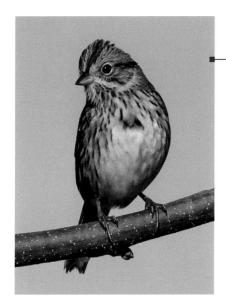

Lincoln's Sparrow. LISP
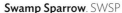

Adult, 10/2015 Howard County Conservancy, Woodstock, MD
Photo: Bonnie Ott
An uncommon and secretive but widespread passage migrant, hiding out in thickets and furtively foraging on the ground near thick cover. Very few birds winter. ▶ Thickets and brush piles at verges of old fields. October.

Swamp Sparrow. SWSP

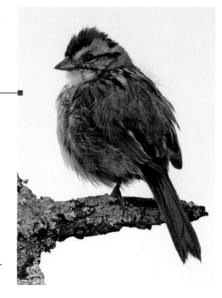

Adult, 6/2015 Finzel Swamp, Garrett County, MD
A fairly common breeder in marshlands and wetlands of the Allegheny Highlands, the lower Eastern Shore of MD, and the DE coast. Also a common passage migrant and wintering species throughout. A wetland species, it also can be found in thickets and hedgerows during migration (peaks late April and late October). ▶ McKee-Beshers WMA, MD; Bombay Hook NWR, DE. March through November.

White-throated Sparrow. WTSP
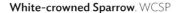

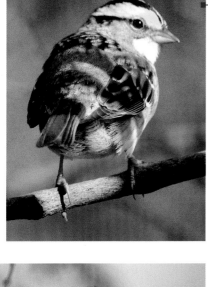

Adult, 4/2013 Patterson Park, Baltimore, MD
A common passage migrant, wintering resident, and back-yard feeder bird. Arrives in mid-October and departs by mid-May. Forages in small flocks in backyards, hedgerows, and at the edge of woodlands. One of the characteristic winter yard birds. ▶ Thickets in suburban environs and backyard feeders. Late autumn, winter, and early spring.

White-crowned Sparrow. WCSP

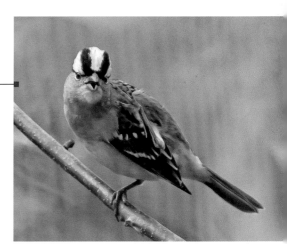

Adult, 10/2014 Howard County Conservancy, Woodstock, MD
Photo: Bonnie Ott
Uncommon passage migrant and winter resident. Prefers more open and less woodsy habitat—especially hedgerows of Multiflora Rose in expanses of farmland. Arrives in the latter half of October and departs in early May. Most win-ter records come from the Western Shore, Piedmont, and eastern sector of the Ridge & Valley province. Singletons appear at local feeders in winter. ▶ New Design Road and Lilypons, MD; Bombay Hook NWR Visitor Center, DE. October.

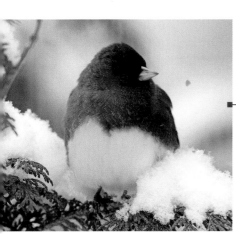

Dark-eyed Junco. DEJU

Adult male, 2/2015 National Arboretum, Washington, DC
A widespread and familiar winter visitor, feeding in small flocks on the ground under feeders and in backyards and in grassy clearings at woodland edge. Arrives in late October and departs in mid-April. Also an uncommon breeder in the Allegheny Highlands, nesting in conifer stands in mixed forest, usually above 2,500 feet elevation. ▶ Common below backyard feeders in the cooler months.

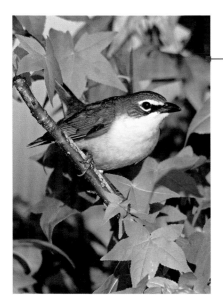

Yellow-breasted Chat. YBCH

Adult, 5/2015 Pickering Creek Audubon Center, Talbot County, MD

A rare passage migrant and an uncommon and patchy breeder. A specialist inhabiting shrubbery and thickets in old fields and regenerating cut-over clearings. Prefers a habitat similar to those used by Blue-winged and Prairie Warblers. Also a rare early winter vagrant. ▶ McKee-Beshers WMA, MD; Bombay Hook NWR, DE. May–June.

Yellow-headed Blackbird. YHBL

Adult male summer plumage, 6/1999 Freezeout Lake, Great Falls, MT

A rare visitor from the West, with about a dozen records a year. Recorded in all months. ▶ Singletons associated with large blackbird flocks near either bay, between October and March. Best found by scanning flocks of Red-winged Blackbirds feeding on ground in pasture or stubble fields.

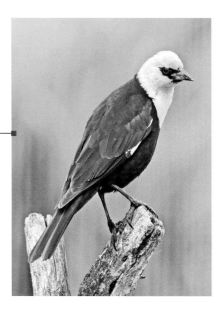

Bobolink. BOBO

Adult male summer plumage, 4/2013 Patterson Park, Baltimore, MD

An uncommon but widespread passage migrant with peaks in mid-May and early September. Migrating flocks drop into any untended grassland plot or even soybean fields. The species prefers large expanses of tall upland grasslands or mature hayfields for breeding. In fall, high overhead, migrating individuals give a weak *pink* note.
▶ The Allegheny Highlands; in the northeastern corner of MD at Fair Hill Natural Resources Management Area; near Emmitsburg, MD. May–June.

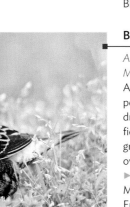

Eastern Meadowlark. EAME

Adult summer plumage, 6/2015 Antietam National Battlefield, Washington County, MD

An uncommon inhabitant of grasslands. Present year-round but the species is migratory, with movements in March–April and October–November. As a breeding bird, the species is widespread, but it is most abundant where rural grasslands are in greatest supply: mainly in the Piedmont, Ridge & Valley province, Allegheny Highlands, and lower eastern shore of the Chesapeake. A scarce wintering bird, best found in low country with an extensive mix of marshland and agriculture. ▶ Hughes Road polo fields, MD; Prime Hook NWR, DE. May–June.

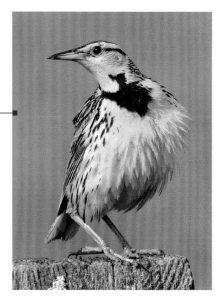

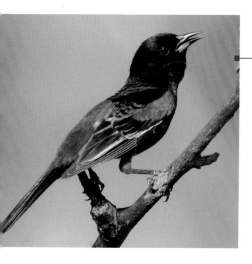

Orchard Oriole. OROR

Adult male, 5/2015 Cromwell Valley Park, Baltimore County, MD
An uncommon breeder, widespread in all but the Allegheny Highlands, where it is rare. Arrives in early May and departs by early August. Hard to find after mid-July. Prefers tall shade trees along water courses and other open habitats, including agricultural land and woodland edges. ▶ Pennyfield and Riley's Locks of the C&O Canal, MD; Prime Hook NWR, DE. May–June.

Baltimore Oriole. BAOR

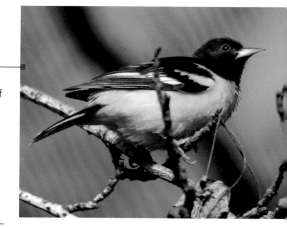

Adult male, 4/2006 Patterson Park, Baltimore, MD
A common and widespread breeder in the northern half of the Region. Also a common passage migrant, with peaks in mid-May and early September. Prefers to nest in tall shade trees in openings, especially sycamores. In summer, less prevalent in the lower Western and Eastern Shores. ▶ C&O Canal, MD; Susquehanna SP, MD; White Clay Creek SP, DE. May–June.

Red-winged Blackbird. RWBL

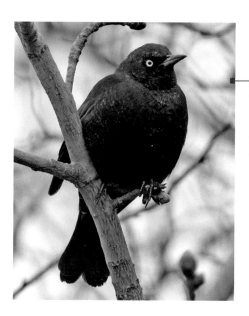

Adult male summer plumage, 5/2008 Kenilworth Aquatic Gardens, Washington, DC
Common to abundant in open farmland and marshes. Although the species is present year-round, it is migratory, forming large flocks in fall, winter, and spring. These typically roost in marshlands on the coastal plain. The species breeds throughout, often even in tiny wetland patches in suburbia. Small flocks sometime visit backyard feeders in very early spring. ▶ Any marshland. April through June.

Brown-headed Cowbird. BHCO

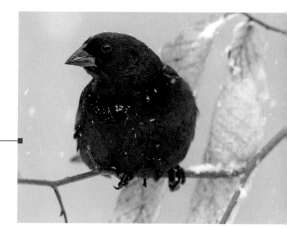

Adult male, 3/2015 Phoenix yard, Baltimore County, MD
Found year-round, but considerably less common in winter. Widespread and common in summer; in winter, more common in the low country near water. Travels in small flocks that in winter join up with other blackbirds. ▶ Open grassy parklands and farmland. April through September.

Rusty Blackbird. RUBL

Adult male summer plumage 3/2015 North Point SP, Baltimore County, MD
An uncommon species, which is a passage migrant and wintering visitor. Prevalence of sightings peaks in mid-spring and mid-autumn. Prefers swampy woodland. Scarce in winter. ▶ McKee-Beshers WMA, MD; Bellevue SP, DE. March and October.

Brewer's Blackbird. BRBL

Adult male, 2/2001 Seventeen Mile Drive, Monterey, CA
A very rare autumn and winter visitor from the West. Nearest breeding habitat is in Ontario and Michigan. The species is extending its range eastward. ▶ Found in association with other blackbirds between October and April, with a peak in November. Only about a dozen records in the past decade.

Common Grackle. COGR

Adult, 3/2015 Mariner Point Park, Harford County, MD
A common and widespread breeder as well as an abundant flocking passage migrant and wintering species. Breeds throughout, mainly in agricultural landscapes, marshlands, and suburbia. Records become more patchy in winter, when the species joins in large foraging and roosting flocks and withdraws to bottomland woodlands and fields near major rivers, estuaries, and the two bays. Competes with the American Robin and Red-winged Blackbird as the most common breeding species in North America. ▶ Tens of millions of grackles and other blackbirds roost in flocks in marshes of upper coastal DE in November and December.

Boat-tailed Grackle. BTGR

Adult female, 5/2015 Slaughter Beach, Sussex County, DE
Photo: Emily Carter Mitchell
A southern tidal marshland specialist and permanent resident, found mainly in the lower Chesapeake Bay and on the Delaware Bay coast north to the bayside vicinity of Bombay Hook NWR. Also fairly common along the Atlantic estuarine marshlands of DE and MD. A small population also inhabits southern St. Mary's County, MD, in the southern sector of the Western Shore. ▶ Assateague Island, MD, and Prime Hook NWR, DE; May through July. Indian River Inlet, DE; winter.

Ovenbird. OVEN

Adult, 5/2014 Rock Creek Park, Washington, DC
A common and widespread breeder, arriving in late April and departing by late September. Favors the interior of deciduous and mixed forest. Peaks of migration are early May and mid-September. The most common and widespread forest-dwelling warbler in the Region. ▶ Forested valley bottoms of Little Bennett Regional Park, MD; White Clay Creek, DE. May–June.

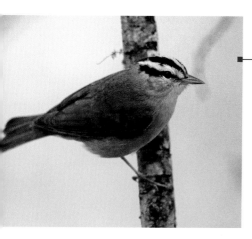

Worm-eating Warbler. WEWA

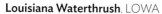

Adult, 5/2015 Millie's Retreat (private), Hurlock, MD
An uncommon but widespread breeder inhabiting hillsides in upland oak-hickory forest as well as wet bottomland forest. Arrives by early May and mostly departs by late August. Breeding concentrations center on the lower Eastern and Western Shores and the Ridge & Valley province.
► In and around Pocomoke State Forest or Patuxent River SP, MD. May–June.

Louisiana Waterthrush. LOWA

Adult, 4/2015 Susquehanna SP, Harford County, MD
A common breeder in association with small clearwater streams within mature deciduous forests, both bottomland and upland. Arrives by early April and departs by late August. ► Bottomland woods of the lower Eastern Shore and in wooded ravines in the Piedmont. Located by its very loud song. April–May.

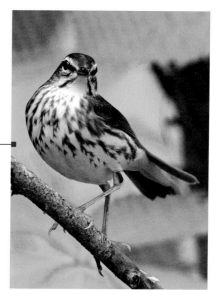

Northern Waterthrush. NOWA

Adult, 6/2015 Finzel Swamp, Garrett County, MD
A common passage migrant, with peaks in early May and mid-September. Also a scarce breeder in wooded swamps in the Allegheny Highlands. In migration can be found foraging on the ground near streams and wet spots or puddles in shaded woodland habitats. ► Swampy stream bottoms adjacent to the Potomac along the C&O Canal, in DC and MD. Early to mid-May.

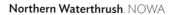

Golden-winged Warbler. GWWA

Adult male, 6/2016 Old Legislative Road, Allegany County, MD
A rare passage migrant expected in early May and early September in deciduous forest canopy or edge. A scarce breeder in the Allegheny Highlands and westernmost Ridge & Valley province, where it prefers regenerating groves of small trees at the edges of old fields and restored surface coal-mine lands at high elevations. ► Wooded verges of scrubby old fields, southwest of Frostburg, MD; in late May and early June. Also Middle Run Valley NA, DE, during migration.

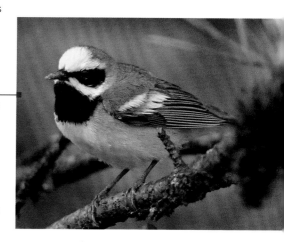

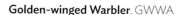

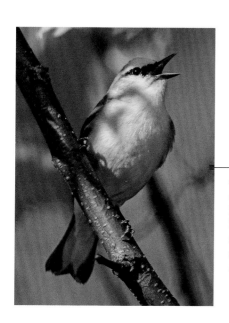

Blue-winged Warbler. BWWA

Adult male, 5/2015 Eden Mill Park, Harford County, MD
An uncommon passage migrant and local breeder, expected from late April to late September. Found breeding in scrubby edges of old fields in rural agricultural landscapes. Breeding birds range from the Piedmont west sparsely into the Allegheny Highlands. ► Blairs Valley, MD. May–June.

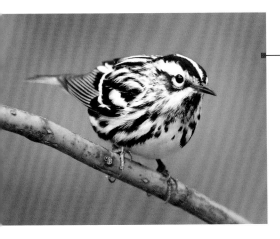

Black-and-white Warbler. BAWW

Adult male, 5/2015 Rock Creek Park, Washington, DC
A common and widespread migrant with passage peaks in late April and early September. Found breeding in moist deciduous or mixed forests throughout. Greatest breeding concentrations in the Allegheny Highlands, the heights of the eastern ridges of the Appalachians, and bottomland forests of the lower Eastern Shore. Most common in extensive mature upland and bottomland forests. ► A singing migrant in mature oaks in Rock Creek Park, DC. Late April through early May.

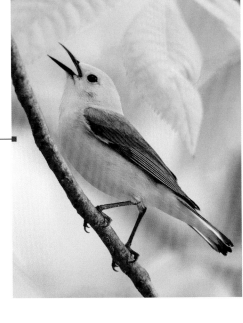

Prothonotary Warbler. PROW

Adult male, 4/2016 Susquehanna SP, Harford County, MD
A common breeder in wooded swamps and other woodlands with standing water, near rivers and in stream bottoms. Breeding concentrations are found in the lower and middle Eastern Shore, the Patuxent watershed, and the Potomac watershed. Arrives by late April and departs mainly by early August. ► This cavity-nester is to be looked for along the C&O Canal or any large river bottom with extensive flooded woods. Late April to mid-June.

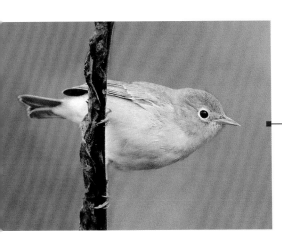

Tennessee Warbler. TEWA

Adult male summer plumage, 6/2015 Pipestone River, Ontario, Canada. Photo: Bruce Beehler
An uncommon passage migrant, with peaks in mid-May and late September. More common in the autumn passage. The migrant passage occurs mainly west of the Chesapeake in spring. ► Located by its distinctive and unmusical staccato series in mid-May in tall oaks in Rock Creek Park or on ridgetops of the western half of the Region. September.

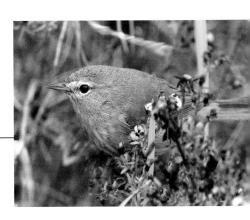

Orange-crowned Warbler. OCWA

Adult female winter plumage, 11/2015 Hughes Hollow, Montgomery County, MD. Photo: Mark R. Johnson
Rare spring and uncommon fall migrant. To be looked for in scrubby edges of clearings between late September and late December. Also a rare winter straggler present in small numbers between January and April. ► Along the coast and along the fall line. October through December.

Nashville Warbler. NAWA

Adult male winter plumage, 9/2015 Howard County Conservancy, Woodstock, MD
An uncommon passage migrant in early May and much of September. In spring it forages in the canopy of oak woods and edge. Also a few pairs breed in the Allegheny Highlands. ► Most prevalent in May and September passing through the Piedmont.

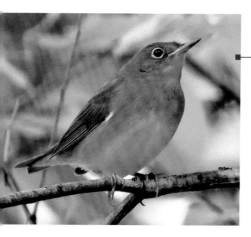

Connecticut Warbler. CONW

Juvenile, 9/2015 Swan Creek Wetland, Anne Arundel County, MD
Photo: Tim Carney (MDOT MPA / MES)

A very rare spring passage migrant and uncommon and elusive autumn migrant. To be looked for from mid-September to mid-October. Often forages on the ground in woodlands and old fields with goldenrod. Very shy. The very few spring records are confined to May and earliest June. ▶ Brandywine Creek SP, DE, in September; also through Western Shore and Piedmont in weedy fields, from mid-September to mid-October.

Mourning Warbler. MOWA

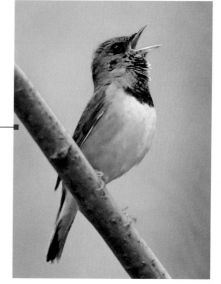

Adult male, 5/2017 Rock Creek Park, Washington, DC

An uncommon late spring passage migrant; autumn passage peaks in early September. A handful of birds breed at the highest elevations of the Allegheny Highlands. ▶ To be listened-for in raspberry thickets at the edge of wet woodlands and clearings regenerating from recent logging activity. A powerful songster that is very shy. Mid- to late May.

Kentucky Warbler. KEWA

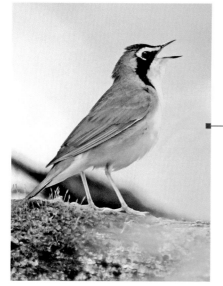

Adult male, 5/2016 Susquehanna SP, Harford County, MD

An uncommon deep-woods breeder, arriving in early May and departing by late August. Inhabits rich and moist bottomland deciduous forest with canopy openings that permit understory growth. ▶ Tuckahoe SP, MD; Susquehanna SP, MD. May–June.

Common Yellowthroat. COYE

Adult male, 4/2012 Patterson Park, Baltimore, MD

The most common non-forest wood warbler in the Region, breeding throughout. Particularly common in association with wetlands. Arrives in late April and departs by early October. A few can be found overwintering. ▶ Weedy thickets, marshland shrubbery, and brushy agricultural edge. May through September.

Hooded Warbler. HOWA

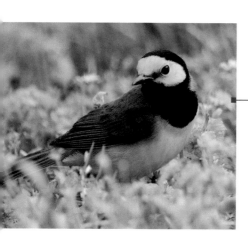

Adult male, 4/2014 Patterson Park, Baltimore, MD

An uncommon breeder in rich deciduous woods in the lower Western Shore, lower Eastern Shore, Piedmont, Ridge & Valley province, and Allegheny Highlands. Rare or absent from many sectors within its patchy range. Prefers extensive forest tracts associated with protected areas. Arrives in early May and departs in late August. Best located by its song. ▶ Woodlands of Jug Bay Wetlands Sanctuary, MD; Chesapeake woodlands of Calvert County, MD. May–June.

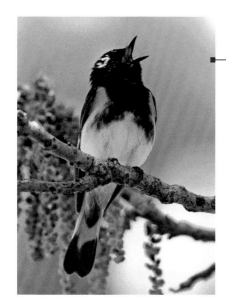

American Redstart. AMRE

Adult male, 5/2015 Milford Mill Trail Park, Baltimore County, MD
A common passage migrant and common breeding species west of the Chesapeake Bay and in the wooded swamplands of the lower Eastern Shore. Arrives in late April and departs by early October. Peaks of passage are mid-May and early September. Migrants are widespread in woodlands. As a breeder, it is absent from the middle and lower Eastern Shore and the open valleys of the Ridge & Valley province. ► Rich deciduous forest in bottomlands and uplands of the Western Shore, Piedmont, and Allegheny Highlands provinces. May–June.

Cape May Warbler. CMWA

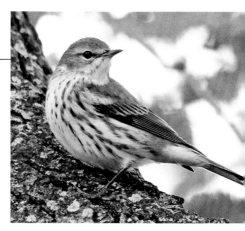

Adult male winter plumage, 10/2015 Ralph's yard, Howard County, MD
A rare spring passage migrant and uncommon fall passage migrant, with peaks in mid- to late May and in late September. As a spring migrant, found preferentially in tall planted spruce trees and canopy oaks. ► Found where migrant warblers traditionally congregate, for instance, the oak stands in the vicinity of the Rock Creek Nature Center, DC, and Middle Run Valley NA, DE. Late September.

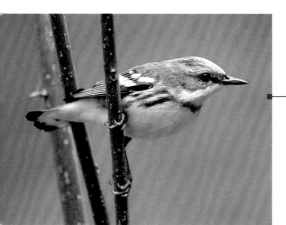

Cerulean Warbler. CERW

Adult male, 4/2015 Susquehanna SP, Harford County, MD
A rare passage migrant and rare breeder between late April and early September. Breeding birds today are most prevalent in mature oak-hickory forest atop high ridges in mountainous country west and north of Frederick. Most or all bottomland breeding populations have disappeared from the Region. ► The northern flanks of Catoctin Mountain, Patapsco Valley SP, and Susquehanna SP (all in MD); White Clay Creek SP, DE. Mid-May to late June.

Northern Parula. NOPA

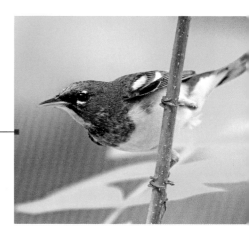

Adult male, 4/2015 Susquehanna SP, Harford County, MD
A common and widespread passage migrant, with peaks in early May and mid-September. Also a breeder in the lower Eastern Shore (locally), Western Shore, Piedmont, and westward, most common in the lower Western Shore. This species breeds both in mountainous upland mixed forest and swampy bottomland woods. ► Sycamores along the Potomac River (DC and MD). Late April to late June.

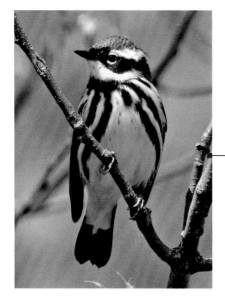

Magnolia Warbler. MAWA

Adult male summer plumage, 5/2012 Patterson Park, Baltimore, MD
A common and widespread passage migrant with peaks in mid-May and mid-September. As a breeder, it is confined to conifer stands within upland forests of the Allegheny Highlands. ► At popular migrant traps such as Rock Creek Park, DC, and Middle Run Valley NA, DE. May and September.

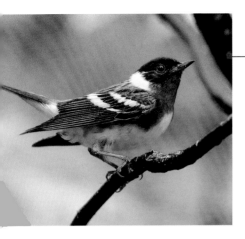

Bay-breasted Warbler. BBWA

Adult male summer plumage, 6/2015 Sandbar Lake, Ontario, Canada. Photo: Bruce Beehler

A rare spring passage migrant (peak mid-May) and uncommon autumn migrant (peak mid-September). ▶ In the canopy of mature oak forest and oak woodlots. Mid-September.

Blackburnian Warbler. BLBW

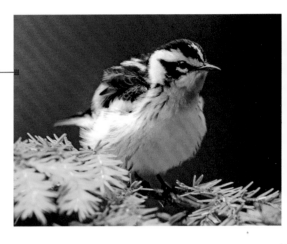

Adult male summer plumage, 6/2014 Savage River Lodge, Garrett County, MD

As a migrant, widespread throughout, foraging in woodlots and forest edge, typically in the canopy. Uncommon in spring, with a peak in mid-May. Fairly common in autumn, with a peak in early September. Breeds in stands of conifers in mixed forest of the Allegheny Highlands, with a scattering of breeding records in the Ridge & Valley province. ▶ At popular migrant traps such as Rock Creek Park, DC, and Middle Run Valley NA, DE. Mid-May and early September.

Yellow Warbler. YWAR

Adult female, 5/2015 Rock Creek Park, Washington, DC

A common passage migrant and widespread and common breeder (though less common in lower Western Shore and patchy in the lower Eastern Shore). Breeds in willows and other woody growth near water and in wet thickets and meadows. Most common north and west of Baltimore. Arrives in mid-April and departs by mid-September. ▶ McKee-Beshers WMA, MD. May–June.

Chestnut-sided Warbler. CSWA

Adult male summer plumage, 5/2014 Carey Run Sanctuary, Garrett County, MD

A common and widespread passage migrant (peaks mid-May and early September). Also a common breeder in the Allegheny Highlands, with a few breeding records eastward in the Ridge & Valley province and northern Piedmont. ▶ At popular migrant traps such as Rock Creek Park, DC. May and early September.

Blackpoll Warbler. BLPW

Adult male summer plumage, 5/2012 Pier 5, Baltimore, MD

A common and widespread passage migrant, with peaks in mid-May and early October. Prefers mature oak canopy for foraging, but can be found in any woodland in passage. Appears in the latter portion of the spring warbler migration, with most birds passing after the 15th of May. ▶ At popular migrant traps such as Rock Creek Park, DC. Mid-May and early October.

Black-throated Blue Warbler. BTBW

Adult male summer plumage, 5/2015 Milford Mill Trail Park, Baltimore County, MD

A common passage migrant, peaking in mid-May and late September. Forages in the understory of forest interior. A common breeder in mixed upland forests of the Allegheny Highlands. ▶ At popular migrant traps such as Rock Creek Park, DC. Mid-May and late September.

Palm Warbler. PAWA

Adult summer plumage, 4/2001 Patterson Park, Baltimore City, MD

A common passage migrant that overwinters in small numbers. The "Yellow" form dominates in the spring passage, with its peak in mid-April. The "Western" form dominates in autumn passage. A few Yellow Palm Warblers pass through mainly in late October. In migration, found in open habitats in shrubbery or on the ground in grassy clearings in agricultural lands, its tail wagging distinctively. ▶ McKee-Beshers WMA, MD; Cape Henlopen SP, DE. April and early October.

Pine Warbler. PIWA

Adult male, 5/2015 Private farm, Dorchester County, MD

Most abundant on the lower Eastern and Western Shores where Loblolly Pines and other mature pines are abundant. Migrants arrive in March and depart in August and September. Also a sparse winter resident in Loblolly Pine stands in the lower Eastern Shore, and with a scattering of records throughout during winter, often at suet feeders. It is most prevalent in the lower Eastern Shore. ▶ Sandy Point SP, MD; Cape Henlopen SP, DE. April–May.

Yellow-rumped (Myrtle) Warbler. YRWA

Adult female 5/2015 Rock Creek Park, Washington, DC

The most common migrant warbler throughout the Region, its passage peaking in mid-April and early November. Also a sparse breeder in conifers of the Allegheny Highlands. Large numbers winter on both sides of the Chesapeake Bay and on the Atlantic and Delaware Bay shores, mainly near water or marshlands. The sheer abundance of this species overwhelms the presence other warbler species at times, becoming something of a nuisance to birders searching for other warbler species. The western form, "Audubon's Warbler," has been recorded several times in MD (between October and February). ▶ Most oak woods in April to early May; all Eastern Shore refuges in October through January.

Yellow-throated Warbler. YTWA

Adult, 5/2006 Patterson Park, Baltimore, MD
A breeding species of river bottoms, wooded swamps, and piney woods. West of the Chesapeake Bay, this species nests in bottomland sycamores alongside the Northern Parula. On the lower Eastern Shore, however, the Yellow-throated prefers to nest in Loblolly Pine stands. Arrives in early April and departs mainly by early September. Typically found singing in the canopy of tall forests. Breeding records concentrated in the lower sectors of the Eastern Shore and Western Shore and along the middle and lower Potomac River. In our Region, this species is rarely seen in migration. ► Sycamores fringing the Potomac in Charles County, MD; Pocomoke River watershed, MD. April–May.

Prairie Warbler. PRAW

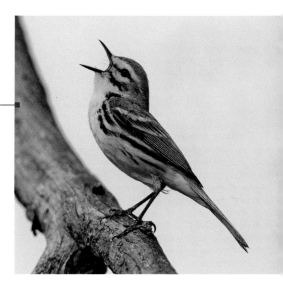

Adult male, 4/2014 Soldiers Delight NEA, Baltimore County, MD
An uncommon passage migrant to be expected in early May and early August. Also an uncommon breeder, found only in dry and shrubby fields with tall borders of Eastern Redcedar and other low trees. Most common as a breeder in the Western Shore, lower Eastern Shore, Piedmont, and the western Ridge & Valley province. ► In Eastern Redcedar fields along River Road near McKee-Beshers WMA, MD, and White Clay Creek SP, DE. May–June.

Black-throated Green Warbler. BTNW

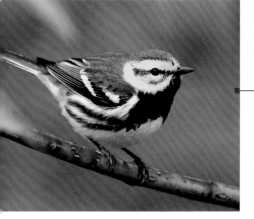

Adult male summer plumage, Savage River Lodge, Garrett County, MD
A common passage migrant with peaks in early May and late September. Found foraging in mature oaks with Yellow-rumped Warblers and others in spring. Also breeds in the Allegheny Highlands and with a scattering of breeding records into the Ridge & Valley province. Breeds in mixed forest and is partial to stands of hemlock and spruce. ► At popular migrant traps such as Rock Creek Park, DC. Early May and late September.

Canada Warbler. CAWA

Adult male, 6/2014 New Germany SP, Garrett County, MD
An uncommon passage migrant (peaks in mid-May and late August). Also breeds in mixed forests of the Allegheny Highlands. To be looked for mainly in understory vegetation of mixed forest, usually near water. Less confiding than the Magnolia. ► Dark tangles at the edge of woodlands. Mid-May and from late August to early September.

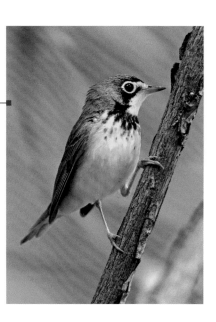

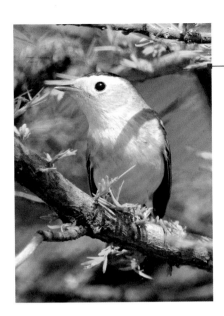

Wilson's Warbler. WIWA

Adult male, 5/2014 Patterson Park, Baltimore, MD
An uncommon passage migrant, with a spring peak of mid-May and an autumn peak of mid-September. As a migrant, found foraging in trees at the forest edge. More common as a migrant west of the Chesapeake Bay. ▶ Hedgerows and thickets near streams and damp spots. Mid-May and mid-September.

Summer Tanager. SUTA

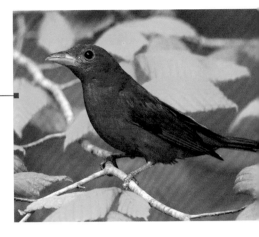

Adult male, 6/2015 Money Make Road, Talbot County, MD
An uncommon breeder in dry deciduous and piney woods of the southeastern quadrant of our Region, mainly the southern sectors of the Western and Eastern Shores. Also an uncommon migrant, with peaks in mid-May and the latter half of September. Most frequent in the edge of canopy vegetation in open woodland; mainly located by its distinctive call. ▶ Jug Bay Wetlands Sanctuary, MD; Prime Hook NWR, DE. May and June.

Scarlet Tanager. SCTA

Adult male, 6/2014 Savage River Lodge, Garrett County, MD
A common and widespread passage migrant, and also a common but often overlooked breeder that inhabits the leafy forest canopy of moist deciduous and mixed forest. During migration, can be found in shade trees, but breeds in the interior of expanses of forest, mainly in upland parks and preserves. ▶ Little Bennett Regional Park, MD; White Clay Creek SP, DE. Early summer.

Northern Cardinal. NOCA

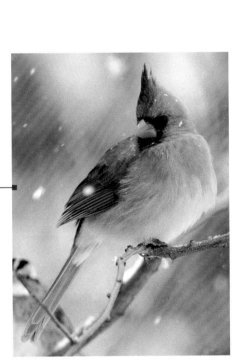

Adult female, 2/2015 National Arboretum, Washington, DC
A commonplace year-round yard bird, regularly visiting feeders in winter. It breeds throughout our Region, prevalent in suburban and edge habitats and moist forest. It does not migrate. Inhabits suburbs, city parks, edges, and openings in woodlands. ▶ Can be attracted to the yard in winter with black oil sunflower seeds.

Rose-breasted Grosbeak. RBGR

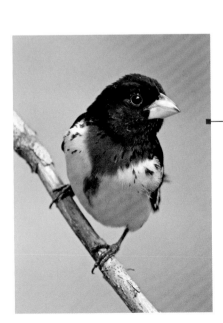

Adult male, 6/2014 Carey Run Sanctuary, Garrett County, MD
An uncommon to fairly common passage migrant and uncommon local breeder west of Hancock, MD. Look for migrants in mid-May and mid-September. Migrants prefer the canopy of deciduous trees at forest edge. Breeds in the Allegheny Highlands and in extensive forests on some higher points in the Ridge & Valley province. ▶ Oak canopy of C&O Canal, MD. Mid-May and mid-September.

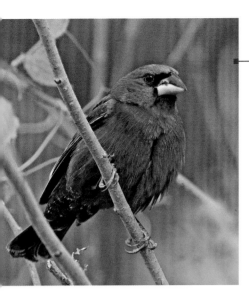

Blue Grosbeak. BLGR

Adult male, 5/2015 Adkins Arboretum, Caroline County, MD
A breeder, arriving in mid-May and departing in mid-September. Common in tree rows, scrubby areas, and woodland edge in open agricultural habitats, mainly south and east of the fall line. Commonplace in the lower Eastern and Western Shores. Less common and often absent west of the Piedmont. ▶ A dark bird singing a rapid musical warble while perched atop trees bordering expansive agricultural lands of the southern Western Shore and southern Eastern Shore. May through August.

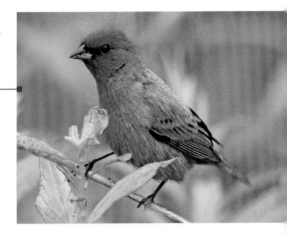

Indigo Bunting. INBU

Adult male, 6/2016 Finzel Swamp, Garrett County, MD
A common and conspicuous breeder in woodlots and woody edges in open agricultural landscapes throughout. A rambunctious songster, singing from a high exposed perch. Arrives in early May and departs by late September. Often found in grassy areas along edges of cornfields. ▶ Woodland edge in agricultural lands. May to early September.

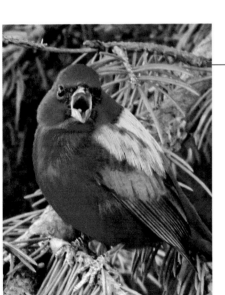

Painted Bunting. PABU

Adult male, 3/2009 Savage, Howard County, MD
Photo: Kurt R. Schwarz
A vagrant from its southeastern breeding range, with some three dozen records for the Region. Most observations were made between late November and May, with a couple of additional records in August. ▶ Appears at backyard feeders, though usually in subdued female/immature plumage. Mainly in autumn.

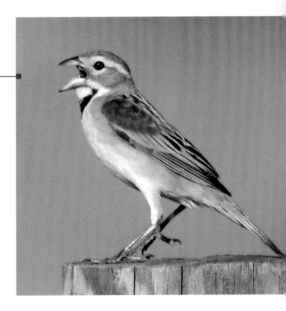

Dickcissel. DICK

Adult male, 5/2016 Keysville Road, Frederick County, MD
An uncommon passage migrant and a rare breeder, arriving in mid-May and departing around mid-October. A few pairs breed every year. This is a prairie species that expands its breeding range eastward from time to time. It should be looked for in weedy fields, scrubby areas, and roadsides on rural agricultural land. Most summer records come from the central Eastern Shore and in the vicinity of Emmitsburg, MD. A small group bred in Howard County, MD, in 2017. Also the plain and sparrow-like female is an occasional feeder visitor during the winter months. In fall at night and around dawn, often heard overhead uttering their call-note—a brief buzzy *fpppt*. ▶ Charles E. Price Memorial Park, Middleton, DE; southwest of Taneytown, MD. June–July.

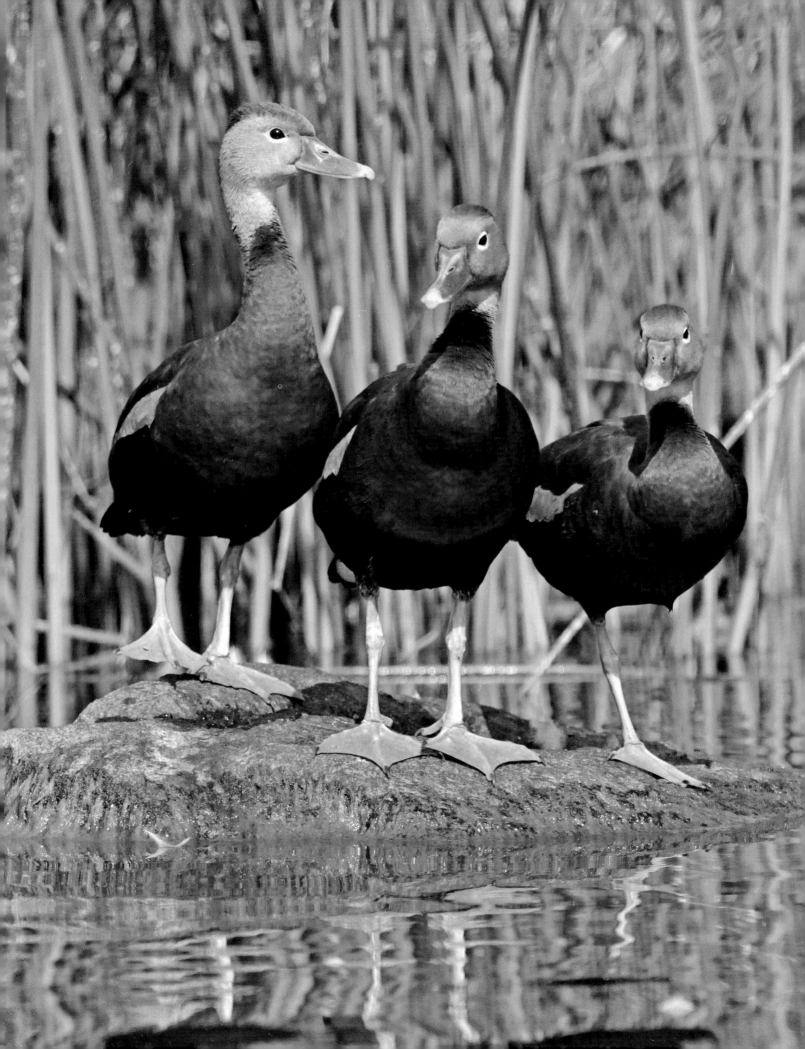

Very Rare or Accidental Species

What follows is a listing of very rare or accidental species—birds seldom recorded from our Region. Birds appear in this chapter if there have been fewer than 10 records for the species over the past decade. In other words, these are birds not seen in the Region every year. A final section of this chapter lists bird species whose reports from the Region have not been formally accepted by the Delaware and Maryland/District of Columbia Records Committees. These include unconfirmed sightings as well as birds of questionable provenience—captive-bred and human-transported individuals.

Black-bellied Whistling-Duck. BBWD. Very rare, with records from throughout the year, from both the Eastern and Western Shore. Still, most records are from the DE coast and the Atlantic shore. Increasing as a seasonal vagrant in the East.

Fulvous Whistling-Duck. FUWD. An irruptive species, now very rare or absent from the Region. Most records come from the coast of Delaware Bay. No records since 1993. Declining as a vagrant in the East.

Pink-footed Goose. PFGO. Accidental, with records in 1953–54, 1959, 2012, 2014, 2016, and 2017 (November to March). All records refer to singleton vagrants in large flocks of other goose species.

Black-bellied Whistling-Duck adult, 6/2011 Patterson Park, Baltimore, MD.

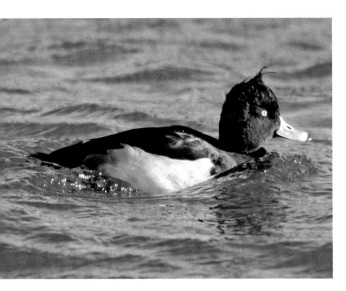 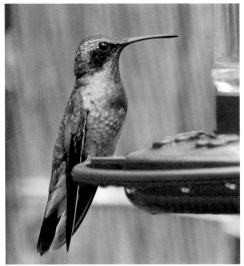

Garganey. GARG. Accidental. A male was recorded from 24 April–12 May 1976 at Bombay Hook NWR, DE. Two reports from MD have not been accepted.

Cinnamon Teal. CITE. Very rare vagrant from the West. Ten records for the Region, with most in the autumn or winter, and nearly all from the Eastern Shore.

Tufted Duck. TUDU. Very rare. Fewer than one sighting per year. Records from November to March from the Eastern and Western Shores.

Barrow's Goldeneye. BAGO. Very rare. Records from November to late March. About a dozen records from the Region. Most records from the Chesapeake or major estuaries thereof. Often with Common Goldeneye or Bufflehead. A single adult male has returned to the vicinity of the Elms Environmental Education Center, in St. Mary's County, MD, each winter from 2011 to 2018.

Masked Duck. MADU. A single specimen record from the upper Chesapeake, on 8 September 1905, on the Elk River near Elkton. Voucher is in the National Museum of Natural History (USNM No. 200705). Accepted by the MD/DC Records Committee.

Greater Prairie-Chicken. GRPC. Extirpated from Region. "Heath Hen" was the name for the East Coast population of this species, which still inhabits the tall-grass prairie of the upper Midwest and prairie states. The Heath Hen was last found on Martha's Vineyard, MA, in 1932. A record from near Marshall Hall, Prince Georges County, MD, in the spring of 1860, was perhaps the last record for our Region.

American Flamingo. AMFL. A single accepted record exists of this tropical vagrant, from August to September 1972, on Assateague Island, MD. Ten other reports have been submitted to the MD/DC Records Committee.

Western Grebe. WEGR. Very rare vagrant from the interior West, to be expected between November and June. Records from lower Delaware Bay, the Atlantic estuaries, the upper Chesapeake, and the Western Shore. Note that this species is difficult to distinguish from Clark's Grebe, a sister species that is much rarer on the East Coast (with no accepted records for our Region).

Passenger Pigeon. PAPI. Extinct. Formerly an abundant flocking species that passed through the Region in spring and fall. A large flight was recorded in the Allegheny Highlands in January 1877. A flock of three was reported from Baltimore County, MD, in 1899. Also a report of a pair observed in Garrett County, MD, in 1903.

Inca Dove. INDO. Accidental. A single record from Laurel, MD, in November 2006.

Common Ground-Dove. COGD. Accidental. Two DE sight records and five MD reports, two of which have been accepted.

Groove-billed Ani. GBAN. Accidental. A single record from Millington, MD, on 3 November 1975.

Mexican Violetear. MEVI. Accidental from Mexico. About a dozen records from east of the Mississippi. Two accepted records from our Region in October 2011: one from the Western Shore and the other from the northeast Piedmont.

Black-chinned Hummingbird. BCHU. A vagrant to our Region from the arid West. A single accepted record from the National Mall, DC, November to December 2003.

Anna's Hummingbird. ANHU. Known from three records between November and March (Prince George's County, MD, in 2004; Middletown, MD, in 2010; and New Castle, DE, from November 2012 to March 2013). A post-breeding vagrant from the West Coast.

Broad-tailed Hummingbird. BTAH. Accidental from the arid West. A single record from Rehoboth Beach, DE, in March 1998.

Allen's Hummingbird. ALHU. Three records of this West Coast vagrant: November 1997 to February 1998, Wilmington, DE; December 2008, Prince Frederick, MD; and November to December 2011, Sharpsburg, MD. Can only be distinguished from the nearly identical Rufous Hummingbird based on measurements taken from the bird in hand.

Calliope Hummingbird. CAHU. Accidental late autumn vagrant, with five records from October to December.

Yellow Rail. YERA. A rarely seen passage migrant, hiding out in wet grassy fields and short-grass marshlands—habitats favored by the Sedge Wren. Exceedingly shy. Never walks about in openings, something the similar Sora often does. To be looked for in marshy habitat in March to May and October to December. It does sometimes vocalize at night in spring while on passage. Should be searched for in early May in the Bombay Hook / Little Creek ecosystem.

Corn Crake. CORC. A single specimen was collected on 28 November 1900 from Stockton, MD (south of Snow Hill). The mounted specimen was exhibited

Calliope Hummingbird immature male, 10/2007 North Beach, Calvert County, MD. Photo: Mark L. Hoffman

Yellow Rail adult, 5/2016 Phoenix Wildlife Center, Baltimore County, MD

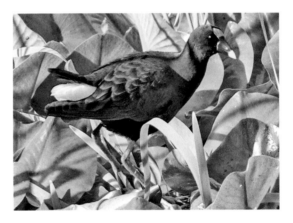

Purple Gallinule adult, 5/2011 McKee-Beshers WMA, Montgomery County, MD. Photo: Mark L. Hoffman

at the December meeting of the Delaware Valley Ornithological Club. The specimen apparently remained in a private collection and was only recently located and photographed. The species is in drastic decline in Europe.

Purple Gallinule. PUGA. Rare irruptive summer visitor (primarily May to July) with only a handful of records from the last decade. Two breeding records from DE in the 1970s. Latest seasonal record is from mid-October. Prefers ponds and marshes with emergent vegetation and overgrown water verges.

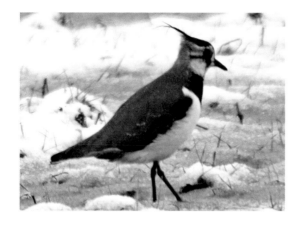

Northern Lapwing adult, 2/2005 Creagerstown, Frederick County, MD. Photo: Mark L. Hoffman

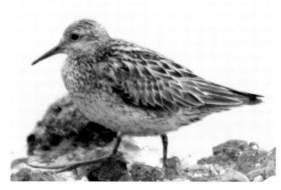

Sharp-tailed Sandpiper adult, 9/2017 Swan Creek, Anne Arundel County, MD. Photo: W. Scott Young

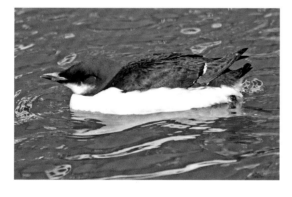

Thick-billed Murre adult winter plumage, 2/2007 West Ocean City, Worcester County, MD. Photo: Mark L. Hoffman

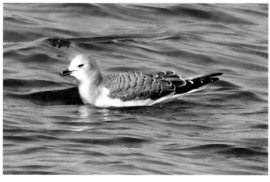

Sabine's Gull juvenile, 7/2017 Poplar Island, Talbot County, MD. Photo: H. David Fleischmann

Limpkin. LIMP. Accidental. Two accepted records from MD in May and June, and two unreviewed reports from May and July.

Northern Lapwing. NOLA. Very rare. Six records, from December, February, March, and July.

European Golden-Plover. EUGP. Accidental. Record from Bombay Hook NWR, DE, in September 2009.

Pacific Golden-Plover. PAGP. Fewer than a dozen records from the East Coast. Accidental to our Region, with a single record from Bombay Hook NWR, DE, in July 1989.

Snowy Plover. SNPL. There is a record of a single bird at Hart-Miller Island, MD, in May 2015.

Wilson's Plover. WIPL. A very rare warm-season vagrant to the Region from the south, most records between April and August. Few recent records. One at Assateague Island in July 2015. Formerly bred on the Atlantic barrier islands of MD. Downy young were banded on Assateague Island on 10 July 1947.

Eskimo Curlew. ESCU. Apparently extinct. Formerly a migrant through the Region. A sight record from Ocean City, MD, was made by R. C. Walker in 1913.

Long-billed Curlew. LBCU. Accidental. Recent records from September 1987 and May 2011—both from the Western Shore. Apparently a regular passage migrant in the early nineteenth century, but this population was decimated by market hunting. Records concentrated around May to June and August to September.

Black-tailed Godwit. BTGD. Accidental. Records from Prime Hook NWR, DE, in June 1994 and July 2012. Note also that there are Bar-tailed Godwit records from Chincoteague, VA, and Cape May, NJ—thus this additional species is to be looked for in season.

Sharp-tailed Sandpiper. SPTS. Accidental. Bombay Hook NWR, DE, in July to August 1993 and at Swan Creek Wetland, south of Baltimore, MD, in August 2017.

Curlew Sandpiper. CUSA. A very rare vagrant. Nearly all records from the coast of Delaware Bay and the Atlantic. One interior record from June at Hart-Miller Island. Records from April to October. Bombay Hook NWR and Little Creek WA, DE; May and late July to September.

Red-necked Stint. RNST. Very rare. 11 records for the Region, from May, July, and August, from the coast of upper Delaware Bay and the Atlantic shore of MD.

Little Stint. LIST. Accidental. Five records for the Region, from the months of May, July, August, and September—four from the DE shore and one unconfirmed record from the Chesapeake Bay.

Wood Sandpiper. WOSA. Accidental. A single record from Prime Hook NWR, DE, in May 2008. There are three records from the East Coast, presumably of birds blown west across the Atlantic. Also known to be an occasional breeder in the Aleutians and a rare migrant to the West Coast.

Great Skua. GRSK. Very rare pelagic visitor, found offshore between December and March.

South Polar Skua. SPSK. Rare pelagic visitor, with a scattering of records offshore from April to September.

Long-tailed Jaeger. LTJA. Very rare pelagic visitor, with offshore sightings from April, May, August, September, and October.

Thick-billed Murre. TBMU. Rare winter pelagic visitor to the Atlantic shore and coast of Lower Delaware Bay, with more coastal sightings than for the Common Murre, but many fewer offshore.

Black Guillemot. BLGU. Three records: Indian River Inlet, DE, in January to February 2005; Broadkill Beach, DE, in February 2013; and Anne Arundel County, MD, in March 1993 (this last was accepted only as *guillemot* sp.). Also one was photographed at Ocean City Inlet, MD, in January 2018.

Sabine's Gull. SAGU. Very rare vagrant. About a dozen records from the Region, in the months of April, May, August, September, and October. Records from the Eastern Shore, Western Shore, and Piedmont. There are records of offshore birds in the Atlantic from May and September.

Ross's Gull. ROGU. Accidental. Back River, Baltimore County, MD, March to April 1990; and Indian River Inlet, DE, January 1997.

Black-tailed Gull. BTGU. Asian vagrant. Records from Sandy Point SP, MD, in July 1984; Assateague, MD, in October 2000; and Fort McHenry, Baltimore, MD, in September 2003.

Mew Gull. MEGU. Accidental. Kenton, DE, in April 1978; Wilmington, DE, in February 1992; Conowingo Dam, MD, in January 1994; and Upper Marlboro, MD, in December 2004.

California Gull. CAGU. Very rare. About 10 records from the Region, scattered between June and January. All records are from the Piedmont and eastward.

Yellow-legged Gull. YLGU. Accidental from Europe. Georgetown Reservoir, DC, 1990–1994; and Laytonsville, MD, from 1991 to 1993 (these various records may pertain to a single persistent and mobile individual). Records from December through March.

Kelp Gull. KEGU. Vagrant from South America. About a dozen records from the East. A single bird was found in January 1999 behind the Sandgates Inn in northern St. Mary's County, MD, and was observed there, intermittently, from 1999 to 2005. It was seen by hundreds of birders over the years. There is also a record from Port Mahon, DE, in May 1996.

Sooty Tern. SOTE. Rare late summer hurricane-driven vagrant. Most records are of birds carried onshore by tropical storms. Most records come from August to October. Best searched for on major inland waterways after an offshore hurricane. Birds were observed on the Potomac at Violette's Lock after the passage of Hurricane Ernesto in 2006.

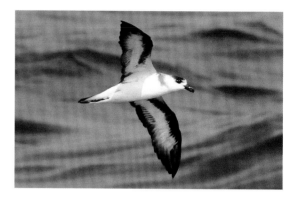

White-tailed Tropicbird adult fall, 8/2016 North Carolina pelagic zone

White-winged Tern. WWTE. Very rare vagrant from Europe. Several records come from the midcoast of DE around the Bombay Hook NWR area. Observations from April, May, July, August, and September. Records are from coastal marshy impoundments.

Whiskered Tern. WHST. Accidental. Observations were made of what was apparently the same bird from July and August 1993 from coastal marshy impoundments within several protected areas along the midcoast of DE. This bird was first observed at Cape May, NJ, before it was found in DE.

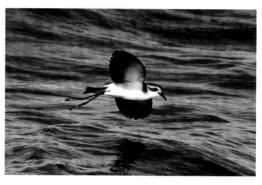

Black-capped Petrel adult, 8/2009 North Carolina pelagic zone

White-tailed Tropicbird. WTTR. Accidental. Slaughter Beach, DE, in August 2011; and from the pelagic zone near the MD/VA border in July 2011.

Pacific Loon. PALO. Very rare vagrant to Region, with a handful of records from February, April, May, June, July, October, November, and December. These sightings range from the Allegheny Highlands to the Atlantic shore.

White-faced Storm-Petrel adult, 8/2008 Maryland pelagic zone. Photo: Mark L. Hoffman

Yellow-nosed Albatross. YNAL. Accidental. Known from four records from the Region (December, January, February, June) from the seas off DE and from Assateague Island, MD.

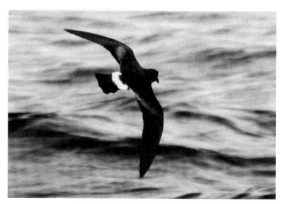

Trindade Petrel. TRPE. Accidental. Breeds off Brazil and wanders the nonbreeding season from southern South America north to the Mid-Atlantic region. One accepted record for our Region, from off the coast of MD in August 2012. This Atlantic-breeding petrel, until recently treated as conspecific with the Herald Petrel, has been split off from the Pacific-breeding form and recognized as the Trindade Petrel. A second observation on the species, from July 2013, has not yet been reviewed by the MD/DC Records Committee.

Band-rumped Storm-Petrel adult 8/2016 New Jersey pelagic zone

Black-capped Petrel. BCPE. Very rare pelagic visitor to Atlantic waters off MD, with reports from May to September. Typically blown into our Region by hurricanes.

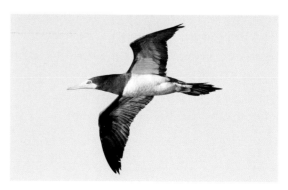

Brown Booby adult female, 9/2015 Locust Point harbor, Baltimore, MD

White-faced Storm-Petrel. WFSP. Rare in the pelagic zone, in August. Apparently, a scarce but regular visitor offshore from late July to September.

Band-rumped Storm-Petrel. BSTP. Rare visitor to the pelagic zone off the Atlantic Coast, mainly in August, but with records spanning June to October. There are two accepted DC records (Anacostia River and Capitol Hill, successive days in August 1893). Many pelagic MD reports yet to be reviewed.

Wood Stork. WOST. A very rare vagrant from the Deep South, with most records in July (range: May to February). Records from both west and east of the Chesapeake.

Magnificent Frigatebird. MAFR. Very rare vagrant. Records confined to the Atlantic shore and lower Delaware Bay, from January, April, June, August, September, October, and November.

Masked Booby. MABO. Accidental from tropical seas, photographed off the coast of Worcester County, MD, in August 2016.

Brown Booby. BRBO. A very rare but almost regular vagrant from tropical seas to the East Coast. Records from our Region from July to November. Also several Chesapeake Bay records.

Neotropic Cormorant. NECO. Accidental. Vagrant from the Gulf Coast, with several records, from May to November. Typically subadult birds.

Anhinga. ANHI. Very rare. About three dozen records, from the Piedmont eastward. Records from April to October, with a peak in May.

Little Egret. LIEG. Accidental. Regional records come from 1999, 2008, 2011, and 2017, including the months of April to August—all records from the shore of Delaware Bay.

Reddish Egret. REEG. Accidental. Four records from the shore of Delaware Bay and the Atlantic, between June and October (1991, 1993, 2003, 2015).

Neotropic Cormorant adult, 7/2017 North Beach, Calvert County, MD. Photo: Daniel Irons

Little Egret adult, 6/2017 Bombay Hook NWR, Kent County, DE. Photo: Daniel Irons

Reddish Egret immature, 9/2015 Ocean City, Worcester County MD. Photo: Mark L. Hoffman

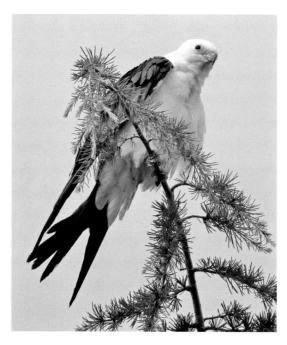

Swallow-tailed Kite adult, 8/2015 Salisbury, Wicomico County, MD. Photo: Ryan Johnson

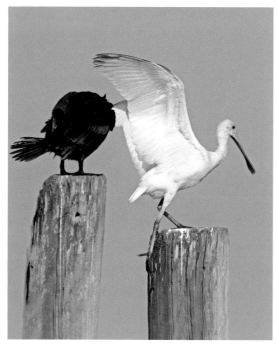

Roseate Spoonbill juvenile, 7/2018 North Beach, Calvert County, MD. Photo: Josie Kalbfleisch

Roseate Spoonbill. ROSP. Accidental. Records from the shore of Delaware Bay, the Atlantic Coast, and Smith Island, MD, during the months of April, June to July, and September.

Swallow-tailed Kite. STKI. Very rare seasonal vagrant to the Region with most records from mid-spring and late summer, mainly from the Eastern and Western Shores.

White-tailed Kite. WTKI. Accidental. Sighting from Town Hill Hawk Watch, MD, on 26 October 1990.

Swainson's Hawk. SWHA. Rare vagrant from the Great Plains with many East Coast records. Most records from September to December. One April record.

Zone-tailed Hawk. ZTHA. Accidental. Cape Henlopen, DE, Hawk Watch, in September 2014. This bird was seen in DE in 2014 after it was observed departing from Cape May, NJ. This is a bird that was first observed in Nova Scotia. What might have been the very same bird was observed at Cape May, NJ, again in 2015.

Burrowing Owl. BUOW. Accidental. Two records: Gortner, MD, on 18 May 1983; and Bombay Hook NWR, DE, on 17 April 2015.

Red-cockaded Woodpecker. RCWO. Breeding was last confirmed in 1958 from the lower Eastern Shore. A pair was observed in May 1974 at Patuxent Wildlife Research Center, MD. Closest recent records come from southeastern Virginia.

Crested Caracara. CRCA. Vagrant from the Deep South. Three recent records from lower coastal Delaware (from Cape Henlopen to near Bethany Beach), from September, December, January, and March. Also an unreviewed report from St. Mary's County, MD, from June 2017.

Gyrfalcon. GYRF. Accidental. Adamstown, MD, in February 1994; and north of Leipsic, DE, in February 2005. Also there is an unreviewed report of a bird from Frederick County, MD, in December 2017. Most eastern birds are immatures of the gray morph.

Carolina Parakeet. CAPA. Extinct. Several shot on the Potomac in September 1865. Known to be widespread in Tidewater Maryland in the nineteenth century. No definite record from DE.

Hammond's Flycatcher. HAFL. Accidental. From the environs of Bombay Hook NWR, DE, in late December 1986; Ocean City, MD, in October 1963

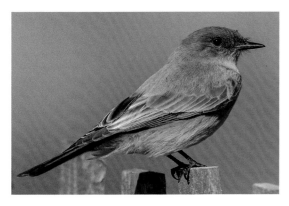

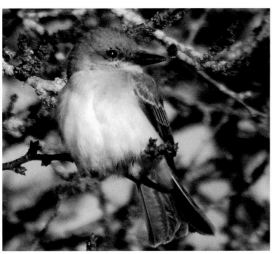

December 2014; and an unreviewed report from near Millington, MD, from December 2015 to January 2016.

Tropical Kingbird. TRKI. Accidental. Records from southwest of Salisbury, MD, in December 2006; and from Prime Hook NWR, DE, in October 2013.

Couch's Kingbird. COKI. Accidental. A single record from northeast of Cumberland, MD, in November 2014.

Gray Kingbird. GRAK. Very rare. Nine records, mainly from Eastern Shore, from May to November.

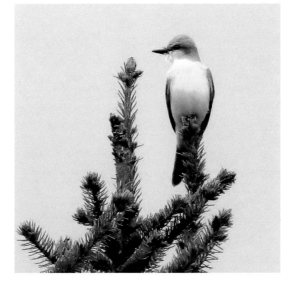

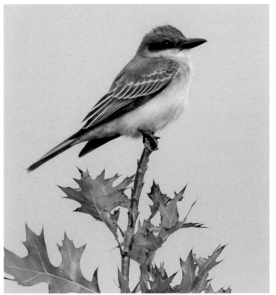

(banded); and near Monkton, MD, from November to December 2005.

Gray Flycatcher. GRFL. Accidental. Observed and photographed at Cape Henlopen SP, DE, in September 1991.

Dusky Flycatcher. DUFL. A record from Cedar Swamp Wildlife Area, DE, in January to February 2002. A second record at Rock Creek Park, DC, in October 2003.

Pacific Slope / Cordilleran Flycatcher. WEFL. A member of this species complex was photographed in November 2015 in Caroline County, MD.

Say's Phoebe. SAPH. Very rare. Eight records between the months of September and January.

Vermilion Flycatcher. VEFL. Accidental. Records from near Indian River Inlet, DE, in May 1993; Assateague Island, MD, in September 1991; Hurlock, MD, in October 2001; near Pocomoke City, MD, in

Say's Phoebe adult, 11/2016 Sandy Point SP, Anne Arundel County, MD. Photo: Daniel Irons

Tropical Kingbird juvenile, 12/2006 Reading Ferry Road, Somerset County, MD. Photo: Mark L. Hoffman

Couch's Kingbird juvenile, 11/2014 Mason Road Pond, Allegany County, MD. Photo: Ryan Johnson

Gray Kingbird juvenile, 11/2017 Queenstown, Queen Anne's County, MD. Photo: Daniel Irons

Scissor-tailed Flycatcher. STFL. Rare vagrant, with more than 15 records for the Region; observations between March and December.

Fork-tailed Flycatcher. FTFL. Very rare vagrant. Seven records from the Eastern and Western Shores, in the months of May, September (four records), October, and November.

Fork-tailed Flycatcher adult, 11/2017 Sunset Park, Ocean City, Worcester County, MD. Photo: H. David Fleischmann

Loggerhead Shrike. LOSH. Very rare. Formerly a common breeder, but only a handful of breeding records for this decade. Most records today are of singletons in the fall, winter, and spring from the eastern Ridge & Valley and western Piedmont. A bird of hedgerows in agricultural fields and short-grass fields.

Northern Shrike. NSHR. Rare winter visitor, typically with one or two visitors per winter to the Region.

Northern Shrike juvenile, 12/2016 Bens Point Road, Queen Anne's County, MD. Photo: Gene Ricks

Bell's Vireo. BEVI. Accidental. Assateague Island, MD, in October 2011; Elk Neck, MD, in October 2011; and Washington, DC, in October 2015.

Boreal Chickadee. BOCH. A very rare winter vagrant to the Region, with nine records, from early November to late April.

Rock Wren. ROWR. Records from Assateague Island, MD, in October 1993; and from Ocean City, MD, in October 2015.

Bewick's Wren. BEWR. Extirpated from the Region. Formerly bred in the western Ridge & Valley and the Allegheny Highlands. Last record from the Region was from Dan's Rock in the Allegheny Highlands in 1979. The easternmost populations of this species have withdrawn westward into the Mississippi Basin.

Rock Wren adult, 10/2015 Sunset Park, Ocean City, Worcester County, MD. Photo: Mark R. Johnson

Northern Wheatear. NOWH. Accidental. Records of singletons from Indian River Inlet, DE, in September 1957; near Easton, MD, in September 1990; at Fox Point, near Claymont, DE, in December 2010; and from Baltimore-Washington International Airport, in October 2012.

Mountain Bluebird. MOBL. Accidental. MD records from December 1985 and November 2003.

Townsend's Solitaire. TOSO. Stray from the montane west. One record from the northern Western Shore of MD, in March to April 1996.

Fieldfare. FIEL. Accidental from Europe. Sight record from Bombay Hook NWR, DE, in March to April 1969.

Varied Thrush. VATH. Rare winter vagrant from the West, with about a dozen reports from the Region. Tends to show up at backyard feeders between November and April.

Sage Thrasher. SATH. Vagrant from the arid west. Two October records from MD and DE.

Bohemian Waxwing. BOWA. Accidental vagrant from boreal Canada. Two February records for MD, in 1994 and 2004.

Pine Grosbeak. PIGR. A very rare winter visitor, with about three dozen records for the Region. Records range from early November to late March. Usually found in small flocks, feeding at exotic shrubs with remnant fruit in suburban habitats. Very few recent records.

Hoary Redpoll. HORE. Vagrant, with about 15 records for the Region. Singletons usually associated with flocks of the nomadic and irruptive Common Redpoll. No records in the last decade. Beware: both redpoll species are quite variable, so positively identifying a Hoary is very difficult (and recent molecular research suggests this species may be nothing more than a color morph of the Common Redpoll). None of the MD reports have been reviewed by the MD/DC Records Committee.

Lesser Goldfinch. LEGO. A single record of this western vagrant comes from Talleyville, DE, in August 2008. The single MD report from 2016 was not accepted.

Chestnut-collared Longspur. CCLO. A rare stray from the Great Plains. The two accepted MD records were from August and January to February. To be looked for in association with Lapland Longspurs.

Smith's Longspur. SMLO. Accidental. Vagrant from the Great Plains. Single record of two birds that were observed on Assateague Island, MD, from November 1976 to January 1977.

Green-tailed Towhee. GTTO. Accidental. North of Wilmington, DE, in February 1964; and southeast of Cumberland, MD, in January 2001.

Spotted Towhee. SPTO. Accidental. Records from Montgomery County, MD, in December 1994, and Baltimore, MD, in May 2004.

Cassin's Sparrow. CASP. An individual was photographed at Point Lookout SP, MD, in September 2010.

Bachman's Sparrow. BACS. No recent records. Formerly bred in and around the lower Western Shore up into southern Pennsylvania, and in the vicinity of DC. Last recorded from the Region in December 1957. There are also reports from the early twentieth century of a population inhabiting the Allegheny Highlands. Today, the nearest breeding population resides in eastern North Carolina. Note that there are reviewable reports from Montgomery and Garrett Counties, MD, from 1972 and 1976.

Lark Bunting. LARB. Rare vagrant from the West. Fewer than two dozen records, from March, May, and July to January.

Baird's Sparrow. BAIS. Accidental. Vagrant from the northern prairies. A single MD specimen record from Ocean City, MD, in October 1966.

Chestnut-collared Longspur adult winter plumage, 2/2015 Chewsville Road, Washington County, MD. Photo: Mark L. Hoffman

Lark Bunting adult winter plumage, 1/2009 New Windsor, Carroll County, MD. Photo: Mark L. Hoffman

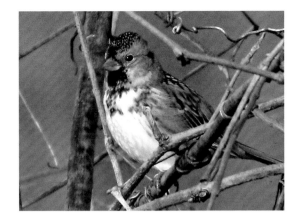

Harris's Sparrow adult winter plumage, 11/2017 Anacostia River Trail, Prince George's County, MD. Photo: Gene Ricks

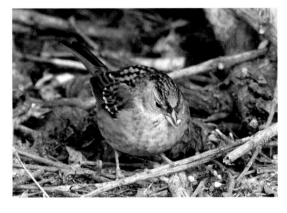

Golden-crowned Sparrow adult winter plumage, 12/2010 Chesapeake Farms, Kent County, MD. Photo: Mark L. Hoffman

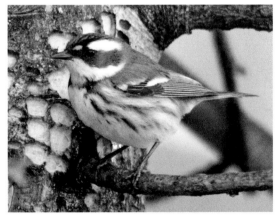

Black-throated Gray Warbler adult female, 12/2016 Brandywine Street NW, Washington, DC. Photo: W. Scott Young

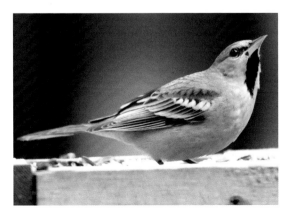

Bullock's Oriole male immature, 2/2013 Yard bird, Harford County, MD. Photo: Mark L. Hoffman

Harris's Sparrow. HASP. A rare migrant and winter visitor, with records scattered from October to mid-May. Many records are of feeder birds.

Golden-crowned Sparrow. GCSP. Accidental from the West Coast. Record from near Rock Hall, MD, from December 2010 to February 2011.

Western Meadowlark. WEME. A handful of records from the Region from January, August, and September. Nearest breeding population is in Indiana.

Bullock's Oriole. BUOR. Vagrant from the Great Plains. Maryland records from September, November to January, February, and March.

Shiny Cowbird. SHCO. Vagrant from the Caribbean. A single record from Montgomery County, MD, observed and photographed from late October 2017 into early 2018.

Swainson's Warbler. SWWA. A rare overshoot spring migrant to Region and a very rare and sporadic breeder in wooded swamps of the lower Eastern Shore, not known to have sung on territory here since 2002. Prefers thickets in disturbed swamp forest. Most records between late April and late July. Its loud musical song is to be listened for in late May in the swamplands of the Pocomoke watershed on the southern Eastern Shore.

Virginia's Warbler. VIWA. Accidental from the arid West. Single record from Pickering Creek, MD, from January to March 2012.

Black-throated Gray Warbler. BTYW. Very rare. A handful of records, from late September to January.

Townsend's Warbler. TOWA. Three MD records: Noland's Ferry, MD, in January 2006; Sycamore Landing, MD, in March 2006; and Assateague Island, MD, in September 2011.

Western Tanager. WETA. Vagrant from the Montane West, with a few spring and fall records (January, April, May, September, October, November, December).

Black-headed Grosbeak. BHGR. Vagrant from West. About a dozen records from the Region, scattered from October to April. Typically found at a backyard feeder.

Lazuli Bunting. LAZB. Vagrant from the West. Records from October to April.

Rejected Species, Species of Uncertain Origin or Changing Taxonomy, or Pending Local Records Committee Review

This list includes only species that have been accepted by the North American Classification Committee of the American Ornithological Society. None of the following has yet been accepted as wild or naturally occurring records by either of our Region's records committees. We include the scientific name with these accounts because these birds are not treated in the coded checklist, where scientific names are provided for all of the species accepted for the Region.

Greylag Goose. *Anser anser*. GRGO. Seven Maryland reports have been uploaded but not yet reviewed by the MD/DC Records Committee. Presumably, all are of exotic origin.

Lesser White-fronted Goose. *Anser erythropus*. LWFG. A probable escaped captive bird was shot by a hunter on 21 December 1972 at Bombay Hook NWR, DE. Discussed in brackets in *Birds of Delaware*. Not accepted by DE Records Committee. A 1976 bird from MD was not accepted by the MD/DC Records Committee. The MD report was published in *Maryland Birdlife* as well as in *American Birds*.

Whooper Swan. *Cygnus cygnus*. WHOS. A captive-bred pair bred in MD, but the species never became established. Two other MD reports were not accepted.

Egyptian Goose. *Alopochen aegyptiacus*. EGGO. Reports from MD and DC with documenting photos but these have not yet been reviewed by the MD/DC Records Committee. Presumably, all are of exotic or questionable origin.

Ruddy Shelduck. *Tadorna ferruginea*. RUSH. Eighteen reports have been logged by the MD/DC Records Committee. None yet reviewed. The general wisdom is that all are of questionable origin.

Baikal Teal. *Sibironetta formosa*. BATE. A report from MD in 1996 was found to be of questionable origin by the MD/DC Records Committee.

Western Tanager male winter plumage, 12/2013 Deer Run Golf Course, Worcester County, MD. Photo: Mark L. Hoffman

Black-headed Grosbeak male immature, 12/2016 Rose residence, St. Mary's County, MD. Photo: J. B. Churchill

Lazuli Bunting adult male winter plumage, 2/2016 Ayers Creek Family Farm, Worcester County, MD. Photo: Kurt R. Schwarz

Falcated Duck. *Mareca falcata*. Nine reports of the species from MD. The only report reviewed by the MD/DC Records Committee was found to be of questionable origin. The others remain to be reviewed, but many are assumed to be this same bird wandering around the region.

White-cheeked Pintail. *Anas bahamensis*. WCHP. An observation from Assawoman Wildlife Area on 25 October 1967 was a probable escape from captivity. Discussed in brackets in *Birds of Delaware*. There are two undocumented MD reports.

Labrador Duck. *Camptorhynchus labradorius*. LABD. Extinct. The last reported specimen was shot in the autumn of 1875 on Long Island, NY. This species probably was a regular wintering visitor to the Region prior to extinction. Audubon (1838 and 1843) mentioned seeing specimens of this species in the market in Baltimore, MD. Greenway (1967) reported that the species ranged southward "at least to the Delaware River and perhaps the Chesapeake Bay." Considered hypothetical by Stewart and Robbins (1958).

Chukar. *Alectoris chukar*. CHUK. Many reports have been logged by the MD/DC Records Committee, but none has been reviewed to date. Presumably, all are of exotic origin since the species is at times released at sites in the Region for live training of hunting dogs.

Gray Partridge. *Perdix perdix*. GRAP. One report was uploaded by the MD/DC Records Committee, but it is not documented. The nearest naturalized breeding populations of this species native to Eurasia exist in Quebec and Wisconsin.

African Collared-Dove. *Streptopelia roseogrisea*. AFCO. More than three dozen reports have been logged by the MD/DC Records Committee, but few are properly documented. This common cage bird bred in small numbers around Baltimore during the 1970s. All of these reports are presumably of exotic/questionable origin.

Clark's Grebe. *Aechmophorus clarkii*. CLGR. There is an unconfirmed sighting from Indian River Inlet, DE, in November 1988. The species is discussed in brackets in *Birds of Delaware*. Various accepted *Aechmophorus* sp. records from Maryland were not identified to species.

Whooping Crane. *Grus americana*. WHCR. There are reports in the literature from the seventeenth century; yet, there is no corroborated record from a specific location in the Region. Reported in brackets in *Birds of Delaware*. That account suggests the occurrence of this species in the Region in the Colonial period. The bird apparently regularly wintered to coastal New Jersey.

Southern Lapwing. *Vanellus chilensis*. SOLA. One sighting from near Ocean City, MD, was found to be of questionable origin.

Spotted Redshank. *Tringa erythropus*. SPRE. One report from Calvert County, MD, was not accepted by the MD/DC Records Committee.

Ivory Gull. *Pagophila eburnea*. IVGU. The single 1969 sighting from Cape Henlopen, DE, was rejected by the DE Records Committee. An 1842 museum specimen labeled "DC, Potomac River," is considered dubious by the MD/DC Records Committee and has not been reviewed.

Zino's/Fea's Petrel. *Pterodroma madeira/feae*. ZIPE/FEPE. A bird that could have been one of these two similar petrel species was observed by a very experienced birder/NOAA observer far out in MD waters on 31 July 2013. Not yet reviewed by the MD/DC Records Committee.

Cape Verde Shearwater. *Calonectris edwardsii*. CVSH. There is a single offshore pelagic observation of this eastern Atlantic vagrant from 21 October 2006 off the coast of Maryland. The MD/DC Records Committee eventually decided that the available evidence did not conclusively support the identification.

Harris's Hawk. *Parabuteo unicinctus.* HASH. Four MD reports from April, May, July, and December, are undocumented. All are presumed to be falconers' birds.

Black-backed Woodpecker. *Picoides arcticus.* BBWO. One sighting from Hockessin, DE, in November 1969, was reported in *Birds of Delaware* but not accepted by the DE Records Committee.

American Three-toed Woodpecker. *Picoides dorsalis.* ATTW. Reports from December 1967 to March 1968 and April 1974 in northern Delaware were reported in *Birds of Delaware.* Not accepted by the DE Records Committee.

Ivory-billed Woodpecker. *Campephilus principalis.* IBWO. Audubon, in publications of 1831 and 1842, reported the species to occur in Maryland. No subsequent corroboration exists. Stewart and Robbins treated the species as hypothetical for the state of Maryland. Probably now extinct.

Prairie Falcon. *Falco mexicanus.* PRFA. In April 2017, a single individual, roosting and flying in Virginia, was also observed to cross over the DC waters of the Potomac. Questions remain about the provenience of this individual. The MD/DC Records Committee is waiting for the Virginia Records Committee to complete its review before beginning the MD/DC Records Committee review process.

Monk Parakeet. *Myiopsitta monachus.* MOPA. A well-known colony existed on the shore of Silver Lake, Rehoboth Beach, DE, at least from 1988 to 2004 (20 birds in 1993). A nest under construction by birds near Laurel, Maryland, was found in May 2012. This population was first discovered in 2010. No evidence of breeding. Those birds are now gone. Considered undesirable because of its potential impact on local fruit crops. One earlier report was accepted by the MD/DC Records Committee as of "questionable origin," a species that may or may not be wild or naturally occurring.

Western Wood-Pewee. *Contopus sordidulus.* WEWP. Rare western vagrant, with multiple autumn reports and two 1960s specimens from Maryland, but none yet formally accepted by the MD/DC Records Committee. Molecular systematic analysis of available specimens has, to date, proved inconclusive. Of interest is one bird netted, banded, and released in 1977 by Chandler S. Robbins that he identified to species by its vocalization. The occurrence of this species in Maryland was listed in the American Ornithologists Union Checklist (1998: 391).

Gray Jay. *Perisoreus canadensis.* GRAJ. DE report of October 1965, discussed in *Birds of Delaware,* was shown to be an escaped cage bird.

Black-billed Magpie. *Pica hudsonia.* BBMA. A Delaware report from March 1957 was deemed a probable escape from captivity. There are eight old reports, mostly undocumented, from Maryland, considered to be exotic or of questionable origin.

Eurasian Skylark. *Alauda arvensis.* EUSK. Introduced to Wilmington, DE, in 1853, the species failed to establish a breeding population. Last observed in 1854.

Sprague's Pipit. *Anthus spragueii.* SPPI. Two sightings from Bombay Hook NWR, DE, on 3 April 1954 and 31 July 1991 were not accepted by the DE Records Committee. Three reports from MD were also not accepted by the MD/DC Records Committee.

European Goldfinch. *Carduelis carduelis.* EUGO. Various reports of this Eurasian species from Maryland; the two reviewed by the MD/DC Records Committee were found to be of questionable origin.

Hermit Warbler. *Setophaga occidentalis.* HEWA. One unconfirmed sighting, from White Clay Creek, DE, on 25 September 1981. Not accepted by DE Records Committee.

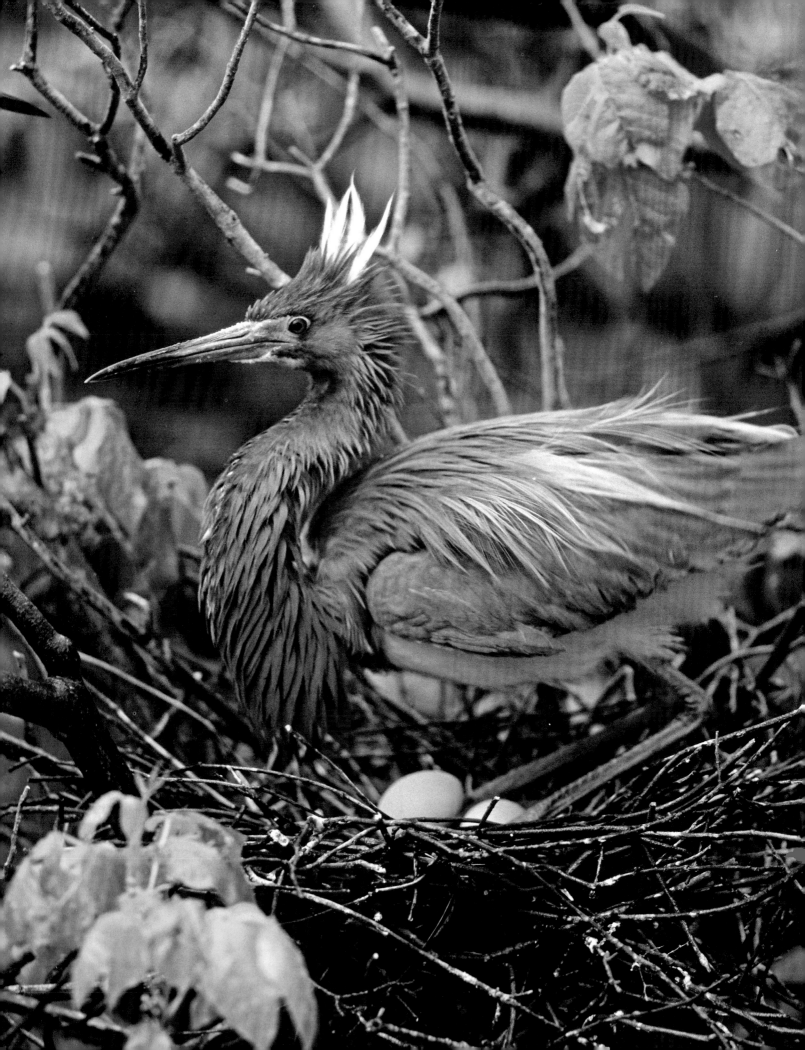

Coded Regional Checklist and Seasonal Occurrence Chart

The table that constitutes this chapter provides information on the seasonal occurrence and abundance of all species accepted as recorded from the Region by the records committees for Delaware and for Maryland and the District of Columbia as of January 2018. It is a useful reference for active birders wishing to know when to expect a particular species and in what habitat and what province. It is modeled after the *Field List of the Birds of Maryland*, which appeared in editions of 1968 and 1996, and *A Field List of Birds of the District of Columbia Region*, which was published in 1947 and reprinted in 1953 and 1961. Here we provide necessary clarifications to the various codes and keys used in the table.

State Occurrence. A check mark confirms the species for the state or district. A check mark followed by a "br" indicates the species currently breeds in the state or province or has bred in the recent past. A check followed by a question mark indicates the record has not been confirmed by the state records committee or that the committee accepted the record but not to species level (e.g., "frigatebird species recorded from DC" or "guillemot accepted for MD." A code of "xtp" indicates the species is locally extirpated and no longer occurs in the state or district. A code of "ext" indicates the species is extinct. A code of "qo" indicates a record exists but is of an individual of questionable origin, such as a captive bird escaped from a zoo or perhaps a bird carried to the region by some human agency (as a stowaway on a ship arriving from overseas, for instance). A check mark enclosed in square brackets indicates the species was treated in early publications as possibly recorded from the state or province but with insufficient substantiation. A check enclosed

Spectacular in full breeding plumage, a Tricolored Heron tends the nest in a remote hummock amid the vast salt marshes of Smith Island.

in parentheses indicates a record currently under review by the records committee. Because of the vagaries of movement and distribution, it is not uncommon for a species to have differing occurrence status in each of the three political units treated by this book.

Favored Habitat. For species that are habitat specialists, between one and three habitats are indicated as favored by the species. These are to aid birders in locating the species. If no habitat is listed, it is a rarity whose presence in the Region is not determined by a specific habitat.

Provincial Occurrence. Indicates where the species is most prevalent, by province (see map delineating the provinces on p. 13). Widespread species are indicated by "WI."

Common Name. Name follows treatment in the 58th Supplement of Birds of North America, issued by the North American Classification Committee of the American Ornithological Society in 2016.

Species Binomen. This, the scientific name, follows treatment in the 58th Supplement of Birds of North America, issued by the North American Classification Committee of the American Ornithological Society in 2016.

MD. State of Maryland.

DEL. State of Delaware.

DC. District of Columbia (Washington, DC).

Habitats. Listing of favored habitats (as noted above).

Provinces. Listing of provinces where most prevalent (as noted above).

Monthly Chart. Abundance of the species by month, with five abundance levels: (1) very rare, (2) rare, (3) uncommon, (4) common, (5) abundant—each coded by a circle of differing diameter.

Extreme Spring Date. For birds that spend the winter in the Region, the extreme spring date indicates the latest departure date recorded for the species (omitting over-summering records). For birds that spend the winter out of the Region, the extreme spring date indicates first arrival (omitting rare wintering records).

Peak Spring. indicates when this migratory species is most abundant in the spring in the Region.

Peak Fall. indicates when this migratory species is most abundant in the fall in the Region.

Common name	Species binomen	MD	DEL	DC	Favored habitats	Provinces
Black-bellied Whistling-Duck	*Dendrocygna autumnalis*	√	√	√	fwm, tid	–
Fulvous Whistling-Duck	*Dendrocygna bicolor*	√	√		fwm, tid	–
Snow Goose	*Chen caerulescens*	√	√	√	agf, bay	ES
Ross's Goose	*Chen rossii*	√	√	√	agf, bay	ES
Greater White-fronted Goose	*Anser albifrons*	√	√	√	agf, bay	ES
Pink-footed Goose	*Anser brachyrhynchus*	√	√		agf, bay	–
Brant	*Branta bernicla*	√	√	√	bay, bea	ES
Barnacle Goose	*Branta leucopsis*	√	√	qo	agf, bay	ES
Cackling Goose	*Branta hutchinsii*	√	√	√	agf, bay	ES
Canada Goose	*Branta canadensis*	√ br	√ br	√ br	agf, bay, sub	WI
Mute Swan	*Cygnus olor*	√ br	√ br	√	fwm, bay	ES
Trumpeter Swan	*Cygnus buccinator*	√	(√)		bay, lak	ES, WS

Extreme Date Fall. For birds that spend the winter in the Region, the extreme fall date indicates the earliest arrival recorded for the species (omitting over-summering records). For birds that spend the winter out of the Region, the extreme fall date indicates the latest fall record (omitting rare wintering records).

Status

√	accepted by state committees
(√)	pending committee review
[√]	stated as "hypothetical" in prior publications
√?	unconfirmed report
br	current breeder
(br)	former breeder
br?	possible breeder
xtp	extirpated
ext	extinct
qo	record of questionable origin

Favored habitat

agf	agricultural field, short-grass pasture, farmland
bay	bay, estuary, large riverway
bea	beach, shore, jetty, shore waters
con	conifer stand, piney woods
for	forest, woodland
fwm	freshwater marsh, impoundment, mudflat
gen	widespread, generalist
lak	lake, pond
oce	oceanic, pelagic
ofh	old field, hedgerow, abandoned orchard
owe	open woodland, edge, glade
sub	suburban, urban
swa	stream wetland, wooded swamp, bog
tid	tidal marshland, mudflat

Provincial occurrence

AH	Allegheny Highlands
ES	Eastern Shore
PI	Piedmont
RV	Ridge and Valley
WI	Widespread
WS	Western Shore

Abundance codes

●	abundant
●	common
●	uncommon
•	rare
○	very rare

[monthly abundance is for the most favorable sites within the Region for that species in that month]

[nb: the checklist sequence follows the 58th Supplement of the American Ornithological Society's Checklist of North and Middle American Birds]

J	F	M	A	M	J	J	A	S	O	N	D	spring extreme date	spring peak	fall peak	fall extreme date
○	○	○	○	○	○	○	○	○		○					
	○	○	○	○	○	○	○	○	○	○	○				
●	●	●	●	●	•	○	○	•	●	●	●		late Feb	early Nov	
•	•	•	○					○	○	•	•	16-Apr			26-Sep
•	•	•	•	○				○	○	•	•	20-May			21-Sep
○	○	○							○	○					
•	•	•	•	•	○	○	○	○	•	•	•	23-May	late Mar	late Oct	29-Sep
○	○							○	○	○	○				
•	•	•	○	○				○	•	•	•	17-Apr	early Mar	early Nov	23-Sep
●	●	●	●	●	●	●	●	●	●	●	●		mid-Mar	early Oct	
•	•	•	•	•	•	•	•	•	•	•	•				
•	•	•	•	•	○	○	○	•	•	•	•				

Common name	Species binomen	MD	DEL	DC	Favored habitats	Provinces
Tundra Swan	*Cygnus columbianus*	√	√	√	bay	ES
Wood Duck	*Aix sponsa*	√ br	√ br	√ br	swa, tid	WI
Garganey	*Anas querquedula*	qo	√	qo	–	–
Blue-winged Teal	*Anas discors*	√ br	√ br	√	fwm, tid	ES, WS
Cinnamon Teal	*Anas cyanoptera*	√	√		fwm, tid	–
Northern Shoveler	*Anas clypeata*	√ (br)	√ (br)	√	fwm, tid	ES, WS
Gadwall	*Anas strepera*	√ br	√ br	√	lak, tid	WI
Eurasian Wigeon	*Anas penelope*	√	√	√	lak, tid	ES, WS
American Wigeon	*Anas americana*	√	√ (br)	√	lak, tid	WI
Mallard	*Anas platyrhynchos*	√ br	√ br	√ br	sub, lak, tid	WI
American Black Duck	*Anas rubripes*	√ br	√ br	√ br	fwm, tid	WI
Northern Pintail	*Anas acuta*	√	√	√	fwm, tid	ES
Green-winged Teal	*Anas crecca*	√ (br)	√ br	√	fwm, tid	ES, WS
Canvasback	*Aythya valisineria*	√	√	√	bay	ES, WS
Redhead	*Aythya americana*	√	√	√	bay	ES, WS
Ring-necked Duck	*Aythya collaris*	√	√	√	lak, swa	WI
Tufted Duck	*Aythya fuligula*	√	√	√	lak, swa	–
Greater Scaup	*Aythya marila*	√	√	√	bay	ES, WS
Lesser Scaup	*Aythya affinis*	√	√	√	bay	ES, WS
King Eider	*Somateria spectabilis*	√	√		bea	ES
Common Eider	*Somateria mollissima*	√	√		bea	ES
Harlequin Duck	*Histrionicus histrionicus*	√	√		bea	ES
Surf Scoter	*Melanitta perspicillata*	√	√	√	bay, oce, bea	ES
White-winged Scoter	*Melanitta fusca*	√	√	√	bay, oce, bea	ES
Black Scoter	*Melanitta americana*	√	√	√	bay, oce, bea	ES
Long-tailed Duck	*Clangula hyemalis*	√	√	√	bay, bea	ES
Bufflehead	*Bucephala albeola*	√	√	√	lak, bay	WI
Common Goldeneye	*Bucephala clangula*	√	√	√	lak, bay	ES, WS
Barrow's Goldeneye	*Bucephala islandica*	√	[√]		lak, bay	–
Hooded Merganser	*Lophodytes cucullatus*	√ br	√ br	√	swa	WI
Common Merganser	*Mergus merganser*	√ br	√	√	lak	WI
Red-breasted Merganser	*Mergus serrator*	√	√ br?	√	bay, oce	ES
Masked Duck	*Nomonyx dominicus*	√			–	–
Ruddy Duck	*Oxyura jamaicensis*	√ br	√ (br)	√	bay, lak	WI
Northern Bobwhite	*Colinus virginianus*	√ br	√ br	√ br?	agf, ofh	ES, WS, PI

												spring extreme date	spring peak	fall peak	fall extreme date
J	F	M	A	M	J	J	A	S	O	N	D				
												18-May	mid-Mar	mid-Nov	16-Sep
													mid-Mar	late Oct	
												24-Feb	early Apr	late Sep	
												4-Jun	late Mar	mid-Oct	
													early Apr	early Nov	
												23-Apr			28-Aug
												4-Jun	mid-Mar	mid-Oct	16-Aug
													early Mar	late Oct	
													early Mar	early Nov	
												26-May	early Mar	mid-Oct	1-Aug
												29-May	late Mar	mid-Oct	1-Aug
												22-May	early Mar	mid-Nov	24-Sep
												17-May	early Mar	late Nov	12-Oct
												2-Jun	mid-Mar	mid-Nov	19-Sep
												31-Mar			15-Dec
												26-May	late Mar	mid-Nov	8-Oct
												4-Jun	late Mar	mid-Nov	27-Sep
												14-May			29-Sep
												26-Apr		early Dec	30-Sep
												21-May			19-Oct
												24-May	late Mar	early Nov	1-Oct
												17-May	late Apr	late Oct	7-Oct
												22-May	early Apr	early Nov	4-Oct
												15-May	late Mar	mid-Nov	23-Oct
												25-May	early Apr	mid-Nov	23-Sep
												14-May	mid-Mar	late Nov	18-Oct
												30-Mar			22-Nov
												14-May	early Mar	early Dec	4-Oct
												15-May	late Feb	early Dec	13-Oct
												15-Jun	mid-Mar	early Nov	6-Oct
													early Apr	late Nov	25-Sep

Common name	Species binomen	MD	DEL	DC	Favored habitats	Provinces
Ring-necked Pheasant	*Phasianus colchicus*	√ br	√ (br)		agf, ofh	WI
Ruffed Grouse	*Bonasa umbellus*	√ br	xtp √ (br)	xtp √	owe, for	AH, RV
Greater Prairie-Chicken	*Typanuchus cupido*	xtp √ (br)	xtp [√] (br?)	xtp √	last reported in the Region in 1893	
Wild Turkey	*Meleagris gallopavo*	√ br	√ br	√	agf, ofh, owe	WI
American Flamingo	*Phoenicopterus ruber*	√			–	–
Pied-billed Grebe	*Podilymbus podiceps*	√ br	√ br	√	fwm, tid, lak	WI
Horned Grebe	*Podiceps auritus*	√	√	√	bay, bea	ES, WS
Red-necked Grebe	*Podiceps grisegena*	√	√	√	bay, bea	ES, WS
Eared Grebe	*Podiceps nigricollis*	√	√	√	bay, lak	WS, ES, PI
Western Grebe	*Aechmophorus occidentalis*	√	√		–	–
Rock Pigeon	*Columba livia*	√ br	√ br	√ br	gen	WI
Eurasian Collared-Dove	*Streptopelia decaocto*	√	√ br?		sub	ES, PI
Passenger Pigeon	*Ectopistes migratorius*	ext √ (br)	ext [√]	ext √	last observed in Region in 1903	
Inca Dove	*Columbina inca*	√			–	–
Common Ground-Dove	*Columbina passerina*	√	√	√	–	–
White-winged Dove	*Zenaida asiatica*	√	√	√	sub, agf	ES, WS
Mourning Dove	*Zenaida macroura*	√ br	√ br	√ br	gen	WI
Yellow-billed Cuckoo	*Coccyzus americanus*	√ br	√ br	√ br	ofh, owe	WI
Black-billed Cuckoo	*Coccyzus erythropthalmus*	√ br	√ br	√	ofh, owe	WI
Groove-billed Ani	*Crotophaga sulcirostris*	√			–	–
Common Nighthawk	*Chordeiles minor*	√ br	√ br	√ br	agf, ofh, sub	WI
Chuck-will's-widow	*Antrostomus carolinensis*	√ br	√ br	√	con, for	ES, WS
Eastern Whip-poor-will	*Antrostomus vociferus*	√ br	√ br	√	for, owe	WI
Chimney Swift	*Chaetura pelagica*	√ br	√ br	√ br	gen	WI
Mexican Violetear	*Colibri thalassinus*	√			–	–
Ruby-throated Hummingbird	*Archilochus colubris*	√ br	√ br	√ br	gen	WI
Black-chinned Hummingbird	*Archilochus alexanderi*			√	–	–
Anna's Hummingbird	*Calypte anna*	√	(√)		–	–
Broad-tailed Hummingbird	*Selasphorus platycercus*	√?	√	√?	–	–
Rufous Hummingbird	*Selasphorus rufus*	√	√	√	–	WI
Allen's Hummingbird	*Selasphorus sasin*	√	√	√?	–	–
Calliope Hummingbird	*Selasphorus calliope*	√	√		–	–
Yellow Rail	*Coturnicops noveboracensis*	√	√	√	fwm	ES
Black Rail	*Laterallus jamaicensis*	√ (br)	√ br	√	tid	ES
Corn Crake	*Crex crex*	√			–	–

J	F	M	A	M	J	J	A	S	O	N	D	spring extreme date	spring peak	fall peak	fall extreme date
•	•	•	•	•	•	•	•	•	•	•	•				
●	●	●	●	●	●	●	●	●	●	●	●				
●	●	●	●	●	●	●	●	●	●	●	●				
					○	○	○	○							
●	●	●	●	●	•	•	•	●	●	●	●	19-May	early Mar	late Oct	24-Jul
●	●	●	●	•	•	•	○	○	•	●	●	14-Jun	early Apr	late Nov	23-Sep
•	●	●	●	•	•				•	•	•	8-Jun	mid-Mar	mid-Nov	12-Oct
○	○	•	•	○		○	○	○	○	○	○	1-Jun	mid-Mar	mid-Sep	22-Aug
○	○		○	○	○				○	○					
●	●	●	●	●	●	●	●	●	●	●	●				
○	○	○	○	○	○	○	○	○	○	○	○				
										○					
○				○	○				○	○	○				
○	○	○	○	○	○		○	○	○	○	○				
●	●	●	●	●	●	●	●	●	●	●	●				
			●	●	●	●	●	●	●	•		2-Apr	mid-May	mid-Aug	22-Nov
			•	●	●	•	•	•	○	○		15-Apr	mid-May	late Aug	10-Nov
									○						
		○	•	●	•	•	●	●	•	○		7-Mar	mid-May	early Sep	25-Nov
		○	•	●	●	●	•	•	•		○	30-Mar			late Dec
		○	•	●	●	●	•	○	○			9-Mar			28-Oct
		•	●	●	●	●	●	●	●	•		14-Mar	early May	mid-Sep	23-Nov
								○							
○		•	●	●	●	●	●	●	•		○	18-Mar	early May	late Aug	15-Dec
								○	○						
○	○	○	○						○	○					
		○													
○	○	○	○			○	○	○	○	○	○				17-Jul
○	○								○	○	○				
								○	○	○					
○	○	•	•	•		○	•	•	●	•	•	20-May			31-Aug
○	○	○	•	•	•	•	•	•	○	○	○	3-Apr			29-Oct
								○							

Common name	Species binomen	MD	DEL	DC	Favored habitats	Provinces
Clapper Rail	*Rallus crepitans*	√ br	√ br	√	tid	ES, WS
King Rail	*Rallus elegans*	√ br	√ br	√	fwm, tid	ES, WS
Virginia Rail	*Rallus limicola*	√ br	√ br	√	fwm	WI
Sora	*Porzana carolina*	√ br	√ (br)	√	fwm	WI
Purple Gallinule	*Porphyrio martinicus*	√ (br)	√ (br)	√	–	–
Common Gallinule	*Gallinula galeata*	√ br	√ br	√	fwm, tid	ES, WS
American Coot	*Fulica americana*	√ br	√ (br)	√	lak, bay	WI
Limpkin	*Aramus guarauna*	√			–	–
Sandhill Crane	*Antigone canadensis*	√ br	√	√	agf	–
Black-necked Stilt	*Himantopus mexicanus*	√ br	√ br	√	fwm, tid	ES
American Avocet	*Recurvirostra americana*	√	√	√	fwm, tid	ES
American Oystercatcher	*Haematopus palliatus*	√ br	√ br		bea, tid	ES
Northern Lapwing	*Vanellus vanellus*	√	√		–	–
Black-bellied Plover	*Pluvialis squatarola*	√	√	√	tid, bea	ES
European Golden-Plover	*Pluvialis apricaria*		√		–	–
American Golden-Plover	*Pluvialis dominica*	√	√	√	bea, tid	ES
Pacific Golden-Plover	*Pluvialis fulva*		√		agf, tid	–
Snowy Plover	*Charadrius nivosus*	√			–	–
Wilson's Plover	*Charadrius wilsonia*	√ (br)	(√)		bea	ES
Semipalmated Plover	*Charadrius semipalmatus*	√	√	√	bea, tid, fwm	ES, WS
Piping Plover	*Charadrius melodus*	√ br	√ br	√	bea	ES
Killdeer	*Charadrius vociferus*	√ br	√ br	√ br	sub, agf, fwm	WI
Upland Sandpiper	*Bartramia longicauda*	√ br	√ br	√	agf	ES, AH
Whimbrel	*Numenius phaeopus*	√	√	√	bay, tid, bea	ES
Eskimo Curlew	*Numenius borealis*	xtp √			last observed in Region in 1913	
Long-billed Curlew	*Numenius americanus*	√	[√]	√	tid	ES
Black-tailed Godwit	*Limosa limosa*		√		tid, fwm	ES
Hudsonian Godwit	*Limosa haemastica*	√	√	√	tid, fwm	ES
Marbled Godwit	*Limosa fedoa*	√	√		tid, fwm	ES
Ruddy Turnstone	*Arenaria interpres*	√	√	√	bea, tid	ES, WS
Red Knot	*Calidris canutus*	√	√	√	tid, fwm	ES
Ruff	*Calidris pugnax*	√	√	√	tid, fwm	ES
Sharp-tailed Sandpiper	*Calidris acuminata*	√	√		–	–
Stilt Sandpiper	*Calidris himantopus*	√	√	√	tid, fwm	ES, WS
Curlew Sandpiper	*Calidris ferruginea*	√	√		tid, fwm	ES

J	F	M	A	M	J	J	A	S	O	N	D	spring extreme date	spring peak	fall peak	fall extreme date
●	●	●	●	●	●	●	●	●	●	●	●				
·	·	·	●	●	●	●	●	·	·	·	·		late Apr		
●	●	●	●	●	●	●	●	●	●	●	●		mid-Apr		
·	·	·	●	●	·	·	●	●	●	·	·		late Apr	late Sep	
			○	○	○	○	○	○	○						
●	○	○	●	●	●	●	●	●	●	·	·		late Apr	late Sep	
●	●	●	●	●	·	·	·	●	●	●	●		late Mar	early Nov	
			○	○											
·	·	○	○	○	○	○	·	○	○	·	·				
○	○	·	●	●	●	●	●	·	·	○	○	23-Mar	late Apr		7-Oct
·	·	·	●	●	●	●	●	●	●	●	·	16-Feb	late Apr	late Aug	1-Dec
●	●	●	●	●	●	●	●	●	●	●	●				
	○	○				○				○					
●	●	●	●	●	●	●	●	●	●	●	●		late May	mid-Sep	
					○		○								
		○	○	○	○	○	·	●	●	○	○	13-Mar		late Oct	6-Dec
					○										
			○												
			○	○	○	○	○	○				6-Apr			21-Sep
○	○	○	●	●	·	●	●	●	·	·	·	1-Apr	mid-May	mid-Aug	12-Dec
·	·	·	●	●	●	·	●	●	·	·	·			early Sep	
●	●	●	●	●	●	●	●	●	●	●	●		late Mar	late Sep	
			·	·	·	●	●	●	·	○		4-Apr	late Apr	early Aug	24-Sep
○			●	●	·	●	●	·	·	·	○	3-Apr	mid-May	late Jul	24-Oct
			○	○		○	○								
					○	○									
			○	○	·	·	·	·	·	○		16-May		late Sep	10-Dec
○	○	○	·	●	·	·	●	●	●	●	·	12-Apr		mid-Nov	16-Dec
·	○	·	·	●	·	●	●	●	●	·			mid-May	mid-Aug	
○	○	○	·	●	●	·	·	●	●	·	○	19-Apr	late May	late Sep	
○	○	○	○	○	○	○	○	○	○	○		2-Apr			27-Nov
					○	○									
		○	·	●	·	●	●	●	·	○		30-Mar	mid-May	early Aug	early Dec
		○	·	·	·	·	○	○				2-May			19-Oct

Coded Regional Checklist and Seasonal Occurrence Chart 383

Common name	Species binomen	MD	DEL	DC	Favored habitats	Provinces
Red-necked Stint	*Calidris ruficollis*	√	√		–	–
Sanderling	*Calidris alba*	√	√	√	bea	ES
Dunlin	*Calidris alpina*	√	√	√	tid, fwm	WI
Purple Sandpiper	*Calidris maritima*	√	√		bea	ES
Baird's Sandpiper	*Calidris bairdii*	√	√	√	fwm, tid	ES, WS
Little Stint	*Calidris minuta*	√	√		–	–
Least Sandpiper	*Calidris minutilla*	√	√	√	fwm, tid	WI
White-rumped Sandpiper	*Calidris fuscicollis*	√	√	√	fwm, tid	WI
Buff-breasted Sandpiper	*Calidris subruficollis*	√	√	√	fwm, bea	ES
Pectoral Sandpiper	*Calidris melanotos*	√	√	√	fwm	WI
Semipalmated Sandpiper	*Calidris pusilla*	√	√	√	fwm, tid	WI
Western Sandpiper	*Calidris mauri*	√	√	√	fwm, tid	ES, WS
Short-billed Dowitcher	*Limnodromus griseus*	√	√	√	tid, fwm	WI
Long-billed Dowitcher	*Limnodromus scolopaceus*	√	√	√	fwm	ES
American Woodcock	*Scolopax minor*	√ br	√ br	√ br	ofh, owe	WI
Wilson's Snipe	*Gallinago delicata*	√ br?	√	√	agf, fwm	WI
Spotted Sandpiper	*Actitis macularius*	√ br	√ (br)	√ br	swa, lak	WI
Solitary Sandpiper	*Tringa solitaria*	√	√	√	swa, lak	WI
Lesser Yellowlegs	*Tringa flavipes*	√	√	√	tid, swa, bay	WI
Willet	*Tringa semipalmata*	√ br	√ br	√	bay, tid	ES, WS
Greater Yellowlegs	*Tringa melanoleuca*	√	√	√	tid, swa, bay	WI
Wood Sandpiper	*Tringa glareola*		√		–	–
Wilson's Phalarope	*Phalaropus tricolor*	√	√	√	fwm, tid	ES
Red-necked Phalarope	*Phalaropus lobatus*	√	√	√	oce, fwm	ES
Red Phalarope	*Phalaropus fulicarius*	√	√	√	oce	ES
Great Skua	*Stercorarius skua*	√	√		oce	ES
South Polar Skua	*Stercorarius maccormicki*	√	√		oce	ES
Pomarine Jaeger	*Stercorarius pomarinus*	√	√		oce	ES
Parasitic Jaeger	*Stercorarius parasiticus*	√	√	√	oce	ES
Long-tailed Jaeger	*Stercorarius longicaudus*	√	√	√	oce	ES
Dovekie	*Alle alle*	√	√		oce	ES
Common Murre	*Uria aalge*	√	√		oce	ES
Thick-billed Murre	*Uria lomvia*	√	√	√	oce	ES
Razorbill	*Alca torda*	√	√		oce	ES
Black Guillemot	*Cepphus grylle*	√?	√		oce	ES

J	F	M	A	M	J	J	A	S	O	N	D	spring extreme date	spring peak	fall peak	fall extreme date
			○		○	○									
●	●	●	●	●	•	•	●	●	●	●	●		late May	early Sep	
●	●	●	●	●	•	•	•	●	●	●	●		late May	mid-Nov	
●	●	●	●	•	○	○		○	•	●	●	5-Jun	late Apr	mid-Nov	19-Sep
		○	○	•		•	●	●	●	●	○	8-Mar		late Aug	10-Dec
			○		○	○	○								
○	○	○	●	●	●	●	●	●	●	•	•	16-Mar	early May	late Jul	
		•	●	•	•	•	●	●	●	•	○	18-Apr	late May	late-Sep	16-Dec
		○	○			●	●	•						early Sep	15-Oct
○		●	●	●	•	•	●	●	●	•	○	1-Mar	mid-Apr	late Sep	4-Dec
			•	●	●	●	●	●	●	○	○	31-Mar	late May	late Jul	8-Dec
•	○	○	○	•	•	•	●	●	●	●	•			mid-Aug	
○	○	•	●	●	●	●	●	●	●	•	○	17-Mar	mid-May	late Jul	15-Dec
○	○	•	•	•	•	•	●	●	●	●	○			late Oct	
●	●	●	●	●	●	•	●	●	●	●	●		mid-May	late Nov	
●	●	●	●	○	○	•	●	●	●	●	●		early Apr	mid-Nov	
○	○	•	●	●	●	●	●	●	●	•	○	10-Mar	early May	early Aug	10-Dec
	•	●	●	•	●	●	●	•	•	•	15-Mar	early May	late Aug	12-Nov	
•	•	●	●	●	●	●	●	●	●	●	•		mid-Apr	mid-Aug	
○	●	●	●	●	●	●	●	●	●	●	●		mid-May	late Jul	
●	●	●	●	●	●	●	●	●	●	●	●		mid-Apr	late Sep	
			○												
		○	●	•	•	●	●	•	○	○	6-Apr	late May	late Aug	4-Dec	
		•	●	•	○	○	●	•	•	○	25-Apr	mid-May	early Sep	28-Nov	
○	•	○	●	●	○	○	○	●	•	●	○		late Apr	early Sep	
○	○	○	○								○	27-Apr			4-Dec
		○	○	○	○					9-May			15-Aug		
○	○		○	●	•	•	•	•	●	•	•		early May		
○		•	•	•	•	•	•	●	●	•	23-Apr	mid-May	late October		
		○	○			○	•	○	○	○	24-Apr			8-Aug	
●	●	●							•	●	20-Mar			13-Nov	
•	•	•	•						•	12-Apr			29-Dec		
○	○	○	○					○	○	13-May			5-Nov		
●	●	●	•	○				○	●	8-May			23-Nov		
○	○														

Common name	Species binomen	MD	DEL	DC	Favored habitats	Provinces
Atlantic Puffin	*Fratercula arctica*	√	√		oce	ES
Black-legged Kittiwake	*Rissa tridactyla*	√	√		oce	ES
Sabine's Gull	*Xema sabini*	√	√		oce, bay, lak	–
Bonaparte's Gull	*Chroicocephalus philadelphia*	√	√	√	oce, bay, lak	WI
Black-headed Gull	*Chroicocephalus ridibundus*	√	√	√	bay, tid	ES
Little Gull	*Hydrocoloeus minutus*	√	√	√	bay, tid	ES, WS
Ross's Gull	*Rhodostethia rosea*	√	√		–	–
Laughing Gull	*Leucophaeus atricilla*	√ br	√ br	√	bay, bea, tid, fwm	ES, WS
Franklin's Gull	*Leucophaeus pipixcan*	√	√	√	–	–
Black-tailed Gull	*Larus crassirostris*	√			–	–
Mew Gull	*Larus canus*	√	√		–	–
Ring-billed Gull	*Larus delawarensis*	√	√	√	gen	WI
California Gull	*Larus californicus*	√	√	√	–	–
Herring Gull	*Larus argentatus*	√ br	√ br	√	bea, tid, bay	WI
Yellow-legged Gull	*Larus michahellis*	√	(√)	√	–	–
Iceland Gull	*Larus glaucoides*	√	√	√	bea, oce, bay	ES, WS
Lesser Black-backed Gull	*Larus fuscus*	√	√	√	bea, oce, bay	ES, WS
Glaucous Gull	*Larus hyperboreus*	√	√	√	bea, oce, bay	ES, WS
Great Black-backed Gull	*Larus marinus*	√ br	√ br	√	gen, bay, bea	WI
Kelp Gull	*Larus dominicanus*	√	√		–	–
Sooty Tern	*Onychoprion fuscatus*	√	√	√	oce	ES
Bridled Tern	*Onychoprion anaethetus*	√	√	√	oce	ES
Least Tern	*Sternula antillarum*	√ br	√ br	√ (br)	bea, tid	ES, WS
Gull-billed Tern	*Gelochelidon nilotica*	√ br?	√ br?	√	bea, agf	ES
Caspian Tern	*Hydroprogne caspia*	√	√	√	gen, lak, bea	WI
Black Tern	*Chlidonias niger*	√	√	√	tid, fwm, oce	WI
White-winged Tern	*Chlidonias leucopterus*		√		–	–
Whiskered Tern	*Chlidonias hybrida*		√		–	–
Roseate Tern	*Sterna dougallii*	√ (br)	√		oce, bea	ES
Common Tern	*Sterna hirundo*	√ br	√ br	√	oce, bea	ES, WS
Arctic Tern	*Sterna paradisaea*	√	√	√	oce	ES
Forster's Tern	*Sterna forsteri*	√ br	√ br	√	bay, tid	ES, WS
Royal Tern	*Thalasseus maximus*	√ br	√	√	bea	ES
Sandwich Tern	*Thalasseus sandvicensis*	√ (br)	√		bea	ES
Black Skimmer	*Rynchops niger*	√ br	√ br	√	bea	ES

J	F	M	A	M	J	J	A	S	O	N	D	spring extreme date	spring peak	fall peak	fall extreme date
○	●	○		○	○						○	4-Jun			6-Dec
●	●	●	●	●	○			○	●	●	●	5-Jun	early Mar	late Nov	26-Sep
		○	○			○	○	○				28-Apr			26-Sep
●	●	●	●	●	●	●	●	●	●	●	●		early Apr	late Nov	
○	○	●	●	○	○	○	○	○	○	○	●	8-May	early Apr		11-Aug
○	○	○	●	●	○	○	○	○	○	○	●	8-Jun	late Mar	early Dec	26-Oct
○		○								○		3-Mar			
●	●	●	●	●	●	●	●	●	●	●	●		mid-Apr	mid-Oct	
○		○	●	●	●	●	●	●	●	○	○	31-Mar			1-Dec
					○			○	○			4-Jul			15-Oct
	○		○							○					
●	●	●	●	●	●	●	●	●	●	●	●		early Apr	mid-Nov	
○	○	○			○	○		○	○						
●	●	●	●	●	●	●	●	●		●	●				
○	○	○								○					
●	●	●	○	○	○	○	○	○	○	●	●				
●	●	●	●	●	●	●	●	●	●	●	●				
●	●	○	○	○	○	○	○		○	○	●				
●	●	●	●	●	●	●	●	●	●	●	●				
○	○	○	○	○	○	○	○	○	○	○	○				
				○	○	○	○								21-Jul
				○	○	○	○								8-Aug
			●	●	●	●	●	●	●	●		1-Apr	mid-May	early Aug	28-Oct
			●		●		●		●	●		23-Apr			13-Oct
		○	●	●	●	●	●	●	●	●	●	15-Mar	late Apr	early Sep	26-Nov
			●		●		●		●	●		16-Apr	mid-May	late Aug	16-Oct
			○	○	○	○	○	○	○						
					○	○									
			○	●	○	○	●	○				30-Apr			19-Sep
	●	●	●	●	●	●	●	●	●		●	20-Mar	early May	early Sep	
			●	○	○	●	○	○				5-May			19-Sep
○	○	●	●	●	●	●	●	●	●	●	●		early May	early Oct	
	●	●	●	●	●	●	●	●	●	●	●	21-Mar	mid-Apr	late Aug	29-Dec
			○	●	●	●	●	○	○			13-May		early Sep	19-Nov
○	○	○	●	●	●	●	●	●	●	●	○	23-Mar	mid-May	mid-Sep	

Common name	Species binomen	MD	DEL	DC	Favored habitats	Provinces
White-tailed Tropicbird	*Phaethon lepturus*	√	√		oce	ES
Red-throated Loon	*Gavia stellata*	√	√	√	oce, bea, bay	ES, WS
Pacific Loon	*Gavia pacifica*	√		√	oce, bay	–
Common Loon	*Gavia immer*	√	√	√	oce, bay, lak	WI
Yellow-nosed Albatross	*Thalassarche chlororhynchos*	√	[√]		oce	–
Northern Fulmar	*Fulmarus glacialis*	√	√		oce	ES
Trindade Petrel	*Pterodroma arminjoniana*	√			oce	ES
Black-capped Petrel	*Pterodroma hasitata*	√			oce	ES
Cory's Shearwater	*Calonectris diomedea*	√	√		oce	ES
Sooty Shearwater	*Ardenna grisea*	√	√		oce	ES
Great Shearwater	*Ardenna gravis*	√	√		oce	ES
Manx Shearwater	*Puffinus puffinus*	√	√		oce	ES
Audubon's Shearwater	*Puffinus lherminieri*	√	√	[√]	oce	ES
Wilson's Storm-Petrel	*Oceanites oceanicus*	√	√		oce	ES
White-faced Storm-Petrel	*Pelagodroma marina*	√	√		oce	ES
Leach's Storm-Petrel	*Oceanodroma leucorhoa*	√	√	√	oce	ES
Band-rumped Storm-Petrel	*Oceanodroma castro*	√	√	√	oce	ES
Wood Stork	*Mycteria americana*	√	√	√	–	ES
Magnificent Frigatebird	*Fregata magnificens*	√	√	√?	oce	ES
Masked Booby	*Sula dactylatra*	√			oce	ES
Brown Booby	*Sula leucogaster*	√	√		–	ES
Northern Gannet	*Morus bassanus*	√	√		oce, bay	ES, WS
Neotropic Cormorant	*Phalacrocorax brasilianus*	√			–	–
Double-crested Cormorant	*Phalacrocorax auritus*	√ br	√ br	√	lak, oce, tid	WI
Great Cormorant	*Phalacrocorax carbo*	√	√	√	bay, bea	ES
Anhinga	*Anhinga anhinga*	√	√	√	fwm, swa	–
American White Pelican	*Pelecanus erythrorhynchos*	√	√	√	tid, fwm	ES, WS
Brown Pelican	*Pelecanus occidentalis*	√ br	√	√	bay, tid, bea	ES, WS
American Bittern	*Botaurus lentiginosus*	√ br	√ br	√	fwm, tid	WS, ES, PI
Least Bittern	*Ixobrychus exilis*	√ br	√ br	√	fwm, tid	ES, WS
Great Blue Heron	*Ardea herodias*	√ br	√ br	√ br	fwm, swa, lak	WI
Great Egret	*Ardea alba*	√ br	√ br	√	tid, fwm	WI
Little Egret	*Egretta garzetta*		√		–	–
Snowy Egret	*Egretta thula*	√ br	√ br	√	tid, bay, fwm	ES, WS
Little Blue Heron	*Egretta caerulea*	√ br	√ br	√	tid, bay	ES

J	F	M	A	M	J	J	A	S	O	N	D	spring extreme date	spring peak	fall peak	fall extreme date
						○									13-Jul
●	●	●	●	●	•	○	○	•	●	●	●	7-Jun	late Mar	late Nov	29-Sep
	○		○	○	○	○	○	○	○	○	○	15-May			19-Oct
●	●	●	●	●	●	•	•	●	●	●	●	12-Jun	late Apr	early Nov	13-Sep
	○			○											
•	•	●	●	•	•			•	•	•	•	12-Jun	mid-Mar	mid-Nov	26-Sep
					○	○									
			○	○	○	○	○								18-Jul
			•	●	●	●	●	•				18-Mar	late Jun	late Aug	28-Oct
		•	●	●	•	•	○	○	○	○		20-Mar	late Jun		28-Aug
			●	●	●	●	●	●	●	●	•	9-May	late Jun	late Nov	8-Dec
•	•	•	•	•	•	•	•	•	•	•	•	18-May			29-Nov
				•	•	•	•					21-Jul			25-Sep
		○	○	●	●	●	●	●	•			10-Mar			27-Oct
					○	○	○								26-Aug
		○	•	•	•	●	•	•				30-Apr		late Aug	31-Oct
				○	○	○	○	○				4-Jun		mid-Aug	29-Aug
○	○		○	○	○	○	○	○	○			25-May			15-Nov
○		○		○	○	○	○	○	○						
					○										
				○	○	○	○	○	○					mid-Jul	3-Dec
●	●	●	●	•	•	○	○	○	•	●	●	1-Jun	late Mar	mid-Nov	13-Aug
		○	○	○	○	○	○	○				9-May			11-Nov
●	●	●	●	●	●	●	●	●	●	●	●		mid-Apr	late Oct	
●	●	●	•	•	○	○	○	•	●	●	●	8-Jun	mid-Mar	late Nov	
		○	○	○	○	○	○	○				3-Apr			20-Oct
●	●	●	●	•	•	•	•	•	•	●	●		early Apr	late Nov	
○	○	•	●	●	●	●	●	●	●	●	●		late May	early Sep	
●	●	●	●	•	•	•	•	•	●	●	●		mid-Apr	late Oct	
○	○	○	•	●	●	•	●	●	•	•	○	3-Apr	early May	late Aug	14-Dec
●	●	●	●	●	●	●	●	●	●	●	●		mid-Mar	mid-Aug	
•	•	●	●	●	●	●	●	●	●		•		early Apr	late Aug	
		○	○	○	○	○									
○	○	●	●	●	●	●	●	●	●	●	○		late Mar	early Sep	
○	○	•	●	●	●	●	●	●	•	•	○		mid-Apr	mid-Aug	

Common name	Species binomen	MD	DEL	DC	Favored habitats	Provinces
Tricolored Heron	*Egretta tricolor*	√ br	√ br	√	tid, bay	ES
Reddish Egret	*Egretta rufescens*	√	√		–	–
Cattle Egret	*Bubulcus ibis*	√ br	√ br	√	agf, tid, bay	ES
Green Heron	*Butorides virescens*	√ br	√ br	√ br	fwm, swa	ES, WS
Black-crowned Night-Heron	*Nycticorax nycticorax*	√ br	√ br	√ br	fwm, swa	ES,WS
Yellow-crowned Night-Heron	*Nyctanassa violacea*	√ br	√ br	√ br	fwm, swa	ES, WS
White Ibis	*Eudocimus albus*	√	√	√	swa, tid, fwm	ES
Glossy Ibis	*Plegadis falcinellus*	√ br	√ br	√	tid, bay, agf	ES
White-faced Ibis	*Plegadis chihi*	√	√		tid, bay, agf	–
Roseate Spoonbill	*Platalea ajaja*	√	√		–	–
Black Vulture	*Coragyps atratus*	√ br	√ br	√	gen	WI
Turkey Vulture	*Cathartes aura*	√ br	√ br	√ (br)	gen	WI
Osprey	*Pandion haliaetus*	√ br	√ br	√ br	bay, tid, fwm	WI
Swallow-tailed Kite	*Elanoides forficatus*	√	√		–	–
White-tailed Kite	*Elanus leucurus*	√			–	–
Mississippi Kite	*Ictinia mississippiensis*	√ br	√	√	swa, lak	ES, WS, PI
Bald Eagle	*Haliaeetus leucocephalus*	√ br	√ br	√ br	lak, tid, bay	WI
Northern Harrier	*Circus cyaneus*	√ br	√ br	√	tid, fwm, agf	WI
Sharp-shinned Hawk	*Accipiter striatus*	√ br	√	√	sub, ofh, for	WI
Cooper's Hawk	*Accipiter cooperii*	√ br	√ br	√	sub, ofh, for	WI
Northern Goshawk	*Accipiter gentilis*	√ br	√	√	for, owe	AH, RV
Red-shouldered Hawk	*Buteo lineatus*	√ br	√ br	√ br	sub, owe, for	WI
Broad-winged Hawk	*Buteo platypterus*	√ br	√ br	√	for	WI
Swainson's Hawk	*Buteo swainsoni*	√	√		–	–
Zone-tailed Hawk	*Buteo albonotatus*		√		–	–
Red-tailed Hawk	*Buteo jamaicensis*	√ br	√ br	√ br	ofh, agf, sub	WI
Rough-legged Hawk	*Buteo lagopus*	√	√	√	tid, fwm, agf	WI
Golden Eagle	*Aquila chrysaetos*	√	√	√	tid, fwm	ES, AH
Barn Owl	*Tyto alba*	√ br	√ br	√	tid, agf, ofh	ES, WS, PI
Eastern Screech-Owl	*Megascops asio*	√ br	√ br	√ br	sub, owe	WI
Great Horned Owl	*Bubo virginianus*	√ br	√ br	√ br	owe, con	WI
Snowy Owl	*Bubo scandiacus*	√	√	√	tid, bea	ES, WS
Burrowing Owl	*Athene cunicularia*	√	√		–	–
Barred Owl	*Strix varia*	√ br	√ br	√ br	for, sub	WI
Long-eared Owl	*Asio otus*	√ br	√ (br)	√	for, owe	WI

J	F	M	A	M	J	J	A	S	O	N	D	spring extreme date	spring peak	fall peak	fall extreme date
○	○	•	●	●	●	●	●	●	●	•	○		early May	mid-Aug	
				○	○	○	○	○							
○	○	●	●	●	●	●	●	●	●	•	○	2-Mar	early May	late Aug	3-Dec
○	○	•	●	●	●	●	●	●	•	○	○	16-Mar	early May	late aug	5-Dec
•	•	●	●	●	●	●	●	●	●	●	●		early Apr	late Aug	28-Nov
		○	●	●	●	●	●	●	•	○	○	3-Mar	late Mar	mid-Aug	30-Nov
	○	○	•	•	•	●	●	●	●	●		26-Feb		mid-Sep	15-Nov
○	○	●	●	●	●	●	●	●	•	○		2-Mar	mid-Apr	mid-Aug	28-Nov
		○	○	○	○	○	○	○	○			20-Mar			11-Oct
		○	○	○	○	○	○					14-Apr			19-Sep
●	●	●	●	●	●	●	●	●	●	●	●		mid-Mar	mid-Oct	
●	●	●	●	●	●	●	●	●	●	●	●		late Mar	late Oct	
○	•	●	●	●	●	●	●	●	●	•	○	7-Feb	mid-Apr	late Sep	
		○	○	○	○	○	○	○	○		○	14-Mar	mid-May		13-Oct
									○						26-Oct
		•	•	●	•	●	•	●	•	●		21-Mar	late May	mid-Aug	15-Oct
●	●	●	●	●	●	●	●	●	●	●	●		mid-May	mid-Sep	
●	●	●	●	•	•	•	•	•	●	●	●		mid-Apr	mid-Oct	
●	●	●	●	•	•	•	●	●	●	●	●		late Apr	mid-Oct	
●	●	●	●	●	●	●	●	●	●	●	●		early Apr	mid-Oct	
○	○	○	○	○	○	○	○	○	○	•	○				
●	●	●	●	●	●	●	●	●	●	●	●		early Mar	early Nov	
	•	●	●	●	●	●	●	●	●	•		28-Mar	late Apr	mid-Sep	21-Nov
		○				○	○	○							
					○										
●	●	●	●	●	●	●	●	●	●	●	●	–	mid-Apr	early Nov	
•	•	•	•					•	•	•		10-May			9-Oct
•	•	●	•	•			•	•	●	•		12-May	mid-Mar	mid-Nov	13-Sep
•	•	•	•		•	•	•	•	•	•	•				
●	●	●	●	●	●	●	●	●	●	●	●				
●	●	●	●	●	●	●	●	●	●	●	●				
○	○	○	○						○	○		1-Apr			16-Nov
		○	○												
●	●	●	●	●	●	●	●	●	●	●	●				
•	•	•	○	○	○	○			•	•	●				

Common name	Species binomen	MD	DEL	DC	Favored habitats	Provinces
Short-eared Owl	*Asio flammeus*	√ br	√ (br)	√	tid	WI
Northern Saw-whet Owl	*Aegolius acadicus*	√ br	√	√	for, con	WI
Belted Kingfisher	*Megaceryle alcyon*	√ br	√ br	√ br	lak, fwm, tid	WI
Red-headed Woodpecker	*Melanerpes erythrocephalus*	√ br	√ br	√	owe, ofh	WI
Red-bellied Woodpecker	*Melanerpes carolinus*	√ br	√ br	√ br	sub, owe	WI
Yellow-bellied Sapsucker	*Sphyrapicus varius*	√ br	√	√	sub, owe	WI
Downy Woodpecker	*Picoides pubescens*	√ br	√ br	√ br	sub, owe	WI
Hairy Woodpecker	*Picoides villosus*	√ br	√ br	√ br	sub, owe, for	WI
Red-cockaded Woodpecker	*Picoides borealis*	xtp √ (br)	[√]		con	–
Northern Flicker	*Colaptes auritus*	√ br	√ br	√ br	sub, owe, for	WI
Pileated Woodpecker	*Dryocopus pileatus*	√ br	√ br	√ br	for, sub	WI
Crested Caracara	*Caracara cheriway*	√	√		–	–
American Kestrel	*Falco sparverius*	√ br	√ br	√ br	agf, ofh	WI
Merlin	*Falco columbarius*	√	√	√	gen, tid, bea	WI
Gyrfalcon	*Falco rusticolus*	√	√		–	–
Peregrine Falcon	*Falco peregrinus*	√ br	√ br	√ br	gen, tid, bea	WI
Carolina Parakeet	*Conuropsis carolinensis*	ext √	ext [√]	ext √	last observed in Region in 1865	
Olive-sided Flycatcher	*Contopus cooperi*	√	√	√	owe	WI
Eastern Wood-Pewee	*Contopus virens*	√ br	√ br	√ br	for	WI
Yellow-bellied Flycatcher	*Empidonax flaviventris*	√	√	√	owe	WI
Acadian Flycatcher	*Empidonax virescens*	√ br	√ br	√ br	for	WI
Alder Flycatcher	*Empidonax alnorum*	√ br	√	√	swa	WI
Willow Flycatcher	*Empidonax traillii*	√ br	√ br	√ br	swa	WI
Least Flycatcher	*Empidonax minimus*	√ br	√ (br)	√	for	WI
Hammond's Flycatcher	*Empidonax hammondii*	√	√		–	–
Gray Flycatcher	*Empidonax wrightii*		√		–	–
Dusky Flycatcher	*Empidonax oberholseri*		√	√	–	–
Pacific-slope/Cordilleran Flycatcher	*Empidonax difficilis/occidentalis*	√			–	
Eastern Phoebe	*Sayornis phoebe*	√ br	√ br	√ br	agr, owe, sub	WI
Say's Phoebe	*Sayornis saya*	√	√		–	–
Vermilion Flycatcher	*Pyrocephalus rubinus*	√	√		–	–
Ash-throated Flycatcher	*Myiarchus cinerascens*	√	√	√	–	–
Great Crested Flycatcher	*Myiarchus crinitus*	√ br	√ br	√ br	owe, for	WI
Tropical Kingbird	*Tyrannus melancholicus*	√	√		–	–
Couch's Kingbird	*Tyrannus couchii*	√			–	–

J	F	M	A	M	J	J	A	S	O	N	D	spring extreme date	spring peak	fall peak	fall extreme date
●	●	●	·	·	·	·	●	·	·	●	●	4-May			11-Oct
·	·	●	·	○	○	○	○	○	●	●	·	10-May	mid-Mar	early Nov	29-Sep
●	●	●	●	●	●	●	●	●	●	●	●				
·	·	·	●	●	●	●	●	●	●	·	·		mid-Apr	mid-Sep	
●	●	●	●	●	●	●	●	●	●	●	●				
●	●	●	●	·	·	·	●	●	●	●	●		late Mar	mid-Oct	
●	●	●	●	●	●	●	●	●	●	●	●				
●	●	●	●	●	●	●	●	●	●	●	●				
●	●	●	⬤	⬤	●	●	●	⬤	⬤	●	●		early Apr	Late Sep	
●	●	●	●	●	●	●	●	●	●	●	●				
○		○						○			○				
●	●	●	●	●	●	●	●	●	●	●	●		early Apr	early Oct	
○	○	·	●	·	○	○	·	●	●	·	·	3-Jun	late Apr	early Oct	19-Jul
○	○	○								○	○				
●	●	●	●	●	●	●	●	●	●	●	●			early Oct	
			○	·	○	○	·	●	○	○		24-Apr	mid-May	mid-Sep	7-Nov
			·	●	●	●	●	●	●	●	·	13-Apr	early May	early Sep	16-Nov
			·	·	·	●	●	·				4-May		early Sep	26-Oct
			·	●	●	●	●	●	○			13-Apr	early May	late Aug	28-Oct
			○	●	●	·	●	·				29-Apr	late May	early Sep	27-Sep
			●	●	·	●	●	○				1-May	late May	late Aug	1-Oct
			○	●	●	·	●	●	·			16-Apr	mid-May	early Sep	18-Nov
								○	○	○					
										○	○				
○	○								○						
									○						
●	●	●	●	●	●	●	●	●	●	●	●		early Apr	early Oct	
○							○	○	○	○					
○		○		·			○	○	○		○				
○							○	○	○	○					
	○	●	●	●	●	●	●	●	○			15-Mar	Mid-May	late Aug	12-Nov
○								○		○					
									○						

Common name	Species binomen	MD	DEL	DC	Favored habitats	Provinces
Western Kingbird	*Tyrannus verticalis*	√	√	√	–	WI
Eastern Kingbird	*Tyrannus tyrannus*	√ br	√ br	√ br	agf, ofh, fwm	WI
Gray Kingbird	*Tyrannus dominicensis*	√	√		–	–
Scissor-tailed Flycatcher	*Tyrannus fortificatus*	√	√		–	–
Fork-tailed Flycatcher	*Tyrannus savana*	√	√		–	–
Loggerhead Shrike	*Lanius ludovicianus*	√ (br)	√ (br)	√	agf	ES, PI, RV
Northern Shrike	*Lanius excubitor*	√	√	√	agf	WI
White-eyed Vireo	*Vireo griseus*	√ br	√ br	√ br	ofh, swa	WI
Bell's Vireo	*Vireo bellii*	√		√	–	–
Yellow-throated Vireo	*Vireo flavifrons*	√ br	√ br	√ br	owe, for, lak	WI
Blue-headed Vireo	*Vireo solitarius*	√ br	√	√	for	WI
Warbling Vireo	*Vireo gilvus*	√ br	√ br	√ br	ofh, owe	WI
Philadelphia Vireo	*Vireo philadelphicus*	√	√	√	for, owe	WI
Red-eyed Vireo	*Vireo olivaceus*	√ br	√ br	√ br	for	WI
Blue Jay	*Cyanocitta cristata*	√ br	√ br	√ br	gen	WI
American Crow	*Corvus brachyrhynchos*	√ br	√ br	√ br	gen	WI
Fish Crow	*Corvus ossifragus*	√ br	√ br	√ br	gen, tid	ES, WS, PI, RV
Common Raven	*Corvus corax*	√ br	√	√	for	AH, RV, PI
Horned Lark	*Eremophila alpestris*	√ br	√ br	√	agf	WI
Purple Martin	*Progne subis*	√ br	√ br	√ br	agf, sub	WI
Tree Swallow	*Tachycineta bicolor*	√ br	√ br	√ br	lak, agf, ofh	WI
Northern Rough-winged Swallow	*Stelgidopteryx serripennis*	√ br	√ br	√ br	sub, fwm, swa	WI
Bank Swallow	*Riparia riparia*	√ br	√ br	√	ofh, agf	ES, WS, PI, RV
Cliff Swallow	*Petrochelidon pyrrhonota*	√ br	√ br	√	lak, fwm, agf	WI
Cave Swallow	*Petrochelidon fulva*	√	√	√	–	–
Barn Swallow	*Hirundo rustica*	√ br	√ br	√ br	gen, agf, tid	WI
Carolina Chickadee	*Poecile carolinensis*	√ br	√ br	√ br	gen, sub	ES, WS, PI, RV
Black-capped Chickadee	*Poecile atricapillus*	√ br	√	√	for, owe	AH, RV
Boreal Chickadee	*Poecile hudsonicus*	√	√		–	–
Tufted Titmouse	*Baeolophus bicolor*	√ br	√ br	√ br	gen	WI
Red-breasted Nuthatch	*Sitta canadensis*	√ br	√	√	con, for, owe	WI
White-breasted Nuthatch	*Sitta carolinensis*	√ br	√ br	√ br	sub, for, owe	WI
Brown-headed Nuthatch	*Sitta pusilla*	√ br	√ br		con	ES
Brown Creeper	*Certhia americana*	√ br	√ br	√	for, con	WI
Rock Wren	*Salpinctes obsoletus*	√			–	–

J	F	M	A	M	J	J	A	S	O	N	D	spring extreme date	spring peak	fall peak	fall extreme date
○	○	○	○	○	○	○	●	●	●	○					23-Aug
○	●	●	●	●	●	●	●	●	●	●	○	14-Mar	early May	mid-Aug	4-Jan
			○	○	○	○	○	○	○	○					
		○	○	○	○	○	○	○	○		○				
			○					○	○						
○	○	○	○	○	○	○	○	○	○	○					
○	○	○	○						○	○	○	13-Apr			13-Oct
○		○	●	●	●	●	●	●	●	○	○	26-Mar	early May	mid-Sep	
								○							
			●	●	●	●	●	●	○	○		5-Apr	mid-May	early Sep	9-Nov
○		●	●	●	●	●	●	●	●	●	○	23-Mar	late Apr	early Oct	
		○	●	●	●	●	●	●	●	○	○	10-Apr	early May	early Sep	27-Nov
		○	●			●		●	●			27-Apr		late Sep	9-Nov
		●	●	●	●	●	●	●	●	●		2-Apr	early May	mid-Sep	24-Nov
●	●	●	●	●	●	●	●	●	●	●	●		late Apr	early Oct	
●	●	●	●	●	●	●	●	●	●	●	●				
●	●	●	●	●	●	●	●	●	●	●	●				
●	●	●	●	●	●	●	●	●	●	●	●				
●	●	●	●	●	●	●	●	●	●	●	●		late Feb	late Nov	
	○	●	●	●	●	●	●	●	○			9-Feb	late Apr	early Aug	23-Oct
●	●	●	●	●	●	●	●	●	●	●	●		mid-Apr	early Oct	
○		●	●	●	●	●	●	●	●	●	○	5-Mar	early Apr	early Sep	7-Dec
	○	●	●	●	●	●	●	●	●	○		29-Mar	early May	late Jul	17-Nov
	○	●	●	●	●	●	●	●	○			21-Mar	early May	early Aug	26-Oct
								○	●	○				mid-Nov	17-Dec
○	○	○	●	●	●	●	●	●	●	○	○		late Apr	early Aug	27-Dec
●	●	●	●	●	●	●	●	●	●	●	●				
●	●	●	●	●	●	●	●	●	●	●	●			late Nov	
○	○	○	○							○	○				
●	●	●	●	●	●	●	●	●	●	●	●				
●	●	●	●	●	●	●	●	●	●	●	●	30-May		mid-Oct	12-Jul
●	●	●	●	●	●	●	●	●	●	●	●				
●	●	●	●	●	●	●	●	●	●	●	●				
●	●	●	●	●	●	●	●	●	●	●	●		late Mar	late Oct	
								○							

Common name	Species binomen	MD	DEL	DC	Favored habitats	Provinces
House Wren	*Troglodytes aedon*	√ br	√ br	√ br	sub, owe	WI
Winter Wren	*Troglodytes hiemalis*	√ br	√	√	swa, for	WI
Sedge Wren	*Cistothorus platensis*	√ br	√ br	√	fwm, tid	ES, WS, AH
Marsh Wren	*Cistothorus palustris*	√ br	√ br	√ br	tid, fwm	ES, WS
Carolina Wren	*Thryothorus ludovicianus*	√ br	√ br	√ br	gen, sub	WI
Bewick's Wren	*Thryomanes bewickii*	xtp √ (br)	√	√	–	–
Blue-gray Gnatcatcher	*Polioptila caerulea*	√ br	√ br	√ br	owe	WI
Golden-crowned Kinglet	*Regulus satrapa*	√ br	√ br?	√	con	WI
Ruby-crowned Kinglet	*Regulus calendula*	√	√	√	con, owe	WI
Northern Wheatear	*Oenanthe oenanthe*	√	√		–	–
Eastern Bluebird	*Sialia sialis*	√ br	√ br	√ br	ofh, agf	WI
Mountain Bluebird	*Sialia currucoides*	√			–	–
Townsend's Solitaire	*Myadestes townsendi*	√			–	–
Veery	*Catharus fuscescens*	√ br	√ br	√ br	for	WI
Gray-cheeked Thrush	*Catharus minimus*	√	√	√	for	WI
Bicknell's Thrush	*Catharus bicknelli*	√	√	(√)	for	WI
Swainson's Thrush	*Catharus ustulatus*	√ (br)	√	√	for	WI
Hermit Thrush	*Catharus guttatus*	√ br	√	√	for, owe	WI
Wood Thrush	*Hylocichla mustelina*	√ br	√ br	√ br	for	WI
Fieldfare	*Turdus pilaris*		√		–	–
American Robin	*Turdus migratorius*	√ br	√ br	√ br	gen, sub	WI
Varied Thrush	*Ixoreus naevius*	√	√		–	–
Gray Catbird	*Dumetella carolinensis*	√ br	√ br	√ br	gen, sub, ofh	WI
Brown Thrasher	*Toxostoma rufum*	√ br	√ br	√ br	ofh, owe	WI
Sage Thrasher	*Oreoscoptes montanus*	√	√		–	–
Northern Mockingbird	*Mimus polyglottos*	√ br	√ br	√ br	gen, sub	WI
European Starling	*Sturnus vulgaris*	√ br	√ br	√ br	gen, sub	WI
Bohemian Waxwing	*Bombycilla garrulus*	√	[√]	√	–	–
Cedar Waxwing	*Bombycilla cedrorum*	√ br	√ br	√ br	owe, gen	WI
House Sparrow	*Passer domesticus*	√ br	√ br	√ br	sub, agf, ofh	WI
American Pipit	*Anthus rubescens*	√	√	√	agf	WI
Evening Grosbeak	*Coccothraustes vespertinus*	√	√	√	sub, ofh, owe	WI
Pine Grosbeak	*Pinicola enucleator*	√	√		–	–
House Finch	*Haemorhous mexicanus*	√ br	√ br	√ br	sub, agf	WI
Purple Finch	*Haemorhous purpureus*	√ br	√	√	con, owe	WI

J	F	M	A	M	J	J	A	S	O	N	D	spring extreme date	spring peak	fall peak	fall extreme date
•	○	•	●	●	●	●	●	●	●	●	•		early May	mid-Sep	
●	●	●	●	•	•	•	•	●	●	●	●		late Mar	late Oct	
•	•	○	○	○	○	○	○	•	•	•	•				
•	•	●	●	●	●	●	●	●	●	●	•		mid-Apr		
●	●	●	●	●	●	●	●	●	●	●	●				
○	○	●	●	●	●	●	●	●	●	•	○	9-Mar	late Apr	mid-Aug	
●	●	●	●	•	•	•	•	●	●	●	●	15-May	late Mar	early Nov	6-Sep
●	●	●	●	●	○	•	●	●	●	●	●	23-May	late Apr	mid-Oct	10-Aug
						○		○			○				
●	●	●	●	●	●	●	●	●	●	●	●		mid-Mar	late Oct	
										○	○				
	○		○												
			●	●	●	●	●	●	●	○		7-Apr	early May	early Sep	7-Nov
			○	●	•	○		●	●	○		25-Apr	late May	late Sep	18-Nov
			•			•	•					2-May	late May	mid-Oct	31-Oct
			●	●	•	○	●	●	●	•		15-Apr	late May	late Sep	27-Nov
●	●	●	●	•	•	•	•	●	●	●	●	28-May	mid-Apr	late Oct	26-Aug
○	○	•	●	●	●	●	●	●	●	•	○	7-Apr	early May	mid-Sep	4-Feb
	○		○												
●	●	●	●	●	●	●	●	●	●	●	●		mid-Mar	late Oct	
○	○	○	○						○	○					
•	•	•	•	●	•	●	●	●	•	•	•		early May	late Sep	
●	●	●	●	●	●	●	●	●	•	•	●		mid-Apr	late Sep	
						○									
●	●	●	●	●	●	●	●	●	●	●	●				
●	●	●	●	●	●	●	●	●	●	●	●				
○	○	○													
●	●	●	●	●	●	●	●	●	●	●	●				
●	●	●	●	●	●	●	●	●	●	●	●				
●	●	●	●	•		○	●	●	●	●	●	29-May	early Apr	mid-Nov	17-Aug
○	○	○	○	○	○		○	○	○	○	○	late June			16-Sep
○	○	○							○	○					
●	●	●	●	●	●	●	●	●	●	●	●				
●	●	●	●	•	•	•	•	•	●	●	●	4-Jun	mid-Apr	late Oct	28-Aug

Common name	Species binomen	MD	DEL	DC	Favored habitats	Provinces
Common Redpoll	*Acanthis flammea*	√	√	√	sub, ofh	WI
Hoary Redpoll	*Acanthis hornemanni*	√	[√]		sub, ofh	WI
Red Crossbill	*Loxia curvirostra*	√	√	√	con, gen	WI
White-winged Crossbill	*Loxia leucoptera*	√	√	√	con, gen	WI
Pine Siskin	*Spinus pinus*	√ br	√	√	gen	WI
Lesser Goldfinch	*Spinus psaltria*		√		–	–
American Goldfinch	*Spinus tristis*	√ br	√ br	√ br	gen, sub	WI
Lapland Longspur	*Calcarius lapponicus*	√	√	√	agf, bea	ES, WS, PI, RV
Chestnut-collared Longspur	*Calcarius ornatus*	√			–	–
Smith's Longspur	*Calcarius pictus*	√			–	–
Snow Bunting	*Plectrophenax nivalis*	√	√	√	bea, agf	WI
Green-tailed Towhee	*Pipilo chlorurus*	√	√		–	–
Spotted Towhee	*Pipilo maculatus*	√			–	–
Eastern Towhee	*Pipilo erythrophthalmus*	√ br	√ br	√ br	ofh, sub, owe	WI
Cassin's Sparrow	*Peucaea casinii*	√			–	–
Bachman's Sparrow	*Peucaea aestivalis*	xtp √ (br)		xtp √	–	–
American Tree Sparrow	*Spizelloides arborea*	√	√	√	ofh, agf	WI
Chipping Sparrow	*Spizella passerina*	√ br	√ br	√ br	agf, sub, owe	WI
Clay-colored Sparrow	*Spizella pallida*	√	√	√	owe, agf	AH, WS, ES
Field Sparrow	*Spizella pusilla*	√ br	√ br	√ br	agf, ofh	WI
Vesper Sparrow	*Pooecetes gramineus*	√ br	√ br	√	agf	WI
Lark Sparrow	*Chondestes grammacus*	√ (br)	√	√	agf, ofh	WI
Lark Bunting	*Calamospiza melanocorys*	√	√		–	–
Savannah Sparrow	*Passerculus sandwichensis*	√ br	√ (br)	√	agf, bea, ofh	WI
Grasshopper Sparrow	*Ammodramus savannarum*	√ br	√ br	√	ofh, agf	WI
Baird's Sparrow	*Ammodramus bairdii*	√			–	–
Henslow's Sparrow	*Ammodramus henslowii*	√ br	√ (br)	√	ofh	AH
LeConte's Sparrow	*Ammodramus leconteii*	√	√	√	–	–
Nelson's Sparrow	*Ammodramus nelsoni*	√	√	√	tid	ES
Saltmarsh Sparrow	*Ammodramus caudacutus*	√ br	√ br		tid	ES
Seaside Sparrow	*Ammodramus maritimus*	√ br	√ br	√	tid	ES
Fox Sparrow	*Passerella iliaca*	√	√	√	owe, ofh, sub	WI
Song Sparrow	*Melospiza melodia*	√ br	√ br	√ br	gen, sub, ofh	WI
Lincoln's Sparrow	*Melospiza lincolnii*	√	√	√	ofh	WI
Swamp Sparrow	*Melospiza georgiana*	√ br	√ br	√ br	fwm, bay	WI

J	F	M	A	M	J	J	A	S	O	N	D	spring extreme date	spring peak	fall peak	fall extreme date
●	●	○	○	○					○	○	○	10-May			23-Oct
○	○	○	○								○				
○	○	○	○	○	○		○	○	○	○	○	21-Jun			11-Aug
○	○	○	○	○					○	○	○	18-May			17-Oct
●	●	●	●	●	●	●	●	●	●	●	●				
						○									
⬤	⬤	⬤	⬤	⬤	⬤	⬤	⬤	⬤	⬤	⬤	⬤				
●	●	○	○					○	○	●	●	1-Apr	mid-Feb	late Nov	1-Oct
○						○									
○								○	●	●					
●	●	●	○						○	●	●	8-Apr	mid-Feb	mid-Nov	8-Oct
○	○	○	○												
			○												
●	●	●	●	●	●	●	●	●	●	●	●		late Apr	mid-Oct	
						○									
●	●	●	○	○					●	●	●	early Apr	mid-mar	early Dec	
●	●	●	⬤	⬤	⬤	⬤	⬤	●	●	●	●		late Mar	late Oct	
○	○	○	○	○			○	○	○	○	○				
●	●	●	●	●	●	●	●	●	●	●	●		mid-Apr	late Oct	
●	●	●	●	●	●	●	●	●	●	●	●		early Apr	late Oct	
○	○	○		○	○	○	●	●	○	○					
●	●	●		○		●	●	●	●	●	●				
●	●	●	●	●	●	●	●	●	●	●	●		mid-Apr	mid-Oct	
○	○	○	●	●	●	●	●	●	○	○			early May	late Aug	
							○								
		○	●	●	○	○	○	○	○			5-Apr			4-Nov
○	○	○	○	○			○	○	○	○		7-May			29-Sep
●	●	●	●	●	○		○	●	●	●	●	5-Jun	early May	mid-Oct	12-Sep
●	●	●	●	●	●	●	●	●	●	●	●				
●	●	●	●	●	●	●	●	●	●	●					
●	●	●	●	○			○	●	●	●	●	13-May	late Mar	early Nov	28-Sep
⬤	⬤	⬤	⬤	⬤	⬤	⬤	⬤	⬤	⬤	⬤	⬤				
●	○	○	●	●	○		●	●	●	●	●	4-Jun	mid-May	late Sep	1-Sep
●	●	●	●	●	●	●	●	●	●	●	●		mid-Apr	mid-Oct	

Common name	Species binomen	MD	DEL	DC	Favored habitats	Provinces
White-throated Sparrow	*Zonotrichia albicollis*	√	√	√	gen, sub, ofh	WI
Harris's Sparrow	*Zonotrichia querula*	√	√		–	–
White-crowned Sparrow	*Zonotrichia leucophrys*	√	√	√	ofh, agf	WI
Golden-crowned Sparrow	*Zonotrichia atricapilla*	√			–	–
Dark-eyed Junco	*Junco hyemalis*	√ br	√	√	sub, ofh	WI
Yellow-breasted Chat	*Icteria virens*	√ br	√ br	√ br	ofh	WI
Yellow-headed Blackbird	*Xanthocephalus xanthocephalus*	√	√	√	–	–
Bobolink	*Dolichonyx oryzivorus*	√ br	√ br?	√	ofh, agf	WI
Eastern Meadowlark	*Sturnella magna*	√ br	√ br	√ br?	agf, ofh	WI
Western Meadowlark	*Sturnella neglecta*	√			–	–
Orchard Oriole	*Icterus spurius*	√ br	√ br	√ br	ofh, owe, swa	WI
Bullock's Oriole	*Icterus bullockii*	√		√	–	–
Baltimore Oriole	*Icterus galbula*	√ br	√ br	√ br	owe, sub	WI
Red-winged Blackbird	*Agelaius phoeniceus*	√ br	√ br	√ br	gen, agf, tid	WI
Shiny Cowbird	*Molothrus bonariensis*	√			–	–
Brown-headed Cowbird	*Molothrus ater*	√ br	√ br	√ br	agf, sub, gen	WI
Rusty Blackbird	*Euphagus carolinus*	√	√	√	agf, swa	WI
Brewer's Blackbird	*Euphagus cyanocephalus*	√	√		–	–
Common Grackle	*Quiscalus quiscula*	√ br	√ br	√ br	gen, sub, ofh	WI
Boat-tailed Grackle	*Quiscalus major*	√ br	√ br		tid, bea	ES
Ovenbird	*Seiurus aurocapilla*	√ br	√ br	√ br?	for	WI
Worm-eating Warbler	*Helmitheros vermivorum*	√ br	√ br	√	for	WI
Louisiana Waterthrush	*Parkesia motacilla*	√ br	√ br	√ br?	for	WI
Northern Waterthrush	*Parkesia noveboracensis*	√ br	√	√	swa, for	WI
Golden-winged Warbler	*Vermivora chrysoptera*	√ br	√	√	ofh, owe	WI
Blue-winged Warbler	*Vermivora cyanoptera*	√ br	√ br	√	ofh, owe	WI
Black-and-white Warbler	*Mniotilta varia*	√ br	√ br	√ br	for	WI
Prothonotary Warbler	*Protonotaria citrea*	√ br	√ br	√ br	swa	ES, WS, PI, RV
Swainson's Warbler	*Limnothlypis swainsonii*	√ (br)	√ (br)		swa, for	ES
Tennessee Warbler	*Oreothlypis peregrina*	√	√	√	owe	WI
Orange-crowned Warbler	*Oreothlypis celata*	√	√	√	ofh	WI
Nashville Warbler	*Oreothlypis ruficapilla*	√ br	√	√	owe, con	WI
Virginia's Warbler	*Oreothlypis virginiae*	√			–	–
Connecticut Warbler	*Oporornis agilis*	√	√	√	ofh	WI
Mourning Warbler	*Geothlypis philadelphia*	√ br	√	√	ofh	WI

J	F	M	A	M	J	J	A	S	O	N	D	spring extreme date	spring peak	fall peak	fall extreme date
⬤	⬤	⬤	●	●	•	·	·	●	●	⬤	⬤		late Apr	late Oct	
○	○	○	○	○				○	○	○					
⬤	⬤	●	●	●	•			•	●	●	⬤	16-Jun	late Apr	late Oct	18-Sep
○	○									○					
⬤	⬤	●	●	●	•	•	•	●	●	⬤	⬤		late Mar	mid-Nov	6-Sep
○	○		●	●	●	●	●	●	●	●	•	3-Apr	mid-May	mid-Sep	
•	•	•	•	•	○	○	•	•	•	•	•	16-May			3-Aug
			●	●	●	●	●	●	●	•	•	8-Apr	mid-May	early Sep	late Dec
●	•	●	●	●	●	●	●	●	●	●	●				
○						○	○								
		○	●	●	●	●	●	●	•			27-Mar	early May	early Aug	12-Oct
○	○	○						○	○	○					
○	○	•	●	●	●	●	●	●	•	○			early May	early Sep	
⬤	⬤	⬤	⬤	⬤	⬤	⬤	⬤	⬤	⬤	●	⬤				
○								○	○	○					
●	●	●	●	●	●	●	●	●	●	●	●				
●	●	●	●	•	○			•	●	●	●	11-Jun	mid-May	early Nov	12-Sep
○	○	○	○					○	○	○	○	24-Apr			29-Sep
⬤	⬤	⬤	⬤	⬤	⬤	⬤	⬤	⬤	⬤	⬤	⬤				
●	●	●	●	●	●	●	●	●	●	●	●				
○	○	•	●	●	●	●	●	●	●	•	•	10-Mar	early May	mid-Sep	
	•	●	●	●	●	●	•	•				28-Mar	mid-May	early Aug	13-Oct
	○	•	●	●	●	●	•	○				16-Feb	mid-Apr	early Aug	7-Oct
○		•	●	●	•	●	●	•	○	○		14-Apr	early May	mid-Sep	13-Dec
		•	•	•	•	•	•	○				19-Apr	early May	mid-Aug	6-Oct
		•	●	●	●	•	●	○				10-Apr	early May	late Aug	26-Oct
○		○	●	●	●	●	●	●	•	•	•	18-Mar	late Apr	mid-Sep	
		○	●	●	●	●	●	○				31-Mar	late Apr	mid-Aug	27-Oct
			○	○	○	○	○					9-Apr			30-Aug
		•	●	●	•		●	●	●	•		19-Apr	mid-May	mid-Sep	27-Nov
●	•	•	•		•			•	●	●	●	24-May	early Apr	mid-Nov	
○	○	○	•	●	•	•	●	●	●	●	•	10-Apr	early May	late Sep	
○	○	○													
			•				•	●	●	•		5-May		mid-Sep	7-Nov
			●	•	•	•	●	•	○			2-May	late May	early Sep	2-Nov

Common name	Species binomen	MD	DEL	DC	Favored habitats	Provinces
Kentucky Warbler	Geothlypis formosa	√ br	√ br	√ (br)	for	WI
Common Yellowthroat	Geothlypis trichas	√ br	√ br	√ br	swa, tid	WI
Hooded Warbler	Setophaga citrina	√ br	√ br	√ (br)	for	WI
American Redstart	Setophaga ruticilla	√ br	√ br	√ (br)	for	WI
Cape May Warbler	Setophaga tigrina	√	√	√	owe, con	WI
Cerulean Warbler	Setophaga cerulea	√ br	√ br	√	for	WI
Northern Parula	Setophaga americana	√ br	√ br	√ br	swa, lak, for	WI
Magnolia Warbler	Setophaga magnolia	√ br	√	√	for	WI
Bay-breasted Warbler	Setophaga castanea	√	√	√	for	WI
Blackburnian Warbler	Setophaga fusca	√ br	√	√	for, con	WI
Yellow Warbler	Setophaga petechia	√ br	√ br	√ br	swa, lak	WI
Chestnut-sided Warbler	Setophaga pensylvanica	√ br	√ (br)	√	swa	WI
Blackpoll Warbler	Setophaga striata	√	√	√	for, owe	WI
Black-throated Blue Warbler	Setophaga caerulescens	√ br	√	√	for	WI
Palm Warbler	Setophaga palmarum	√	√	√	agf, ofh	WI
Pine Warbler	Setophaga pinus	√ br	√ br	√ br	con	WI
Yellow-rumped Warbler	Setophaga coronata	√ br	√	√	gen	WI
Yellow-throated Warbler	Setophaga dominica	√ br	√ br	√ br	con, lak	WI
Prairie Warbler	Setophaga discolor	√ br	√ br	√	ofh	WI
Black-throated Gray Warbler	Setophaga nigrescens	√	[√]	√	–	--
Townsend's Warbler	Setophaga townsendi	√			–	–
Black-throated Green Warbler	Setophaga virens	√ br	√	√	for	WI
Canada Warbler	Cardellina canadensis	√ br	√	√	for, owe	WI
Wilson's Warbler	Cardellina pusilla	√	√	√	owe, swa	WI
Summer Tanager	Piranga rubra	√ br	√ br	√	owe, con	ES, WS, PI
Scarlet Tanager	Piranga olivacea	√ br	√ br	√ br	for, owe	WI
Western Tanager	Piranga ludoviciana	√	√		–	–
Northern Cardinal	Cardinalis cardinalis	√ br	√ br	√ br	sub, gen	WI
Rose-breasted Grosbeak	Pheucticus ludovicianus	√ br	√ (br)	√	for, owe	WI
Black-headed Grosbeak	Pheucticus melanocephalus	√	√	√	–	–
Blue Grosbeak	Passerina caerulea	√ br	√ br	√ br?	ofh, owe	ES, WS, PI
Lazuli Bunting	Passerina amoena	√			–	–
Indigo Bunting	Passerina cyanea	√ br	√ br	√ br	ofh, owe, gen	WI
Painted Bunting	Passerina ciris	√	√	√	–	–
Dickcissel	Spiza americana	√ br	√ br?	√	ofh, agf	ES, WS, PI

J	F	M	A	M	J	J	A	S	O	N	D	spring extreme date	spring peak	fall peak	fall extreme date
			●	●	●	●	•	•				10-Apr	early May	late Aug	27-Oct
•	•	•	●	●	●	●	●	●	●	●	•		mid-May	mid-Sep	
			●	●	●	●	●	•	•			6-Apr	early May	mid-Sep	30-Oct
			●	●	●	●	●	●	●	•	○	27-Mar	mid-May	mid-Sep	6-Dec
○			•	•	○		●	●	●	○	○	17-Apr	mid-May	late Sep	
			●	●	●	●	•	○	○			16-Apr	early May	late Aug	12-Oct
○		•	●	●	●	●	●	●	•	•	10-Mar	late Apr	mid-Sep	4-Dec	
			•	●	●	●	●	●	●	•		15-Apr	mid-May	mid-Sep	16-Nov
			○	●	•	•	•	●	●	○		22-Apr	mid-May	mid-Sep	28-Nov
			●	●	●	●	●	●	●	○		19-Apr	early May	mid-Sep	19-Nov
○			●	●	●	●	●	●	●	•	○	4-Apr	early May	early Aug	25-Dec
			●	●	●	●	●	●	●			15-Apr	early May	mid-Sep	31-Oct
			•	●	●	•	•	●	●	•		21-Apr	mid-May	early Oct	23-Nov
			●	●	●	●	●	●	●	○		3-Apr	early May	late Sep	9-Dec
●	•	•	●	●		•	●	●	●	●		late Apr	late Sep		
●	•	●	●	●	●	●	●	●	●	●	●		early Apr		
●	●	●	●	●	•	•	•	●	●	●	●		early May	mid-Oct	
○	○	•	●	●	●	●	●	•	○	○		mid-Apr	early Sep		
○	○	○	●	●	●	●	●	●	•	○		mid-May	mid-Sep		
○							○	○	○	○					
○		○						○							
			●	●	●	●	●	●	●	•		1-Apr	early May	early Oct	22-Nov
		○	●	●	●	●	●	●			19-Apr	mid-May	late Aug	31-Oct	
○			•	●	•	●	●	●	•	○		19-Apr	mid-May	mid-Sep	
○	○	○	•	●	●	●	●	•	○	○		early May	early Sep		
			●	●	●	●	●	●	●	•		9-Apr	mid-May	mid-Sep	23-Nov
○	○		○	○			○	○	○	○					
●	●	●	●	●	●	●	●	●	●	●	●				
○	○	•	●	●	●	●	●	●	•	○		early May	mid-Sep		
○	○	○	○							○					
			●	●	●	●	●	●	•	○	1-Apr	early May	mid-Sep	3-Dec	
○	○	○	○					○		○					
○	○	○	●	●	●	●	●	●	•	○		mid-May	late Sep		
○	○	○	○	○	○	○	○	○	○	○	○				
•	•	•	•	●	●	●	●	●	•	•	•				

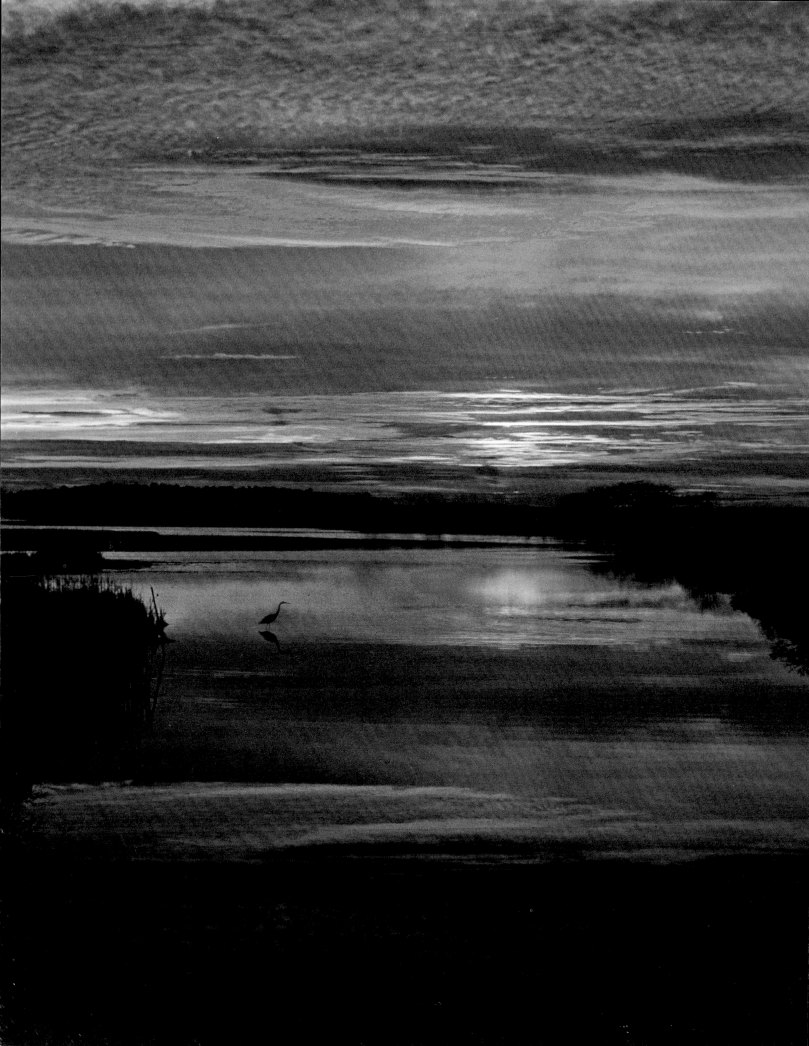

Best Birding Localities

This section is a birder's guide to the best birding sites in the Region. These sites are grouped by province and listed alphabetically. A final section details nationally significant birding sites outside our Region that are within a half-day's drive. All of these sites are shown on the map on the endpapers and are identifiable by the site number used below in the text. For each, we provide a website (when available), a GPS-ready address, and additional directional details as needed to find particular birding localities. In many instances we have dispensed with the comprehensive driving directions because of the now near-universal availability of either Google Maps or car-based GPS. Many of the accounts here are derived from various local birding websites and other bird-finding guides. We thank those sources for these narratives. We also note that *Finding Birds in the National Capital Area* by Claudia Wilds, though out of print, remains the most comprehensive birding site guide for the Region.

Fees for visiting state parks and wildlife areas are increasing. Because these are subject to change, we typically do not provide the specifics of entrance costs but, instead, encourage you to visit the area's website to learn of the latest seasonal fees. At this time, there is no charge to bird Indian River Inlet, whereas the out-of-state fee to visit Cape Henlopen SP is $10 per car. Since July 2017, a Conservation Access Pass is required for any motor vehicle entering a Delaware State Wildlife Area. Delaware State Parks charge an entrance fee from March 1 to November 30, which is double for those with out-of-state license plates. For those on a budget, some advance online research is worthwhile.

A lone Great Blue Heron awaits a last meal as sunset sweeps over the marsh at Blackwater NWR.

Eastern Shore

1. Abbott's Mill Nature Center. 3 miles southwest of Milford, DE. Set on the shore of a pristine mill pond, this site features a network of walking and paddling trails. It features good woodland birding at any season (conifers and deciduous), and the pond is good for ducks in winter. Permanent residents: Barred Owl and Pileated Woodpecker. Breeding birds: Prothonotary, Pine and other warblers, and a Purple Martin colony. The small nature center, operated by the Delaware Nature Society, maintains a fine collection of live specimens of native reptiles, amphibians, and fish. GPS address: 15411 Abbotts Pond Road, Milford, DE. Website: www.delaware naturesociety.orgAbbottsMillNatureCenter

2. Assateague Island State Park. Access via Route 611 south of Ocean City, MD. Assateague Island is a 37-mile-long island along the coasts of Maryland and Virginia. Most of the Maryland and Virginia portions are managed by the National Park Service as Assateague Island National Seashore. The southern end of Assateague Island is accessible via Chincoteague, VA (see "Sites Outside Our Region Worth Visiting" at the end of this chapter). The state of Maryland manages a 2-mile section as the As-

Perhaps the sand dunes of Assateague Island National Seashore feel a bit like home for this Snowy Owl visiting from the Arctic tundra.

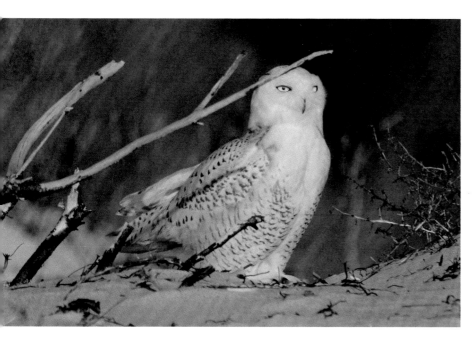

sateague SP. The island's rich mosaic of coastal dwarf forest, dune, and marsh habitats offers feeding and nesting opportunities for 300 species of shorebirds, songbirds, raptors, waterfowl, and waders. The National Seashore is a good place to look for Snowy Owl in irruption years. Northern Gannet is reliable offshore, with Common and Red-throated Loons flying north or south according to season. Bayside Camping Area in the National Seashore can produce rarities in fall and winter. During the summer months, wading birds, such as Great Egrets and Clapper Rails, hunt in the shallow waters along the marsh edge also populated by Saltmarsh Sparrows and Seaside Sparrows. In early spring, Piping Plovers arrive and begin to perform their elaborate territorial and courtship displays. GPS address: 6915 Stephen Decatur Highway, Berlin, MD. Websites: https://www.nps.gov/asis/index.htm; http://dnr.maryland.gov/publiclands/Pages/eastern /assateague.aspx

3. Assawoman Wildlife Area. 3 miles southwest of Bethany Beach, DE. Tucked just inside Delaware's southeastern corner, Assawoman Wildlife Area is a quiet oasis amid burgeoning summer beach communities. Given the refuge's bayside location, one might expect waterbirds to be the main attraction; however, the mix of Loblolly Pine forest and wildlife food crops is often excellent for landbirds, too. The main road leads to Mulberry Landing, passing an observation tower, which is worth the climb. In summer, flocks of Black Skimmers forage in the adjacent bodies of water, and egrets may blanket these in white. Check the wooded edges in this area for landbirds, too, including Brown-headed Nuthatch and Blue Grosbeak. Very good for waterfowl in winter and a regular location for Eurasian Wigeon. Directions for Assawoman Wildlife Area: From Bethany Beach, go west on Route 26 for 0.1 mile. Turn left (S) onto Kent Avenue and follow it 1.4 miles. Just after the Assawoman Canal Bridge, turn left (SW) onto Double Bridges Road. After 3.3 miles, turn left (SE) onto Camp Barnes Road.

Follow Camp Barnes Road, bearing left at 0.6 mile and continuing another 1.1 miles to the wildlife area entrance on right (Mulberry Landing Road). Website: http://www.ecodelaware.com/place.php?id=278

4. Blackwater National Wildlife Refuge. Located 12 miles south of Cambridge, MD, encompasses more than 29,000 acres of tidal marsh, mixed hardwood and Loblolly Pine forests, managed freshwater wetlands, impoundments, and croplands. It serves as an important resting and feeding area for migrating and wintering waterfowl and is one of the chief wintering areas for large flocks of Canada Geese. The refuge supports one of the highest concentrations of nesting Bald Eagles on the East Coast. The wildlife drive extends for 3.5 miles. Ross's Geese occur every year, but one must sort through flocks of Snow Geese to find one. The best time to view waterfowl is November through February. Wintering species include Tundra Swan, Canada and Snow Goose, and more than 20 duck species. Numerous marsh and shorebirds arrive in the spring and fall, searching for food in the mudflats and shallow waters of Blackwater River. The refuge woodlands provide a year-round home for owls, towhees, woodpeckers, Brown-headed Nuthatches, and Wild Turkey. Also look for the endemic Delmarva Fox Squirrel and the exotic Sika Deer. Visitor Center hours: Monday–Friday, 8 a.m.–4 p.m.; weekends, 9 a.m.–5 p.m. It is best to approach the refuge by birdy and less cluttered Egypt Road rather than busy Routes 16 and 335. GPS address: 2145 Key Wallace Drive, Cambridge, MD. Website: https://www.fws.gov/refuge/Blackwater/

5. Bombay Hook National Wildlife Refuge. 7 miles southeast of Smyrna, DE, is Delaware's single best-known birding site, with exceptional wildlife viewing throughout the year. The experience is centered around the wildlife drive that traverses freshwater and saltwater marshes, ponds, mudflats, woodlands, and fields. Visitors may park anywhere along the sides of this drive and scan the marshes or lakes from the comfort of their car. Raymond Pool is the most reliable spot in Delaware to find American Avocets and is often loaded with other shorebirds and waterfowl in season. Lighting here is most favorable in the morning. The number of shorebirds can vary dramatically over the course of the day so a revisit four to six hours later may yield different species and numbers. Shearness Pool hosts a great variety of waterbirds, as does the open area of salt marsh to its east, called Leatherberry Flats. The Snow Goose spectacle near the Allee House at Bombay Hook from late October into midwinter is often stunning and Bald Eagles are seen here year-round. The boardwalk walking trails are good places to see nesting marsh specialists, such as Marsh Wrens and Seaside Sparrows. The agricultural fields along Whitehall Neck Road are productive for "grass-pipers," including Buff-breasted Sandpiper and are popular with Horned Larks and meadowlarks in winter. Many of the rare birds recorded in Delaware were found at Bombay Hook, especially shorebirds and waterfowl. Visitor Center hours: Monday–Friday, 8 a.m.–4 p.m.; weekends, 9 a.m.–5 p.m. GPS address: 2591 Whitehall Neck Road, Smyrna, DE 19977 Website: https://www.fws.gov/refuge/Bombay_Hook/

6. Bill Burton Fishing Pier State Park. A fishing pier and state park on the north side of the Choptank River in Trappe, MD, opposite to the town of Cambridge and includes 25 acres of land upriver from the pier in Talbot County. Birdlife: The pier is an excellent observation spot for Osprey, Canada Geese, and a variety of ducks and shorebirds. The area is especially good for viewing Common Goldeneye, Common Loon, and Horned Grebe in breeding plumage before they depart in spring. In addition, for years now, locals and bird photographers have fed corn to various duck species at the end of Oakley Street and other spots along the Cambridge, MD, waterfront, on the south side of the Choptank. Large flocks of Canvasbacks, Lesser Scaup, and American Wigeons approach for the handouts of corn. A Bald Eagle or

two is usually seen, as well as gulls and diving ducks out on the Choptank. Ospreys nest on the bridge. Tips: Parking is sometimes difficult so be aware of property rights and observe the usual courtesies. On occasion, big Snow Goose flocks roost by day out on the Choptank. Best seasons: Fall migration and winter. The pier is located adjacent to Maryland Route 50 at the Frederick C. Malkus Bridge near Cambridge on the Eastern Shore. GPS address: 29761 Bolingbroke Point Drive, Trappe, MD. Website: http://dnr .maryland.gov/publiclands/Pages/eastern/choptank pier.aspx

7. Cape Henlopen State Park. This state park in Lewes, DE, has just about everything—ocean, bay, dunes, a hawk watch, pine forest, weedy fields, salt marsh, mudflats, and freshwater wetlands, all connected by an excellent road and trail network. The park is a good place to find a few Brown-headed Nuthatches and is perhaps the most reliable site in Delaware for Red-breasted Nuthatches. Note that one of the best birding areas in the park, Gordons Pond, is accessed from the north side of Rehoboth Beach, while all others listed here are reached via the main entrance east of Lewes. Check the habitat garden and feeders at the Seaside Nature Center for Brown-headed Nuthatches, and listen for them in the pines beyond the building. From the Cape Henlopen Point parking lot, you can look west (to your left as you face the point) to scan Delaware Bay or east to look over the ocean. The point is one of those magical birding spots where just about anything might turn up. It's an excellent spot for gulls, terns, loons, sea ducks, and shorebirds, including Piping Plovers, a few pairs of which nest here each summer in a roped-off area. The point is also a regular site for Snow Buntings in winter. A volunteer hawk watch is conducted from September through November, from atop a bunker in the ocean-side dunes, about 0.5 mile south of the Point. Visitors are welcome to participate. At the south end of the Lewes section of the park, the Fort Miles Historic Area and Herring Point offer commanding views

out over the ocean and have produced several rare sparrows and flycatchers. The rock jetties at Herring Point often have Purple Sandpipers from mid-October well into May. GPS address: 42 Cape Henlopen Drive, Lewes, DE. Website: www.destateparks .com/park/cape-henlopen/

8. Chino Farms. Chester River Field Research Station, Chestertown, MD. The field station was established in 1999 with the initiation of a project to restore a native grassland landscape habitat on 228 acres of farmland and a migratory bird banding station on Chino Farms. Recently merged with the Center for Environment & Society at Washington College, the station continues its research while providing educational opportunities for both the public and up-and-coming biologists. Washington College students team up with ecologists and colleagues from other institutions to study the impact of grassland restoration on migratory bird populations. Students are given a variety of opportunities to participate in field research projects through the Center for Environment & Society. Please contact the station regarding visits, volunteering, and internship opportunities. Tours and banding demonstrations are given with prior arrangement. The station welcomes bird clubs, scout groups, or families to learn more about the station's work. Migratory bird banding runs March through May and August through November. Breeding grassland studies are conducted May through August. More than 2,000 Grasshopper Sparrows have been banded. GPS address: Chino Farm Lane, Chestertown, MD. Website: https://www.washcoll.edu/centers/ces/crfrs/

9. Deal Island Wildlife Management Area, Dames Quarter, MD. Features 13,000 acres of tidal marshland, open water, forested wetlands, and a 2,800-acre impoundment in Dames Quarter, MD. There are 9 miles of flat trails suitable for hiking, nature photography, birding, hunting, and other recreational activities but these trails are not actively marked. Birdlife: Many species of waterfowl nest, feed, and migrate here. The island also supports one

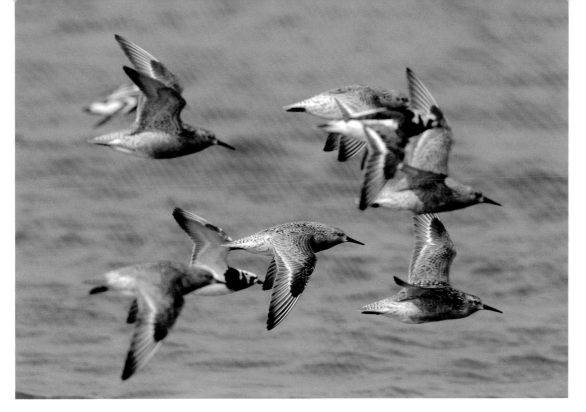

Strong binoculars will help pick out Red Knots among all the migrating shorebirds viewed from the DuPont Nature Center at Mispillion Inlet.

of the largest concentrations in the state of herons, egrets, and ibis. One of Maryland's few breeding populations of Black-necked Stilts thrives here. Mosquitoes and other biting insects as well as ticks are common from spring through early fall. Best season: Winter, for large numbers of waterfowl. Open all year, but portions may be closed during the hunting season. Directions: From US Route 13, take MD 363 west from Princess Anne about 11 miles to Deal Island, WMA. Marked parking areas located off Deal Island, Riley Roberts, and Drawbridge Roads. Website: http://dnr2.maryland.gov/wildlife /Pages/publiclands/eastern/dealisland.aspx

10. DuPont Nature Center at Mispillion Harbor Reserve. East of Milford, DE, off Route 36, the nature center is an excellent place to view shorebirds (especially Red Knots) in May. DNREC's DuPont Nature Center is a science-based educational and interpretive facility with interactive exhibits designed to connect people with the Delaware Bay's natural history and ecology. More than 130 species of birds, plus fish, shellfish, and other animals, can be found in the surrounding estuary habitat. Inside the center, visitors can view Horseshoe Crabs and shorebirds along the shoreline over 100 yards away using a remote camera and 42-inch plasma viewing

screen. Aquariums feature live Horseshoe Crabs, fish, shellfish, and terrapins. Not open in winter. The marshes along the entry road are the most reliable sites in the state for Clapper Rail and Seaside Sparrows. Slaughter Beach, 0.5 mile south of Mispillion, allows close-up views of feeding flocks of shorebirds and Horseshoe Crabs though be careful to maintain a respectful distance from the shorebirds. GPS address: 2992 Lighthouse Road, Milford, DE.

11. Eastern Neck National Wildlife Refuge. Near Rock Hall, MD, the wildlife refuge is a major feeding and resting place for migrating and wintering waterfowl. The refuge has been visited by more than 240 species of birds. Staff has documented more than 50,000 waterfowl of 33 different species on and near the refuge. Also the area supports seasonal populations of herons, rails, and shorebirds. Tundra Swans visit the refuge between late November and March. Bald Eagles build nests in January. American Woodcocks perform courtship displays in late March. Warning: Ticks, chiggers, and mosquitoes are abundant during the summer months. Best seasons: All year. Hours: 7:30 a.m. until 30 minutes after sunset. GPS address: 1730 Eastern Neck Road, Rock Hall, MD. Cost: Free. Website: https://www.fws.gov/refuge /eastern_neck/

12. Elliott Island Road, Dorchester County, MD. From Vienna, halfway between Cambridge and Salisbury, head south off Route 50 on Market Street (which becomes Elliott Island Road—MD Route 192), a 19-mile drive. The southernmost 10 miles go through open, tidal, mostly salt marshes with many "islands" of Loblolly Pine, favored by nesting Bald Eagles. The scenic qualities of this road alone are worth the visit, the southern parts of which give out onto broad expanses of Fishing Bay, where there are sometimes hundreds, or even thousands, of Canvasbacks, Lesser Scaup, and Ruddy Ducks in winter. In the breeding season, the Elliott Island marshes are full of Seaside Sparrows, Willets, Virginia Rails, and Marsh Wrens, plus a few Clapper Rails and Boat-tailed Grackles. At the extreme south end at McCready's Creek, Northern Gannets and Brown Pelicans are sometimes seen in the distance. A few Short-eared Owls patrol the marshes at dusk in the cold months. This is the longest stretch of paved road that traverses tidal marshes anywhere in the Northeast. Much of it is part of Fishing Bay Wildlife Management Area. Formerly, this was one of the best places in the Region to hear Black Rails, or, in Maryland, to see and hear Sedge Wrens and Henslow's Sparrows. Website: http://www.mdbirdingguide.com/Elliott_Island_Road

13. Hickory Point Cypress Swamp. A Maryland Natural Area situated near Rehobeth, MD (not Rehoboth, DE!). Much of Hickory Point is best explored by meandering up the tidal areas and through the swamp by kayak or canoe. While there is no maintained trail network, day hikers can use abandoned logging roads for access to the oak-pine and oak-heath forests found in the uplands. The area encompasses 2,000 acres owned and managed by the state of Maryland. Much of the biological diversity at this site can be attributed to the variety of habitats present, such as oak–Loblolly Pine forests, mixed oak-heath forests, tidal Bald Cypress forests, Atlantic White Cedar swamps, and brackish tidal shrublands and marshes. The extensive system is an ideal habitat for forest interior–dwelling species, such as the Barred Owl and Black-and-white Warbler. This is one of those places meant for explorers. Directions: From Pocomoke City: Cross the Pocomoke River heading south on US 13. At the junction of US 13 and US 113, turn right (west) onto Old Virginia Road / Pocomoke Beltway. Continue 1.9 miles to MD 371 (Cedar Hall Road). Stay straight and follow MD 317 for 2.8 miles. Turn right onto Hickory Point Road and travel another 2 miles (paved road becomes a dirt road). Follow the dirt road to a small parking area at the front of a gate (which blocks the remainder of the road) and park here. GPS address: Hickory Point Road, Pocomoke City, MD. Website: http://dnr.maryland.gov/wildlife/Pages/Natural Areas/Eastern/Hickory-Point.aspx

14. Hooper's Island, Dorchester County, MD. If one cannot go to Smith or Tangier Islands, Hooper's will furnish nearly equal exposure to watermen's culture, with sleek, white workboats and piles of crab pots. North of the island a turn west on Swan Harbor Road provides distant views of sandbars favored by a few Sanderlings, turnstones, and oystercatchers, as well as Bald Eagles and many Forster's Terns through intervening, open, private properties and in winter of sometimes hundreds of Tundra Swans and Canada Geese. Midway along Swan Harbor Road's length, the expansive view sometimes is the site of sizable raptor flights late September to early November. The first bridge south, at Honga, where one can legally but precariously walk, offers excellent views of distant Barren Island (a unit of Blackwater NWR) and the Honga River with associated winter waterfowl and loons. South of the high Ferry Narrows Bridge (no stopping, parking, or foot access) are jetties and a small parking area. Scan here for Common Goldeneye, Long-tailed Duck, Bufflehead, scaup, loons, and grebes in season. A few very distant gannets and Brown Pelicans may be visible. At high tide, shorebirds often roost on the jetties, and there are a few records of Purple Sandpiper. Anywhere along Hooper's Island Road big Redhead

flocks are possible—sometimes more than 1,000—and smaller groups of Ruddy Ducks. This is a very scenic road. A few Clapper and Virginia Rails are in the more extensive tidal marshes. There are always some Bald Eagles. Directions: About 15 miles south of Cambridge, a paved road extends from the T-junction of Route 335 and Smithville Road, 12.9 miles southeast to Hoopersville.

15. Indian River Inlet, Delaware Seashore State Park. 7 miles south of Rehoboth Beach, DE. Much of the narrow sand and salt marsh barrier that separates Rehoboth and Indian River Bays from the open ocean is preserved within Delaware Seashore SP. Beloved by beachgoers and anglers, the park also has outstanding attractions for visiting birders. South of Dewey Beach and north of Indian River Inlet are a number of short park roads that offer access to the ocean beach or to the Rehoboth Bay shore. New Road and Towers Road (bay side) are often very good for ducks, geese, loons, and grebes in season. Any of the oceanside roads are worth a peek, both for waterbirds and, in the dune scrub, for landbirds. Indian River Inlet is a dynamic place, a narrow channel where tidal mixing stirs up a lot of aquatic life, attracting a rich mix of birdlife. Check the North and South Jetties from October through March for sea ducks, including Long-tailed Duck, both scaup, all three scoters, possibly eiders or Harlequin Ducks, and alcids in some years (Razorbill and Dovekie in recent winters). This is the premier site in the state for photographing sea ducks, as the inlet is relatively narrow and has solid walkways on either side on which to stand. Feeding flocks of Bonaparte's Gulls may yield rarities like Little or Black-headed Gulls, and the jetty rocks typically host Purple Sandpipers. The light tower here is the most reliable site in Delaware for Great Cormorants. Offshore, you may see Brown Pelicans (warmer months) or Northern Gannet (cooler months). On the south side of the inlet the South Indian River marsh is excellent for Nelson's and Saltmarsh Sparrows, Clapper Rails, American Bittern, and Tricolored Heron in season, and the ad-

jacent campground is good for Snow Buntings in winter. The bay itself is less commonly birded, but on very windy days, it can be a better place to observe loons and sea ducks. GPS address: 39415 Inlet Road Rehoboth Beach, DE. Website: www.destateparks.com/park/delaware-seashore/

16. Little Creek Wildlife Area. 5 miles east of Dover, DE. This wildlife area and Port Mahon Road constitute one of Delaware's classic birding hotspots. It is a good location from which to observe the Horseshoe Crab spawning and shorebird migration in late May and is also famous for rails, marsh sparrows, and winter raptors. It is one of the most consistent places in Delaware for Short-eared Owls from mid-November through February, during the hour or so around sunrise and sunset (but that distinction may go to Broadkill Beach Road, specifically, the bridge 2 km from the road's end). The brushy fields and hedgerows near the headquarters of Little Creek Wildlife Area, 1.6 miles south of the Port Mahon Road turnoff, are a good place to check for sparrows and other seasonal landbirds. East of there, the low woods around the observation tower can be excellent for migrants. The impoundment visible from the tower can be swarming with birds, or almost devoid of them, depending on water levels. Directions for Port Mahon Road: From the intersection of Routes 8 and 9 just north of the town of Little Creek, DE, go south on Route 9. After 0.3 mile, turn left (east) on Port Mahon Road. In 1 mile, there are several large fuel tanks to the north. Continuing on the main road past the tanks, there is a productive stretch of marsh to the left (north), which hosts Sedge and Marsh Wrens in winter, as well as American Bitterns, though all are uncommon. About 1.25 miles past the tank farm, you will arrive at the bay shore. The next 1.5 miles offer good birding along the shore, and the wooden fishing pier allows birders to overlook a vast expanse of marsh for Short-eared owls, Northern Harriers, and, in some years, Snowy Owls. Directions to headquarters and the observation tower: From the intersection of Route 9 and Port Mahon

Road, go 1.6 miles south on Route 9. Turn left (east) at the Little Creek Wildlife Area sign. Turn left (north) just past the headquarters area and follow the road as it winds its way to a small parking area (about 1.25 miles from Route 9), where a short boardwalk trail leads to the observation tower. Website: http://www.ecodelaware.com/place.php?id=268

17. Ocean City Inlet, Ocean City, MD. The best place to see many ocean-dwelling waterbirds at close range. Winter regulars include Common and Red-throated Loon, Horned Grebe, Great Cormorant, Brant, Greater Scaup, Long-tailed Duck, Red-breasted Merganser, all three scoters, and on the jetties, Purple Sandpiper, Ruddy Turnstone, and Bonaparte's, Herring, Ring-billed, and Great Black-backed Gulls. Winter rarities include Harlequin Duck, King and Common Eider, Black-legged Kittiwake and Little, Black-headed, Glaucous, and Iceland Gull. In winter, search the Atlantic Ocean for loons and grebes, gulls, and occasional murres and razorbills. Tips: A spotting scope is essential. Be careful when walking on the (slippery) jetty rocks when they are wet. Best seasons: A year-round location but best birding is fall through spring, when the tourists and parking fees are generally absent. Worth visiting shortly after passage of a tropical storm for rarities. Hours: Always open. Parking: $2–$3 an hour, depending on season. Directions: On entering Ocean City, turn right (south) on Philadelphia Avenue and follow it to the end. In winter, turn at the Oceanic Hotel and drive straight ahead to the north jetty. Park in the lot and scan the north and south jetties as well as the head of the south jetty, especially at the turn of the tides. GPS address: 809 S. Atlantic Avenue, Ocean City, MD. Website: http://www.mdbirdingguide.com/Ocean_City_Inlet

18. Pea Patch Island. Located just off Delaware City, hosts one of the largest breeding colonies of herons, ibises, and egrets in the Mid-Atlantic region. The DNREC Division of Parks and Recreation takes a monthly census of birds using the colony from the edge of the Delaware City pier. Herons, egrets, and ibis leaving and returning to the colony are tallied. It is possible to join the counters for the monthly census, which occurs early evenings from March through August each year. This is a great opportunity to learn how to identify these beautiful birds—beginners are welcome. Note that many of these herons forage during the day at nearby Dragon Run marsh (at the end of Dragon Run Park) where excellent views can be obtained. A number of other species are often seen during the survey, including Osprey, Bald Eagle, and Caspian Tern. The island hosted a Union prison during the Civil War and can be visited by ferry during the summer months; the heron colony can be viewed at a distance from an observation platform during the visit. Warning: The island is swampy and has biting deerflies and mosquitoes. GPS address: Fort Delaware State Park, Delaware City, DE. Website: http://decitysalemferry.com/Explore/FortDelaware.aspx

19. Paulagics Cruises, out of Lewes, DE. This company offers the only regular in-Region pelagic birding cruises and is the best option for adding pelagic seabirds to one's life list. Prepare for windy, cold, and wet weather in autumn and winter; also, some may wish to bring anti-seasickness pills or patches. Depending on the season, you'll see shearwaters, storm-petrels, fulmars, alcids, waterfowl, and rare gulls and terns. Also opportunities for cetaceans, sharks, strange fish, and sea turtles. Almost all trips go to both Delaware and Maryland offshore waters. GPS address: 107 Anglers Road, Lewes, DE (departure site for boat in Lewes Harbor). Website: http://paulagics.com/

20. Pickering Creek Audubon Center, Talbot County, MD. Its 410 acres include great habitat diversity, but most notable are the shallow ponds built to attract waterbirds, especially from mid-March through April. The shorebird viewing is outstanding in spring and fall. Birdlife: Waterfowl, shorebirds, wading birds, and songbirds. Mature hardwood forest supports forest-interior dwellers and a host of woodpeckers. Eagles are frequently sighted

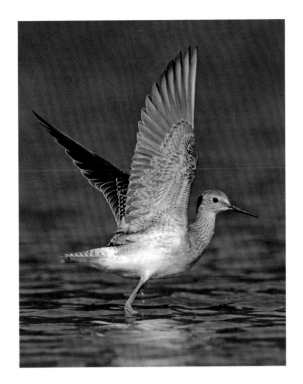

over the property. May and June provide opportunities for viewing both Orchard and Baltimore Oriole. Expect displaying American Woodcock from late February through early April. Good birding year-round. Hours: Dawn to dusk, daily. GPS address: 11450 Audubon Lane, Easton, MD. Website: http://pickeringcreek.audubon.org/

21. Pocomoke Swamp / Great Cypress Swamp. 4 miles west of Selbyville, DE, managed by Delaware Wild Lands. The Great Cypress Swamp is the largest remaining forested area on the Delmarva Peninsula. Low lying, wet, and densely vegetated, the swamp's inaccessibility has unquestionably aided its preservation. It is a treasure trove of typically southern breeding birds, beginning in mid- to late April. Less explored by birders at other times of year, the area has potential to turn up interesting species at any time. The unpaved Hudson Road loop is a good place to start, traversing several forest types in a short distance. The Great Cypress Swamp is a large area, with many landowners. Access is generally limited to public road edges. The nonprofit conservation group Delaware Wild Lands has preserved approximately 10,000 acres. Directions for the Hudson Road loop: From US 113 just north of Selbyville, go west on Route 54 toward Gumboro. Just before the 3-mile mark, you will en-

ter a nice patch of swamp forest. Birding here is not recommended, however, as the road shoulders are narrow. Instead continue on, watching carefully on the left (southeast) for Hudson Road (Road 418), which is reached 5.9 miles from US 113. Follow Hudson Road, which is unpaved, 0.5 mile, to where it bends sharply right (south). The forest along the next 0.5 mile is excellent. In another 0.7 mile, Bethel Road intersects Hudson from the right. Continuing straight on Hudson will take you almost immediately across the Maryland-Delaware state line and into more forest. To return to Route 54 from the Bethel-Hudson junction, go right (northwest) on Bethel 0.7 mile, then turn right (north) on Donaway Road, which rejoins Route 54 in 0.9 mile. Website: www.dewildlands.org/our-work/great-cypress-swamp/

22. Pocomoke River State Park. 3.5 miles southwest of Snow Hill, Maryland, and **Pocomoke State Forest**, immediately to the west, include swamp forest adjacent to the Pocomoke River and birdlife similar to that found in the Pocomoke Swamp (no. 21). This whole area is worth exploring on early mornings in May and early June for warblers, Barred Owls, Summer Tanagers, Brown-headed Nuthatches, and more. Website: http://dnr.maryland.gov/public lands/Pages/eastern/pocomokeriver.aspx

23. Poplar Island. Both Poplar Island and Hart-Miller Island are popular birding localities in the Bay. Both are restricted-access. Maryland Environment Service runs regular trips to Poplar Island that are open to birders. After landing on the island, a bus takes birders to selected sites. Waterfowl, herons, raptors, shorebirds, and rarities. GPS address: 21548 Chicken Point Road, Tilghman, MD. Website: http://tourtalbot.org/businesses/poplar-island-tours/

24. Prime Hook National Wildlife Refuge. 5 miles northeast of Milton, DE, ranks among the Mid-Atlantic's finest birding spots, though it has never achieved quite the renown of its sister refuge, Bombay Hook, mostly because of Prime Hook's somewhat confusing geographic layout. Though it takes a

little while to orient yourself to the several access points, it's more than worth the effort. Broadkill Beach Road slices across the southern portion of the refuge and allows access to the headquarters area, with its network of foot trails and the very productive Broadkill Impoundment. Farther north, sections of Prime Hook Beach Road and Fowler Beach Road traverse diverse wetland habitats and also offer great birding. It is easy to spend anywhere from a few hours to several days exploring. At the headquarters area, take the Boardwalk Trail (a 0.5-mile loop) or the Dike Trail (a 1-mile loop), each of which can be covered in an hour or so and feature freshwater marsh and forest edge. Longer hikes for those so inclined can be easily pieced together here, too. The Broadkill Impoundment stretches for nearly a mile along the south side of Broadkill Beach Road, just before the town of Broadkill Beach. It is a favorite spot for watching Snow Geese and sifting the flocks for rarer species like Ross's and Cackling Goose. The impoundment is a superb shorebirding site, the species list varying with the water levels. Prime Hook Beach Road and Fowler Beach Road also feature roadside wetland birding from gravel pull-offs and are good for uncommon winter visitors such as Short-eared Owls and Rough-legged Hawks. The wetlands along the former are a bit more fresh, while the latter has a more saline environment. From snipe to bitterns, terns to falcons, and rails to sparrows, there's plenty to see in season. GPS address: 11978 Turkle Pond Road, Milton, DE. Website: www.fws.gov/refuge/prime_hook/

25. Smith Island, Maryland. Access via a 12-mile boat cruise from Crisfield, MD, on the Eastern Shore, or longer trip from Point Lookout, MD, on the Western Shore. A world apart, rich in watermen's tradition, mostly marshy, very isolated, unique. Most ferries only wait a few hours on Smith Island before they return to the mainland. A 1+-mile road connects the small towns of Ewell and Rhodes Point. Golf carts available for rent. Ferries mostly go to Ewell, but the Capt. Jason II

goes to isolated Tylerton. There are few overnight places to lodge. Smith Island is the best place to see, in the warmer months, herons, egrets, and Glossy Ibis as there are big colonies in the island's hammocks. Waterfowl are abundant, especially divers, seen from the ferries during the colder months. There are also oystercatchers. A few miles south of the island, in Virginia, is South Point Marsh, which has a nesting colony of more than 1,000 Brown Pelicans and hundreds of Double-crested Cormorants. In May and June Wilson's Storm-Petrels can be seen from the Point Lookout ferry. Seaside Sparrows are abundant in summer, and Clapper Rails all year. The northern third of the island is the Glenn L. Martin National Wildlife Refuge, accessible only by boat. The website of the Smith Island Cultural Center provides details on ferries, lodging, and where to eat. Website: smithisland.org

26. Ted Harvey Conservation Area—Logan Lane Tract. 7.5 miles southeast of Dover, DE. The Logan Lane Tract is dependably productive for a fine variety of marsh and bayside birds and may produce less common species, such as American Avocet, Black Skimmer, or Gull-billed Tern. Birders cover three principal areas at the Logan Lane Tract: (1) the north impoundment, (2) the bay shore (these first two reached by the northern access road), and (3) the south impoundment. Note that birding access to this area may be restricted during hunting season. Directions to the Logan Lane Tract: From the intersection of Route 9 and US 113, just south of Dover, take Road 68 (Kitts Hummock Road) to the east. Turn right (south) at the sign reading "Ted Harvey Conservation Area–Logan Lane Tract" on the right (south) side of the road, just under 2 miles from Routes 9 and 113. For the north impoundment, take the first left (east), 0.4 mile after leaving Road 68, just before the house on the right. Continue 0.6 mile farther, then turn left (northeast), arriving at the impoundment shore in 0.4 mile. For the bay shore, instead of turning left for the north impoundment, continue about

0.5 mile to the small parking area. From there, walk the quarter mile east toward the bay, birding the marsh and mudflats along the way. At the bay, you may also wish to turn right (south) and walk down the beach, scanning the bay, the shoreline, and the eastern edge of the south impoundment, visible across the dunes to the west. Website: http://www .visitdelaware.com/listings/ted-harvey-conservation -area-logan-lane-tract/2327/

27. Thousand Acre Marsh. 1.5 miles south of Delaware City, DE. Thousand Acre Marsh is a privately owned expanse of freshwater wetlands just south of the Chesapeake & Delaware Canal mouth. It is excellent for ducks, rails, bitterns, herons, and egrets. Start by scanning the Saint George's Creek Area, just south of Reedy Point Bridge. The mudflats to the west here can be excellent for shorebirds as well as terns and Glossy Ibis. Saint George's Creek itself, which winds through the tidal marsh east of Route 9, has King and Clapper Rails. The section of Dutch Neck Road just west of Reedy Point Bridge provides views of the main wetlands area to the south and the fields here are good for Cattle Egrets in spring. The bridge itself often has roosting or nesting Peregrine Falcons. Farther west on Dutch Neck Road, the Greer's Pond area is a great place to watch and listen for species such as Wood Duck, Least Bittern, Virginia Rail, and Sora. Directions: From the intersection of Route 9 and Clinton Street in Delaware City, go south 2.2 miles, crossing Reedy Point Bridge, and turn right (west) onto South Reedy Point Road at the Saint George's Creek Area. Pull off on the road shoulder and scan the flats to the west and the creek to the east. From here, continue west on South Reedy Point Road 0.8 mile to Dutch Neck Road and turn left (southwest). Scan the marsh to the south of Dutch Neck Road over the next 0.9 mile, then bear left slightly, arriving at Greer's Pond on the right (north) in another 0.2 mile. Please note that, unlike most sites on the Delaware Birding Trail, much of the land around Thousand Acre Marsh is private, not public, though

birding is allowed from several roadside pull-offs. A more popular and relaxing option is to visit the Ashton Tract, an excellent recently acquired birding area with an ADA-compliant viewing platform that overlooks a productive mix of marshes, open water, and woodland. This site was only established in 2015 and has already recorded several rare birds, and the brushy trails near the platform are excellent for wintering sparrows. Ashton Tract is located by continuing south from the Reedy Point Bridge on Route 9 then turning right on Thorntown Road then right again on a smaller road. Continuing south on Route 9 brings you to the Port Penn wetlands, which is an excellent spot for migrating shorebirds that is overlooked by a boardwalk and other parts of the Augustine Wildlife Management

Northern Harriers are one of the easier birds to see at Thousand Acre Marsh in winter as they loop over the reeds.

Area, which is good for shorebirds during migration, and has beach access via a parking lot from which to search for seabirds during migration and winter. Website: http://www.ecodelaware.com/place.php?id=404

28. Tilghman Island (Black Walnut Point), Talbot County, MD. Offers extensive views looking west over the Chesapeake Bay. There are a series of long pound nets offshore, where, in season, some Brown Pelicans and hundreds of Double-crested Cormorants, the occasional Great Cormorant, sometimes dozens of Ospreys, and Great Blue Herons, perch on the pilings. Good area for Common Loons and Horned Grebes, especially in March and early April. Tilghman Island is the "Cape May" of the Eastern Shore of Maryland. In the fall, there can be substantial hawk flights as well as passerines. Diving ducks, scoters in particular, are often abundant in the colder months, Northern Gannets in late fall and early spring. One is certain to see a few Bald Eagles. There is a commodious public parking area right next to the Bay, popular with anglers and sightseers. The local Talbot Bird Club has field trips here on Sundays in August, sometimes later in the fall, too. GPS address: 4417 Black Walnut Point Road, Tilghman, MD. Website: http://www.mdbirding guide.com/George_Henry

29. Trap Pond State Park. 5 miles southeast of Laurel, DE. The beautiful, cypress-lined Trap Pond offers the best access to southern forest types in Delaware,

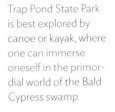

Trap Pond State Park is best explored by canoe or kayak, where one can immerse oneself in the primordial world of the Bald Cypress swamp.

with excellent opportunities for both hiking and boating. Built around a 90-acre mill pond, the park features a fine network of flat, sandy trails that allow for leisurely exploration. Prothonotary and Pine Warbler, as well as Summer Tanager, breed here, and Pileated Woodpecker and Barred Owl are year-round residents. Recommended areas include the Island Trail and the adjacent section of the Hike & Bike Trail, both accessed from the ball fields just beyond the nature center on the pond's south side. On the east shore, the Cypress Point Trail and the stretch of the Hike & Bike Trail between the campground and Cypress Point are also good. More ambitious walkers may even want to walk the entire Hike & Bike Trail, circling the pond in 4.9 miles. For the best views of the magnificent bald cypress forest, rent a boat or join a naturalist-led cruise into the pond's scenic headwaters (mid-April through October), or put your own canoe or kayak in at Trap Pond or nearby Trussum Pond. Directions for Trap Pond SP: From US 13 and Route 24 just east of Laurel, go east on Route 24 for 4.6 miles and then turn right (south) on Road 449 (Trap Pond Road). For the Cypress Point Trail and nearby Hike & Bike Trail, watch on the left (east) for the turnoff to the campground (Goose Nest Road), 0.9 mile from Route 24, just before crossing Trap Pond. Turn left onto Goose Nest Road, then right (southeast) after 0.2 mile into the campground entrance. Continue 0.7 mile to the Cypress Point parking area. GPS address: 33587 Baldcypress Lane, Laurel, DE. Website: www.destateparks.com/park/trap-pond/

30. Truitt's Landing, Truitt's Landing Road, Worcester County, MD. An excellent year-round birding site for waterfowl, herons, raptors, shorebirds, and sparrows. It is a beautiful area of extensive marshes and wetlands looking out on Brockatonorton Bay, which opens out to Chincoteague Bay and the back of Assateague Island. Early morning visits in winter are particularly rewarding with views of large flocks of wintering Snow Geese, Tun-

dra Swans, and hundreds of ducks, including Gadwall, American Wigeon, American Black Duck, Bufflehead and Hooded and Red-breasted Merganser. Summer brings a wide variety of shorebirds, gulls, terns, and coastal specialties, such as Saltmarsh and Seaside Sparrow, Black Skimmer, Tricolored Heron, Glossy Ibis, and Short-billed Dowitcher. This is a reliable site for rails: King, Virginia and Clapper Rail are present and often heard. From Snow Hill, take MD 12 south. After crossing US 113, go 1.8 miles and turn left (east) on Cherrix Road. After 1.3 miles, turn right. This is Truitt's Landing Road, but there is no sign. After 1.0 mile, proceed straight onto the dirt road. Continue to where the road ends at the water. Website: https://www.birdingbuddies.com/birds/location/united_states/maryland/truitts_landing_/

31. Tuckahoe State Park, north of Queen Anne, MD. Surrounds the upper reaches of Tuckahoe Creek, a quiet Eastern Shore stream flowing south to the Choptank River and bordered for most of its length by wooded marshlands supporting an abundance of wildlife. The trails, for the most part, are remarkably dry. The lake is excellent for migrants during spring and fall. Summer birds include Warbling Vireo, Prothonotary Warbler, Baltimore Oriole, and Orchard Oriole. One or more Green Herons frequent the wetland. Best during migration but also can be interesting in summer and winter. Hours: Dawn to dusk. Cost: Free. Directions: Tuckahoe SP is located approximately 35 miles east of the Bay Bridge, just off MD Route 404, on Maryland's Eastern Shore. Make a left (east) at the intersection of Route 50 and Route 404. Go approximately 8 miles until you come to the intersection of Routes 404 and 480. Make a left (north) on Route 480. To your immediate left, take Eveland Road. Once on Eveland Road follow directional signs to area of choice. GPS address: 13070 Crouse Mill Road, Queen Anne, MD. Website: http://dnr2.maryland.gov/publiclands/Pages/eastern/tuckahoe.aspx

32. Battle Creek Cypress Swamp Sanctuary.

Owned by the Nature Conservancy and operated by the Calvert County Natural Resources Division. It is one of the northernmost Baldcypress swamps in the United States. An elevated boardwalk crosses the swamp and an additional quarter-mile arboretum trail leads through a fallow field of approximately 20 acres. The gardens surrounding the nature center are productive for spring migrants. The nature center features interpretive and live-animal exhibits. Birdlife: Nesting Prothonotary, Parula, Hooded, and Kentucky Warblers, as well as Yellow-throated Vireo. The Winter Wren winters here. Tips: Gardens and nature center deck are good viewing sites. Best seasons: Spring and winter. GPS address: 2880 Grays Road, Prince Frederick, MD. Website: http://calvert parks.org/bccss.html

33. Cylburn Arboretum.

Located in northwest Baltimore. A beautiful 207-acre urban park with 3.5 miles of woodland trails. Mature hardwood trees representative of the Piedmont make up the bulk of the forested areas, though there are some conifers. The plantings alongside the trails contain an outstanding diversity of wildflowers. Cylburn is managed by the Baltimore City Department of Recreation and Parks with support from the Horticultural Society and Cylburn Arboretum Association. Cylburn is the home base of the Maryland Ornithological Society. The Baltimore Bird Club holds its monthly meetings here and offers regular bird walks; both are open to the public. Birdlife: More than 150 species have been reported. There are many year-round resident species, including Great Horned Owl. Orioles, warblers, tanagers, vireos, kinglets, and gnatcatchers are common passage migrants. Best seasons: Spring and fall migration, although the site offers pleasant birding year-round. Hours: April 1 to October 23, Tuesday–Sunday, 8 a.m.–8 p.m.; October 25 to April 1, Tuesday–Sunday, 8 a.m.–5 p.m. Closed on Mondays and federal holidays. Visitor center hours are more restricted. GPS address: 4915 Greenspring Avenue, Baltimore, MD. Websites: http://baltimorebirdclub.org/ http://cylburn.org/

34. Dumbarton Oaks Park / Montrose Park / Oak Hill Cemetery,

R Street and 30th Street, NW, Washington, DC. This site offers a mix of oak woods and parkland that is excellent birding in spring and fall for migrant songbirds. This parkland backs onto Rock Creek Park. This is a good place to wander on a spring morning in search of warblers and thrushes. GPS address: 3100 R Street, NW, Washington, DC. Website: https://dopark.org/

35. East Potomac Park, Hains Point.

East Potomac Park is a 300-acre peninsula in SW Washington, just south of the Jefferson Memorial, constituting a grassy wedge of land between the Potomac River and the Washington Channel. The southern area of the park is known as Hains Point. Birdlife: Gulls, present all year, congregate at the Tidal Basin, the Golf Course, and on the Potomac. Ring-billed and Laughing Gulls arrive in August, with Herring and Great Black-backed Gulls in the fall. January–March is the best time for rarities, with Iceland, and Glaucous possible. Lesser Black-backed are frequently present from late September to early April.

The Western Shore's sole cypress swamp, Battle Creek, has a boardwalk to view the curious cypress knees poking up.

Franklin's Gulls may be present summer and early fall and Bonaparte's during April migration. Caspian and Forster's Terns may be found during summer and fall migration. In the Channel and on the water beyond, look for Common Loon and Horned Grebe in March and November. In the trees along the river and in the air in winter, search for accipiters, Bald Eagle, and Merlin. On the golf course, look for Black-bellied Plover, Greater and Lesser Yellowlegs, peeps, Pectoral Sandpiper, and Wilson's Snipe and occasional American Golden-Plover, Upland Sandpiper, and Ruddy Turnstone. Cattle Egrets are regular in spring. Tips: In winter, the area is best after about a week of subfreezing temperatures when the Washington Channel and Potomac River are partially frozen. This may result in a fish kill that attracts large numbers of gulls. Best seasons: During migration periods, shorebirds will be attracted to the golf course after rains that result in water pools and muddy conditions; winter for gulls, loons, grebes, and raptors. Hours: Open every day. GPS address: 927 Ohio Drive, SW, Washington, DC. Website: http://dc.about.com/od/restaurant1/a/East PotomacPk.htm

36. Fletcher's Boat House / Fletcher's Cove, Canal Road, Washington, DC. a favorite spring site for fishermen and birders in the DC area, part of the C&O Canal National Historical Park between Chain and Key Bridges. Fletcher's is a small cove leading out to the Potomac River. For boaters interested in bird or turtle watching, Fletcher's Cove is one of the best places along the entire canal to canoe or kayak. Birdlife: Best location in DC for breeding Orchard and Baltimore Orioles and Warbling Vireos. Concentration point for swallows, Chimney Swifts, gulls, and Caspian Terns. Woods support breeding owls and Wood Ducks and is a breeding place for Prothonotary and Yellow-throated Warblers and Northern Parula. A mile west along the C&O Canal towpath to the Chain Bridge is a good spot for waterbirds and raptors. Look for Ospreys, teal, snipe, and American Bitterns during migration,

and sparrows in winter. Black-crowned Night-Herons are frequent along the water's edge. Tips: Follow the canal towpath and explore side trails down to the river. Best seasons: Spring, fall, and winter. Hours: Open sunrise to sunset, all year. GPS address: 4940 Canal Road, NW, Washington, DC. Website: https://www.canaltrust.org/discoveryarea /fletchers-cove/

37. Fort McHenry National Monument, Baltimore Harbor, MD. This historic park is an excellent spring and fall migrant trap, as well as a place to scope for loons, grebes, ducks, and falcons while walking the seawall trail—perhaps best in winter. The site has a large species list. A good place to look for herons, raptors, gulls, and migrant songbirds in season. GPS address: 2400 East Fort Avenue, Baltimore, MD. Website: https://www.nps.gov/fomc/learn/nature /birds.htm

38. Fort Smallwood Park. Consists of 90 acres at the tip of a peninsula in northeastern Anne Arundel County, where the Patapsco River and Rock Creek meet the Chesapeake Bay. Includes beach, pond, mature hardwoods and conifers, mowed grassy areas, and a 380-foot fishing pier. Easy walking. Site of the Anne Arundel County hawk watch, late February to early June. In most springs, 10,000 or more raptors are counted. Birdlife: Winter—ducks, sapsuckers, various songbirds. Spring—ducks, loons, migrating hawks, Sora, shorebirds, warblers, and more. Summer—herons, flycatchers, vireos, and orioles. Tips: Take East Drive toward the water and park near Battery. Good views for waterfowl and other migrants. Go south 100 yards or so along the Chesapeake to the hawk watch site on the west side of the pond. Check tall Sweetgums and pines for seed-eating species and woodpeckers. Check large pond to the east of Battery for ducks, herons, terns. Best seasons: Winter for waterfowl and migrant passerines and spring for migrating raptors. Hours: 7:00 a.m. to dusk. Closed Wednesdays. Cost: $6.00/ car or free with seasonal pass or proof of military service. GPS address: 9500 Fort Smallwood Road,

Pasadena, MD. Website: http://www.aabirdclub.org/ (click on Hot Spots, then the button for the site you want)

39. Hart-Miller Island. Public access to Hart-Miller Island is administered through Gunpowder Falls State Park. It is accessible only by boat. The impoundments are managed by the Maryland Environmental Service. The western shore of the island offers safe mooring, wading, and access to a 3,000-foot sandy beach. Hart-Miller also includes Hawk Cove and Pleasure Island, which also provide recreational opportunities and camping. The 1.8-mile Long Trail Loop boasts interpretive signage about the various wildlife and different ecosystems. Large numbers of waterfowl use the waters surrounding the island as well as the impoundments until frozen out in the winter. In summer, many broods of Mallards can be seen along with small numbers of breeding Wood Ducks and American Black Ducks. Many species of nonbreeding ducks may spend the summer here also. In migration, huge rafts of scaup (mostly Lesser) and Ruddy Ducks occupy the surrounding waters. Hundreds of Northern Shovelers, Northern Pintail, Green-winged Teal, and mergansers may occupy the impoundments. Gulls and terns also use the island as a resting area. Hart-Miller is especially known for its large flocks of Caspian Terns. If conditions on the mudflats in the impoundments are ideal, thousands of shorebirds may be present. All the regularly occurring shorebirds to be found in Maryland have been seen at Hart-Miller, including such northern Chesapeake Bay rarities as Purple Sandpiper, Black-necked Stilt (a sometime breeder), American Oystercatcher, Hudsonian and Marbled Godwits, Curlew Sandpiper, Buff-breasted Sandpiper, and Maryland's only record of Snowy Plover. Peregrine Falcons nest on a nearby light tower. Songbird migration is highlighted by the large number of sparrows to be seen in the vegetation surrounding the impoundments and the large flocks of blackbirds using the marshy areas. A walking tour of the island is possible through the Baltimore Bird Club. Website: http://dnr.maryland.gov/publiclands/Pages/central/hartmiller.aspx

40. Jug Bay Natural Area. Comprises a series of sanctuaries and state lands on both sides of the Patuxent River. Jug Bay Wetlands Sanctuary, Lothian, MD, is on the Anne Arundel County side of the river along with the Parris N. Glendening Nature Preserve at Jug Bay. On the Prince George's County side are Patuxent River Park and Merkle Wildlife Sanctuary. Both sides of the river have parts of Patuxent River Natural Resource Management Area. Jug Bay is a widening of the river, producing a convoluted shoreline bordered by brackish marsh and inlets, affording ideal habitat for waterfowl from late fall to late winter, with some fall-off during midwinter. During fall, stands of Wild Rice harbor migrating rails, especially Soras. Mudflats attract interior-migrating shorebirds. Many Osprey pairs nest on close-in platforms and Bald Eagles are present year-round. In addition, there is a 0.5-mile boardwalk over a freshwater marsh, numerous trails through deciduous forests, and an open field (though leased for crops during breeding season). During migration there can be a rich diversity of species. During fall—Sora and Virginia Rail in the marshes. After harvest, the leased cornfields may harbor sparrows and Horned Larks. The region features nesting Least Bittern, Horned Lark, Summer

Osprey are thriving along the Jug Bay Natural Area, and the nestlings offer close-up views to boaters in early summer.

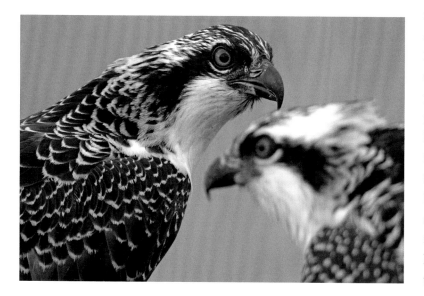

Tanager, Blue Grosbeak, Orchard Oriole, and more. Tips: Don't miss the boardwalk along Black Walnut Creek. Best seasons: Fall, late winter, and spring. Hours: 8 a.m. to dusk, all year. GPS address: 16000 Croom Airport Road, Upper Marlboro, MD. Website: http://www.jugbay.org/

41. National Arboretum. Consists of 446 acres in northeast Washington, DC, with 9 miles of roads winding through and connecting gardens and collections of trees, shrubs, and herbaceous plants cultivated for scientific and educational purposes. Birdlife: A variety of hawks and sparrows in winter with Barred and Great Horned Owls in the extensive conifer groves at Hickey Hill; sometimes Long-eared and Barn Owls. Conifer groves also support flocks of kinglets and Red-breasted Nuthatches in a good winter. Virginia Pines attract lingering warblers in December and January. Large flocks of robins and waxwings are found in scattered hollies, hemlocks, and fruit trees south of Hickey Hill. Bald Eagles have bred in tall Tulip Poplars. Best seasons: Winter; also spring/summer for certain breeders and passage migrants. Hours: 8:00 a.m.–5:00 p.m., every day of the year, except Christmas. Cost: Free. Parking: Free parking with large lots located near the National Grove of State Trees, close to the R Street and the New York Avenue entrances. Directions: The National Arboretum is located in the northeast section of Washington, DC, approximately 10 minutes from the Capitol. There are two entrances: One listed below in the GPS address, and the other at 24th and R Streets, NE, off of Bladensburg Road. GPS address: 3501 New York Avenue, NE, Washington, DC. Website: http://www.usna.usda.gov/

42. The National Zoological Park (the National Zoo). A 163-acre wooded park located in northwest Washington, DC. Home to captive exhibits of birds, great apes, big cats, Asian Elephants, insects, amphibians, reptiles, aquatic animals, small mammals and more. Look for the Black-crowned Night-Heron rookery in the trees by the waterfowl pond,

usually active from late March to midsummer. Pileated Woodpeckers are resident in the woodlands. In the waterfowl pond look for Wood Duck, American Black Duck, American Wigeon, and Gadwall. Vultures and Red-tailed, Cooper's, and Sharp-shinned Hawks have been known to frequent the mammal compounds. Tips: Olmsted Walk, the wide, wavy main path up and down the zoo's impressive hill, is home to wild birds year-round. Best seasons: Winter; also spring for migrants. Hours: Open every day, except Christmas. From May 1 to September 15, the grounds are open 6 a.m.–8 p.m. Cost: Free. Parking: There is a charge for parking. From May to September, lots may fill by 10:30 a.m. GPS address: 3001 Connecticut Avenue, NW, Washington DC. Website: https://nationalzoo.si.edu/

43. Parker's Creek Preserve / American Chestnut Land Trust, Calvert County, MD. This mix of trust and state lands on the Chesapeake Bay's Western Shore protects the watershed of Parker's Creek, the largest stream along the Calvert Cliffs. It contains forested uplands, rich bottomlands, old fields, and both fresh- and salt-water wetlands. Among the noteworthy woodland breeders are Acadian Flycatcher, Yellow-throated Vireo, Wood Thrush, Worm-eating, Kentucky, and Hooded Warblers, and Scarlet Tanager. Fields and forest edges host American Woodcock, Yellow-breasted Chat, Orchard Oriole, Summer Tanager, and Blue Grosbeak. Wetlands breeders include Marsh Wren, Prothonotary Warbler; several species of rails have been recorded from the preserve, with Virginia the most

A wonderful place to visit any season, the National Arboretum has plenty of trimmings to interest local birds like this hungry American Robin.

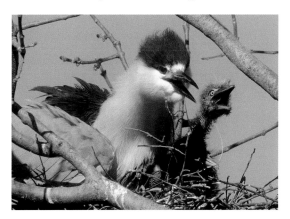

At the National Zoo in Washington, DC, wild Black-crowned Night-Herons put on a great nesting show, right next to the Bird House.

common. ACLT offers 22 miles of trails crossing hardwood forest, swamps, and scattered fields, while canoeists and kayakers can paddle the creek from the sandy beach (known to yield fossil sharks' teeth) through saltwater marsh and wooded freshwater wetlands. Tips: Some hunting is permitted on parts of the preserve, so be alert. Best seasons: spring and fall migration; early summer for breeders. Hours: 1 hour before sunrise to 1 hour after sunset. GPS address: Double Oak Road, Prince Frederick, MD. Website: www.acltweb.org and http://dnr.maryland.gov/wildlife/Pages/publiclands/southern/parkers-creek.aspx.

44. Patterson Park, Baltimore City. A large, 137-acre city park located in a residential neighborhood in downtown East Baltimore. The park is the heart of the neighborhood and includes open fields of grass with scattered large trees, paved walkways, historic battle sites, a lake, and more. The park is notable for its man-made Boat Lake, which attracts numerous species of waterbirds. Dating from the Civil War era, the 2.5-acre lake was dredged and renovated in 2003 to include wetlands planting and environmental education signage. Flat, paved pathways make for easy birding around the entire park. More than 200 species of birds have been reported, including Baltimore Oriole, House Wren, and Wood Thrush. The park is notable for hosting a breeding population of Wood Ducks at the Boat Lake. Wintering birds on the lake include American Wigeon, American Black Duck, Northern Shoveler, and Ring-necked Duck, as well as Pied-billed Grebe and American Coot. Tips: The park is well used during the day but nighttime visits are not recommended. Best seasons: Spring and fall migration. Hours: Sunrise to sunset. GPS address: 27 South Patterson Park Avenue, Baltimore, MD. Website: http://patterson park.com/

45. Patuxent Research Refuge, National Wildlife Visitor Center, Laurel, MD. Established in 1936. Upland forests constitute the majority of the refuge's land base. Trails and old roads wander through woodlands and meadows. Prominent are Cash and Reddington Lakes—and several smaller ponds. The visitor center includes a museum devoted to wildlife. Nesting Bald Eagle, Osprey, Wood Duck, Hooded Merganser, Green Heron, Warbling Vireo, and swallows. Winter—waterfowl, sparrows, and Rusty Blackbirds on the lakeshore. A good spot for migrant thrushes and warblers. Tips: Walk down the boardwalk to Lake Reddington in fall. Best seasons: All. Hours: Grounds are open sunrise to sunset, every day, except Thanksgiving, Christmas, and New Year's Day. GPS address: 10901 Scarlet Tanager Loop, Laurel, MD. Website: https://www.fws.gov/refuge/Patuxent/visit/NWVC.html

46. Point Lookout State Park, Scotland, MD (in St. Mary's County). Point Lookout SP is one of the premiere birding locations in Maryland. Being a park on a southern-oriented peninsula makes for a wonderful autumn migrant trap. Year-round Brown-headed Nuthatches and American Woodcock on migration in late winter into spring. Fabulous waterfowl viewing from many points. Located at the confluence of the Potomac River and the Chesapeake Bay, it has a long list of rarities to its credit. The Point is often a good spot to watch raptor migration or to scope for gulls, terns, Brown Pelicans, Northern Gannets, or Great Cormorants in the winter. From the picnic area north to the fort, abundant scrubby habitat is excellent for birding during migration. The campgrounds, the museum, and pines around the picnic area between the point and the fort are where you are most likely to find the Brown-headed Nuthatch. Red-headed Woodpeckers may be found along the Periwinkle Trail behind the museum. The fishing pier juts out 700 feet into the Chesapeake and provides excellent waterfowl watching in winter. Similarly, the causeway, with deep water near the road, offers close views of waterfowl on the Bay side. Tips: The weather at Point Lookout may differ significantly from farther inland, particularly in winter. Be prepared for harsh wind and cold. Best seasons: Spring

and fall migration. Avoid summer and holiday weekends when the park may reach maximum occupancy; arrive early. Hours: 6 a.m. to sunset (park is open 24 hours for fishing, boat launch, and hunting where permitted). GPS address: 11175 Point Lookout Road, Scotland, MD. Website: http://dnr2 .maryland.gov/publiclands/Pages/southern/point lookout.aspx

47. Rock Creek Park (Nature Center, Maintenance Yard, and Stables). A large urban park bisecting the Northwest quadrant of Washington, D.C. At 1,700 acres, Rock Creek Park is one of the largest urban parks in the nation. It is the major migration route of birds through urban Washington and thus has become famous as a site to view warblers and other songbird migrants. The area of greatest interest to birders is the West Ridge, from Military Road south to Broad Branch Road, encompassing military field, the nature center, the maintenance yard, the horse center, and a number of adjacent picnic areas. Birdlife: The high ridge bordering the west bank of

Rock Creek between Broad and Military Roads is the best site for migrating warblers in the city, the forested ridge serving to concentrate them. Pileated Woodpeckers are present year-round. Accipiters winter in the park. Tips: In migration period, begin at the clearing at Picnic Area 16 on Ridge Road, work that and the clearing of the horse area just to the south, then drive back up to the maintenance yards, and finish at the nature center, just south of the intersection of Military Road and Glover Road. The most famous migrant songbird site is the clearing behind the maintenance yard, south of the horse center. Park in the maintenance yard parking lot and follow woodland trail that passes to the left (north) of the buildings to get there. Experienced birders are present in this clearing most spring mornings. Expect various vireos, warblers, thrushes, and more. Best seasons: Spring and autumn migration. Hours: Open sunrise to sunset, all year. GPS address for Nature Center: 5200 Glover Road, NW, Washington, DC 20015. Website: http://www.mdbirds.org/sites/dcsites /ccorridor.html

With its iconic Boulder Bridge, Rock Creek Park is an expansive green oasis for birds and bird-watchers in the heart of the nation's capital. Photo: Emily Carter Mitchell

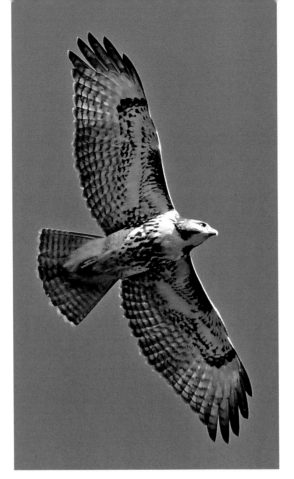

The walk up the hill to Ashland Hawk Watch is worth the effort, as various raptors often pass low overhead, like this young Red-tailed Hawk.

48. Sandy Point State Park. A 786-acre park just north of the western terminus of the Chesapeake Bay Bridge. Habitat includes beach, jetties, mowed fields, woodlands, pond, and marsh. A small nature center is open in summer. Birdlife: Winter—Gadwall, Black Duck, Canvasback, Greater and Lesser Scaup, Long-tailed Duck, Bufflehead, Common Goldeneye, Hooded and Red-breasted Merganser, Ruddy Duck, Horned Grebe, Bonaparte's Gull, Yellow-rumped Warbler, White-throated Sparrow, Dark-eyed Junco. Spring—Wood Duck, Common Loon, Northern Gannet, Osprey, Hermit Thrush, Pine Warbler, Savannah Sparrow, Fox Sparrow, Swamp Sparrow. Summer—Barn Swallow, Cedar Waxwing, Chipping Sparrow. Autumn—Brown Pelican, Sharp-shinned Hawk, Sanderling, Northern Flicker, Eastern Phoebe. Avoid times of heavy recreational use in summer. Hours: January 1 through March 31—7 a.m. to sunset; April 1 through October 31—6 a.m. to sunset; November 1–December 31, 7 a.m.–5 p.m. GPS address: 1100 E. College Parkway, Annapolis, MD. Website: http://dnr2.maryland.gov/publiclands/Pages/southern/sandypoint.aspx

Piedmont

49. Ashland Hawk Watch and Nature Center, Hockessin, DE. Headquarters of the Delaware Nature Society, the Ashland Nature Center is an excellent spot for a morning or an afternoon hike in search of woodland and field birds and is very good for migrant passerines during spring and fall with occasional guided bird walks (check website for details). There are four self-guided nature trails on 130 acres of forest, meadow, and freshwater marsh. The nature center maintains an active bird-feeding station overlooked by a blind popular with photographers, especially in winter. An autumn hawk watch was initiated here in 2007 and runs daily September to November; visitors are welcome. Follow the signs from the nature center or the parking lot to the hawk watch, which is atop the hill above the overnight lodge. Directions to the Ashland Nature Center: Route 41 south from Hockessin. Turn left (east) at the traffic light onto Brackenville Road. After 2 miles on Brackenville Road, turn left (north) onto Barley Mill Road at the stop sign, then immediately left again (west) into Ashland Nature Center parking area. GPS address: 3511 Barley Mill Road, Hockessin, DE. Website: www.delawarenaturesociety.org/AshlandNatureCenter

50. Audrey Carroll Audubon Sanctuary. Located west of Mount Airy in Frederick County, MD. A lovely 129-acre complex of meadows, woodlands, and wetlands. Especially nice for birds such as the Black-billed Cuckoo that prefer young forest for nesting. The site supports many species of birds, both passage migrants, permanent residents, and breeders. GPS address: 13030 Old Annapolis Road, Mount Airy, MD. Website: http://www.centralmd audubon.org/sanctuary.htm

51. Brandywine Creek State Park. 4.5 miles northwest of Wilmington, DE. A diverse assemblage of forests, thickets, fields, and meadows bordering the Brandywine, this state park features excellent walking and woodland birding at any time of year and is a

very good site for less-common migrants in the fall. The most direct way to access the park's riverside forest, where one typically encounters the best numbers of migrant songbirds, is from the east side of the river at Thompson's Bridge. On the west side of the Brandywine, the main entrance to the park offers open hillside habitats and some lovely scenic vistas. The entrance road winds past brushy fields where Grasshopper Sparrows and Eastern Meadowlarks nest. Park at the Brandywine Creek Nature Center and check the excellent bird-feeding station; inquire also about any naturalist-led activities that may be available. Directions to Thompson's Bridge: From the intersection of Routes 202 and 92, north of Wilmington, go west on Route 92 (Beaver Valley Road). After 0.3 mile, follow 92 as it bears left (south) and becomes Thompson's Bridge Road. Route 92 descends toward the Brandywine Creek, reaching it in another 1.4 miles at Thompson's Bridge. Turn left (south) into the parking area immediately before crossing the bridge. From there, one can follow a section of the Northern Delaware Greenway either north or south, then backtrack to the parking area. About a mile north of Thompson's Bridge, the greenway intersects with Ramsey Road. This area is a favorite spot for many local birders during spring and fall migration. Going south from Thompson's Bridge, the greenway leaves the park in about 1.5 miles at Rockland Road. Directions to Brandywine Creek Nature Center: From Thompson's Bridge, follow Route 92 1.4 miles to a 4-way stop sign at Adams Dam Road. Go left (southeast) on Adams Dam Road 0.3 mile; the park entrance is on the left (north); the nature center is 0.7 mile up the entrance road. GPS address for the Nature Center: 41 Adams Dam Road, Wilmington, DE. Website: www.destateparks.com/park/brandywine-creek/

52. C&O Canal, Pennyfield / Violette's / Riley's Locks, Montgomery County, MD. The stretch of the C&O Canal from Pennyfield west to Riley's Lock has a diversity of habitat, including the Potomac River, flooded portions of the C&O Canal, and adjacent woodlands, impoundments, and marshes that provide for rich birding opportunities for migrating, nesting, and over-wintering birds. Some of the best views of the river are provided at Violette's Lock and Riley's Lock. Note that the river runs ap-

The various locks of the C&O Canal along the Maryland side of the Potomac River offer fabulous spring birding, with easy access and diverse habitat.

proximately east–west along this stretch of canal. An early morning bird walk might want to proceed west from Pennyfield toward Violette's and Riley's in order to keep the sun at one's back. The approximately 3.2-mile walk from Pennyfield to Riley's could be birded in a half-day. The approximately 6.4-mile round trip would constitute a full day of birding. Birdlife: Abundant spring vireos and warblers; nesting species, including Bald Eagle, Prothonotary and Yellow-throated Warblers, Louisiana Waterthrush, Northern Parula, Baltimore Oriole, and owls, flycatchers, swallows, herons, and woodpeckers. Migrants of note include Bonaparte's Gull and Caspian and Forster's Terns. Over-wintering waterbirds include ducks, grebes, and coots. Tips: The Potomac River is quite broad in this area, and a spotting scope will aid identifying birds on the river. Best season: All year, with a peak in spring. Cost: Free. Directions: Pennyfield Lock—going northwest on River Road (Route 190) turn left on Pennyfield Lock Road, about 100 yards past the Travilah Road intersection. Proceed 0.7 miles to parking area. Violette's Lock—going northwest on River Road (Route 190) turn left on Violette's Lock Road about a quarter mile prior to the Seneca Road (MD 112) intersection (at bottom of a small valley). Proceed 0.6 miles to parking. Riley's Lock / Seneca Aqueduct—going northwest on River Road (Route 190) turn left on Riley's Lock Road about 1 mile after the Seneca Road intersection (at bottom of long hill). Proceed 0.7 miles to the parking lot. Website: http://www .riverexplorer.com/details.php4?id=607

53. Conowingo Dam. Located in northeastern Maryland on the Susquehanna River. The primary birding attractions are gulls, Bald Eagles, waterfowl, and herons. The best viewing area is Fisherman's Park located at the base of the dam in Harford County. Conowingo Dam is an electricity-generating plant. When the turbines are in operation, the intake valves deliver water and fish through the dam into the river downstream, thus providing food for the birds. Birdlife: Large numbers of gulls are present

For bird photographers, Conowingo Dam is the place to be in late fall, as Bald Eagles swoop down to grab fish all day long.

from December through February. Bald Eagles are present year-round but begin arriving in big numbers in mid-October, peaking in late November, and remaining through mid-March. Large numbers of vultures roost during the day in the trees by the parking lot. Tips: There have been occasional sightings of Golden Eagles and various rare gulls. Best from late fall to early spring. Hours: Open daily from 1 hour before sunrise to 1 hour after sunset. Dress warmly. GPS address: Conowingo Dam, Darlington, MD. Website: http://www.visitmary land.org/listing/visitor-centers/conowingo-visitor -center

54. Cromwell Valley Park, Baltimore County, MD. Comprises 460 acres of pasture, streamside, cultivated gardens, open fields, woods, hedgerows, orchards, and wooded hills. To date, some 200 bird species have been reported. The park's Nature Education Center offers programs for children, adults, and families. With Loch Raven Reservoir and Gunpowder Falls immediately to the east, and with several streams running through the park, water-related species, such as Great Blue Heron, Osprey, Belted Kingfisher, and various gulls and terns, often make an appearance. Swallows are common in the warm months. Songbirds include both orioles, Bobolink, Eastern Meadowlark, Indigo Bunting, and Eastern Bluebird, as well as flycatchers and vireos. Cromwell Valley Park is situated on a fall raptor mi-

gration route and its hillside provides a ringside seat for this. The hawk watch can be accessed from the Willow Grove parking lot by walking 0.2 mile uphill (west) on the paved emergency access road. Best seasons: Spring and fall. Hours: Sunrise to sunset. GPS address: 2175 Cromwell Bridge Road, Parkville, MD. Website: http://www.cromwellvaleypark.org/

55. Elk Neck State Park. Turkey Point at Elk Neck SP is the tip of a peninsula between the North East and Elk Rivers. The Turkey Point area of Elk Neck SP, which is separated from the rest of the state park by a private residential community, consists of hardwood forest and open meadows. A loop trail goes from the parking lot to the Turkey Point Lighthouse at the tip of the peninsula. Camping and a day-use picnic area are available in the main part of the state park. Birdlife: Spring and late summer and early fall bring good flights of migrating songbirds. Later in the fall, Red-breasted Nuthatches, Purple Finches, and Pine Siskins may be seen. Migrating raptors fly low over the peninsula on their southward migration and are best viewed at the hawk watch at Turkey Point. Tips: Hiking boots or sturdy shoes are suggested for trail use. Sunscreen and insect repellent are recommended from late spring to fall. Restrooms are seasonal. Best seasons: Late summer to late spring. Hours: Sunrise to sunset. 5 miles north of Elk Neck is the pleasant town of North East. The waterside park here is an excellent place to obtain close views of Osprey and Bald Eagle hunting during the summertime and is very good for waterfowl (especially mergansers) in the winter. GPS address for Turkey Point: 4395 Turkey Point Road, North East, MD. Website: http://dnr2.maryland.gov /publiclands/Pages/central/elkneck.aspx

56. Fair Hill Natural Resources Management Area, Cecil County, MD. Includes more than 5,000 acres, encompassing a variety of habitats attractive to a large list of birds. Located in the northeast corner of Cecil County, bordering Pennsylvania and less than a mile from the Delaware line, Fair Hill offers expansive areas of grasslands, woodlands, and stream-side habitat adjacent to the Big Elk Creek and the western branch of the Christina River. Miles of trails and a series of parking lots enable birders to reach all these areas. Birdlife: Spring migration brings songbirds to the woodlands of Fair Hill. Also, Green Herons, Great Egrets, Great Blue Herons, Spotted Sandpipers, Solitary Sandpipers, and waterthrushes can be found along Big Elk Creek and the Christina. In early summer, expansive grasslands feature nesting Grasshopper Sparrows, Field Sparrows, dozens of Bobolinks, Eastern Meadowlarks, and Red-winged Blackbirds; the state delays mowing in some of these fields to promote nesting. The site supports an impressive list of regular breeders. Fall migration produces a good passage of songbirds. Winter at Fair Hill features shrubland and grassland birds. A large roost of both Black and Turkey Vultures is present year-round. Tips: Trails, especially those along Big Elk Creek, can be quite muddy in the spring so boots are recommended. Also, Fair Hill NRMA is a major equestrian area; horses and riders can be encountered on trails. Best seasons: All year. Hours: Sunrise to sunset. GPS address: 300 Tawes Drive, Elk-

Late summer grasslands like those of Fair Hill are a great place to look for those elusive Bobolinks and other classic field birds.

ton, MD. Website: http://dnr2.maryland.gov/public lands/Pages/central/fairhill.aspx

57. Fort DuPont State Park, south of Delaware City, DE. An excellent migrant trap, especially in fall, and is a fine vantage point from which to scan the Delaware River for waterbirds. In spring and early summer, birders can enjoy the procession of herons, egrets, and Glossy Ibis making their way to and from the rookery on Pea Patch Island. The best birding is generally along the River View Trail. Scan the river from the overlook just beyond the parking lot. Yellow-crowned Night-Herons, scarce in Delaware, are regularly seen flying along the riverbanks. The weedy fields here are good for wintering sparrows and overwintering warblers. As well as being an excellent birding area, it is also an intriguing site from a historical perspective and offers guided tours of the former military base. Directions to the River View Trail: From the intersection of Route 9 and Clinton Street in Delaware City, go south 0.4 mile, and bear right (southeast) into Fort DuPont SP on North Reedy Point Road. In 0.1 mile, take the first left (east) onto Wilmington Avenue, which ends at the River View Trail parking lot in another 0.6 mile. GPS address: Fort DuPont State Park, Delaware City, DE. Website: www.destateparks .com/park/fort-dupont/

58. Gunpowder Falls State Park. Established in 1959 to protect the Big and Little Gunpowder Falls Valleys, Gunpowder Falls SP is now one of Maryland's largest state parks, encompassing 18,000 acres in noncontiguous blocks scattered through Harford and Baltimore Counties. The park hosts varied topography ranging from tidal wetlands to steep and rugged uplands. There are more than 120 miles of trails, protected state wildlands, historic sites, fishing and canoeing/kayaking streams, a swimming beach, and a marina. The park has six separate areas, including the Hammerman area and the adjacent Dundee Creek Marina, located east of the City of Baltimore, near where the Gunpowder River empties into the Chesapeake Bay. Habitat at the

Hammerman and Dundee Creek areas includes beach front, tidal wetlands, open fields, and deciduous/pine forests. Several short hiking trails through both wetlands and forest are available. For those who wish to bird the area by boat, canoe, or kayak, rentals are available at the nearby Dundee Creek Marina. The Hammerman and Dundee Creek areas offer good birding during spring and fall migration. The park attracts a variety of seasonal migrants (warblers and vireos) and waterfowl in the winter. There are nesting Bald Eagles and Ospreys during the summer months. Winter brings many ducks on the open waters of the Gunpowder River. Gulls and terns pass through in spring and fall. A good selection of sparrows can be found in late fall through early spring. Tips: The park will likely fill to capacity on holiday weekends and many other weekends during the summer. Best seasons: Fall, winter, and spring, prior to Memorial Day. Hours: Open year-round, except Christmas Day. April–October, 8 a.m. to sunset; November–March, 10 a.m. to sunset. Website: http://dnr2.maryland.gov/publiclands /Pages/central/gunpowder.aspx

59. Howard County Conservancy / Mt. Pleasant. Located on 232 acres of rolling hills with a variety of habitats, is ideally suited for nature study and exploration. Home to more than 140 species of birds, offering beautiful vistas of the Patapsco Valley. The area has lots of nesting fields for open country birds and is great for sparrows in late fall and winter. Includes a nature center and a hawk watch. GPS address: 10520 Old Frederick Road, Woodstock, MD. Website: https://www.hcconservancy.org/mt -pleasant/

Hughes Hollow (see no. 64. McKee-Beshers Wildlife Management Area).

60. Irvine Nature Center, Baltimore County, MD. This large field complex with lots of trails, is a reliable spot for Northern Harrier and American Tree Sparrow in winter. It supports lots of nesting birds in spring. Located northwest of the City of Baltimore, Irvine is a private, nonprofit nature education

center that offers free public access to its 116 acres, consisting mainly of meadows, wetlands, and deciduous woods. Trails wind through the property. Birding can be very good in the colder months. Tips: Trails can be muddy and wet, so boots are recommended. Best seasons: Fall, winter, and spring. Hours: 9 a.m.–5 p.m., 7 days a week, year-round. GPS address: 11201 Garrison Forest Road, Owings Mills, MD. Website: http://www.explorenature.org/

61. Liberty Reservoir Cooperative Wildlife Management Area. A 9,200-acre tract of land, is located on the border of Baltimore and Carroll Counties. The reservoir covers more than 3,000 acres and is 11 miles long, with 82 miles of shoreline. The reservoir was formed by damming the North Branch of the Patapsco River to produce a source of drinking water for the City of Baltimore. Liberty Reservoir and the lands around it are owned by the city and managed in a cooperative agreement with the Maryland Department of Natural Resources to protect the reservoir while providing public recreational opportunities. Liberty Reservoir CWMA is open to birding, hiking, horseback riding, and fishing. The lands surrounding Liberty Reservoir are forested, and all the usual forest-dwelling bird species can be found here in appropriate seasons: warblers, flycatchers, vireos, thrushes, woodpeckers, and more. Swallows, including Cliff, can be found in the summer months. Wood Ducks nest here. Notable perching birds breeding in this area include Willow Flycatcher, Veery, Wood Thrush, Hooded Warbler, Kentucky Warbler, Louisiana Waterthrush, Pine Warbler, Prothonotary Warbler, and Worm-eating Warbler. The greatest diversity of species is found at the north end of the reservoir, near Route 140 / Baltimore Boulevard. Use a map to explore the entire CWMA. Best seasons: Spring, summer and fall; winter can be good for ducks, sparrows, and woodpeckers. Be aware of hunting seasons and plan your visit accordingly. Hours: Sunrise to sunset. Website: http://dnr2.maryland.gov/wildlife/Pages/publiclands/central/liberty.aspx

62. Little Bennett Regional Park. The largest park in Montgomery County, at 3,700 acres, is located in Clarksburg, MD. The park includes a diversity of habitats, from stream-bottom to ridgetop forest, open fields, hedgerows, and wetlands. The park has 20 miles of trails and has some of the highest-quality streams in the county. Little Bennett is also home to 11 historic sites and points of interest. It is a great spot for butterflies, including the Olive Juniper Hairstreak and Maryland's state insect, the Baltimore Checkerspot. Also, it includes good areas for dragonflies and damselflies: vernal pools, swamps, streams, springs, and seeps each support different species. Breeding warbler species include Louisiana Waterthrush, Common Yellowthroat, American Redstart, Prairie Warbler, Blue-winged Warbler, Black-and-white Warbler, Kentucky Warbler, Northern Parula, Pine Warbler, Worm-eating Warbler, and Ovenbird. Other notable breeding species include Wild Turkey, Yellow-billed Cuckoo; Acadian, Great Crested, and Willow Flycatchers; Yellow-throated, White-eyed, and Red-eyed Vireos; Wood Thrush, Veery, Yellow-breasted Chat, Scarlet Tanager, Indigo Bunting, and Blue Grosbeak. Barred, Great Horned, and Eastern Screech-Owls all breed in the park. Long-eared Owls have wintered. GPS address (Kingsley Trail parking lot): Clarksburg Road, Clarksburg, MD (coordinates: 39.266033, −77.280639). Website: http://www.montgomeryparks.org/parks-and-trails/little-bennett-regional-park/

63. Loch Raven Reservoir, Baltimore County, MD. Provides habitat for birds of upland forest and open water. More than 200 species of birds have been reported from Loch Raven and its surrounding lands. Winter brings a selection of waterfowl, loons, and grebes. Wood Ducks nest here and can be found in the warm months. Herons can also be found in the warm months and Great Blue Heron is present year-round. Bald Eagles, Red-shouldered Hawks, and Red-tailed Hawks are also found year-round. Other hawks pass through during spring and fall migration. Ospreys are present spring through fall. A selection

of shorebirds may be present, particularly in the Paper Mills Flats area at the north end of the reservoir. Flycatchers, vireos, and warblers are present in migration and some stay to breed. Tips: On weekends, Loch Raven Drive is closed between Providence Road and Dulaney Valley Road. Walk-ins and biking are allowed. Scopes, and sometimes boots, are useful. Open for hunting during archery season for deer; plan accordingly. Best seasons: Winter and spring are best. Hours: Sunrise to sunset, year-round. GPS address: (coordinates: 39.463870, −76.576941). Website: http://dnr2.maryland.gov/wildlife/Pages/publiclands /central/lochraven.aspx

64. McKee-Beshers Wildlife Management Area/ Hughes Hollow. Located just off River Road in western Montgomery County, McKee-Beshers WMA is a 2,000-acre tract of woodlands, fields, wooded bottomland, and managed wetland impoundments. The WMA shares a common boundary with the Chesapeake and Ohio Canal to the south and borders Seneca Creek SP, a 1,200-acre public park and hunting area on the east. It provides habitat for a great diversity of birds. Biologists deliberately flood forest during the fall and winter to create "greentree reservoirs," which attract Wood Ducks as well as other waterfowl, which migrate through or spend the winter here. Acres of sunflowers are planted each year at McKee-Beshers WMA to attract gamebirds. The main dike is a good spot for viewing a variety of water and landbirds. In spring, look for Pied-billed Grebe, Green-winged and Blue-winged Teal, Wood Duck, and Hooded Merganser. A side dike loops around to the west and back to Hunting Quarter Road; it affords nice views into the marsh and passes through good habitat for warblers in migration. In late spring, Sora and Common Gallinule are regular and Virginia Rail is occasional. Least Bittern, Warbling Vireo, Yellow and Prothonotary Warblers, and both Orioles are annual nesters. Red-shouldered Hawks and Barred Owls also breed and are year-round residents. If time permits, walking southeast beyond the main dike leads to a mix of woods,

hedgerows, and open field areas that can be productive during spring and fall migration for a variety of landbirds. Tips: A spotting scope is strongly suggested at the impoundments. There are no toilet facilities at the site. Best seasons: Year-round, but birding can be unsafe during hunting seasons. Currently, there is no hunting on Sundays at any time of the year. Hours: 24 hours. GPS address: Hunting Quarter Road, Poolesville MD (coordinates: 39.083562, −77.405066). Website: http://dnr2.mary land.gov/wildlife/Pages/publiclands/central/mckee beshers.aspx

65. Middle Run Natural Area. Located on the outskirts of Newark, DE, is an ungated, free park that has been the focus of a decade-long habitat management partnership between the city and the Delaware Nature Society in which invasive plant species have been removed and thousands of native trees have been planted with the aid of volunteers. It features a dedicated birding trail within a larger network of grassy trails through prime habitat for a diversity of birds. The Delaware Nature Society operates free guided bird walks here every Tuesday during spring and fall migration and almost all of the eastern warblers, vireos, and flycatchers are seen here each year. Breeding birds include Prairie Warbler, Yellow-breasted chat, and Blue-winged Warbler. A series of ponds in the corner of the park have breeding Wood Ducks and has hosted several unusual shorebirds and herons. Middle Run is accessed by taking Paper Mill Road north of Newark, turning right at Possum Park Road, and then immediately left onto Possum Hollow Road. The trail is signed and starts by the parking lot. Website: http://www.delawarenaturesoci ety.org/DNS_Docs/Locations/Middle_Run_Birding _Trail_Brochure.pdf

66. Newark Reservoir. Located only a few miles from Middle Run (see no. 65), is located on a hill-top overlooking downtown Newark, DE, and has a paved trail around it popular with walkers and birders. It has shallows at one end that attract migrating shorebirds and the main body of deeper

water has attracted several rare or uncommon waterbirds, including Greater White-fronted Geese and Cackling Geese, Horned and Red-necked Grebes, both loons, and several uncommon ducks. There is also a trail through the adjacent woods which is good for migrating warblers. This is an excellent place to search for unusual birds displaced by a storm. It is accessed by taking Paper Mill Road north of Newark and then turning right onto Old Paper Mill Road. Website: https://newarkde.gov /459/Newark-Reservoir

67. Patapsco Valley State Park. The Henryton Birding Trail at Patapsco Valley SP has one of the county's finest mature woodlands, giving local naturalists a chance to observe many of the county's rarer birds and wildflowers. It consists of floodplains and upland deciduous forest and some field and edge. Scrubland is accessed by walking upstream about 1.5 miles and then ascending to the ridgetop. Because it is often much cooler near the river, an extra layer of clothing is merited on spring mornings. Layout: Henryton Road leads downhill from Old Frederick Road (Route 99) to the South Branch of the Patapsco River. The road dead ends almost at the river where a bridge once crossed. The area is also popular with fishermen and horse riders. Listen for Worm-eating Warblers along the slopes and Louisiana Waterthrushes in the stream valley. Spring and fall bring waves of neotropical migrants, many of which favor mature woodlands and bottomlands. Birdlife: Worm-eating, Yellow-throated, and Cerulean Warblers nest in small numbers, as do Acadian Flycatcher, three vireo species, Wood Thrush, Veery, Ovenbird, Kentucky and Hooded warblers, and Scarlet Tanagers. Tips: If you arrive before sunrise, you may wish to first walk downstream a short distance where an east-facing slope receives the first sun. Best seasons: Spring and fall migration, or late spring for neotropical breeders. Hours: 8:00 a.m. to dusk. GPS address for Henryton Road access: Henryton Road, Marriotsville, MD (coordinates: 39.350780, −76.913892). Website:

http://www.howardbirds.org/birdinghowardcounty /Henryton/henryton_overview.htm

68. Patuxent River State Park, southwest of Damascus, MD. Includes extensive pine plantings and deciduous woods, scrub and second-growth, upland forest and river floodplain, cultivated fields, streams, a pond, a beaver-created wetland, and bird feeders in winter at the headquarters building on Annapolis Rock Road. The main parking area on the south side of Annapolis Rock Road is marked by a small sign across from the entrance. Trails are generally dry, except after heavy rains or where they drop down to cross small streams. Two nice spots are worth visiting in midspring: The crossing of the Patuxent on Hipsley Mill Road and the intersection of Hipsley Mill Road and Annapolis Rock Road. Both are excellent for breeding and migrant warblers. Birdlife: Wild Turkey, American Woodcock, Barn Owl, Eastern Whip-poor-will, Red-headed Woodpecker, Common Raven, Winter Wren, migrant and nesting warblers. Best seasons: spring.

Imagine the surprise of hiking in Patuxent River State Park and discovering a Long-eared Owl who poses for pictures! Photo: Anthony VanSchoor

Hours: Dawn to dusk. GPS address: 3850 Hipsley Mill Road, Woodbine, MD (coordinates: 39.265508, −77.114715). Website: http://mdbirdingguide.com/Patuxent_Annapolis_Rock_Road

69. Seneca Creek State Park, Montgomery County, MD. Encompasses 6,000-plus acres spanning 14 miles of Seneca Creek in several separate parcels. The portion described here is the most frequently birded sector and includes Clopper Lake, the second largest body of water in Montgomery County. Terrain rolls quite a bit and some trails are fairly steep. Mostly includes deciduous woods and open meadows/mowed areas with one large white pine stand. The trail along the north side of the lake affords good views of waterfowl; a scope is usually helpful. The Lakeside Trail runs entirely around the lake but is very long. Numerous picnic areas around the park offer nice woodland birding in migration seasons. Visiting on weekends in the warmer months is not recommended—the park becomes crowded. Get a trail map from the visitor center. Kingfisher parking area is elevated and allows good views of birds near the dam and in a little cove that is otherwise difficult to bird without spooking waterfowl. Birdlife: Waterfowl in winter, especially diving ducks such as Ring-necked and Bufflehead; loons are regular in winter and early spring. Warblers and vireos in migration periods; Red-breasted Nuthatch and Golden-crowned Kinglet in the pine stand. Best seasons: Winter for waterfowl; spring for passerine migrants. Hours: 8 a.m. to sunset, March–October; 10 a.m. to sunset, November–February. GPS address for Clopper Lake: Seneca Creek Road, Gaithersburg, MD. Website: http://dnr2.maryland.gov/publiclands/Pages/central/seneca.aspx

70. Soldier's Delight Natural Environmental Area, Baltimore County, MD. A serpentine barren with lots of piney woodlands. It is a reliable place to see Pine Warbler and Prairie Warbler as breeders. Many other songbirds breed here, too. The site encompasses 1,900 acres of serpentine barren, the largest in the state. The ground in the barrens area is underlain by serpentine, a bedrock high in magnesium and deficient in essential plant nutrients, leading to growth of a scrubby, sparse grassland. The mineral composition of the soil supports a unique plant community adapted to these conditions. Soldiers Delight hosts 39 rare, threatened, or endangered plant species, as well as rare insects, rocks, and minerals. Prescribed burning is being used to return the area to its natural condition. There are surrounding buffer areas of deciduous forest. Seven miles of marked hiking trails wind through Soldiers Delight. Nesting birds include those adapted to scrub-shrub conditions, including Prairie Warbler, Yellow-breasted Chat, American Woodcock, and Eastern Whip-poor-will. Other nesting species include various warblers and both tanagers. Winter brings good numbers of Golden-crowned Kinglet and Red-breasted Nuthatch to the pines. During migration, the best trails are through the deciduous woods in the western part of the property off Wards Chapel Road. Tips: Hunting is carried out on portions of the area; be aware of hunting seasons and plan accordingly. Nocturnal breeding species may be found at dusk by walking trails from a small parking area on Deer Park Road north of the main entrance. Best seasons: Year-round. Hours: 9 a.m. to sunset. GPS address: 5100 Deer Park Road, Owings Mills, MD. Website: http://dnr2.maryland.gov/publiclands/Pages/central/soldiersdelight.aspx

71. Sugarloaf Mountain / Stronghold, southwest of Hyattstown, MD. The southeasternmost ridge of the Appalachians in Maryland and a short drive from Interstate 270. Sugarloaf has an elevation of 1,282 feet and is covered by mature forest, with many rock formations on its slopes and at its summit. The land surrounding the mountain is mostly agricultural fields, with some second-growth stands of forest. Sugarloaf Mountain is privately owned by Stronghold, Inc., founded in 1946 to protect and share Sugarloaf and its large tract of upland forest with the public. Hiking, birding, and other nature-oriented

activities are welcomed. Common Ravens nest on the mountain cliffs. Breeding birds include Yellow-throated Vireo, Ovenbird, Louisiana Waterthrush, American Redstart, Northern Parula, and Worm-eating, Kentucky, and Black-and-white Warblers. In spring and fall migration, Sugarloaf is good for many additional wood warblers, as well as Rose-breasted Grosbeak, Swainson's Thrush, and Hermit Thrush. Best birding seasons: Spring and early summer. The hike to the summit overlook is stunning when the leaves are changing in mid-October. Hours: Open daily, 8 a.m. until 1 hour before sunset, year-round. Cost: Free, although visitors are encouraged to become members of Stronghold, Inc. Parking: Available at the park entrance and on the mountain at several trailheads. Parking spaces are limited, especially during the busy spring and fall weekends. GPS address: 7901 Comus Road, Dickerson, MD. Website: http://www.sugarloafmd.com/

72. Susquehanna State Park, Harford County, MD. Contains 2,600 acres of mature forest, open fields, multiple streams, and the mighty Susquehanna River. The park offers a variety of recreational opportunities as well as points of historical significance. Extending from Conowingo Dam to the Lapidum boat ramp, this park offers hiking and biking trails, fishing, boating, and excellent birding opportunities. Considered one of the best birding areas in Harford County, the lush forests are breeding grounds for many forest-dwelling species, including warblers, vireos, and orioles. The Susquehanna River is also a major migratory route for countless gulls, waterfowl, raptors, and passerines. Notable breeding species include Cerulean Warbler found in the Deer Park Picnic area and Prothonotary Warbler found in flooded woodlands along the river's edge. The Lapidum area provides good viewing for waterfowl. Best seasons: Spring and fall migration. Winter for waterfowl. Hours: Open from sunrise to sunset. Deer Park Picnic area open from 10 a.m. to sunset. GPS address: 4188 Wilkinson Road, Havre de Grace, MD. Website: http://dnr

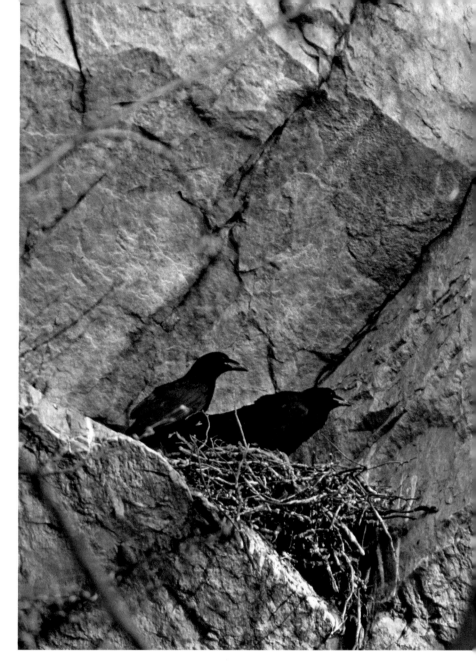

.maryland.gov/publiclands/Pages/central/susquehanna.aspx

73. Swan Harbor Farm, Havre de Grace, MD. This Harford County, MD, green space offers a large pond with freshwater marsh and pasture. It is excellent for bitterns, rails, snipe, migrant shorebirds, and Marsh Wren in late spring. Located on the banks of the Chesapeake Bay just south of the town of Havre de Grace, this is a 530-acre working farm and special events venue operated by the Harford County Department of Parks and Recreation. A nature trail runs through the woods along the bay front; behind the mansion house, a wooden platform provides an overlook of the bay. More than

Before the Appalachian ridges start, Sugarloaf Mountain offers a taste of mountain life, with nesting Common Ravens on a rock wall.

250 species have been observed at Swan Harbor Farm Park. The freshwater marsh located within the farm area is a prime draw for migrating ducks, herons, and shorebirds. Several types of rails are seen on a regular basis. The open fields in winter are good for Snow Buntings, Horned Larks, American Pipits, and sparrows. Year-round residents include Canada Goose, Mallard, Pied-billed Grebe, Double-crested Cormorant, Great Blue Heron, Black and Turkey Vultures, Bald Eagle, Cooper's Hawk, and Red-shouldered and Red-tailed Hawk. The variety of wintering waterfowl is outstanding, including Snow Goose, Tundra Swan, Gadwall, American Wigeon, American Black Duck, Northern Pintail, Green-winged Teal, Canvasback, Redhead, Ring-necked Duck, both scaup, Bufflehead, Common Goldeneye, Hooded Merganser, Common Merganser, and Ruddy Duck. Tips: Walk the path around the marsh; use the blind to observe the area. Take the trails through the woods along the water's edge. Best Seasons: Year-round. Winter provides great waterfowl viewing. Spring, summer, and fall bring a large variety of migrants, including shorebirds. The town of Havre de Grace has a fascinating duck decoy museum, highlighting the significance of waterfowl hunting to the Chesapeake. Hours for Swan Harbor Farm: Open daily from sunrise to sunset. GPS address: 401 Oakington Road, Havre de Grace, MD. Website: http://www.sanharborfarm.org/

74. Triadelphia Reservoir. Located on the Patuxent River in Howard and Montgomery Counties. A permit is required for birding here. There are four sites open to birding on the reservoir. Brighton Dam: Brighton Dam Road runs across the top of the dam. There is a sidewalk along the north side only. From this vantage point, one looks out over an expanse of water constituting the southern end of the reservoir. Pigtail: From Triadelphia Road, a long gravel road ends in a parking lot with a boat ramp at the north end of the cove. When water levels are high, there is water adjacent to the parking lot. During late summer, under normal conditions,

mudflats will begin to emerge just south of the parking lot. The path along the east side of the cove allows birders to walk parallel to the flats and the water. Big Branch: Much of the most productive area can be seen from the parking lot and boat ramp located at the head of the cove (a telescope is valuable.) When water levels begin to drop, mudflats emerge close to this location. In the course of weeks or months, the flats may expand south a considerable distance, so that walking from the ramp along the left (east) edge may allow closer looks at shorebirds. Greenbridge: From the boat ramp on Greenbridge Road one can view the dam area as well as upstream. Also, if you find the stairs off the parking area, walk down to the inlet, and go left around the inlet, you come to a wide dirt road. If you proceed along that road you will come to another vantage at a pipeline crossing the reservoir. In late summer into fall, dropping water levels yield mud, providing shorebird habitat. Birdlife: Waterfowl, eagles, shorebirds, gulls, terns, woodland birds. Bald Eagles are abundant in winter at Brighton Dam. Cliff Swallows nest on Brighton Dam, starting in May. As water levels drop in late summer into fall, shorebird habitat increases at all sites, except Brighton Dam. A few Bonaparte's Gulls can be present in winter. Large numbers of Common Mergansers winter on the reservoir, often with a few Red-breasted Mergansers among them. Best seasons: Spring for swallows, fall through spring for waterfowl and gulls, fall for shorebirds, summer and early fall for terns. Hours: March 15–November 30, conditions permitting, a half-hour before sunrise to sunset. Closed Thanksgiving, Christmas, New Year's Day. GPS address: 26 Brighton Dam Road, Brookeville, MD. Website: https://www.wsscwater.com/watershedregs#bird

75. White Clay Creek State Park. 2 miles north of Newark, DE, features one of Delaware's finest birding walks, linking Hopkins Bridge and the Wedgewood Road Footbridge, although there is a network of other excellent trails here crossing a mix of grass-

land and woods. Well worth visiting year-round, it is especially rewarding from April to November. Uncommon breeding birds found here include American Redstart, Veery, Blue-winged Warbler, Yellow-throated Warbler, and Warbling Vireo. The park is the only known Delaware breeding site for Cerulean Warblers, but their numbers here are declining. Please refrain from playing recorded calls to attract the species. The trail circuit can be accessed from either the Chambers House Nature Center, Hopkins Bridge, or the Wedgewood Road Footbridge area. If you have limited time, or just want a shorter walk, park at the Wedgewood Road Footbridge parking area and cross the footbridge. Directions to Chambers House Nature Center: Take DE 896 (New London Road) north from Newark. Turn right (east) on Hopkins Road. After 1 mile, turn left (north) on Creek Road. The parking lot is on the left (west) in 0.2 mile. The nature center is in the historic house beyond the lot. Note: The gated parking lot for the nature center may not be open until 8 a.m. Those wanting an earlier start may find parking along Hopkins Road, to the east of the bridge. Please observe posted parking restrictions. GPS address: Chambers House Nature Center, Newark, DE. Website: www.destateparks.com/park/white-clay-creek/

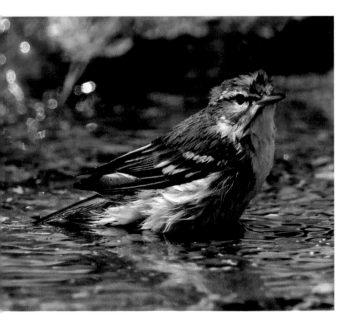

Ridge & Valley

76. Blairs Valley (see Indian Springs Wildlife Management Area). North of Clear Spring, MD, it is a beautiful valley for springtime birding. The valley features many local songbird breeders, including Blue-winged Warbler. This is one of the best (and most beautiful) sectors of the Indian Springs Wildlife Management Area. Expect ticks in the warmer months. GPS address: Blairs Valley Lake 4, Clear Spring, MD. Website: http://dnr.maryland.gov/fisheries/Pages/hotspots/blairsvalley.aspx

77. C&O Canal access points. The C&O Canal and adjacent Potomac River offer excellent birding in the Ridge & Valley province. There are many access points, such as Fort Frederick State Park (including Big Pool) and the Neck (or Prather's Neck), which is a few miles east of the Park, and many other sites worth exploring during the spring migration season. When the weather favors songbird movement in the Region, these sites burst with passage migrants. The forested ridges, the river course, and the canal are a winning combination for songbirds at many sites from western Frederick County to Allegany County. GPS address: 11100 Fort Frederick Road, Big Pool, MD.

78. Catoctin Mountain Park, northwest of Thurmont, MD. Managed by the National Park Service and encompasses 8 square miles on the Catoctin Mountain ridge, on the eastern ramparts of the Appalachian Mountains. It features sparkling streams, rock outcroppings, extensive hiking trails, and panoramic views. The Manahan Road area (on the northern verge of the park) has the most reliably present population of nesting Cerulean Warblers in this part of Maryland and nesting populations of several other warbler species. The nearby Owens Creek Picnic Area includes the Brown's Farm Nature Trail that is also good for warblers, including Louisiana Waterthrush. Wood Thrush, Ovenbird, and other denizens of mature deciduous forests are common throughout the park. Also: Hooded and

Crown jewel of White Clay Creek State Park, a female Cerulean Warbler finds a quiet pool for a quick bath.

Kentucky Warblers, American Redstart, Yellow-throated Vireo, Veery, Baltimore Oriole, and Scarlet Tanager. In migration, the park is a good place to find a variety of additional warbler species, migrating hawks, and thrushes. Warning: Copperheads and Timber Rattlesnakes are occasionally seen on rock outcroppings. Black Bears are common but rarely seen. Trails vary in difficulty; hiking boots are recommended. Best seasons: Year-round, but spring and fall migration periods are most productive. Hours: Open daily, sunrise to sunset. Visitor center hours: 9 a.m.–5 p.m. during the fall; closed on the following federal holidays: New Year's, Martin Luther King Jr. Day, Presidents Day, Veterans Day, Thanksgiving Day, Christmas. Cost: Free. Parking: Paved and gravel parking is available throughout the park; roadside parking is only permitted along Manahan Road. GPS address: 6602 Foxville Road, Thurmont, MD 21788. Website: https://www.nps.gov/cato/index.htm

79. Cunningham Falls State Park. One of Maryland's most popular state parks, Cunningham Falls SP is located in northern Frederick County in the picturesque Catoctin Mountains. The park encompasses 6,000 acres, of which 4,397 remain wild with few trails. Cunningham Falls SP is divided into two separate and distinct areas: The William Houck area includes the lake, Cunningham Falls, camping, and trails. The Manor Area includes the Scales & Tales Aviary, the historic Catoctin Iron Furnace, and additional camping. The park has breeding populations of Worm-eating and Kentucky Warbler, American Redstart, Ovenbird, Yellow-throated Vireo, Baltimore Oriole, Wood Thrush, and Scarlet Tanager. In migration, the park is a good place to find a variety of additional warbler species, migrating hawks, and thrushes. Warning: Copperheads and Timber Rattlesnakes are occasionally seen. Black Bears are common, but rarely seen. The Houck/lake area should be avoided during the summer weekends and holidays. Hiking boots are recommended on the trails. Best seasons: Year-

round, but spring and fall migrations are most productive. Hunting is allowed in the park; be aware of hunting seasons and plan your visit accordingly. Hours: 8 a.m. to sunset, April–October; 10 a.m. to sunset, November–March. GPS address (Houck Area): 14011 Catoctin Hollow Road, Thurmont, MD. Website: http://dnr2.maryland.gov/publiclands/Pages/western/cunningham.aspx

80. Green Ridge State Forest, east of Flintstone, MD. 47,560 acres and is the largest contiguous block of forested public land in Maryland. It is rich in both natural and cultural heritage and remains a "working forest" today, as it is managed by the Maryland Department of Natural Resources Forest Service to conserve the natural ecological processes, while supporting the economy of the region through an active forest management program. This rugged and forested area provides expanses of habitat for an array of breeding forest songbirds. The high ridges are good for breeding Eastern Whip-poor-will, Cerulean, Hooded, and Worm-eating Warblers, Blue-headed Vireo, Black-capped Chickadee, Ruffed Grouse, and Wild Turkey. A series of connected roads allow you to explore this forest and the C&O Canal and sinuous Potomac River just to the east. GPS address: Green Ridge Road Southeast, Oldtown, MD. Website: http://dnr2.maryland.gov/forests/Pages/publiclands/western_greenridgeforest.aspx

81. Indian Springs Wildlife Management Area (WMA), Washington County. 6,400-acre tract of state-owned hunting land managed by the Department of Natural Resources (DNR). Indian Springs is a wonderful birding destination for spring and fall migrants. Most of the habitat is upland deciduous woodlands of oak and maple, with numerous streams and a 30-acre man-made lake stocked for fishing in Blairs Valley. There are wetland areas upstream from the lake and below the dam. Agricultural fields at Indian Springs are planted to provide habitat and winter food for game and nongame species. There are numerous parking areas and access points for Indian Springs. Turning north onto

One can easily get lost in the emerald expanse of Green Ridge State Forest, laced with miles of meandering streams.

AT&T Road from Hanging Rock Road takes you into a bird-rich valley with a stream along the western edge of the road. Farther to the west along Hanging Rock Road will bring you to Catholic Church Road, with numerous "birdy" spots along the road and the side roads off of it. The area around the lake just north of the intersection of Blairs Valley Road and Hanging Rock Road contains the headquarters for Indian Springs WMA. A trail circles the lake, and there are several other trailheads here. Wandering around the roads and trails within the WMA can be very rewarding for the avid birder and naturalist. There are vast areas of intact upland hardwoods and fields to explore. Birdlife: A great starting point is the land on either side of Blairs Valley Road, just south of the Pennsylvania state line. To the east, a small parking area allows access to overgrown fields that are well into secondary successional growth, supporting White-eyed Vireo and Gray Catbird as well as Eastern Whip-poor-will and Chipping Sparrow. The west side of Blairs Valley Road contains a large wetland/field and wooded swamp where American Woodcock display in March. Breeding birds include Blue-winged Warbler, Indigo Bunting, Scarlet Tanager, Yellow-breasted Chat, and others. Following the trail to the west takes you up the east face of Bear Pond Mountain. Listen for Common Ravens that nest in the rock outcroppings along the ridge. Wood Thrush, Blue-gray Gnatcatcher, Northern Parula, American Redstart, Black-and-white Warbler, Ovenbird, Worm-eating Warbler, Eastern Wood-Pewee, Acadian Flycatcher, Red-eyed Vireo, Yellow-billed Cuckoo, and many others breed in the rich woods of this mountain, along with Pileated, Downy, Hairy, Red-bellied Woodpeckers, and Northern Flicker. Along AT&T Road are Louisiana Waterthrushes as well as other breeding songbirds. Best seasons: Spring and fall migration. Be aware of hunting season and visit accordingly. Hours: 24 hours a day, 7 days a week, year-round. Website: http://dnr.maryland.gov/wildlife/Pages/publiclands/western/indiansprings.aspx

While the birding is great at South Mountain Recreation Area, the views of the Potomac River are nothing less than spectacular.

82. Monument Knob, Boonsboro, MD. The hawk watch atop Washington Monument SP, is located right on the Appalachian Trail. It is a regular but fairly informal hawk watch atop the stone monument, which straddles South Mountain. One or more counters are present many days, at least through the morning hours; volunteers are most needed in the afternoons. The view from the stone tower is breathtaking. The view alone is worth the visit, but since South Mountain is a migratory bird flyway, the park offers excellent all around bird-

watching opportunities. Directions: Located off Alternate Route 40, near Boonsboro, MD. Take I-70 to Frederick and go west on Alternate Route 40 to Monument Road. Take Monument Road to the park entrance. Follow the right fork about 0.5 mile into the park to the Monument Trail. The hawk watch is located at the top of the tower, about a quarter mile walk uphill. GPS address: (coordinates: 39.498994, −77.623701). Website: http://hawk count.org/siteinfo.php?rsite=279

83. South Mountain Recreation Area. A multiuse area weaving along the South Mountain ridge from the Pennsylvania border on the north to the Potomac River on the south. The recreation area encompasses South Mountain SP, Greenbrier SP, Washington Monument SP (site 82 above), Gathland SP, as well as the South Mountain State Battlefield and the Maryland section of the Appalachian Trail, which runs through all of these parks and is designated as a National Scenic Trail. The South Mountain Recreation Area offers 13,000 acres of forest in South Mountain SP, an extensive trail system for year-round hiking, a 42-acre lake in Greenbrier SP, and a superb hawk-watching site at Washington Monument SP. Many parts of the recreation area are easily accessible and offer opportunities for the most casual to the more serious outdoor enthusiast. In addition to short or overnight hikes along Maryland's 41 miles of the Appalachian Trail, visitors can enjoy camping, boating, fishing, swimming, and picnicking. Elevations range from 250 feet at the Potomac River to 1,900 feet at High Rock. Birdlife: A number of warblers are seen in this area, including Cerulean, Black-throated Green, Black-and-white, Kentucky, and Hooded Warblers, as well as American Redstart, Ovenbird, and Louisiana Waterthrush. Other birds of note include Broad-winged Hawk, Wild Turkey, Common Raven, and Scarlet Tanager. Hours: Greenbrier SP: 8 a.m. to sunset. GPS address (Greenbrier SP): 21843 National Pike, Boonsboro, MD. Website: http://dnr2.maryland.gov/parkquest /Pages/SouthMountain.aspx

Allegheny Highlands

84. Big Run State Park / Savage River State Forest.
Southwest of Frostburg, MD. This park and the surrounding state forest offer a diversity of Allegheny Highland forested habitat as well as the Savage Reservoir and Savage River. This huge green space (more than 59,000 acres) is a birder's paradise in late spring and early summer, with a dozen warblers, vireos, and other forest songbirds (Scarlet Tanager, Rose-breasted Grosbeak). Great birding during spring migration, as well as during the beginning of the nesting season. GPS address (Big Run SP): 10368 Savage River Road, Swanton, MD.

85. Cranesville Swamp, western Garrett County, MD. A boreal peat bog, nestled in a mountain valley known as a frost pocket, where cold conditions occur often enough for northern plants to persist here. A trail hike through the spruce and larch forest (located in West Virginia) gives access to the birds and plants of Cranesville Swamp. Visitors may hear the croak of a Common Raven at midday or the toots of the Saw-whet Owl during a nighttime visit. Birds to look for include Willow Flycatcher, Alder Flycatcher, Golden-crowned Kinglet, Northern Waterthrush, Nashville Warbler, and Swamp Sparrow. The bog includes many rare species of plants. GPS address: White Trail, Terra Alta, WV. Website: http://dnr2.maryland.gov/wildlife/Pages/NaturalAreas/Western/Cranesville-Swamp.aspx

86. Dan's Rock Wildlife Management Area, south of Frostburg, MD. Drive to the summit of Dan's Rock for a spectacular vista and some good ridge-top birding during spring and fall migration. This site is a great hawk watching spot in autumn. The road to the summit of Dan's Rock is birdy, as are many sites down in the valley below Dan's Rock (south of Lonaconing is Old Legislative Road, famous for its Golden-winged Warblers and Henslow's Sparrows). GPS address: 17600 Old Dans Rock Road SW, Rawlings, MD.

87. Herrington Manor State Park. Nestled in the Garrett State Forest west of Oakland and 4 miles from Swallow Falls SP. Plentiful fish in the lake attract nesting Bald Eagles and Osprey. Twelve miles of trails throughout the park take birders through prime nesting habitat for birds of the northern hardwood forest: Blackburnian, Black-throated Blue, and Black-throated Green Warblers. Raptors, including Broad-winged Hawk and several species of owl, are common in the park. Year-round: Expect to find birds only found in winter in other parts of Maryland, such as Black-capped Chickadee, Dark-eyed Junco, and Winter Wren. Best seasons: Spring, fall, winter. Hours: Sunrise to sunset. There is a seasonal entry fee. GPS address: 222 Herrington Lane, Oakland, MD. Website: http://dnr2.maryland.gov/publiclands/Pages/western/herrington.aspx

88. Finzel Swamp, in northeastern Garrett County and westernmost Allegany County, MD. A swamp/bog with lots of dead snags for perching birds. Good birding any time of year but at its best in late spring. This 326-acre preserve is owned by The Nature Conservancy. The trail through the swamp is usually dry but waterproof footwear is recommended, just in case. The trail continues past the swamp out to a pond in the Allegany County part of the preserve. The American Larch (Tamarack) trees that dot the swamp are rare in Maryland. Another northern tree that occurs is Red Spruce. Birdlife: A good place to see Sora and Virginia Rails. Breeding birds of interest include Ruffed Grouse, Alder Flycatcher, Veery, Northern Waterthrush, and Swamp Sparrow. Tips:

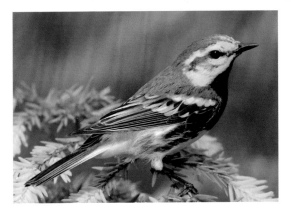

Finzel Swamp is one of several great venues at the eastern verge of the Allegheny Highlands for nesting warblers like the Black-throated Green Warbler.

The rails are often found near or just past the third bridge of the main walkway. Best seasons: Spring, summer, and fall. Hours: Dawn to dusk. Cost: Free. Parking: Gravel lot at the end of the Cranberry Swamp Road. GPS address: 305 Cranberry Swamp Road, Frostburg, MD. Website: http://dnr2.mary land.gov/wildlife/Pages/NaturalAreas/Western /Finzel-Swamp.aspx

89. Mount Nebo Wildlife Management Area, Garrett County, MD. A 1,863-acre tract consisting of an extensive wetland complex with man-made and beaver ponds, thick alder and wetland shrub cover, and isolated pockets of Red Spruce and Eastern Hemlock. Approximately 90% of the WMA is dominated by mixed hardwood forest in various age classes. This area is actively managed for species like American Woodcock and Alder Flycatcher. Mt. Nebo Road bisects the WMA between Garrett Highway / Route 219, and Oakland–Sang Run Road and is gated at both ends, preventing travel by vehicle. Foot travel is welcome on the 1.02 miles of gravel road between the gates. About 0.30 miles from the parking lot on the east end of Mt. Nebo Road, a road intersects from the south that leads 0.83 miles to the southernmost pond. From this pond, it is an additional 1.4 miles to the southern parking area. Birdlife: Various sparrows, warblers during migration, various breeding warblers, ducks, Green and Great Blue Herons at the ponds; American Woodcock displaying on early spring evenings; Ruffed Grouse, kinglets, Alder and Least Flycatchers, vireos, Yellow and Black-billed Cuckoos; Cedar Waxwing and Red-tailed Hawk. Tips: Parking areas and access roads are gravel and may not be maintained in winter. Trails are maintained but not actively marked. Be aware of hunting seasons and visit accordingly. Best seasons: Spring, summer, and fall. Hours: Open 24 hours a day, 7 days a week. GPS address: Mt. Nebo Road, Oakland, MD. Website: http://dnr.maryland.gov/wildlife/Pages/public lands/western/mtnebo.aspx

To get lost in the Appalachian wilderness, travel to Potomac State Forest, with breathtaking scenery such as Cascade Falls.

90. New Germany State Park, Garrett County, MD. Gorgeous upland mixed forest with a large scenic lake and lovely wooded stream valleys. Lots of breeding songbirds: Winter Wren, Blue-headed Vireo, Canada Warbler, Black-throated Green Warbler, Blackburnian Warbler, Northern Waterthrush, Dark-eyed Junco, and others. Good place to look for nesting Broad-winged Hawk. This is a great place to camp for a few days in early June to soak up the woodland birdsong typical of late spring in New England. GPS address: 349 Headquarters Lane, Grantsville, MD. Website: http://dnr.maryland.gov /publiclands/Pages/western/newgermany.aspx

91. Potomac-Garrett State Forest. Two large tracts of upland forest in Garrett County. Potomac State Forest is in the southwestern verge of the county, on the north fork of the Potomac, where there is a gorgeous rocky stream in a deep, forested valley. Great for a weekend of primitive tent camping. This area is great for Black-throated Green Warbler and Least Flycatcher, and nearby recovered surface coal mine

lands support populations of Henslow's Sparrows (look for the dry and scrubby open lands on the back roads outside of the forest tracts). Garrett State Forest is just west of Swallow Falls State Park and just east of the West Virginia border. Just south of Cranesville Swamp. Wander the forest roads in late spring in search of northerly breeders. GPS address: 1431 Potomac Camp Road, Oakland, MD. Website: http://dnr.maryland.gov/forests/Pages/publiclands /western_potomacforest.aspx

92. Rocky Gap State Park.

Just west of Flintstone, MD, and north of Interstate 68, is a state-owned recreation area with resort features. The state park's 3,000 acres include Lake Habeeb, nestled at the foot of Evitts Mountain. The park's man-made lake, fed by Rocky Gap Run, covers 243 acres and sports white sand beaches. Hiking trails include the 4-mile Lakeside Trail and the 5-mile Evitt's Homesite Trail, which climbs Evitts Mountain amid streams with hemlock, Mountain Laurel, and rhododendron growing nearby. The quarter-mile Touch of Nature Trail is a paved route to an accessible fishing dock. Birdlife: The best spot in Allegany County for finding waterfowl (especially on a rainy autumn day). Also noted for turning up some of the rarer birds ever found in the county. Occasionally, there are shorebirds at the beach at the end of the main entrance. Caspian, Common, and Forster's Terns are often seen at Rocky Gap in spring. Also a great spot for migrant passerines in spring and fall. The pine stands found throughout the park host singing Pine Warblers. Tips: Best early in the morning before boaters, fisherman, and other recreational users disturb birds on the lake. Avoid summer weekends and holidays. Best seasons: Spring, autumn, winter. Parts of the park are used for hunting. Be aware of hunting seasons and visit accordingly. Hours: Open 24 hours a day, 7 days a week, year-round. GPS address: 12500 Pleasant Valley Road, Flintstone, MD. Cost: $2 day use fee in winter, $5 in summer for MD residents, $3/$6 for out-of-state visitors. Website: http://dnr2.maryland .gov/publiclands/Pages/western/rockygap.aspx

The Mt. Aetna Area of Savage River State Forest has numerous hiking trails through lush habitat, as these torches of Cardinal Flower attest.

93. Savage River State Forest / Mt. Aetna Area,

Garrett County, MD. Fabulous Appalachian high elevation habitat with a high-end resort lodge and restaurant atop the mountain—a possible base for a weekend of birding in late spring for those not interested in roughing it. Many breeding birds, including Common Raven, Blackburnian Warbler, American Woodcock, Golden-crowned Kinglet, Blue-headed Vireo, Ruffed Grouse, and even Northern Goshawk on rare occasions. GPS address: 1600 Mt. Aetna Road, Frostburg, MD. Website: http://dnr2.maryland.gov/forests/Pages/savageguide _mttract.aspx

94. Swallow Falls State Park,

in Western Garrett County, MD. Features three of Maryland's most spectacular waterfalls along a 1.25-mile trail through old-growth hemlock forest. The Youghiogheny River and several of its tributaries converge in the park. At nearly 60 feet tall, Muddy Creek Falls, on the park's main trail, is Maryland's tallest. The trails at Swallow Falls weave through a 40-acre grove of old-growth Eastern Hemlocks. Managed as a sensitive area, the dense forests in the park provide ample cover for birds such as Golden-crowned Kinglet, Blue-headed Vireo, Wood Thrush, and various northern warblers—Blackburnian, Magnolia, Black-throated Blue, Black-throated Green, Canada, and more. Tips: The trails can get crowded on summer weekends and holidays. Best seasons: Spring, fall, and winter. Hours: Sunrise to sunset. GPS address: Maple Glade Road, Oakland, MD. Website: http://dnr2.maryland.gov/publiclands /Pages/western/swallowfalls.aspx

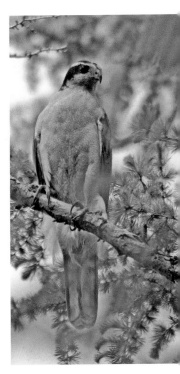

Savage River State Forest has been home to the ultimate mountain bird, a Northern Goshawk, but beware, they fiercely protect their territory.

Sites Outside Our Region Worth Visiting

Pennsylvania

95. Hawk Mountain Sanctuary, Kempton, PA. This is the most famous hawk watch on Earth. A wonderful hawk-watching experience in September or October when a northwest wind is blowing. A good northwest wind on or around the 15th of September can produce huge numbers of passing Broad-winged Hawks, though any windy day in October can be worthwhile. The weekends can be mayhem because of an overflowing parking lot. Tip: It is always much colder on the mountaintop, so bring additional layers for the long day outside, and sunscreen. The hike to the north lookout is slightly challenging so wear appropriate footwear. A properly timed autumn visit to Hawk Mountain should be on every birder's bucket list. Warning: Weekends in the high season see huge crowds and full parking lots. GPS address: 1700 Hawk Mountain Road, Kempton, PA. Website: http://www.hawkmountain.org/

96. Waggoner's Gap Hawk Watch, north of Carlisle, PA. Managed by the Audubon Society of Pennsylvania, this is a superb autumn hawk watch with excellent volunteer hawk counters in place. Be prepared for cold and wind on this very exposed rocky ridge. Go on days promising brisk northwest or light southeast winds. Early November days with decent northwest winds can produce good counts of Golden Eagles, more so than Hawk Mountain. Directions: Take Route 74 north from Carlisle, PA. Park at the height of land or in the parking lot on the north side of the mountain. GPS address: Waggoner's Gap Hawk Watch, Waggoners Gap Road, Landisburg, PA (coordinates for parking lot: 40.278606, −77.276432). Website: http://www.waggap.com/Directions.htm

Virginia

97. Back Bay National Wildlife Refuge, south of Virginia Beach, VA. Includes a thin strip of barrier island coastline typical of the Atlantic and Gulf Coasts, as well as upland areas on the west bank of Back Bay, totaling 9,250 acres. Habitats include beach, dunes, woodlands, agricultural fields, and emergent freshwater marshes. The majority of refuge marshes are on islands within the waters of Back Bay. Thousands of Tundra Swans, Snow and Canada Geese, and a large variety of ducks visit the refuge during the fall/winter season. Refuge waterfowl populations usually peak during December and January. The refuge also provides habitat for other wildlife, including such threatened species as the Loggerhead Sea Turtle, Piping Plover, Mink, River Otter, and Cottonmouth snake, and recently recovered species such as the Brown Pelican and Bald Eagle. Back Bay NWR provides 8 miles of scenic trails, a visitor contact station, interpretive programming, and, with advance scheduling, group educational opportunities. Directions: Immediately south of Sandbridge Beach, VA, at the southern end of Sandpiper Road. The refuge has a nice headquarters building. Best to check access issues ahead of time. GPS address: 4005 Sandpiper Road, Virginia Beach, VA. Website: https://www.fws.gov/refuge/back_bay/

98. Chincoteague National Wildlife Refuge, Chincoteague, VA. Situated on the southern portion of Assateague Island, this is one of the most famous East Coast wildlife refuges for birders. Chincoteague refuge includes more than 14,000 acres of beach, dunes, marsh, and maritime forest. Established in 1943 to provide habitat for migratory birds, the refuge today provides habitat for waterfowl, wading birds, shorebirds, and songbirds, as well as other species of wildlife and plants. The refuge also provides wildlife-dependent recreational opportunities, such as fishing, hunting, wildlife photography, and environmental education. Worth visiting year-round for access to the Atlantic, coastal estuaries, and piney woods habitats that support many resident and migratory birds. Most famous for its winter waterfowl concentrations and its autumn shorebird migration. Good birding in any season.

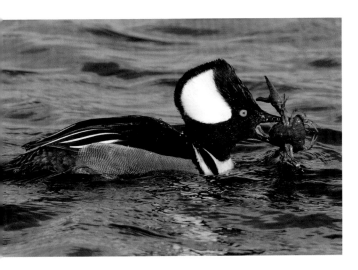

Also features the ponies! The causeway from the mainland to Chincoteague Island is excellent for birding but has few areas to pull off the road. GPS address: 8231 Beach Road, Chincoteague Island, VA. Website: https://www.fws.gov/refuge/Chincoteague/

99. Huntley Meadows Park, south of Alexandria, VA. This small but bird-rich park includes bottomland hardwood forest and a central wetland and boardwalk. Birding is good year-round but especially in midspring. Great for migrant warblers and marsh birds. Featured species include Hooded Merganser, Green Heron, Red-headed and Pileated Woodpeckers, and Prothonotary Warbler. Mississippi Kite can be found in spring on occasion. GPS address: 3701 Lockheed Boulevard, Alexandria, VA. Website: http://www.fairfaxcounty.gov/parks/huntley-meadows-park/

100. Kiptopeke-Cape Charles, Virginia. There is much bird activity here in the fall. The Cape Charles Christmas Bird Count began in 1965 and usually tallies 150 or more species. The hawk watch, conducted September to November since 1977, often records 20,000 or more raptors at Kiptopeke State Park. Fall Monarch research and tagging here has been conducted since 1998. There is also the Delmarva Tip Butterfly Count, initiated in 1999, on the last Sunday in July, when 40 or more species can be located within the same boundaries as the Christmas Bird Count. Finally, a sea watch for Chesapeake Bay is held just north of the state park,

begun in 2013, from October into early December. GPS address: 3540 Kiptopeke Drive, Cape Charles, VA. Website: www.cvwo.org

101. Leesylvania State Park, Woodbridge, VA. Located along the Potomac River on the peninsula between Neabsco Creek and Powells Creek, the park comprises mixed hardwood forests, river frontage, tree-covered and open picnic areas, swamps, and scattered open areas. Freestone Point often attracts diverse and abundant migrants in spring and fall, with the Lee's Woods trail that circles up through the wooded slopes above the main parking lot especially productive on mornings after heavy flights. Also of particular interest to bird watchers are the swampy shore along Powells Creek and the one-mile-long Bushey Point trail. Viewpoints along the Potomac provide opportunities for scanning over-wintering waterfowl, gulls, and Bald Eagles. In addition, the variety of habitats supports a diverse list of breeding birds. The park can become quite crowded on weekends (especially in early summer and fall), so early morning visits are more enjoyable (and rewarding) then. GPS address: 2001 Daniel K. Ludwig Drive, Woodbridge, VA. Website: https://www.dgif.virginia.gov/vbwt/sites/leesylvania-state-park/

102. Mason Neck State Park, southeast of Lorton, VA. Beautiful bottomland hardwood forest and access to the western shore of the Potomac. Great spring birding for songbird migrants on the Bayview Trail: Acadian Flycatcher, Yellow-throated Vireo, Prothonotary Warbler, and Scarlet Tanager. The bluff at the Visitor Center offers an excellent vantage point for scanning Belmont Bay for wintering waterfowl and year-round Bald Eagles. GPS address: 7301 High Point Road, Lorton, VA. Website: http://www.dcr.virginia.gov/state-parks/mason-neck#general_information

103. Occoquan Bay National Wildlife Refuge, southeast of Woodbridge, VA. Wetland habitats cover about 50% of the refuge and include wet

Huntley Meadows Park offers great viewing for a variety of waterbirds, especially Hooded Mergansers, who have a taste for crayfish.

meadows, bottomland hardwoods, open freshwater marsh, and tidally influenced marshes and streams. About 20% of the unit is upland meadows, with the remaining vegetated areas consisting of mature or second-growth forest. The plant diversity of this refuge is outstanding—650 plant species are known to be present. Birds: Nesting Osprey, wintering Bald Eagles and American Tree Sparrows, and displaying American Woodcock in early spring (and much more!). GPS address: 14050 Dawson Beach Road, Woodbridge, VA. Website: https://www.fws.gov /refuge/occoquan_bay/

104. Roosevelt Island, Washington, DC. This low wooded island in the Potomac across from downtown Washington, DC, is worth visiting on a midspring morning for songbird migrants. It is also a pleasant woodland walk anytime of the year. Migrant songbirds visit the oaks of the slight upland area that features a giant statue of Theodore Roosevelt. The marsh at the south end of the island attracts Swamp Sparrows and Marsh Wrens, as well as wandering Snowy and Great Egrets. Permanent residents include Barred Owls and Pileated Woodpeckers. The island is best visited by bicycle and the Mount Vernon bike path south from Key Bridge. By

car, the parking lot is only accessible by exiting right (east) off the northbound lane of the George Washington Parkway in Virginia, just north of Theodore Roosevelt Bridge. GPS address: Exit right at ramp at these coordinates: 38.897843, −77.067783. Website: https://www.nps.gov/this/index.htm

105. Saxis Marshes, 10 miles east of Chincoteague, VA, on the Chesapeake Bay. Wet broom sedge grasslands and open needlerush marshlands are home in late spring to Sedge Wren (occasional), Marsh Wren, Clapper and Virginia Rails, and Seaside Sparrow. Look for Rough-legged Hawk in winter. Formerly hosted Black Rail and Henslow's Sparrow. Directions: West on Road 695 from Route 13. GPS address: Saxis Road, Saxis, VA (coordinates: 37.921927, −75.700324). Website: https://www.dgif .virginia.gov/wma/saxis/

106. Snicker's Gap Hawk Watch, Bluemont, VA. At the high point where Route 7 passes west over the Blue Ridge. Can be very productive for Broadwinged Hawk in mid-September, with counts in the hundreds or thousands when a light east wind is blowing. GPS address: Snickers Gap Appalachian Trailhead, Bluemont, VA. Website: http://hawk count.org/siteinfo.php?rsite=494

Just a stone's throw from our Region, the various nature reserves at Cape May, NJ, offer world-class birding, especially during fall migration. Photo: Bruce Beehler

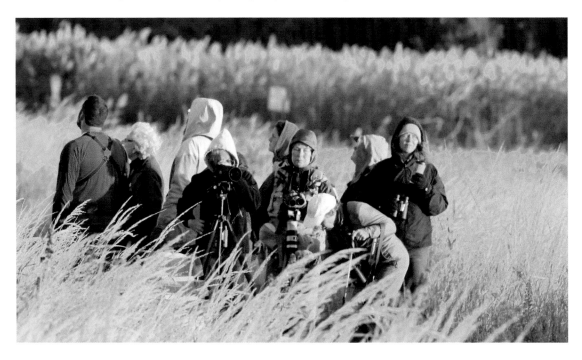

Pelagic seabirding cruises with Brian Patteson of Hatteras, NC, deliver close encounters with a bevy of sea creatures, including these Atlantic Bottlenose Dolphins.

New Jersey

107. Edwin B. Forsythe / Brigantine National Wildlife Refuge. North of Atlantic City, NJ, protects more than 47,000 acres of southern New Jersey coastal habitat. It is managed for migratory birds. The refuge's location along one of the Atlantic Flyway's most active flight paths makes it an important link in seasonal bird migration. Forsythe hosts birds in all seasons. It is sensational during both spring and fall migration, as well as for wintering waterfowl, including rare geese and ducks. Forsythe supports a diversity of species but also birds in large numbers. Note that the refuge was heavily damaged by Hurricane Sandy in late October 2012. GPS address: 800 Great Creek Road, Galloway, NJ. Website: https://www.fws.gov/refuge/edwin_b_forsythe/

108. Cape May, New Jersey, southernmost New Jersey. Accessible from our Region either by the Cape May–Lewes Ferry in Lewes, DE (itself a great opportunity for bird-spotting), or by highway via the Delaware Memorial Bridge into New Jersey and then southward to Cape May. This is one of our nation's premier birding hotspots. Best in autumn but also good in spring and winter. There are always good birds to be seen—even in summer. Visit Higbee Beach in September, the hawk watch platform at Cape May Point in late September and October, and the sea watch in Avalon (to the north) in October to early December to experience the autumn migration in full. Get your bearings at the Northwood Center at Cape May Point, which is an excellent place to buy bird books, feeders, and other bird-related items. It also has a fine selection of optics for sale, which you are welcome to try out on the birds around the center. Birds: Waterbirds in fall and spring; raptors in fall; songbird migrants in autumn and spring; rarities at any time. Also a great place to find concentrations of expert birders during the peak autumn season. This is a great place to spend a long autumn weekend birding and relaxing. GPS address: 306 County Highway 629, Cape May, NJ. Website: http://www.njaudubon.org/SectionCapeMayBirdObservatory/CMBOHome.aspx

Pelagic

109. Seabirding Pelagic Cruises, Hatteras, NC. Brian Patteson leads the most famous and most frequent East Coast pelagic trips, departing from the Outer Banks of North Carolina, where it is only a short trip to the Gulf Stream waters. This is the place to see Black-capped Petrel in late May and late September. Over the year, these cruises find all the shearwaters, petrels, jaegers, and storm-petrels that can be seen in the Mid-Atlantic region. GPS address to boat slip: 58848 Marina Way, Hatteras, NC. Website: http://www.patteson.com/.

Contributors

Author

Bruce M. Beehler is an ornithologist, conservationist, and naturalist. He is currently a Research Associate in the Division of Birds at the National Museum of Natural History, Smithsonian Institution. Beehler has spent much of his scientific career studying and working to conserve birds and their forest habitats. After conducting doctoral fieldwork in the Pacific, Beehler worked for 10 years at the Smithsonian's National Museum of Natural History, followed by stints at the Wildlife Conservation Society, US Department of State, Counterpart International, Conservation International, and the National Fish & Wildlife Foundation. Beehler is an elective Fellow of the American Ornithologists Union and has served on the boards of RARE, American Bird Conservancy, and Livingston-Ripley Waterfowl Conservancy. Today, he serves on the Advisory Council of the Rainforest Trust and the boards of the Tree Kangaroo Conservation Programme and the Maryland Ornithological Society. Beehler has published 10 books and authored scores of technical and popular articles about nature. In 2007, Beehler was featured on *60 Minutes* documenting an expedition he led to the Foja Mountains in the interior of New Guinea in which scores of new species were discovered. Today, Beehler writes books on wildlife and natural places in North America. Visit Beehler's nature blog at https://birdsandnaturenorthamerica.blogspot.com.

An overgrown meadow in New Castle, DE, provides fabulous habitat for a host of sparrows, finches, and other songbirds.

Lead Photographer

Middleton Evans is a Baltimore-based wildlife photographer with more than 20 years' experience photographing wild birds all across North America. He is recognized as a leader in wildlife photography in Maryland. Evans's work has appeared in six books, annual calendars, and various work assignments. In addition, Evans is a seasoned presenter to a variety of public audiences, in which he discusses his stunning nature images. He is a graduate of Duke University and McDonogh School. His favorite achievement was documenting the wildlife of Baltimore's Patterson Park over 15 years for a deluxe coffee-table book entitled *The Miracle Pond* (Ravenwood Press, 2015). Evans has served on the board of Audubon Maryland / DC and was selected by Maryland Public Television as one of Maryland's six distinguished photographers of the twentieth century. Visit Evans's website at www.ravenwoodpress.com/.

Technical Editor

Robert F. Ringler has birded the Maryland-Delaware-DC area for more than five decades and is considered by many to be one of the deans of Maryland birders. In addition, Ringler has collected records of bird sightings from all sources, and knows more about the historical occurrence of birds in our Region than any other living person.

Photography Notes

A number of people were extremely helpful in providing access to special locations and for suggesting venues to see key species. We offer a special thank-you to these gracious souls: Dave Curson, Jon Shaw and Anne Habberton, Kyle Rambo, Mike Dreisbach and Jan Russell, Dave Brinker, Paul Spitzer, Gerda Deterer, Megan DiFatta, Chris Homeister, Wayne Bell, George Radcliffe, Mac MacDonald, Greg Futral, Tim Carney, Ryan Johnson, Rob Mardiney, Tom Roland, Richard Orr, Bonnie Ott, David Fleischmann, Gene Ricks, Keith Eric Costley, Kurt R. Schwartz, Ralph Cullison, Anthony VanSchoor, Derek Stoner, Greg Kearns, Mark R. Johnson, Bob Walck, Tom Dembeck, Kathy Woods, Hugh Simmons, Dan Small, Mary Gustafson, George Williams, Mike Callahan, and Bryan Glorioso.

We are grateful to Brian Miller of Full Circle Lab for his expert eye in color balancing all the images in this collection.

We would like to thank the following photographers for permission to reproduce their copyrighted images.

Numbers refer to pages; letters refer to page position: t = top, m = middle, b = bottom, l = left, r = right.

Bruce Beehler, 15, 24, 31t, 38t, 44–45, 49, 50, 145, 233, 238, 279, 292bl, 294ml, 306tl, 317br, 324ml, 326br, 328mr, 350ml, 353tl, 444
William Burt, 121, 302br

449

Tim Carney, 329br, 343bl, 344tr, 351tl

J. B. Churchill, 299ml, 303tr, 323br, 335br, 371m

Chip Clark, 276

Keith Eric Costley, 129b, 232t, 305br, 342bl

Marie-Ann D'Aloia, 184

H. David Fleischmann, 52b, 257, 362b, 368t

Mark L. Hoffman, 246b, 254b, 305tl, 315ml, 330tl, 337ml, 340bl, 342ml, 360m, 360r, 361t, 361b, 362t, 362m, 364m, 365b, 367m, 369t, 369b, 370m, 371t

Daniel Irons, 301mr, 326tl, 331tl, 365t, 365 m, 367t, 367b

Mark R. Johnson, 122t, 188, 198t, 205t, 292tr, 292br, 303tl, 306br, 313bl, 322tl, 324tr, 341ml, 350br, 368b

Ryan Johnson, 237, 328tr, 366t, 367m

Josie Kalbfleisch, 366b

Emily Carter Mitchell, 20, 148–49, 154, 201t, 255, 302bl, 348bl, 423

Frank Nicoletti, 76t

Bonnie Ott, 27, 57, 200, 218, 242, 251, 312br, 339tr, 340ml, 345tl, 345br

Gene Ricks, 300ml, 307bl, 313tr, 368m, 370t

Kurt R. Schwarz, 296ml, 300br, 340br, 357bl, 371b

Anthony VanSchoor, 191, 309ml, 322bl, 327bl, 431

W. Scott Young, 52t, 70, 325ml, 362m, 370m

Unless otherwise noted, the photographs in this volume were shot with Nikon equipment by Middleton Evans. A number of the images date to the film era, recorded on a variety of Kodak and Fuji films. The bulk of the collection was made with Nikon digital cameras, ranging from the D2H to the D500 models. Every effort was made to provide images recorded in our Region, but it was deemed acceptable to use images shot outside our Region when there was no high-quality local image available. Because of the scarcity of pelagic viewing opportunities in our Region, several of the pelagic species were photographed off New Jersey, Virginia, and North Carolina, where more pelagic trips are offered. With the photography coming from a variety of mediums, shot on various camera systems, and provided by 21 photographers in all, the entire collection was color balanced in Lightroom on a calibrated iMac monitor at Full Circle Lab, to create a consistent look for CMYK printing.

Addendum

What follows are remarkable observations and new state records that have been received since we completed the final manuscript in January 2018. This addendum includes two new species accepted for the Region—Elegant Tern and Monk Parakeet. Note that these two do not appear in the master occurrence list in chapter 28. Therefore, that list includes only 467 species, whereas the Regional list is now 469 species—the number that appears on page 5.

The first list includes records accepted by a state or district records committee. The second list includes records that remain pending with the committees.

Species Records Accepted by the Region's Records Committees

Pink-footed Goose, Ridgely, MD, February 2018.

Trumpeter Swan: first record for Delaware (decision 2017). Prime Hook NWR, DE, January 2016.

Limpkin, Howard County, MD, June 2018.

Zino's/Fea's Petrel, pelagic zone of Maryland, July 2013.

Trindade Petrel, the pelagic zone of Maryland, July 2013.

Western Grebe, Berlin, MD, February 2018.

Sabine's Gull, Washington, DC, September 2017, and Poplar Island, MD, September 2017.

Elegant Tern: first record for Delaware (decision 2018). Cape Henlopen, DE, August 2017. Note that this species does not appear in the main table of chapter 28.

Black Guillemot, Ocean City, MD, January 2018.

Prairie Falcon, Washington, DC, 25 March to 16 April 2017. This bird was mainly based in Virginia but occasionally strayed into Washington, DC, territory. First record for Washington, DC (decision 2018).

Monk Parakeet: newly recognized species for Delaware (decision 2017). Smyrna, DE, September 2009. Note that this species does not appear in the main table of chapter 28.

Scissor-tailed Flycatcher, Washington, DC, May 2018.

Western Tanager: first record for Delaware (decision 2018). Sussex County, DE, January 2018.

Observations Not Yet Reviewed by the Records Committees

White-winged Dove, Calvert County, MD, May 2018.

Eurasian Collared-Dove, Bowie, MD, April 2018, and Dorchester County, MD, September 2018.

Masked Booby, pelagic zone of Maryland, August 2016.

Brown Booby Ocean City, MD, November 2017, and Queen Anne's County, MD, and Kent County, MD, in July 2018.

Black-capped Petrel, pelagic zone of Delaware, September 2016.

Juvenile Long-tailed Jaeger, Deep Creek Lake, Garrett County, MD, September 2018.

Great Skua, pelagic zone of Delaware, February 2016.

South Polar Skua, pelagic zone of Delaware, September 2016.

Reddish Egret, Gordons Pond, Delaware, October 2018.

Gyrfalcon, Violette's Lock, Montgomery County, MD, December 2017.

Le Conte's Sparrow, Queen Anne's County, MD, April 2017.

Black-throated Gray Warbler, Cape Henlopen, DE, September 2018.

Index

Scientific names of birds appear only in chapter 28 (the seasonal checklist of birds), accompanying English common names. Scientific names are included in the index for specialists who prefer to use them. Common names of birds are listed under the generic (second) name of the bird. For example, "Black-crowned Night-Heron" is inverted as "Night-Heron, Black-crowned." Page numbers for species accounts in chapters 26 and 27 are in boldface. Page numbers for illustrations (excluding those in chapter 26) are in italics.

453

The Maryland Ornithological Society (MOS) is a nonprofit, statewide organization of people who are interested in birds and nature. It was founded in 1945 and incorporated in 1956 to promote the study and enjoyment of birds. MOS fosters knowledge about our natural resources and their appreciation and conservation. MOS also maintains 10 sanctuaries to encourage the conservation of birds and bird habitat, and publishes a technical journal documenting the state's birdlife.

MOS supports 15 local chapters across the state, each of which offers field trips, bird counts, and conservation projects for members and other local participants. Lively and informative programs complement regular meetings where members and guest speakers share their knowledge and expertise.

Anyone who enjoys watching birds should join the Maryland Ornithological Society. Beginners as well as experienced birders are encouraged to become participating members. Local chapters conduct programs and activities for people of all ages, from children through seniors. Moreover, anyone interested in the conservation of birds and bird habitats should join MOS. The state MOS organization acts as an advocate for birds at the state and national levels and local chapter work on behalf of birds at the local and county level. The MOS cosponsors important conservation initiatives, provides expert testimony to support environmentally sound bird and habitat management, and organizes fund-raising drives to support purchases of conservation lands.

Whether you simply like to look out your window at a bird feeder or put on hip waders for a trek through the swamp, membership in the Maryland Ornithological Society will enrich your birding life. No matter what your birding ability, you will meet new friends, grow in your knowledge of birds and nature, and have fun.

Your membership in the Society provides support for the sanctuary program, scholarships and research grants, and subscriptions to publications of the Society. More importantly, however, your membership means you become a partner with those who care about wise stewardship of our natural resources. Join today!

Maryland Birdlife is published twice annually to present the results of bird studies in and around Maryland. This journal was edited for many decades by world-renowned ornithologist Chandler Robbins. The final issue under his expert oversight was published in 2014. *Maryland Birdlife* contains original articles, notes, and research papers primarily pertaining to Maryland and the Mid-Atlantic region. All submissions are subject to editorial review and acceptance. Articles and research papers are peer-reviewed. *Maryland Birdlife* is provided to members of the MOS as part of their membership package.

The *Yellowthroat*, the newsletter of the Maryland Ornithological Society, is issued five times a year and contains articles of interest to the Maryland birding community. It is free to all MOS members. Each issue of *The Yellowthroat* contains newsworthy items as well as regular columns and features.

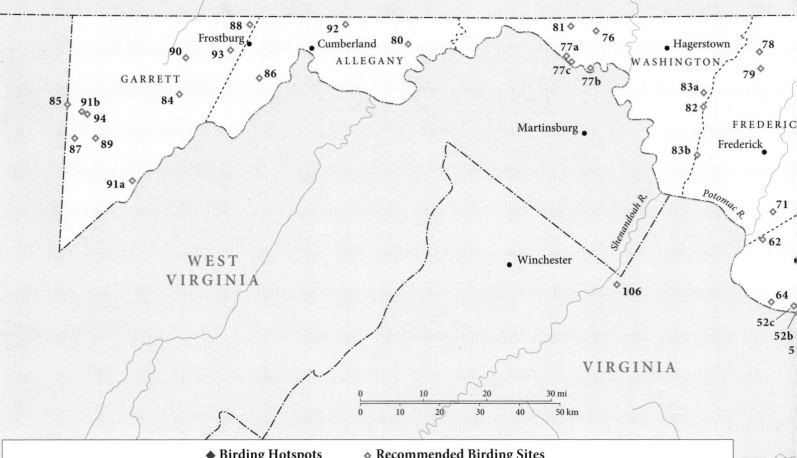

◆ **Birding Hotspots** ◇ **Recommended Birding Sites**
(numbers refer to accounts in Chapter 29)

1	Abbott's Mill Nature Center	40	Jug Bay Natural Area
2	Assateague Island State Park	41	National Arboretum
3	Assawoman Wildlife Area	42	National Zoological Park
4	Blackwater National Wildlife Refuge	43	Parker's Creek Preserve
5	Bombay Hook National Wildlife Refuge	44	Patterson Park
6	Bill Burton Fishing Pier State Park	45	Patuxent Research Refuge
7	Cape Henlopen State Park	46	Point Lookout State Park
8	Chino Farms	47	Rock Creek Park
9	Deal Island Wildlife Management Area	48	Sandy Point State Park
10	DuPont Nature Center at Mispillion Harbor Reserve	49	Ashland Hawk Watch and Nature Center
11	Eastern Neck National Wildlife Refuge	50	Audrey Carroll Audubon Sanctuary
12	Elliott Island Road	51	Brandywine Creek State Park
13	Hickory Point Cypress Swamp	52a	Pennyfield Lock
14	Hooper's Island	52b	Violette's Lock
15	Indian River Inlet	52c	Riley's Lock
16	Little Creek Wildlife Area	53	Conowingo Dam
17	Ocean City Inlet	54	Cromwell Valley Park
18	Pea Patch Island	55	Elk Neck State Park
19	Paulagics Cruises	56	Fair Hill Natural Resources Management Area
20	Pickering Creek Audubon Center	57	Fort DuPont State Park
21	Pocomoke Swamp/Great Cypress Swamp	58	Gunpowder Falls State Park (various sites)
22	Pocomoke River State Park	59	Howard County Conservancy/Mt. Pleasant
23	Poplar Island	60	Irvine Nature Center
24	Prime Hook National Wildlife Refuge	61	Liberty Reservoir Cooperative Wildlife Mgmt Area
25	Smith Island	62	Little Bennett Regional Park
26	Ted Harvey Conservation Area-Logan Lane Tract	63	Loch Raven Reservoir
27	Thousand Acre Marsh	64	McKee-Beshers Wildlife Mgmt Area/Hughes Hollow
28	Tilghman Island (Black Walnut Point)	65	Middle Run Natural Area
29	Trap Pond State Park	66	Newark Reservoir
30	Truitt's Landing	67	Patapsco Valley State Park
31	Tuckahoe State Park	68	Patuxent River State Park
32	Battle Creek Cypress Swamp Sanctuary	69	Seneca Creek State Park
33	Cylburn Arboretum	70	Soldier's Delight Natural Environmental Area
34	Dumbarton Oaks Park	71	Sugarloaf Mountain/the Stronghold
35	East Potomac Park, Hains Point	72	Susquehanna State Park
36	Fletcher's Boat House/Fletcher's Cove	73	Swan Harbor Farm
37	Fort McHenry National Monument	74	Triadelphia Reservoir
38	Fort Smallwood Park	75	White Clay Creek State Park
39	Hart-Miller Island	76	Blairs Valley

77a	Big Pool
77b	Prather's Neck
77c	Fort Frederick
78	Catoctin Mountain Park
79	Cunningham Falls State Park
80	Green Ridge State Forest
81	Indian Springs Wildlife Management Area (several)
82	Monument Knob
83a	South Mt Recreation Area (Greenbrier SP)
83b	South Mt Recreation Area (Gathland SP)
84	Big Run State Park/Savage River State Forest
85	Cranesville Swamp
86	Dan's Rock Wildlife Management Area
87	Herrington Manor State Park
88	Finzel Swamp
89	Mt. Nebo Wildlife Management Area
90	New Germany State Park
91a	Potomac-Garrett State Forest (Potomac)
91b	Potomac-Garrett State Forest (Garrett)
92	Rocky Gap State Park
93	Savage River State Forest/Mt. Aetna Area
94	Swallow Falls State Park

Outside the Maryland-Delaware Region

95	(NS) Hawk Mountain Sanctuary (NS = not shown on map)
96	(NS) Waggoner's Gap Hawk Watch
97	(NS) Back Bay National Wildlife Refuge
98	Chincoteague National Wildlife Refuge
99	Huntley Meadows Park
100	(NS) Kiptopeke-Cape Charles, VA
101	Leesylvania State Park
102	Mason Neck State Park
103	Occoquan Bay NWR
104	Roosevelt Island
105	Saxis Marshes
106	Snicker's Gap Hawk Watch
107	(NS) Edwin B. Forsythe NWR/Brigantine
108	Cape May, NJ
109	(NS) Seabirding Pelagic Cruises, Hatteras, NC